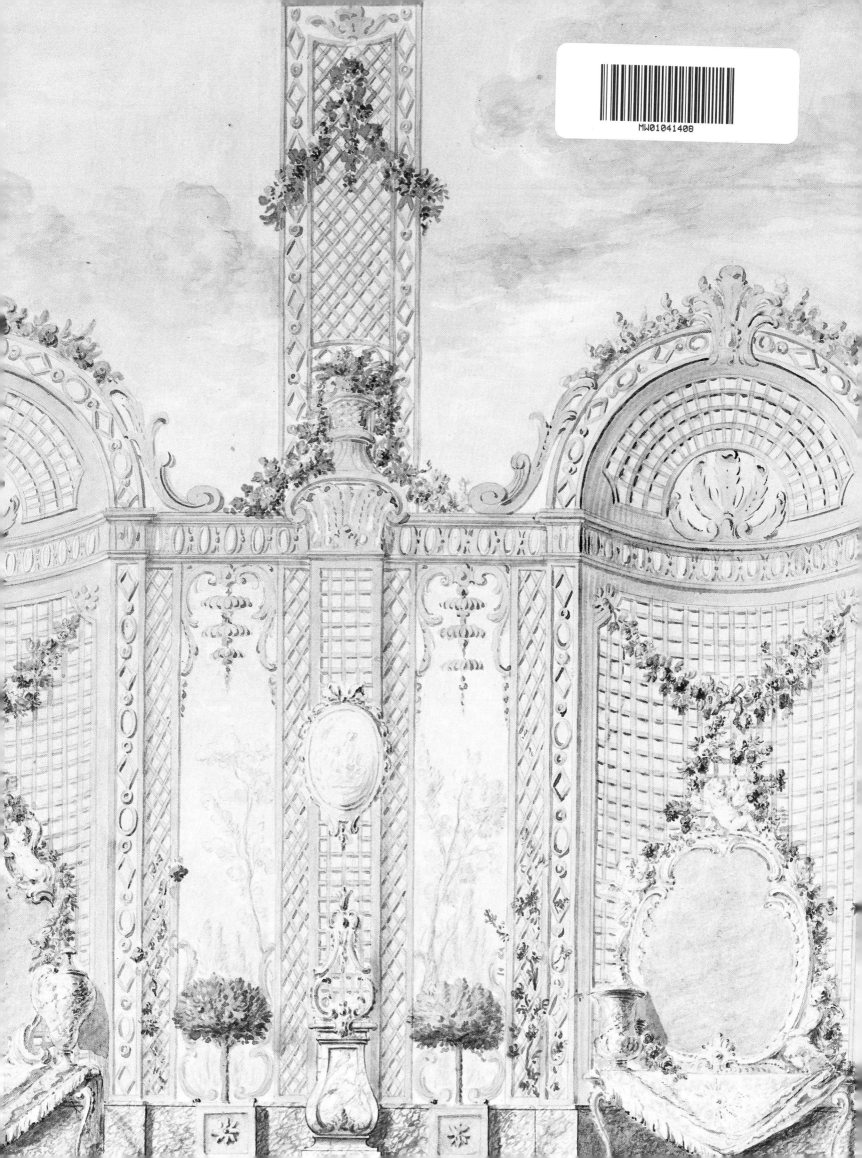

The History of Decorative Arts

Classicism and the Baroque in Europe

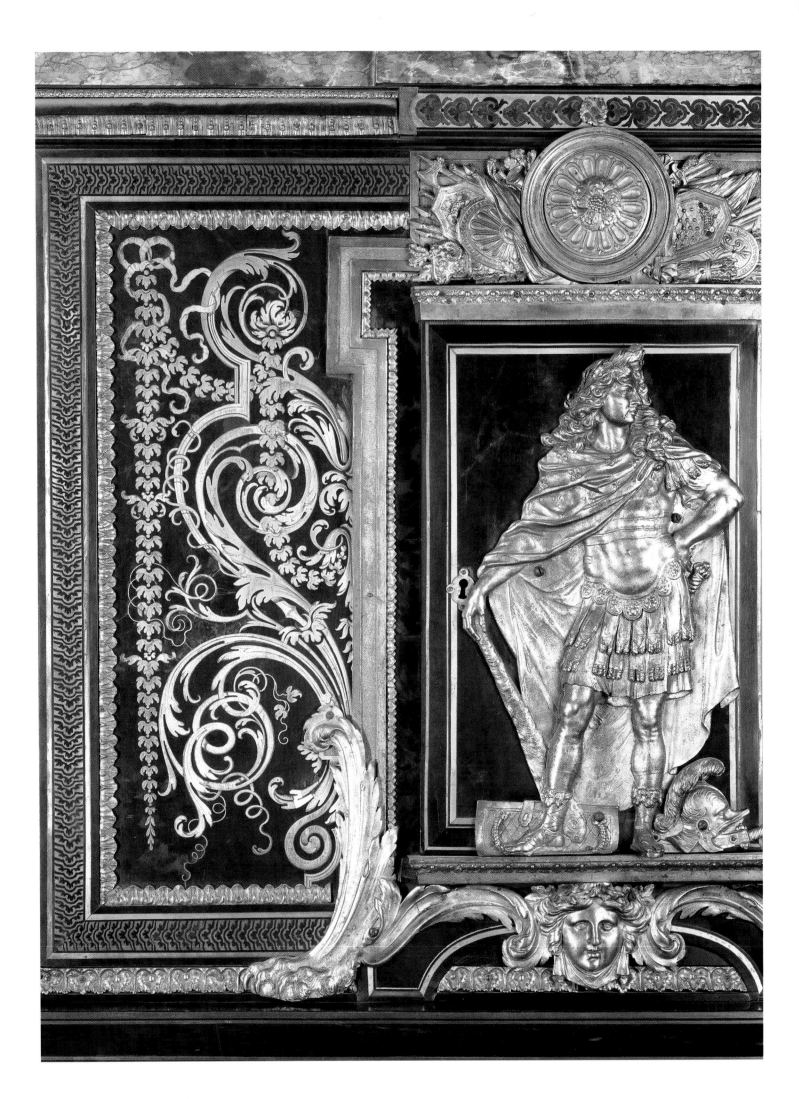

The History of Decorative Arts

Classicism and the Baroque in Europe

UNDER THE DIRECTION OF **ALAIN GRUBER,** *Doctor of the History of Art*

WITH CONTRIBUTIONS BY

BRUNO PONS

Advisor for Research and Exterior Relations, Ecole Nationale du Patrimoine

JOHAN R. TER MOLEN

Curator of the Department of Decorative Arts, Boymans-van Beuningen Museum

URSULA REINHARDT

Doctor of the History of Art

ROBERT FOHR

Art Historian and Critic

TRANSLATED FROM THE FRENCH BY **JOHN GOODMAN**

Abbeville Press Publishers

NEW YORK LONDON PARIS

JACKET FRONT

Folding screen, Jacques de Lajoue, c. 1735–40 *(see page 359)*.

JACKET BACK

TOP LEFT: Ewer, Adam van Vianen, Utrecht, 1614 *(see page 26)*. TOP RIGHT: Detail of wall painting in the
dining room at the Château of Vaux-le-Vicomte, 1656–61 *(see page 123)*. BOTTOM LEFT: The gardens at Het Loo,
Apeldorn, Holland, 1686–1702 *(see page 185)*. BOTTOM RIGHT: Plate decorated with dragon motif, faïence,
Rouen, c. 1760 *(see page 252)*.

FRONTISPIECE

Detail of a *cabinet d'apparat*.
Paris, Louvre

*W*ith its Boulle marquetry and rich gilt bronze fittings, this piece perfectly exemplifies the fusion of Baroque
and classical idioms characteristic of Italian and French productions of the period. Within the frame—and
presented as if it were a secular host—is a relief figure of Louis XIV as the Gallic Hercules, wearing a wig but
otherwise dressed like a Roman warrior. This cartouche, defined by moldings, is supported by lion's feet
sprouting acanthus and is surmounted by a trophy of arms. The cabinet's surfaces feature marquetry work of
pewter and brass arrayed in delicate configurations of acanthus rinceaux against a tortoiseshell ground.
The fittings are all cast in forms with ancient pedigrees that appealed to classicizing French taste.

In the original French edition, the chapter "Acanthus" was translated from the German by Elizabeth Ramella,
and the chapter "The Auricular Style" was translated from the Dutch by M.-L. Domela Nieuwenhuis.

Graphic Design: Ecran / Papier – Pierre Dusser

ENGLISH-LANGUAGE EDITION

Editor: Jacqueline Decter
Manuscript Editor: Stephen Robert Frankel
Copy Editor: Jane Martin
Typographic Design: Barbara Sturman
Production Editor: Owen Dugan
Production Manager: Lou Bilka

First edition

2 4 6 8 10 9 7 5 3 1

This work was published with the assistance of the Centre national du livre.

ISBN 0-7892-0079-1

LIBRARY OF CONGRESS CATALOGING-IN-PUBLICATION DATA
The Library of Congress has cataloged the previous volume as follows:
Art décoratif en Europe. Renaissance et maniérisme. English.
The history of decorative arts. The Renaissance and mannerism in Europe / preface by Jacques Thuillier ;
editor, Alain Gruber ; with the collaboration of Margherita Azzi-Visentini . . . [et al.] ;
translated from the French by John Goodman.
p. cm.
Traces the use of interlace, rinceaux, grotesques, Moorish tracery, and strapwork in the decorative arts.
Includes bibliographical references (p.) and index.
ISBN 1-55859-821-9
1. Decorative arts, Renaissance—Catalogs. 2. Decoration and ornament, Renaissance—Catalogs.
3. Decoration and ornament—Europe—Mannerism—Catalogs. I. Gruber, Alain Charles.
II. Azzi-Visentini, Margherita. III. Title.
NK760.A7813 1994
745.4'43—dc20 94-11053

Contents

~ *Preface* ~

This volume, which treats the period between 1630 and 1760, is the second in a set of three that examine the history of ornament and its application in the European decorative arts.

In France the discipline of art history is relatively young. Certain areas of its inquiry, while long the focus of research in German- and English-speaking nations, have been broached by the French only rarely and selectively, and such is the case with the field under consideration here. Initially, the ambitious undertaking embodied in this project is likely to produce a certain disorientation, for it is premised on an understanding of the evolution of the European decorative arts that goes against the contemporary interpretive grain. In France, and perhaps elsewhere as well, the term *ornament* lends itself to confusion. There is no real consensus among the interested communities—whether professional or amateur—as to its meaning. This lack of precision is a relatively recent phenomenon, however; it seems to have developed in the 1930s, when ornament as defined here lost much of its importance. The following introduction will examine the meanings ascribed to the word during the one-hundred-and-thirty-year period studied in this volume.

It should be self-evident that the work of art can be broken down into three essential elements: form, decoration or ornament, and execution. This taxonomy, which prevailed for centuries and even millennia, is not easily mapped onto contemporary artistic production, or onto the artistic sensibility as presently conceived. But it remains fundamental to any adequate appreciation of works produced in the past.

Form is relatively easy to define: it is judged in accordance with criteria of proportion that are as applicable to architectural volumes as to the shape of a snuffbox or the compositional equilibrium of a painting.

For centuries, execution has been the part that led us to appreciate an artist's craft or virtuosity. The methods and techniques acquired from teachers, refined during an apprenticeship and perfected in the course of a career, determined assessments of a production's quality. Often, and especially in the case of luxury objects, the use of rare and sometimes intractable materials was also taken into account.

Ornament consists of everything that adds to the basic forms a note of elegance, a decorative touch that distinguishes basic tectonic construction from artistic creation. A paradigmatic example often cited in art-theoretical treatises is the difference between a column and a simple post. The latter, however perfectly proportioned, becomes a column only when it culminates in a decorated capital.

Each of the three volumes in this series consists of five chapters devoted to principal ornamental currents of the period, with an introduction that presents historical and artistic information about the period. Given the richness of the material, the only way to avoid chaos was to be very selective and to impose a strong organizational scheme, and I am fully aware that many will disagree with some of the choices made

here. By way of compensation, each essay is lavishly illustrated with images selected by the authors to elaborate on and reinforce the ideas presented in the texts.

The authors were asked to examine the diffusion and use, on an international scale, of specific sets of decorative motifs devised and engraved by ornamentalists, but each was left free to choose the analytic approach best suited to the problems posed by the particular motif or style.

The reader is thus given two modes of access to the subject: a somewhat theoretical one in the essays, and a more concrete one in the carefully juxtaposed images and accompanying explanatory captions. Hopefully, this arrangement will encourage readers to discern connections on their own, and prompt them to take a heightened interest in the objects that surround them: if we have furthered a richer understanding of the vicissitudes of artistic creation and a fuller awareness of the intricate networks of influence incessantly playing over the field of the decorative arts, then our goal will have been achieved.

Alain Gruber

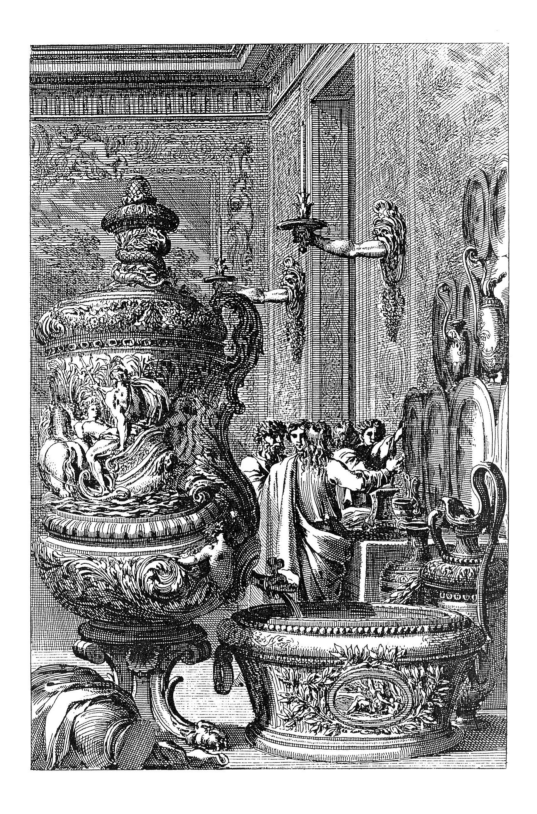

Engraving from a set entitled *Les Vases,*
Jean Le Pautre, published by Pierre
Mariette, 1657.

Private collection

The principal elements here—a large urn from
which liquid flows into a basin—are presented in a
decor that, while inflected with antique elements
(such as the togas worn by the figures), is in fact
a sumptuous Baroque interior. On the walls,
decorated with tapestries featuring rich borders
dominated by grotesque motifs, are eccentric
candelabra. A mixture of different decorative
styles is displayed here not only in the human
arms emerging from the auricular lion jaws
of the candelabra but also in the vases on the
buffet. In the foreground ensemble, acanthus
rinceaux are combined with garlands of
flowers and figured reliefs.

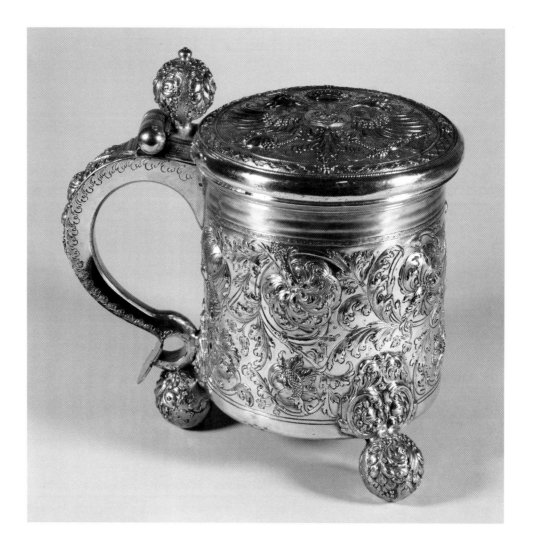

Large mug, partially gilded silver,
unidentified metalworker, Riga, c. 1680.

Private collection

*I*n accordance with a formula typical of opulent
drinking vessels from the Baltic region, this
monumental beer mug is mounted on three ball
feet that resemble pomegranates but are here
composed of acanthus leaves wrapped around
their seed pods. Another of these balls serves as a
thumb-piece for the cover, which is decorated
with a two-headed eagle, emblem of the free
Hanseatic city of Riga. The cup of the vessel is
encrusted with an elegant rinceau pattern
composed of acanthus and fanciful variations on
real acanthus blossoms. Plumes of acanthus are
delicately inscribed on the sides of the large,
solidly constructed handle.

Introduction

⁓ ◦⟡◦ ⁓

*I*n 1957 Victor L. Tapié published a book entitled *Baroque et Classicisme* that met with great success. The ideas advanced in it were new to France, where the term *Baroque* still retained certain pejorative connotations with which *classicism* was unencumbered. In the interim, French art historians have come to accept his point of view, first articulated by Jakob Burckhardt and thereafter given more sophisticated form by Cornelius Gurlitt, Heinrich Wölfflin, Werner Weisbach, A. E. Brinckmann, Fiske Kimball, and several other German- and English-speaking scholars.

Consistent with the values of the era, Tapié's brilliant and original study was limited to architecture, painting, and sculpture, omitting the decorative arts. It is with the intention of filling this gap as well as in hopes of dispelling the longstanding antipathy between these two categories that we decided to subtitle the present volume "Classicism and the Baroque." For in the domain of the decorative arts the two stylistic tendencies managed to cohabit quite comfortably, even in countries renowned for their supposed aversion to anything touched by the Baroque spirit.

The Baroque loves everything that is theatrical, fantastic, inventive, and luxurious: ample forms; animated movement; lines that are curved, undulating, and broken; polychromy; rich and varied materials; artifice and opulence. In France it was closely linked to the Italianizing taste that held sway at court in the mid-seventeenth century, generating a line of development in the decorative arts that continued more or less unimpeded from 1630 to 1760. However, this current was in dialogue with opposing tastes generated by another France, that of a bourgeoisie sufficiently prosperous and cultivated to impose its own preferences. This class was wedded to tradition, suspicious of originality, drawn to simplicity and even austerity, attached to realism and rationalism, order and unity, renouncing all unnecessary ornament, and thus its natural affinities were with a more classical idiom. While the so-called major arts have usually adhered to classical precepts, the decorative arts are by their nature more Baroque in spirit. The international success of French art in the seventeenth and eighteenth centuries is probably due in large

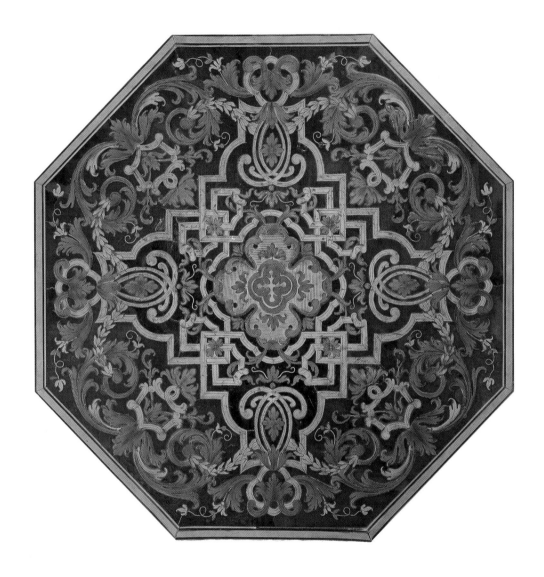

Candlestand top in the style of
André-Charles Boulle, c. 1680.

Paris, Musée Carnavalet

This small octagonal top of a stand intended to sup-
port a candlestick is decorated with ribbon interlace
configurations, alternately angular and curved as in
arabesque designs. Pewter ribbons intermingle
with copper acanthus florets and rinceaux set into a
tortoiseshell ground. Furniture of this type was
intended for the most sumptuous surroundings, and
was already extremely rare in the period.

part to the remarkable success with which it combined these two apparently incompatible vocabularies, consistently attaining a satisfying formal equilibrium.

Artistic movements are inextricable from historical events, and genius can function only in circumstances favorable to its development. Indeed, such conditions are crucial in the decorative arts, which are intimately shaped by the environment in which they are intended to give pleasure. The political circumstances in Europe around 1630 reflected the instability that had been pervasive there for more than a century. Incessant religious struggles that masked other, more narrowly social conflicts had engulfed all of northern Europe in a wave of blood and destruction that swept across the Holy Roman Empire from 1618 to 1648, precipitating its decline. Only the extent of the havoc wrought by the Thirty Years' War can explain the extraordinary outburst of creativity that followed upon the Treaty of Westphalia. Despite an uncertain future, a taste for embellishment of the everyday world, for luxurious dress and jewelry, became widespread, and paintings, books, and objets d'art were collected with frenzied enthusiasm.

The extensive reconfiguration of territorial boundaries effected at this time, which created Europe essentially as we know it today, was rife with implications for the artistic sphere. In the Medieval period and the Counter-Reformation, art had functioned as an instrument of religion; it now became a powerful political tool. The personalities holding the reins of government began to play a determinative role, controlling important commissions and so shaping taste. While patrons protected artists, they also kept them in a state of dependence. Beginning in the Renaissance, the most admired creative figures were less subject to the constraints imposed by this protectorship arrangement, especially in Italy, but in the rest of Europe it gradually became the norm. The famous quarrel between Gian Lorenzo Bernini, summoned to Paris in 1665, and the entourage of the young Louis XIV provides an emblematic example of the different mind sets then typical of Italy and France. The celebrated architect-sculptor had been asked to submit a design for completing the Louvre, but, seeing that it was greeted with less than the beatific enthusiasm to which he was accustomed, he returned to Italy in a huff. Bernini was in a much more privileged position than most decorative artists, whose works were regarded as nothing more than the realization of ideas generated by ornamentalists. Conditions could be even worse for some of them, if we can believe reports indicating that porcelain craftsmen working for Augustus II (1670–1733), grand elector of Saxony and king of Poland (and called Augustus the Strong), were held in quasi-detention.

From 1630 to 1760, France managed to impose its artistic hegemony on all of Europe. It owed this dominance to a few strong personalities who came from Italy or were deeply indebted to the Italian tradition. In 1612 Marie de Médicis (widow of King Henry IV and regent for her son Louis XIII) commissioned a sumptuous new residence, the Luxembourg Palace, to be modeled after the Palazzo Pitti in Florence, where she had spent her childhood. Ten years later, in choosing an artist to execute an ambitious painting cycle for the palace, she turned to Rubens, who was Flemish but whose sensibility had been shaped by his exposure to the small, luxurious courts of northern Italy. The queen mother surrounded

herself with Italians, who proceeded to set the tone in Paris. Léonora Galigaï, her lady-in-waiting, commissioned lodgings for herself in the Louvre whose extreme refinement dazzled other, less sumptuously housed courtiers and filled them with envy. In the same period the famous marquise de Rambouillet, of Italian origin, assembled a collection of beautiful objects—bronzes, Florentine porcelains, Venetian glass and crystal, Portuguese tiles, chinoiseries and productions imported from the Far East, Flemish paintings—which she displayed in her Parisian residence, whose interior disposition and decor were to revolutionize interior decoration. Marie de Médicis inculcated a taste for things Italian in her daughter-in-law, Anne of Austria, who arrived at the French court quite young and was overwhelmed by its luxurious accommodations, so strikingly different from what she had known in Spain. The ever-nimble Cardinal Mazarin, who came to France from Italy at the age of thirty-two, sought to seduce French public opinion with *fêtes,* theatrical presentations, and artistic manifestations of all kinds. Court life became brilliant, thanks to the presence of numerous Roman aristocrats exiled in France after the election of Pope Innocent x in 1644 and the Italian artists who followed in their wake. Mazarin, too, acquired sumptuous objects and arranged for their elegant display in his residence, thereby laying the foundations for the royal collection of such items, some of which can be viewed today in the showcases of the Galerie d'Apollon in the Louvre.

This milieu encouraged the young Louis xiv to develop Italianate tastes—a predilection for opulence, polychrome marbles, precious objects, extravagant furniture, and shimmering fabrics. From the gigantism of the Palace of Versailles to the fantasy of the Porcelain Trianon (now destroyed) and the richly colored Palladianism of his château at Marly, the king's tastes broke with the French classical tradition. But in the second half of his reign, on the advice of his entourage and his first minister Colbert, the sovereign favored a more rational, balanced style, the one now generally associated with the name of the Sun King. This idiom, which quickly spread throughout Europe, managed the remarkable hat trick of successfully combining the contradictory traditions of classicism and the Baroque. Henceforth, France was to remain faithful to this equilibrium, which allowed for fantasy but contained it within clearly circumscribed limits. The first half of the eighteenth century offers ample evidence of the formula's success. Neither Louis xv's regent (who ruled until Louis attained his majority in 1723) nor, later in the century, the king himself would have dreamed of disrupting the natural evolution of this trend, whose broad outlines had been laid down by their great predecessor.

Louis xiv's revocation in 1685 of the Edict of Nantes, which had protected the religious freedom of Protestants in France, had a much smaller impact on French artistic potential than has often been maintained. Nonetheless, Protestant emigrés were sufficiently numerous and active to exercise great influence abroad—especially in Holland, but also in England, Prussia, Sweden, and Switzerland. Although Louis xiv is often taken to task for this action, it effectively encouraged the spread of French taste. Had it not prompted the emigration of many artists who retained their attachment to French ways, the eyes of seventeenth-century Europe would have been less consistently fixed on the French example.

Arabesque designs, ink with gray wash
highlights, Nicolas Pineau, early
eighteenth century.

Paris, Musée des Arts Décoratifs

*I*n the tradition of Jean Le Pautre, who engraved
many similar compositions beginning in the mid-
seventeenth century, these arabesque designs—
meant to have an antique flavor—exemplify the
tendency to feature fantastic juxtapositions of
figures and objects in such motifs. The composi-
tions here are dense, as opposed to the airiness of
the first grotesques. A taste for asymmetrical
configurations is beginning to assert itself,
providing a foretaste of the rocaille, and the many
vegetal elements recall acanthus ornaments.

Vestibule in the Daun-Kinsky Palace,
Johann Lukas von Hildebrandt, 1713–16.

Vienna

The architectural fantasy displayed in the main-floor vestibule of this palace staircase would have been unthinkable in France at the time. Classical elements given codified form in the recent Italian and French traditions here engage in a playful dialogue with decorative elements that are undeniably Baroque in spirit: twinned pilasters with fantastic capitals, frames (setting off alternating mirrors and niches) that anticipate the rocaille, and a frieze with trophies of arms under the balcony. The banisters, composed of acanthus rinceaux and interlace bands reminiscent of arabesques, are punctuated by pedestals with pairs of gamboling putti supporting lamps.

The Low Countries, long receptive to influence thanks to their cosmopolitanism and prosperity, welcomed foreign artists and made it easy for their own to spend time in the great European artistic centers. Antwerp was at the peak of its glory in the second half of the sixteenth century and, despite political difficulties, managed to keep its artistic traditions vital throughout the seventeenth century. The Dutch Netherlands, which were Protestant, cultivated a formal vocabulary that, ultimately, was not so very different from that favored by their rivals, the Spanish Netherlands (present-day Belgium). Merchants in both Amsterdam and Antwerp, having become wealthy through both traditional commerce and the intelligent management of their India Companies, acquired a taste for decorative extravagance. Opulent clothing, lace, furniture, metalwork, faïence and porcelain, and flowers and gardens claimed much of their attention in both regions, the sole difference being that northern epicurism was less ostentatious than the southern variety. The stadholders of the United Provinces of the Netherlands, who dreamed only of monarchy, found consolation for their relative political impotence by assembling admirable collections. William III, Prince of Orange, was elected stadholder of six of the seven Dutch provinces in 1672 (and in 1677 married the King of England's daughter, Mary, the two of them succeeding to the British throne in 1689). He remained Louis XIV's staunchest enemy till the day he died, but he greatly admired the Sun King's artistic policies. Thus, after 1685, French Huguenot artists such as Daniel Marot, Paul du Ry, and Jean de Bodt were welcomed with open arms.

The rulers of the numerous German duchies and principalities that enjoyed exceptional vigor after the Thirty Years' War, while almost all enemies of Louis XIV, also professed unreserved admiration for the splendor with which he surrounded himself. They, too, wanted luxurious palaces housing rich collections of objets d'art, furniture, and paintings, surrounded by gardens à la française. Princes of the Church were among the most ostentatious: those in Cologne, Mainz, Trier, Münster, Paderborn, Würzburg, and Salzburg presented themselves as grandiloquently as did any secular prince. Along with the duchies and principalities of Württemburg, Baden, the Palatinate, Ansbach, Bayreuth, Hesse, and Hanover, three powerful nations—the Bavaria of Maximilian II Emmanuel (allied with Louis XIV in the War of the Spanish Succession), the Prussia of Frederick I, Frederick William I, and Frederick the Great, and, above all, a Saxony united with Poland during the reigns of Augustus the Strong and his successor, Augustus III—bestowed lavish commissions that spurred the development of the European decorative arts.

After the definitive victory over the Turks in 1683 Austria assembled a gigantic power encompassing Bohemia, part of Poland, Hungary, the Balkans, and northern Italy. Its rulers, loyal to traditions inherited from the dukes of Burgundy, maintained the committed patronage policies of Maximilian I and Maria-Theresa. Still other commissioning figures came to the fore in addition to the Hapsburg family—notably, the house of Liechtenstein and, above all, in the late seventeenth and early eighteenth centuries, Prince Eugene of Savoy, grandnephew of Cardinal Mazarin, who loved opulent trappings as much as his enemy Louis XIV. In Vienna he built the Belvedere, assembling impressive collections for it that passed to the crown after his death. The example set by personalities of

this stamp encouraged ecclesiastical princes to abandon all scruples and transform their churches and monastery-palaces into monumental expressions of the triumphant Counter-Reformation.

Compared with the German states in the years after 1648, the Italian ones—formerly so crucial to the development of the decorative arts—cut pale figures indeed (with the possible exception of Tuscany under the last of the Medici). In seventeenth-century Venice, Rome, Turin, Milan, and Genoa, long-established craft traditions that were the envy of all Europe gave way to fabrications of undeniable charm and grace but often of slipshod workmanship. Naples, however, escaped this unhappy development for a time, thanks to its union with Spain.

Through the first half of the seventeenth century, neither Spain nor Portugal managed to profit in any durable way from the riches seized in the Americas. Seville remained the greatest economic power of the day, and the flourishing port cities of Lisbon and Cadiz were distribution centers for all the world's wealth, but all the profits accruing from their transactions ended up in Amsterdam and London. Portuguese decorative arts reflect this dependence: the country's rulers turned alternately toward London and Paris to satisfy their needs. In Spain—whose political decadence in this period was paralleled by that of its secular artistic production, despite the presence of geniuses like Velázquez, Zurbarán, and Murillo—the finest metalwork and fabrics were made for the Church. Even the arrival of Philip, duke of Anjou, installed in 1700 by his grandfather Louis XIV on the Spanish throne, which he occupied through the entire first half of the eighteenth century, had little impact on local production, for he commissioned the hoard of treasures he accumulated from craftsmen in France and Italy.

In Sweden during this period, rulers without interest in the arts relied on the good taste of their own court-appointed architects, Nicodemus Tessin the elder and his son, who served successively as de facto artistic spies at the courts of Louis XIV and Louis XV. The elder Tessin built the Swedish version of Versailles at Drottningholm, and he began (and his son continued) the design and construction of the Royal Palace in Stockholm, after the old one burned down in 1697. Many of the precious objects they gathered were diplomatic gifts from the king of France, who was committed to maintaining an alliance with this Scandinavian nation despite its distance; perhaps not incidentally, it was the source of many important commissions to French artists. The Tessins' legacy was regarded as so beneficial that Gustavus III, a discerning art lover and collector, continued to favor the arts on a grand scale in the second half of the century, emulating in this regard his neighbor Christian VII, the king of Denmark.

After having enjoyed a period of exceptional achievement in the first half of the sixteenth century thanks to the presence of Hans Holbein the younger at the court of Henry VIII, England entered a period of relative artistic lethargy. But a century later, under Charles I, the court began to rival those on the continent, owing once again to the galvanizing effect of a gifted foreign artist—in this case Anthony Van Dyck. The arrival of many Huguenot refugees at the end of the seventeenth century facilitated a marked improvement in the quality of

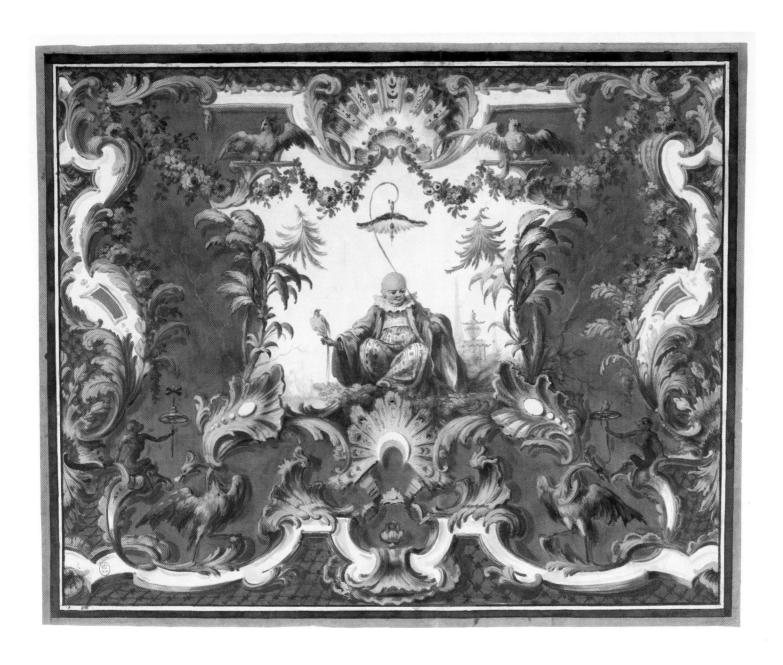

Design for an overdoor, watercolor,
anonymous, Paris, c. 1730.

Paris, Bibliothèque Nationale

This design closely resembles the work of Jacques
Vigoureux Duplessis, the talented designer of
theater sets and festival decors who worked with
Jean Bérain and remained a specialist in chinoiserie
until his death in 1732. In this graceful, balanced
composition, exotic motifs are combined with
acanthus leaves in curve-countercurve configura-
tions typical of rocaille ornament. The overall
effect is reminiscent of arabesques by Bérain.

decorative arts production. The sophisticated tastes of William III of Orange, who accompanied his wife Mary Stuart from Holland when they ascended the English throne in 1689, also helped to raise standards. Subsequently, responsibility for their maintenance rested largely in the hands of the upper echelons of society, as the rulers from the house of Hanover (who succeeded the Stuarts beginning in 1714), neglected the arts until the end of the eighteenth century. However, with the exception of a few domains, such as textiles and porcelain, the decorative arts were not practiced in England at levels comparable to those prevailing in other European nations. Though not insensitive to beauty and quality, the English preferred to accumulate objects from abroad, which they collected during the so-called grand tour, that took them all over Europe, with Italy being especially favored.

This brief historical overview has highlighted a few patrons who had a particularly beneficial effect on the development of the decorative arts. The following paragraphs introduce the five ornamental motifs discussed at length in the five chapters of this volume.

At the end of the sixteenth century, the *auricular style*—so named after its affinity with the fluid, globular morphology of the human ear—appeared at the court of Prague, devised by the many Italian artists in the extravagant and fantastic entourage of Holy Roman Emperor Rudolf II. This peculiar idiom, which was subsequently taken up by artists in the Low Countries, is characterized by supple, elastic-seeming shapes, often of zoomorphic and even anthropomorphic inspiration. Although it disappeared in the mid-seventeenth century, it is distantly but unmistakably connected with the rocaille and, later, with Art Nouveau. It was decided that a style having reached its apogee in the Low Countries would be most authoritatively treated by a Dutch historian, and so this chapter was written by Johan R. ter Molen, curator at the Boymans–van Beuningen Museum in Rotterdam.

Copied after ancient models and idealized by the great masters of the Italian Baroque, the deeply serrated and scalloped contours of *acanthus* leaves have been used to represent flowers, feathers, drapery, and valances, and appear in all manner of vegetal forms derived from late fifteenth- and sixteenth-century rinceaux. More than any other foliage, acanthus corresponds to the opulence of the Baroque style, figuring in its architectural schemes in the form of decorative reliefs, stucco ornament, friezes, and moldings, as well as in smaller objects in a broad range of styles. Ursula Reinhardt, an art historian and archeologist educated in both Germany and France, seemed perfectly equipped to trace the sources of this motif and its resurgence throughout Europe in this period.

Having myself studied textiles and festival decorations in the style known as *chinoiserie*—the subject of several important books appearing over the last two decades—I realized how indebted ornamentalists working in this mode were to illustrated books published by Jesuit missionaries beginning in the mid-seventeenth century. A flourishing trade with the Far East, developed by the various India Companies of Holland, England, Portugal, and France, supplied the European market with porcelain, fabric, furniture, and lacquer affordable

only by the wealthy. But the taste for such exotic products was shared by the less privileged, and imitations—dubbed "chinoiseries"—were produced for them in large quantities. This inventive ornamental style, which eventually cut free of its Eastern sources, had a profound impact on the evolution of the decorative arts.

Neither France nor the rest of Europe ever tired of the bizarre constructs known in the West—since the discovery of their ancient prototype in Nero's Domus Aurea (Golden House) in Rome—as *grotesques*. Having been reinvigorated in the late seventeenth century by the brilliant ornamentalist Jean Bérain, they enjoyed a resurgence under the name *arabesques*. Profiting from circumstances favoring the international diffusion of models originating at Versailles, these motifs—which despite their new name bear no traces of Arabic or Eastern influence, but whose generic exoticism was a crucial determinant of their success—lent themselves to a wide range of uses in the realm of interior decoration.

The *rocaille*—also called the *rococo*—is certainly the the eighteenth century's most original contribution to the European decorative vocabulary. Evolved from strapwork and the auricular style, it is curiously related to the practice of juxtaposing, for reasons of economy, several ornate decorative motifs or design solutions on a single sheet, resulting in singularly asymmetrical compositions. This and its other defining characteristics—the interplay of curves and counter-curves, abstraction, affectation, and a taste for things out of scale—made it especially prone to exaggeration, above all in Germany, where the style flourished over an extended period. Bruno Pons, with his cosmopolitanism and exceptionally open mind, seemed the ideal person to write the chapters on *arabesques* and the *rocaille*.

Other decorative motifs were ubiquitous in the period, too, and they sometimes appeared in conjunction with those discussed at length in this volume. Flowers enjoyed particular favor. The discovery of new continents and the establishment of maritime routes that shortened trips to distant regions revealed the existence of species previously unknown, which were catalogued and even cultivated in Europe. Many reigning sovereigns felt obliged to maintain botanical gardens. Artists searched for new floral motifs in these gardens and in numerous illustrated treatises, as precisely delineated floral forms had become an obsession in all the decorative arts. The first tulip bulbs arrived in Vienna in 1555, having been brought there by an ambassador from Antwerp who was representing the Holy Roman Emperor at the court of Suleiman the Magnificent. Beginning in the early years of the seventeenth century, tulip mania held sway in the Low Countries, reaching its height in the years between 1630 and 1650. Images of this flower, which is especially receptive to stylized treatment, were avidly sought after. A taste for fantastic flowers paralleled that for botanically accurate ones, and art occasionally surpassed nature in the so-called *fleurs des Indes,* or India flowers, inspired by painted or printed fabrics imported from the Far East.

Although each chapter is devoted to a single ornamental family, one should be wary of drawing conclusions as to artistic influence and evolution; while not entirely devoid of logic, these proceed in ways that are anything but systematic. Ornamental motifs circulated widely and were used with considerable freedom.

Prints after decorative designs were rarely appropriated whole. Gifted artisans made it a point of honor to give anything they touched a personalizing inflection, and they frequently combined elements drawn from various models and authors; the successful integration of such various forms required special skills. Such, at least, was the case in the sixteenth century, when a scarcity of printed models made ingenuity of this kind a virtual necessity. Beginning in the mid-seventeenth century, however, a proliferation of such models made it less crucial: a wider range of available preconceived solutions made it easier for craftsmen of more modest gifts to produce satisfying results in a broad range of decorative arts productions.

France dominated the field in the years between 1630 and 1760, and, accordingly, it is given the lion's share of attention here. Other national traditions take center stage in the accompanying volumes. Italy and Germany are prominently featured in the first volume, which deals with the years between 1480 and 1630, when their workshops were the most important centers for the generation and consumption of prints circulating ornamental motifs. The Anglo-Saxon world will assume an important role in the third volume, devoted to the period from 1760 to the outbreak of World War II.

Alain Gruber

Watch case, engraved and embossed silver,
Gilles Martinot, Paris, early eighteenth century.
Paris, Louvre

Several decorative elements gravitate around a medallion containing a shoulder-length profile of Louis XIV. This cameo is suspended beneath a canopy that hangs from an armature of interlaced ribbon motifs intertwined with acanthus rinceaux. Fantastic birds of Chinese inspiration appear with classical putti. Most of the vegetal elements derive from acanthus. This arabesque composition in the style of Bérain vaguely recalls sixteenth-century grotesques.

FACING PAGE

Binding in the style of Jacques-Antoine Derôme,
volume II of an Italian-language edition of *On the Nature of Things* by Lucretius, Paris, 1761.
Paris, Bibliothèque de l'Arsenal

The art of bookbinding, notoriously traditionalist, was periodically reinvigorated in the eighteenth century by a handful of gifted practitioners. The complicated technical procedures involved in producing polychrome mosaic bindings and applying numerous small stamps explain the scarcity of examples of this quality. Here interlace motifs merge into acanthus leaves, as in arabesque designs. The central motif, with its six lobes and stylized feathers, produces a slightly exotic Asiatic effect. The corners are decorated with palmettes.

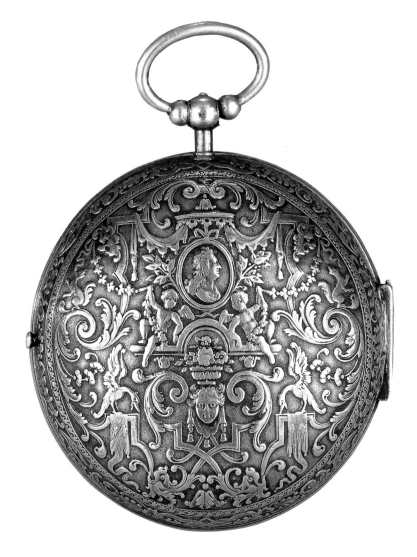

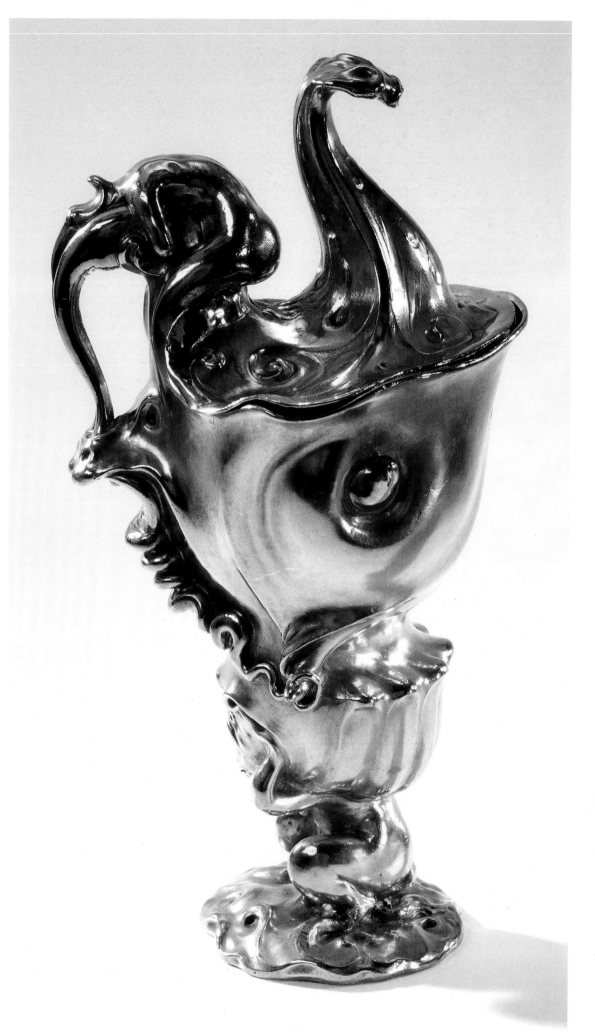

Ewer, silver gilt,
Adam van Vianen,
Utrecht, 1614.

Amsterdam, Rijksmuseum

'This extravagantly shaped
ewer, which appears to be
made of a pliable material, was
executed for the Amsterdam
goldsmiths' guild by Adam van
Vianen. The main volume,
shaped like a shell or perhaps a
dolphin head, is supported by
a crouching simian figure. The
handle is composed of the body
of a woman leaning forward;
her falling hair appears to
turn into a stream of liquid that
pours onto the muzzle of a
diabolical creature. A beard of
tendril-like hair emerges from
the area around this monster's
open mouth. This object,
which was represented in many
contemporary paintings, is a
benchmark in the evolution
of the auricular style in the
Low Countries.

The Auricular Style

*A*lthough variants of the auricular style can be found in seventeenth-century decorative arts productions from many European nations, the current is most closely linked to Dutch metalwork. Two dynasties of Dutch goldsmiths with international reputations, the van Vianens of Utrecht and the Lutmas of Amsterdam, had a determining influence on the style's evolution. By mid-century their work had become known to a rather large public, thanks to the diffusion of prints after their designs.

After the death of Paul van Vianen in 1613 in Prague, where he had been the official goldsmith to Rudolf II, the Amsterdam goldsmiths' guild resolved to honor the memory of their celebrated colleague by commissioning a commemorative object. The commission was awarded to the deceased artist's brother, Adam van Vianen, who was based in Utrecht. He executed a silver-gilt ewer that, *page 26* upon its completion in 1614, was placed in the guild's Amsterdam meeting hall. The German artists' biographer Joachim van Sandrart described it as follows in his book *L'Academia todesca della architectura, scultura e pittura oder Teutsche Academie der edlen Bau-, Bild- und Mahlerey-Kunste* (II, Nuremberg, 1675, page 342): "a ewer . . . made of a single silver ingot . . . everything in it was represented in a grotesque or *Snackerey* style, as things of this genre are called; this ewer was held to be passing strange."

Considered the archetype of the auricular style, with its forms so suggestive of the forms of the ear, this object attracted the attention of both metalworkers and artists. At least ten paintings executed in Amsterdam include depictions of it. As early as 1615 it figured in a *Crucifixion* by Pieter Lastman, who placed it at the foot of the cross. But it was most admired by followers of Rembrandt, and, after *page 29* mid-century, representations of it are not uncommon.

Naturally, the goldsmiths of Amsterdam were the first to seriously explore the possibilities suggested by this auricular prototype, and the style's early development is best traced through an examination of their work. Without doubt, the finest master goldsmith practicing there at the time was Johannes Lutma the elder. Along with his son, who shared his father's name, he was celebrated by

the poet Joost van den Vondel as the most gifted metalworker of his time, in whom "the spirit of Paul [van Vianen] seems reborn."

Close examination of Adam van Vianen's ewer, fashioned in repoussé from a single silver ingot, reveals that its strange design harbors a host of surprises. As the light plays over it, new details continually reveal themselves. It is as if van Vianen set out to demonstrate his virtuosity by giving hard metal the aspect of some more malleable material prone to constant changes of shape. The base seems agitated by waves, from which emerge the staring eyes of a schematic dolphin head; a simian creature crouching in the water supports the vessel's recipient, whose form resembles both a large shell and an open-mouthed dolphin. There is a kind of bottleneck before it rises to full height from which proceeds a serpentine squiggle. The object's very substance seems drawn upward, erupting on its cover into what looks like a jet of liquid; closer scrutiny reveals the head and neck of a terrible sea monster.

This description highlights some of the typical characteristics of the auricular style as it developed in Holland in the early seventeenth century. First, the illusion of malleability: the forms and motifs of earlier styles are used, but they seem to melt into a molten mass. In most instances the style is restricted to an object's decorative passages, but on occasion—as in the ewer by Adam van Vianen—the entire design is given over to the idiom, making the notion of mere "decoration" inapplicable.

Also typical is the zoomorphic character of the deliquescent shapes and surfaces: from certain angles, they seem inhabited by animals and horrific monsters. The mysterious world of the sea is especially privileged: the peculiar creatures and objects found there—dolphins, rays, shells, mollusks—provide the style with an inexhaustible repertoire of forms.

The motif of the grotto was also used by many artists working in this style. Shortly after 1620, for example, Jacques de Gheyn, who had spent several years in the Haarlem studio of Hendrick Goltzius, designed an artificial grotto with a wall fountain for the garden of the house of the stadholder, the Prince of Orange, in The Hague. It was executed not for Prince Maurice of Nassau—who commissioned the project—but for his successor and brother, Frederick Henry. Though page 56 it has since disappeared, a surviving drawing features a bearded old man seated on the head of a crustaceous monster, presiding nervously over a viscous environment swarming with marine animals, snakes, and other disturbing creatures.

page 57 In this connection, it is worth mentioning a curious painting by Carel de Hooch. Visible through openings on the right is a landscape, perhaps Italian, but the rest of the composition is taken up by a damp grotto—apparently a burial ground—dominated by a monument supported by two columns; between them is a commemorative inscription framed by auricular elements that appear to emerge from a fantastic mustachioed head.

The human anatomy is another favored theme of the auricular style. Shortly after 1600, dissections of the human body began to be performed publicly in the Low Countries and in Prague. These unprecedented spectacles were of great interest not only to doctors but to artists as well. The knowledge so acquired was

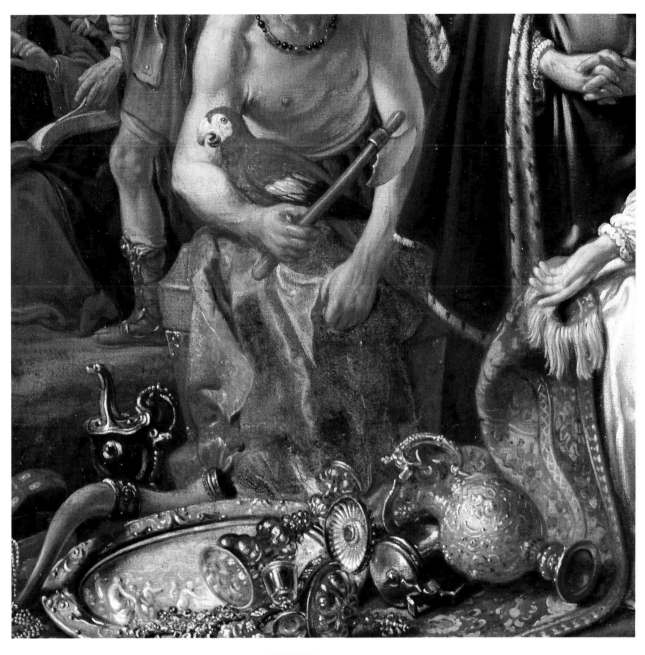

The Adoration of the Lamb,
oil on canvas, Claes Moeyaert, c. 1652.

The Hague, Catholic Church of Saint James

This rather complex composition is based on the Apocalypse of
Saint John. In the sky, a heavenly host pays homage to the Lamb
of God. John the Baptist is the painting's central figure. On the
earth below, a Franciscan monk preaches the Christian faith
to representatives of all the world's peoples and cultures. A pile
of gifts made of precious metals appears at the bottom on
a rich carpet.
Among these "earthly treasures" is the Adam van Vianen ewer of
1614 (page 26) and the Paul van Vianen platter of 1613 (page 58).
These objects were famous in the seventeenth century and were
represented in several paintings.

soon made available in medical treatises and sets of engravings. The subtitle of one such book, published in The Hague in 1634, indicates that it was intended for use by "painters, sculptors, and engravers" as well as by "surgeons." The auricular style frequently employs forms derived from human anatomy. Its cartouches often evoke patches of skin splayed open as in a dissection; and the handles of imple-

page 61

ments created in its distinctive idiom—for example knives and spoons—sometimes resemble bones to which shreds of muscle and skin remain attached. Motifs designed to look like male or female genitals also appear; this tendency is evident

pages 61, 64

in prints based on designs by Johannes Lutma and Gerbrandt van den Eeckhout. An extremely curious—and unusually literal—instance of such anatomical morph-

page 58

ing is to be found in a drinking cup made by Adam van Vianen in 1618: its inner surface is carefully modeled to resemble the interior of a human skull.

This last example brings us to another important feature of the auricular style: its frequent references to death and the vanity of existence. Such prominent display of human body parts would inevitably bring to mind the fragility of human life, but such moralizing associations are further buttressed by the use of precious materials: this implies that, while earthly goods can indeed be accumulated, they are of no use when we find ourselves confronted with the beyond. Cer-

page 74

tain sumptuous still lifes by artists such as Willem Kalf, for example, were doubtless meant to be read in this way, and it is not accidental that the silver objects included in such compositions almost always feature decorative elements in the auricular style.

It follows that the style was eminently appropriate for use in religious

pages 68, 69

buildings, in which God's word stressed the brevity of life. Objects intended to

pages 33, 61, 62

memorialize deceased individuals or to be used in funerals provide further evidence of the perceived connection between the style and mortality. In Haarlem, the city magistrates were reminded of the hour at which an execution was to take

page 76

place by a "death clock" decorated not only with figures and symbols traditionally associated with death but also with auricular shapes and cartouches in the manner of Lutma. This preoccupation with mortality is given even more pronounced

page 63

expression in a mirror decorated with a painted *vanitas* composition featuring an extinguished candle in a candleholder after a design by the van Vianens, such that onlookers' more frivolous thoughts are quickly tempered by reminders of their own fragility and impending death.

The Birth of the Auricular Style

The auricular style was conceived around 1600 by a group of artists who, while divided between two distinct cultural centers, were in close contact with one another. Some of them were based in Prague, having come from different parts of Europe to work at the court of Rudolf II; the others lived in Haarlem, one of the great cultural centers of Holland.

Born in Antwerp, the painter Bartholomäus Spranger was one of the

emperor's favorite artists, and he enjoyed great celebrity in Prague. His work served as the point of departure for the northern variant of mannerism, a style that originated in Italy and was fashionable during the final decades of the sixteenth and the first quarter of the seventeenth centuries. The group of artists at the Prague court, heavily influenced by Spranger, played a particularly important role in mannerism's dissemination; among its most prominent members were the painter Hans van Achen, the engraver Egidius Sadeler, and the goldsmith Paul van Vianen.

Paul van Vianen was born in Utrecht about 1570. He traveled through Europe for a few years, working from 1596 to 1601 at the Bavarian court in Munich, and was named the official goldsmith to Rudolf II in 1603, remaining in Prague until his death in 1613. In addition to being a remarkable metalworker, he was a talented draftsman with a gift for landscape, and he used the resulting compositions when devising decorative schemes for his silver pieces, on which they sometimes appear in relief. One of the earliest works in which he employed auricular forms is a cup executed in 1607: on its foot are landscape compositions in delicate relief framed by motifs of anatomical derivation. Later he would allow this vocabulary to expand beyond such decorative borders and consume entire compositions. To take one example, a ewer made by him in 1613, the year *page 58* he died, features a foot and a protruding knob-handle on its cover with whimsical forms of curiously indeterminate character.

A few years earlier, in 1610, Egidius Sadeler had enriched a large cartouche *page 64* surrounding an engraved portrait of Georg Schrotl a Schrotenstain with striking cartilaginous forms. Sadeler belonged to the circle of Paul van Vianen, and on June 15, 1613, immediately after the announcement of the latter's death, Adam van Vianen sent a message from Utrecht to Prague asking Sadeler to look after his brother's estate, in collaboration with Hans van Aachen and a Dutch businessman, and also to arrange the chaperoned return to Utrecht of Paul's young children.

In Haarlem, shortly before 1600, a propitious cultural climate began to coalesce, favored by the presence of artists who sought refuge there after the fall of Antwerp to the Catholic Prince of Parma (governor-general of the Spanish Netherlands) in 1585. Cornelis Cornelisz van Haarlem, Hendrick Goltzius, and Karel van Mander were the most remarkable of these figures. They were in constant contact with Spranger and other Prague artists, and were strongly influenced by their peculiar brand of mannerism. Engraved compositions in this idiom, some of them directly after Spranger's work, were widely disseminated in the Low Countries. A print by Goltzius depicting Bacchus, probably from 1595 *page 55* and typical of his style, is revealing in this regard. In the center, the god of wine seems to offer up a toast to Cornelisz, to whom the image is dedicated: he lifts his right hand, in which he holds an odd-looking cup. Its irregular surface, so characteristic of the auricular style, features a fantastic mask, the eyebrows of which form the rim of the cup, and the vessel's earlike handles appear to be made of some pliant, cartilaginous material.

Van Mander is best known as the author of the *Schilder-Boeck* (1614), a series of painter's biographies; the portrait of the author published in its first edition is framed by a cartouche whose scrolled outer edge is suggestive of the auricular idiom. Van Mander was also a talented painter and draftsman. One *page 55* of his drawings, securely datable to 1598 and depicting Perseus in combat with the dragon, is surrounded by a lobed frame whose forms are reminiscent of soft drapery.

In Utrecht, another group of artists was also drawn to the mannerist style cultivated in Prague and Haarlem; it was dominated by Abraham Bloemaert, Joachim Wtewael, the goldsmith Adam van Vianen, and the engraver Chrispyn de Passe II. As early as 1613, the latter artist used auricular forms to decorate the title page of an emblem book published by G. Rollenhagen. But he went much further in a decorative design framing an engraved portrait of Johan van Olden-barnevelt, a Dutch statesman who was sixty-one in 1618: its tattered scroll forms, which suggest fragments of cartilage and flayed skin, feature a mixture of ana-tomical elements and disturbing, fantastic animal heads. It is not unlike the frame in the above-mentioned print by Sadeler, and also has much in common with designs by Adam van Vianen published by his son Christiaen under the title *Modelles Artificiels*, although this volume did not appear until 1650.

Unlike his brother Paul, Adam van Vianen never left his native city, where he continued to work until his death in 1627. Beginning in 1614, when he completed the celebrated silver memorial ewer, much of his production featured auricular forms. But they had figured in at least one piece he exe-*page 55* cuted several years earlier, in 1610—a silver cup whose central composition depicts Ulysses and his companions seated around Circe's table. Its border features two discreet auricular masks, and in the foreground of the narrative scene there is a rather extravagant wine cooler in the form of an eccentric, auricular animal body.

Sets of Ornamental Prints

Before studying the subsequent development of the auricular style and its vari-ous applications, it is worth querying the extent to which earlier ornamental engravings and decorative objects played a role in its inception. One of its most characteristic features, the use of apparently pliant forms derived from the human anatomy, first appeared in Italy. As early as 1531, Agostino Musi (known as Agostino Veneziano) executed a series of prints representing antique vases with handles that seem to be made of cartilage and tendons. Similar designs *page 54* were published by Enea Vico in 1543. A few years later, in 1552, this same artist completed an engraving of a candlestick, the base of which is simple in form and decorated with familiar antique motifs. Its top, however, features a rim, sup-ported by two masks, that is very differently conceived, melting into a pliant, fleshy mass. Vase designs by Polidoro Caldara (known as Polidoro da Caravaggio) are also composed of elements seemingly made of a supple, flexible material;

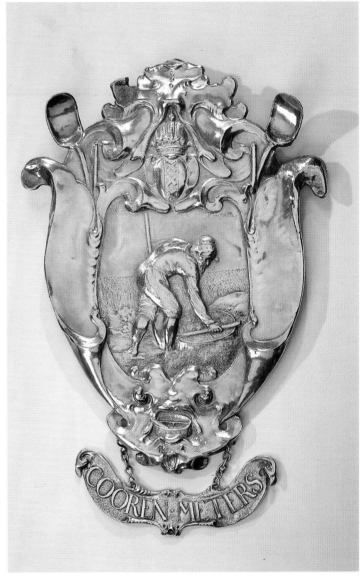

Designs for a candlestick and a candlesnuffer,
ink and wash, Erasmus Hornick, Prague,
late sixteenth century.

London, Victoria and Albert Museum

*W*hile the design for the candlestick is altogether conventional in a
classicizing mode, the candlesnuffer incorporates unusual anatomical shapes.
It was in the circle of artists working at the court of Emperor Rudolf II in
Prague that the auricular style began to appear in the form familiar to
us from work produced in the Low Countries

Funerary plaque of the wheat measurers' guild,
silver, Johannes Lutma, Amsterdam, 1633.

Amsterdam, Rijksmuseum

*T*his is one of a series of four plaques, which are among Lutma's earliest
works. During the funeral of a guild member they were attached to a cloth
covering his casket. The central vignette of this plaque, which pictures a
licensed measurer doing his work, is framed by an auricular cartouche; the
open mouths of the animal-like masks at its top and bottom contain the
emblem of Amsterdam and a bushel of wheat, respectively. The overtones of
vanitas imagery, frequently used in auricular ornament, are particularly
appropriate here.

these were first published in Rome in 1582, some four decades after his death. Taking this series as a model, Egidius Sadeler published in 1604, in Prague, engravings of objects featuring similar ornamental motifs. Such images doubtless influenced the auricular style as initially devised by Paul van Vianen, but he was probably inspired as well by designs of the Antwerp-born goldsmith Erasmus Hornick, which entered the collection of Emperor Rudolf II after the artist's death in 1583. Many of these feature objects incorporating bizarre combinations of human, animal, and fantastic beings. In one of these drawings, a conventionally classicizing candlestick is juxtaposed with a candlesnuffer the shape of which brings to mind a bird's skull.

page 33

As early as the mid-sixteenth century, Cornelis Bos (c. 1510–1555) and Cornelis Floris (c. 1514–1575), both of whom had lived in Italy, brought the ideas of artists such as Enea Vico to the southern Netherlands, and their own works also feature objects in the auricular style. Although Bos had a marked preference for scrolled forms that are rather stiff, a drawing made by him in 1548 pictures an oil lamp whose edges seem to be made of a ductile material. Cornelis Floris went further: some of his prints depict objects that seem to be made of some malleable substance, but above all they are crawling with human figures and animals. One of his ewers, for example, is shaped like a snail shell but appears to be made of folded skin, and has a crayfish clinging to the belly of its spout; a bearded man sits on top of it and, leaning forward, supports on his back the tail of a monstrous reptile that serves as its handle. But unlike objects in true auricular style, this one's overall design remains quite traditional.

page 56

The development of the French ornamental vocabulary was also strongly influenced by Italian models. A significant role was played, for example, by the designs of Federico Zuccaro, published in Paris by Pierre Firens about 1625; the artist, who lived in France sometime around 1575, was by that time long since dead. The shapes in his cartouches are rather stiff, but some of their rolled configurations intimate the more fluid style to come. The frames used by Daniel Rabel around his landscapes are freer and more extravagant: here the forms take on a pronounced relief, thanks to protruding snouts and loose scrolls, parts of which resemble fragments of skin.

page 84

page 84

Stefano della Bella (b. 1610), a Florentine whose many skills included goldsmithing, which he learned in a master's shop, worked between 1640 and 1650 in Paris, where he executed a large part of his print oeuvre. He, too, used ornamental forms similar to those associated with the auricular style. The title page for his *Paisages Maritimes* series is especially interesting in this connection. Its shell-like cartouche, flanked by dolphins, softens in its lower reaches into whimsical rolled shapes. His ornamental prints, such as his *Capricii* or the set he published in 1646 under the title *Raccolta di Varii Cappricii,* feature comparable elements. Jacques Callot (1592/3–1635) of Nancy, who lived in Florence for many years beginning in 1612, was influenced there by similar decorative forms. This eclectic artist produced designs for vases and table ornaments that seem to be made of malleable material and incorporate frightening masks and fragments

page 84

of human anatomy. The resemblance of these sketches to the silver work of the van Vianens is striking.

Shortly after 1600, motifs similar to those typical of the auricular style began to appear in German decorative prints. The cartouches of Lucas Kilian, published for the first time in his collection *Neues Schildbüchlein* of 1610, are still a *page 87* bit stiff and symmetrical, but they include masks that trail off into rolled skin or deformed human and animal figures. These images were part of an international current whose influence is also discernible in the French works previously discussed. More typical of German ornament from the period are prints that use scrolls and the Germanic forms known as *Schweifgrotesken,* but that also employ incidental decorative forms suggestive of the auricular style. Such is the case, for example, in the *Neuws Compertament Buchlein* (New handbook of compartment designs) of Gottfridt Müller, published in 1621. The designs of Friedrich Unteutsch were even more influential; the title page of his collection *Neues Zieratenbuch* (New book of ornaments), published around 1650, indicates that these images were intended for use by artists, sculptors, and furniture makers.

Curiously, in the Low Countries, where it appeared rather early and was taken up by a group of prestigious artists, the auricular style didn't really catch on until the middle years of the seventeenth century, when ornamental prints of compositions in this mode began to proliferate. Few such sheets were available in the time of Adam van Vianen, but some furniture designs by Chrispyn de Passe II published in the collection *Boutiqve Menvserie* in 1621 must be numbered *page 39* among them. These are designs for pieces in a Renaissance style employing a wide range of ornamental motifs; most are rather conventional, but occasionally the artist threw in auricular cartouches among his several proposed design solutions, allowing the viewer to compare the resulting effect with that produced by more canonical elements.

As mentioned earlier, preparatory drawings by the goldsmith Adam van Vianen were published around 1650 by his son Christiaen, under the title *Modelles Artificiels,* or *Constighe Modellen;* after its trilingual title page, which features an auricular border, there follows a series of *Vaisseaux d'argent et autres Œuvres Capricieuzes* (Silver vessels and other caprices), most of which picture designs for repoussé ewers made from single silver ingots. All manner of contorted objects appear on these sheets: in addition to the famous ewer of 1614, there are salt- *pages 71, 60* cellars, candelabra, basins, handles, covers, and spouts. In the case of certain designs for oval platters, only a single quadrant is illustrated; in a few copies of *Modelles Artificiels,* supplementary folding sheets have been pieced together *page 66* to form the entire image using proofs and counterproofs. All of these models give off the peculiar perfume typical of van Vianen silverware: in these whimsical forms, human figures and marine animals can be glimpsed emerging from a gelatinous substance that also harbors images of frightening faces and anatomical fragments. A few of the pictured designs were actually made, and in such cases the objects themselves may have served as models for the prints. Other, isolated sheets representing comparable objects can be securely attributed to the *page 60*

van Vianen workshop on stylistic grounds; they may well have been intended for a second volume that was never published.

In the same period, just after the middle of the seventeenth century, a series of prints based on designs by Johannes Lutma appeared in Amsterdam, some of them executed by his son Jacob. The ornamentation in these prints, which feature convoluted scrolls of what look like fragments of skin, is more Baroque than that found in the van Vianen designs, and their deliquescent forms resist identification.

Interest in auricular decoration was stimulated in Amsterdam by Gerbrandt van den Eeckhout, who was a publisher as well as a painter and printmaker. *page 64* He executed engravings with cartouches in which female torsos and dogs are discernible, and from whose emphatic folds larvalike forms emerge. His designs indicate how the auricular vocabulary might be used in furni- *pages 61, 66* ture as well as objects made of precious metals: a set of model prints by him that appeared in 1655 bears the title *Verscheyde Aerdige Compartementen en Tafels.* In addition, van den Eeckhout, a student of Rembrandt, depicted in some of his paintings certain objects in the auricular style, notably the Adam van Vianen ewer of 1614.

The idea that this vocabulary was suitable for all sorts of media found further support in a set of ornamental prints published by Clément de Jonge, which brought together work by van den Eeckhout, Lutma, and the van Vianens: the title page of *Constige Vindingen,* as it was called, indicates that these designs were intended for execution in "gold, silver, wood, or stone." However, the style would be extensively employed only in metalwork; instances of its use in sculpture and other forms of the decorative arts are rare.

<hr />

Auricular Ornament in the Low Countries

Silver. ∼ It has already been noted that one family of goldsmiths, the van Vianens, played an especially important role in the early history of the auricular style. Thanks to an unequaled mastery of silver-working techniques, they were able to give form to their most whimsical fantasies. The new idiom plays only a decorative role in their earliest pieces, which stick to conventional formats. The previously mentioned cup made by Paul van Vianen in 1607 is a case in point. Its inner surface depicts the Judgment of Paris, framed by rather stiff foliage, but most of the other ancillary elements are auricular in character. The three scenes on the plaque inscribed on its back, for instance, alternate with motifs that resemble a human pelvis, and the landscapes on its base are separated from one another by forms inspired by tendons and cartilage. The groups of trees decorating the knot of the cup's stem are framed by what appear to be strips of skin topped by a deformed animal head.

page 58 A large oval platter featuring a depiction of the story of Diana and Acteon,

executed by Paul van Vianen in 1613, the year of his death, has a border decorated with similar pelvis motifs, here alternating with bizarre masks. This object marks a decisive advance in the style's development, for the platter's four ball feet are shaped like the joints of bones. The matching ewer features similarly idiosyncratic forms: its handle recalls a curved tendon, and its base is composed of gelatinous forms with no clear referent. This ensemble was made in Prague but was taken to the Low Countries shortly thereafter, where it attracted considerable attention. In 1637, an Amsterdam goldsmith was even accused of having made copies of these pieces without their owner's permission and of then selling the copies to the king of Poland. In 1651 a depiction of the platter was included in *page 29* a religious painting by Claes Moeyaert. Adam van Vianen made even more extensive use of the auricular vocabulary. There is only a hint of it in a cup he *page 55* produced in 1610—two fleshy masks in an otherwise conventional band around the central scene—but when he created his celebrated ewer of 1614, a memorial *page 26* to his dead brother, the entire piece became an expression of the auricular universe, and it seems to be made of some peculiar malleable substance. The style also figures prominently in Adam's subsequent production, which sometimes incorporates figures of humans and animals emerging from skin or drapery, or *page 58* slithering over viscous surfaces.

Adam van Vianen had a few students who worked in the same spirit after his death. His son Christiaen continued his workshop in Utrecht but spent many years in London (on and off between c. 1630 and 1666), and Michiel de Bruyn (van Berendrecht), a colleague from the Utrecht workshop, eventually followed him there and became his assistant. Like his master, de Bruyn executed a few works of such exuberance and invention that they were immediately acquired for prestigious collections, but he also produced utilitarian objects for both private individuals and men of the cloth, such as chalices, ewers, and candelabra, all in silver. These are more traditional in character, employing auricular motifs such as cartouches and masks with considerable discretion. While the more extravagant objects intended for collectors bear his signature, those meant for everyday use carry only the obligatory stamps attesting to the quality of the metal.

In Amsterdam, Johannes Lutma continued to work in the spirit of the van Vianens. His earliest works include four funerary plaques made for the *page 33* wheat measurers' guild in 1633, framed by motifs that resemble large stylized folds of peeling skin; some of these motifs evoke fantastic masks or heads, the mouths of which—it is implied—utter the words spelled out nearby. These pieces are not unlike the more eccentric cartouche designs published by Lutma *page 75* about ten years later. One of Lutma's works, dated 1641, recalls the Adam van *pages 58, 59* Vianen cup modeled like a human skull: a small monster perches on its curvaceous rim as if about to quench its thirst. This idea had previously been used by Christiaen van Vianen, in 1632, in the design of a large basin at whose rear he depicted an animal sucking up the liquid and, ingeniously, the resulting concentric ripples as well, which he engraved in the vessel's lower surface. This piece

was apparently a particular favorite of Lutma's, for it is pictured in the portrait etching Rembrandt made of him in 1656.

page 59

Another portrait of the same goldsmith, this one by Jacob Adriaensz Backer, shows him seated behind the top of an auricular cartouche; also pictured

page 59

here, on a nearby table, is one of a series of four saltcellars made by Lutma between 1639 and 1643. Its pedestal is in the shape of a seated putto, its base features auricular forms and masks, and its cup, a shell-like form with a wavery edge, is decorated in the same style. Adam and Christiaen van Vianen also made saltcellars supported by figured pedestals, but sought to harmonize the various parts of each piece, whereas Lutma conceived the central figure as a distinct ele-

page 60

ment, setting it apart from the rest by not gilding it. In another piece by Lutma, the trowel used to lay the foundation stone of the new Amsterdam City Hall in 1648, auricular forms are both incised and embossed: the handle is shaped like bone and muscle, while the blade bears an engraved commemorative vignette within a lobed cartouche.

In 1643 and 1645 Lutma received payments from Amsterdam's theater for having executed a set of silver medals, which were to be given to "inspectors" to wear as a way of signifying permanent free entry for them. On the front and back of each of these oval medals is an auricular cartouche closely related to ornamental engravings published by Lutma: in one, a nest is shown beneath a flowering eglantine, the theater's symbol, while the other bears the emblem of the city of Amsterdam. Two other medals ornamented with the same character-istic border are also attributed to Lutma: a silver medal awarded by the Delft civic guard to the champion or "king" of its annual shooting competition, and

page 62

another bearing the motto and portrait of Frederick Henry, Prince of Orange. Comparable pieces were produced by Wouter Muller, an Amsterdam medal maker, but in his work the decoration is usually reduced to a modest cartouche bearing a textual commentary on the scene above it. Muller also produced

page 62

funerary medallions featuring skeletons and "vanitas" symbols; after the addi-tion of a memorial inscription, these tokens were given to friends and relations of the deceased.

It was not only in Utrecht and Amsterdam that works in the style of Lutma and the van Vianens were made; other goldsmithing centers also took it up. In a

page 74

cup stand made by Andries Grill in The Hague in 1642, for example, Lutma's influ-ence is clearly discernible. This silver-gilt piece incorporates an infant Bacchus astride a barrel; the stand proper (which he supports on his head) and the three dolphins constituting the base are decorated with auricular elements. Such objects must have made a strong impression on painters, for they frequently depicted them in interiors and still lifes.

page 41

A remarkable covered silver-gilt hanap given by Elisabeth, queen of Bohe-mia, to the city of Leiden, where her children had received their education, was also executed in The Hague. Made by Hans Coenraadt Breghtel in 1641, it is almost completely enveloped by auricular motifs. In the princely circles for which such sumptuous objects were produced, solid silver or silver-plated fur-niture with auricular decoration was probably not uncommon. This supposition

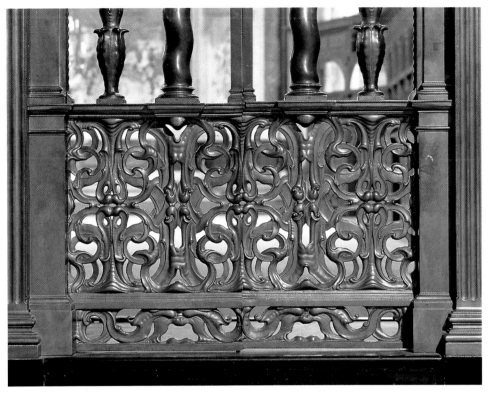

Doors of the choir screen (detail),
copper, after designs by Johannes Lutma,
Amsterdam, c. 1650.
Amsterdam, Nieuwe Kerk

Design for an armoire,
print, Chrispyn de Passe II.
Amsterdam, Rijksprentenkabinet

This print is from a book first published in Utrecht
in 1621, *Schrinwerckers winckel* or *Boutiqve Menvserie,*
a work republished in Amsterdam in 1642 and
1651. It includes alternative motifs throughout
the composition, offering several choices to the
client and/or craftsman. The design's armature
and most of its details are consistent with
Renaissance models, but the door panel on the
left carries two fluid auricular motifs.

page 70 is based on a painting by Bartholomeus van der Helst of 1652, a portrait of Henrietta Maria Stuart (1631–1660), widow of the stadholder William II; the uprights of the silvery chair on which she sits feature auricular motifs that suggest bones. Furthermore, it seems likely that a lavish silver bed realized in 1674 by John Cooqus, the son-in-law and student of Christiaen van Vianen, was in the same style; this piece was given by Charles II of England to his mistress Nell Gwyn. As the style held special appeal for people of influence and erudition, it was considered especially suitable for diplomatic gifts, and as a result Dutch metalwork rapidly became known throughout Europe and even beyond. Ambassadors to the court of the czars took some of these objects to Russia, notably two enormous partially gilded lamp holders made by Breghtel in 1647 with wall plaques featuring auricular ornament, and a vase executed that same year by the Amsterdam goldsmith Jan van de Velde with handle and spout in the form of a slithery, cartilaginous snake.

After 1659 the auricular style, which had become widely known through prints, was current throughout the northern Low Countries. The overall design concepts governing most of this production remained conventional, with the new idiom being limited to decorative elements. Seventeenth-century Groningen, for instance, was renowned for the goblets adorned with plaited bands and crowns *page 65* of thorns produced there in large numbers; we can see from an example dated 1656 that, while auricular cartouches were sometimes incised on their outer surfaces, the goblets retained their classic shape.

With the advent of new decorative motifs, notably the floral configurations rich in foliage and flowers so typical of the Baroque, the auricular vocabulary was effectively—and sometimes quite literally—edged out of the *page 65* field. The consequences of this shift are discernible on a plate made by the goldsmith Claes Fransen Baerdt in 1681: here, a flower motif dominates each of the eight lobes, displacing the auricular ornament to delicate framing elements. This plate bears a curious resemblance to another that was doubtless produced in Batavia (now Jakarta, the capital of the Indonesian archipelago, then a Dutch colony). And still another silver platter from the period, this one used in the Dutch church at Jaffna in Sri Lanka, features an even stranger combination of auricular cartouches and masks with animals rendered in a typically Asiatic style.

Non-precious Metals. ~ Unlike goldsmiths, ordinary metalworkers restricted their use of auricular motifs to accessory decoration. The rare copper or bronze objects on which such motifs appear were almost always intended for use in a religious context.

Without a doubt the most imposing piece of this kind is the twelve-meter- *page 68* long choir screen in the Nieuwe Kerk in Amsterdam, designed by Johannes Lutma and executed in 1650. Its overall design is rather conventional, with a marble base, Corinthian pilasters, and a classicizing architrave. But the doors *page 39* and panels separating these elements are filled with sinuous auricular motifs, which also dominate the elaborate "crown" above the architrave. Bonelike

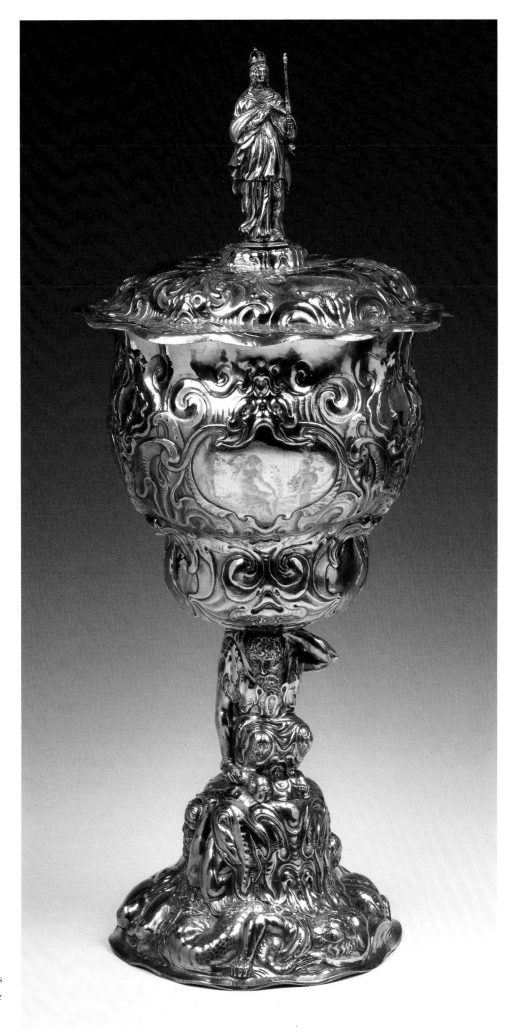

Hanap, silver gilt,
Hans Coenraadt Breghtel,
The Hague, 1641.
Leiden, De Lakenhal

'The surface of this hanap is covered with
auricular motifs, the details of which are rather
crude, perhaps due to the vessel's large scale
(79 cm). It was given by the queen of Bohemia to
the city of Leiden, where her sons had received
their education. The stem of the vessel is in the
form of an old man supporting the cup on his
back, crouching on a base that features human
figures emerging from a viscous ground so
characteristic of the style. A figurine representing
the queen stands atop the cover. The maker of this
piece, Hans Coenraadt Breghtel, like his colleague
Andries Grill, was descended from a family of
goldsmiths from southern Germany.

forms and skinlike ribbons are combined in interlace configurations reminiscent of ornamental prints by German artists such as Unteutsch; it is quite possible that the use here of this particular inflection of the style, rare in the Low Countries, was determined in part by a desire to harmonize with the Gothic architecture of the church.

page 69 A simpler variant of this model can be found in the village of Leens, where a member of the Tjarda van Starkenborch family donated copper finials and crowning elements for placement atop a low wooden choir wall. At its center is an escutcheon bearing the family's coat of arms, the border of which is in the auricular style, as are the flanking rinceaux, into which small monstrous beings have been playfully integrated.

Other copper objects intended for ecclesiastical use sometimes feature similar decorative motifs. Certain copper lamps, conceived as large polished spheres from which candle-bearing arms protrude, are topped by small shields with auricular cartouches bearing the initials of the individuals who donated these costly objects to the church. To cite another example, auricular forms *page 69* were occasionally incorporated into the openwork decoration of copper lecterns until the early eighteenth century.

In order to safeguard their Japanese monopoly and stimulate trade contacts, the Dutch community in Deshima sent an annual delegation to the shogun bearing lavish gifts. Beginning in 1636, the latter included masterpieces of European metalwork. They seem to have been much appreciated by the recipients, for they were placed in a sacred place near the tomb of Tokugawa Ieyasu and his successors (who ruled Japan from 1603 to 1867) in Nikkō, where they remain today.

In 1640, the Dutch offerings included two lamps whose feet, composed of scrolled volutes, are decorated with auricular forms. That same year the delegation also delivered a dozen double-armed lamps with mountings designed as auricular cartouches. The most extraordinary piece is a lantern given in 1643, about 3 meters high and weighing 4,523 pounds, which was suspended from an open structure in typical Japanese style. Some of the decoration on this colossal object is close to the auricular vocabulary, notably the curved braces culminating in dolphin heads and the openwork grilles of rinceaux given an auricular inflection. It is topped by cartouches bearing the Tokugawa emblem. This exceptional piece is the work of Joost Gerritsz, an Amsterdam metalworker, but both the overall effect it produces and its decorative detailing suggest that Johannes Lutma, also of Amsterdam, may have had a hand in its design.

Many everyday objects were made of pewter in the seventeenth century, but by its nature this metal is ill-suited to complex decoration, and auricular motifs are almost never found on pieces made of this alloy. There is, however, one notable exception: the large pewter pots commissioned by the city of Amsterdam from the sculptor Artus Quellinus and executed in 1652. Their scrolled, balusterlike handles terminate in snakes' heads, and they bear relief designs that recall vertebrae, a typical auricular motif.

Glass and Ceramics. ~ The auricular style did not affect the standard shapes used in making glassware, but it did play a modest role in the decoration of such objects, notably in the form of painted ornament. Certain Römer glasses bear engraved auricular shields, and auricular cartouches bearing texts or vignettes *page 79* sometimes appear in stained-glass windows. Ornament in the style was also used on Dutch pottery, but very rarely. An example is a painted vase from 1693 *page 73* decorated with a vignette of a potter at work; both this scene and the text below it are contained within cartouches featuring fantastic masks reminiscent of ornamental prints by van den Eeckhout. A figurine executed around 1700 in the Delft *page 80* workshop of Lambert van Eenhoorn represents a fiddler; he is perched atop a tripod base with three dolphin feet meant to evoke the similar forms of luxury silverware in the auricular style.

Textiles and Tapestries. ~ Textile designers employed the auricular vocabulary very sparingly, preferring to use less eccentric forms such as columns, flowers, and foliage in their borders. From time to time, however, they included lobed cartouches as frames for biblical or mythological scenes. In the *page 73* seventeenth century, the walls of prosperous middle-class households were sometimes decorated not only with tapestries but also with gilt-leather panel- *page 72* ing, which occasionally featured repeated motifs using elements of the auricular vocabulary. Archival sources indicate that Joost Lutma, a brother of the goldsmith Johannes Lutma, made instruments employed in the production of such leather appliqué panels.

Furniture. ~ Both furniture and woodwork must have been decorated in the auricular style beginning in the mid-seventeenth century, but as most of these pieces have since disappeared it is difficult to get a sense of what they looked like. A few surviving images, however, afford us glimpses of their extravagant shapes and design motifs. In the paintings of Rembrandt and his students, one frequently finds depictions of elaborate canopied beds featuring elements carved *page 71* and ornamented in the style, and there is reason to believe that doctors and specialists in the occult sciences favored the use of this vocabulary in their furniture: genre images depicting such figures often include chairs whose capri- *page 70* ciously shaped backs bring to mind parts of the human anatomy and whose legs and feet are conceived in the same spirit, sometimes resembling dolphins. Jan Verkolje executed a portrait of Cornelis s'Gravesande, the official anatomist of Delft, shown sitting on a chair whose uprights are decorated with auricular motifs. A doctor who also lived in Delft, Reinier de Graaf, was depicted by the same artist seated in his office at a table that, judging from the ornamentation of its visible leg, is in a similar idiom.

In surviving furniture designs, the most exuberant decoration is found in tables made with marble or wooden tops supported by richly carved legs. These sometimes sport auricular motifs that recall prints by van den Eeckhout, creat- *page 76* ing a strange effect intensified by the gilding of the wood. There are also some

page 80 richly carved table supports in the auricular style featuring tripod feet composed of stylized dolphin heads.

 Such elements were generally used sparingly, for the most part being judiciously incorporated into traditional forms and decorative schemes. The prints *page 39* of Chrispyn de Passe II, for example, demonstrate how auricular motifs can be integrated more or less painlessly into traditional Renaissance formats. Several pulpits with passages in the style have been preserved. The best known one was made by Albert Vinckenbrinck in 1647–49 for the Nieuwe Kerk in Amsterdam; its rich carvings feature a lobed cartouche bearing the emblem of the city. But *pages 46, 78* some provincial churches also have pulpits with extravagant cartouches inserted into otherwise conventional designs.

 Secular furniture, too, was conceived in this spirit, incorporating auricular *page 77* motifs into entirely orthodox formats. Such a case is a so-called *toogkast* armoire, named after the design of the doors, which culminate in classical arch forms recast in the auricular vocabulary.

 There are also examples of carved frames influenced by ornamental prints *page 75* from Amsterdam. Those framing two portraits by Cornelis Jonson van Ceulen dating from 1654 are cases in point, as is a small frame after a design by Johannes Lutma intended to receive a miniature. To cite another example, a wooden *page 81* butcher's sign from Groningen features a polychrome relief of a spitted pig carcass suspended by its hind legs, surrounded by a carved auricular frame decorated with similar reliefs of objects associated with the trade.

Interior Decoration. ∼ When auricular ornament was used in residential decors, it was always with great discretion, generally in a supporting role within conventional classicizing frameworks. Thus the ornamental economy of these ensembles was quite different from that prevailing in eighteenth-century interiors, which feature decors conceived as organic wholes with matching furniture and ornamental objects. Much of the woodwork in the Deventer city hall was executed by two local sculptors, Derck and Jacob Daniels. In 1652–53 *page 46* they created a monumental mantelpiece supported by marble columns for the mayor's office; the carved decorations feature festoons combined with suspended bunches of fruit and vegetables, and an auricular cartouche bearing the town's emblem in the middle of its cornice. Elsewhere in the same building—for example, in the woodwork behind the mayor's seat in the council room and on the door of the large entrance hall—classical forms such as pilasters, cornices, and rounded pediments are decorated with auricular forms. Similar woodwork in the Nijmegen city hall was destroyed during World War II; this featured a carved wooden door to the aldermen's meeting room made in 1657, decorated with an auricular cartouche supported by two lions and bearing the town's emblem.

 We can get a better sense of the sparing use of such ornament in Dutch *page 77* interiors from a painting by Emanuel de Witte dated 1678. It depicts a family gathered in a room whose fireplace and doorway are decorated with tradi-

tional classicizing woodwork, and whose walls are partly covered with costly gilded leather. But the table, most of which is hidden by an oriental carpet, has scrolled feet in the auricular style, and the frame of the mirror hanging above it features similar forms. Note also that there is a wide border on the silver platter full of fruit that the daughter of the house offers her father, and we can be fairly certain that its pronounced lobes were separated from one another by an auricular pattern, as in an example from Friesland in the northern part of the Low Countries dating from 1681.

page 65

Among the rare examples of wood with more exuberant auricular carvings are two fragments of a stair banister. These are composed of elegant rinceaux combining anatomical elements and monstrous beings, with one end displaying the form of a human figure.

page 69

Although auricular ornament largely disappeared after 1680, having been replaced by new styles, it continued to exercise a certain influence after that point. The stucco-work overdoors in the vestibule of a patrician house in Alkmaar by Herman van Gorkum, dated 1744, feature low-relief vase motifs that are free variations on designs in *Modelles Artificiels;* they stand out oddly against the rest of the decor, which is in late Louis XIV style.

Exterior Decoration. ~ Auricular motifs were occasionally used to decorate house façades. An early example is the relief of the Haarlem town emblem on the pediment of the Vleeshal (Meat Market), 1602–03, attributed to Hendrick de Keyser. The edges of the cartouche are turned down and appear to be quite pliable; this detail is reminiscent of decorative forms used at about the same time by such Haarlem artists as Goltzius and van Mander. In 1606 de Keyser used an auricular mask to effect a transition between a terra-cotta bust and the wooden base on which it stands.

In the mid-seventeenth century, after the publication of Lutma's prints, cartouches of this type figured on European façades rather frequently, especially in Amsterdam. Large buildings were often topped by pediments decorated with them, often bearing the owner's coat of arms. A case in point is the house on Jodenbreestraat where Rembrandt lived from 1639 to 1659, although the features in question were added after his departure. In a residence on the Herengracht built by the architect Philips Vingboons, the pediment contains an oculus win-dow surrounded by such a cartouche. Vingboons and his students frequently incorporated cartouches of this type into the gabled houses they designed, using them to frame a pair of oval windows on their top floors. These gables are usually of brick (stone being used only for their sculpted ornament), though in some instances the entire façade was made of stone, in which case the decoration was sculpted directly onto it. Occasionally when the house is narrow, the cartouche is placed on the façade's central axis, marking the spot where a pulley beam protrudes. Such cartouches might bear the owner's name and the date of construction, or an attribute indicating the building's purpose or its occupant's profession. The old headquarters of the goldsmiths' guild in The Hague is

page 82

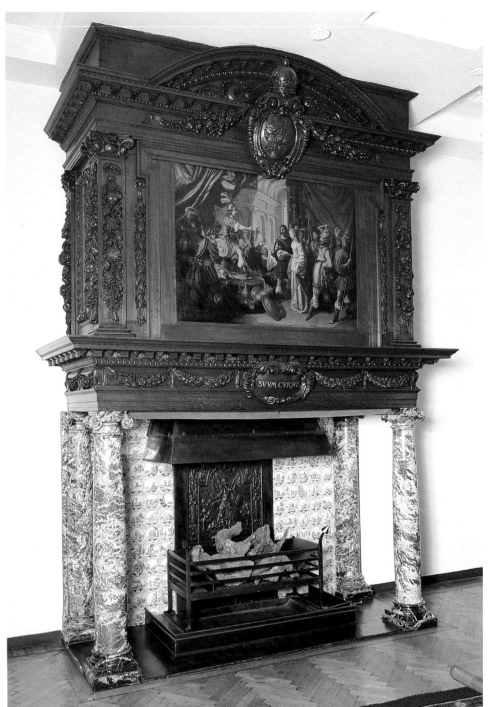

Mantelpiece in the mayor's office,
Derck and Jacob Daniels,
Deventer, 1652–53.

Deventer, City Hall

The wooden overmantel resting on marble
columns is conceived along classical lines. The
carved decorations, executed by the brothers
Derck and Jakob Daniels, feature garlands and
festoons. Above the painting by Dirk Hardenstein,
which represents the Continence of Scipio, is an
auricular cartouche bearing the arms of the city of
Deventer. A simpler cartouche in the same style
below the painting frames the motto of the city
regents, which is quite appropriate to the image:
Suum cuique (To each his own).

Wooden relief panel with an auricular
cartouche from the pulpit of the church
in Duesburg, Hendrick Wytwelt, c. 1659.

Duesburg, Protestant church

While the overall conception of this pulpit is
traditional and features classical ornament, the
panels are decorated with auricular cartouches
directly influenced by Lutma's ornamental
print designs.

Sign on the former headquarters of
the goldsmiths' guild, c. 1650.
The Hague, Binnenhof

*I*n the center of this stone cartouche is a bas-relief
of a large covered hanap, a ring, and a chain. The
scrolled border surrounding this motif, which is
decked out with tools of the goldsmith's trade,
is in the auricular style.

Poster, lithograph printed by Senefelder,
Huib Luns, Amsterdam, 1925.
Rotterdam, Gemeente Archief

*T*his poster was designed for a 1925 exhibition
commemorating the six-hundred-and-fiftieth
anniversary of the founding of Amsterdam.
The city emblem, placed in the center of the
composition, is surrounded by a fantastic mask
composed of auricular forms and strange
creatures resembling dolphins. The auricular
style has become indelibly associated with
Amsterdam's golden age.

page 47 identifiable by an auricular cartouche bearing reliefs of the tools of the trade and a large hanap made with them. A house facing the old Utrecht fish market is decorated with a sign composed of an auricular cartouche bearing a trident of *page 83* the type used in eel fishing.

The building designed by Justus Vingboons for the iron and arms merchants Louys and Hendrick Trip on the Kloveniersburgwal in Amsterdam, erected in 1660–62, features an especially lavish decorative scheme. Between its eight Corinthian pilasters supporting an architrave and pediment, the inset façade is pierced by three rows of windows; above and below these are panels featuring garland motifs and (in four of the panels) auricular cartouches, with masks suggestive of dolphin heads at the far left and right.

<center>⁓ ◗◖ ⁓</center>

Other Countries

As already indicated, objects decorated in the auricular style were regularly exported from the Low Countries. They were usually precious gifts presented by the Estates-General or the Dutch East India Company to important political figures they hoped could be swayed to act in their favor; examples of such objects can be found today in Russia and even in Japan.

But the Dutch who lived in Asia also occasionally commissioned local artists to execute objects designed after auricular models from the Low Countries. Thus, there are silver platters made in Indonesia and Sri Lanka using decorative schemes that were clearly influenced by the style.

The auricular style as practiced in the Low Countries was imitated in the rest of Europe, too, and in certain countries it developed into idiosyncratic variants. In Germany, for instance, two distinct ornamental currents emerged that might be termed auricular. The ornamental prints published by Unteutsch certainly had the greatest influence there. These engravings were inspired by *Schweifgrotesken,* a typically German variant of scrollwork featuring intertwined C-shaped volutes combined with auricular motifs. Such designs were used in several branches of the decorative arts—mainly to decorate woodwork and large armoires—but only as ancillary ornament, without affecting the basic configuration of the objects or furniture being ornamented. In most cases the ensemble was conceived after Renaissance architecture, and their principal parts are in that style, but these are fitted out with whimsical decorations (masks, etc.) in an auricular idiom. Simple wooden *page 87* chairs were given backs covered with such forms, and armchairs were given arm panels bearing auricular relief designs. Similar decorations are found in the reliefs preserved in Skokloster Castle outside Uppsala, Sweden, notably *page 86* the remarkable ceiling stuccos in its principal rooms dating from 1663–64, the result of a collaboration between the German Hans Zauch and the Italian Giovanni Anhtoni.

Much the same could be said for goldsmith work produced in Germany

and in regions susceptible to German influence, including Scandinavia, Poland, and Switzerland. In fact, almost all of Europe's artistic centers turned out objects based on traditional forms but with ornamentation inspired by Unteutsch's engravings. In the second half of seventeenth century, this version of the auricular style was most prevalent in the beer mugs known as *Humpen,* *page 89* often dominating their bodies, covers, and handles. Similar motifs play over the surfaces of diverse objects produced in Hamburg and Augsburg: ewers, platters with wide decorative borders, and the indigenous cups known as *Konfekstschalen.* Even pieces intended for export soon received such decoration— *page 86* for example, the small vases known in Russia as *brachina,* which were pro- *page 88* duced in Hamburg in large numbers. But some German goldsmiths preferred a version of the auricular style that was closer to the one practiced by the Dutch. One notable example is the base of a work by Nuremberg goldsmith *page 52* Christoph Jamnitzer—a sculpture of Hercules supporting the terrestrial globe— completed by Jeremias Ritter in 1620. A piece made in Augsburg in 1655 features a silver escutcheon inserted within a cartouche reminiscent of the Lutma designs published shortly before. These prints continued to influence German metalwork until the eighteenth century. Thus the small vases with convoluted shapes used by Johann Melchior Dinglinger in a famous centerpiece known as *Des Lebens Höchste Freuden* (Life's greatest joy) dating from 1728 are taken directly from *Modelles Artificiels.*

The auricular style did not have much impact in Italy and France. It had become known in those two countries through the Italian ornamental prints already mentioned, which had some influence on the sculpture and decorative arts produced there. The motifs resembling stylized strips of skin used by Enea Vico and other artists appear on two porphyry vases in *page 54* the "Egyptian" style once displayed at the Palazzo del Tè in Mantua, for example, and late-sixteenth-century majolica, notably the sparely decorated work known as *bianchi di Faenza,* is sometimes decorated with fantastic masks and elements of fluid, indeterminate character. Comparable motifs can also be found in Venetian glass. Early-seventeenth-century Italian art- ists devised a few decorative schemes having a pronounced affinity with the auricular style; these prints were especially admired in France, where they were republished. At the same time Jacques Callot, while in Italy, conceived designs very close to the auricular style. Ebony cabinets and other luxury fur- *page 85* niture designed and executed in France in the years around 1640 some- times feature cartouches whose edges seem soft and pliable. Jean Cotelle used similar forms in his interior decorative schemes—for example, in several of *page 85* the ceiling designs he devised for his patroness, the Princesse de Guémené, at the Hôtel de Rohan.

The evolution of English taste was much influenced by the van Vianens and their students. Shortly after 1630, Christiaen van Vianen was named offi- cial goldsmith to King Charles I, for whom he executed several important commissions. Unfortunately many of these pieces were destroyed—notably the

seventeen-piece altar service that he made in 1637 for St. George's Chapel at Windsor, which was stolen by Cromwell's troops during the civil war and melted down in 1641. A few survive, however, as do a handful of objects pro-

page 90

duced by London goldsmiths that show his influence; we illustrate an inkstand from 1639 whose decoration is especially rich.

After the Restoration, in 1660, Christiaen van Vianen returned to London and entered the service of Charles ii. Michiel de Bruyn (van Berendrecht), who trained in the workshop of Adam van Vianen, later became Christiaen's partner and executed many commissions for the British aristocracy. Silverware decorated with auricular motifs seems to have been considered the height of elegance in English court circles for some time, and important gifts were often executed in the style. About 1661 the city of Plymouth presented the king with a magnificent auricular piece now preserved in the Tower in London; in a contemporary source, it is said to be masterfully sculpted with "curious figures" and may have been used as a censer. This enormous object bears no identifying stamps, but it is attributed to the goldsmith Peter Oehr i of Hamburg. Other important objects from this period influenced by the van Vianens are preserved in the Tower, too, notably the saltcellars known as "Saint George's Salts" and several chandeliers.

After the death of Christiaen van Vianen, his son-in-law John Cooqus

page 90

continued to serve his clients at the court for some years; two wine pitchers by Cooqus from about 1670 survive. This style, introduced by Christiaen van Vianen and his students and much appreciated at court, was widely imitated; many English goldsmiths aware of its popularity took it up in turn. In most cases they merely added auricular motifs to traditional designs. However, the English returned to the brand of the style associated with the van Vianen family much later: in the eighteenth century cream pitchers were produced that bear an extraordinary resemblance to designs in *Modelles Artificiels,* and similar objects continued to be produced into the nineteenth century. A silver cup with an

page 91

inkwell depicted in a portrait of Robert Vernon dating from 1848 is an obvious example. In 1892, the firm R. & S. Garrard & Co. offered small plates in the style of Adam van Vianen, featuring borders decorated with male and female figures against a curiously fluid ground.

In England, the style's influence was limited by and large to metalwork, but a few auricular sculptures were made there. The style's characteristic forms

page 78

are discernible, for example, in works by the sculptor Francesco Fanelli, who shared clientele with Christiaen van Vianen, and auricular cartouches were sometimes used to frame coats of arms and texts, especially in funerary pieces. In the realm of prints, ornament in the style appeared sporadically in the work of artists who came to England after having lived in the Low Countries. For instance, Wenzel Hollar, originally from Prague, used auricular ornament to decorate a few engraved portraits and topographical images in England, and in 1643 the watercolorist Peeter Rottermond surrounded a portrait of Sir William Waller with a frame composed of anatomical motifs.

Conclusion

Auricular ornament can be considered an extension of mannerism, which is characterized by unlimited invention and technical virtuosity. Works produced in this style set out to dazzle and disturb by violating the natural scheme of things—by producing, for example, hard metal objects that appear to be soft and malleable. The also tend to incorporate bizarre motifs susceptible to multiple interpretations. Those who used auricular ornament in these ways, whether as the primary creative figure or as "mere" executants, effectively refrained—as Ernst Gombrich wrote in *The Sense of Order*— from forcing their own personalities on the viewer and thus allow us a certain freedom of interpretation.

Although the earliest examples of the auricular style appeared before the middle of the sixteenth century in Italy, it was given new life about 1600 by a group of artists with close ties to the court of Emperor Rudolf II in Prague, and by another group in Holland. The van Vianens played a particularly important role in both consolidating the style and setting its limits.

Artists and craftsmen continue to be fascinated by the designs and productions of this remarkable family of goldsmiths. In the Netherlands, eminent early-twentieth-century metalworkers like Frans Zwollo and Carel J. A. Begeer sometimes embraced a similar vocabulary and similar aims—delighting, for instance, in the challenge of making metal seem malleable. A poster designed *page 47* in 1925 by Huib Luns for an exhibition commemorating the six-hundred-and-fiftieth birthday of Amsterdam features a text inscribed within a cartouche reminiscent of Lutma: an appropriate and no doubt self-conscious gesture, for, like the work of Rembrandt, the auricular style is indelibly associated with the artistic and economic golden age of the Netherlands.

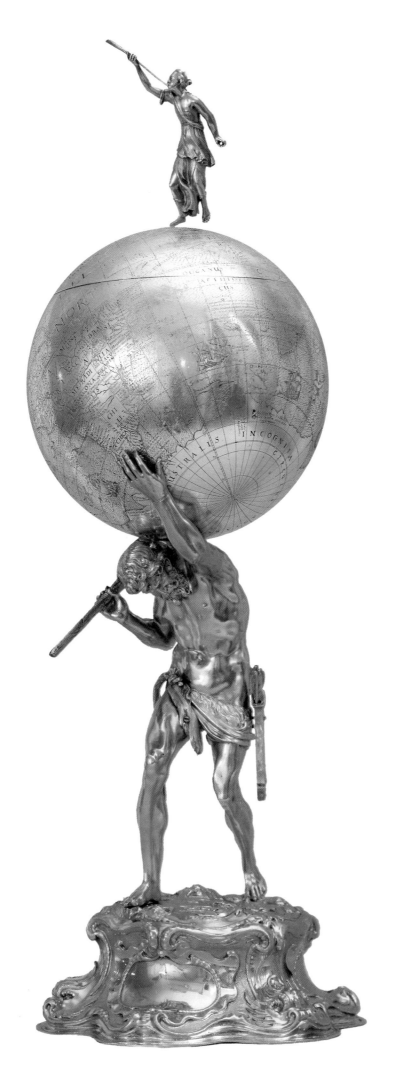

Hercules supporting the terrestrial
globe, silver gilt, Christoph Jamnitzer
and Jeremias Ritter, Nuremberg, 1618–20.
Stockholm, The Royal Collections

The figure of Hercules stands on a base featuring
ornate auricular motifs similar to Dutch work
produced by the school of the van Vianen family.
This element may have been entirely executed by
Jeremias Ritter, who completed the piece as a
whole after Jamnitzer's death. The globe was
engraved by Johann Hauer.

ABDITA NATVRÆ
vel
SVCCESSIO TEMPORIS

SYMBOLVM ÆTERNITATIS

Zwen Ægÿptilche gefäs von Porphir, vier Schue hoch,
welche in der Gallerie zu Mantua geſtanden, aber A. 1630. in
der Blünderung zerſchlagen worden, welche Abriß die Königin
Chriſtina aus Schweden in Rom davon halte.
J. B. F. v. E. del.

Deux Vaſes Egiptiens de porphŷre hauts de quatre
pies, qui etoient dans la gallerie de Mantoue, caſſes en ſuite
par le pillage l'an 1630. dont la Reine Chriſtine de Suede
a eu le modele a Rome.

Two Egyptian porphyry vases, etching,
Johann Bernhard Fischer von Erlach (1656–1723), print
from *Entwurf einer historischen Architektur* (Outline of
a historic architecture), Vienna, 1721.

Basel, University Library

The book by Fischer von Erlach from which this plate is taken was published
several times after its first edition of 1721. This image represents two vases
whose Egyptian flavor derives from the whimsical "hieroglyphs" appearing on
them. But those aside, their conception is altogether consistent with the
sixteenth-century manneristic aesthetic epitomized by the work of Giulio
Romano, notably the Palazzo del Tè in Mantua, which was built to his designs.
As it happens, the vases pictured here were exhibited there until they were
destroyed in 1630; Fischer von Erlach had seen images of them during
his Roman sojourn.
Curved bands resembling strips of flesh appear to be peeling from the surface
of the vases and, at the top, form the vessels' handles. The auricular style was
initially inspired by decoration of this kind.

Design for a candlestick, engraving, Enea Vico, 1552.

London, Victoria and Albert Museum

The flange of the socket appears to be made of a malleable material, and its
general conception anticipates the auricular style.

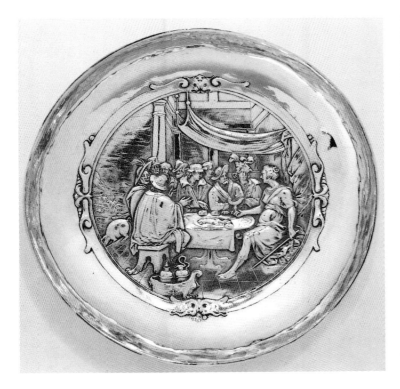

Silver cup, Adam van Vianen, Utrecht, 1610.

Amsterdam, Rijksmuseum

The central scene, with its depiction of Ulysses at Circe's table in low repoussé, is surrounded by a border incorporating two fleshy masks, an indicator of the nascent style. But the auricular vocabulary is given freer expression in the wine cooler in the composition's foreground. The form of this extravagant object brings to mind the stiffened skin of a quadruped animal: there are flattened faces on its sides and rear; paws with long claws emerge from its base; and breastlike mounds protrude from its front.

Perseus and Andromeda, ink and wash, Karel van Mander, Haarlem, 1598.

Paris, Institut Néerlandais, F. Lugt collection

Karel van Mander, a painter and the biographer of many artists from Holland and elsewhere, was a member of the mannerist circle in Haarlem that maintained close ties with the Prague group in the years around 1600. The cartouche framing this scene already displays the pliable, skinlike character that would become so prevalent in the auricular style.

Bacchus, engraving, Hendrick Goltzius, Haarlem, c. 1595.

Amsterdam, Rijksprentenkabinet

This print is dedicated to Cornelis Cornelisz, who, like Goltzius himself, belonged to the group of mannerist artists based in Haarlem. The drinking cup that Bacchus holds in his right hand is typically auricular in conception: its surface is fluid and irregular, and it features a prominent flattened mask.

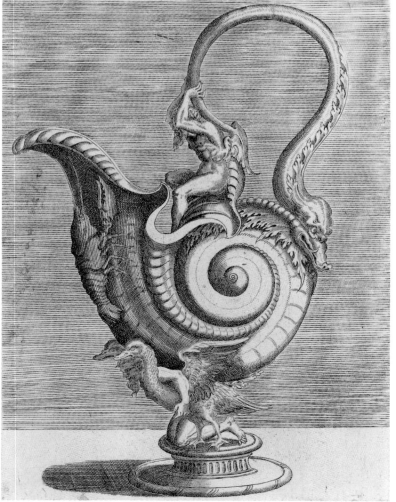

Design for an artificial grotto (detail), brown ink with
black wash highlights, Jacques de Gheyn II, c. 1620.
London, British Museum

This design, devised for the residence of the stadholder in The Hague,
has much in common with the auricular style. The central motif, a
bearded old man who seems to merge with the viscous shell-like material
around him, recalls ornamental prints by Cornelis Floris.

Design for a ewer, print,
Cornelis Floris (1514–1575), mid-sixteenth century.
Rotterdam, Boymans-van Beuningen Museum

One of the auricular style's most cherished strategies is the juxtaposition
of animate with other natural forms. Eventually the boundaries between
them would become elusive, but here the various component elements
remain quite distinct from one another, marking it as an artifact of
the style's prehistory.

Funerary Monument in a Grotto,
oil on copper, Carel de Hooch, c. 1635.
Private collection

This enigmatic image depicts a grotto that has
been transformed into a burial ground, and is
dominated by a commemorative plaque suspended
between two columns and bearing an inscription
dedicated to a famous Roman emperor: *Divo
Octaviano Augusto Octavii.* The bottom of the
plaque's wide frame incorporates the head of an
old man with a mustache, and its coagulant shapes
are typical of the auricular vocabulary.

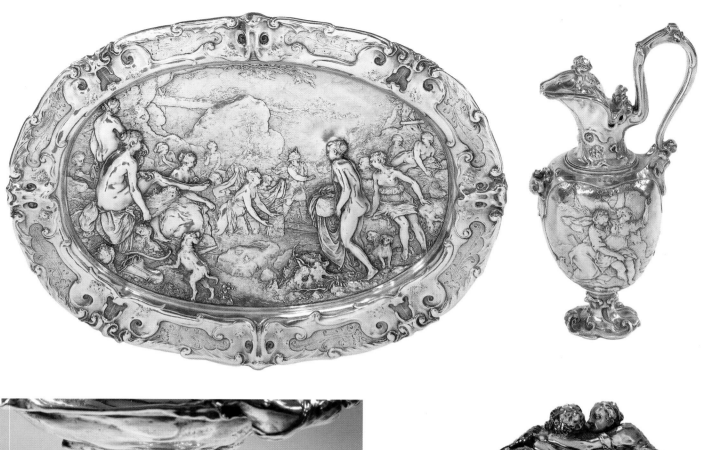

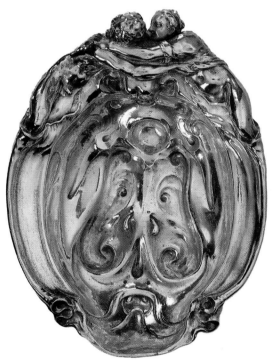

Ewer and platter, Paul van Vianen, Prague, 1613.

Amsterdam, Rijksmuseum

The ewer is decorated with scenes from mythology depicting Hera and Callisto, and Callisto's punishment, but these narratives are surrounded by auricular ornament: the base has a vaguely crustaceous character; the handle recalls a stretched tendon; odd creatures inhabit the cover and collar; and—as in the same artist's 1614 memorial ewer (see page 26)—a gush of liquid lifts its "head" above the spout.

The matching platter features a relief of Diana and Acteon; its border is decorated with ambiguous auricular shapes that suggest both bones and masks.

Cup (full view and detail), silver, Adam van Vianen, Utrecht, 1618.

Amsterdam, Rijksmuseum

The base of the cup consists of what looks like flowing drapery, out of which peer three human faces; the stem swells to form a strange crouching monster with bat's wings. An amorous couple emerges out of a primal ooze that coalesces into auricular shapes. As the beverage is consumed, a semi-nude female figure emerges from the surface of the interior, sitting in the cup just below the couple's arms. But the biggest surprise is reserved for last. After taking the final gulp, the drinker sees that the symmetrical inner surface is configured like the interior of a human skull; the artist undoubtedly used Vesalius's book on anatomy when designing it.

Portrait of Johannes Lutma, oil on wood, Jacob A. Backer, c. 1643.

Amsterdam, Rijksmuseum

The goldsmith Johannes Lutma is represented with mallet in hand; on the workbench at right are a jar full of punches and stamps and a saltcellar he executed *(at right).*

Cup, silver, Johannes Lutma, Amsterdam, 1641.

Amsterdam, Rijksmuseum

The conception of this shell-shaped cup is very much in the spirit of the van Vianens: its entire surface is given over to auricular ornament, and an odd, squidlike monster perches on its rim. Rembrandt included a cup like this one in the portrait of Lutma that he etched in 1656.

Saltcellar, silver with partial gilding, Johannes Lutma, Amsterdam, 1639.

Amsterdam, Rijksmuseum

This saltcellar, whose tripod foot and culminating shell-shaped receptacle are gilded to set off the figure between them, is one of a series of four produced by Lutma between 1639 and 1643. In all of them the putto holds a branch of coral, a shell, and some seaweed.

Design for a candlestick, etching, Adam van Vianen, c. 1650.

Amsterdam, Rijksprentenkabinet

This sheet is number twenty-three in *Modelles Artificiels,* a collection of prints published around 1650 by Christiaen van Vianen. It includes designs by his father, the celebrated goldsmith Adam van Vianen, as well as himself; the etchings were executed by Theodor van Kessel. The elder van Vianen, who died in 1627, enthusiastically introduced the auricular vocabulary into metalwork. The conception and detailing of this candlestick are typical of his style.

Trowel, silver, Johannes Lutma, Amsterdam, 1648.

Amsterdam, Rijksmuseum

This piece was made for the laying of the foundation stone of the Amsterdam city hall. Its handle has a vaguely anatomical form, and the surface of its blade is decorated with an incised cartouche in a similar style.

Designs for a mirror frame and a candlestick, pen and wash, Adam or Christiaen van Vianen.

Stockholm, National Museum

This drawing, probably from the van Vianen workshop, closely resembles the prints in *Modelles Artificiels* but was not included in it. Note that the shaft of the candlestick is identical to the one in the design illustrated above. Likewise, the frame, which features rounded upper corners and a quicksilver auricular surface from which emerge auricular masks, is similar to the framing border on the volume's title page.

Knife, silver and steel,
Low Countries, seventeenth century.

Amsterdam, Rijksmuseum

The auricular motifs on the handle of this knife include, at the end,
a form that suggests an animal head.

Spoon, silver, Amsterdam, 1659.

Private collection

This piece, the work of an unknown Amsterdam silversmith whose
initials were IS, has a handle that resembles a tiny bone. Its significance as a
vanitas motif is confirmed by the text engraved on the back of the cup,
which commemorates the death on June 15, 1659, of Annetie Keutinck, the
widow of Amsterdam mathematician Jan Olfersz.

Designs for spoons and a pedestal,
etching, Gerbrandt van den Eeckhout, c. 1653.

Amsterdam, Rijksprentenkabinet

This sheet is one of a series published by Cornelis Danckerts, *Verschijde
Constige Vindingen*, that includes designs by van den Eeckhout, Lutma, and
Adam and Christiaen van Vianen. The spoon handles have scrolled ends
and resemble small bones from which the surrounding flesh has been
partially stripped away. It is difficult to say on what scale the pedestal
design was intended to be executed, but its forms unmistakably
evoke male and female genitalia.

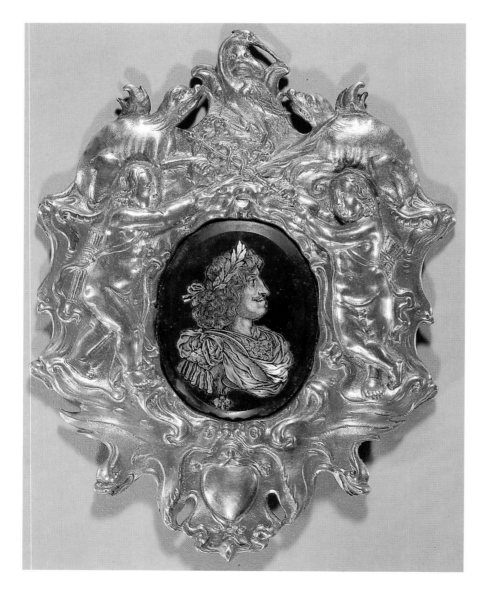

Medal with an effigy of Frederick Henry,
Prince of Orange, bronze, Johannes Lutma,
Amsterdam, c. 1643.

Leiden, Koninklijk Penningkabinet (Royal Medal Cabinet)

Both the stadholder's portrait and the inscription beneath
it—*Patriaeque patrique*—are surrounded by an auricular
cartouche similar to those appearing in prints after designs
by Lutma. The reverse bears another cartouche in the same
style framing an image of a jug immersed in water, with
the inscription *Vigilando*.

Mortuary medal, silver,
Wouter Muller, Amsterdam, 1670.

Leiden, Koninklijk Penningkabinet

Medals of this type were given to the friends and relations
of a deceased person. They could be made of silver or some
other medal, in accordance with the family's financial
resources. In this example, an auricular escutcheon above
which rises the figure of Death is flanked by two putti.
The commemorative inscription records the death in 1670
of Balthasar Justus van Dortmont.

Portrait and frame,
mother of pearl and gilt copper, Denmark,
second half of the seventeenth century.

Copenhagen, Rosenborg Castle

This small metal auricular frame surrounds a painted
"cameo" portrait of Frederick III, King of Denmark
(1609–1670), attributed to Jeremias Hercules.

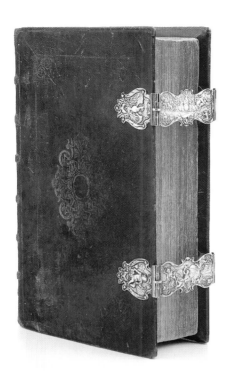
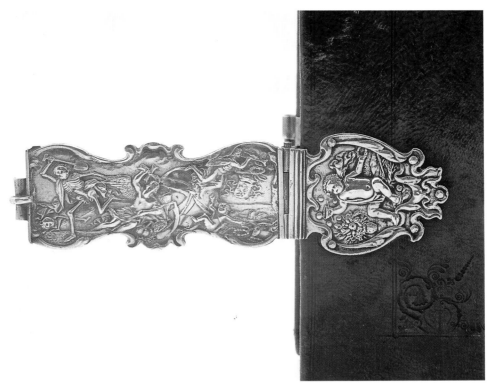

Book with silver clasps (general view and detail),
Low Countries, c. 1655.

Rotterdam, Boymans-van Beuningen Museum

Jacob Cats, a wealthy poet, gave special sets of the 1655 edition of his
complete works to public institutions such as the Estates-General and the
governing bodies of cities with whom he maintained close ties. These
volumes are bound in Moroccan leather and fitted with silver clasps
decorated with biblical and allegorical scenes surrounded by auricular
frames. In the detail illustrated here, Death battles with Time and a
putto blows bubbles, a standard *vanitas* motif.

Mirror with a painted *vanitas* still life,
mirrored glass in wooden frame, Low Countries,
late seventeenth century.

Boston, Museum of Fine Arts

Painted on the bottom portion of the mirror is a still life of a tabletop
piled with books, a cloth, a skull on which rests a wilting sprig of vegetation
(hops?), a scallop shell above which bubbles float, and a candlestick holder
with a burnt candle; the latter object resembles designs by the van Vianens
published in *Modelles Artificiels*. The composition, a moralizing *vanitas* taken
from a print by Petrus Schenck, was meant to prompt viewers to reflect
on their mortality.

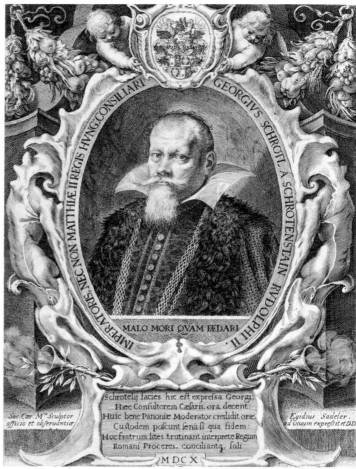

Title page, engraving, Gerbrandt van den Eeckhout.

Amsterdam, Rijksprentenkabinet

This is one of three title pages to *Plusieurs Nouveaux Compartemens,* a compilation of designs by van den Eeckhout; the others are in Dutch and Latin. The elaborate auricular cartouche features emergent dogs, female torsos, and masks as well as forms suggestive of genitalia, similar to those used by Lutma.

Portrait of Georg Schrotl a Schrotenstain, engraving, Egidius Sadeler, Prague, 1610.

Amsterdam, Rijksprentenkabinet

Sadeler, who is here identified as *sculptor* serving Emperor Rudolf II, was a member of Paul van Vianen's circle in Prague. The portrait image (which pictures an advisor to the emperor) is traditional in conception, but its oval frame is an auricular jumble of shell and bone forms, rolled skin, and other vaguely anatomical shapes, which extend down to frame the inscribed cartouche below.

Design for a covered decanter, pen and black charcoal with white highlights, attributed to Gerbrandt van den Eeckhout, c. 1650.

Schwerin, Staatliches Museum

This decanter with pivoting handle is shaped like a gourd and sits on clawed feet; its surface is encrusted with auricular ornament similar to that in prints by the artist.

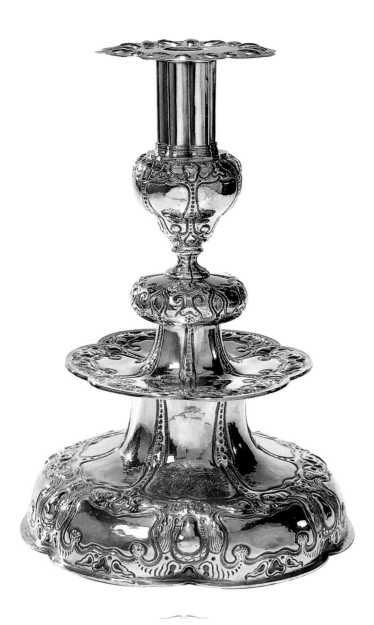

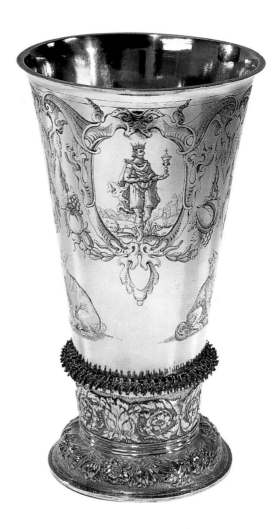

Candlestick, silver, Willem Brugman, Delft, 1652.

Amsterdam, Rijksmuseum (Deutzenhofje loan)

Dutch goldsmiths in small cities also incorporated auricular motifs into their
work, but rarely deviated from traditional formats. This candlestick holder is
a case in point. It is one of a set of four, one of which is known to have been
executed in 1652 by Johannes Grill, a master goldsmith based in Amsterdam.

Goblet, silver, Hyndrick Muntinck the younger,
Groningen, 1655–56.

Amsterdam, Rijksmuseum

Many goblets of this type, with a crown of thorns slightly above the base, were
produced in seventeenth-century Groningen. Here the smooth surface above
is incised with three auricular cartouches framing figures of the three magi.

Large platter, silver, Claes Baerdt, Bolsward, 1681.

Leeuwarden, Fries Museum

Auricular ornament slowly gave way to other vocabularies in the second
half of the seventeenth century. This development can be seen on the piece
shown at the right, of a type known as a *plooischotel*. Each of its broad rim's
lobed segments features a large, realistic flower motif framed by auricular
tracery elements; the heavily worked flowers overpower the delicate
auricular borders.

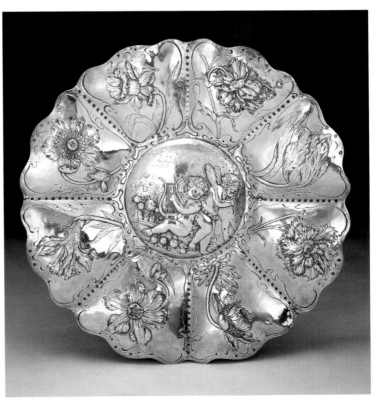

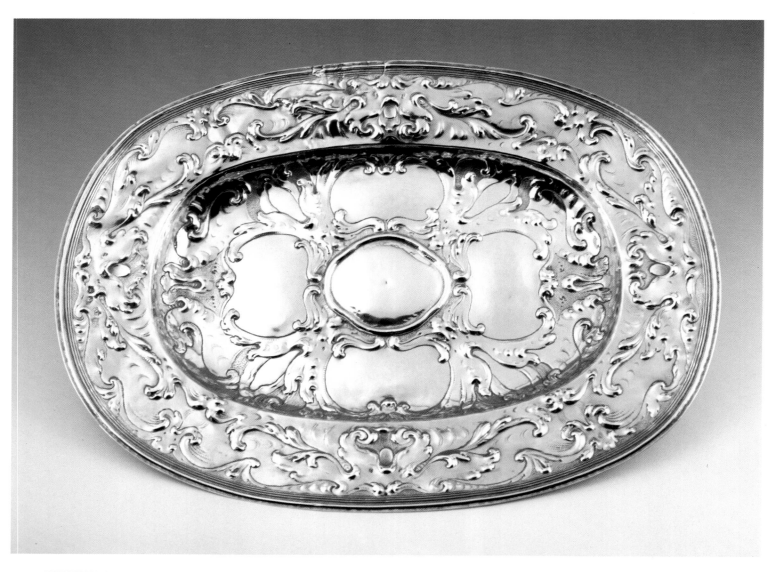

Platter, silver, Cornelis de Haan, Rotterdam, 1681.

Rotterdam, Boymans-van Beuningen Museum (lent by the Old Catholic Church of SS. Peter and Paul, Rotterdam)

This piece by a Rotterdam silversmith was produced after the fact to match the ewer illustrated on the opposite page; its surface is covered with auricular scrollwork resembling vegetation.

Design for a platter, four etchings, Adam van Vianen, designed c. 1625 and published c. 1650.

London, British Library

Modelles Artificiels includes several prints picturing only single quadrants of platter designs. The British Library owns a copy that features fold-out sheets displaying the entire images compiled from proofs and counterproofs. In the example shown at left, the platter's border and the entire area within it feature auricular ornament; the medallion in the center was designed to accommodate the base of a matching ewer.

FACING PAGE

Ewer, silver, Michiel de Bruyn (van Berendrecht), Utrecht, 1652.

Rotterdam, Boymans-van Beuningen Museum (lent by the Old Catholic Church of SS. Peter and Paul, Rotterdam)

The surface of this piece, the work of a silversmith who apprenticed with Adam van Vianen, is partially covered with auricular ornament derived from anatomical shapes, and its handle resembles an eel-like creature.

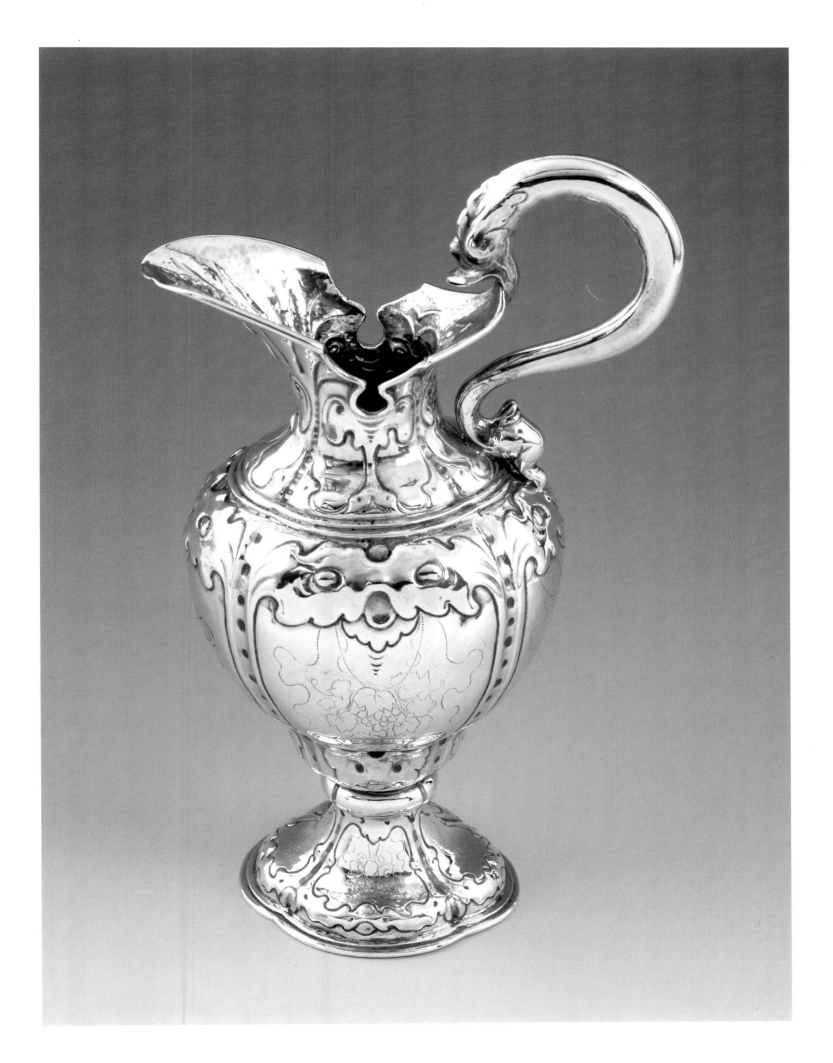

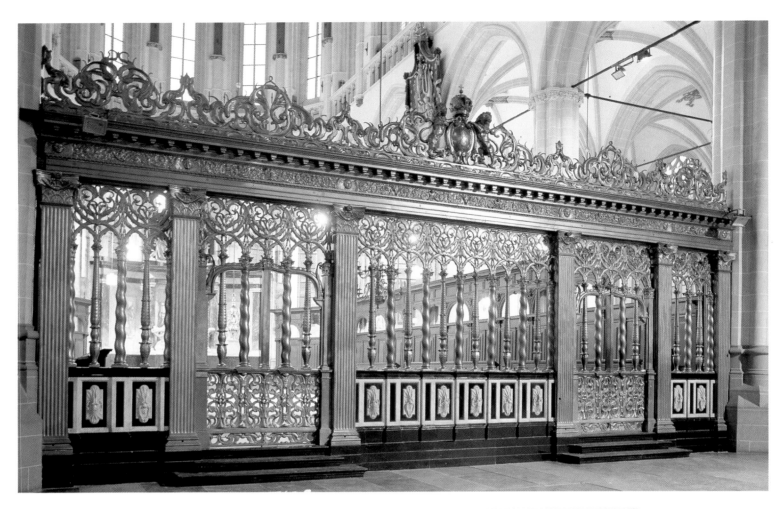

Choir screen, copper and marble,
after designs by Johannes Lutma, Amsterdam, c. 1650.

Amsterdam, Nieuwe Kerk

The armature of this screen is classical, but auricular ornament occupies much of its intervening spaces. The escutcheon carrying the emblem of the city resembles designs in Lutma's ornamental prints, but the rest of the non-classical decoration is closer to German variants of the style. The metalwork was executed by craftsmen known only by their initials, SD and IK.

Choir screen in the Nieuwe Kerk in Amsterdam,
etching, Johannes Lutma the younger.

Rotterdam, Boymans-van Beuningen Museum

Johannes Lutma the younger executed this etching after drawings by his father; some details differ from those in the screen as it stands today.

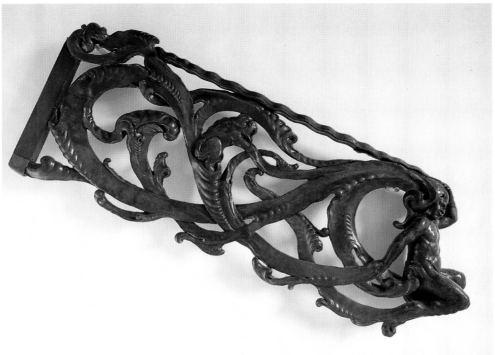

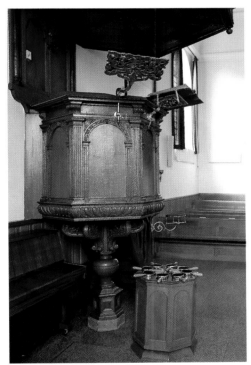

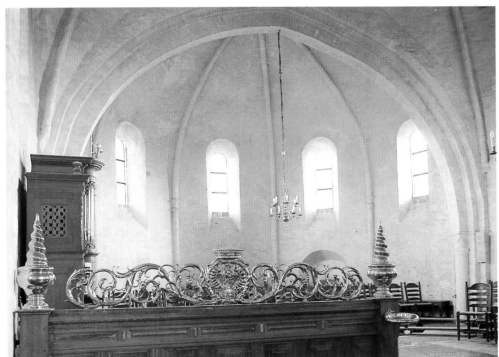

Lectern, copper, Low Countries,
mid-seventeenth century.

Benthuizen, Protestant church

This openwork lectern is dominated by auricular
forms in which two small monsters and a mask
can be discerned.

Pulpit, oak, mid-seventeenth century.

Benthuizen, Protestant church

This illustration shows the lectern in its original
location; the smaller one next to it dates from 1713.

Balustrade, exotic wood,
Low Countries, c. 1650.

Rotterdam, Boymans-van Beuningen Museum

In this carving, probably part of a stair balustrade,
traditional rinceaux are given an auricular
inflection. The crouching monster in the center
recalls designs originating in Lutma's circle. At the
far right, a putto grips the curving tendril-like
forms. An almost identical fragment now in
London's Victoria and Albert Museum is almost
certainly from the same decor.

Upper portion of a choir wall,
wood and copper, second half of the
seventeenth century.

Leens, Dutch Reformed Church

One of two low barriers separating this church's
apse from its nave, it is surmounted by copper
finials and a decoration of rinceau-like forms
animated by small monsters. In the center,
surrounded by an auricular frame, are the
crowned arms of the donor, a scion of the Tjarda
van Starkenborch family of Groningen.

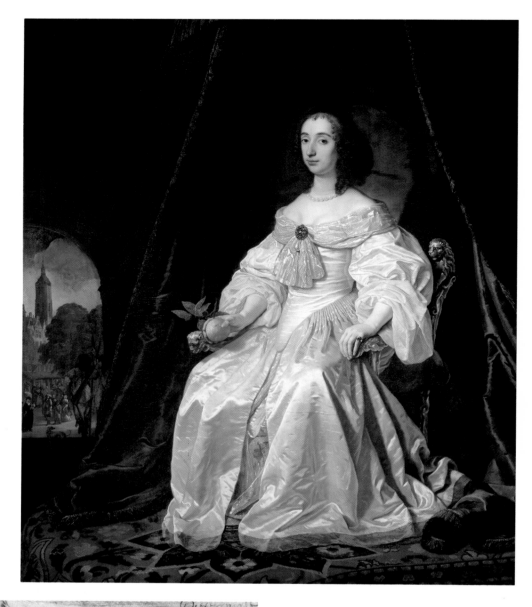

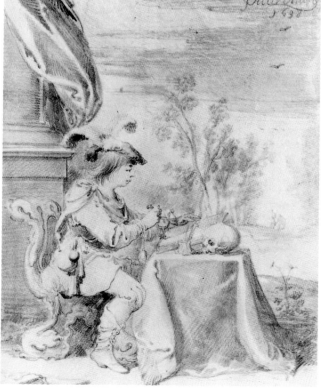

Portrait of Henrietta Maria Stuart, oil on canvas, Bartholomeus van der Helst, 1652.

Amsterdam, Rijksmuseum

This portrait represents the young daughter of King Charles I of England shortly after his execution and the death of her husband, the stadholder William II, Prince of Orange; she holds an orange in her right hand, and sits on a silver armchair with auricular uprights suggestive of bones.

Young Man Reading, charcoal on parchment, Pieter Quast, 1638.

Private collection

The figure, who seems to be engaged in some scientific work—or an occult ritual—sits on a chair whose eccentrically curved forms have a vaguely anatomical character, and whose feet are shaped like twisting dolphins.

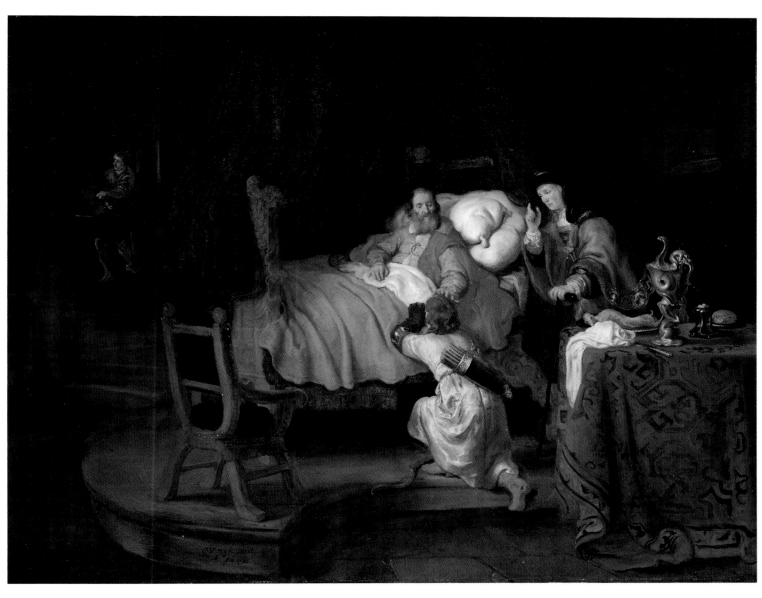

Isaac Blessing Jacob, oil on canvas,
Gerbrandt van den Eeckhout, 1642.
New York, The Metropolitan Museum of Art

Van den Eeckhout produced several compilations
of ornament prints in which auricular forms
figure prominently, and his interest in the style
is also reflected in his paintings. Here, the aged
Isaac lies in an elaborate bed decorated with
auricular designs, and Adam van Vianen's
commemorative ewer of 1614 sits on a nearby
table (page 26).

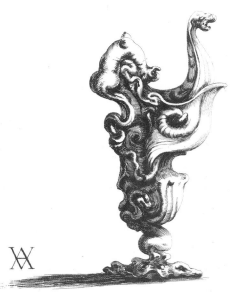

Design for a ewer, etching,
Adam van Vianen, published c. 1650.
Amsterdam, Rijksprentenkabinet

This sheet, number forty-two in *Modelles Artificiels,*
represents the celebrated silver-gilt commemora-
tive ewer by Adam van Vianen commissioned
by the goldsmiths of Amsterdam.

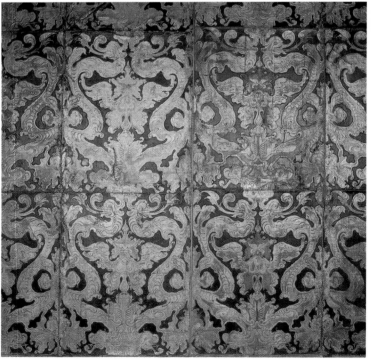

Office of the Drapers Syndics
(general view and detail of wall
covering), c. 1640.

Leiden, De Lakenhal

*A*round 1640, a drapers' hall was built in Leiden
after designs by Arent s'Gravesande. One of
the wings of this building, where fabric quality
was assessed, contains the syndics' office, which
features a barrel-vaulted ceiling. Its walls are
now covered with gilded leather panels from the
Haagse Schouw, a nearby inn. The repeated
design—in this case, a striking auricular
composition—was stamped into the leather
and partially covered with gold and silver leaf;
the whole then received several coats
of yellow varnish.

Carpet, wool and silk, the Low Countries,
second half of the seventeenth century.

Private collection

This carpet was perhaps meant to hang on an open screen in a private
residence, so that both sides would be visible. The biblical vignette in the
lower half is framed by an auricular cartouche.

Vase, faïence, Delft, 1693.

Amsterdam, Rijksmuseum

The two vignettes on this piece are framed by cartouches similar to those by
van den Eeckhout. One of them pictures a pottery workshop in which,
according to the inscription, an *opkapper* (faïence maker) is at work; the other
shows a shoemaker. The imagery and the inscribed date (1693 12/11) suggest
that this vase may well have been executed as a masterpiece—that is, an
object executed in order to qualify for membership in the guild.

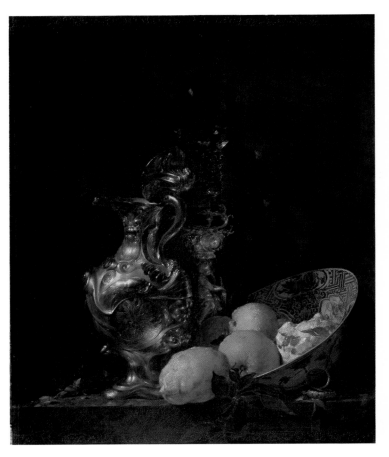

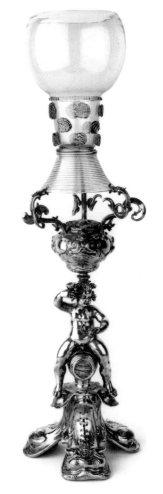

Still Life, oil on canvas, Willem Kalf,
second half of the seventeenth century.

Amsterdam, Rijskmuseum

*I*n this painting, Kalf scrupulously renders a number of costly objects—
exotic and otherwise—especially cherished by the prosperous middle-class of
his day: a ewer (probably by Christiaen van Vianen) and a glass-stand in the
same style are juxtaposed with a Chinese porcelain bowl and some oranges
and lemons, one of them peeled.

Design for a face powder box, print, Johannes Lutma.

Amsterdam, Rijksprentenkabinet

*T*he four sides of this rectangular box are smooth, but it sits on curious
bonelike feet and its convex cover features an elaborate auricular design.
There are two alternative designs given for the cover's handle—either
a putto or a generic knob.

Glass-stand, silver, Andries Grill, The Hague, 1642.

The Hague, Gemeente Museum

*T*his silver stand is the work of a goldsmith of German ancestry residing
in The Hague, and it is reminiscent of designs by Lutma and the
van Vianens. Three dolphin heads are joined to form the tripod base,
which is decorated with auricular motifs, as is the knoblike form
atop the infant Bacchus's head.

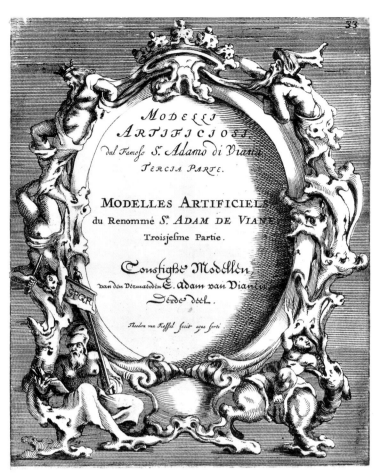

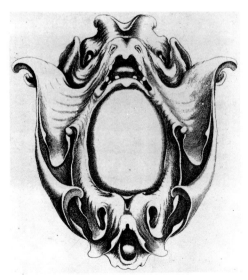

Small frame, wood, Low Countries,
mid-seventeenth century.

Private collection

This small auricular frame intended for a
miniature portrait is quite similar to
Lutma's designs.

Design for a cartouche,
etching, Johannes Lutma.

Amsterdam, Rijksprentenkabinet

This print is from the *Veelderhande Nieuwe
Compartemente,* a series published in 1653. The
cartouche's motifs look like merging folds of skin,
in places taking on a vermicular or masklike
appearance. Such designs were executed in a
variety of media.

Title page of part 3 of *Modelles Artificiels,*
etching, Christiaen van Vianen,
published c. 1650.

Amsterdam, Rijksprentenkabinet

Modelles Artificiels is an anthology of prints in
three series of sixteen sheets, each with its own
title page. While the text indicates that all the
designs are by Adam van Vianen, it seems likely
that the three title pages were executed by
his son Christiaen about 1650.

Frame, gilded linden-wood,
Low Countries, c. 1655.

Enschede, Rijksmuseum Twente

This frame, which surrounds a portrait of Jasper
Schade painted by Cornelis Jonson van Ceulen of
Utrecht in 1654, is encrusted with auricular
ornament in the Amsterdam style of Lutma and
van den Eeckhout; some of its forms are
anatomical while others evoke animal heads.

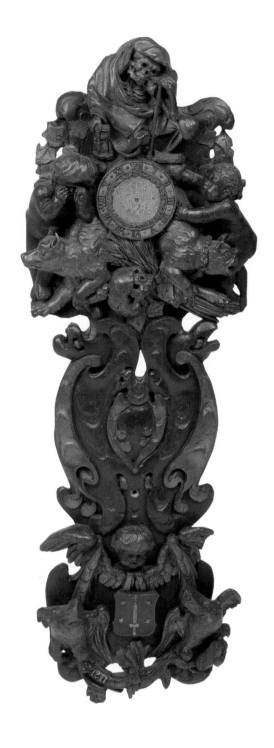

Table, gilded walnut and marble,
Low Countries, c. 1660.

Utrecht, Centraal Museum

The marble top rests on a walnut base whose legs,
which resemble volutes springing into life, are
braced by stunning auricular masks.

Table designs, print,
Gerbrandt van den Eeckhout, c. 1650.

Amsterdam, Rijksprentenkabinet

This sheet engraved by Pieter Schut features two
designs for auricular table supports. Seemingly
elastic masks and anatomical forms flow into one
another without interruption.

Death Clock, painted and
gilded oak, Haarlem, second half of
the seventeenth century.

Haarlem, Frans Hals Museum

The face of this "clock," which hung in the
aldermen's tribunal, indicated the hour set for
capital executions. The decorative figures and
symbols evoke death; the lower portion features
an auricular cartouche similar to those
published by Lutma in 1653.

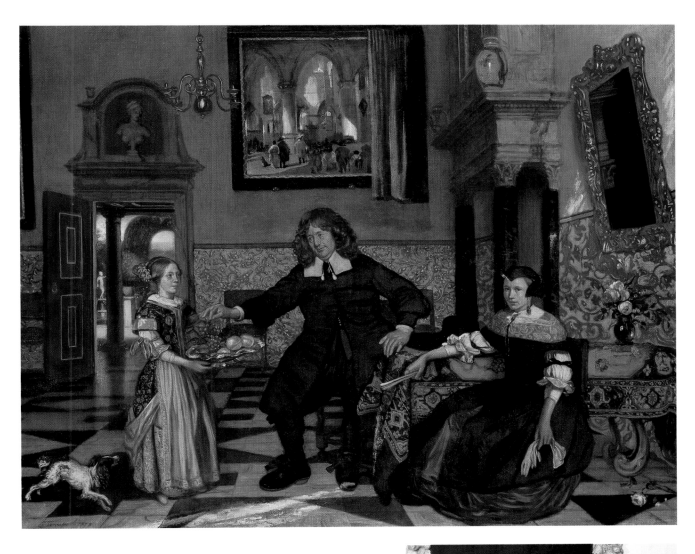

Family in an Interior, oil on canvas,
Emanuel de Witte, 1678.

Munich, Alte Pinakothek

The sober, classical decor of the room surrounding this
prosperous Dutch family is punctuated by auricular
details: the legs of the table covered by an oriental carpet
are in a sinuous auricular style reminiscent of work by
van den Eeckhout, and the gilt frame of the mirror
above is in the same spirit.

So-called *toogkast* armoire, oak and ebony,
Low Countries, c. 1650.

Amsterdam, Rijksmuseum

This armoire, which sits on ball feet, is conceived along
classical lines: pilasters support its molded cornice, and its
two door panels culminate in arches, the feature that
occasions the name *(toogkast)* given such pieces. In this
instance, however, the arches are made of auricular
forms suggestive of bone or shell.

Mantelpiece in the mayor's office (detail),
Derck and Jacob Daniels, Deventer, 1652–53.

Deventer, City Hall

The arms of the city surmounted by the imperial crown are framed by
an auricular cartouche.

Mantelpiece in the Great Hall,
attributed to Francesco Fanelli, c. 1639.

Richmond, Ham House

When Ham House was redecorated, full-length figures of Mars and Minerva
were placed on the mantel in the Great Hall; tradition has it they are portraits
of William Murray and his wife, the house's owners at the time. The Minerva
(right) carries an escutcheon with prominent auricular "wings." Fanelli is known
to have worked with Christiaen van Vianen during the latter's English sojourn.

Pulpit (detail and full view), wood, Hendrick Wytwelt, c. 1659.

Duosburg, Dutch Reformed Church

The overall design of this pulpit is conventional. Serpentine columns with Corin-
thian capitals punctuate the corners and frame the intervening relief panels, the
decoration of which varies: some are configured like the bay of a classical arcade
with angel heads in the spandrels, while others are decorated with a shell. But
the center of each panel contains a large auricular cartouche, and the style's
influence is also discernible in other details, such as the angel-headed support
beams on its pedestal and the cartouche-like braces on the canopy support.

Stained-glass window with a vignette of the city
of Hoorn, Jozef Oostfries, Hoorn, 1656.

De Rijp, Dutch Reformed Church

One of the windows in the church was donated by the city of Hoorn;
in this portion of it, an image of the city is framed by an aggressively
plastic auricular cartouche.

Römer glass with painted decoration,
second half of the seventeenth century.

Rotterdam, Boymans-van Beuningen Museum

The cup of this wine glass is decorated with shields in relief painted with
the coat of arms of the Duvelaar family of Zeeland and surrounded by
tendrils in a rinceau configuration; the shield is surmounted by a putto
blowing a horn. The painted escutcheon surrounding the shield bears traces
of auricular influence. The same museum owns another glass that is
almost identical but bears the arms of Johanna Le Sage; she was the wife
of Pieter Duvelaar, the burgomaster of Middleburg, and these pieces
may have been made for their marriage.

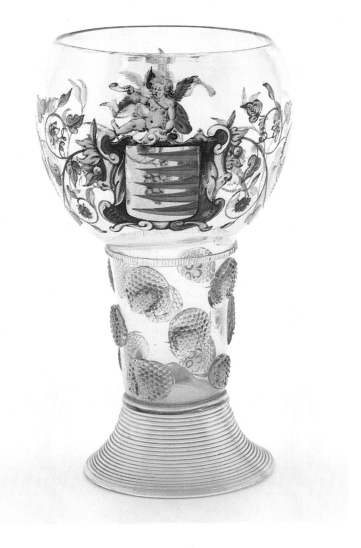

Fiddler, faïence,
Lambert van Eenhoorn, Delft, c. 1700.

Amsterdam, Rijksmuseum

*I*n accordance with a contract dated 1691,
Guillaume Nieullet produced molds for teapots
and novelty pieces for the Delft pottery
entrepreneur Lambert van Eenhoorn. Among
them were three types of musician figurines;
examples in both stoneware and painted faïence
survive. The tripod base of this piece is a crude
imitation of auricular forms current in
mid-seventeenth-century silver.

Table, walnut, Low Countries, c. 1700.

Utrecht, Centraal Museum

*T*his small round-top table has an elaborately
carved tripod base composed of foliage, garlands
of fruit, and putti bestriding dolphins whose
heads have been given an auricular inflection.
Tradition has it that the ambassadors negotiating
the Treaty of Utrecht in 1713 presented their
credentials on this table.

Butcher's sign, wood, second half of
the seventeenth century.

Groningen, Groninger Museum

This sign in carved and painted wood comes
from a butcher's shop on the Oude Kijk in 't
Jatstraat in Groningen. In the center is a splayed
pig carcass hanging by its back feet; this is framed
by a wide border with rolled auricular edges in
which appear tools and objects associated
with the butcher's trade.

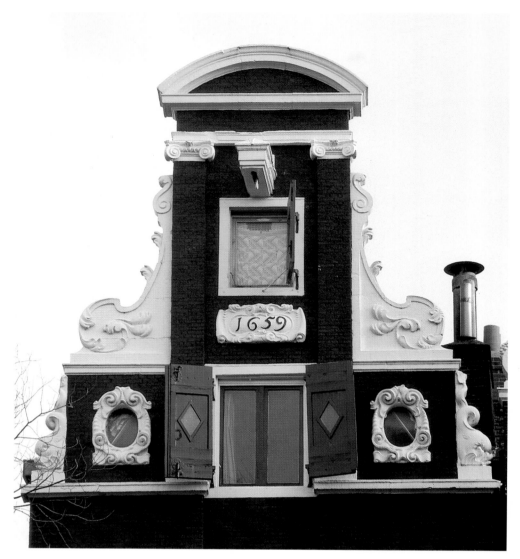

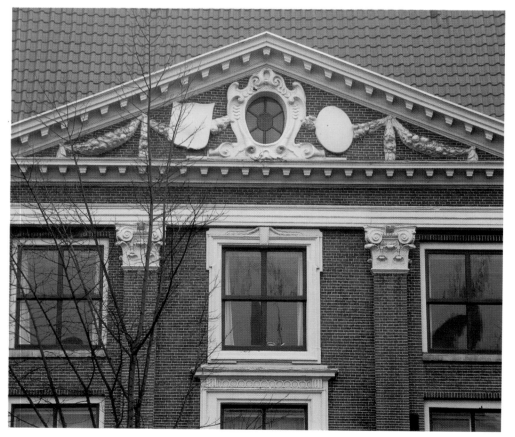

House façades (general view and detail).
Amsterdam, Herengracht 59, 61, and 63

The house on the left bears the date 1659 and is called "At the Dog," after a sign that has since disappeared. The two identical houses on the right were built in 1665–66; their top floors were originally storage lofts. All three buildings are in the style of architect Philips Vingboons and culminate in tall narrow gables braced by volutes. On the floor below, the brick façades are pierced by oval windows surrounded by auricular cartouches in the style of Lutma; in no. 59, the plaque bearing the date has a similar form, and rotund dolphins function as volutes.

House pediment, 1663.
Amsterdam, Herengracht 386

This monumental house was built in 1663 after designs by Vingboons. Its brick façade is disposed along classical lines, featuring Doric and composite pilasters and a pediment. Much of the stone detailing is mainstream classical, too, but the oval window in the center of the pediment is framed by an auricular cartouche.

Sign on the house known as *Inde Verghulde Elgher*
(At the golden trident).

Utrecht, Vismarkt 9

This mid-seventeenth-century sign on what was once a fish market features
an auricular cartouche culminating in a mask. Tridents like the one pictured
were used for eel fishing.

Portrait of Prince William II, oil on canvas,
attributed to Willem van Honthorst.

Zeist Castle, near Utrecht

Laurens Buysero, who in 1645 built the residence in The Hague known as Huis
aan de Boschkant after designs by Pieter Post, commissioned portraits of four
stadholders of the House of Orange (William I, Maurice of Nassau, William II,
and William III, the latter represented as a youth and accompanied by his mother
Henrietta Maria Stuart) and had them set into the woodwork of its Great Hall.
Its walls were covered in gilt leather, and it also featured a mantelpiece with
portraits of the stadholder Frederick Henry and his wife Amalia van Solms
(the parents of William II). The house no longer exists, but the paintings survive
and are now in Zeist Castle. The four portraits mentioned first are in identical
formats and depict their princely subjects as though viewed through the arch of
an arcade—also painted—each surmounted by his coat of arms in an auricular
cartouche. In the portrait of William II this illusionistic element is similar to a
design in Johannes Lutma's series *Verscheide Snakeryen*, published in 1654.

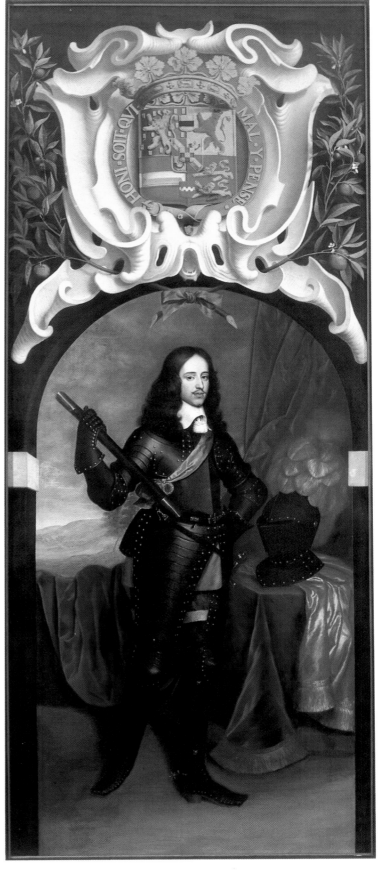

Title page, etching,
Stefano della Bella (b. 1610),
Paris, 1646–47.

Rotterdam, Boymans-van Beuningen Museum

The text of this title page from the series *Paisages maritimes* appears on an auricular cartouche; dolphins twist around the protrusions of the extravagant, shell-like form that evokes a crab.

Cartouche containing a landscape
vignette, etching, Daniel Rabel.

Amsterdam, Rijksprentenkabinet

This cartouche, which features masks as well as protruding elephant trunks and curls of skin, has a pronounced auricular flavor.

Design for a cartouche,
print, Federico Zuccaro.

Amsterdam, Rijksprentenkabinet

This design is from a series published in Paris in the seventeenth century; its curvilinear, constantly mutating forms are typical of the auricular style.

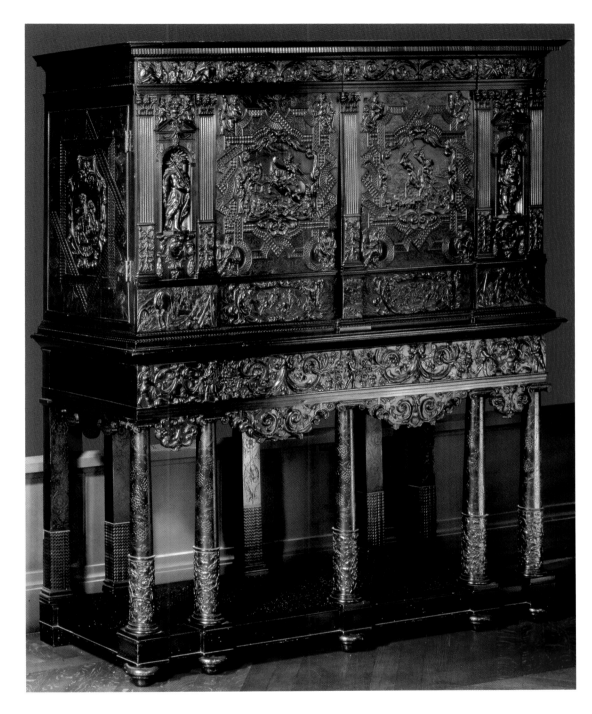

Cabinet, ebony, France, c. 1640.

Paris, Louvre

Toward the middle of the seventeenth century,
cabinets made of dark wood, supported by
columns, and featuring doors with mythological
scenes in low relief framed by pilasters, were in
vogue at the French court and among wealthy
collectors. Eventually they were made in Paris, but
initially they were imported, notably from
Antwerp. The present example incorporates
ornamental detailing with an auricular inflection,
and other such pieces appropriated scenes on
platters designed by the van Vianens.

Design for a ceiling
decoration, ink and wash,
Jean Cotelle, c. 1630–40.

Oxford, Ashmolean Museum

The allegorical figures at either end of
the central cartouche are Abundance
(with a cornucopia) and Strength (with
a sword); they are framed by auricular
cartouches of coruscating forms that
extend into the rest of the composi-
tion. Some of Cotelle's designs were
published as prints.

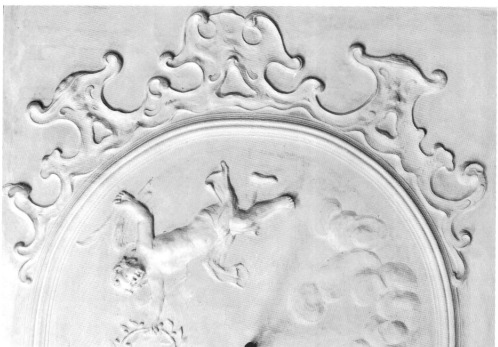

Sword and scabbard, silver gilt,
enamel, and steel, Abraham Drentwett,
Augsburg, 1653.

Munich, Schatzkammer der Residenz

The handle and scabbard of this lavish piece,
known as the *Pfälzer Schwert* (Palatine sword) are
covered with undulating auricular ornament; the
ends of the hand-guard terminate in lion heads.

UPPER LEFT

Plate, partially gilded silver,
David Bessmann, Augsburg, c. 1660.

Doorn, Huis Doorn, near Utrecht

The recess in this plate contains a scene from
the story of David and Abigail. The wide auricular
border features ferocious masks, and four lions
spring from its four corners. An analogous motif
appears in certain prints by Stefano della Bella
in the anthology *Raccolta di varii Cappricii*
(Compilation of diverse caprices), published in
Paris in 1646. This piece was owned by the
German emperor Wilhelm II during his exile
in the Low Countries after 1918.

Ceiling decoration (detail), stucco,
Giovanni Anhtoni and Hans Zauch, 1663–64.

Balsta (Sweden), Skokloster Castle

The central oval, which pictures two airborne angels carrying a laurel wreath,
is surrounded by auricular shapes whose stiffness betrays their ancestry from
the German variant of the style.

Chair, wood,
southern Germany, c. 1650.

Magdeburg, Kulturhistorisches Museum

The back of this so-called *Stabelle* chair is carved with auricular ornament similar to that in prints by Friedrich Unteutsch; a strategically placed opening doubles as the gaping maw of the mask that dominates the composition.

Ornamental design, print,
Jacob van der Heyden, c. 1610–20.

Paris, Bibliothèque des Arts Décoratifs

Based in Strasburg, van der Heyden published a collection of designs under the title *Compertamenti* that are close to the style's German variant. The composition on sheet 4, illustrated here, features a mask surrounded by scrolled and lobed forms shown in illusionistic relief.

Design for a cartouche, print,
Lucas Kilian, 1610.

Nuremberg, Germanisches Nationalmuseum

This sheet, from the 1610 collection entitled *Neues Schildbüchlein* (New little book of shields), features a cartouche with scrolled edges; the beard of its central mask merges with a membranous surface that envelops two human figures.

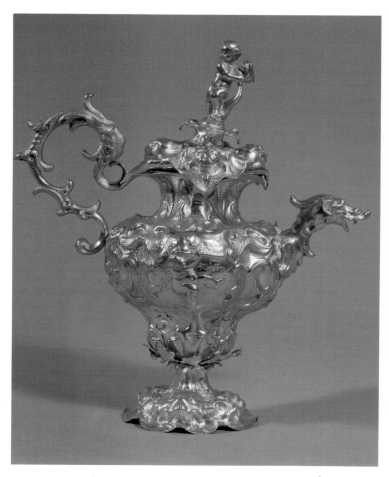

Ewer, gold,
Hinrich Lambrecht II, Hamburg, c. 1650.
Copenhagen, Rosenborg Castle

The entire surface of this ewer is covered with
auricular forms; its handle and spout, which
terminate in dragon heads, are conceived in the
same spirit. This piece, along with a matching
gold platter and pair of candlesticks, has
been used by the Danish royal family for
baptisms since 1671.

Vase, silver gilt,
Jacob Duriahr, Hamburg, c. 1625.
Saint Petersburg, Hermitage

This small vase, whose sides are decorated
with typical auricular forms in low relief against
a stippled ground, is of a type specially produced
for export to Russia, where it was known
as a *brachina*.

FACING PAGE

Beer mug, silver,
Hermann Lambrecht, Hamburg, c. 1670.
Copenhagen, Rosenborg Castle

Many German beer mugs from the second half of
the seventeenth century are decorated with
auricular motifs. In this example the characteristic
swirling, cartilaginous forms are limited to the
base, the cover, and the handle, from which
protrudes a strange doglike head.

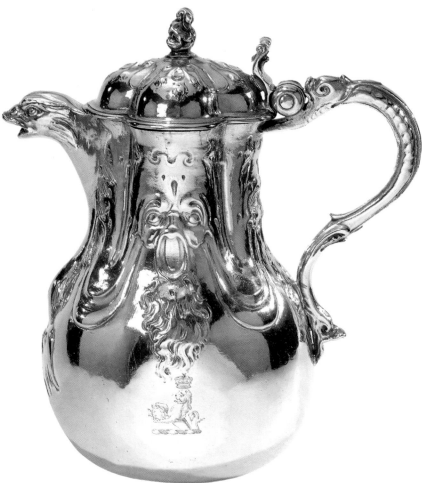

Inkstand, silver,
attributed to Alexander Jackson,
London, 1639.

*London, Victoria and Albert Museum
(on loan from an anonymous collector)*

This rectangular inkstand, which rests
on four crouching quadrupeds, is richly
decorated with auricular patterns and
motifs; alternately gelatinous and shell-
like configurations frame its narrative
vignettes. It may have been produced
in the London workshop of Christiaen
van Vianen, even though it bears the
legally obligatory stamp of a goldsmith
belonging to the London guild.

Wine pitcher, silver,
John Cooqus, London, c. 1670.

Amsterdam, Rijksmuseum

The upper surface of this pitcher,
one of a matched pair, is decorated
with auricular masks and swirls; its
spout is shaped like a dolphin head, and
the knob handle on its cover has been
given a curiously indeterminate,
kneaded form.

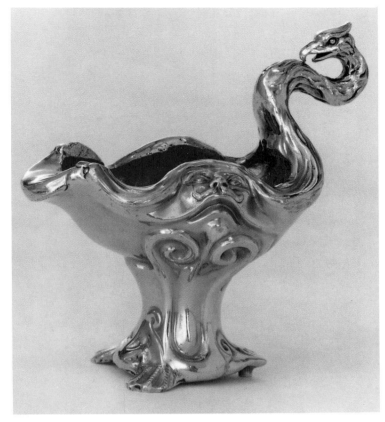

Portrait of Robert Vernon, oil on panel,
Henry Collen and George Jones, 1848.

London, The National Portrait Gallery

Robert Vernon (1774–1849), collector and patron, is here
shown seated at his desk, on which is placed an eccentrically
shaped cup on top of which sits an inkwell and a feather pen.
Both of these pieces are in the style of the van Vianens but were
probably produced in the nineteenth century *(see below).*

Inkwell, silver, England, nineteenth century.

Private collection

This object, inspired by the work of the van Vianens,
is decorated with rather crude paraphrases of auricular
motifs; its serpentine handle culminates in the head of a
bird of prey. An identical piece is represented in the
portrait illustrated above.

Covered porridge bowl, silver, London, c. 1660.

Boston, Museum of Fine Arts

This porringer, which the incised arms indicate belonged to
John Evelyn, was made by an English goldsmith much
influenced by Christiaen van Vianen. Its entire surface is
decorated with coruscating auricular motifs, and the knob
handle on its cover is shaped like a crouching figure.

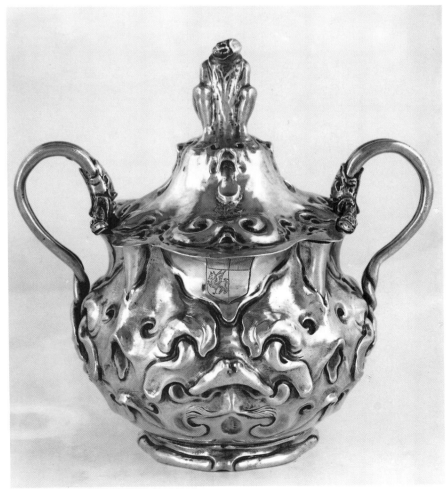

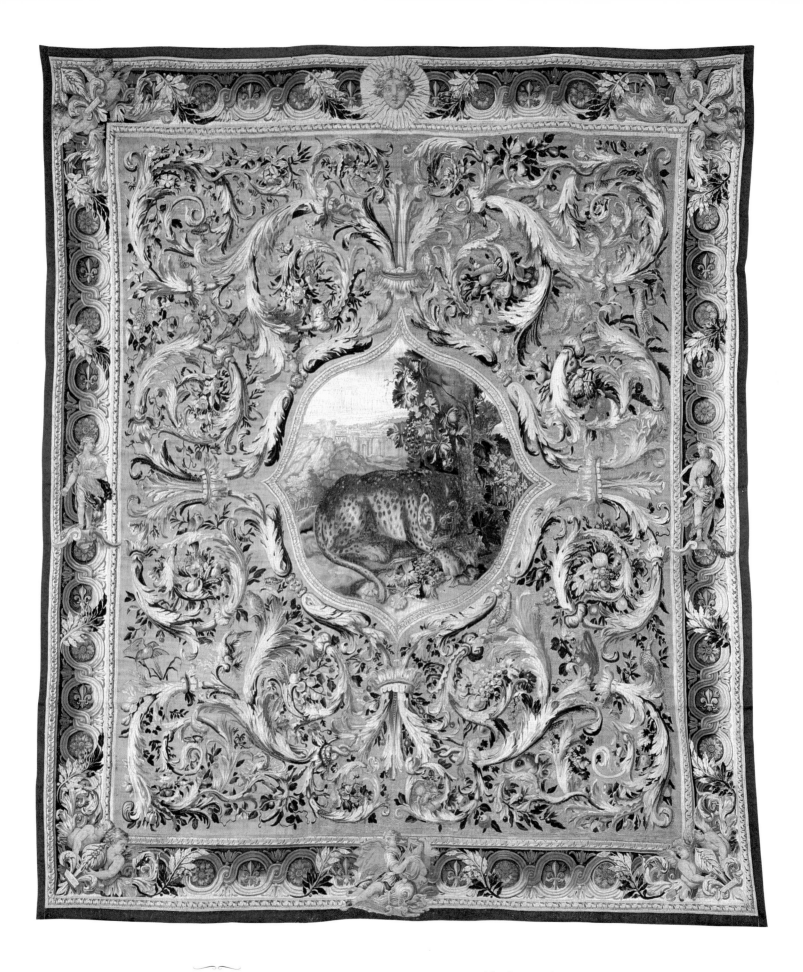

The Tiger, or *Earth,* wool and silk, seventeenth century.

Paris, Mobilier National

This tapestry is one of a set of eight depicting the elements and the seasons. The designs of this series were almost certainly by a French seventeenth-century artist inspired more or less directly by Raphaelesque ornament. A likely candidate is Charles Errard (1606–1689), who worked in Rome from 1627 to 1647.

Acanthus

Unlike the other ornamental motifs examined in this series, acanthus is not primarily associated with a single period, or even just a few specific periods, but has been prevalent in decoration ever since antiquity. Acanthus leaves have appeared in conjunction with every style and during every epoch, usually playing a subordinate role. To cite one important example, they were ubiquitous in Baroque ornament. In the seventeenth century, decoration was limited to a small repertory of motifs—festoons, garlands, and volutes, to name three—and rarely interfered with basic structural elements. But this limited role soon expanded: an assertive plasticity became the order of the day, and, as a result, complex forms attained a new monumentality. Acanthus decoration followed suit.

Genesis and Evolution of Acanthus

In ornament, acanthus is depicted as a lobed, serrated leaf with scalloped or jagged edges and with veins that do not join at their bases (or do so just barely). The motif occurs as a single leaf as well as in continuous configurations of sinuous rinceaux with new branches emerging from splayed, elongated leaves. Such rinceaux are sometimes punctuated with acanthus rosettes culminating in pointed calixes. It can also be animated with human figures or fantastic animals. Acanthus has often been used to decorate friezes of various kinds, where it functions as a vertical or horizontal boundary, thus assuming a secondary role; in such cases it often appears in conjunction with grotesques, candelabra, and ribbon patterns. Sometimes isolated leaves can be used to set off other objects or even merge with them, becoming autonomous in a way that makes it difficult to say whether their role is "decorative" or primary.

The term *acanthus* appears as early as Vitruvius, referring to a motif that resembles several varieties of the plant indigenous to the Mediterranean basin, especially *Acanthus spinosus,* with its narrow, jagged leaves, and the more rounded *Acanthus mollis.* The motif—known in the Germanic countries as *Bärenklau*

(literally, "bear-claw")—did not result from a direct imitation of nature, as some with a scientific bent have attempted to demonstrate. In his work *Stilfragen* (1893; translated as *Problems of Style*, 1993), Alois Riegl hypothesized that the acanthus motif developed from the palmette. Carl Nordenfalk, convinced that no evolutionary trajectory proceeding from palmette to full-fledged acanthus could be identified, noted that a gradual transformation from stylized forms to more naturalistic ones was discernible in Greek art of the 5th century B.C., and that during the second half of the century palmette ornaments in reliefs and painted on white-ground *lekythoi* took on a more three-dimensional character. According to Roar Hauglid, this evolution eventually resulted in the introduction of vegetal forms into the ornamental vocabulary: the purely abstract shapes used in volutes and palmettes became more mimetic when small shoots first appeared at the ends of their stems, and over time they increasingly came to resemble a model existing in nature—namely, acanthus. Such emerging leaves are visible on palmette acroteria and in the sinuous patterns on the frieze of the Erectheion on the Acropolis in Athens, where they are punctuated by periodic lotus blossoms and palmettes. It should also be noted that the Greeks used acanthus on burial stelae and in funerary scenes on white-ground *lekythoi*. It seems likely that in this period the plant was associated with mortality and funerary ritual, but such meanings have no bearing on its subsequent evolution.

According to Ernst Gombrich, the many theories regarding the development of ornamental acanthus locate the origins of each variation in a period distant in time because no one has ever managed to trace them all within the complex evolution of the rinceau motif. Many important variations were introduced in antiquity itself—for example, the bloodlessly classical vocabulary prevailing under Augustus gave way to pulpy plasticity around the first century A.D. under the Flavian emperors and Hadrian. So we find ourselves confronted with the following question: are modern acanthus designs directly inspired by ancient ones, or has each period devised an acanthus idiom appropriate to its own aspirations, using antique prototypes only selectively when these seemed helpful?

In the following paragraphs an overview of the history of acanthus ornament will be sketched. The Corinthian order, one of the three ancient Greek architectural orders, is characterized above all by the presence of acanthus in its capitals, which feature volutes emerging from two rows of vertical acanthus leaves (sometimes harboring small flowers) to support projecting consoles, which in turn support the entablature. The Corinthian capital is an Attic invention. The earliest surviving instance of this elegant form—which blurs the boundary between the architectural and the artisanal—is on a single column inside the temple of Apollo at Bassae, from the late fifth century B.C.; its first use on an exterior elevation appears to be the Choragic monument of Lysicrates in Athens, built a century later. It attained full splendor only after Hellenism began to free itself from the tyranny of prevailing architectural rules, and became especially popular in the eastern Empire. A few columns from the Olympeion, or Temple of Olympian Zeus, in Athens were transported to Rome around 85 B.C., and they

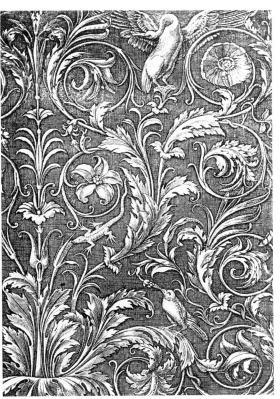

Ara Pacis (detail), marble, Rome, 13–9 B.C.

Rome

'The Ara Pacis (Altar of the Peace of Augustus), was built on orders from the Roman Senate to celebrate the victorious return of Augustus from Spain and Gaul in 13 B.C. It was dedicated in the year 9 B.C. The various portions of the altar were excavated in different periods; the beautiful acanthus rinceaux on its lower surfaces were much imitated in ornamental prints.

Engraving inspired by a fragment of the Ara Pacis, Agostino Musi, known as Agostino Veneziano, c. 1535.

Private collection

Agostino Musi, a Venetian who settled in Rome, became a student of Marcantonio Raimondi. This design, modeled after a fragment of the Ara Pacis, demonstrates that in the years 1535–36 Musi made direct copies from ancient compositions. Generally, decorative designs from antiquity were of great importance for sixteenth-century ornamentalists.

helped to assure the complete triumph of the Corinthian order on Roman soil. Acanthus became the dominant decorative form of the empire.

page 97

Decorative styles evolved as well. Initially the Romans adopted the delicate rinceau configurations favored by the Greeks. Their influence can still be discerned in the Ara Pacis, erected about 13 B.C. during the reign of Augustus: its decorative panels feature relatively spare acanthus rinceaux spiraling to either side of a central vegetal stalk suggestive of a candelabrum motif. But the Roman appetite for decorative extravagance soon asserted itself, and classical restraint gave way to ever more vigorous forms. A frieze from the Forum of Trajan (c. 110 A.D.), decorated with supple, robust acanthus rinceaux, exemplifies this tendency: coils of densely intertwined leaves and tendrils project out from the frieze's surface, covering it almost completely and casting deep shadows.

page 104

Beginning in the third century, the cycle of copying and recopying exacted its inevitable toll, and the motif's formal energy began to be depleted. The celebrated candelabrum motifs in Hadrian's villa, for example, with their overlapping leafy motifs, are distinctly reminiscent of the Choragic monument of Lysicrates. Finally, on the Arch of Septimius Severus, erected by the Senate in 203 at the entrance to the Roman Forum to celebrate the tenth anniversary of the emperor's accession to the throne, and to commemorate his great military victories, variously stylized acanthus motifs are used throughout: on the capitals, in the flowering rinceaux, and in the friezes of ascending scrolls of leaves punctuated by leafy rosettes. In late antiquity, ornamental acanthus reverted to the flat palmette form, and rinceaux became more rigidly stylized, featuring intricate openwork patterns of leaves detached from their grounds. This Byzantine idiom was adopted in the parts of Italy subject to the influence of the eastern Empire—in Ravenna, for example, where it influenced the capitals in the Basilica of San Vitale.

The Carolingian renaissance prompted the reemergence of acanthus in northern Europe. It appears, for example, in the Corinthian capitals of the porch of the gatehouse at Lorsch Abbey (eighth century). It figures in discontinuous—as opposed to continuous—rinceaux in painted illumination from the period, and it was also used in the borders of ivory plaques until the mid-tenth century. The illuminators of the Winchester school produced acanthus leaves of exceptional vigor.

Medieval architecture consistently employed forms close to acanthus, especially when trying to underline its ties to antiquity. As might be expected, this phenomenon was particularly widespread in areas where Roman traditions remained strong. Architectural decoration in southern and central France, for instance, has a distinctively antique flavor. Classical acanthus appears on the churches of Saint-Trophime and Saint-Gilles-du-Gard in Arles; and an acanthus rinceau on the north portal of the church of Saint-Etienne in Bourges (mid-twelfth century) is altogether consistent with ancient models. An ingeniously stylized but nonetheless clearly Roman acanthus leaf decorates the pilasters and capitals of Saint-Guillaume-le-Desert (late twelfth or early thirteenth century). Further north, canonical Corinthian capitals appear on portals of the cathedrals

in the German cities of Speyer and Mainz (around 1100); their form was doubt-less transmitted by stonecarvers from northern Italy. Vegetal forms resembling acanthus, usually called thistle to mark the distinction between them, often emerge from motifs based on indigenous plants that dominated the naturalistic floral decor of early Gothic monuments. In candlesticks designed in the form of capitals, acanthus typical of Corinthian capitals is so radically transformed as to become unrecognizable. The creeping and climbing leaves used to decorate con-soles, capitals, keystones, and pediments beginning in the fourteenth century are perhaps distant relatives of primitive acanthus. Toward the end of the fifteenth century these acanthus-like shapes assumed a new prominence, usually in the form of small leaves—as, for instance, in Martin Schongauer's designs for metal-work. Finally, the rinceaux on the Breisach altarpiece, the work of Master HL (1526), assumed an altogether new form: here the foliage coils and uncoils with an unprecedented amplitude. The Gothic propensity for foliate ornament of great freedom tended to liberate the classical acanthus motif, but the growing Italian antique revival movement soon bridled its more extravagant impulses.

In Italy the influence of ancient models on the decorative arts never fully ceased, even during the Middle Ages. The powerful acanthus rinceaux enlivened by putti and animals in the relief above the Porta della Mandorla of Florence Cathedral, a work by Nanni di Banco of the early fifteenth century is a case in point. The rigorously classical tendency of the Quattrocento was paralleled by a strong naturalist current. Ornamental acanthus, which can often seem austere, was only one among many motifs used in this period to produce an opulence consistent with Leon Battista Alberti's (1404–1472) notion of *varietà,* with espe-cially beautiful results on its ravishing tombs. The jagged acanthus leaves emerg-ing from the lion-paw feet in the tomb of Carlo Marsuppini in Santa Croce, *page 104* in Florence (c. 1453–55), are unusually striking; they are the work of Desiderio da Settignano (1428–1464). Antonio Averulino, known as Filarete, who was also under the direct influence of antique models—in this case probably from the reign of Nero—surrounded the panels of his great bronze doors for Saint Peter's in Rome (completed 1445) with volutelike acanthus rinceaux animated by fig-ures and animals. In 1472 Alberti framed the portal of the church of Sant'Andrea in Mantua with a border of elegant flowering acanthus rinceaux emerging from vases. It was toward the end of the fifteenth century, under the guidance of Leonardo, Raphael, Michelangelo, Sangallo the younger, Bramante, and Peruzzi, that a monumentality inspired by ancient monuments took hold in Rome. Decoration was made entirely subservient to basic structural elements. When not altogether avoided in favor of the grotesques so fashionable in the brief High Renaissance, acanthus rinceaux assumed forms dating from the reigns of Augustus and the Flavian emperors. In the designs of Vignola and Palladio, purely architectonic form and figural decoration held sway.

As will be seen shortly, the resurgence of stucco decoration in these years was important, for this material was particularly suitable to acanthus ornament. Witness the the frieze and rich candelabrum designs in the Villa Madama in Rome (1519–23): the decor in this building, the work of Giulio Romano and Giovanni da

Udine (overseen by Raphael until his death in 1520), combines stucco sculpture and reliefs with paintings; they were influenced by the decorations in Nero's Domus Aurea (Golden House), which had been excavated shortly before work on the project began. Elaborate stucco reliefs featuring handsome acanthus rinceaux also decorate the façade and interiors of the Casino of Pius IV in the Vatican gardens, a work by Pirro Ligorio completed in about 1561. Some of the buildings by Galeazzo Alessi, the eminent Genoese architect, also feature decorative schemes with acanthus friezes. In the north, the hunting lodge erected in 1555–56 by Ferdinand I in Hvedza, near Prague, includes decorative elements consistent with this early Italian Renaissance idiom: figures and acanthus motifs alternate in the panels of its polygonal ceiling.

With the full flowering of the Italian Renaissance, acanthus ornament, previously used only in architectural and sculptural contexts, began to appear in the full array of decorative arts productions: furniture, *cassoni* (marriage chests), candleholders, arms, and ceramics. It was in these same years that ornamental prints, whose designs could be translated into many different media, first became an important graphic vehicle for the transmission of decorative motifs, and acanthus often figured prominently on these sheets. In the early sixteenth century, Zoan Andrea of Mantua and Giovanni Antonio da Brescia, working under the influence of Andrea Mantegna, executed a number of acanthus compositions that, while a bit severe, were full of fantasy and enlivened by animals and human-like figures. Agostino Musi, known as Agostino Veneziano, helped to *page 97* give this spare style currency by paraphrasing a relief panel from the Ara Pacis in one of his prints (c. 1535). The engravers Marco Dente of Ravenna—who like Veneziano worked in the studio of Raphael's student Marcantonio Raimondi— and Enea Vico of Parma produced many variations on a similar "candelabrum" motif, featuring a central vegetal stalk or other vertical form surrounded by coiling acanthus rinceaux. But already in the second half of the century, a penchant was emerging for acanthus motifs with a different lineage. An ornamental print made by Francesco Ricciarelli in 1580, for instance, was inspired by a frieze in the Forum of Trajan. Battista Pittoni of Vicenza and Giovanni Mutiano of Brescia also created designs of acanthus rinceaux suggestive of volutes, often animating them with lively figures. In sixteenth-century Italy, acanthus had to compete with a new type of ornament, strapwork, and shortly thereafter with the auricular style, which owed nothing to antique precedent.

In France, however, things proceeded differently. At Fontainebleau, such Italian artists as Rosso and Primaticcio (known in France as Primatice) created an entirely new decorative system based on the elaborate compartmental scheme of Michelangelo's Sistine ceiling. Acanthus did not play a major role in this development, even in the ornamental prints designed by Jacques Androuet du Cerceau for use by decorative-arts craftsmen. Toward the mid-sixteenth century, new types of ornamental motif attained prominence in France, notably grotesques, strapwork, *moresques* (also known as Moorish tracery), and interlace. The broad-leafed acanthus rinceaux in prints designed around 1565 by architect Jean Bullant, who practiced in Ecouen and Paris, are not typical French artifacts of the period.

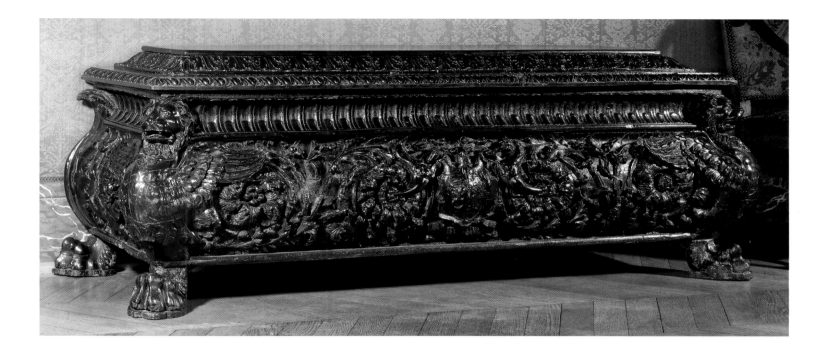

Cassone, walnut, Rome or Florence, c. 1550–60.

Paris, Musée des Arts Décoratifs

*I*n the Middle Ages, large chests were the most important pieces of storage furniture. The Italian marriage chests known as *cassoni,* which were painted and decorated with stucco relief, and later sometimes carved, remained in widespread use in the Renaissance. The shape of this one, which sits on claw feet and features griffins at the front corners, recalls Roman sarcophagi, and its ornamental motifs are also of antique derivation.

Decoration of antique inspiration figures prominently in paintings produced in the Low Countries and in France in the late fifteenth century, and painters who also turned out decorative arts designs were responsible for introducing new ornamental motifs into tapestries, furniture, glassware, stained-glass, and metalwork. Dutch engravers published ornamental prints in the new style from about 1520 onward. An image by Lucas van Leyden (1494–1533), whose earliest depictions of foliage betray the influence of late Gothic models, features "acanthusized" creatures similar to those merging into powerful acanthus rinceaux in compositions by the artist known only by the initials IG.

In Germany, early-sixteenth-century designs by minor masters of the decorative arts helped to disseminate acanthus compositions in the Italian tradition, often derived from examples produced in the Low Countries. Cities such as Nuremberg, Augsburg, and Vienna maintained close commercial ties with Italy, which facilitated such exchanges.

Ornamental prints functioned as the ambassadors of new forms, and as such they were extremely important for craftsmen unable to visit Italy. The first designs by Augsburg native Daniel Hopfer feature luxuriant rinceaux somewhat analogous to flamboyant Gothic acanthus, but in the 1520s he and his son published prints directly inspired by Italian models. In the early years of the century, Bartel and Hans Sebald Beham of Nuremberg as well as Heinrich Aldegrever of Nuremberg and Soest produced objects decorated with rinceaux of scraggy acanthus foliage. Somewhat later, Aldegrever devised a dense,

symmetrical composition of acanthus motifs enriched by objects and figures, with an abundance of its leaves sprouting from climbing stems. Acanthus rinceaux are especially prevalent in model prints from 1551 by Peter Hille, a native of Frankfurt-an-der-Oder. This evolution did not continue, however, for about 1540 in Germany classical ornament began to be replaced by grotesques, strapwork, and moresques. The style disseminated by model prints proved most influential in metalwork. Typical of this trend are the many goblets and cups produced by the municipal silver works in Lüneburg, such as a splendid hanap made in 1522 by H. Grahow decorated with acanthus leaves, volute rinceaux, and delicately incised acanthus rinceaux.

Italy

In early-seventeenth-century Italy, the classical vocabulary became fashionable once more. By and large, ornament ceded pride of place to richly articulated structural elements. There were, however, a few notable exceptions, and acanthus was among them: stucco work and wooden relief paneling from the period attest to a continuing Italian taste for acanthus motifs in interior decoration. Giovanni Battista Pocco's stucco ceiling for the portico of Saint Peter's Basilica in Rome was completed in 1615, but despite this late date it is basically mannerist in conception, and its many small recessed panels are framed by acanthus friezes. Acanthus is one of the many decorative motifs given prominence in Pietro da Cortona's frescoed ceilings in the five rooms of the Galleria Palatina of the Palazzo Pitti in Florence (1637–65), begun by him but completed by Ciro Ferri. Beautiful panels of acanthus rinceaux also figure in the ceiling of the Church of the Gesù, the mother church of the Jesuits in Rome (the interior of which was originally designed by Vignola, 1568–84, then redecorated 1669–83), although they are all but overwhelmed by the sumptuous seventeenth-century additions. The most prominent of these are the expansive ceiling painting by Giovanni Battista Gaulli and the accompanying stucco figures by Antonio Raggi, which invade every available space and disconcert the eye with their illusionistic effects.

In Piedmont, though, a tradition of foliate rinceau quickly took hold. The stucco reliefs in the Castello del Valentino in Turin by Alessandro Casella and Isidoro Bianchi, with the assistance of the latter's sons (1641), are among the earliest examples. In the late seventeenth century, Domenico Beltramelli, the period's most successful stuccador, covered the walls and ceiling of the church of San Trinità in Bra with lavish decorations, including caryatids and putti that look down on the viewer from elevated corner niches surrounded by luxuriant acanthus. Another fine example, this one in a secular context, is the series of richly page 130 sculpted and gilded ceilings in the Royal Palace in Turin executed by Pietro and Bartolomeo Botto between 1660 and 1663.

Also deserving of mention are the frames with magnificent carved acanthus produced in Bologna throughout the seventeenth century. In those from the first half of the century, the acanthus leaves adhere to the edge of the

frame; but in the later years they become more assertive, taking the form of unusually vigorous rinceaux.

The evolution of acanthus ornament can be followed in Italian ornamental prints. Acanthus rinceaux by Polifilo Giancarli and Bartolomeo d'Agnelli display a bold monumentality that, in Giancarli's images, is given even further emphasis by the inclusion of figural motifs. A half-century later, about 1670, Domenico Bonaveri of Bologna accentuated the three-dimensional effect produced by his acanthus compositions by using high-contrast chiaroscuro. Designs for carriages and luxury furniture by Filippo Passarini published in Rome at the end of the century are also worthy of interest: on these sheets, lively rinceaux invade and heighten the forms.

page 150

France

The new style was introduced into France in the form of picturesque rinceau designs incorporating human figures and animals by Stefano della Bella, who was born in Florence in 1610 and resided for some years in Paris. His compositions strongly influenced the work of Jean Le Pautre (1618–1682) and Paul Androuet du Cerceau (1630–1710), and direct exchanges of this type had a considerable impact on the development of French ornament. Italian influence was already a factor under the queen mother, Marie de Médicis, augmenting that from images originating in the Low Countries. Beginning in 1643, the year of Louis XIII's death, Mazarin was effectively in charge of the French state until Louis XIV attained his majority; he summoned Italian artists and craftsmen to Paris, and in these same years several French ones went to Italy to complete their training.

In a first phase, which coincided with the architectural careers of François Mansart (1598–1666), Jacques Lemercier, and Louis Le Vau (1612–1670), a strong classicizing tendency was in evidence. Jean Cotelle's rather dry designs for stucco ceilings with panels bordered by acanthus (about 1630–40) exemplify this stylistic moment. The stucco decor in the Hall of the Antonines in the Louvre features acanthus motifs that are equally classical in inspiration, but here they figure in an opulent architectonic design in which floral and geometric elements are given a clearly subsidiary role. The grandiose decorations in the queen mother's apartments were realized during the second Parisian sojourn of Francesco Romanelli (1655–57), a student of Pietro da Cortona. Romanelli's influence is also discernible in the designs of Charles Le Brun (1619–1690) for the nearby Galerie d'Apollon (1663): classicizing acanthus decorates some of its ceiling pendentives incorporating both painting and stucco work, the latter executed by the Marsy brothers and Thomas Regnaud under the supervision of François Girardon. In Le Brun's heyday, which began about 1661 (he not only oversaw the decoration of the royal palaces but also managed the Gobelins tapestry manufactory and the mobilier royal), French art acquired a stylistic unity in which Baroque and classical forms were happily conjoined. As a consequence of this unexpected alliance, the prominent role assigned acanthus in Italy and Germany was considerably reduced: it is

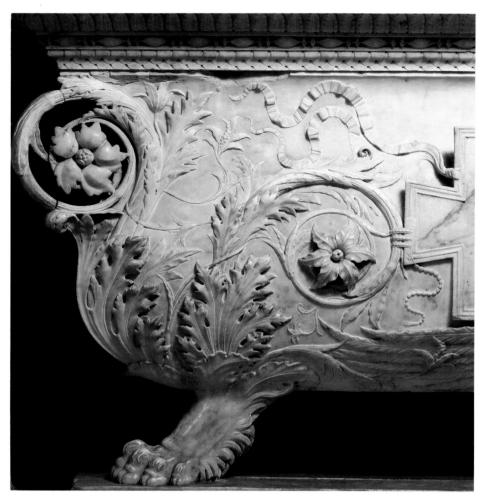

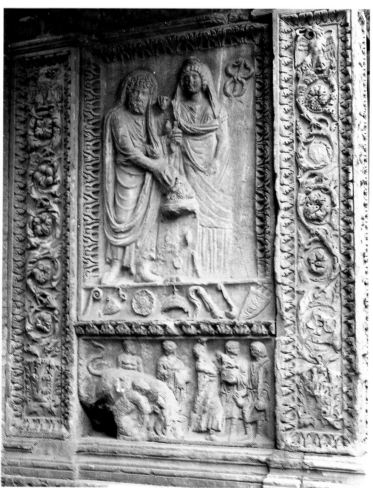

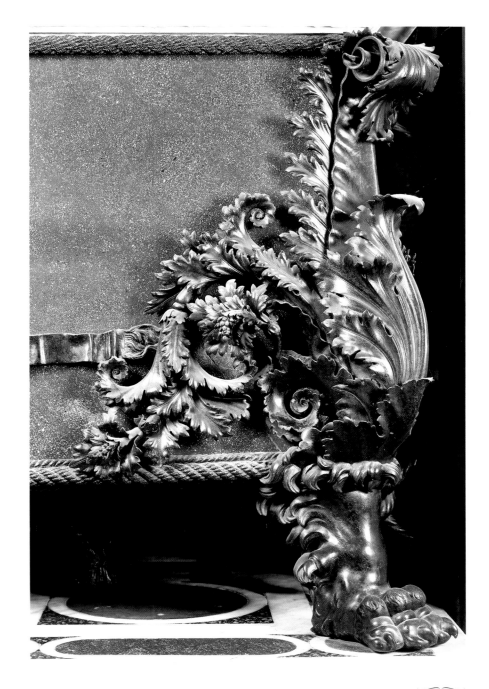

FACING PAGE

Tomb of Carlo Marsuppini (general view and detail), Desiderio da Settignano, Florence, 1453–55.

Florence, Santa Croce

Several large funerary monuments of a type previously reserved for major historical figures appeared in Florence and elsewhere in the first half of the fifteenth century. This impressive tomb, whose sumptuous decoration in an antique style was conceived by Desiderio da Settignano (c. 1428–1464), a student of Rossellino, contains the remains of Carlo Marsuppini, a humanist who was secretary to the Florentine Republic.

Arch of Septimius Severus (detail), Rome, 203.

Rome, Forum Romanum

This arch was built at the entrance to the forum by the Senate to honor the Emperor Septimius Severus and his family, who are depicted making sacrifices on its reliefs. The crowded and rather crudely executed acanthus rinceaux are typical of early third-century Roman art.

Portal of the church of Sant'Andrea in Mantua, Leon Battista Alberti, 1472.

Mantua, Sant'Andrea

In this structure, Leon Battista Alberti (1404–1472) created a church design that was to prove enormously influential throughout the sixteenth century. Although it had only risen a few feet above the ground at the time of his death, it is generally agreed that the portal, with its rich acanthus rinceaux of antique inspiration, bears the stamp of his imagination.

ABOVE

Tomb of Piero and Giovanni de' Medici (detail), Andrea Verrocchio, 1472.

Florence, San Lorenzo, old sacristy

The sarcophagus of Piero and Giovanni de' Medici, the sons of Cosimo, is one of the first major works of Verrocchio (1435–1488), who was initially trained as a goldsmith. Its ornamental fittings are of bronze, including the virtuosic acanthus leaves at the corners of the porphyry sarcophagus. The absence of religious symbolism and allegory usually found on funerary monuments is striking.

almost entirely absent, for instance, from the decorations at Versailles, the most important center of French artistic development in this period.

The designs of Parisians Jean Le Pautre and Paul Androuet du Cerceau, two of the greatest decorators in the French tradition, exemplify the general stylistic development. They worked for the court, lavishing their imaginations on royal palace decor and festival decorations. Their fantastic compositions, which often feature unusually pliant acanthus foliage, recall the candelabrum motifs in *page 122* Italian sixteenth-century prints. The powerfully veined leaves in Le Pautre's designs from the 1650s are wildly agitated, with cascading configurations reminiscent of designs by Stefano della Bella, but his later work is much more serene, featuring rinceaux composed of leaves modestly entwined around the less animated stems that anchor the composition. The interesting frame designs conceived by Paul Androuet du Cerceau and Alexis Loir in the century's final quarter deploy surging tendrils mixed with linear and ribbon ornament, elements also prominent in the elegant arabesques of Jean Bérain (1637–1711).

This opulent, emphatically magnificent style was adopted for French luxury furniture, which gradually acquired a character consistent with contemporary decorative schemes, and the resulting ensembles had a rare harmony. French furniture designers had long been faithful to the richly carved and detailed formats devised in the Renaissance. Under Louis XIII, chairs were carved with acanthus motifs clearly influenced by the decorative tradition of the Low Countries. In the mid-seventeenth century, however, the classicizing acanthus rinceaux already seen in stucco ceilings began to appear on the doors of cupboards and sideboards, and entirely new types of furniture came into being in the century's second half. Lavish floral configurations incorporating acanthus-like foliage are prominent in the marquetry panels of André-Charles Boulle (1642–1732), the era's most inventive furniture designer. However, elegant arabesque rinceaux with leaves unlike acanthus dominate most metal-inlaid furniture of the period. Acanthus is seen in unconstrained form only *page 128* in grillework, as in some interesting designs by Le Pautre and at the château *page 137* at Maisons (designed by Mansart, 1642–50), the magnificent gates of which feature antique-inspired acanthus rinceaux similar to those in designs by Jean Marot (1619–1679).

French silversmiths attained a new level of achievement in the years around 1660, but very little of this Baroque production survives. In 1688 Louis XIV found himself obliged to take radical measures to finance his expensive military campaigns, and had all the silver owned by the crown melted down, including the celebrated silver furniture in the Hall of Mirrors at Versailles. But a gold ornamental *page 148* box from about 1645, known as the Anne of Austria casket, has survived and is now in the Louvre; it is covered with a dense network of incised and repoussé configurations of flowering acanthus. The lavish Lennoxlove toilet service, made in Paris in the 1660s (now in the Royal Scottish Museum, Edinburgh), gives a further indication of the splendor and elegance typical of metalwork produced for the French court in these years; some of the pieces in this set are decorated with handsome acanthus motifs.

Classical ornament played a small, almost insignificant role in contemporary ceramic production. Acanthus rinceaux appear on faïence plates made in Marseille and Nevers along with figural vignettes, but valance motifs incorporating arabesque compositions were used much more frequently, and these are only distantly related to acanthus.

page 158

Finally we turn to tapestries and carpets, the borders of which often took the form of rigorously symmetrical acanthus rinceaux. Superb examples were produced by the Savonnerie manufactory, notably the carpets made there for the Galerie d'Apollon in the Louvre. It is worth noting that identical motifs were sometimes used in parquet floors, as can be seen in designs dating from 1682 for the *cabinet d'or* (gilded cabinet) of the Dauphin at Versailles.

England

Ornament evolved quite independently in England. Edward Pierce, active about 1640, the only Englishman whose ornamental prints have come down to us, must have spent time in Italy and/or the Low Countries, for his acanthus-rich grotesques have a pronounced Italian quality. England has had a rich autonomous tradition of plasterwork, which is heavier and less delicate than continental stuccowork, and many English plaster ceilings of the period feature beautiful foliage patterns. Luxuriant acanthus borders appear in an otherwise austere ceiling in Coleshill, in Berkshire, from the early 1650s; the classical volute rinceaux in this design doubtless reflect the influence of Sir Roger Pratt, a great traveler and gentleman architect who knew Italy firsthand.

The Restoration in 1660 put Charles II on the throne and prompted a new surge of activity: a puritanical era gave way to one in which the pleasures of life were savored to the full, and one consequence of this change was the rise to prominence of opulent acanthus motifs. The most renowned plasterers of the time— John Grove father and son, Henry Dogood, and Edward Goudge, all employed in the late seventeenth century by the Royal Office of Works—produced an impressive number of rich white ceilings with acanthus decoration. One remarkable ensemble from about 1675 survives intact in Ham House in Richmond: there, *page 116* animated volute acanthus of classical inspiration covers the walls, ceilings, and mantelpieces. Stairs with wooden risers featuring carved flowers and acanthus rinceaux, apparently modeled after Dutch examples, were made for several English country houses. The stairway from Cassiobury House in Hertfordshire *page 136* (now in the Metropolitan Museum), which dates from the 1670s, is a particularly fine example. It is the work of Grinling Gibbons, who, born of English parents in Rotterdam in 1648 (d. 1721), emigrated to England in 1667. His wood carvings, which feature fluent scrolled acanthus interspersed with flowers and fruit, recall similar work by Jakob van Campen and the school of Artus Quellinus. The foliage of the stairway in Dunster Castle, in Somerset, is enlivened by hunting vignettes.

Acanthus was used on English furniture of the early Renaissance, but it had a crude, indistinct character. A more sophisticated form was widely used

during the final years of the Stuart reign, notably on the bases, decorated with rinceaux and covered in silver or gold, that were used to support precious Chinese or Japanese lacquer cabinets. It is interesting to note that heavy, even pompous carved wood remained fashionable in England into the 1730s. Horace Walpole found the designs of William Kent in this vein to be "incommensurably ponderous." Decoration on the walnut and acajou tables in vogue during the same years, however, was limited to single large acanthus leaves on the upper curves of the legs. In England, unlike in France, many silver objects from the period have fortunately survived. The large saltcellars and sumptuous vases with acanthus leaves in repoussé, dating from 1660–80, are impressive. The pure acan-

page 150 thus rinceaux on the Calverley toilet set (1683–84) are both opulent and crisply classical in form.

The Low Countries

Ornamental acanthus played a rather insignificant role in Holland. In one interior from the 1620s, wide friezes decorating the borders of the ceiling contrast sharply with the accompanying wall treatments and furniture, which are mannerist in conception. It is the classicism and reserve prevailing in the frieze, however, that were to dominate seventeenth-century Dutch interior decoration. The complete absence of carved rinceaux from the celebrated Dutch armoires of the period is

page 136 telling in this regard. However, a few richly carved stair rails, balustrades, benches, and pieces of gilded furniture decorated with acanthus volutes were produced toward the end of the century, doubtless as a result of Flemish influence by way of Quellinus. The energetic rinceaux on the marble communion rail in the chapel of the Holy Sacrament in Antwerp Cathedral, carved by Henri-François Verbrugghen about 1687, is a typical example of acanthus ornament executed in Flanders but palpably influenced by Italian models.

The prints of Daniel Marot (c. 1663–1752), who as a Protestant was obliged to leave France in 1688 after the revocation of the Edict of Nantes, introduced the French style of ornament to Holland; in fact, his designs, which resemble those by Le Pautre, proved one of the most crucial vehicles for its dissemination.

page 153 His compositions filled with energetic acanthus motifs found their way onto Delft tiles, for instance, which were widely sought-after. Most of the ornamental designs on Delft faïence were copied from Far Eastern models, but acanthus leaves sometimes appeared on Baroque drinking vessels and on plates decorated with narrative vignettes.

Germany and Austria

Acanthus ornament took its own path in Germany and Austria. It was only around 1650–55 that a repertoire of classical architectural forms took root in those regions. Classical acanthus was introduced there by itinerant Italian artists who

fully exploited stucco's potential for richly plastic compositions. The decor in the Church of the Theatine Order in Munich, built by Enrico Zuccalli (c. 1642–1674), who succeeded the Bolognese architect Agostino Barelli in 1667, is among the earliest examples of this style. A frieze of vigorous scrolling acanthus runs the length of its walls, and acanthus motifs fill the pendentives above the lateral chapels. The candelabrum panels on the entry wall, featuring large acanthus leaves animated by putti, are especially impressive. These reliefs are the work of a team directed by the stuccador Giovanni Niccolo Perti of Como. *page 120*

The decoration in the convent church in Waldsassen (1695–96) is even more grandiose and luxuriant. Choir stalls with acanthus ornament carved by Martin Hirsch, among the most beautiful in Franconia, complete a decorative scheme dominated by stucco acanthus rinceaux on the vault, the work of Giovanni Battista Carlone, born in Sciarra near Como; gilded frames of openwork foliage above the stalls make the final effect still more sumptuous. But here, as in Carlone's decorations in the cathedral in Passau, acanthus is one among many motifs figuring in the richly modeled stucco.

Generous use of acanthus is one of the dominant characteristics of the so-called Wessobrunn school of stuccadors, affiliated with the Benedictine abbey of the same name in southern Germany; acanthus leaves are especially prominent in work there by Johann Schmuzer (1642–1701) and his sons. Reliefs executed at the abbey by Schmuzer between 1685 and 1690 are typical of the Wessobrunn *pages 118–19* style: deeply serrated acanthus and herbaceous foliage, cherubim heads, stylized shells, and isolated flowers cover the ribs of the vaults. His acanthus volutes in the pilgrimage church in Vilpertshofen (executed between 1687 and 1692) are even more lush and exuberant. Stuccos on the ceiling of the convent church in Obermarchtal are more reserved, including volute acanthus friezes almost classical in their restraint. After Johann Schmuzer's death, his sons developed a lighter style of ornament, avoiding the heavy acanthus so prevalent in his work. The *Wappensaal* (Hall of arms) in Köpenick Castle is a fine example of a late seventeenth-century manorial interior: its shields borne by caryatids are imposing, and the putti gamboling through the acanthus leaves bordering the ceiling betray the Italian origin of their creator, Giovanni Caroveri.

Thanks to decorative prints, it is quite easy to trace the evolution of ornamental acanthus in Germany. It was not taken up in the region as part of a style that was already well defined; instead, these images trace a process of transformation in which relatively organic foliage gradually developed from late Gothic ornament, eventually coming to resemble Italian and French acanthus rinceaux. Baroque ornament and floral motifs became prominent in both luxury furniture and refined metal objects. The work of architect and furniture-maker Johann Indau in Vienna, after 1682, and of Johann Unselt, who collaborated with Ulrich *page 130* Stapff in Augsburg beginning in 1690, demonstrate how broad-leafed compositions could evolve out of a late Baroque decorative idiom. The first designs of Nuremberg-based furniture-maker Georg Gaspar Erasmus reveal a sensibility still totally immersed in the auricular style. Thus the character of German acanthus ornament in the medium of woodcarving is totally different from that of

Italy and France: sinuous, regular rinceaux configurations are rare, and the foliage expands to cover entire surfaces in ways that violate the rules of classical decorum. The results are especially striking when these convoluted leaf networks are used on furniture such as beds and chairs. Marcus Nonnenmacher (b. 1653), furniture-maker to the court in Prague, was still producing such pieces as late as 1710. The luxuriant acanthus compositions in an Italian mode done in 1679 by Matthias Echter, a painter and copper-plate engraver, exploit the great freedom allowed him on paper, as opposed to the constraints imposed on craftsmen working in more intractable materials. Designs by Johannes Thunkel and Johannes Heel, goldsmiths practicing in Augsburg and Nuremberg, feature central motifs that resemble acanthus. In the work of Johann Conrad Reuttimann, active in Augsburg from 1676 to 1691, acanthus leaves in C-scroll configurations envelop prominent flowers. The acanthus rinceaux in ornamental prints produced around 1700 by Leonhard Heckenauer the younger and Georg Bodenehr have more energy and momentum. Only in 1720, in a collection of foliage and volute designs published by Johann Eysler, is there any trace of the delicate inflections that had been developed in France over the second half of the seventeenth century, even though the title pages of the earlier collections by Reuttimann and Bodenehr specifically mention "French foliage." The illustrations in the volume *Neu ersonnene Goldschmied-Grillen* (New designs for metalwork) by Wolfgang Hieronymus von Bömmel of Nuremberg, which consist of delightfully absurd animals and figures composed entirely of foliage, exemplify the freedom with which acanthus was manipulated in Germany at this time.

Stucco, repoussé work, and wood carving are all particularly well suited to high-relief modeling, which partially explains the prevalence of deeply carved wooden acanthus motifs juxtaposed with the stucco reliefs in German and Austrian churches. Acanthus ornament decorates many altars, organ cases, and pulpits, and was sometimes used to cover entire walls, as in the famous "acanthus altars" whose wide borders are completely overrun with restless foliage and flowers. A fine example can be seen in the Church of Saint Catherine in Reuth.

Ornamental acanthus played an important role in furniture design. Among the earliest examples is a buffet made by Johann Friedrich Keller in 1663 for the saffron importers' guild in Basel, which had side panels decorated with auricular forms and acanthus. Subsequently, pure acanthus came to be the preferred mode of ornament for large armoires, the most imposing pieces of furniture in German and Austrian middle-class interiors. Elegant acanthus motifs that complemented their architectural character were often used on armoires made in southern Germany, Augsburg, Ulm, and Basel. In contrast, bold patterns of lush foliage (often animated by mythological figures) were favored for the doors of the vestibule armoires known as *Schappen,* versions of which were produced in Hamburg, Bremen, and along the Baltic Sea from Lübeck to Gdansk. Other sorts of furniture—beds, cradles, and chairs—entirely composed of foliage continued to be made in southern Germany and Austria for many years. The bed of the von Sommer family in Munich (late seventeenth century), for example, seems to have been directly inspired by the prints of Johann Unselt. Similar pieces were

page 131

page 146

page 150

page 117

page 132

page 131

Design for acanthus rinceaux animated
by lions and a cockfight, pen with wash
highlights, Stefano della Bella.
Paris, Bibliothèque Nationale

ᴾainter and engraver Stefano della Bella, born in Florence in 1610, was initially trained as a gold-smith. His designs combining animals and figures with foliate motifs were widely imitated both inside and outside of Italy; from 1639 to 1650 he resided in Paris, where his work was influential.

produced for the court in Berlin. Acanthus foliage—unthinkable in this form in France and England—was generously employed on these pieces of richly carved furniture, designed to harmonize with the decor of ceremonial reception rooms. An upholstered bench made for Frederick II of Prussia prior to the period of Schlüter's activity in Berlin (beginning in 1694) and an étagère with braces in the shape of acanthus volutes, intended for Oranienburg Castle, are the two master-pieces of this gilded and silver-plated production, but small tables and consoles featuring large leaves, occasionally animated by figures, were also produced in this court style. Such pieces convey something of the opulent effect produced by the silver furniture and decor of the palace in Berlin, which was intended to make visible the wealth of the absolute ruler and the state he controlled. Most of this furniture was melted down to finance the military campaigns of Frederick II, just as in France under Louis XIV. However, a pair of lavish thrones survives: *page 129* shaped like the old-fashioned X-chairs of the Renaissance, indicating the elector's obeisance to tradition, they are decorated with silver repoussé acanthus motifs. They were executed by Augsburg-based goldsmith David Schwestermüller and date from about 1675.

As already noted, very little French goldsmith work from the period survives, but many examples of contemporary German metalwork have come down to us. Augsburg was the principal center for the production of such pieces, but objects of remarkable quality were also made in other cities. Floral ornament was favored until about the middle of the seventeenth century, but

acanthus had completely supplanted it by the century's end, largely as a result of the influence of ornamental print designs in which its leaves figured prominently. Contemporary metalworkers produced many liturgical objects—such as monstrances, altar candelabra, and ciboria—decorated with vigorous foliage,

pages 147, 149

but they also used such motifs on countless drinking vessels—such as goblets, mugs, and hanaps—intended for middle-class consumption. These pieces feature scrolling acanthus designs either in relief or incised, with the latter technique being favored in objects produced toward the end of the century, when the motifs acquired a new delicacy. The effect they produced was often enriched by selective gilding.

Acanthus is less pervasive in other media during this period. On German and Austrian pottery, for instance, almost the only examples to be found are the timid acanthus friezes on beer mugs from Creussen (c. 1660–70) and the dark brown rinceaux incised on pieces made in Muskau. As for faïence, craftsmen working in this material were strongly influenced by Far Eastern models: patterns and compositions originating in China and Japan were closely imitated by artisans from Frankfurt to Delft. As a result, very little Baroque ornamental acanthus is to be seen on pottery from the German-speaking regions, but lively acanthus forms appear in a few of Jakob Irminger's designs for stoneware and porcelain made by Johann Friedrich Böttger (1682–1719) in Meissen between 1710 and 1716.

It was rare for glassware to be decorated with pure acanthus rinceaux. Only one manufactory used acanthus forms with any consistency, utilizing an unusual technique. The establishment in question is the cut-and-polished

page 155

glass works established by Count Christoph Leopold Schaffgotsch for Friedrich Winter at Hermsdorf, in Silesia (1690–91), where thick, transparent glass crystal worthy of comparison with rock crystal was cut and engraved with lapidary

page 154

instruments. In the early eighteenth century, the double glasses from Bohemia known as *Zwischengoldgläser* were often decorated with foliage and acanthus rinceaux, but they are an exceptional case.

Acanthus was also rare on pewterware, even though this material was as pliable as silver, but examples of it do exist, such as a bottle with a screw-on stopper made around 1700 in Nuremberg. The only tin and pewter objects to feature acanthus leaves with any frequency in this period were large altar candelabra.

The Scandinavian Countries

The German variant of acanthus was enthusiastically adopted by the Scandinavian countries, especially in the medium of wood carving. Altars with rich acanthus reliefs were produced in Denmark as early as 1670–80, but acanthus ornament became firmly established there only after 1686. From that year on, Christian Nerger, a German sculptor affiliated with the court of Christian v, executed acanthus-laden carvings, stuccos, and woodwork for the royal palace in Copenhagen. His organ case in the same city's Church of the Redeemer sits on the backs of elephants and is covered with unruly acanthus foliage reminiscent of

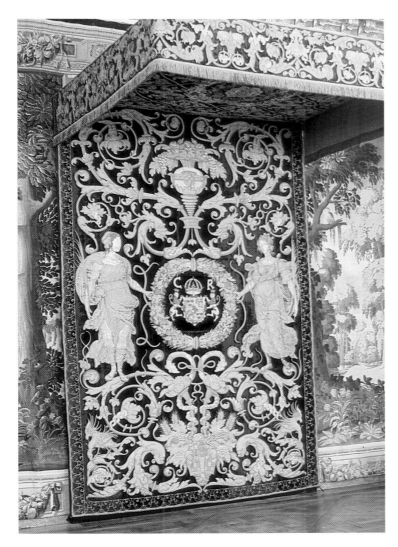

Dais of the throne in the audience room
of the Royal Palace in Stockholm, gold
and silver silk embroidery on a velvet
ground, Italy, early sixteenth century.

Stockholm, The Royal Collections

*I*n the 1690s this audience room was remodeled to
serve as Charles XI's bedchamber. The painted ceil-
ing and stucco decor by French artists J. Fouquet
and René Chauveau (1663–1722) date from this
renovation, but the dais is early-sixteenth-century
Italian work. Catherine Jagellon, the wife of
John III, was probably responsible for obtaining it;
the Swedish arms and the initials CR were added
later, probably for Queen Christina.

Portrait of John III, seventeenth-century
copy after J.B. van Uther.

Gripsholm Castle (Sweden)

*J*ohn III (1537–1592), the son of Gustav I Vasa,
was kept a virtual prisoner at Gripsholm with his
wife Catherine Jagellon by his brother until the
latter's mental instability became obvious. He was
crowned in 1569, and in 1587 he obtained the Polish
throne for his son Sigismund. In this portrait from
Gripsholm Castle, the king is dressed in clothing
made of a splendid fabric featuring gold rinceaux
patterns against a black ground.

designs by Johann Indau, although here acanthus is combined with ribbon interlace of French inspiration.

Sweden adopted the pure vegetal style of acanthus favored in France, largely as a result of the influence of Nicodemus Tessin the younger, who had close French ties and markedly francophilic tastes. The style really took root after 1681, when Burchard Precht of Bremen arrived at the Swedish court. But while the elegant French version was favored by the nobility, the wilder German variant was preferred by the middle class, as is evidenced by a number of contemporary altars, tombstones, consoles, and mirror frames featuring acanthus borders. Swedish architecture, too, bears the stamp of Tessin's attraction to French classicism, and wooden sculpture produced by the Precht studio was disseminated throughout the country. However, stuccadors from the Como region introduced another variant of acanthus to Sweden, which had no decorative vocabulary of its own: elegant volutes were modeled by Pietro Petretti and Giovanni Galli, active in Vilna, and by Giuseppe Marchi, who in 1697 succeeded Giovanni and Carlo Carove at Drottningholm Palace.

Acanthus ornament was put to notably wide and creative use in Norway between 1675 and 1695. Since the most prominent merchant families in Christiania (now Oslo) were composed of German and Danish immigrants during these years, it might be said that acanthus was "imported" by them. The local artisans who took up this vocabulary decorated the interiors of several churches in the city and in the surrounding region, using rich acanthus schemes. Foliate rinceaux remained a fixture of popular Norwegian art until the end of the eighteenth century; wood carvings in this picturesque and flowery style were executed with a particular flair in Gudbrandsdal, the seat of a peasant aristocracy.

Conclusion

Having considered the triumph of acanthus in the Baroque era, especially in the years between 1660 and 1720, a summary account of its subsequent fate is in order. The motif's autonomy was fundamentally compromised in rocaille decoration, but even here it played an important role. Pure acanthus ornament returned to favor with the advent of European neoclassicism in the 1770s: in addition to reflecting the first-hand experience of antique Roman monuments, Louis XVI decorative arts productions were informed by a desire to revive the rich tradition of Gallic classicism so vibrant under Louis XIV. Ornamental prints of the seventeenth and even the sixteenth century were republished, and as a result the number of new decorative compositions issued in this form was relatively small. Gilles-Paul Cauvet (1731–1788) and Henri Salambier (active c. 1770–1820) were among the few designers to create such model images in the second half of the eighteenth century. The picturesque and decorative volute acanthus rinceaux by Salambier were most faithfully copied in porcelain designs.

The brand of neoclassicism that sprang up in England and Italy developed more or less independently of its French counterpart and had a pronounced aca-

page 135

demic, archeological cast. The work of Robert Adam and his circle was influenced not only by ancient models but also by the ornamental style prevalent in Renaissance Rome. Acanthus was prominent in English stucco work; the exquisite decorative ensembles produced by Robert Adam and Joseph Rose in the 1760s incorporated acanthus rinceaux of great delicacy and refinement. This style was emulated in Ireland, where the stuccadors James McCullagh and Michael Reynolds adorned the walls of Powerscourt House in Dublin with elegant compositions of acanthus rinceaux. But decorative stucco aside, in eighteenth-century Italy and England acanthus was regarded as but one of many ornamental motifs with an ancient pedigree.

A final flowering of ornamental acanthus occurred between 1815 and 1840. Static, planar acanthus motifs were widely used in Munich buildings by Leo von Klenze that epitomize the era's taste in many respects. They also appear on Biedermeier furniture and silver, usually as isolated leaves as opposed to volute rinceaux. They continued to be used in subsequent nineteenth-century decorative arts productions of a historicizing bent, but there's no denying that by this time acanthus had lost its vitality, usually appearing as a subsidiary element in works executed in specific period styles. Soon it completely disappeared from view. Flowers and foliage play a crucial role in the Art Nouveau vocabulary, but, despite its vegetal character, acanthus—an ornament whose successive incarnations were sometimes classically austere and sometimes extravagantly Baroque, but whose roots in the ancient world were always apparent—was ill suited for appropriation by the practitioners of this free style, which made a clean break with tradition. In the twentieth century, any object decorated with acanthus involuntarily evokes antique associations. It would seem that this strain of ornament, which was at its peak in the Baroque era, has now totally disappeared from the working vocabularies of architects and designers—a regrettable loss, for, as we have seen, acanthus occasioned remarkable displays of creativity and invention in successive generations of European decorative artists and craftsmen.

White Cabinet of the
Duchess of Lauderdale *(above)*
and Queen's Cabinet *(left)*, c. 1675.
Ham House (England)

The interiors of Ham House, a peaceable manor
built in 1610, largely reflects the taste of Elizabeth
(daughter of William Murray, first count of Dysart),
whose second husband was John Maitland, first
duke of Lauderdale, a favorite of James II. The
suite of rooms in its "new" wing were decorated in
accordance with prevailing fashion. The ceiling
in the cabinet of the Duchess of Lauderdale is by
Antonio Verrio (c. 1639–1707), who after having
worked in Paris in the early 1670s introduced late
Baroque decorative painting to England.

Interior of the abbey church at Speinshart,
decorations dating from 1696.

Speinshart (Germany)

The abbey church at Speinshart is richly decorated with frescoes and stuccos
by Carlo Domenico and Bartolomeo Luchese, from Melide. The pews,
installed in 1714, skillfully carved and heightened with discreet applications of
color, add the finishing touch to this sumptuous decor; their end panels feature
scrolling rinceaux entwined with the abbey's emblem, symbols of the four
elements, putti holding the instruments of the Passion, and flowers.

Stucco work in the nave,
Church of Saint Emmeran, Ägid Quirin Asam, 1731–33.

Ratisbonne (Germany), Saint Emmeran

The capitals of the nave pilasters in the collegiate Church of Saint Emmeran
exemplify the freedom with which Ägid Quirin Asam (1692–1750), a superbly
gifted decorator, interpreted classical models. Filling the space between the
upended volutes of each capital are stylized acanthus motifs and a spiderweb
pattern that are very far removed from models in nature and that have a
marked affinity with the rocaille vocabulary.

Acanthus altar, 1712.

Oberegglham (Germany), Church of Saint James the Major

Foliage plays an important role in German Baroque sculpture, appearing
on altars, organ cases, and choir stalls. Bavaria produced the "acanthus altar,"
which features a wide frame of luxuriant, deeply undercut carved foliage
surrounding an altar painting, which is all but overwhelmed by the elaborate
setting. Here, the acanthus foliage has ribbon motifs running through it.

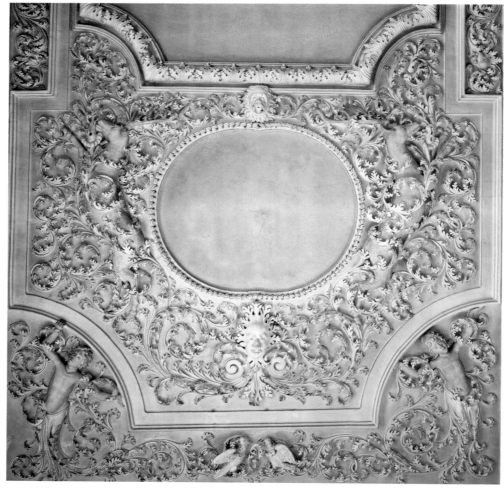

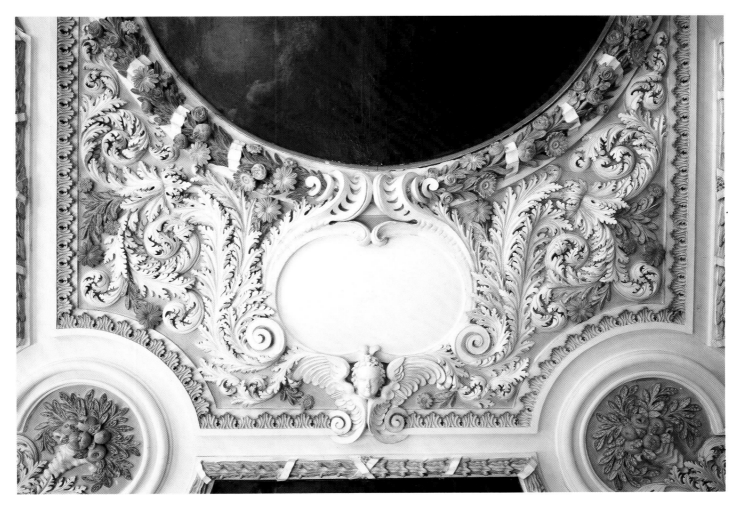

FACING PAGE

Grand corridor,
stucco, 1685–90.
Wessobrunn Cloister (Germany)

Hall of Tassilio,
stucco, 1699–1700.
Wessobrunn Cloister

ABOVE AND RIGHT

Hall of Saint Benedict,
stucco, 1690–95.
Wessobrunn Cloister

*I*n the seventeenth century, this Benedictine
abbey fostered the so-called Wessobrunn school
of stuccadors, which was responsible for an
unprecedented flowering of elaborate, large-scale
stucco decoration: the Schmuzer, Feichtmayr,
and Zimmermann families all trained and worked
there. The stuccos in the cloister are by Johann
Schmuzer (1642–1701), whose work is characterized
by the generous use of acanthus.

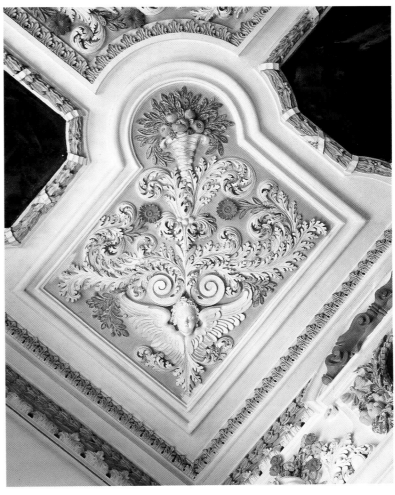

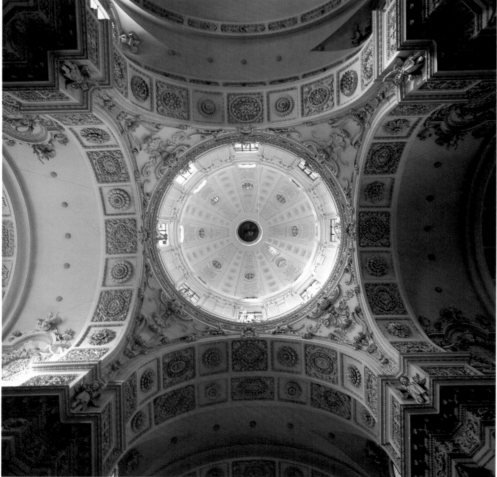

Partial view of the stucco
decorations in the Church of the
Theatine Order, c. 1672–88.
Munich, Theatinenkirche

The first generation of stuccadors to work in
southern Germany and Austria were almost all of
Italian origin. Henrietta Adelaide of Savoy, wife
of the elector of Bavaria, had vowed to have a new
church built after the birth of a male heir, and this
sanctuary fulfilled that commitment. It was built
by Enrico Zuccalli of Roveredo (c. 1642–1674),
who succeeded Agostino Barelli as head of the
project. Acanthus rinceaux animated by putti and
large stylized flowers are pervasive in the heavy
stucco reliefs by Giovanni Niccolo Perti.

Dome in the Church of
the Theatine Order, c. 1672–88.
Munich, Theatinenkirche

Note the C-scrolls and acanthus-derived forms
in the pendentives.

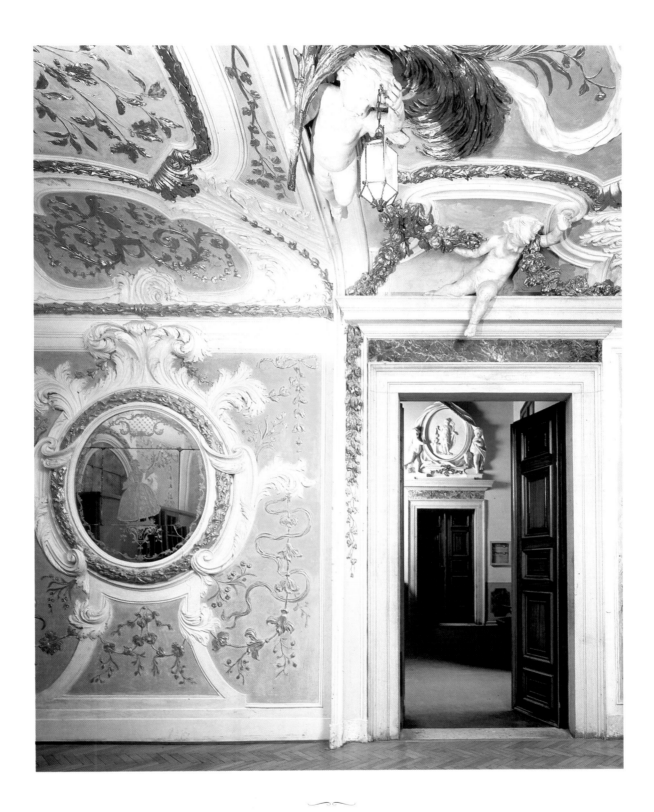

Corridor, *piano nobile* (main floor)
of Villa Widmann.

Bagnoli di Sopra (Veneto)

The Widmann family, originally from Carinthia,
were granted Venetian patriciate status in 1646.
Their palace, built in 1630, is an early work of
Baldassare Longhena (1598–1682), the great
Baroque architect who designed the Church of
the Salute. It contains a magnificent stucco decor
by Giuseppe Mazza of Bologna (1653–1741);
the inventive frame designs combine C-scrolls
with large acanthus leaves.

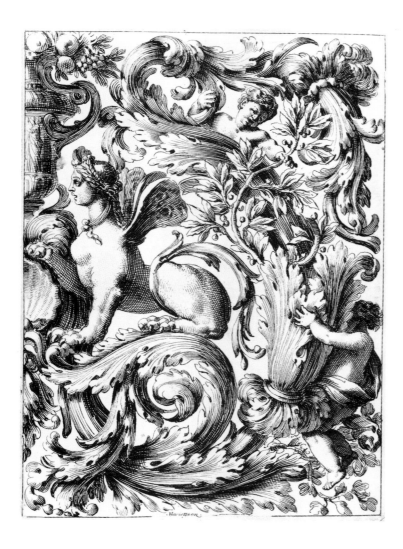
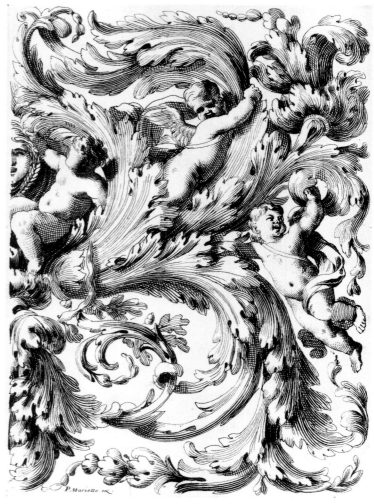

Two rinceau designs, ornamental prints,
Jean Le Pautre, published by Pierre
Mariette, c. 1650.

Private collection

*J*ean Le Pautre was born in Paris in 1618 (d. 1682)
and his activity there is documented beginning in
1643. He devised a decorative idiom in which the
more novel ornamental forms of his day are
combined with Baroque and antique motifs;
remarkably, he succeeded in making these various
elements harmonize perfectly. The grandiose
acanthus rinceaux of his earliest designs are so
agitated as to suggest roiling water, an effect that
is heightened by the use of deep shadows. He
delighted in populating his compositions with
fantastic animals and human figures; like much of
his production, the two illustrated examples are in
the Italian tradition exemplified by the work
of Stefano della Bella.

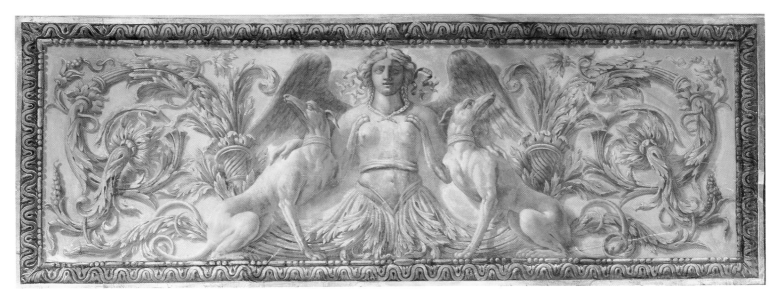

Detail of ceiling, bedroom of
Nicolas Fouquet, 1656–61.
Château of Vaux-le-Vicomte

Detail of wall painting,
dining room, 1656–61.
Château of Vaux-le-Vicomte

The château and gardens at Vaux constitute one of
the most perfect artistic ensembles of the second
half of the seventeenth century. Nicolas Fouquet,
the powerful French overseer of finances, commis-
sioned the architect Louis Le Vau (1612–1670) to
draw up plans for the building; André Le Notre
(1613–1700) provided a setting worthy of it in his
garden designs; and Charles Le Brun (1619–1690)
was responsible for the interior decoration. The
results bear the stamp of Italian influence: the
ceremonial rooms combining stucco work and
paintings bring to mind Pietro da Cortona's ceilings
in the Palazzo Pitti, while some of the decorative
wall paintings are free paraphrases of grotesques
by Raphael and his school. When Fouquet was
disgraced and imprisoned by Louis XIV in 1661,
Le Brun and almost all the artists who had worked
with him at Vaux were hired by the king and put
to work at Versailles, where they continued to
explore the same decorative vein.

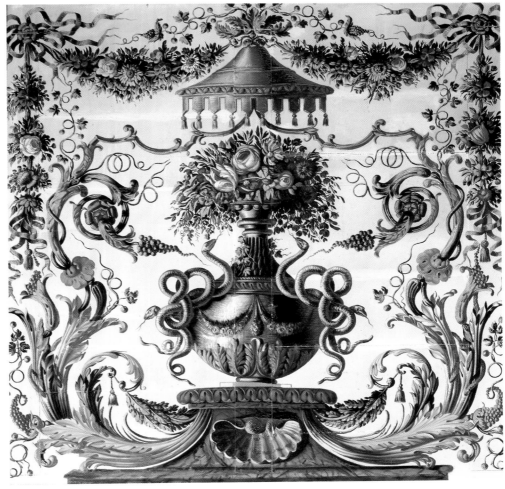

Marquetry cabinet (full view
and detail), France, second half of
the seventeenth century.

Paris, Musée des Arts Décoratifs

Marquetry designs featuring flowers and foliage
were much appreciated in England and Holland.
Ornamental print designs combining naturalistic
flowers with acanthus forms often served as the
models for these compositions. Early in his career,
André-Charles Boulle (1642–1732) also produced
wood marquetry pieces of this type.

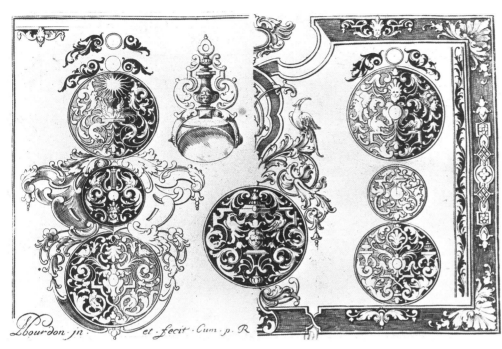

Plates from *Livre premier,
Essais de gravure . . .,* prints,
Pierre Bourdon, c. 1703.

*Paris, Bibliothèque d'Art et d'Archéologie,
Fondation Jacques Doucet*

Paris-based engraver Pierre Bourdon made a
specialty of designs for jewelry, pocket watches,
and decorative boxes. His compositions combining
delicate ribbon motifs with acanthus have a
marked affinity with similar designs by Boulle.

Coin chest, metal marquetry with bronze
appliqués, Gilles-Marie Oppenord,
France, early eighteenth century.

Versailles, Musée National du Château

The fittings by Oppenord on this piece are of
exceptionally high quality. Their delicate undulat-
ing patterns, like those of the inset acanthus
rinceaux, ally them with ribbon motifs, recalling
designs by Jean Bérain, whose grotesque
compositions remained influential until the mid-
eighteenth century, especially in southern
Germany and Austria.

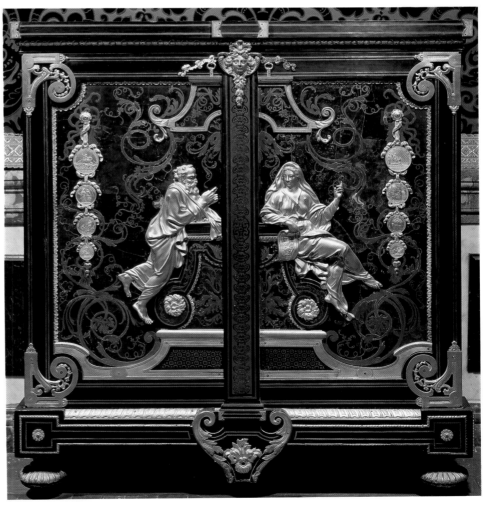

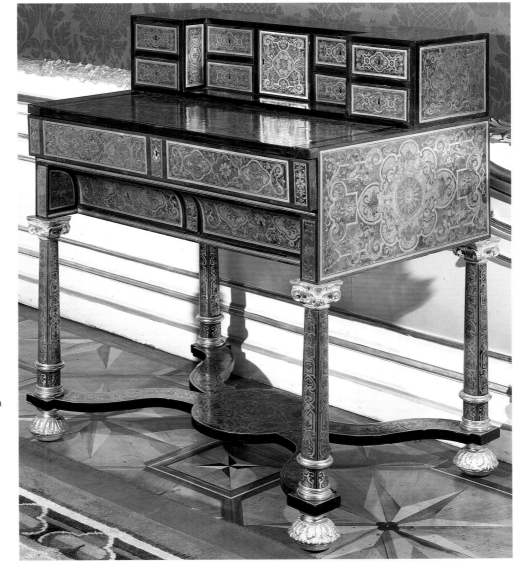

FACING PAGE

Tabletop (detail),
Boulle marquetry, Vienna, c. 1700.
Vienna, Hofburg

Boulle marquetry furniture was so appreciated in Austrian court circles that it was produced in Vienna rather than imported from France. This tabletop can be dated to about 1700 by the emblem of Leopold I (who died in 1705), which makes it the oldest surviving example of this Austrian production. The delicate strapwork and foliage patterns are of exceptional quality and resemble ornamental print designs by Johann Eysler.

Desk, Boulle marquetry, Vienna,
first quarter of the eighteenth century.
Vienna, Hofburg

This piece, which was made in Vienna, was intended for use by the emperor. An almost identical desk and matching table are now in Harrasch Castle in Rohrau, in lower Austria; in fact, the similarities are so striking that the pieces must have been produced in the same workshop. The acanthus here is extremely elegant but is used sparingly.

Title page of *Groteschgen Werk*, print,
Paul Decker the elder, c. 1700.
Cologne, Museum für Angewandte Kunst

Paul Decker the elder (1677–1713) played an important role in the dissemination of foliate and strapwork ornament in southern Germany and Austria. His compositions are influenced by Bérain, but the rather lush foliage favored by him is more in the spirit of designs by Daniel Marot.

Commode, tortoiseshell with
Boulle marquetry, André-Charles
Boulle, Paris, c. 1680–1700.

Paris, Louvre

*A*ndré-Charles Boulle raised the technique of
inlaying brass and tortoiseshell—also current in
Italy and Germany—to a new level of virtuosity
and sophistication. His furniture generally
features bronze fittings of high quality; some of
those on this superb commode take the form
of acanthus leaves. The prints of Jean Le Pautre
often influenced the design of such fittings:
compare these, for example, with the acanthus
leaves in the print illustrated above.

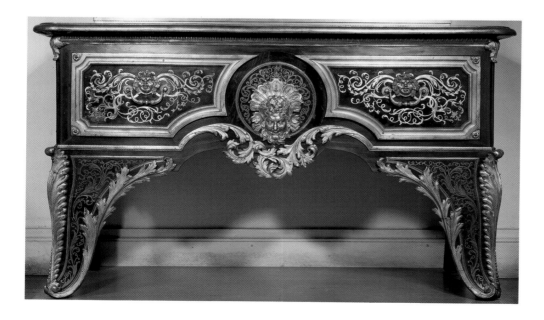

Title page of *Escussons ou Entrées
de Cerures et autres Ornemens servants à
embellir la Cerurie,* print, Jean Le Pautre,
published by Pierre Mariette,
Paris, 1650–60.

Private collection

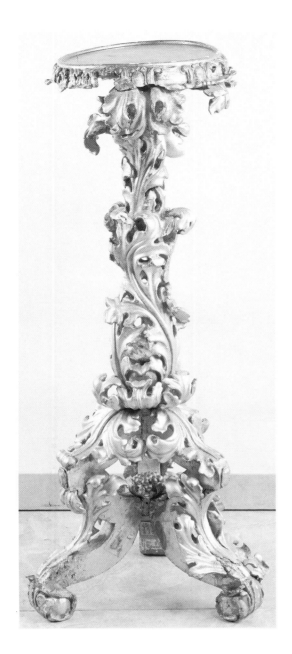

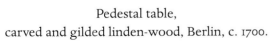

Pedestal table,
carved and gilded linden-wood, Berlin, c. 1700.
Berlin, Charlottenburg Palace

It was only during the second half of the seventeenth century, and then only in the households of prosperous individuals belonging to court circles, that tables such as this began to be used to support candelabra. They were often disposed in pairs with a matching mirror console. In most cases, their bases took the form of serpentine columns, but here the pedestal is completely given over to twisting acanthus. This piece belongs to a family of acanthus furniture fashionable at the Berlin court around 1700; their designs were probably inspired by Dutch models.

Wall console,
carved and gilded wood, early eighteenth century.
Paris, Musée des Arts Décoratifs

Delicate and inventive consoles such as this one were much appreciated in the seventeenth and eighteenth centuries. They were used to support porcelain vases, most often Chinese or Japanese imports.

Throne in the form of a folding chair, wood encased in silver repoussé, David Schwestermüller, Augsburg, c. 1675.
Berlin, Kunstgewerbemuseum

All of the silver furniture—either solid or made of wood and covered with silver appliqué—made for Louis xiv fell victim to the fiscal demands of the king's military campaigns and were melted down in 1688. A similar story unfolded in Berlin, but a few pieces of ceremonial furniture from the court of Frederick ii survive, such as this throne shaped like an old-style Renaissance X-chair. It was made in Augsburg, an important center for the production of silver furniture.

Title page of *Neues Zierrathen Büchlein,* print,
Johann Unselt, Augsburg, 1690.

Private collection

Published compositions by sculptor Johann Unselt, who became a guild master in
Augsburg in 1681, were instrumental in encouraging the use of ornamental acanthus
in objects made of carved wood. Later prints of his work published by Ulrich Stapff
(Augsburg, 1696) include an interesting design for a bed-frame composed entirely
of leaves in lively rinceau patterns.

Frame decorated with foliage and putti, wood, Bologna, c. 1680.

Venice, Museo Correr

Bologna played an important role in the development of the frame. In the seven-
teenth century a type of frame was developed featuring severe borders complemented
by acanthus; after the century's midpoint, agitated openwork rinceaux began to
appear that fought free of the frame, with strikingly vigorous results. In this example
their energy is further accentuated by gamboling putti.

Frame design, print, Matthias Echter, from
Raccolta di Varii Cappricii et Nove Inventionii, Graz, 1679.

Private collection

This sheet by Matthias Echter, born in Weiz and active in Graz until 1697,
demonstrates how Italian ornamental print designs were appropriated by northern
artists. In this example, putti nestle into wild, jaggedly lobed acanthus leaves.

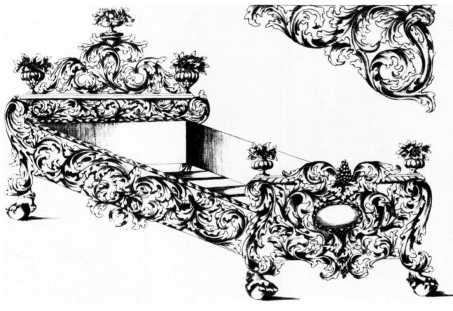

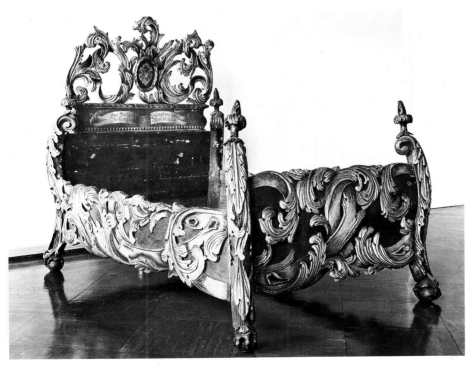

Cradle, painted and gilded wood,
last quarter of the seventeenth century.
Graz, Landesmuseum Joanneum

This cradle composed entirely of carved acanthus rinceaux
is an interesting example of late-seventeenth-century
Austrian furniture. At the corners, four painted putti
emerge from the gilt foliage.

Design for a bed, print, Marcus Nonnenmacher,
from *Der architektonische Tischler oder
Pragerisches Säulenbuch . . . ,* Nuremberg, 1710.
Private collection

Furniture-maker Marcus Nonnenmacher, who was born
in Constance in 1653 and practiced in Prague until his death
in 1720, produced numerous designs for wooden furniture
composed of carved acanthus leaves. However, they were
not published until 1710, and it seems unlikely that they
exerted much influence at that late date, when a lighter
idiom dominated by ribbon ornament had become
pervasive in Germany and Austria.

Bed with arms of the von Sommer family,
Munich, late seventeenth century.
Munich, Bayerisches Nationalmuseum

Carved wooden beds were an ideal vehicle for the
Baroque decorative vocabulary; the gilded acanthus leaves
on such pieces intermingle in luxuriant patterns that can
nonetheless be quite open in feeling. Examples such as this
one, which features vigorous rinceaux, are very close to
designs in the same vein in ornamental prints.

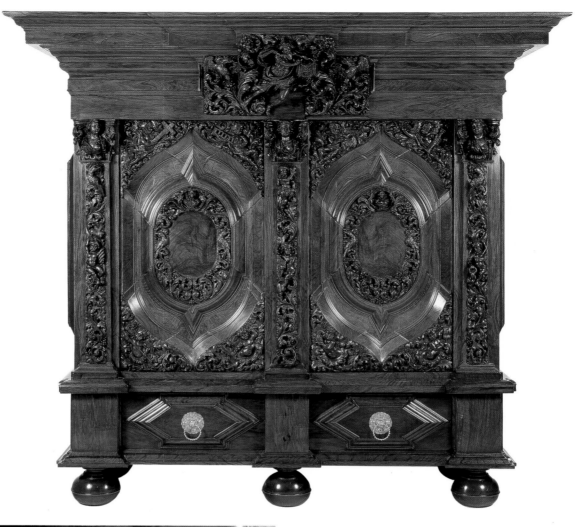

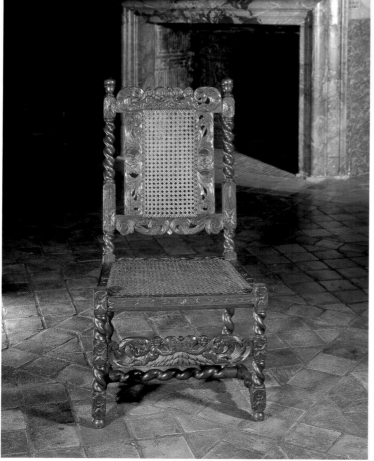

Vestibule armoire (*Schapp*), walnut veneer and carved ebony,
Hamburg, late seventeenth century.

Berlin, Kunstgewerbemuseum

Large vestibule armoires with two doors were an important vehicle for
acanthus ornament in seventeenth- and eighteenth-century Germany. These
Schappen, as they were called, were placed in the entry vestibules of prosper-
ous merchants in northern Germany. Variants were produced in Hamburg,
Bremen, and along the Baltic coast from Lübeck to Dantzig. In most cases
they are richly carved; the present example features instruments of the Passion
arrayed against turbulent fields of acanthus foliage.

Cane chair, turned and carved wood,
last quarter of the seventeenth century.

Ecouen, Musée de la Renaissance

In the second half of the seventeenth century a new type of chair became
current in the Netherlands, where it remained popular both in court circles
and among members of the middle class until about 1750. It is characterized
by a caned seat and back, serpentine uprights, and panels of acanthus
rinceaux. It was successfully introduced into England by Dutch furniture
makers, but its heyday in France was brief.

Title page of *Ornemens de Panneaux pour l'enrichissement des lambris de chambres et galeries,* print, Jean Le Pautre, published by Pierre Mariette, 1659.

Private collection

Unlike the designers of German ornamental prints, Jean Le Pautre was not a minor master but a court decorator who designed the interiors of French royal palaces as well as elaborate festival decorations.

Jewel casket (top), Saint-Lucy wood, and Holy-water basin, eastern France, late seventeenth century.

Paris, Musée des Arts Décoratifs

The decoration on these two objects reflects the influence of French ornamental prints such as those by Jean Le Pautre. The cover of the box is carved with sinuous acanthus scrolls; the holy-water basin features curved acanthus leaves combined with C-scrolls and garlands of flowers.

Bérain's prints were devised primarily to serve as models
for interior designers, furniture makers, and their clients. This
wall panel shows how his compositions were sometimes put to
use; it features ribbon ornament, rinceaux, garlands of flowers,
a vase, and a mascaron above a cartouche enclosing a
crowned monogram.

Openwork panel, carved oak,
late seventeenth century.
Paris, Musée des Arts Décoratifs

The skill with which late-seventeenth-century ornamental
compositions were adapted to suit specific needs is illustrated
perfectly by this panel, which combines sinuous bandwork with
acanthus foliage and centers around a lilylike form. Cascading
flowers contribute to the simple yet rich effect.

Title page of *Ornemens Inventez par
J. Bérain,* print, Jean Bérain.
Paris, Bibliothèque Nationale

Jean Bérain (1637–1711), who signed his work Jean I
Bérain, was the most prolific and inventive of the
great seventeenth-century French masters of the
ornamental print, and was the principal court
decorator after Le Brun's fall from grace in 1685.
Large acanthus leaves played an important role in
his earliest compositions (1667), but his later work
is dominated by other decorative elements.

Frieze design, pen, wash, and gouache,
Gilles-Paul Cauvet, c. 1770–80.

Paris, Musée des Arts Décoratifs

\mathcal{G}illes-Paul Cauvet (1731–1788), a native of Aix,
was, like Henri Salembier (active c. 1770–1820),
one of a handful of designers who published
original ornamental prints in the second half of the
eighteenth century; his work exemplifies the
neoclassical reaction against rocaille decoration
that was gaining momentum in the 1760s.

Balustrade in the Throne Room,
carved and gilded wood, Francesco
Novaro, c. 1785.

Turin, Palazzo Reale

\mathcal{R}arely has acanthus been accorded such promi-
nence as in this virtuosically carved balustrade
featuring thick, ropelike rinceaux, here combined
with putti, vases, incense burners, torches,
garlands, and a running-dog frieze on the base—in
short, with the full panoply of late-eighteenth-
century neoclassical accoutrements.

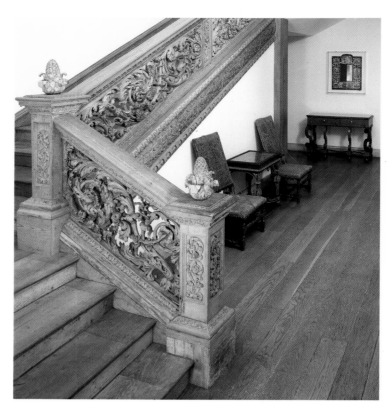

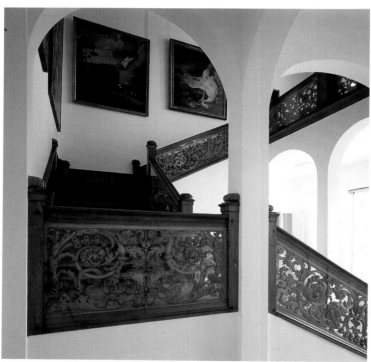

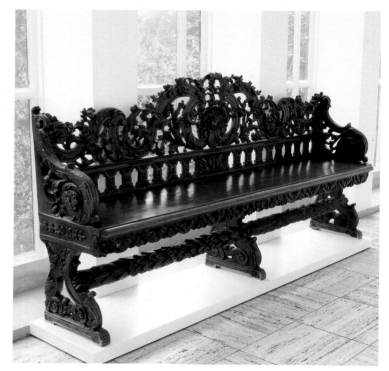

Stair from Cassiobury House
(Hertfordshire), oak, pine, and ash,
Grinling Gibbons, 1670.

New York, The Metropolitan Museum of Art

*M*agnificent carved stairways were executed for
several English country houses in the late 1600s. In
this example by Grinling Gibbons (1648–1721), the
volute acanthus has a Gallic flavor and may well
have been influenced by French ornamental prints
such as those by Jean Le Pautre.

Stair with carved balustrade,
last quarter of the seventeenth century.

Rotterdam, Boymans–van Beuningen Museum

*E*laborately carved stairways, like similarly
rich benches, were placed in entryways to
impress visitors.

Bench, maker unknown, Utrecht,
late seventeenth century.

Rotterdam, Museum Boymans–van Beuningen.

A great many carved wooden benches like
this one survive in Holland; they are extremely
uncomfortable and were intended primarily
for show.

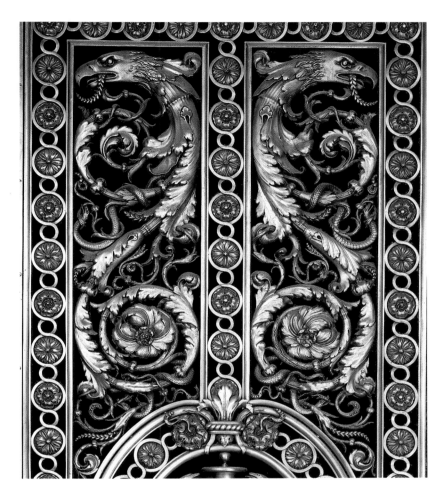

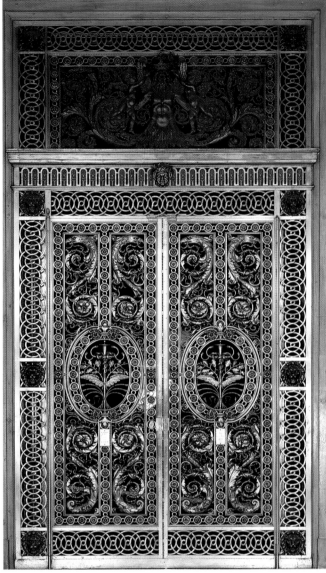

Gates of the portal to the château at Maisons
(full view and detail), wrought iron, François Mansart,
between 1642 and 1650.

Paris, Louvre

*A*rchitect François Mansart (1598–1666) built the château at Maisons, his purest
and most sophisticated design, for the président de Longueil. The magnificent
portal from this residence is now installed at the entrance to the Galerie
d'Apollon in the Louvre; its classicizing acanthus rinceaux harmonize perfectly
with the severe elegance of his conception, notably with the exquisitely carved
stonework detailing of the vestibule to which it originally led.

Design for a portal, print, Jean Marot,
mid-seventeenth century.

Paris, Bibliothèque des Arts Décoratifs

*P*aris-born architect Jean Marot (1619–1679) published many architectural
prints; they are difficult to classify, however, since they appeared under the
aegis of several different publishers (and some were printed by his own studio).
They include several designs for portals and gates, enabling fine metalworkers
to keep their work in tune with contemporary styles. Classicizing acanthus
rinceaux are prominent elements of Marot's compositions.

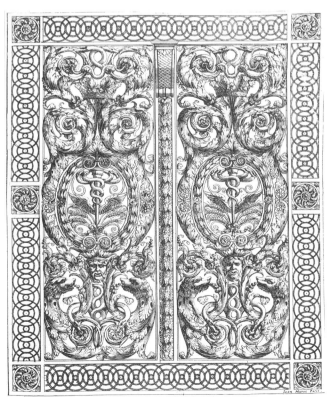

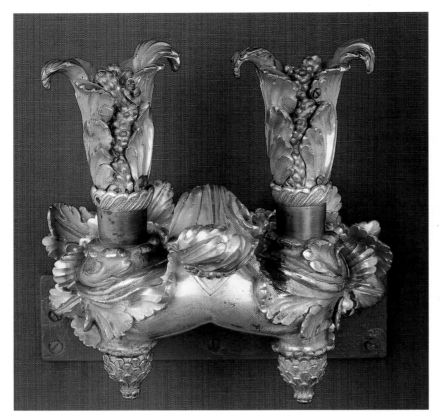

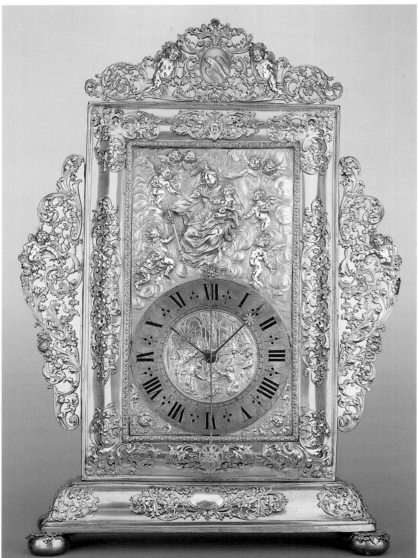

Double spigot, gilt bronze,
Paris, mid-eighteenth century.

Paris, Musée des Arts Décoratifs

This piece demonstrates how acanthus ornament can transform
a functional object into a small work of art. The metalworker was
doubtless inspired by print designs such as the one illustrated on
the previous page.

Foliate motif, print from
*Receuil de différents ornements dessinés
par Percenet*, c. 1761–62.

Paris, Bibliothèque d'Art et d'Archéologie, Fondation Jacques Doucet

Table clock, silver gilt, Thomas Pröll, c. 1710.

Zurich, Schweizerisches Landesmuseum

The elaborately ornamented case of this elegant table clock,
which bears the arms of the Schnyder von Wartensee family, is by
goldsmith Thomas Pröll of Diessenhofen (the clock's original works
have been lost). The rondel inside the clockface depicts the
judgment of Solomon, while the central panel above it features a
relief of the Madonna surrounded by angels. The projecting
placques of acanthus animated by putti, like the acanthus motifs
on the frame, are typical of the period.

Balustrade (detail), wrought iron and gilt bronze, c. 1730–40.

London, Wallace collection

In 1724 Louis XV purchased the portion of the hôtel Mazarin known as the hôtel de Nevers from the marquise de Lambert, with the intention of using it to house his library and coin collection. Plans for the necessary remodeling were drawn up immediately, but they were in limbo until the death of the marquise in 1733, when they were realized under the direction of Robert and Jules Robert de Cotte. This elegant balustrade bearing the king's monogram, composed of delicate ribbon ornament and acanthus foliage, may well have been designed by Nicolas Pineau (1684–1754) or Jacques François Blondel (1705–1774).

Balustrade of the Saint Ignatius altar, bronze, Rome, 1696–1700.

Rome, Church of the Gesù

The principal church of the Jesuit order (officially recognized in 1540) was erected in 1568 on the orders of Cardinal Alexander Farnese. It was built to designs by Vignola and completed under the direction of Giacomo della Porta, but its magnificent interior decoration dates from about a century later. Andrea Pozzo and his assistants made abundant use of precious materials such as silver and lapis lazuli in decorating the chapel that houses the tomb of Saint Ignatius to the left of the nave, which features this superbly crafted bronze balustrade.

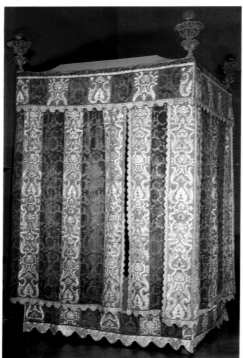

Bed of the maréchal d'Effiat,
second half of the seventeenth century.

Paris, Louvre

Elaborate beds were essential fixtures in noble
households, but it was not until the Baroque era
that a clear preference became apparent for tester
beds in the French and Italian mode. Surmounted
by canopies supported by four uprights, they were
richly hung with precious cloth that all but
obscured the wooden frames.

Cope (detail),
embossed silk velvet, c. 1725.

Zurich, Schweizerisches Landesmuseum

The liturgical vestment known as a cope is also
sometimes called a pluvial, a Latin term used by
the Romans to designate a mantle protecting
them from the rain. Pluvials were first used in
open-air church processions.

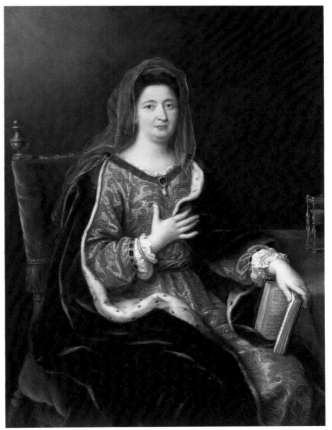

*Portrait of Françoise d'Aubigné, marquise
de Maintenon* (general view and detail),
Pierre Mignard, oil on canvas, 1694.
Versailles, Musée National du Château

Pierre Mignard (1612–1695) was born in Troyes. After a
stint in the Parisian studio of Simon Vouet and a Roman
sojourn that lasted more than twenty years, he settled in
Paris in 1658; five years later the queen mother awarded
him the prestigious commission to paint the dome of
the church of Val-de-Grâce. He remained very much in
Le Brun's shadow until the death of Colbert in 1683,
but thereafter he found work at court, and on Le Brun's
death in 1690 he was named to the latter's post as first
painter to the king, at the instigation of Louvois. This
canvas, in which the subject's piety and severity are
beautifully conveyed, is typical of Mignard's distinguished
portrait production. The marquise wears a dress made
of a burnished gold brocade decorated with an
elegant acanthus pattern.

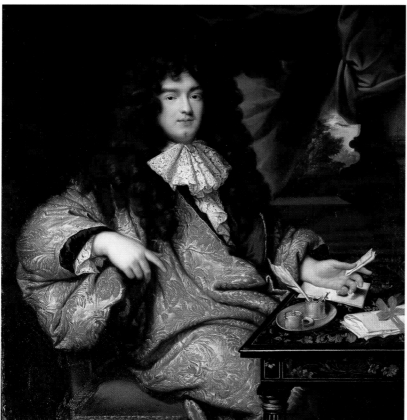

Lace, *gros point de Venise,*
second half of the nineteenth century.
Calais, Musée des Beaux-Arts et de la Dentelle

This piece of lace, which features ample acanthus rinceaux, is inspired by designs executed after 1660 in Venice and subsequently in France. The subjects in the two portraits illustrated on these two pages wear collars made of similar lace.

Portrait of Jean-Baptiste Colbert,
marquis de Seignelay (general view and detail),
Marc Nattier, oil on canvas, 1676.
Versailles, Musée National du Château

The portraitist Marc Nattier, whose sons Jean-Baptiste and Jean-Marc Nattier were also painters, became a member of the Royal Academy in 1676. In this portrait of Colbert's eldest son, his namesake, in whom the minister had placed high hopes that were dashed by the youth's premature death, the artist depicted his subject as a man of state attending to his correspondence; he is dressed in a magnificent housecoat decorated with a sumptuous acanthus design, and he sits at an elegant marquetry table.

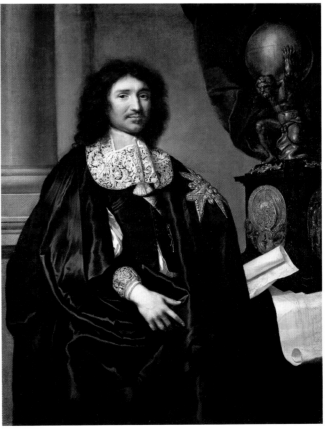

Portrait of Jean-Baptiste Colbert,
Claude Lefebvre, oil on canvas, 1666.

Versailles, Musée National du Château

Claude Lefebvre (1632–1675), a student of Eustache
Le Sueur who collaborated with Le Brun beginning in 1655,
was an eminent portraitist; he became a member of the
Royal Academy in 1663. Here he depicts Colbert as a
powerful minister with a strong interest in architecture
(note the floor plans at the foot of the elaborate clock, which
is topped by an Atlas figure doubtless meant to signify
the heavy burdens of his office); he is dressed in the solemn
mantle of the Order of the Holy Spirit, and his lace
collar features a rich acanthus design.

Gio. Batta. Lenardi delin.

Arnoldo V. Westerhout sculp.

Ciro ferri Rom. inu: And.º Cor. fecit Gio: Batta. Lenardi delin: Arnoldo 'van Westerhout fiam. Sculp:

Two spun sugar centerpieces, prints by Arnoldo van Westerhout after drawings by Giovanni Battista Lenardi, 1688.

Private collection

Elaborate decorations featuring putti, triumphs, and other symbolic and ornamental motifs were often placed on sumptuous banquet tables; some were made of spun sugar, like these two examples created for a feast given in 1687 by the ambassador of James II of England, Lord Castlemaine, at the Palazzo Doria-Pamphili in Rome. Note how acanthus ornament is used here to enrich the final effect and add a sense of forward momentum.

Rear view of the coach used by the ambassador of James II of England for his ceremonial entry into Rome, design by Ciro Ferri, print by Arnoldo van Westerhout after a drawing by Giovanni Battista Lenardi, 1688.

The solemn entry of Lord Castlemaine, James II's extraordinary ambassador to Pope Innocent XI, took place in January of 1687. The designs of the magnificent coaches made in Rome for this occasion survive in the form of prints. They feature vigorous acanthus foliage similar to that in ornamental prints by Filippo Passarini published in 1698.

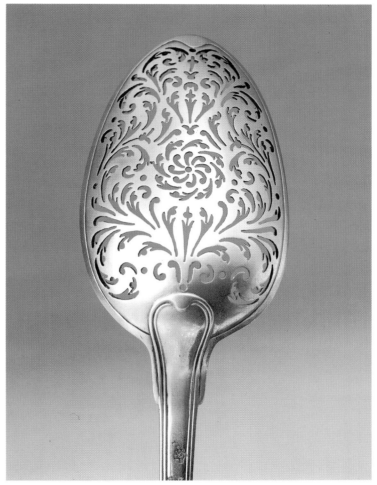

Rosette, print from *Receuil de différents ornements dessinés par Percenet*, c. 1761–62.

Paris, Bibliothèque d'Art et d'Archéologie, Fondation Jacques Doucet

Rosettes and acanthus leaves were used in antiquity to decorate ceiling coffers in buildings in the Corinthian order. The architect and ornamentalist L. N. Percenet, born in 1736, used this motif after 1760 in a spirit of antique revival.

Olive spoon, Pierre-Nicolas Sommier, 1787–88.

Paris, Musée des Arts Décoratifs

This piece demonstrates the freedom with which rosette designs like that in Percenet's print were sometimes used by craftsmen working in various media.

Marble rosette, Naples, seventeenth century.

Naples, Certosa San Martino

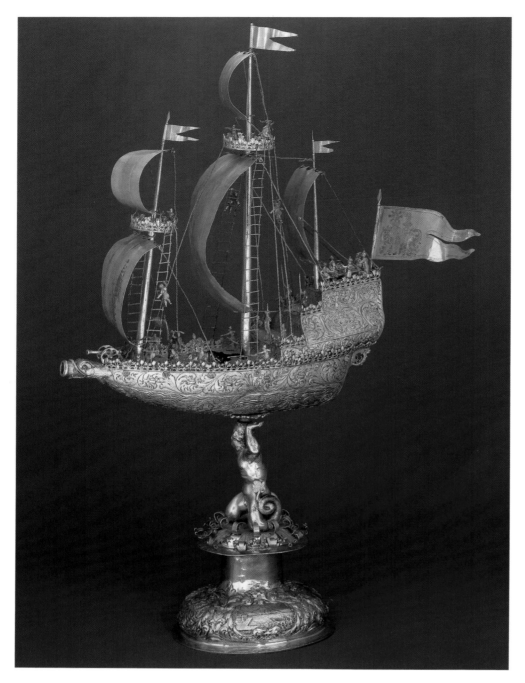

Drinking vessel in the shape of a ship,
partially gilded silver, Hans Georg
Deucher, Zurich, 1682.

Zurich, Schweizerisches Landesmuseum

This impressive object—it is 64.5 cm high—
was made by Zurich-based goldsmith Hans Georg
Deucher. Franz von Sonnenberg (1603–1685),
Prince of the German Empire and Grand Master
of the Order of Saint John in the German-
speaking nations, presented it in 1682 as a gift to
Lucerne, his native city. It is decorated with
acanthus patterns inspired by the designs of
Johann Conrad Reuttimann.

Designs of flowering rinceaux,
Johann Conrad Reuttimann,
Augsburg, 1678.

Private collection

Johann Conrad Reuttimann worked in Augsburg
from 1676 to 1691, and that is all we know about his
biography. He produced a number of typically
German acanthus prints. The illustrated examples
are from a set of six plates published in 1678; they
exemplify the increasingly popular practice in
Germany of combining flowering rinceaux—which
had dominated until then—with traditional
acanthus forms.

Covered goblet, gilt silver, Paul Solanier,
Augsburg, 1695–1700.
Private collection

*I*n the late seventeenth century, acanthus
designs became lighter and more elegant. They
increasingly took the form not of richly three-
dimensional reliefs against a gold ground but
rather of delicately incised patterns, notably
on drinking vessels with smooth exterior surfaces.

This refined goblet, a typical work by Paul
Solanier, has the owner's initials and date, 1696,
on the bottom.

Designs for acanthus rinceaux and volute
acanthus, prints, Leonard Heckenauer
the younger, from *Romanisches Laubwerk*,
Augsburg, c. 1700.
Private collection

*A*fter a sojourn in Italy, Leonhard Heckenauer
the younger lived and worked in Augsburg, his
native city. The set of prints of his designs
published by Jeremias Wolff is entitled *Roman
Foliage*, but the precisely delineated forms on
these sheets have a distinctly German flavor.
These compositions would have been suitable
for use by craftsmen working in silver
engraving and repoussé.

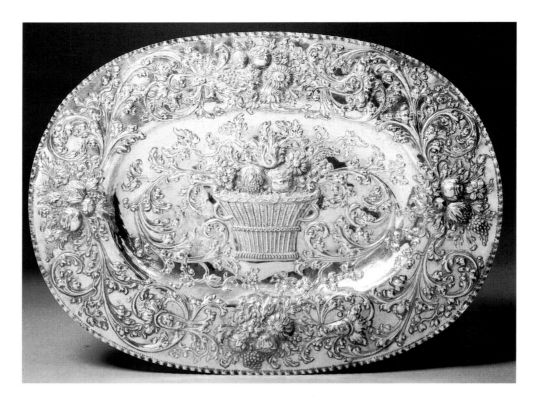

Platter, silver,
Meister mit dem Mühleisen, Cologne,
late seventeenth century.

Cologne, Museum für Angewandte Kunst

Silverware intended exclusively for display was
much prized in the Baroque era, and the present
piece is a case in point. This large platter's elaborate
relief work—which originally stood out against
a gold ground, traces of which remain—would
have precluded its use for any other purpose.
It serves as a reminder that works of high quality
were sometimes produced outside Nuremberg and
Augsburg, the most prestigious centers of
goldsmithing in the German-speaking countries.

Anne of Austria casket,
gold, probably Paris, c. 1645.

Paris, Louvre

This ornamental box (22 × 45 × 34 cm) was
perhaps given to Anne of Austria by Cardinal
Mazarin. Its dense, elegant pattern of acanthus
rinceaux animated with flowers against a blue
silk ground covers the surface of a wooden
container and is a stunning example of virtuosic
goldsmithing. Presumably it was made by an
artist with strong ties to the court.

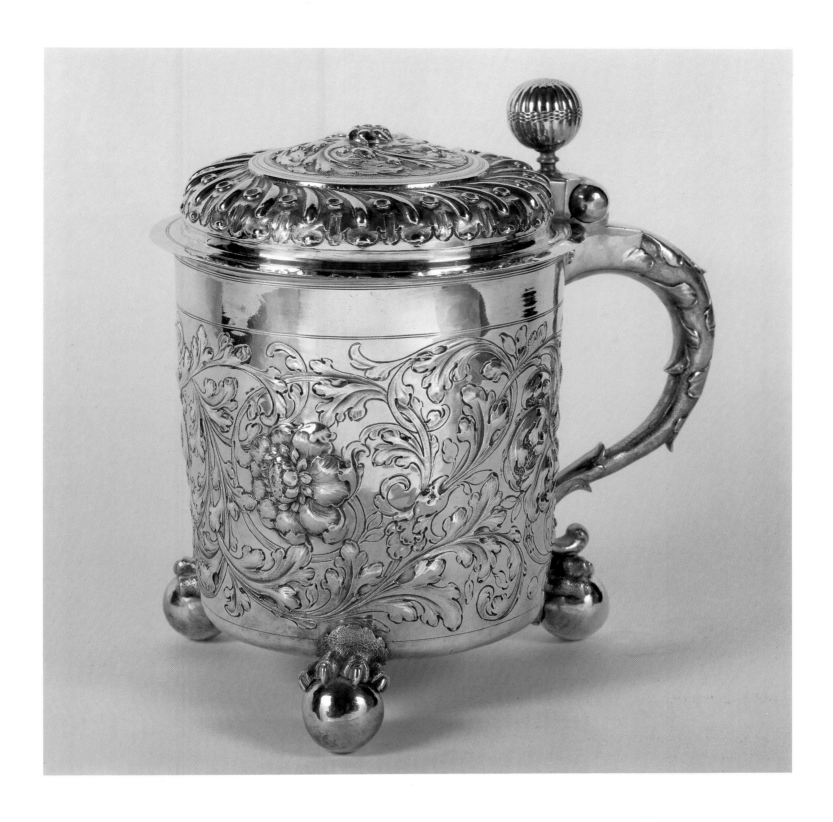

Hanap, partially-gilded silver repoussé,
unknown master, Augsburg, c. 1680.

Private collection

ℋanaps, intended for the consumption of warm
beer, entered widespread use in the Germanic
nations in the course of the sixteenth century. In
the 1660s they were often decorated with lobed
acanthus patterns. This example is transitional
in character: the rinceaux have a new delicacy, and
the use of a contrasting ground gives them
considerable relief. The elegant foliate gadrooning
on the cover attests to the growing influence
of French ornamental models, which would soon
conquer Europe.

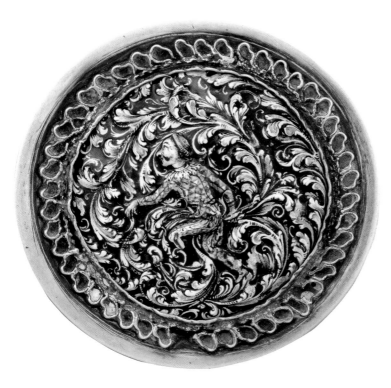

Print from *Neu ersonnene Goldschmied-Grillen,*
Wolfgang Hieronymus von Bömmel, Nuremberg, c. 1700.
Private collection

These delightful animals and figures composed entirely of acanthus leaves—
designated as *Chimären,* or amusingly fantastic beings—revive a vein of
imagery current in Germany at the beginning of the century.

Harlequin surrounded by acanthus, enameled plate,
Augsburg or Dresden, c. 1700.
Private collection

This tiny plate (2.5 cm in diameter) now serves as the top of a silver snuffbox,
but it was probably made to be placed on the stopper of a container in a
toiletry set. The composition—it pictures a harlequin trying vainly to
extricate himself from a tangle of pink and white acanthus arrayed against a
black ground—is reminiscent of eccentric designs by Wolfgang Hieronymus
von Bömmel (see illustration above) and is in the spirit of fantastic imagery
favored by the Dresden court. This is a miniature masterpiece of the
enamelist's art as practiced in the workshop of Johann Melchior Dinglinger,
which found its most complete expression in a kind of fantastic secular
ciborium produced in 1728.

Dish from the Calverley toiletry set, silver repoussé,
Master WF, London, 1683–84.
London, Victoria and Albert Museum

Works produced in England during the Restoration, under the reign of
Charles II, reflect the intense delight taken in things sumptuous and luxurious
after the Puritan era had ended. This ensemble, which survives intact, is an
excellent example; its designs, which combine acanthus rinceaux and
mythological vignettes, are influenced by French and Italian models.

Acanthus motif, one of a set of four frieze designs,
print, Domenico Bonaveri, c. 1670.

This design demonstrates how an artist born about 1640 transposed the
celebrated acanthus rinceaux on the Ara Pacis into a more full-bodied
composition. Similar acanthus forms appear on the Calverley toiletry set.

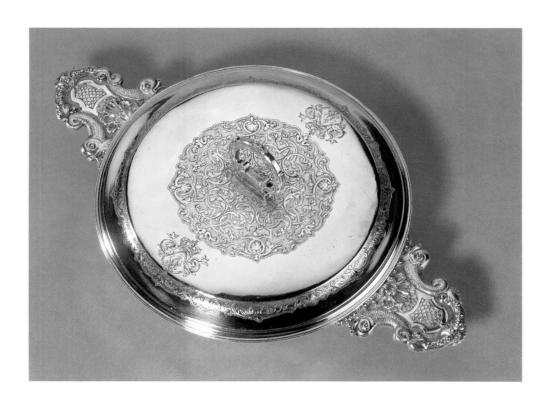

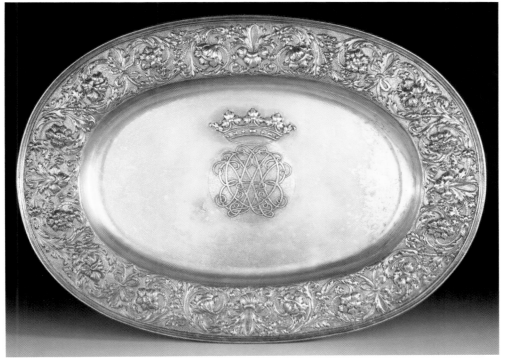

Covered bowl, silver gilt,
Sebastien Leblond, Paris, 1690–92.
Paris, Louvre

Small bowls with flat projecting handles such as this were widely used in the seventeenth and eighteenth centuries. Their shape is freely modeled after that of wine cups. When equipped with hinged covers, as here, they could be used when traveling or as part of a toiletry set, for it was customary to consume broth while dressing in the morning. The arms and monogram of Monseigneur, a son of Louis XIV, figure on this example, which is decorated with elegant rinceaux patterns.

Glove tray, silver-gilt repoussé,
stamped by Master DG (Denis Godin?),
Paris, c. 1660.
Paris, Louvre

This oval tray with an elegant rinceau border was part of an elaborate toiletry set. Such ensembles were often used by the nobility in seventeenth-century France. Anne of Austria seems to have initiated the custom of dressing in front of courtiers, and it quickly caught on, prompting the production of lavish objects such as this.

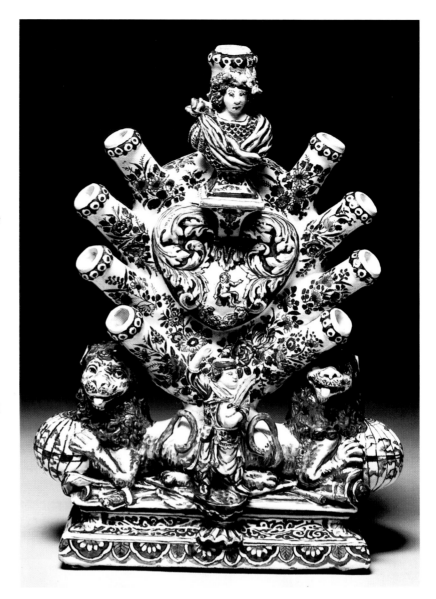

Scene of gallantry, faïence tiles, c. 1730–40.

Lisbon, 17 calcada do Combo

There was something of a building boom in the Portugal of King John v (1706–1750), and large areas both inside and outside of many of the resulting structures, both sacred and secular, were covered with the white-and-blue faïence tiles known as *azulejos*. The compositions were often inspired by early eighteenth-century French prints; this example is a case in point, but its framing motifs are in a more cumbersome and outdated Baroque idiom.

Plate, faïence with fired decoration in blue, red, and ocher, Rouen, c. 1725.

Paris, Louvre

The dense yet delicate acanthus pattern is inspired by designs nielloed and incised on the lavish jewel caskets fashionable in this period. The combination of canonical cobalt blue with ocher was an innovation introduced into Rouen faïence by Michel Poterat (d. 1721) in the early years of the eighteenth century.

Tulip holder, white faïence with painted decoration, Lambert van Eenhorn, studio of Metalen Pot or Louwijs Vistorsz de Dobbelde Schenckan, Delft, c. 1700.

Cologne, Museum fur Angewandte Kunst

There was an important turning point in the history of European ceramics in the early seventeenth century, when the Dutch East India Company (founded 1602) flooded the Dutch market with Chinese porcelain. These delicate objects with blue decoration were much prized by the wealthy, and Dutch craftsmen did their best to imitate them. Delft faïence was developed as a result; it reached its peak between 1660 and 1730, and was sought after throughout Europe. Eventually its makers were inspired not only by Far Eastern models but also by indigenous imagery, notably Dutch landscapes and seascapes, genre scenes, mythological subjects, and scenes from the bible.

Plate, faïence with painted decoration, Nevers, second half of the seventeenth century.

Sèvres, Musée National de Céramique

During the second half of the seventeenth century, Nevers faïence gradually freed itself of Italian influence, which had become its ornamental stock in trade via the Conrade family, originally from Liguria. Narrative decoration was not abandoned altogether, but, increasingly, French prints served as the models. Whether drawn from classical mythology or contemporary novels, their subjects had a new freshness and insouciance. The acanthus motif on the border of this piece is indebted to mid-seventeenth century designs by French ornamentalists.

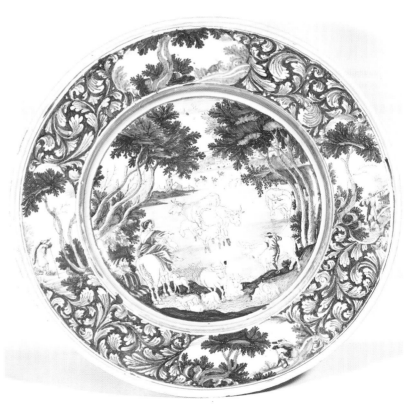

Double-glass tumblers, Bohemia,
first third of the eighteenth century.

Cologne, Museum fur Angewandte Kunst

Zwischengoldgläser (double-glass tumblers) are
made as follows: two objects are made, one with a
bottom and one without, such that the former fits
perfectly into the latter. Gold leaf is applied to the
outer surface of the inner piece and delicately
incised with decorative motifs, which are often set
against a red ground, as here. Early examples tend
to feature rinceaux designs; more recent ones
are decorated with narrative scenes between
narrow acanthus friezes that encircle the top and
bottom of the vessel.

Miniature keg, salt-glazed stoneware,
Muskau, c. 1670–75.

Cologne, Museum fur Angewandte Kunst

A great deal of salt-glazed stoneware was
produced in the German-speaking nations during
the sixteenth and seventeenth centuries. Its fabri-
cation, based on a medieval technique, involved
firing a mixture of clay and fusible stone at a
temperature high enough to vitrify the stone but
not the clay. It was made in Cologne, Frechen,
Siegburg, and Raeren in the Rhineland, as well
as in the Westerwald, in Hesse, and in Saxony.
Each of these regions developed its own formats
and ornamental motifs. Particularly sumptuous
pieces were turned out in Creussen, in Franconia.
Lobed acanthus often appears on stoneware
produced in Muskau, in Lausitz, during the second
half of the seventeenth century.

FACING PAGE

Footed goblet, clear glass carved in relief,
Friedrich Winter, Hermsdorf (Silesia),
late seventeenth century.

Berlin, Kunstgewerbemuseum

*W*orking for his patron Christoph Leopold
Schaffgotsch, Friedrich Winter perfected a tech-
nique for producing glass drinking vessels with
carved relief designs of such quality that they are
worthy of comparison with rock crystal. Some
of his goblets take the form of cornucopias
covered with animals and acanthus.

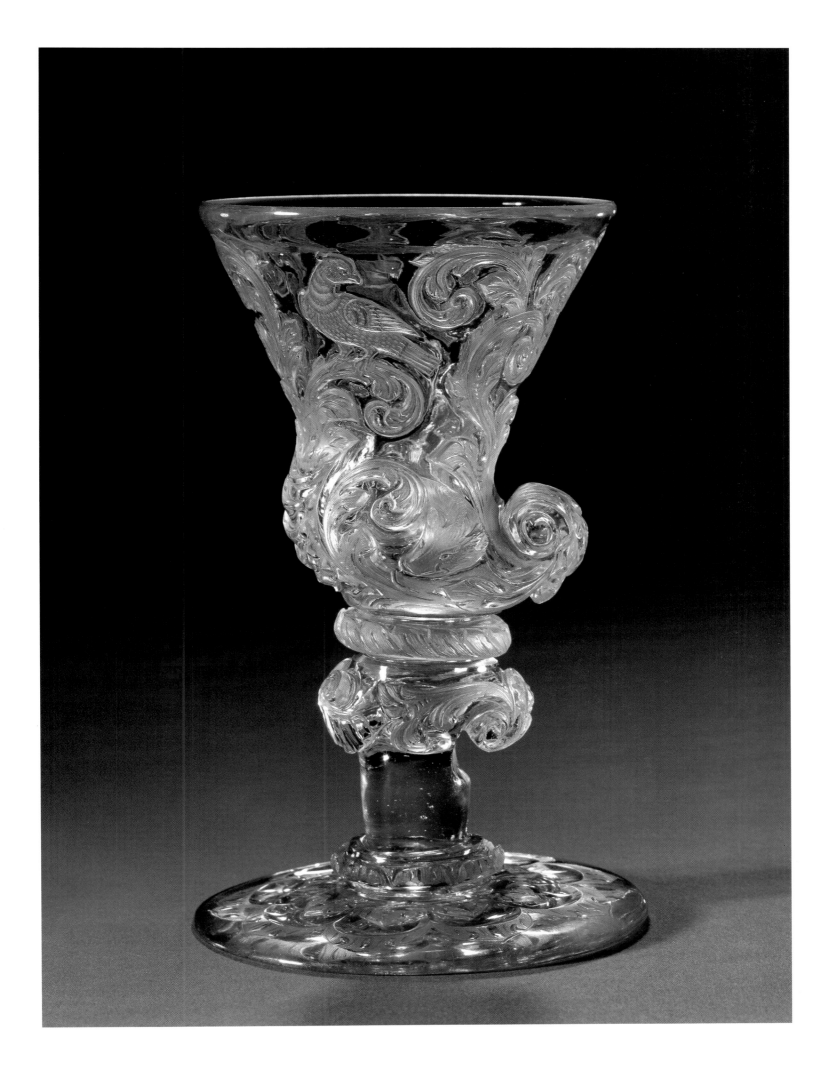

...iling of the bedroom in the Stockholm palace of
...rawing and watercolor, René Chauveau, c. 1697.

Stockholm, Nationalmuseum

...odemus Tessin the younger devised the plans for his own
... near the Royal Palace in Stockholm. The basic conception
...orromini, but the interiors reflect Parisian designs of the

1690s. René Chauveau, the son of engraver François Ch...
arabesque ceiling designs for the building (see also pa...
admirer of Jean Bérain, and the influence of his work is...
The complex iconographic program is an amalgam o...
themes: the times of day, the four elements, and the v...
house of this cosmopolitan artist, the arabesque take...
allusive character consistent with the Renaissa...

Arabesques,
or New Grotesques

The arabesque was a locus of considerable invention in the seventeenth and early eighteenth centuries, especially in France, where the decorative idiom was substantially reimagined. Designs by Jean Bérain, Claude III Audran (1658–1734), and Antoine Watteau (1684–1721) epitomize the "new arabesque" style which developed there. Despite the rich fantasy of their work, however, it was not entirely without precedent.

The Terms "Arabesque" and "Grotesque"

Arabesques were in more or less constant use from the sixteenth to the nineteenth centuries. In both the Renaissance and neoclassical eras, artists working in this decorative mode were inspired by ancient Roman models that had only recently been brought to light. Raphael's efforts in the genre were freely based on the decorations in Nero's Domus Aurea (Golden House) in Rome, while designers in the second half of the eighteenth century looked to the wall paintings unearthed in Pompeii and Herculaneum. In both cases, artists were able to contemplate decorative compositions of a type previously accessible only through a famous passage by Vitruvius (46–30 B.C.), the architectural theorist who lived under Caesar and Augustus. Here is his description: "What is painted on our walls no longer has any fixed or regular model. There are only monsters; columns are replaced by reeds . . . One sees candelabra supporting small temples, from whose pinnacles emerge delicate and flexible leaves which, contrary to every expectation, carry small figures, some with animal heads, others with human faces, but in every case things that are not, never have been, and cannot ever be."

Unlike those devised in the Renaissance and neoclassical periods, however, the new arabesques of the seventeenth and early eighteenth centuries were not prompted by archeological finds. Authenticity and accuracy were not given high

priority by their designers: when they looked to earlier models, these were likely to be Raphael's decorations in the Vatican *Loggie* or sixteenth-century compositions by Dutch and Italian decorative artists.

The nature of this imitative process, which fostered the introduction of successive variations, prompted the invention of a new decorative genre. The productions of this second renaissance of the arabesque were all the more complex and polymorphous as they were devised in concert with ornamental modes of more recent vintage: rinceaux, acanthus, and interlace motifs that had been transmuted into ribbonwork or moresques. The reinvigoration resulted from the intermingling of many strains of ornament in the years between 1630 and 1760, by which time so complete a transformation had been effected that it is difficult for us today to reconstitute the various stages in this evolutionary process.

The very term *arabesque* is potentially misleading. It is often construed as referring to purely ornamental designs from which the human figure is absent, but it was not understood thusly in either the ancient world—witness the passage by Vitruvius—or the Renaissance. With regard to the period under investigation here, note that in 1692 the director of the French Academy in Rome, La Teulière, wrote his superior, the director of the king's buildings, that he was having the students copy the arabesques in the Raphael *Loggie* because, "in addition to the foliage rinceaux, which are a minor element in the overall design, these *rabesques* [sic] are given variety by all sorts of nude and draped figures, men, women, children, animals, birds, fish, mascarons, flowers, fruit, landscapes, perspectives: in short, they bring together everything in nature." We can only wonder whether La Teulière was aware of the paradox inherent in his designating arabesques as the model for all things natural.

Not content with fantastic creatures and semi-human figures, Raphael and Giovanni da Udine introduced the full-length human figure into the mix. The subsequent arabesque designs of Claude Gillot (1673–1722) and Watteau also make use of such figures, but usually in the context of landscape and allegorical vignettes that give them a greater spatial coherence, putting them at odds stylistically with their more fluid and free-associational surroundings.

In the seventeenth century it became clear that the term *arabesque* had been mistakenly attributed—probably in the Middle Ages—to an ornamental mode that had nothing to do with the Islamic world. One indicator, perhaps, of the irrelevance of the term's etymology is the fact that the French often referred to such compositions as *rabesques* (see the La Teulière quote above). In all probability, artists of the ancient world would have been quite surprised to learn that their decorative schemes for rich patricians were called "arabesques." But a closer look suggests that the Arabs had not been completely forgotten in the eighteenth century.

European artists rarely visited Islam, but French architect Pierre de Vigny (1690–1772) was sent to Constantinople in the early eighteenth century to oversee construction of the French embassy there, built to designs by Robert de Cotte (1656–1735). De Vigny was an enthusiastic traveler with a particularly open mind, and after his return home this experience enabled him to see French architecture from a perspective not shared by many of his contemporaries. Consider his

observations on early-eighteenth-century French rococo decoration: "Brackets, shields, pendants, and even clouds are made to support columns, pilasters, frontispieces, entablatures, and whole galleries in an almost entirely Arabic way. Room cornices are all out of proportion and have no fixed profile. Everything that is round or rectangular is rejected from interior decoration, as is the virile mode of ancient ornament; they are replaced by a light idiom resembling patterned flower beds."

In this case, an unusually cultivated artist recognized something Arabic—or as we would say, Islamic—in the art of his time, notably in the rinceau-like ornamental compositions used in formal gardens. But this association occurred to few, if any, of the designers who reinvented the arabesque.

The term *grotesque* was also used on occasion to designate such designs. Were the two words interchangeable in this period? The arabesques devised by the Raphael studio for the Vatican *Loggie* were engraved by La Guertière around 1670 and given the title *Miscellanae Picturae Vulgo Grotesques* (Miscellaneous images commonly called grotesques); another set of prints was published in Italy with the title *Picturae Quas Grotteschas Vulgo Vocant* (Pictures of what are commonly called grotesques). In this case the origin of the term is clear: it was coined after the excavation beginning about 1480 of decorated rooms in the Domus Aurea—subsequently dubbed *grotte* (grottoes) by the Romans— from centuries of accumulated embankments and retaining walls.

Indeed, the two words were often used interchangeably in these years, but certain distinctions remained operative. *Grotesque* was sometimes used instead of *arabesque* (the more generic of the two terms) when referring to designs that featured fantastic animals, or to stucco relief compositions that had been uncovered in the ruins of ancient houses. But the most literal meaning of the term was not forgotten; this was foremost in Piranesi's mind, for example, when he gave the title *Grotteschi* to a set of four prints in 1745. These images of ancient fragments in overgrown ruins are very much in the spirit of the Venetian rococo, but they are completely unrelated to what is now generally understood as grotesque ornament.

It is but a short step from excavated Roman "grottoes" to the garden grotto, one that's all the easier to take because the development of the mannerist garden grotto paralleled that of the arabesque in crucial respects. These extravagant constructions built with large masonry blocks and encrusted with rocks and shells arranged in decorative compositions—a popular feature of fifteenth-century Italian gardens—were still a fashionable conceit in seventeenth-century garden design, often featuring monsters that would have been perfectly at home in arabesque designs. The most famous French example was the Grotto of Thetis in the gardens of Louis XIV's Versailles (1664, destroyed 1684). Although arabesques were not a part of that grotto's decor, many of its walls were covered with compositions in the grotesque tradition featuring mascarons made out of shells and other natural materials that bring to mind similar images devised by Giuseppe Arcimboldo (1527–1593). The garden grotto flourished throughout the sixteenth and seventeenth centuries, occasionally becoming more domesticated, notably

in examples built for the gardens of urban residences. All of them are lost, but surviving documents indicate that the genre continued to evolve in the eighteenth century, assuming the character of the nymphaeum, which more closely resembled a palace decor than a phenomenon of nature. In the most popular French building manual of the period, the *Cours Complet d'Architecture* (Complete course in architecture, 1690) by Charles-Augustin D'Aviler (1653–1700), the grotto is treated as a desirable pendant to the conservatory or garden room. Thus as the eighteenth century advanced, there was a growing tendency for grotto decorations to resemble those in the principal residence, and increasingly these ensembles came to resemble reception rooms decorated with rocaille cartouches.

page 332 Only one French designer produced prints that show the taste for rustic grotto decoration during that period: Pierre-Quentin Chedel (1705–1762). The set of fantastic images in the grotesque tradition published by him in 1738 feature jumbles of marine forms and strange fountains—inspired by the Greek myths of the river Alpheus or Peneus—arranged in compositions that have a central European flavor.

Such nuances aside, the terms *grotesque* and *arabesque* were used more or less interchangeably, a surprising fact that begins to make sense when their respective etymologies are examined. In any case, both derive from the same idea, and although references to specific ancient models are absent from eighteenth-century French arabesques, their general conception remained indebted to ancient prototypes—to such an extent that *La Grotte,* an arabesque composition engraved after a design by Watteau featuring a central grotto vignette, can be fully understood only in relation to the etymology outlined above.

<p style="text-align:center">～◦～</p>

Evolution of the Arabesque

German and French artists continued to use a wide range of arabesques throughout the seventeenth and eighteenth centuries, although in truth they sometimes produced designs whose links to the traditional formats are difficult to discern. In contrast, Italian artists of this period (with the exception of a few, such as *page 215* Agostino Mittelli) continued to use arabesque compositions that might have been invented a century or two earlier.

Rinceaux and foliage, especially acanthus, continued to play a dominant role in early-seventeenth-century arabesques. In 1638 Thomas Picquot published a collection of ornamental prints for metalworkers entitled *Livre de diverses ordonnances de feuillages, moresques, grotesques, rabesques et autres* (Book of miscellaneous compositions of foliage, moresques, grotesques, rabesques, and others). Foliage still prevails in these designs, but it has been augmented by grotesque and arabesque elements.

French artists engaged in the decoration of interiors in the mid-seventeenth century were fully aware of the manifold opportunities afforded by the ara-*page 180* besque. The study of Madame de La Meilleraye in the Arsénal in Paris, decorated between 1637 and 1640 by Noel Quillerier (1594–1669), and Jean Bertrand, features

Arabesque study, sanguine, pen and wash, Claude Gillot.

Berlin, Kunstbibliothek

*I*n this superb drawing by Gillot (1673–1722), the placement and posture of the animals are more crucial than the arabesques themselves. The low horizon line suggests that this was a tapestry design.

Second design for the curtain and proscenium of an opera house, drawing, sanguine, pen, and wash, Gilles-Marie Oppenord, 1734.

Paris, Ecole Nationale Supérieure des Beaux-Arts

*A*rchitect and ornamentalist Oppenord (1672–1742), who often used traditional motifs in novel ways, made several designs for a projected opera house in Paris. In this one, an elaborate grotesque composition frames images of Apollo's victory over Marsyas in a musical competition, which entailed the latter's being flayed alive (oval on right).

Plate 2 from *Livre premier des essais de gravure* (First book of print models), print, Pierre Bourdon, 1703.

Paris, Bibliothèque d'Art et d'Archéologie, Fondation Jacques Doucet.

*I*n this image, arabesque designs are deliberately associated with tobacco smoke, and by implication with drunkenness and sensual indulgence.

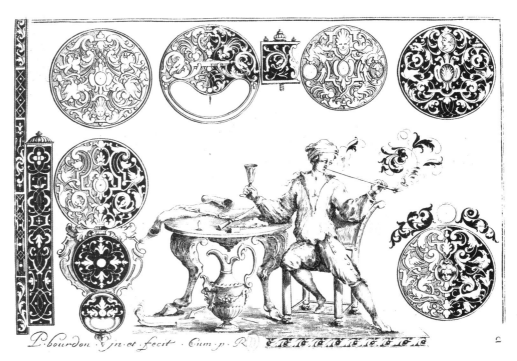

large panels in which vegetal elements are reduced in favor of large female figures, some shown working together (hanging garlands, blowing trumpets, etc.), others treated more like traditional grotesques; the figures, though more caricatural than burlesque, fulfill the chief criteria of arabesques, especially their fantastic arrangement in superimposed registers. These compositions are in the spirit of those by Simon Vouet (1590–1649) for the Palais Royal, a decor now lost but accessible in engravings by Michel Dorigny in the *Livre de grotesques peint au cabinet de la reine régente au palais royal* (Book of painted grotesques in the cabinet of the queen regent [Anne of Austria] in the palais royal); these feature similar figures combining elegant postures with expansive gestures. It is perhaps not surprising that artists who conceived of themselves primarily as history painters should have accorded such importance to the human figure in their decorative work, but vegetal elements are still present in these designs, notably acanthus.

The grotesques designed by Charles Errard (c. 1606–1689) for two decorative schemes in the Louvre—Anne of Austria's apartments (mid-seventeenth century) and the small Galerie d'Apollon—also feature arrangements of rinceaux and large painted figures, although the latter are less animated than those typical of Vouet and his circle. Errard's compositions are filled to overflowing: the figures are important but ultimately dominated by the many decorative elements surrounding them.

These grotesque compositions (which must stand in for many hundreds of comparable decorative panels from the period now lost) differ considerably from those by Raphael and Giovanni da Udine, but the Vatican *Loggie* were never completely forgotten, if only because their ornament had been devised by Raphael, the most venerated of artists.

At the 1673 estate sale of Casimir, king of Poland, Louis XIV had his agents purchase four Brussels tapestries to complete a set of three already in his possession and described at the time as follows: "a set of tapestries made of wool and silk heightened with gold, made in Brussels, designed by Giulio Romano, representing the Triumphs of Love with the Muses and various other figures, subjects, and *crotesques* [sic], against different gold grounds with festoons of flowers and fruit." The sixteenth-century attribution of the designs to Giulio Romano was unfounded, and in the following century their authorship was assigned to Raphael, again without foundation. In 1684 painter Noël Coypel (1628–1707) was commissioned to produce a new set of tapestry cartoons paraphrasing the seven compositions, which were woven at the Gobelins factory under the collective title *The Triumph of the Gods;* an additional composition entirely by Coypel, *The Triumph of Philosophy,* was added, making a complete set of eight hangings. Coypel was an intelligent choice for this project: from 1673 to 1676 he had served as director of the French Academy in Rome and thus was familiar with the arabesque tradition as reinaugurated by Raphael and his studio. The surviving documents pertaining to this commission provide further evidence of the interchangeability of the terms *grotesque* and *arabesque*. Receipts acknowledging payments made to Coypel in 1684 refer to "*rabesque* designs after Raphael," while the 1695 document acknowledging his final payment describes the project as "eight arabesque *tableaux* painted by

page 214

him after Raphael for weaving at the Gobelins." Although the set first woven in 1686 was usually designated as either the "arabesque" set or the *Triumph of the Gods* set, Coypel's painted cartoons were inventoried in 1690 as "grotesque tableaux after Raphael." Several sets were produced, the last in 1703. These large, vibrantly colored tapestries, which feature columned porticoes under which are gathered gods, cupids, chimeras, and grotesque figures, are the most spectacular examples of Renaissance grotesque compositions produced in this period.

It is worth noting that under the ancien régime several pieces from the *Triumph of the Gods* set were hung at the château of Fontainebleau, where grotesque ornament figured prominently on the ceilings and in the window embrasures of the Ulysses Gallery (1541–1559, destroyed 1738–39), whose decoration had been overseen by Primaticcio. In 1723 the duc d'Antin, superintendent of the king's buildings, had a set of these tapestries hung in the royal bedroom of his château at Petit-Bourg, presumably because the king was to sleep there on his way to Fontainebleau; and in 1731 he had a set shipped to the French Academy in Rome, where Nicolas Vleughels, its director, remembered the initial commission of *page 212* almost forty years earlier. This gift was intended in part as a tribute to the mother country of the arabesque tradition, an acknowledgement of the Italian origins of the idiom so masterfully reinvented by the French over the preceding half century.

The Months, another set of tapestries in this tradition, was first woven at *page 214* the Gobelins beginning in 1709–10. Like the *Triumph of the Gods* set, these hangings were new versions of older arabesque designs and so were regarded as having a desirable "historical" cachet.

However, the weaving of narrative or allegorical compositions devised by painters remained the central focus of tapestry production. In subsequent years grotesques remained confined to borders, but these designs provide preliminary indications of the reinterpretation of arabesque composition that was to blossom in the work of Bérain. As the second half of the seventeenth century advanced, a hierarchy of genres was being codified in France that was totally alien to the grotesque, which plays on notions of ambiguity in the relationships of various categories and parts. About 1687 borders were designed for the two sets of mythological tapestries after Raphael and Giulio Romano, respectively. In *page 191* both cases the principal compositions were by artists from painting's golden age who helped revivify the arabesque tradition, and this fact surely influenced the decision to commission Jean Lemoyne le Lorrain, Bon Boulogne (1649–1717), and Claude Guy Hallé (1652–1736) to design arabesque framing elements for them. The vertical border compositions are dominated by figures under pavilions linked by ornamental elements of various kinds. Lemoyne le Lorrain and Jean Lemoyne de Paris (1638–1713) had a greater influence on the evolution of the French grotesque than is generally acknowledged. Early in his career, Lemoyne de Paris published a set of prints after designs by Bérain, with whom he collaborated on occasion, and he worked regularly for the duc d'Orléans, painting elaborate decorative interiors for the Palais Royal and the château at Saint-Cloud that are now destroyed. He also published a set of ceiling designs in *page 190* a style similar to that of Bérain, with whom he remained on friendly terms.

Jean Bérain and
the Transformation of the Arabesque

The name of Jean Bérain has become synonymous with grotesque decoration during the final decades of Louis XIV's reign, which saw the transformation of the grotesque into the rococo arabesque. Unlike the artists previously discussed in this chapter, he was not a painter but an authentic ornamentalist: he devised models that craftsmen working in a wide range of media—painting, tapestry, containers, sculpture, etc.—could appropriate and modify in accordance with their own needs. His designs were widely disseminated in the form of prints, which were crucial to his success and influence. The grotesque tradition was not his sole theater of activity, but it was in that field—and in festival decoration—that he enjoyed the greatest success. Indeed, his lavish theatrical costumes were often decorated with arabesque designs of one sort or another—a fact of considerable interest, for Vitruvius mentions the use of arabesques in ancient Roman theatrical decors.

Some of Bérain's compositions resemble Renaissance arabesques. His most famous images boast a wealth of tiny details that demand close looking; these designs feature large trellis porticoes suspended from airy, incongruous supporting elements over which scramble tiny silhouetted men and animals reminiscent of those in prints by Jacques Callot. In some cases these figures are frankly burlesque, but Bérain had also mastered the more serious grotesque mode devised by his predecessors during the century's middle years as a way of setting off allegorical figures, which are fully integrated into these compositions. However, it is in the more whimsical vein that his genius reveals itself most fully.

Although panels were still covered with dense networks of ornament, the ornament had become lighter, a process taken still further when lush rinceaux *page 184* were replaced by leaner scrolled configurations in the work of Daniel Marot, *page 200* and then became positively spindly in designs by Bernard Turreau, known as Toro (1672–1731). Solid backgrounds came to play an increasingly important role in the overall desired effect. The basic compositional armature was provided not by luxuriant acanthus but by a form of ribbon- or bandwork (the Germanic variant of which was known as *Bandlwerk*), which was pervasive in designs by Paul *pages 192, 208* Decker the younger (1685–1742), the Wessobrunn school of stuccadors, and the Nuremberg goldsmiths.

The delicate version of Bandlwerk that became ubiquitous in French decoration between 1680 and 1720, notably in designs by Bérain, has an elegance and élan all its own. Its origins, however, are to be seen in pilaster-like columns of ornament found in the hangings and painted decor of residences in many European countries, such as those of the house of Orange and the electors of Saxony and Brandenburg. Sometimes, as in the gallery of Charles XII in the Royal Palace in Stockholm, they assumed the form of wood and stucco ornament. Even these

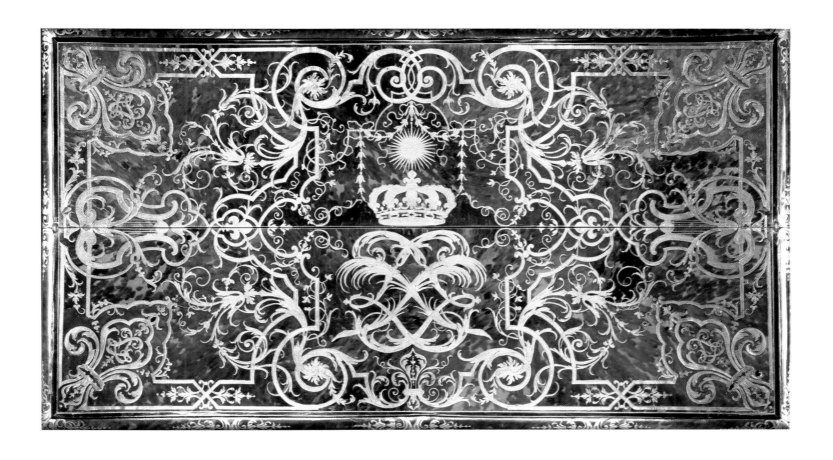

Desktop, Alexandre-Jean Oppenord, c. 1685.

New York, Metropolitan Museum of Art

The desk in red tortoiseshell with copper marquetry inlay—by the father of Gilles-Marie Oppenord, who was from the Netherlands—is one of a matched pair produced for Louis XIV's private study at Versailles. The royal monogram is surrounded by ornate ribbonwork and rinceau designs. Note the lyres at either end, allusions to the Sun King as the new Apollo. Here we see an early example of the supple linear patterns that would be the basic component of new arabesques.

Parterre de l'hôtel de Marsan du dessin de Monsieur le Nautre (Planted garden terrace of the hôtel de Marsan designed by Monsieur Le Nôtre), print, 1697.

Paris, Bibliothèque des Arts Décoratifs

This symmetrical garden design by André Le Nôtre simultaneously evokes marquetry inlay, embroidery designs, and the notion of the mirror image so central to the new arabesque idiom (see also the print by Gabriel Huquier on page 183). It is a telling indicator of the close ties between arabesques and garden design.

examples, however, ultimately derive from fabric and metalwork, and thus provide evidence of the links between interlace and the new arabesque.

The pilaster format resurfaced in Bérain's compositions, which were always clearly contained by framing elements. Tapestries and other hangings required borders, and commissions for such designs encouraged Bérain's penchant for them. Within the area defined by the frame, he established clear spatial hierarchies, a characteristic that sets his work apart from the delicate arabesque patterns traced against white grounds on the ceilings of Renaissance palazzi. A typical Bérain composition features a central element—usually figures inside some sort of pavilion—that sets the tone. This is surrounded by picturesque figures and vignettes distributed over a filigree network of pillars, bandwork, stairs, etc. and accorded varying degrees of emphasis, but the central episode remains somewhat dominant. As the eighteenth century advanced, however, the importance of such motifs in the overall scheme increased, with arabesques increasingly assuming a subordinate role.

Ties between arabesque decoration and border design were especially close during this period, when ornamentalists produced prints of "arabesques" or "grotesques" that, despite these designations, are complex decorative compositions that elude conventional categorization. Such grotesque borders figure prominently in Paul Decker's designs for silver boxes and in Pierre Bourdon's *Essais de gravure* (Models for engravers), published in Paris in 1703, one of which pictures a box design featuring grotesque festoons that is actually a complicated border pattern.

The Contribution of Metalwork

The best painters were not alone in influencing the evolution of arabesque and grotesque designs; metalworkers played a role as well. Small objects such as boxes, watches, and glasses were frequently decorated with arabesque patterns, as is demonstrated by numerous French and German prints from the period. Many designs intended primarily for engraving on such metal artifacts were inspired by moresques, the forms of which were ideal for treatment in the black-ground patterns known in the Germanic territories as *schwarz Ornament,* or black ornament. The addition of masks, rinceaux, and other ornamental elements to these compositions effectively transforms them into grotesques.

Bérain was born into a dynasty of gunsmiths with considerable experience in chasing and engraving silver, copper, and steel. These techniques call for a mastery of the burin comparable to that required of printmakers. Bérain's earliest known engravings, published in 1659 and again in 1667, are of somewhat heavy grotesque designs for muskets. It is also worth noting that another French master of the arabesque, Claude Gillot, produced designs for musket ornament that were subsequently engraved. So similar are the skills involved in metalworking and printmaking that it was not difficult for these resourceful artists to make the transition between the two fields, and their actions were not without precedent.

Weaponry has always been a privileged vehicle for ornament. The transgressive, assertive nature of the more spectacular of these objects made them ideally suitable for decoration with fantastic and horrific beasts; sometimes such ornament incorporates traits of the enemy in a gesture of symbolic subjugation. There is reason to suspect that the arms of the Turks who laid siege to Vienna in 1683 influenced the development of the arabesque vocabulary in subsequent years.

Silver and gold objects with engraved or damascened ornament played an important role in the evolution of the arabesque genre. Indeed, this could be said of all the metalworking arts: complex patterning contained within distinct boundaries was crucial to all of them.

Paul Decker the elder (1677–1713), an architect who worked in the Holy Roman Empire in the late seventeenth century, devised numerous examples of *groteschgen Werk* for small boxes in various formats, all featuring surfaces *page 186* entirely covered with refined arabesque patterns around a central figure. As an architect, he was concerned primarily with the design of grotesque compositions for larger surfaces, but he set out to embrace ornament in its entirety, on whatever scale, producing models that he considered appropriate for use by metalworkers as well as painters and stuccadors. Responding to a similar impulse, a seventeenth-century Parisian goldsmith named Chaudière published a set of prints—rather mediocre, it would seem—intended as wall panel designs and entitled *Grotesques et mauresques pour panneaux de lambris inventez par le sieur Chaudière orfèvre* (Grotesques and moresques for use on wall panels, devised by Chaudière, goldsmith), published by Trouvain.

The metallic arts would find a new field of application in furniture in the tortoiseshell and copper marquetry technique preeminently associated with André-Charles Boulle (1642–1732), its most accomplished practitioner, who sometimes used designs by Bérain. The makers of French luxury furniture, who were often originally from the Netherlands, lacked the skills and training necessary to produce arabesque designs entirely of their own invention. They often paraphrased compositions by Bérain, Daniel Marot, and Bernard Picard (1673–1733) available in print form, and occasionally they drew on earlier sources such as the superb grotesque designs by Cornelis Bos. *page 189*

⌇

Prints

The development of these complex and seductive arabesque models was largely a function of their widespread circulation in print form. Ornamental prints have played a crucial role in the dissemination of decorative compositions since the Renaissance, but the precise ways they functioned in this image marketplace varied considerably over the years. I've already noted the late-seventeenth-century links between the metalworking arts and printmaking in connection with muskets, and it is not coincidental that during this period the great northern European centers of printmaking and metalworking were the same cities: Paris, Nuremberg,

and Augsburg. The prints in question featured not only arabesques but rocaille and exotic motifs. The Netherlands played a dominant role in the ornament-print market of the sixteenth and early seventeenth centuries, but after 1650 that position was increasingly assumed by France and Germany.

This print production played a crucial role in the art of the rococo. It encompassed French prints published in France as well as German prints by both German and French designers. Augsburg made a specialty of republishing compositions by French artists, often in the form of counterparts, or reverse knockoffs, of the originals. The editors of these bogus collections often shuffled the images and gave them captions containing false information deliberately written to mislead their prospective purchasers. However dubious this practice might seem to us, it kept many designs in circulation long after they had become unfashionable in their nation of origin.

Such prints presented patterns with no fixed sense of scale, facilitating the appropriation of designs initially conceived for small surfaces onto large ones. To a certain extent this fluidity had been characteristic of the use of ornamental prints since the late medieval period, but the explosive growth of this production in the first decades of the eighteenth century considerably blurred the distinction between what was appropriate for execution *en grand* as opposed to *en petit*. This ambiguity was central to the rococo aesthetic as a whole and eventually became the focus of controversy in France, where beginning in the 1740s it was often condemned by nostalgic advocates of the so-called *grand goût,* or grand taste, a phrase meant to evoke the classicizing visual culture of the Louis XIV era at its most imposing. As a result, the question of scale played an important role in the rhetoric of neoclassical reaction.

page 194 The pirated editions of Bérain's work made it accessible to a much wider public, and as a result of his celebrity many works have been mistakenly attributed to him, notably a famous set of tapestry designs actually produced by Jean-Baptiste Monnoyer. But Bérain was without question one of the genre's most accomplished masters.

~

The Rococo Arabesque after Bérain

Well before the end of Louis XIV's reign, another French artist began to exert considerable influence on the evolution of the grotesque. In 1693, Daniel Cronström, the Swedish envoy to France, wrote as follows: "After Bérain, the most celebrated artist in this genre is Audran, the nephew of Audran the engraver. . . . He is very much at odds with M. Bérain, whom he distrusts." Cronström goes on to describe his style as "somewhat different from Bérain's: it is more delicate, more svelte." The ornamentalist in question is Claude III Audran, and, while Cronström's characterization of his work is vague, it is accurate as far as it goes.

In Audran's mature designs the forms are more brightly colored and often have a fragile quality; their filigree networks, which sometimes trace virtual spider webs, stand out in vivid silhouette against the backgrounds, which as a result

Ceiling design, pen, watercolor,
and gold wash, Claude III Audran.

Stockholm, Nationalmuseum

This design by Audran (1658–1734) is presented
in two alternative forms (on either side of the
central crease). The organizational armature is just
as light but somewhat busier than those preferred
by Bérain. The distant influence of Italian *grotteschi*
such as those in the Raphael *loggetta* and in later
ornamental prints—those associated with Enea
Vico, for example—is discernible here, notably
in the transparency of the whole and the
prevalence of figures and fantastic creatures, but
the forms have been attenuated and rendered
more precious by the judicious application of
gold wash to most of the tracery motifs and the
use of a palette dominated by violets, purples, and
pinks. The result has a linear delicacy that is
distinctively French. Compositions such as this
one seem to have influenced Watteau's
decorative idiom (see below).

The Coquette, print from volume I of
Figures de différents caractères (Figures of
diverse character), François Boucher
after Antoine Watteau, Paris, 1727.

Paris, Bibliothèque Nationale

This print, from a compendium of images after
drawings and paintings by Watteau (1684–1721),
faithfully reproduces a fan design by the artist
now in the British Museum, London. In the
manuscript notes of Pierre-Jean Mariette,
the influential connoisseur and member of the
circle of Jean de Jullienne (the sponsor of this
novel enterprise), it is described as "a cartouche of
ornaments enclosing some grotesque figures."
The grotesque elements in question are the two
profile heads emerging from delicate branches
on either side, the membranous element floating
above the center, and the skewed Greek-key
motifs at the bottom.

LA COQUETE

become more prominent. In ceiling designs, the resulting ethereal effect is heightened by Audran's replacement of Bérain's heavy central medallions with airier configurations, and by the progressive attenuation of the ornamental armature, often dominated by webbed forms and valances.

Audran, who quickly became known as a painter of grotesques and arabesques, was not the only artist of his generation to modify the grotesque vocabulary associated with Bérain. He faced competition from Claude Gillot, an accomplished theatrical designer and draftsman who was also a remarkably gifted inventor of arabesques, which he often populated with extravagant figures and fantastic beasts.

Audran, however, usually painted only the ornamental and framing elements in his compositions, preferring to leave the figures to artists such as François Desportes and Jean-Baptiste Oudry, who specialized in animals. And fortune was kind to him: for a time the young Antoine Watteau worked in his studio, where he produced superb decorative designs.

page 207

Watteau's career as an ornamentalist began in another studio: that of Gillot. When Carl Gustav Tessin of Sweden (son of Nicodemus Tessin the younger) was in Paris briefly in 1715, he wrote of an upcoming visit to Watteau, describing him as a "student of Gillot, Flemish by birth, works quite successfully on grotesques, landscapes, and fashion images." This is an accurate reflection of the artist's reputation before 1717, when his *Embarkation for Cythera* was accepted by the Royal Academy as his reception piece—a painting in the new genre of the *fête galante,* with which his name was thereafter associated. A few arabesque designs by Watteau survive. Their dates and intended uses are matters of conjecture, but there can be no doubt as to their divergence from the formats preferred by Audran. This is discernible in both the ornament proper and the figures, which are grouped into narrative vignettes. But the most striking departures from precedent concern the relationship between figures and ornament and the quality of the figures themselves. Audran had displayed considerable

page 210

invention in his integration of figure and decoration, but in Watteau's compositions the figural elements take on new prominence, occasionally overflowing into the surrounding arabesque configurations.

Watteau's arabesque designs became well known in the form of engravings, most of them published posthumously, such as the group of prints after his work in a collection often called the *Recueil Julienne,* after Jean de Julienne (1686–1766), the Parisian collector who sponsored the project. At the end of the eighteenth century another set of arabesque designs by him from the Cossé collection were published in a volume of neoclassical arabesques, a fact that might be taken to indicate the distinctive quality of Watteau's arabesque invention. Certain of his arabesques were engraved by François Boucher, who himself went on to produce arabesque panel designs, and by Gabriel Huquier (1695–1772). As a result, Watteau's ornamental style became widely accessible and was much imitated abroad, especially in England and Germany. Increasingly, these images, some of which were paraphrases of Watteau's compositions, took the form of pastoral images surrounded by rococo ornament. Huquier did not hesitate to

invent entirely new frames in keeping with current fashion to set off some of his later prints after Watteau.

The nature of these designs made them ideal for use on fans and firescreens. It was images such as these—often published by Huquier, who was himself an ornamentalist—that disseminated the new arabesque idiom throughout Europe.

Despite this development, artists such as Christophe Huet (d. 1759) in France and Audien de Clermont in England remained faithful to the style of Audran, which for all its idiosyncrasies was closer to the Renaissance grotesque tradition—so much so, in fact, that Audran was asked to restore the mid-sixteenth-century arabesque ornament at the château of Fontainebleau. Audran's particular style was taken up and developed by Claude-Joseph Billieux, in the Rhineland, and by Johann Adolph Biarelle and Pillement in Russia. But both these strains of influence—associated with Audran and Watteau, respectively—contributed to the gradual displacement of the Italian grotesque tradition by the French one, whose models were copied far more faithfully than were other forms of rococo ornament.

The circle of artists involved in the genesis of the French arabesque in this period was remarkably small, and its members were engaged in what was quite literally a collaborative project. To a remarkable extent, the participating artists worked with and directly influenced one another; much knowledge and expertise was exchanged—in both directions—between master and workshop assistant.

Another artist involved in these developments should be mentioned here, although he stands somewhat apart: architect and designer Gilles-Marie Oppenord (1672–1742). His decorative style was a synthesis of Italian and French elements, for unlike his ornamentalist compatriots he had long sojourned in Italy, where he assiduously studied and drew monuments and decorative schemes both ancient and modern. In his sketchbooks he juxtaposed small details with expansive compositions, a practice that encouraged him to think in terms of incremental juxtaposition. An artist of rich invention, his personal stamp is discernible on everything he touched. He was thoroughly conversant with the Western iconographic tradition, and as a result his designs are more thematically coherent than those of other decorators of the period. The pondered, intellectual quality of his arabesque compositions undoubtedly owes much to the influence of his Italian sojourn.

<hr />

The Thematics of the Arabesque

Watelet and Lévesque, in their *Dictionnaire des arts de peinture et sculpture* (Dictionary of the arts of painting and sculpture), published in 1792, characterize arabesques as agreeable and truthful to a degree, but state that the final effect they produce is illogical, fantastic, and unstable. They state that arabesques are the "dreams of painting," an image they develop as follows: "Reason and taste dictate that they not be the dreams of a sick person but rather musings comparable to

those experienced by an eastern voluptuary under the influence of a skillfully measured dose of opium." In one plate from the *Livre premier des essais de gravure* (First book of models for engravers), by Pierre Bourdon, from 1703, a man smoking a pipe is pictured adjacent to various ornamental compositions, several of which are clearly meant to decorate tobacco boxes. The smoke mutates into an arabesque flourish—an ingenious visual metaphor for the shifting forms that one might associate with an agreeable stupor.

page 163

The free-associational quality of the arabesque is something it shares with dreams (making it a favored genre of decoration for beds and bedding) and states of intoxication, induced by whatever substance. Hence the prevalence in arabesque compositions of bacchanalian imagery featuring drunken satyrs and nymphs giving free reign to their every desire. Celebrations of all kinds constitute another thematic preoccupation—which is fitting, given their break with everyday routine and their association since antiquity with fronds and branches woven during processions. Then there are the ever-present burning braziers, cassolettes, tripods, and perfume pans, which evoke the trances of ancient seers.

page 199

The arabesque has a privileged relationship to everything that evolves and transforms itself. Ovid's *Metamorphoses* is rich in narratives of transformation, and it was duly plundered for arabesque vignettes. Among those most frequently encountered are Daphne changing into a tree, Acteon into a stag, and Clytie into a sunflower; but the empire of Flora, the sorrows of Narcissus, and the rustics turned into frogs by Latona also appear in arabesque compositions.

This propensity for things transformational led to the frequent use of the signs of the zodiac, which represent changes taking place within us. Some works incorporate them quite straightforwardly, as in the arabesque *Months* tapestries designed by Audran, but in other works such imagery can be oblique and allusive.

page 214

The arabesque also has an affinity for the burlesque mode, and there are several reasons for this. First, laughter indicates a sudden change of attitude stimulated by some outside force, one that in the Christian West is often assumed to be mischievous. Furthermore, a pronounced taste for things burlesque developed in late-seventeenth-century France, largely due to the growing influence of contemporary comic theater. The Italian comedy was all the rage in these years, and mockery was its common currency. In Paris, it was not uncommon for the Italians, as they were called, to produce barely disguised satirical versions of new productions at the Opéra and the Comédie Française shortly after their premieres. The more prestigious companies got their revenge: in 1697 the Italians were outlawed as punishment for a piece attacking Madame de Maintenon, Louis XIV's morganatic wife. But the repertory of stock figures from Italian theater continued to haunt the French imagination, just as their satirical genre was subsequently taken up by French opéra-comique troupes. The many commedia dell'arte types in arabesque compositions by Audran, Gillot, Watteau, and Nicolas Lancret (1690–1745) were more or less directly inspired by the theatrical antics of their professional counterparts.

Singeries—images of monkeys "aping" humans—were ubiquitous in this period, particularly in the work of Audran and Huet. Momus, the Greek god of

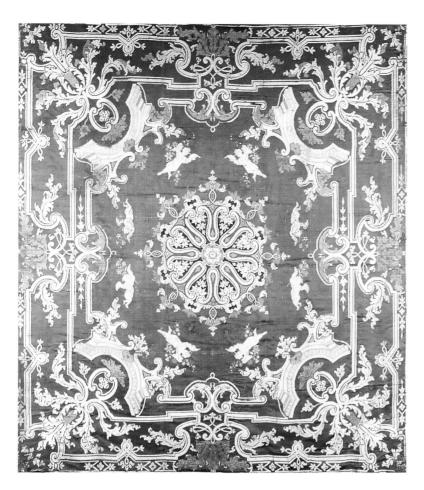

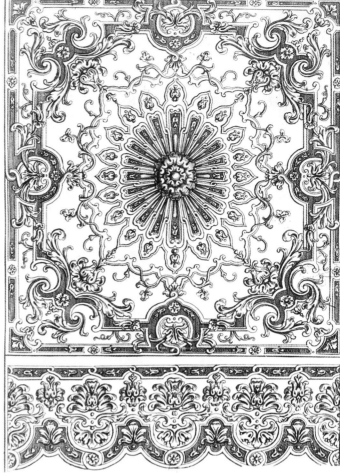

Bed canopy, late seventeenth century.
Paris, Musée des Arts Décoratifs

Such canopies often featured a central medallion with forms derived from moresques, but the balance of their compositions varied greatly; in late-seventeenth-century Europe, bandwork derived from interlace was frequently used. The vogue for arabesque designs led to the combination of various ornamental strains, resulting in arabesque-like configurations such as those visible in the outer border. A similarly hybrid idiom was used in printed designs for *portières* (door hangings) by Gillot.

Plate 2 and title page, *Livre d'Ornemens propre pour les meubles et pour les Peintres inventé et dessiné par Bacqueville* (Book of ornaments for furniture and painters invented and engraved by Bacqueville), P.-P. Bacqueville, early eighteenth century.
Paris, Bibliothèque d'Art et d'Archéologie, Fondation Jacques Doucet

Plate 2 pictures a bed canopy design whose central rose is surrounded by a fringed aureole. The juxtaposition of this composition with the one shown on the title page (below) demonstrates the perceived affinity between such motifs and arabesques. The latter design seems appropriate for the headboard of a bed, perhaps executed in tapestry or embroidery. The rather heavy arabesque idiom derives from early-seventeenth-century models. The two musicians sit beneath "Chinese" belled parasols, the segments of which are related to the dagger-and-mouchette forms characteristic of moresques.

blame and mockery, figures prominently in the arabesque pantheon. Watteau made frequent use of his changeable face, which could take the form of an old man with strange ears or a young one wearing the mask of a satyr.

Another popular arabesque theme—it, too, an index of external influence exercised over us—is that of Folly, or Madness. The association of such imagery with dreams, strange apparitions, and fugitive impressions places it in opposition to all that is logical and readily subject to control, turning the very notion of objectivity to ridicule.

Given the focus on inner flux in the iconography of the arabesque, it is not surprising that love and courtship figured prominently in its imagery. Stories of passion, both happy and unhappy, abound in these compositions—such as the transformation narratives of the *Metamorphoses,* Diana and Acteon, and the loves of the gods. The titles of Watteau's published arabesques bear witness to this affinity: *La Cause badine* (The Flirtation), *Le Berger content* (The Happy *page 207* Shepherd), *L'Heureux moment* (The Happy Moment), *L'Enjôleur* (The Seducer), *Le Frileux* (Pierrot in Winter), *Le Galant* (The Galant), and *Le Faune* (The Faun). Watteau's fascination with the arabesque is consistent with the genre's preoccupation with change and emotional fluidity, constant themes of his easel paintings, which often bring together figures in various stages of erotic interest, infatuation, frustration, and dejection.

The arabesque idiom welcomed visual puns and double meanings, too, and these sometimes veered toward the salacious, notably in images of a woman on a swing—for example Watteau's *L'Escarpolette* and *La Balanceuse* (The Swing and Woman Swinging). These readily lend themselves to erotic readings, an exercise encouraged by the suggestive poems printed beneath them in their posthumous incarnations as prints. Jean-Honoré Fragonard, who tended to make the sensual cast of his imagination more explicit, produced a painting which epitomizes this strain of imagery even as it pushes it toward the frankly smutty: *The Swing,* 1767 (London, Wallace Collection).

A more general link between licentiousness and the arabesque was commonly understood during that period. The previously mentioned *Triumph of the* *page 214* *Gods* tapestry series was all but abandoned by the Gobelins weavers after 1703, a reflection of the continuing influence of the pious and puritanical Madame de Maintenon over the aging Louis XIV. Even in the mid-eighteenth century it was considered racy, leading the administrators of the Garde-Meuble de la Couronne (royal furniture repository) to decide that henceforth they would be displayed in men's living quarters.

It was not by chance that the French arabesque reached its apogee during the Regency (1715–24). This was a moment of reaction against the dour tone set by the French court during Louis XIV's last years, and so was characterized by a heady atmosphere of liberation from social and cultural constraint. Accordingly, mockery and playful critique flourished—and the arabesque along with them. One senses that both the artists and the patrons shaping this golden age of the genre were partial to unbuttoned conviviality. Watteau was surely not the melancholic type generally depicted in the earlier literature on him,

and an artist such as Pierre-Alexis Peyrotte (1699–1769) must have been jovial company indeed: it is easy to imagine him indulging a pronounced taste for the ironic quip, spicing his conversation with suggestive remarks and swipes at the clergy.

<hr />

Applications

Despite appearances, the thematics of arabesque imagery have considerable logic and coherence. The same could be said of the uses to which the genre was put. In the seventeenth century, the ceilings of large rooms were entirely covered with arabesque designs; but when the idiom began to feature sparer, more delicate forms, architects tended to reserve arabesque compositions for the ceilings of smaller, more intimate spaces. It was feared that their tiny figures would be lost on larger surfaces, all the more so given the taste for encompassing white grounds. Indeed, this was the chief criticism directed against the Ulysses Gallery at Fontinebleau, which was destroyed in 1738–39. But something of the earlier practice persisted in the tendency, prevalent long after Louis XIV's death, to decorate interior cornices with grotesque designs rather than with architectural detailing. It also became quite common to place grotesque compositions not in large galleries and public rooms, as in the seventeenth century, but rather in bathing and dining rooms, as in the ancient world: bacchanalian imagery is, after all, thematically appropriate for such spaces.

Arabesques soon dominated French tapestry, becoming prevalent in the production of both the Gobelins and the Beauvais factories. In addition to wall hangings, which were used in the period like large painted panels, they wove upholstery covers for chairs and sofas. Such small surfaces were ideal vehicles for delicate arabesque designs.

The affinity between dreams and the arabesque led to their being preferred for use in bedrooms as opposed to more social spaces. As already noted, the genre was often employed on bedding, either in the form of *Bandlwerk Ornament* or that of the new French arabesque, which found favor with the wealthy.

Most of the eighteenth-century masters of the arabesque devised decorations for harpsichords, whose eccentric shapes presented particular problems. It had been a longstanding practice to paint landscapes and mythological scenes on the inside surface of their covers, but in the early eighteenth century such compositions gradually gave way to arabesques incorporating dancers, musicians, and commedia dell'arte characters. Music-making and the arabesque genre have much in common: music, like love, is fleeting, yet both can induce feelings of great intensity, just as rapidly evolving arabesque compositions can produce a pleasure that owes much to their transformational character.

pages 200, 201

But the arabesque was also associated with pomp and circumstance. Its elaborate forms made it suitable for showy expenditure, which in this period was held to be an obligation for those of high social station. Hence its appearance on coaches, carriages, and sedan chairs, occasioning an exposure to the elements

that telegraphed extravagance with particular force. The combination of formal complexity with a subjective, intimate tone made the arabesque vocabulary ideal for decorating such vehicles, for they carried their privileged occupants from private spaces into public ones.

The many links between the arabesque and imagery of festivals and the theater has already been noted. Dazzling transformation scenes and infernal grottoes were staples of contemporary stagecraft, as were dreams, intrigue, and dramatic reversals. It might reasonably be maintained that the theater and the arabesque mutually influenced one another in this period, and that a full understanding of the transformational economy operative in the one entails study of the other.

European garden design in the Baroque period was intensely theatrical, and it, too, was affected by changes in the arabesque vocabulary, through the evolution of rinceaux and bandwork motifs. Formal gardens often featured planted borders known as parterres whose designs imitated embroidery patterns. As developed by Daniel Marot in the Netherlands and by André Le Nôtre *pages 185, 167* (1613–1700) and Claude Desgots in France, the patterns of these plantings became increasingly complex, employing the conceit of mirror reflections so important in ornamental work generally during this period. The text by architect Pierre de Vigny quoted at the beginning of this chapter illustrates the ease with which one could move from abstract ornament in the Islamic tradition to the ribbon-work designs of contemporary European gardens: for Vigny and his contemporaries, the two belonged to a single decorative system.

The Hidden Arabesque

The infatuation with the arabesque, which led to its virtual reinvention during this period, affected many spheres of artistic expression, including several where its influence might be easy to miss. Grotesque mascarons, widely used in both interior decoration and exterior façades and appearing in contexts as various as the Pont Neuf and Versailles, were made to express a wide range of emotional and emblematic meanings: amusement and terror, phlegm and melancholy, America and Europe, air and fire. These mascarons had a venerable tradition of their own, one that never entirely merged with that of the arabesque but that overlapped it. In luxury furniture, hooved feet and gilt-bronze fittings in the form of bearded faces or satyr heads were not unusual; insofar as these evoke bacchanalian imagery, they reflect the prevailing taste for the arabesque.

The arabesque is also closely linked to the chimeras and dragons—or *figures hiéroglyphiques,* as contemporaries called them—which proliferated in the French decorative arts in the first decades of the eighteenth century. These fantastic creatures could lay claim to a theatrical pedigree, for they were staples of Baroque spectacle. Their most ingenious manifestations were as supports for console tables, which in this period assumed forms so sinuous that they resemble materialized arabesques.

During the Regency, specialists in carved decorative panels had a marked predilection for term figures (human torsos and heads emerging from stone bases) and female busts, which in their designs often merge into foliage or framing elements. These, too, were appropriated from the arabesque vocabulary, as were the free-floating profile heads said to be *en espagnolette* (literally, like a small Spanish woman)—a designation that may derive from a contemporary theatrical type but the origins of which remain somewhat mysterious.

The picturesque porticoes in compositions by Audran, Gillot, Watteau, and Oppenord occasioned more borrowings from the arabesque vocabulary. In his notebooks, Gillot drew and redrew these small pavilions with their domes of foliage or trelliswork, and such fascination was widespread, for similar structures appear in ephemeral festival and garden decorations of the period. Even more notable, perhaps, is the extent to which sculptures placed within trellised bowers and gazebos inspired by contemporary arabesque designs proliferated in eighteenth century gardens. A notable example was found at Versailles, where from 1705 to 1778 the sculptures originally executed for the Grotto of Thetis were displayed in the *Bosquet des bains* (Bosquet of the Baths) beneath delicate valances made of gilded lead (destroyed; contemporary maquette in the Versailles collections). The movement of these marbles from a garden grotto—a structural type with privileged relation to the Renaissance grotesque tradition—to what were in effect sumptuous arabesque pavilions realized in three dimensions is worthy of note, for it parallels the developmental trajectory of the French arabesque during these same years.

The arabesque was ubiquitous during this period, especially in northern Europe, where it not only influenced a broad array of decorative arts productions but became a fixture in the contemporary imagination. At the beginning of the history examined in this chapter, arabesques were composed primarily of interlace and rinceaux; as the mid-point of the eighteenth century approached, their formal vocabulary became so confused with that of the rocaille that it is all but impossible to distinguish arabesque from rococo elements in compositions by Johann Michael Hoppenhaupt (1709–1769) and Jeremias Wachsmuth (1712–1779), for example.

The porcelains produced in such quantities in these years—notably those from the Frankenthal factory—display the same tendency. They depict groups of figures, often shepherds and shepherdesses, in rococo environments freely inspired by prints of compositions in a similar vein by Watteau, Huquier, Boucher, and François de Cuvilliés. Are these objects arabesque or rocaille? Difficult to say, for the monsters of the former had coupled surreptitiously with the aquatic creatures of the latter, giving birth to forms of ambiguous pedigree.

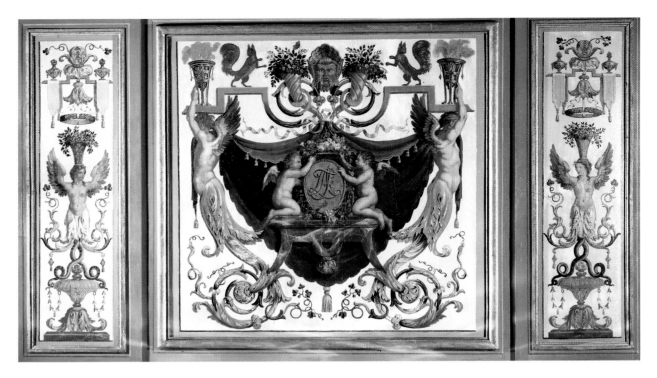

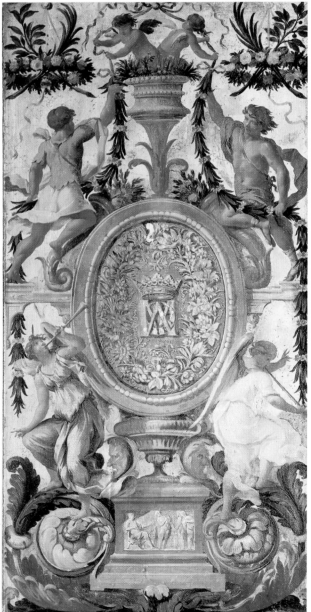

Wall panel from the *salle des buffets*, c. 1660.

Château of Vaux-le-Vicomte

French finance minister Nicolas Fouquet had Louis Le Vau
design this lavish château on a site not far from Paris, and
engaged Charles Le Brun to oversee its interior decoration.
Work came to an abrupt halt shortly after an imprudently
lavish *fête* held in the king's presence on August 17, 1661,
when Fouquet was arrested for embezzling state funds. Here,
as elsewhere in the decorative work, residual acanthus rin-
ceaux merge with fanciful arabesque configurations. Conven-
tional arabesque elements are arrayed around the owner's
monogram. Note the squirrels; this animal figured
on Fouquet's family arms and is omnipresent at Vaux.

Wall panel from the *cabinet* of the maréchale
de La Meilleraye, the Arsénal, Paris, Noël
Quillerier and Jean Bertrand, 1637–40.

Paris, Bibliothèque de l'Arsénal

The painter Noël Quillerier (1594–1669) and Jean Bertrand
decorated the rooms of the maréchal de La Meilleraye and
of his new wife, Marie de Cossé Brissac. After returning from
an Italian sojourn, Quillerier secured a place for himself in the
circle of Simon Vouet (1590–1649), who had also resided in
Italy. Vouet, much the superior artist, devised famous ara-
besque decorations for the rooms of the regent Anne of
Austria in the Palais Royal, but his designs survive only in the
form of engravings, whereas Quillerier's scheme still exists.
It was clearly inspired by Vouet, who devised a new decora-
tive idiom dominated by rather pompous and elegantly
demonstrative figures very like the ones here, which are
made appealingly playful by the way they clamber over
the acanthus and cornucopias.

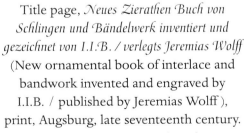

Title page, *Neues Zierathen Buch von Schlingen und Bändelwerk inventiert und gezeichnet von I.I.B. / verlegts Jeremias Wolff* (New ornamental book of interlace and bandwork invented and engraved by I.I.B. / published by Jeremias Wolff), print, Augsburg, late seventeenth century.

Paris, Bibliothèque des Arts Décoratifs

This volume of interlace and bandwork designs was published in Augsburg. Interlace patterns dominate but are combined with the characteristic arabesque vocabulary of cascading flowers and fruit, tasseled hangings, drapery, and mascarons. The gothic script of the title mirrors the cursive quality of the surrounding patterns, much as arabic script does in Islamic ornament.

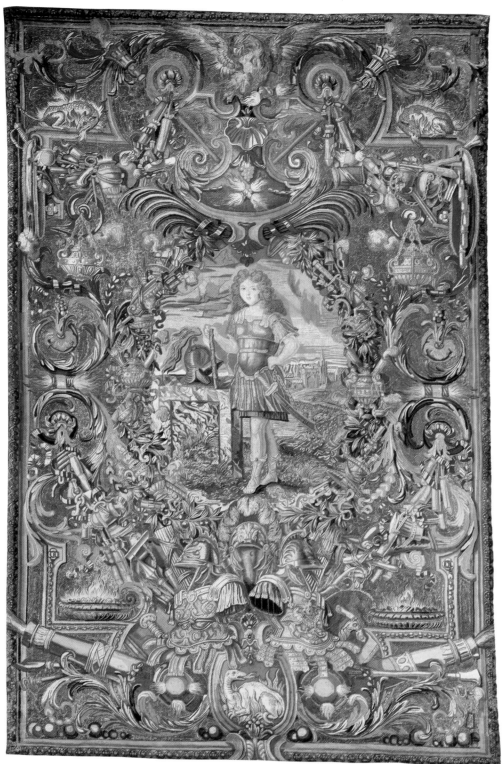

Fire, tapestry woven in *petit point,* or tent stitch, c. 1683.

New York, Metropolitan Museum of Art

This is one of a set of embroidered hangings, the others being *Spring, Summer,* and *Air* (which suggests that originally they figured in coordinated sets of the four elements and seasons). They were made for Madame de Montespan (1641–1707), probably after designs originating in the studio of Le Brun, in the workshops established by her in the Saint Joseph-de-la-Providence convent; each is an allegorical portrait of one of the illegitimate children she bore Louis XIV. The boy—shown as Mars—is probably the comte du Vexin (1672–1683), abbot of the Abbey of Saint-Denis pictured in the background. The central oval is framed by laurel fronds intertwined with martial accoutrements, while the surrounding field is filled by acanthus rinceaux, bandwork, and ribbonwork combined with weaponry, armor, incense burners, burning salamanders, etc.—imagery linked to fire and warfare. This eclectic but masterful design marks an important step in the evolution of new arabesques, pointing the way toward the elegantly varied configurations favored in later Gobelins productions.

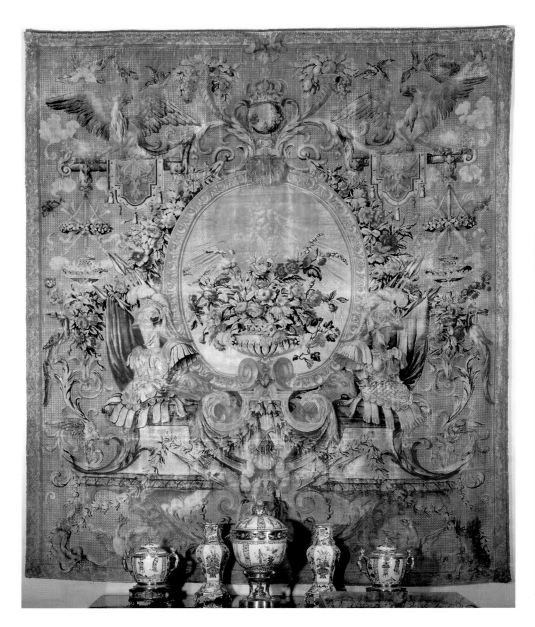

So-called *Tapestry of the King's Gondola,* silk,
Savonnerie factory, 1682–85.

Paris, Louvre

The beginnings of the new French variant of the arabesque are difficult to
date with any precision, for the idiom emerged gradually from acanthus,
interlace, and other established motifs. This silk tapestry is one of a set
produced at the Savonnerie factory in the Dupont workshop, probably after a
design by Lemoyne le Lorrain. In the center of the composition is a large oval
medallion containing a lavish bouquet of flowers, above which floats a gold
glory bearing the head of Apollo; at its base are two trophies of arms. On
either side are grotesque configurations composed of monkeys, fantastic
masks, acanthus, birds, flowers, smoking braziers, lily wreaths, and burning
torches, all suspended from an elegantly detailed beam surmounted by
acanthus and animated by fluttering birds and butterflies. Out of the acanthus
emerge eagles and cornucopias that frame a blue globe supporting a crown
and bearing the fleur-de-lis, emblem of the French royal House of Bourbon.
The patterned gold ground makes the details difficult to discern, but the
sumptuousness of the overall effect is undeniable.

Design for the so-called *Tapestry of the
King's Gondola,* drawing, attributed to
Lemoyne le Lorrain.

Stockholm, Nationalmuseum

Both of the two alternative designs on this sheet
were presumably rejected, for they both differ
considerably from the hanging now in the Louvre
(above left). The text at the bottom stipulates that
it was to be executed in pure silk so as to be as
pliable as Genoa velvet, and that the colors were
to be brighter than in the drawing.

The design is given a grotesque character by the
fantastic creatures emerging from rinceaux, as
well as by the two parallel candelabrum compo-
sitions. All the component elements are given
equal emphasis, even the royal monogram and the
lyre surmounting it—another reference to
Louis XIV's identification with Apollo, which is
given more explicit form in the final version.

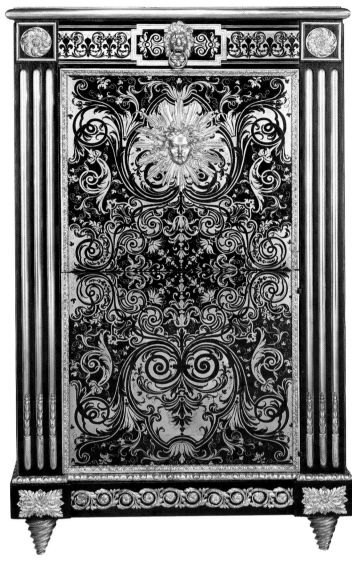

Print from *Nouveau Livre de principes d'ornements*
(New book of principles of ornament), engraved by
Gabriel Huquier after Claude Gillot.

Paris, Bibliothèque d'Art et d'Archéologie, Fondation Jacques Doucet

The plates in this volume are prefaced by a page of instructions in which
Gabriel Huquier (1695–1772) advises the user to slide a tilted hand mirror over
the images as indicated in the vignette below the text, a procedure he asserts
will result in the discovery of "an infinite number of symmetrical forms
which your eyes would not otherwise perceive."

Secrétaire à abattant (front and side views),
Philippe-Claude Montigny, 1770–75.

Malibu, J. Paul Getty Museum

Montigny (1734–1800), an *ébeniste* (maker of marquetry furniture) who
contributed to the revival of the heavy, opulent Louis XIV style in the late
eighteenth century, produced many pieces in the copper and tortoiseshell
inlay technique preeminently associated with the work of André-Charles
Boulle (1642–1732). This piece helps to clarify the advice given by Huquier
in his *Nouveau Livre de principes d'ornements (see above).* It incorporates
seventeenth-century marquetry panels that were presumably made to
serve as tabletops. If brought together, the two narrow side panels would
form a stylized sunburst design. The marquetry patterns are based on
sinuous arabesques, as opposed to grotesques, but Montigny's addition
of a bronze mask of Apollo on the front brings the design closer to
the grotesque idiom.

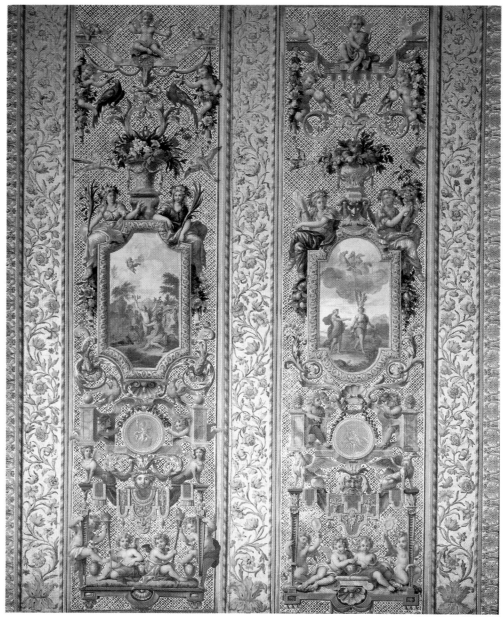

Wall panel design for Montagu House,
pen and ink, Daniel Marot, c. 1690.

London, Victoria and Albert Museum

*I*n 1685, the year of the revocation of the Edict of
Nantes, Protestant architect and engraver Daniel
Marot (c. 1663–1752) fled to Holland, where he
became the principal designer to William of
Orange. In 1694 he emigrated with his royal patron
(newly ascended to the British throne) to London,
where he produced a series of wall panel designs

for the residence of the first duke of Montagu.
These are conceived as vertical grotesque compo-
sitions with central panels depicting episodes from
Ovid's *Metamorphoses*. On the drawing above,
Marot provides color notes for the painters: flesh
tones for the figures; natural colors for the narra-
tive vignettes, flowers, and fruit. While these and
other details are consistent with the French ara-
besque tradition, the independence of the figures
from one another is something of a departure and
sets his work apart from that of Jean Bérain.

Painted wall panels from
Montagu House in London,
Charles de Lafosse (1636–1716),
Jacques Rousseau (1630–1693),
Jean-Baptiste Monnoyer (1634–1699),
and Jacques Parmentier (1658–1730),
after designs by Daniel Marot, c. 1690.

*Boughton House, The Duke of Buccleuch
and Queensbury*

These panels are among the most significant
recent discoveries relevant to the evolution of the
arabesque, for they are undoubtedly based on
surviving drawings by Daniel Marot *(see left)*. The
duke of Montagu, an enthusiastic francophile and
a former ambassador to the court of Louis xiv,
engaged the French artists listed above partly
because they had all produced decorative work for
the Sun King, and the resulting arabesques have
the desired French elegance and panache.

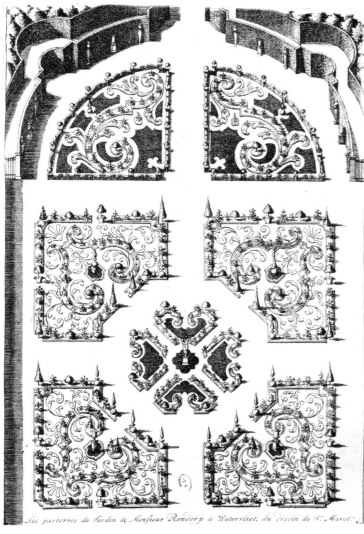

Les parterres du Jardin de Monsieur Rendorp à Watervliet, du dessin du S.ʳ Marot.

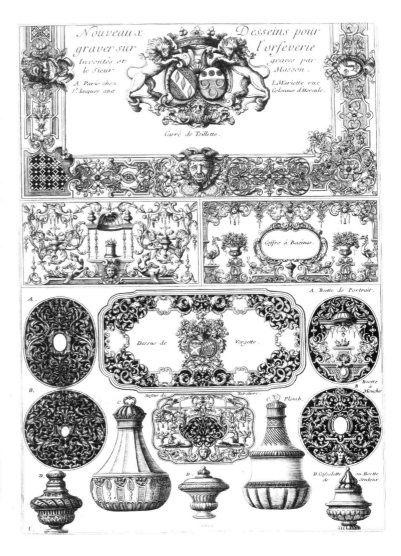

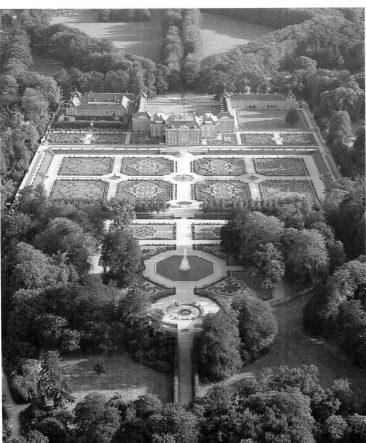

Garden parterres of Monsieur Rendorp,
print, Daniel Marot.
Paris, Bibliothèque des Arts Décoratifs

Title page, *Nouveaux desseins pour graver l'orfèvrerie*
(New designs for engraved goldsmith work), print, Masson.
London, Victoria and Albert Museum

This page of designs intended for goldsmiths provides an illustration of the ease with which decorative forms were circulated and adapted to suit different projects. The use of various techniques and the demands of widely varying formats encouraged the modification of established motifs in ways that sometimes gave them a grotesque character.

The gardens at Het Loo, 1686–1702.
Apeldorn (Holland)

After arriving in the Netherlands in 1685, Daniel Marot was placed in charge of the work at Het Loo, the stadtholder's residence. The superb gardens there, recently restored, feature "embroidery" parterres that are smaller than those in contemporary French garden designs. Most such plantings have disappeared, obscuring the considerable degree to which they influenced ornamentalists in the period, notably the makers of real embroidery; such designs circulated in the form of prints like the one reproduced above.

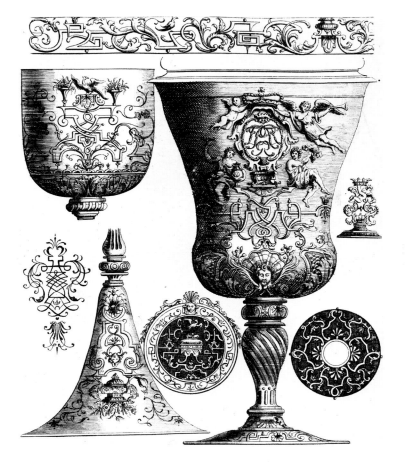

ABOVE

Two prints from *Groteschgen Werk vor Mahler Goldschmidte Stucator Inventirt durch Paulus Decker Architectum* (Grotesque designs for painters, metalworkers, [and] stuccadors invented by Paulus Decker, architect), Paul Decker the elder, Augsburg.

Paris, Bibliothèque d'Art et d'Archéologie, Fondation Jacques Doucet

The architect Paul Decker here provides a set of model designs suitable for execution in a wide range of sizes and media. Though the title describes them all as grotesques, they include interlace, moresques, and elements conventionally associated with grotesque compositions. Some of the patterns bring to mind champlevé enamel and niello work.

Grotesque composition, print, Jean Bérain.

Paris, Bibliothèque Nationale

This design is in the Italian mannerist tradition but evidences a shift toward the whimsical French grotesque epitomized by the work of Gérard Audran (1640–1703). In the center, three merry diners seated precariously on delicate bandwork raise toasts around a mysteriously levitating table; below them, a pair of behatted monkeys roasts a chicken, while on either side servants rush to deliver more food and drink, ascending stairs supported by corpulent term figures that are playful allegories of Gluttony. Musicians serenade from columned balconies, while Bacchic figures (which also appear in the two oval medallions) gambol over the eccentrically arched entablature crowning the whole, which is overgrown with grapevines. Garlands, canopies, parasols, trellises, and decorative birds abound, but the final effect is remarkably airy and transparent (see also page 194).

Tapestry from the set known as
The Attributes of the Marine, after designs
by Jean Bérain, 1688–89.

Private collection

'This tapestry is one of a set woven in the Parisian workshop of Jean Hinard after designs by Bérain. The lavish cycle—it included eight large hangings and four small ones, in all of which gold thread was freely used—was commissioned by the marquis de Seignelay, the son of Colbert and Minister of the Marine renowned for his extravagance. This piece is among the few surviving works known indis-putably to be based on drawings by Bérain; an engraving that varies only slightly from the exe-cuted version was included in the set of prints reproducing designs by the artist (1711). The trellis-like compositions framing the principal figures rep-resent a sober, and probably earlier, variant of Bérain's more fanciful arabesque idiom *(see opposite page),* which was given wide currency in print form and frequently imitated. The arms under the canopy were originally those of the marquis de Seignelay, but after his death they were replaced by those of Charles of Lorraine, count de Marsan, his former wife's second husband.

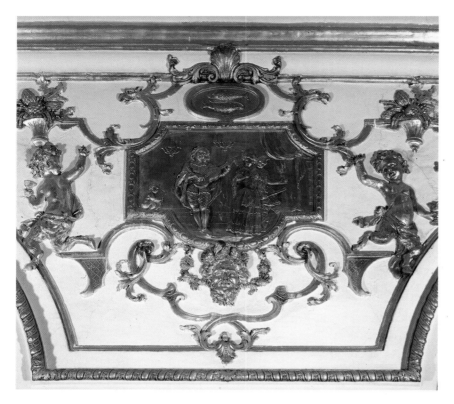

Grand salon in the hôtel du Petit Luxembourg (detail), 1710–13.

Paris, residence of the president of the French Senate

Toward the end of Louis XIV's reign, this Parisian residence was extensively remodeled by architect Germain Boffrand (1667–1754). Pictured here is Pisces, one of the zodiac spandrels in the arcaded wall of the grand salon; its gilded ornamental composition resembles arabesque designs by Bérain.

Plate 4 from *Neues Inventierte Laub und Bandlwerk von Silber Arbeiten zu finden in Nürnberg* (New foliage and bandwork designs by Nuremberg silversmiths), print, Hieronymus Bölmann, Nuremberg, c. 1710–30.

Paris, Bibliothèque des Arts Décoratifs

These model designs, with their repeated motifs and readily adaptable compositions, were as well suited for use by makers of marquetry furniture as they were for goldsmiths. Here the armature is composed of *Bandlwerk*, a Germanic derivative of interlace, but combined with characteristically arabesque elements: canopies, bouquets, terms, birds, and acanthus.

Plate 4 from *Nouveau livre d'ornemens de plafonds* (New book of ceiling ornament), print, engraved by Gérard Joullain after a design by Jean Bérain.

Paris, Bibliothèque d'Art et d'Archéologie, Fondation Jacques Doucet

The fragmentary, asymmetrical nature of this composition makes it all but unique in Bérain's published oeuvre. It is one of his most attractive designs and brings to mind Italian ceiling decorations featuring tiny figures against a white ground. Realistic notions of scale are abandoned: the term figures, tortoises, elephants, etc. punctuating its elegant filigree pattern are all of comparable size.

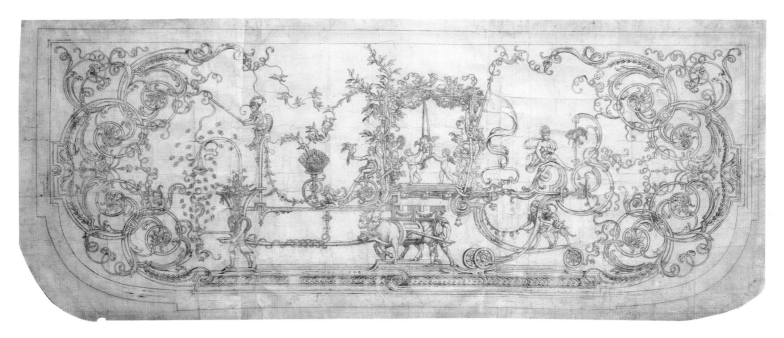

Design for a tabletop,
engraving, red and black ink,
early eighteenth century.

Boston, Museum of Fine Arts

This Bérain-like design for a marquetry tabletop
is attributed to the Boulle workshop, but many of
its features—notably the curious bandwork
harness encasing the oxen and the man leading
them forward—derive from grotesque prints by
Cornelis Bos (c. 1510–1555), some of which are
dated 1550. Several pieces survive in which
marquetry tops influenced by these images are
combined with table bases engraved after designs
by Boulle. This is a fine example of how
seventeenth-century French artisans adapted and
extended the grotesque idiom of the Italian
Renaissance, with seductive results.

Title page [?], *Neues groteschgen Werk
inventirt durch P. Decker Architectum*
(New grotesques devised by P. Decker,
architect), Paul Decker the elder,
Augsburg, c. 1705.

Paris, Bibliothèque des Arts Décoratifs

These free-floating but rather cumbersome
grotesque designs somewhat resemble Bérain's
early work, which contemporary French orna-
mentalists had largely abandoned for the lighter
idiom subsequently developed by Audran.

Ceiling of the bedroom in the
hôtel de Mailly (detail), 1687–88.

Paris, 27 quai Voltaire

Several of the ceilings in this Parisian hotel were
painted by André Camot after designs by Jean
Bérain, but this is the only one to survive. In 1776,
when there was a new interest in Roman
arabesques, this room was described as a *cabinet
d'arabesque*, but in 1708 the ceiling was said to be in
the form of an *impériale*, a term designating either
an elaborate bed canopy or a fabric-lined coach
ceiling, both of which usually featured central
medallions like the one seen here. The gold
patterns against a white ground illustrate why
certain rooms were called *cages* by the French in
the seventeenth century. The arabesques rise from
thick bases and consist of bandwork, acanthus, and
grapevines. The grotesque character of the whole
is reinforced by lion snouts as well as "relief"
medallions, which bring to mind ancient Roman
stucco ornament.

Plate 4 from *Plusieurs dessins de plafond
dédiés au duc d'Orléans*, Jean Lemoyne,
known as Lemoyne de Paris.

*Paris, Bibliothèque d'Art et d'Archéologie,
Fondation Jacques Doucet*

Lemoyne de Paris (1638–1713) and Lemoyne le
Lorrain are known to have worked with Jean

Bérain, notably on the edition of prints after his
work. They also made important contributions to
the grotesque tradition. Most of their production
has disappeared, for the bulk of it was commis-
sioned by Monsieur, Louis XIV's brother, for the
château at Saint-Cloud (destroyed). This design is
dominated by a large central medallion resembling
a dome. The corner composition, featuring

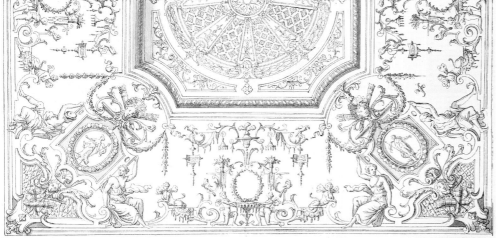

trophies of arms, reclining figures, and pictorial medallions are in the tradition of Le Brun, but the intervals between them are occupied not by narrative or allegorical paintings—as in Le Brun's decor at Versailles—but by elegant grotesque compositions.

Ceiling design, pen and ink.

Stockholm, Nationalmuseum

The basic configuration of this design is similar to that at the left, but the absence of the heavy cornice elements considerably lightens the effect. Though usually attributed to Bérain, it is closer in style to Lemoyne de Paris.

The Marriage of Alexander and Roxanne, tapestry after a composition by Raphael, border designed by Lemoyne le Lorrain.

Paris, Mobilier National

Appropriately enough, the border of this tapestry was conceived as an homage to Raphael as the rejuvenator of the classical arabesque tradition.

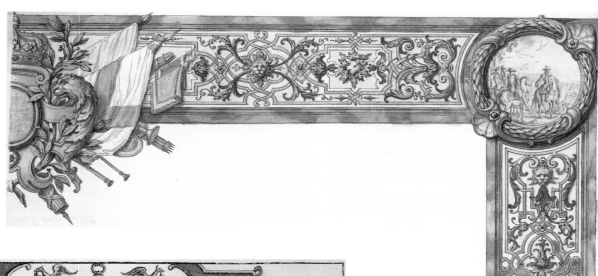

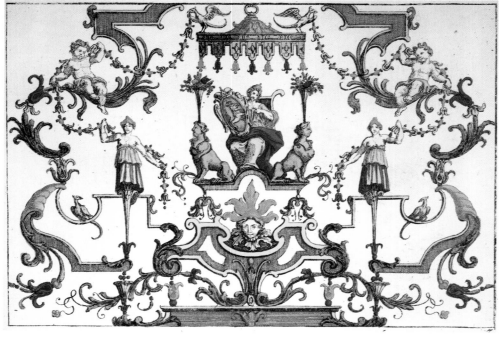

Grotesques, hand-colored print,
Paul Decker the younger,
Augsburg, c. 1705–10.
Cologne, Museum für Angewandte Kunst

This impression of a print by Decker the younger (1685–1742) was colored at some later date. The effect produced by such designs could vary considerably according to the palette used by the artists and craftsmen appropriating them.

Border design for a tapestry from the *Battles of Charles XI* cycle, drawing and watercolor, workshop of Jean Bérain, 1696–97.
Stockholm, Nationalmuseum

Nicodemus Tessin the younger initiated a project to have woven in France a set of tapestries after paintings by Johann Philipp Lemke picturing the victories of Charles XI of Sweden, with border designs commissioned from Jean Bérain. Note that the border's lower section consists only of grotesque compositions, but that grotesque motifs are combined with patterns of bandwork in the upper section, an indication of how these two ornamental genres were largely interchangeable in the period, which tended to view them as pictorial and textile variations on the same idea. In the end, however, this design was rejected.

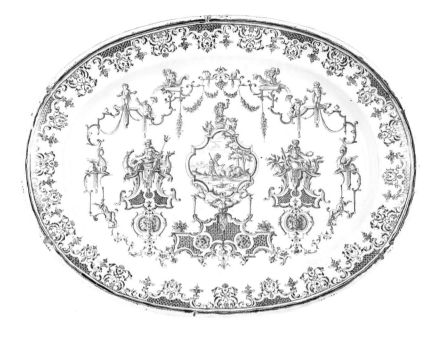

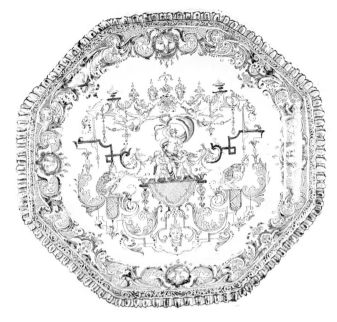

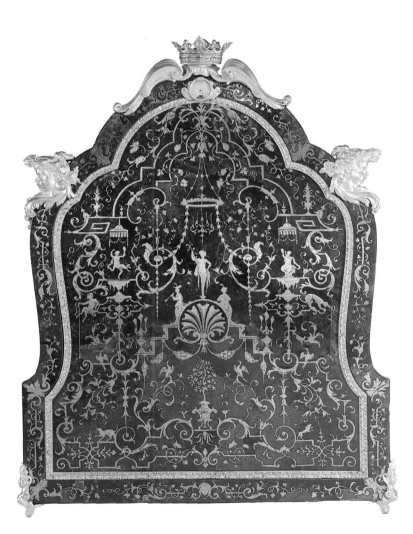

Oval platter, Moustiers faïence, c. 1720.

Paris, Musée des Arts Décoratifs

This is a typical example of Moustiers faïence, which was often decorated with fanciful grotesque designs in the style of Bérain. Here, a central vignette with a knight and a dragon is flanked by depictions of Neptune and Ceres.

Octagonal platter, Nevers faïence, 1736.

Sèvres, Musée National de Céramique

Designs in the Bérain idiom long remained popular on ceramics, although in later productions the style is considerably coarsened, as here. The introduction of many colors blunts the effect, and certain elements stand out awkwardly, such as the moresques configurations on either side of this example.

Mirror back, tortoiseshell and gilded copper inlay with gilt brass fittings, 1713.

London, Wallace Collection

This sumptuous mirror was made by La Roüe in 1713 for the duchesse de Berry. Boulle marquetry technique provided an ideal medium for the display of arabesque designs, and luxury objects such as this one played an important role in both the perfecting and the dissemination of the new French arabesque idiom.

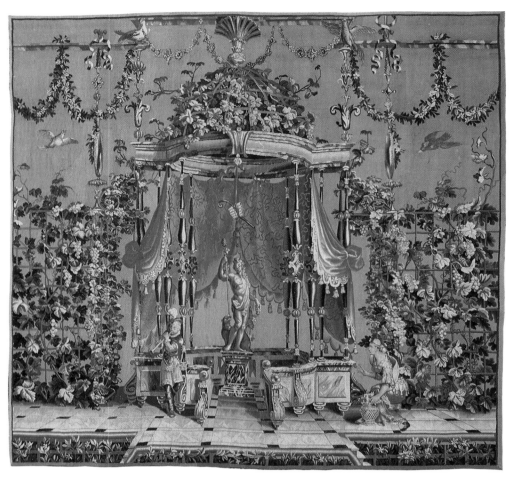

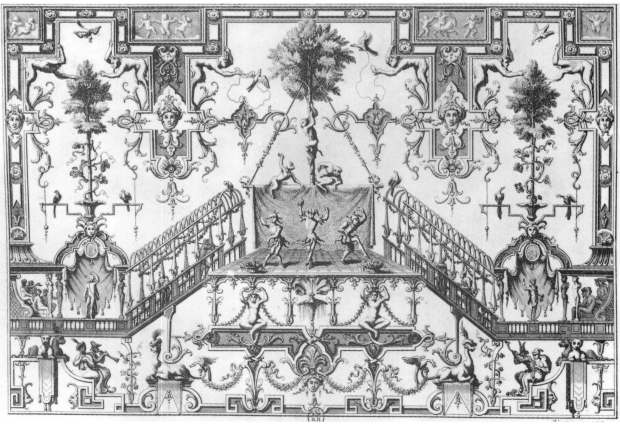

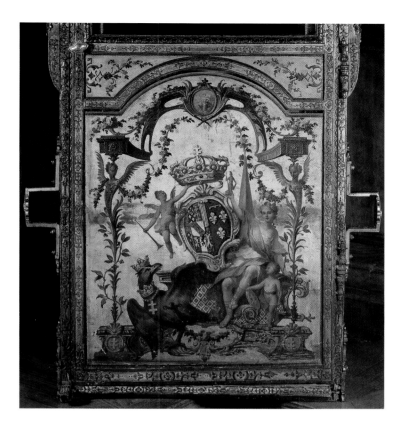

FACING PAGE

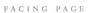

The Offering to Bacchus, tapestry, Beauvais factory, c. 1690.
Aix-en-Provence, Musée des Tapisseries

This is from a cycle of French grotesque tapestries produced by the Beauvais factory. The designs were long attributed to Bérain but are in fact by Jean-Baptiste Monnoyer (see also page 184). The entire set consists of six pieces: three horizontals featuring animals, animal-tamers, acrobats, musicians, and commedia dell'arte characters; and three verticals depicting offerings to statues of Pan and Bacchus. Trellised pavilions supported by fantastic blue teardrop columns are prominent in all the compositions. The unusual *tabac d'Espagne* (Havana yellow) backgrounds doubtless helped to assure the set's considerable success.

Grotesque composition, print, Jean Bérain.
Paris, Bibliothèque Nationale

This is a typical example of Bérain's fanciful grotesque idiom, with its tiny figures situated within delicate configurations of trelliswork, stairways, tasseled hangings, garlands, etc. (see also page 186). This image, centered around a trio of jesters dancing on a mysteriously suspended stage, is notable for its affinity with Italian Renaissance models (although the griffins at the bottom are given a deliciously French inflection by their flamboyant hats) and the ambiguous treatment of the framing elements, which are not readily distinguishable from the composition proper: note how the T-squared satyrs at the top interact with the nearby birds and trees. Bérain's prints were first published late in his life (most of them around 1690 and 1703–10), but they were subsequently copied by printmakers in Augsburg and the Netherlands, facilitating the dissemination of his designs.

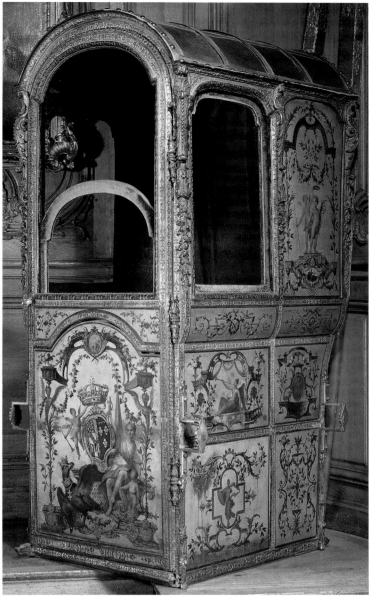

Sedan chair (detail and full view), carved, gilded, and painted wood, Paris, c. 1700.
Paris, Musée du Petit Palais

This sedan chair bearing the arms of the Orléans and Lorraine families was made for Elisabeth-Charlotte d'Orléans, known as Mademoiselle de Chartres, the daughter of Monsieur, Louis XIV's brother. On October 13, 1698, she married Duke Léopold of Lorraine, inaugurating a brilliant period at Nancy and Lunéville, the centers of Lorraine court life. The chair's many arabesque panels are all different. The largest, on the front, bears the princess's arms within an arabesque configuration topped by a blue-green portico of unusual pliancy, variations of which appear in several of the other panels.

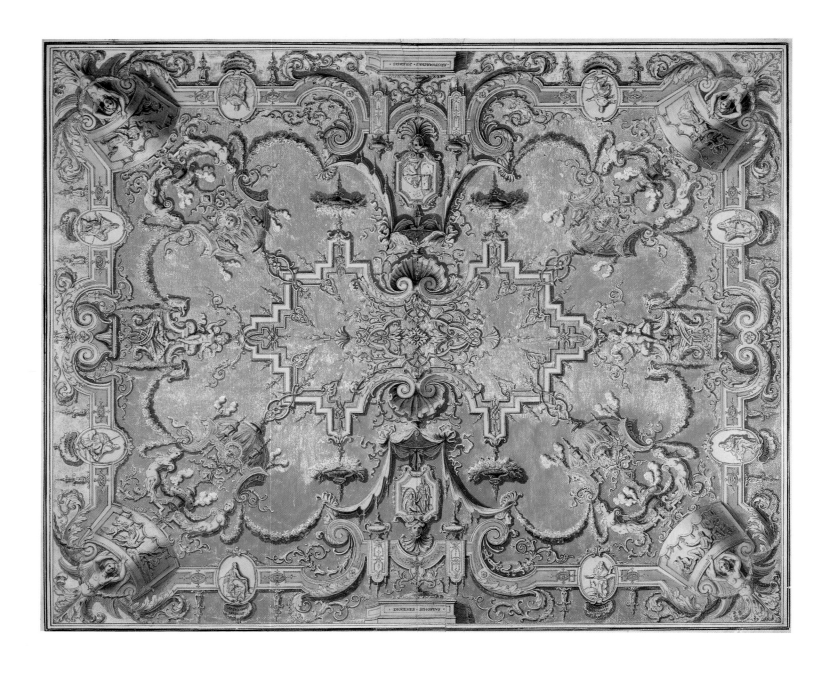

Design for the ceiling of the drawing room in the
Stockholm residence of Count Tessin, drawing and
watercolor, René Chauveau, 1697.

Stockholm, Nationalmuseum

This is one of three arabesque ceiling designs devised by Chauveau for the
residence of Nicodemus Tessin the younger (see also page 158). A delicate gold
filigree pattern in the manner of Bérain stands out against a lapis-lazuli
ground, suggesting the roof of a gilded cage against the sky. The room-as-cage
conceit was not new, but its evocation here is unusually successful: it's as
though the tortoiseshell ground in a panel of Boulle marquetry had been
removed, leaving only the openwork grill of its copper inlay design. Ten
medallions picture a selection of eminent Greek philosophers (Antisthenes
the Cynic, Diogenes in his tub, Democritus, Heraclitus, Thales, Socrates,
Plato, Aristotle, and Pythagoras) along with the mythological
figure Aristeus and his bees.

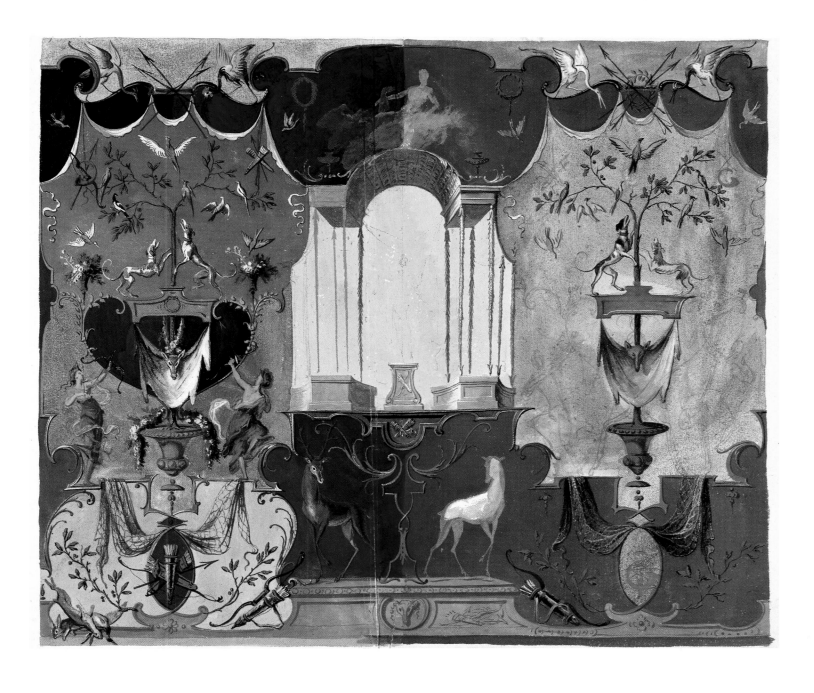

Decorative composition, gouache,
Claude III Audran, c. 1699 (?).

Stockholm, Nationalmuseum

The purpose of this gouache from the collection of designs by Audran
remains a matter of conjecture. It could be connected with a painted décor,
but the way the colors are applied suggests that it was probably conceived for
weaving; judging from the hunt motifs, it might well be a preparatory
composition for the set of *Diana* tapestries produced at the Gobelins. Note the
resemblance of the central pavilion to those in the *Triumph of the Gods* set
overseen by Noël Coypel (1628–1707), a project on which Audran collaborated.
The striking color contrasts as well as their disposition seem to be
conscious allusions to ancient Roman wall paintings.

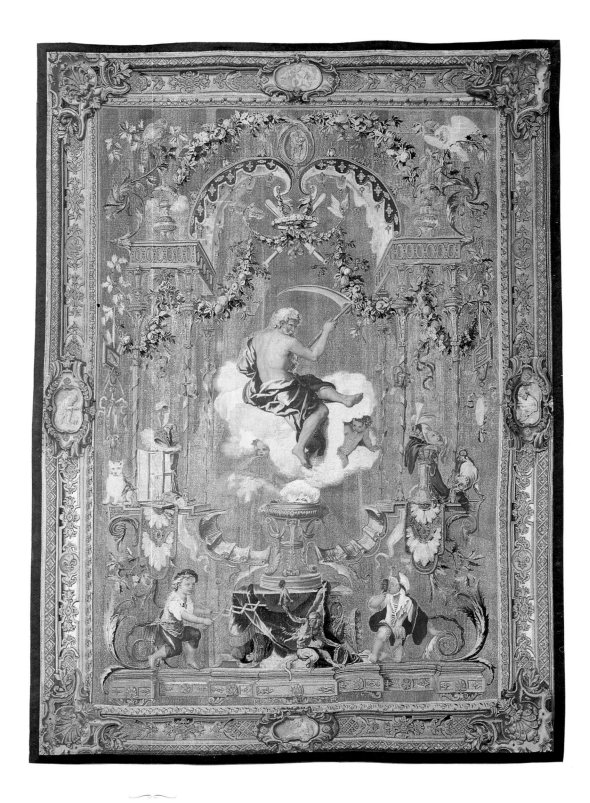

Saturn (or *Winter*), Gobelins tapestry
from the set known as the *Portières des dieux,*
after a design by Claude III Audran,
1699–1710 and after.

Paris, Mobilier National

*I*n 1699, Audran was commissioned to produce designs
for a set of eight vertical tapestries on the theme of the
four seasons and the four elements as personified by
classical deities, and thus called the *Portières des dieux.*
(Portière means "door-hanging," but tapestries in this
format were not necessarily placed over doors.) Louis
de Boullongne the younger (1654–1733) and Michel

Corneille (1642–1708), among others, collaborated with
Audran on the figures; François Desportes (1661–1743)
may well have been responsible for the animals. In 1710,
de Boullongne received a payment for designing
children for the *Juno* tapestry. The compositions struck
a new note, and the set remained in demand
throughout the eighteenth century. Here, Saturn
appears on a cloud beneath a delicate arabesque
portico, surrounded by various animals, vases, masks,
and cornucopias—which often figure in Audran's
work—as well as children, rinceaux, and a medallion
bearing a sign of the zodiac.

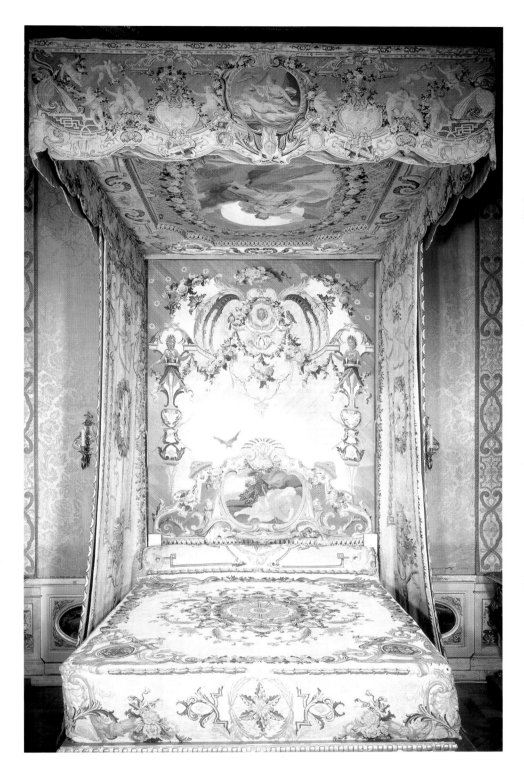

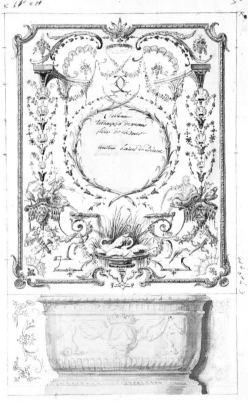

Design for a bathroom, drawing and
watercolor, Claude III Audran.

Stockholm, Nationalmuseum

The monogram on the central medallion of the tub
in this design indicates it was intended for the French
royal family. Nothing more is known about the com-
mission, but a date prior to 1720 seems unlikely.
Ornamental compositions like this one have little in
common with ancient grotesques, but their frequent
use in bathing cabinets serves as a reminder that their
predecessors were used in ancient baths. The
inscription indicates that the central medallion was to
be filled with an image of the triumph of Venus
accompanied by sea nymphs, and that an adjacent wall
was to feature a depiction of Diana at her bath.

Bed fitted with tapestries, c. 1720–30.

Château de Vaux-le-Vicomte

The affinity between dreams and arabesques—the logic of both is free-
associational—made this decorative style ideal for bedrooms. The tapestry
above this bed incorporates an illusionistic headboard featuring a large
cartouche that pictures a sleeping shepherd, but the balance of its composition
is given over to a rather fantastic design not unlike the new arabesques in
ornamental prints. This one is notable for its white central field, across which
an isolated bat flies. As often in such compositions, the top of the pavilion
insinuates a hint of spatial recession into the otherwise planar design.

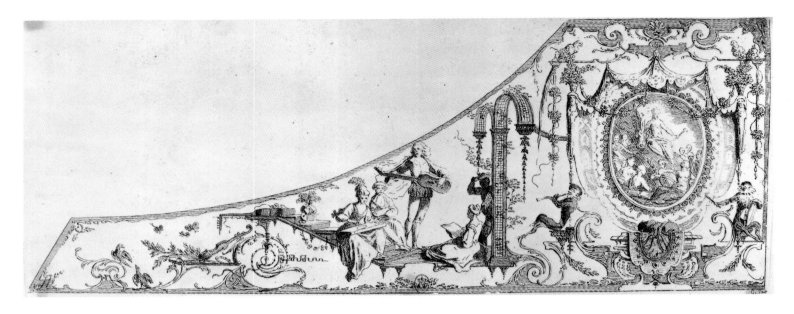

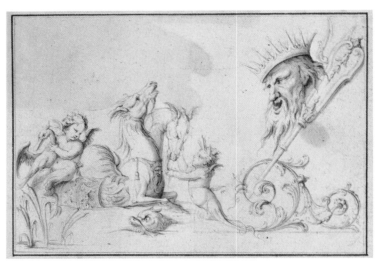

Cover of harpsichord case, Claude Gillot, print executed by the comte de Caylus.

Paris, Bibliothèque Nationale

Given the irregular shapes of their panels, great ingenuity was required to devise successful decorative compositions for harpsichord cases. Audran produced several such designs and painted the instrument belonging to painter Nicolas de Largillière (1657–1746). The illustrated composition by Gillot survives in the form of an etching made by the comte de Caylus, a celebrated Parisian collector, antiquarian, and arbiter of taste. He has cleverly divided the rectangular field on the right from the narrow one on the left with an image of arched trelliswork, which allows the two areas to flow together.

Ornamental motifs, drawing and wash, Bernard Turreau, known as Toro, c. 1729.

San Francisco, The Fine Arts Museums

The sculptor Toro (1672–1731) was also a prodigious designer. Burgundian by birth, he worked primarily in Toulon and Aix-en-Provence. His finest ornamental drawings are executed in wash applied with a thin brush. His Baroque sensibility was somewhat at odds with the prevailing taste of his day, and this precluded his receiving prestigious commissions. There is a surrealist air to the curious juxtaposition of images on this sheet, combining putti, marine horses, an oversize head of Neptune, and an upended rudder, but the rinceau on the right effectively integrates the disparate elements, giving the whole a surprising visual logic that at the same time manages to preserve its more disturbing qualities.

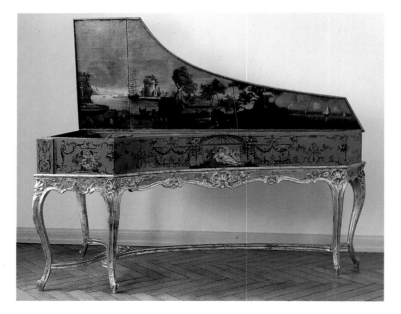

Harpsichord, G. B. Giusti, early eighteenth century.

Flensburg, Städtisches Museum

Harpsichord cases were often painted in this period, most often by specialists but occasionally by gifted artists at the beginning of their careers. In the seventeenth century the most striking images—often mythological landscapes with a musical theme—were executed on the instruments' inside covers, which are raised during performances. Gradually, however, arabesque patterns displaced such imagery. The transitional example at left probably dates from the early eighteenth century; its side panels feature arabesques while its inside cover pictures a seaside landscape.

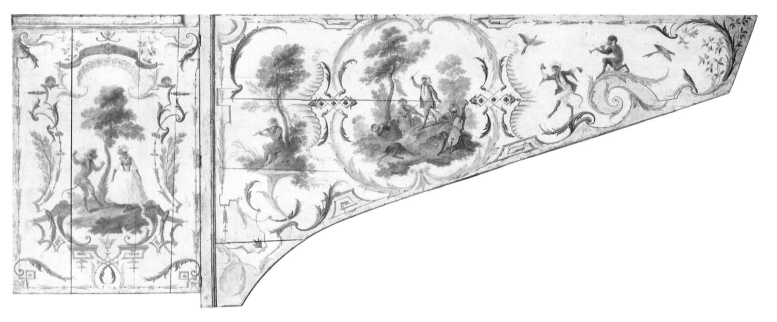

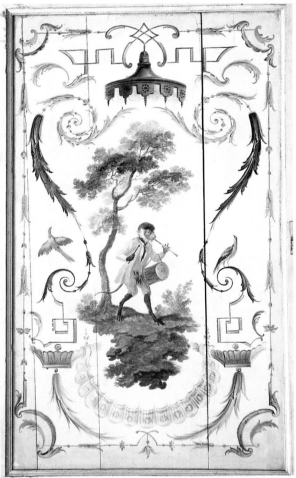

Harpsichord case painted by
Christophe Huet (two details), 1733.

Château de Thoiry, La Panouse collection

These filigree compositions against a white ground are
characteristic of the art of Christophe Huet (d. 1759). Huet
worked in the tradition of Watteau, Gillot, and Audran, all of
whom painted or produced designs for harpsichord cases,
but few of these instruments have survived.

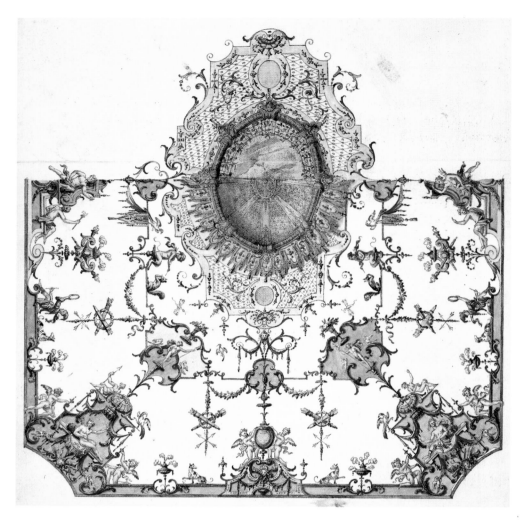

Ceiling design for the château d'Anet,
pen, watercolor, and gold wash,
Claude III Audran.

Stockholm, Nationalmuseum

Audran produced designs for the château d'Anet
on several occasions: first for the duc de Vendôme
and then, after the latter's death in 1712, for the
duchesse du Maine. It is fitting that Audran
worked in this Renaissance château built by Diane
de Poitiers, restoring its arabesque decorations and
twice producing others of his own, thereby
updating a French tradition extending over the
preceding century and a half, beginning with the
Ulysses Gallery at Fontainebleau (1641–60). Both
Audran's indebtedness to Bérain and certain
departures from his example are discernible here.

Though Audran's style was (as the Swede
Cronström once wrote to him) more delicate and
attenuated than Bérain's, there is no mistaking the
element of homage paid the elder artist. In this
example, probably from relatively early in his
career, the *impériale* format, with its large central
medallion, resembles similar designs by Bérain, but
the forms are thinner, producing a filigree effect
against the white ground. Gold is not entirely
absent but is used sparingly for emphasis. In the
designs by Audran illustrated on the facing page,
the central valanced medallion so characteristic of
Bérain's work has been replaced by openwork
trellis or lace patterns, a transition that exemplifies
the different temperaments of the two artists, and
clearly reveals the stylistic evolution that occurred
over the two decades between them.

Ceiling of the Blaues Kabinett, Johann
Baptist Zimmermann, c. 1723–24.

Schleissheim, Neues Schloss

This ceiling with silver stucco patterns, initially
against a white ground (now replaced by a blue
one) to complement adjacent walls covered with
brocade woven with silver thread, is a fine exam-
ple of the appropriation of painted arabesque
compositional formulas for relief work. The design
incorporates a moresques medallion and airy
porticos in the manner of Audran (still active in
France at this time), although here they are
given a decidedly Germanic inflection.

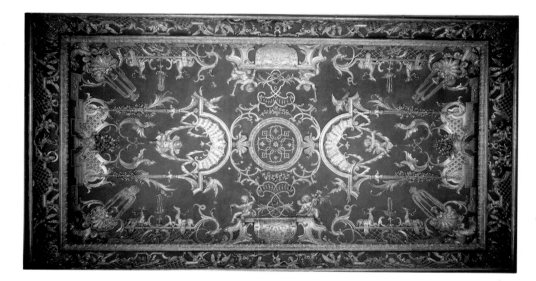

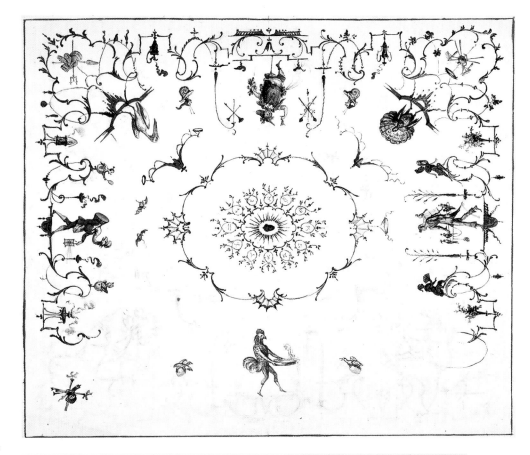

Ceiling design, pen and watercolor, Claude III Audran.

Stockholm, Nationalmuseum

This design is grotesque in two senses: as a belated derivative of ancient *grotteschi,* and in its use of fantastic creatures that might be deemed "grotesque" in a more generic sense. These hybrids of men and animals personify the elements and the parts of the day. In the center, a small mask of Apollo radiating light is surrounded by a filigree of tendrils enclosing delicately painted signs of the zodiac, emblems that were frequently used in arabesque designs. If one compares the present composition to the whimsical arabesques against a gold ground that Audran designed for the Menagerie at Versailles (1698–99, destroyed), that were among his greatest successes, this design appears to be considerably later in date.

Ceiling of the study of the hôtel Angran de Fonspertuis, Claude III Audran, 1723.

Paris, 21 Place Vendôme

Collector and financier Angran de Fonspertuis commissioned Audran to design a painted arabesque ceiling for the study in his residence, the decoration of which was overseen by Jacques V Gabriel (1667–1742) beginning in 1719. This, along with a ceiling at Clichy, is one of the few surviving works by Audran that is securely dated. It is also a rare example of a genre of interior decoration that was once quite fashionable in France. Audran's style has evolved considerably. Henceforth his compositions featured smaller figures, valance motifs with spiky ornaments, and livelier colors, all deployed as here against a white ground. Included in the design are four oval paintings of female nudes, set apart from the rest of the composition by their illusionistic painterly style and elaborate frames.

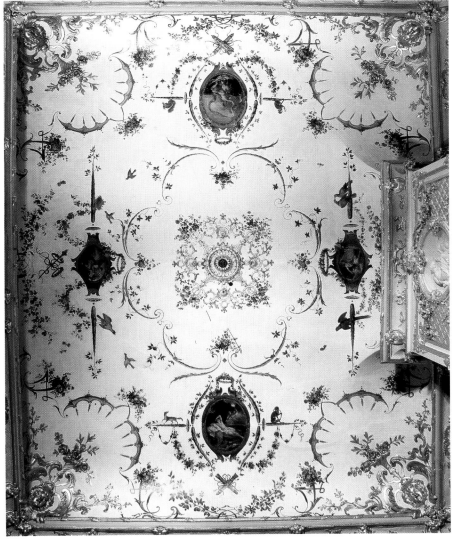

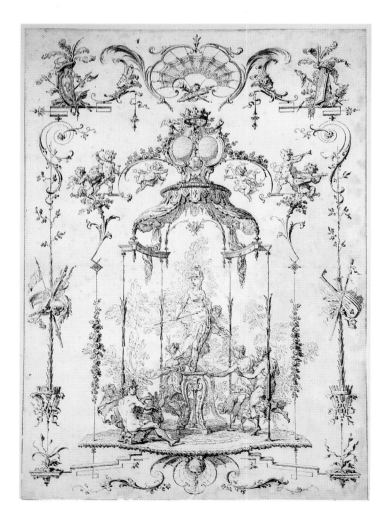

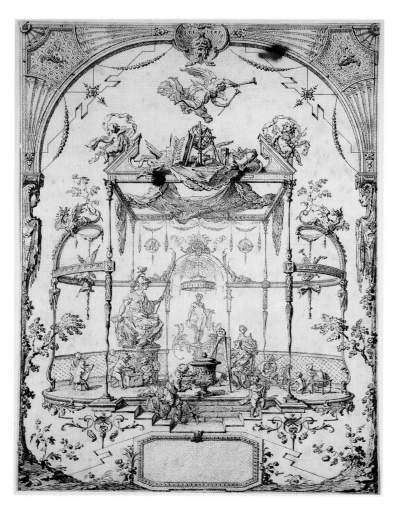

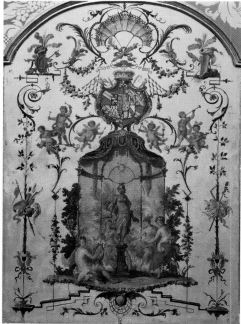

Panel from the sedan chair of
Cardinal Armand-Gaston de Rohan.
Strasbourg, Musée des Arts Décoratifs

This painted panel bearing the arms of the
Cardinal du Rohan was based on a design by
Gilles-Marie Oppenord. Its shape suggests

that it was part of a sedan chair. Comparison with
Oppenord's original design *(see above)* reveals
certain modifications. The space encompassed
by the central pavilion has been given a realistic
color scheme, which sets it apart from the gold
ground of the surrounding field.

Offering to Minerva, pen and brown ink,
Gilles-Marie Oppenord, c. 1730 (?).
Berlin, Kunstbibliothek

The central motif in this composition, which is
typical of the new arabesque perfected in the
decade after Louis XIV's death, is a delicate pavilion
sheltering a statue of Minerva, all drawn in
perspective. But whereas comparable structures in
Audran's work would be surrounded by two-
dimensional elements, Oppenord has extended the
perspective treatment to the platform and to
other elements throughout the composition.
J. D. Ludmann has demonstrated that this drawing
was the model for the sedan chair panel illustrated
at left, but we cannot be sure that Oppenord's
design was created expressly for this commission,
for it features a double escutcheon over the gazebo
that does not correspond to the cardinal's arms.

Homage to Apollo, pen and brown ink,
Gilles-Marie Oppenord, c. 1730 (?).
Berlin, Kunstbibliothek

This design features a perspectival treatment even
more pronounced than is usual in Oppenord's
work, delineating several layers of depth with the
size of the figures diminishing proportionately as
they recede. Such carefully gauged spatial effects
represent a departure for the French arabesque
idiom of the period. The framing elements have
a marked Italian flavor, notably the sphinxes
emerging from term figures on either side. The
composition might have been intended to serve as
a title page, and it seems to be connected in some
way with work undertaken at La Granja (Spain),
the palace north of Madrid that was built in
imitation of Versailles for Philip V of Spain by
sculptor René Frémin (1672–1744): the foreground
figure is shown carving a large vase, and the
seated statue of Minerva resembles a sculpture
executed by Frémin for this Spanish park.

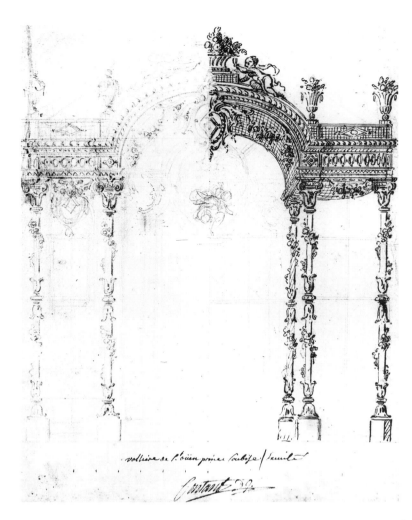

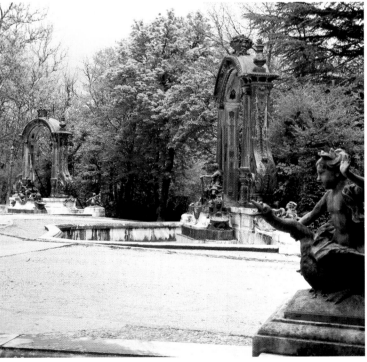

Design for the aviary of the Prince de Soubise in Saint-Ouen,
pen and brown ink, Pierre Contant d'Ivry, c. 1740.

Berlin, Kunstbibliothek

This resembles a study for a tapestry cartoon, but in fact it is an architect's
preparatory design for an aviary of exotic birds that was erected in the gardens
of the château at Saint-Ouen. The slender columns bear a striking resemblance
to those in arabesque designs by Gillot, Watteau, and Oppenord.

Fountain design, pen, ink, and wash, Gilles-Marie Oppenord.

Montreal, Canadian Centre for Architecture

At the beginning of the eighteenth century, Oppenord drew various ornamen-
tal designs in the pages of a copy of a French edition of Cesare Ripa's *Iconologie*
of 1593, published in 1636, with illustrations by Jacques de Bie and commentaries
by Jacques Baudoin. This fountain, which features a sculpted group under an
arch supported by columns whose bases are not classical, has a generic
resemblance to the pavilions characteristic of French arabesques as well as a
more specific similarity to the fountains at La Granja. This may not be merely
by chance: René Frémin used designs by Oppenord for several lead vases
executed for the Spanish park.

Fountains at the *Ochos Calles* (plaza of the eight paths),
René Frémin, c. 1732.

Palace of La Granja (Spain)

These fountain complexes were conceived as frames for views down shady
paths leading into the park at La Granja. Each of the eight figures—Saturn,
Minerva, Hercules, Ceres, Neptune, Victory, Mars, and Cybele—stands out
against a backdrop of receding greenery. The framing arches, which resemble
arabesque pavilions, make decidedly unclassical use of classical elements: their
column shafts are decorated with foliage and stand atop narrow bases, and
these units are buttressed by massive volutes.

Two panel designs, drawing and
watercolor, Claude III Audran.

Stockholm, Nationalmuseum

The grotesque genre lends itself to mockery. Its
monkeys and other animals mimicking humans
are ideal vehicles for turning social customs and
mores to ridicule. These two arabesque panels are
decorated with emblems of fire and air, above
which are pictured ostrich-like birds in human garb

(compare the figures in the ceiling design on
page 203). The meaning of such personifications
can be enriched through the addition of subsidiary
elements and attributes. When Audran's father
designed a ceiling incorporating allegories of the
sciences and the arts, he appended an ironic
commentary on false practitioners in the form of
a monkey and a parrot. As Caylus once observed,
Audran "made us forget the heavy, oppressive
style of his predecessors in this mode."

FACING PAGE

The Seducer, oil on panel,
Antoine Watteau, 1709.
Private collection

The Faun, oil on panel,
Antoine Watteau, 1709.
Private collection

The early biographers of Watteau state that after
receiving early training with Gillot, in 1707–8 he
worked in Audran's studio. The two panels at right
were part of the decor produced during these
same years for the Parisian residence of Louis
Béchameil, marquis de Nointel (on the rue de
Poitiers). They were engraved in 1731 and 1738 by
Aveline along with six other panel designs in
a similar format (*The Drinker, Folly, Momus, The
Grape-Picker, Pierrot in Winter,* and *Bacchus*)—
all characteristic arabesque personifications
appropriate for a dining room. These are the only
two originals of the set to have survived (in the
nineteenth century they were discovered set into
a door). Delicate arabesque motifs in a style
typical of Audran surround beautiful figural
vignettes that bear Watteau's unmistakable stamp.
Documents found in Nointel's papers after his
death record payments made to Audran and
"the other painter" (perhaps Watteau). There has
been much speculation concerning the precise
disposition of these panels. It is extremely unlikely
that they were used as wall panels. The perspec-
tive of four of the scenes is from slightly above,
while in the other four it is from slightly below
(note the small platforms supporting the figures in
the two panels shown here), which suggests that
they were arranged in two registers, probably in
two doors of four panels each. Their designs
would have complemented arabesque Beauvais
tapestries known to have been in Nointel's collec-
tion. In any case, these compositions exemplify the
two stylistic poles between which the arabesque
universe unfolded: one realistic, represented by
the amorous couple; the other more fantastic and
artificial, represented by the statue of Bacchus
in its trellis pavilion.

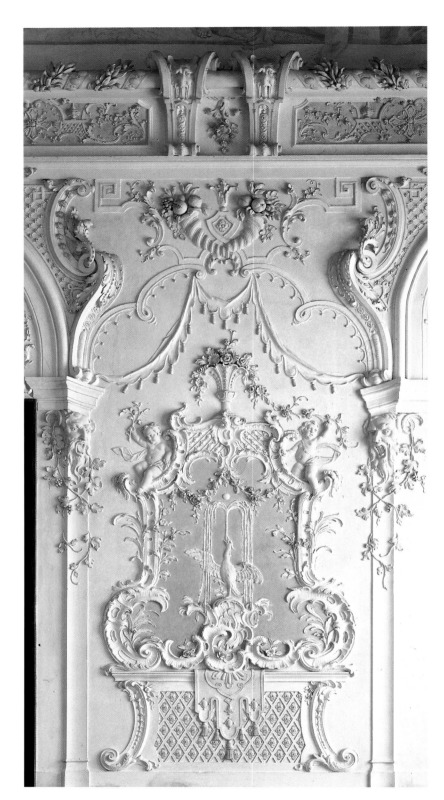

FACING PAGE

Decorative panel design, drawing and watercolor, Claude III Audran.
Berlin, Kunstbibliothek

Such panels were often used in bathing rooms and dining rooms, perhaps in emulation of ancient practice. This design is notable for the beautiful seated figure of Folly in the center and the bizarre long-necked chimeras, French Regency variations on an ancient theme.

Wall painting (detail), Christophe Huet, c. 1740.
Château de Champs

The paneling in the large salon of the château de Champs, which dates from the end of the reign of Louis XIV, was repainted with arabesque and chinoiserie designs by Christophe Huet about 1740, when it was owned by the duc de La Vallière. Claude III Audran had done work for this same château shortly before 1733. The illustrated dado panel is notable for its asymmetry and its elegant birds.

Decorated wall panels from the hôtel Peyrenc de Moras, Place Vendôme, Claude III Audran and Nicolas Lancret, 1724.
Paris, Musée des Arts Décoratifs

In 1724, financier Abraham Peyrenc de Moras commissioned Jacques V Gabriel to build and decorate a residence on the Place Vendôme. The corner room on the main floor, which had a superb view of the square, was decorated with paneling carved by some of the most eminent wood sculptors of the day and then painted with arabesque designs by Audran. He worked on this project with the young Nicolas Lancret, then largely unknown. As with Watteau, Audran had him execute the figures, but the result is markedly different from those produced by the earlier collaboration. The figures are more crisply delineated, their gestures more precisely described. Pictured here are a female pilgrim—an homage to Watteau's great painting of 1717, *The Embarkation for Cythera*—and an amorous Turk. These panels were originally placed on either side of a window; several others from the set are now in a private collection. Tradition has it that Lancret's contributions to this decor were so admired that he was summoned to work at Versailles.

Pier in the northern antechamber or music room (subsequently the billiard room), Johann Baptist Zimmermann (stuccador) and Josef Effner (architect), 1723–24, modified in 1756.
Schleissheim, Neues Schloss

Here an entire section of wall has been given over to a large arabesque composition in stucco relief. The central motif is arrayed against a tinted ground, giving it more prominence than the rest of the design, whch is mostly white. The base, the tasseled hanging, the swags of fabric, and the hint of a valance are all typical of the genre. *Bandlwerk* and vegetal elements still play important roles, but the incorporation of two grotesque masks brings the whole closer to the new arabesque idiom.

Wall panel from the so-called *Grande Singerie* in the château de Chantilly, Christophe Huet, c. 1735.
Château de Chantilly

The wall panels and ceiling of the study in the small château at Chantilly were painted by Huet for Louis-Henri de Condé, the duc de Bourbon. The paintings, which feature richly costumed Chinese figures, monkeys, etc., are not securely dated; they may have been added to earlier carved panels. The largest ones feature elaborate gilded framing elements similar to those on the margins of arabesque prints after Watteau, Boucher, Gabriel Huquier, etc. Arabesques and exotic imagery are mutually compatible, for both are predicated on decorative visual fantasy.

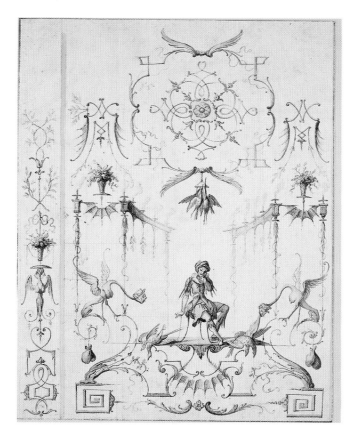

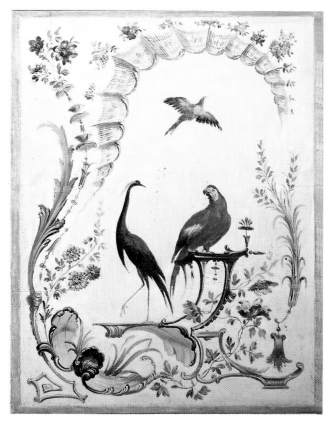

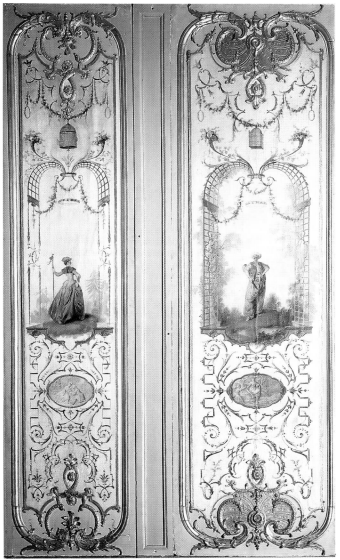

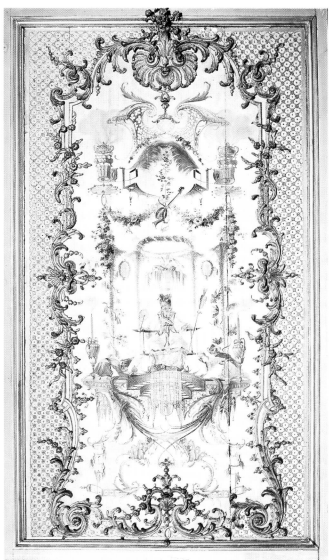

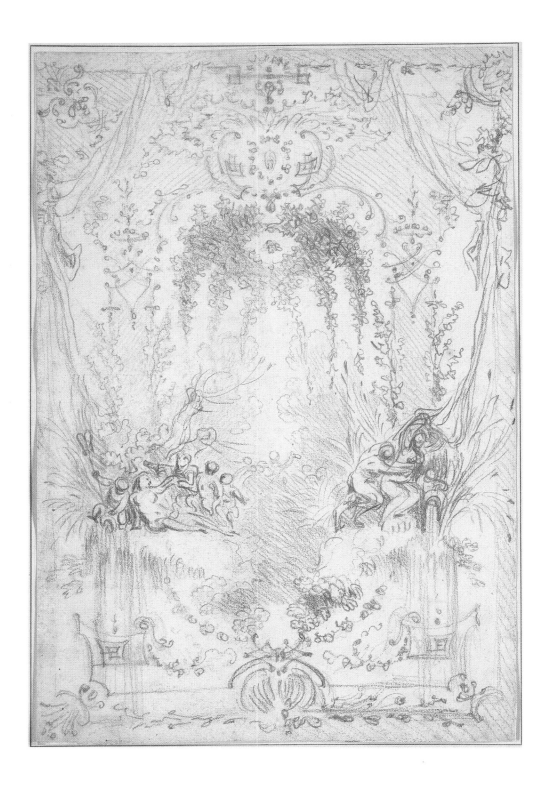

The Arbor, sanguine drawing,
Antoine Watteau, c. 1716.
Washington, D.C., National Gallery of Art

Before his reception by the Royal Academy in 1717, Watteau was best known as an arabesque painter. This drawing is one of a handful of such designs securely attributable to him; it was subsequently engraved by Huquier, who gave it this title. Characteristically, the center is all but empty; it is framed by a delicate trellised arbor, an element frequently used in new arabesques after 1715. The relationship between the figures and their surroundings is differently conceived than in the work of Bérain and Audran: here, thanks to the visual device of the drapes, the figural groups can spill over into the field of the border. This sheet reveals much about Watteau's working methods. He would draw half of an ornamental armature and fold the paper over to complete the design with a counterproof image; then he would add the figures and other details. Such procedures based on mirror reflections played an important role in the elaboration of arabesque designs (see Huquier print on page 183).

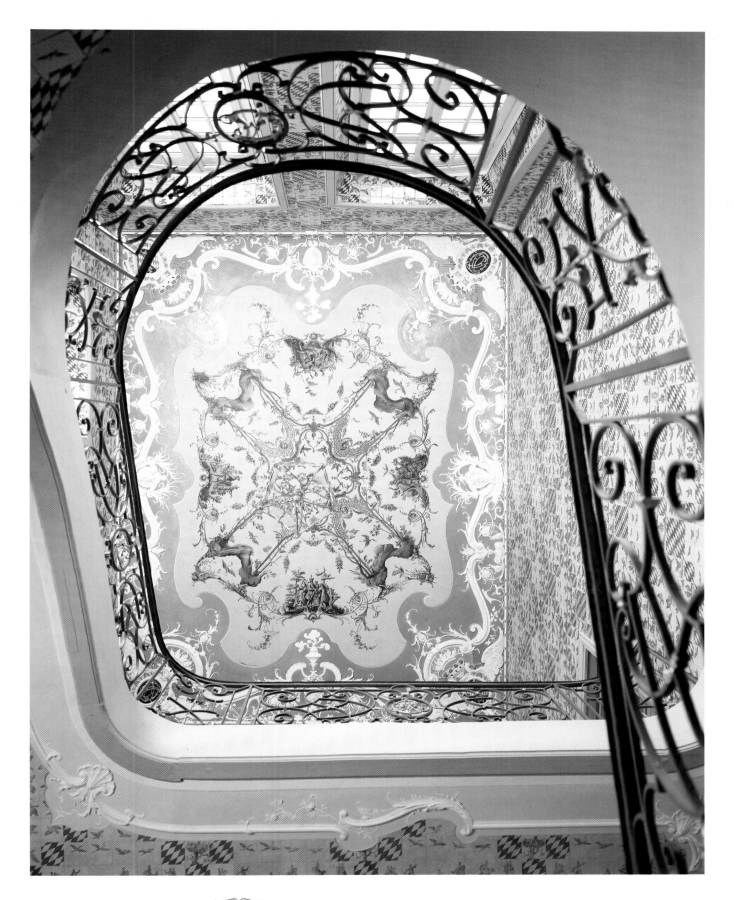

Staircase ceiling in Falkenlust
hunting lodge, painted by Stephan
Laurenz de La Roque, 1736.

Brühl (Germany)

When Clemens August of Bavaria, the elector of
Cologne, had a pavilion built in the park of his
palace at Brühl for his morning hunting expeditions, its decoration reflected his passion for falcon
hunting. In the central portion of this ceiling
painted blue and white (the colors of the house of
Wittelsbach), designed by Stephan Laurenz
de La Roque, exoticized falconing vignettes are
surrounded by arabesque compositions.

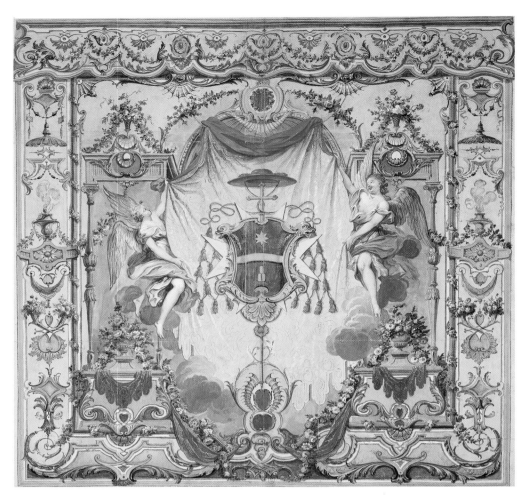

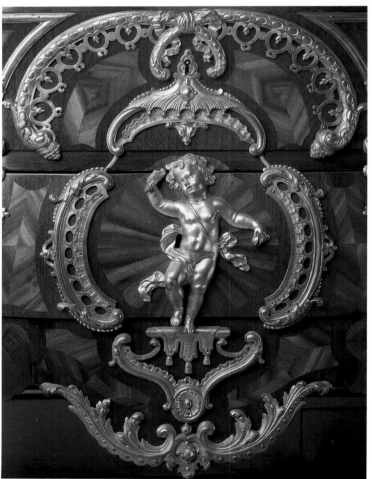

Design for a tapestry dais bearing the arms of
Cardinal Albani, drawing and watercolor, 1731.

Paris, Bibliothèque Nationale

To publicize the achievements of French tapestry makers, the duc d'Antin,
superintendent of the king's buildings, decided to present Cardinal Albani, the
nephew of Pope Clement XI, with a tapestry dais. Albani was flattered but
requested that it be unusually large, as he intended to install it in a church. The
director of the French Academy in Rome, Nicolas Vleughels, insisted that a
special design be made, for "with the ornaments that are so well executed in
France, this should be a magnificent piece." This drawing—probably by Pierre
Josse Perrot—was the result. The design, which pays homage to the Roman
grotesque tradition but with a distinctively French inflection, is complex and
presented the weavers at the Gobelins factory with multiple problems.

Commode (detail), attributed to Charles Cressent.

Munich, Residenzmuseum

The sumptuous gilt-bronze fittings on this commode take the form of a putto
standing on a valanced platform and sheltered by a Moorish pavilion, elements
characteristic of the arabesque vocabulary during the Regency (1715–24).
Cressent (1685–1768) was one of the finest makers of luxury furniture in the
first half of the eighteenth century; like Boulle, he was partial to elaborate
bronze fittings, of which he was a master craftsman and designer.

Carpet design for the dais in the Salon of
Mercury at Versailles, drawing and
watercolor, Pierre Josse Perrot and
Blin de Fontenay the younger, 1724.

Paris, Bibliothèque Nationale

This design for a Savonnerie carpet—intended
for placement beneath the king's ceremonial bed at
Versailles—is worked up in two alternative color
treatments; the one on the right was executed. It
employs the arabesque vocabulary typical of royal
commissions at this time. The border is treated like
an interior cornice and features rinceaux, skewed
Greek key configurations, cornucopias (similar to
those by Audran), and webbed medallions resem-
bling bat's wings. But it is the color contrasts that
are most notable: the use of different tones to
isolate adjacent, eccentrically shaped fields makes
the final effect sumptuous rather than delicate.
In arabesque prints of the period such contrasts
could only be suggested by the use of cross-
hatching; here the full importance of such color
decisions is readily apparent.

The Triumph of Minerva (detail), Gobelins tapestry, after a design by Noël Coypel.

Paris, Mobilier National

Seven of the eight compositions in the Gobelins tapestry set known collectively as *The Triumph of the Gods* were adapted by painter Noël Coypel from an earlier series of Brussels tapestries (and one of these seven was based on still earlier tapestry designs). The eighth composition, *The Triumph of Philosophy,* was entirely Coypel's own invention. The cartoons were commissioned in 1684; weavings were produced from 1686–87 to 1695. Precisely because of the successive reworkings, this project is instructive about the process of transmission; in this case, what resulted were designs informed by a growing fascination with the Renaissance arabesque tradition. Some portions of the "original" images were faithfully reproduced, while others were handled more freely. The long-standing attribution of these compositions to Raphael and Giulio Romano is without foundation, but it serves as an indicator of the high regard in which they were held.

Grotesques of *The Months,*
Gobelins tapestry, after designs
by Claude III Audran.

Paris, Mobilier National

Commissioned in 1709 for weaving in low-warp at the Gobelins factory, this tapestry was intended to hang in the bed alcove of the grand dauphin in the new château at Meudon. The design consists of a sequence of vertical arabesque panels—each featuring the personification of a month, accompanied by appropriate attributes and signs of the zodiac—separated by decorative borders. The component compositions are independent of one another, but their three superimposed registers align across the field. This work is important, for it anticipates the coming eclipse of the bandwork arabesque associated with Bérain. Desportes and Watteau may have collaborated with Audran on this commission, and perhaps on other aspects of the decor at Meudon.

FACING PAGE

Painted vault (detail), Palazzo Doria-Pamphili, Genesio del Barba, 1734.

Rome, Palazzo Doria-Pamphili

This gallery in the palazzo Doria-Pamphili was painted with grotesque designs in the eighteenth century. Remarkably, the designs are altogether consistent with examples a century or two earlier in date: in Rome, the city in which grotesques were invented, the original formats did not evolve. The grotesque designs of European artists who had studied Roman examples first-hand can usually be distinguished from compositions by those who did not.

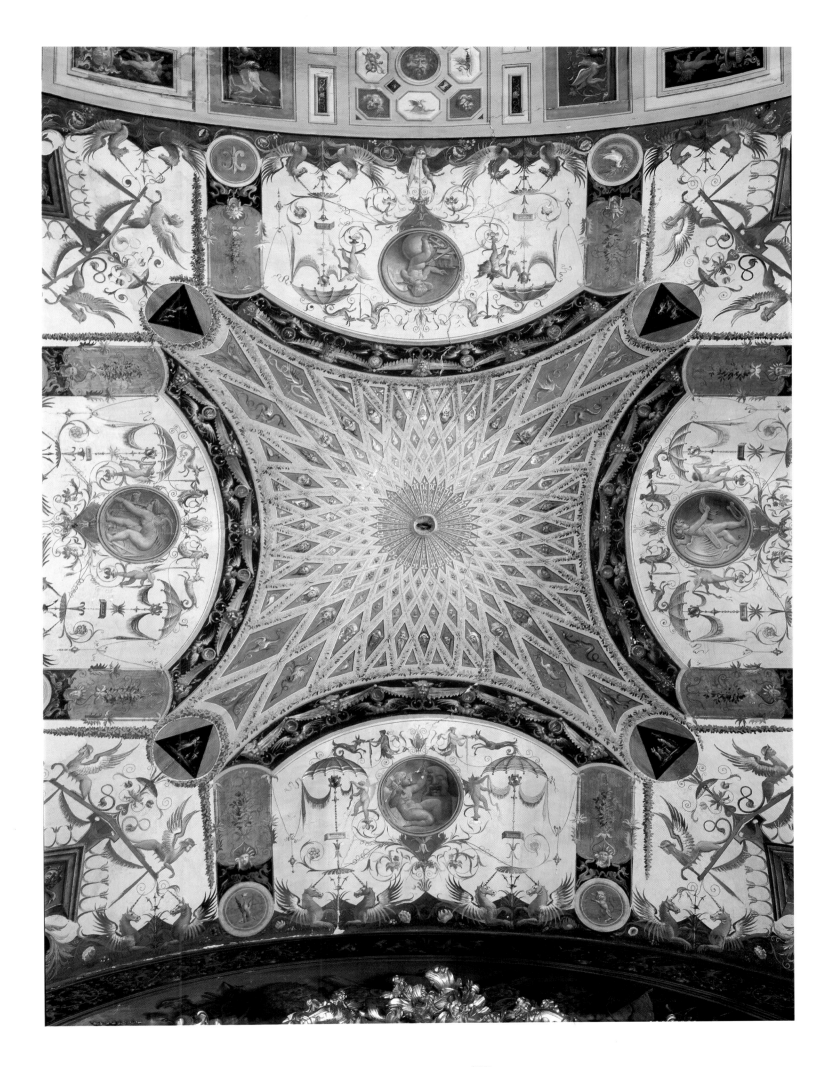

Falcon Hunting, drawing and watercolor, c. 1740.

Berlin, Kunstbibliothek

This design for a large arabesque panel was long attributed to Pierre-Alexis Peyrotte (1699–1769), but the palette is not his, and the rigidity of the trellis ornaments above the hunters is inconsistent with French practice. The sheet probably originated in the circle of the painter Johann Adolph Biarelle, known as Biarelli; born in Namur, he worked at the Ansbach court and was a designer in the service of the elector of Cologne until his death in 1750. Thus the subject of falcon hunting was familiar to him (see page 211). Here, a new relationship between the figures and the arabesques proper is proposed: reversing the French trend of the century's opening decades, the framing elements assume a new importance. This distinction is consistent with the differences more generally between the rococo and rocaille aesthetics prevailing in France and the Germanic countries, respectively, although these mutually influenced one another.

Panels from the rooms of the dauphine
Marie-Josèphe de Saxe, c. 1747

Versailles, Musée National du Château

These panels were made for the dauphin's second wife, the mother of Louis XVI, and were initially installed on the ground floor of the château; subsequently they were moved to the *arrière cabinet* of Marie-Antoinette's apartments on the main floor. The figural compositions assume great importance here, and these designs owe their affinity with the new arabesque idiom to the charmingly pliant trellis framing elements. As in contemporary French prints, the relationship between figure and surroundings is quite different from that found in traditional arabesque designs.

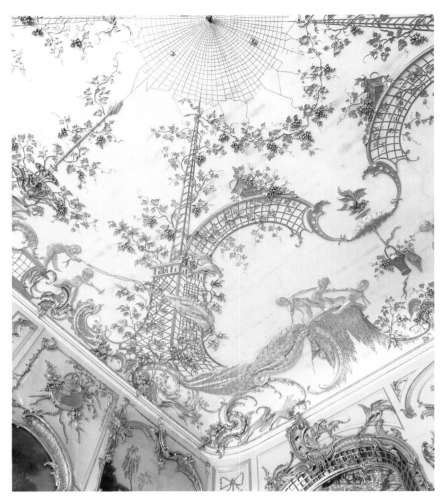

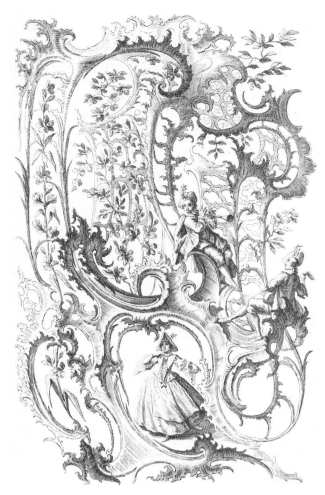

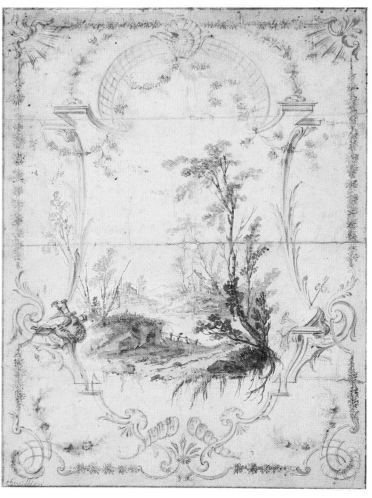

Ceiling of the music room, château of Sans-Souci, Karl Josef
Sartori, Johann Merck, Georg Franz Ebenhech, 1746–48.

Potsdam (Germany)

The gilded stucco reliefs here occupy the entire ceiling. The spiderweb in
the center is a playful variant of the moresque medallions prominent in
more conventional arabesque ceiling designs, while the trellises recall
grotesque pavilions.

Print, Jeremias Wachsmuth, published by Johann Georg Hertel.

London, Victoria and Albert Museum

Wachsmuth (1712–1779) was one of the most prolific and original designers
in Augsburg, and here he gave his imagination free reign. It is often difficult
to associate his compositions with any precise purpose, and on this sheet con-
temporary formulas for panel designs have been stretched and manipulated
into an asymmetrical jumble whose sole aim is to delight the viewer. The
bottom coalesces—more or less—into a rococo cartouche; above, stray ves-
tiges of arabesque trellises and pavilions are detectable, and the figures
cavalierly perched on the surging forms are reminiscent of those gamboling
through Renaissance grotesques.

Decorative panel design, drawing, pen, and watercolor,
Jean-Baptiste Chevillion, c. 1740–50.

Berlin, Kunstbibliothek

Chevillion (d. 1758) was a designer employed by the Gobelins factory;
his ornamental style was influenced by Audran and Peyrotte but is readily
distinguishable from that of Huet. The composition here features a landscape
devoid of figures, whch is unusual for this genre.

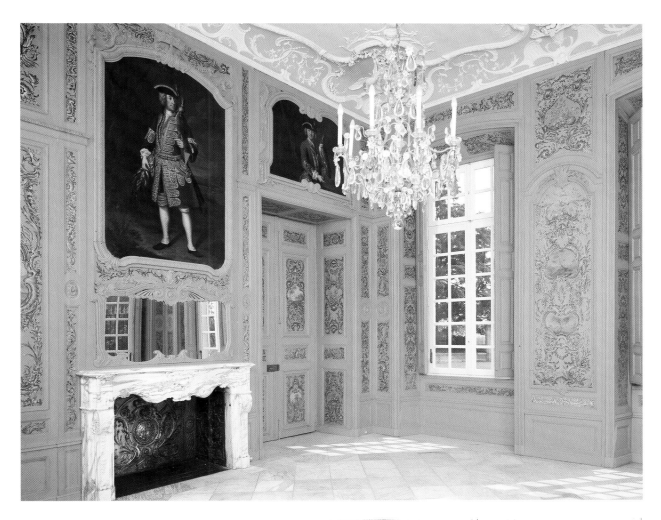

Dining room of Falkenlust hunting lodge,
decor attributed to Johann Adolph Biarelle.
Brühl (Germany)

Germany gave birth to curious hybrids of the contempo-
rary decorative idiom, largely due to the presence there of
François de Cuvilliès (1695–1768). The arabesque panel
compositions in this decor retain the standard format of
vignettes surrounded by more abstract patterns, but the
vegetal forms of the latter are stiffer and spikier than
their French counterparts.

Print from *Panneaux à divers usages*
(Panels for various purposes), Charles-Albert
de Lespilliez (1723–1796) after designs by
François de Cuvilliès.
Paris, Bibliothèque des Art Décoratifs

Here, it is difficult to classify the ornamental vocabulary
as either rococo or arabesque, for the two idioms are
combined. In the design on the left, fretlike trellises and
rocaille C-scrolls surround a cryptic emblem or trophy
composed of intertwining serpents, a medallion, out-
spread wings, and a winged hat, but the basic scheme
is consistent with arabesque practice. The components
on the right are similarly heterogeneous, but the
composition is even more asymmetrical.

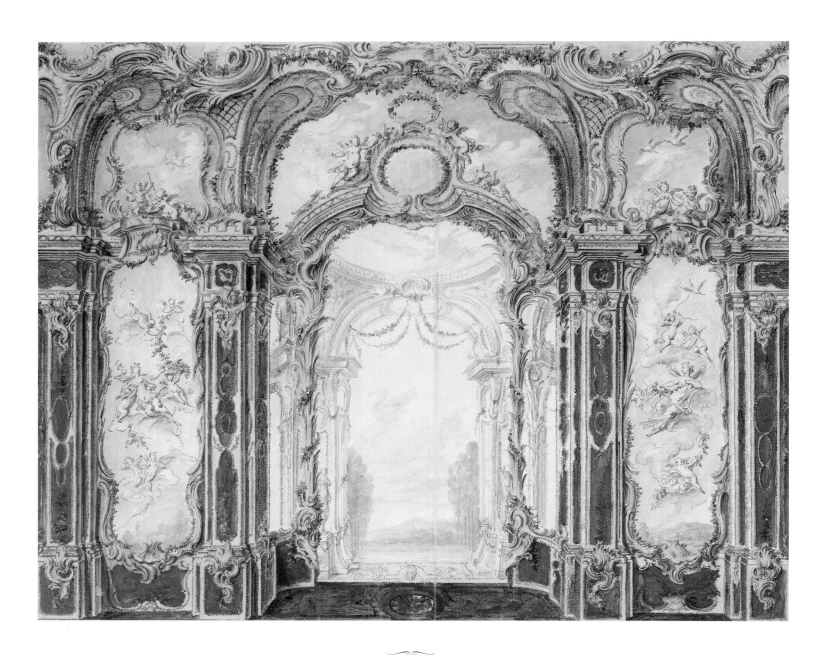

Design for a portable salon,
Jean-Baptiste Chevillion.

Paris, Bibliothèque Nationale

ᴅecorative work such as this remained
independent of the walls and was designed for
reassembly in different locations. Portable salons
could be painted on canvas or executed in more
substantial materials. This design, a more
elaborate version of which also survives (Saint
Petersburg, Hermitage), exemplifies the difficulty
of distinguishing between the rococo and
arabesque ornamental vocabularies from the
Regency onward. The basic elements of this
composition are arabesque, but they have been
recast in the vaguely crustaceous forms typical
of the rocaille. Such polyglot designs were
common in the century's middle decades. When
Chevillion succeeded his master Pierre Josse
Perrot at the Gobelins and Savonnerie factories in
1747, he described himself as a "painter of ceiling
ornaments and *cabinets d'arabesques.*"

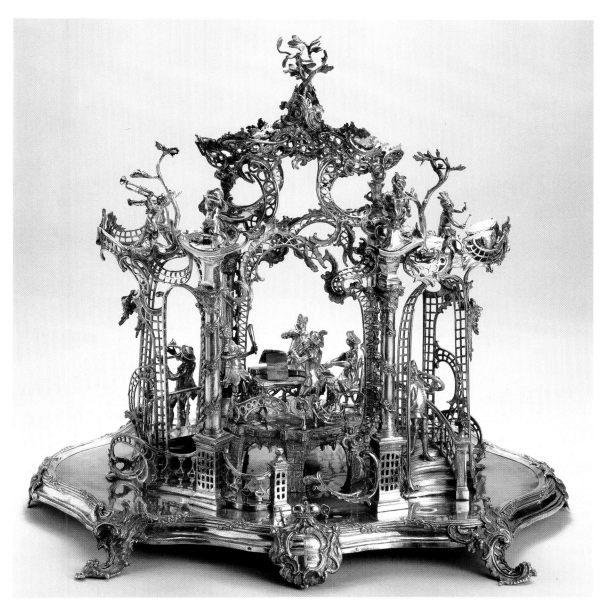

Centerpiece, silver,
Bernhard Heinrich Weyhe,
Augsburg, 1761–63.
Munich, Bayerisches Nationalmuseum

Design for a centerpiece,
drawing, c. 1755–60.
Augsburg, Städtisches Bibliothek

*A*s the drawing makes clear, this elaborate piece
was intended to hold lemons. Several such center-
pieces with related themes were sometimes placed
on a single banquet table. This one evokes winter,
with motifs of dead branches, and a group of
musicians giving a concert—an indoor diversion
proper to that season.

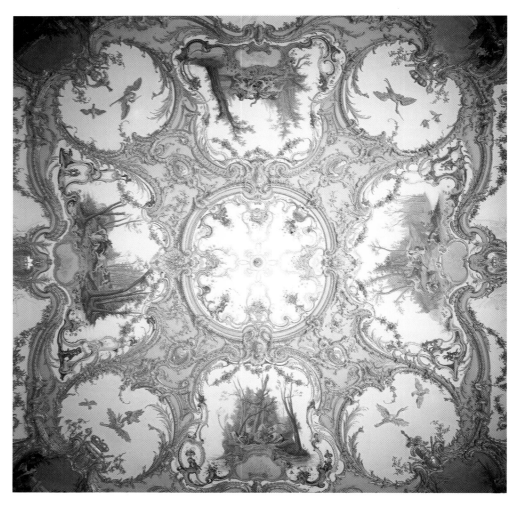

Ceiling of the Audience Room,
c. 1753–54.
Schloss Brühl (Germany)

The elaborate ceilings in the ceremonial rooms of this palace—the residence of Clemens August of Bavaria, elector of Cologne—combine stucco work and paintings, many of the latter after images by Hondius, Lancret, Huet, Oudry, Boucher, and others. In the audience room, rocaille swirls surround paintings by Claude-Joseph Billieux, who incorporates new arabesque painted frames in the manner of Christophe Huet limning those in gilt relief. Once again, the two ornamental vocabularies have been integrated.

Wall design, print, Johann Michael Hoppenhaupt (1709–1769).
Paris, Bibliothèque Nationale

While the forms in this design have a rocaille stamp, some arabesque compositional elements have been retained, notably the picturesque tableaux on either side and the central pair of musicians beneath a trellis pavilion. Compositions such as this were admired by Frederick the Great, who had similar decorative schemes executed for himself around 1760.

FACING PAGE

Golden Gallery, Georg Wenzeslaus von Knobelsdorff (architect) and Johann August Nahl (sculptor).
Berlin, Charlottenburg Palace

Completed in 1746 after designs by Knobelsdorff (1699–1754), architect to Frederick the Great, and sculptor Nahl (1710–1785), this gallery alternates mirrors with large wall panels decorated with rococo compositions. Its two ends are treated differently, however: the area of the wall next to and above each door is covered with elaborate gilt arabesque designs, although in a vocabulary so transformed as to be virtually unrecognizable. In the section illustrated, the trellis motif was meant to set off a sculpture placed on the real marble base below it, varying the classic arabesque formula. The *fête galante* relief groups on the door are especially appropriate here: Frederick was an admirer of Watteau, Lancret, and Jean-Baptiste François Pater, and one of the doors led to a room that contained Watteau's last painting, the *Enseigne de Gersaint* (1721).

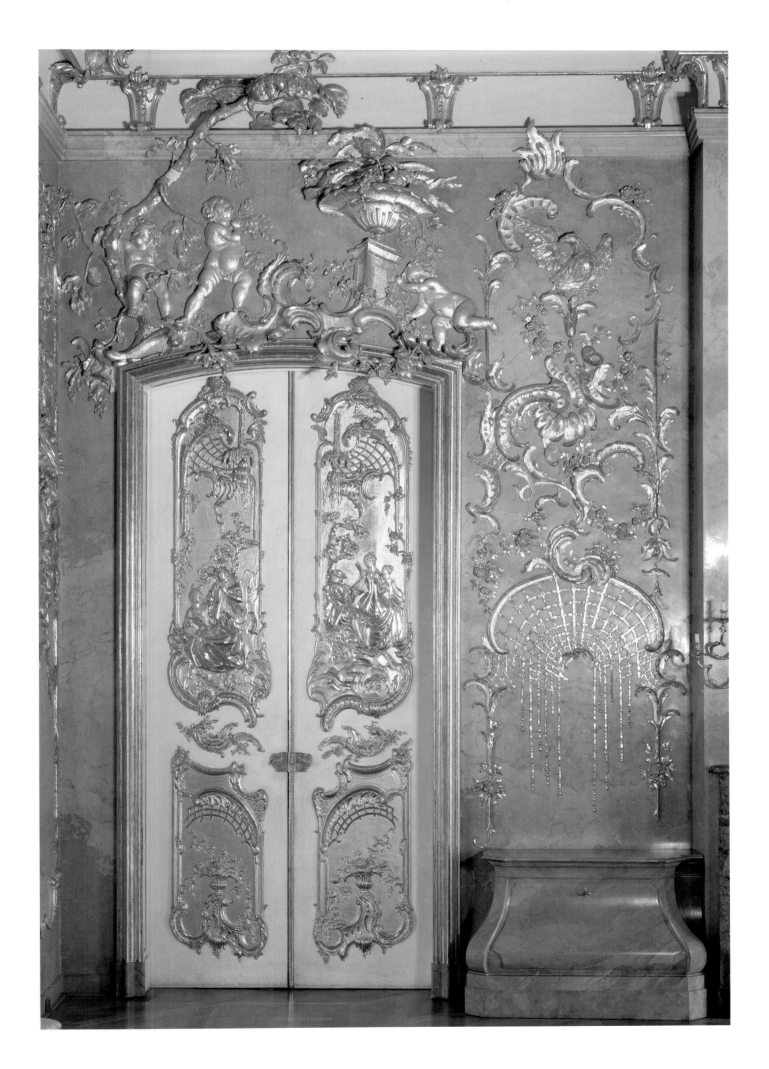

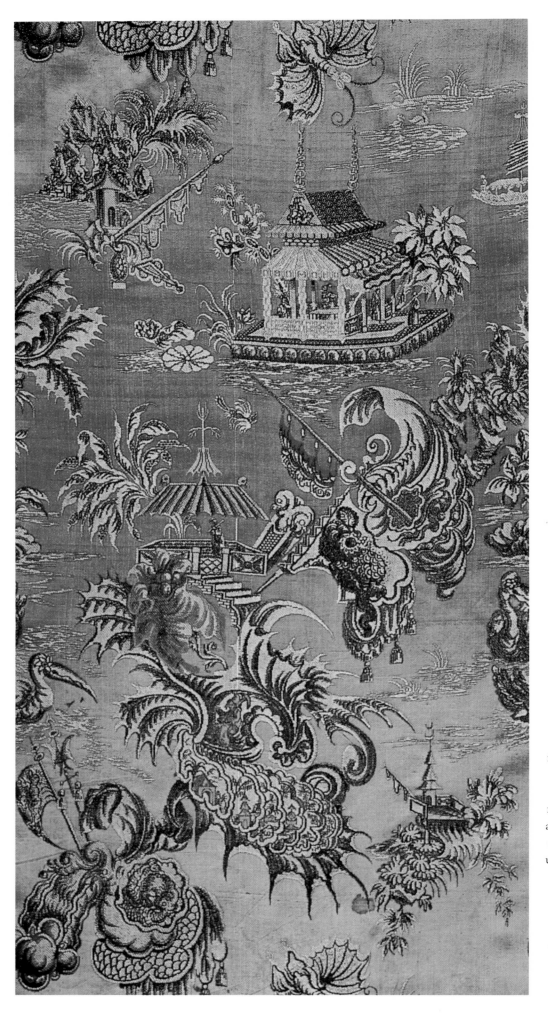

Silk damask from a dress,
Lyons, c. 1750.
Zurich, Landesmuseum

The section of silk damask shown here is
a late example of the rich fabrics with
fantastic motifs woven in gold or silver thread
known since the early twentieth century as
"bizarre silks." First made in Lyons about
1690, and soon thereafter in Venice, they were
also frequently copied by designers in England
and Holland, and remained in greatest vogue
until about 1725. Their decorative forms derive
from the Chinese and Japanese ornamental
vocabularies, but generally these have been
transformed into extravagant variants of
the originals, sometimes assuming an
almost abstract character. These fabrics were
used to make clothing, both for men and
for women, but were felt to be too fancy
for interior decoration.

Chinoiserie

—◦◦—

*T*he choice of artistic terms can be a trap. In a study such as this, devoted to what are most widely referred to as the Louis XIV, Louis XV, and Louis XVI styles, it should be made clear that the dates of these successive reigns coincide only approximately with the ornamental vocabularies associated with them in these stylistic catch phrases. In the Introduction, I have attempted to justify the selection of decorative styles and/or motifs treated in this volume. All of the terms in question are problematic, to say the least, but all have entered widespread use—to such an extent that attempts to replace them with more judicious nomenclatures and taxonomies are almost certainly bound to fail. They have long shaped our perception of the decorative arts production of this period and will continue to do so, for they have become too deeply rooted to dislodge.

—◦◦—

Approaching the East

The term *chinoiserie* presents these problems in an acute form. When it first appeared in France in the 1830s, the word was associated with a rather cheap brand of exoticism frequently encountered in the interiors of the nouveaux riches. Accordingly, from the beginning it carried pejorative connotations, and these have remained attached to it, even in relatively sophisticated circles.

In the seventeenth and eighteenth centuries, what we regard today as chinoiserie would have been described in French as *indien* or *des Indes,* appellations deriving from "India," which after the arrival there of Vasco da Gama in 1498 served as the base of Portugal's campaign of colonialist expansion in the Far East.

Unlike moresques and arabesques, chinoiserie is an entirely Western invention. Its sources are to be sought primarily in fantastic descriptions of distant Cathay, and only secondarily in the products imported from the East in growing quantities beginning in the late Middle Ages. It is one of seventeenth- and eighteenth-century Europe's most original contributions to the ornamental tradition: rarely has a decorative vocabulary given such free reign to fantasy and

derived so little from the imitation of extant models. Chinoiserie never laid claim to a genuine Far Eastern pedigree. One index of this is the admiration expressed by the Chinese themselves for European productions in this mode, which they viewed as typical examples of Western art without suspecting their own role in its genesis.

In keeping with the true characteristics of the genre, this chapter does not include the most faithful imitations of Far Eastern artifacts—an exclusion all the more appropriate, given that most date from the late nineteenth century and thus fall outside its chronological parameters. The more meticulous, scholarly interest in things Chinese cultivated by Europeans after 1755 will be discussed only briefly. This preoccupation was encouraged by the publication in 1757 of *Designs of Chinese Buildings, Furniture, Dresses, Machines and Utensils . . .* by English architect William Chambers (1723–1796). Its precise illustrations, based on drawings made by him during a trip to China shortly before, were enormously influential, leading to the production of many Western copies in the second half of the eighteenth century. But these pieces were informed by a spirit of almost ethnographic accuracy very much at odds with the one that prevailed in the great period of chinoiserie, which by that time had come to a close.

Prior to mid-century, Western knowledge of China was limited and vague, a situation that invited fantasy of the most extravagant variety. Even the most serious eighteenth-century works dealing with this distant realm were full of absurd theories and misinformation; some of their authors went so far as to assert, for example, the existence of sustained ties between China and ancient Egypt. This extreme level of ignorance explains the pervasive Western tendency to view the Far East monolithically—as reflected in the widespread use of the generic phrase *des Indes* to describe anything having to do with any of the region's many cultures and traditions. The first volume in this series emphasized the considerable debt of sixteenth-century European decorative artists to Ottoman models, which was facilitated by the relative proximity of Turkey and Persia to Europe, and by the resulting accessibility of objects produced by the craftsmen of those regions. But in the seventeenth and eighteenth centuries, European ornamentalists also began to appropriate the forms and motifs of the less familiar cultures of the Far East and to freely manipulate them with equanimity.

page 281 Mix and mix again might be said to have been the rule of thumb for producers of chinoiserie in this period. A single composition might include Turks, Indians, Chinese, and even monkeys, without any logical pretext whatsoever, and the contemporaries of Descartes, Buffon, and Kant were not embarrassed by such curious juxtapositions. They were the common currency of a mode that, if the reader will allow me to coin a new descriptive phrase, might best be termed *orientalist exoticism.*

But however European, the style is rooted in visual and intellectual models from the Far East. One of the principal aims of this chapter is to examine the circumstances surrounding their introduction into the West.

In antiquity, geographic reality was such that curiosity about distant lands could only be directed toward the East. The regions to the north and south of

"the known world" were difficult to reach from the Mediterranean basin, and protracted voyages on the open sea were precluded—and in any case, the existence of the Western hemisphere was unimagined. Many dreamed of the East, but rare were those who, like Alexander the Great, experienced it firsthand. Alexander's moment of triumph there was brief, but the commercial and cultural ties it inaugurated between East and West had long-lasting implications.

In the first century B.C., silk, which the Greeks associated with China, was the center of a lucrative and steadily expanding trade conducted over both land and sea routes. Romans of both genders with any pretensions to elegance demanded the luxurious fabric in ever larger quantities, a phenomenon that was often criticized by writers and thinkers with a moralizing bent: Seneca and Pliny saw it as a sign of decadence, and warned that if the silk craze continued unabated it would lead to nothing less than the fall of the Roman Empire. Toward the end of the third century A.D., successive barbarian infiltrations and invasions impeded the steady flow of caravans over the steppes of central Asia, and eventually the Arab conquest resulted in the closure of the maritime trade routes as well. The result was a hiatus in direct commercial relations with the Far East that lasted almost a millennium, for only in 1498 did Vasco da Gama's famous expedition reach Calicut after rounding the southern tip of Africa.

Despite these disruptions, indirect commerce continued throughout most of this period, ceasing only during moments of grave crisis. Constantinople and Syria played crucial roles in the new commercial regime, which by its nature made for trade that was slower and less reliable than under the previous conditions.

At the beginning of the sixth century, the emperor Justinian (527–65) resolved to break what was in effect a Persian monopoly on Eastern trade. Unable to prevent the import of silk, he set out to achieve his goal by establishing silkworm farming and silk manufacture in the Peloponnese, an experiment that unfortunately proved short-lived. However, discoveries made in Dura-Europos, Palmyra, and Egypt prove that during the Middle Ages contact with China never entirely ceased. The phoenix, peacock, and dragon motifs used in Byzantine art (which might be described as early examples of chinoiserie) provide evidence of the survival of the silk route during the seven centuries separating the reign of Justinian from the papacy of Gregory X (1271–76).

Apparently, the West remained completely oblivious of the golden age of Chinese culture under the Tang dynasty (618–907), and also of the extreme refinement characteristic of productions under the succeeding Song dynasty (960–1280). It was fighting for its very life, after all, and the revival of commercial ties with the Far East was not one of its more pressing concerns. Nonetheless, the Crusades provide some indication of the degree to which the dream of the East continued to haunt the medieval imagination in this period. These massive campaigns to recover Jerusalem from the infidel resulted in an increased awareness of Eastern art, and so prompted European ornamentalists to begin to think in terms inspired by its often luxurious productions.

While the Crusades were cutting swaths of blood and destruction across the Near East, the Mongol invasion of China was wreaking havoc in Asia. After

the turbulent period under Genghis Khan early in the thirteenth century, his successors established the Throne of the Dragon (the Mongol dynasty in China, also known as the Yuan dynasty), and the resulting political stability made it possible once more to travel the silk route. Among the fortunate adventurers who in 1275 were able to enter the service of the Kublai Kahn (1215–1294)—then the Mongol emperor of China—was Venetian explorer Marco Polo, who remained there for seventeen years. This date marks the true beginning of the history of chinoiserie, for he provided Europe with information that fueled its fantasies about the Middle Empire.

There were probably more such merchants than we now realize, but Marco Polo's is the only name to have come down to us. It survives because he dictated his memoirs in the relative calm of the Genoan prisons in which he was incarcerated after returning to Italy. His account of his travels, given compelling narrative form by a fellow inmate from Pisa named Rustichello, was originally called *Divisament dou Monde* (Franco-Italian for *Description of the world*); it was circulated in manuscript form in many different versions under the inexplicable title *Il milione* but is known in English as *The Travels of Marco Polo*. His descriptions of the Far East confirmed the observations of a predecessor, the Franciscan Guillaume de Rubrouck, who had been sent by Louis IX of France on a diplomatic mission to the Great Khan of Mongolia between 1252 and 1254. Although unillustrated, the initial version of *Il milione* was copied time and again, and as a result the information it contained about the mysterious realm at the end of the world soon attained the status of myth. Its vivid details captured the imagination of its many readers, both in Italy and elsewhere.

<hr />

The Establishment of a European Presence in the Far East

The image of China that crystallized in the European imagination at the end of the thirteenth century proved so seductive that it remained largely intact until the mid-eighteenth century. Rich in fruit and flowers, inhabited by strange animals and exotically plumed birds, it was also characterized by a successful system of government and a cheerful population notable for its refined courtesy. The existence of such an imaginary paradise seems absurd today, but it was taken more or less seriously in the West for centuries. Giovanni dal Piano dei Campini (1182–1251), a Franciscan monk from Italy, visited the emperor of China in 1246, and subsequently described his experiences there in his *History of the Mongols, Known to Us as the Tatars*. About 1325 Oderic of Pordenone, a Franciscan friar who ventured to Tatary, India, Sumatra, Borneo, China, and Tibet, recorded an account of his travels, and it confirmed the information in Marco Polo's book, adding a rich store of material about the daily life of the Chinese. This last proved a spur to Western fantasy. Oderic's text had a limited readership, for it circulated only in manuscript, but it was pillaged by the author of the most popular medieval account of the Orient, Jean d'Outremeuse, who published his book under the

pseudonym Sir John Mandeville. He never set foot anywhere near the East, but his text was wildly successful, and it continued to be influential as late as the seventeenth century. It remained a fundamental reference for artisans working within the chinoiserie mode.

Such fantasizing was furthered by historical circumstances. While the West was convulsed by the Hundred Years' War, tumult in China led to the closure of much of its empire to Western merchants. The prohibition of European trade was not lifted until 1533. In the interim, deprived of Far Eastern imports, the West, and Italy in particular, began to produce fabrics decorated with exotic motifs that are among the first chinoiserie textiles.

Vasco da Gama's discovery in 1498 of the maritime route to India and the subsequent establishment of a Portuguese presence on the Malabar Coast initiated a new era in relations between Europe and Asia. In 1494, Pope Alexander VI divided the world into spheres of influence to be controlled by Spain and Portugal, with Portugal receiving jurisdiction over Africa and most of Asia, and thus leading that nation into playing an important role in the history of chinoiserie, thanks to the Jesuits. The privileged ties between the Portuguese court and this new order founded by Ignatius Loyola led to widespread missionary activity in Asia, beginning in the coastal areas of southern India. As a result, the Jesuits became crucial middlemen in cultural, scientific, and artistic exchanges between Europe, India, and the Far East. In 1542 Father Francis Xavier, a founding member of the Jesuits, arrived in Goa (a Portuguese outpost on India's west coast) and became a principal figure in these relations. After gaining converts among the poor of southeastern and southwestern India for three years, Xavier ventured as far afield as Madras, Ceylon, Cochin, Malacca, the Moluccan islands, and Japan. In 1552, he contracted a fever and died on the island of Sancian off the southern coast of China while trying to gain entrance into that country, which was then closed to foreigners. In his missionary activity in Japan, from 1549 to 1551, realizing that he was dealing with a cultured and sophisticated people, he changed his approach to one of studied display and found it to be more effective. His advocacy of this kind of adaptability to the customs of the people being evangelized set an important precedent. Some of those who followed this more conciliatory strategy neglected religion in the interest of nourishing favorable commercial relations with China and Japan. The Jesuits' presence in Japan soon became so strong that Xavier's immediate successor as their superior in the Far East, Coelho, was able to make it much easier for merchants to trade in that country, which was still hesitant in its dealings with foreigners. Unfortunately, Coelho went too far and began to meddle extensively in internal affairs, prompting the Japanese to curb all foreign influence. In 1614 the Tokugawa Ieyasu ordered all Jesuit missionaries expelled and commanded all Japanese Christians to return to Buddhism. In 1624 the Spaniards were expelled, then the Portuguese in 1639, and in 1640 all Europeans except a few Dutch merchants, who were permitted to remain in Nagasaki under strict control. From then until 1854 they represented Japan's only contacts with the West.

The Jesuits made tentative incursions into China from the Portuguese island colony of Macao in hopes of expanding their foothold in Asia. Xavier's successors

even managed to reside in Canton (Guangzhou) from 1555 to 1575, but their sojourn proved largely unsuccessful. In 1582 Father Matteo Ricci, a scholar educated in science and mathematics at the order's Roman college—and after studying Chinese for a year in Macao—was sent with fellow Jesuit Michele Ruggieri to establish a mission at Zhaoqing, just west of Canton. There, they tried to win over the Chinese by adopting their language and customs. Though failing to convert them, Ricci managed to impress Chinese scholar-officials with his erudition, and flattered them by composing a map of the world showing China at its center. From 1589 to 1601, he moved northward, establishing missions at Zhaozhou, Nanchang, and Nanjing, converting the literati through a policy of accommodation. He succeeded in entering Beijing in 1601, and lived there until his death in 1610. In his efforts to attract and convert the Chinese intelligentsia, Ricci immersed himself in the teachings of Confucius. His book *The True Meaning of the Lord of Heaven* (begun 1593, published 1603), intensified Western curiosity about China.

After Ricci's death, Rome came to feel that his successors' enthusiasm for Chinese culture was becoming excessive—understandably, given that many of the pope's Catholic missionaries were becoming courtiers, mandarins, and advisors to the emperor. But the Jesuits succeeded in maintaining Europe's interest in China by sending home enthusiastic accounts of their experiences. Fully aware that the pope would have disapproved of their compromising tactics, they idealized all aspects of China and their dealings with its rulers. After returning to Rome from Beijing, papal ambassador Juan Gonzalez de Mendoza, for instance, published a *History of the Great Realm of China* (1585), which proved immensely popular, running through sixty-six editions in seven languages. Similar volumes by Richard Hakhuyt, Levinus Hulsius, Giovanni Battista Ramusio, Gaspar da Cruz, Bento de Goes, and, of course, Matteo Ricci retained their authority well into the seventeenth century. All of them presented a utopian vision of China, which explains the admiration that seventeenth- and eighteenth-century deist intellectuals often expressed for the Middle Empire. Comparable publications continued to appear after 1650, but by then the bibliographic foundations of the chinoiserie phenomenon had been laid.

It was, of course, not only monastics who established ties with the upper echelons of Japanese, Chinese, Indian, and Siamese society; merchants did so as well, and their relations proved immensely profitable. Whether Portuguese, Dutch, Spanish, English, or (somewhat later) French, their methods were more brutal than those of the missionaries. Thomas Pires, an envoy from the king of Portugal, failed to establish contact with Beijing, but from his arrival in Canton, in 1517, he cultivated relations with indigenous merchants eager for gain. In 1557 the Portuguese opened their settlement in Macao after having traded successfully with the Japanese since 1542, but they had competition from the Spanish, who established a foothold in the Philippines beginning in 1571. Only the union of the two Iberian nations in 1580, effected by the marriage of Philip II to a Portuguese princess, ended the incessant jockeying for control that had long kept them at odds.

The Dutch entered the scene with the establishment of their East India Company in 1602. Based in Formosa, its representatives traded with both China

and Japan, and eventually managed to negotiate a commercial monopoly with Japan. These dealings left their mark on Dutch chinoiserie.

In 1579, England, still on the lookout for new commercial opportunities, assumed control of the Istanbul markets, which had been the endpoint of the Asian silk route for a millennium and had previously been controlled by the Venetians. Its own East India Company was created in 1609 and was authorized by royal warrant to trade with "Cathay, China, Japan, Korea, and Cambay," but the Portuguese blocked their access to Siam.

France was the last European power to establish trade links with the East. A French East India Company was launched in 1664, but the determination of the previously established nations to block its access proved successful until the early years of the eighteenth century.

All these private commercial ventures brought back to Europe—at great expense—objects of all kinds purchased from local merchants. Richard Hakhuyt described the *Madre de Dios,* a Spanish ship seized by the English in the Azores in 1592, arriving in Dartmouth filled with drugs, spices, porcelain, lacquer, and other objects. They sold at such astronomical prices that local entrepreneurs soon began to make copies of the exotic decorative objects. This was the natural consequence of a demand that considerably outstripped the available supply, and in any case the clientele that could afford the originals was quite small. But this moment might be said to mark the birth of desires that chinoiserie would strive to satisfy until the advent of neoclassicism. The latter movement coincided with the development in Europe of a deeper knowledge of the art, architecture, and gardens of China, which revealed the extent to which the West's previous idea of them was pure projection, and so relegated chinoiserie to the realm of pure fantasy.

Chinese Models

As the supply of Far Eastern imports was insufficient to meet the demands of even a restricted clientele, the larger public had to make do with imitations, or find vicarious satisfaction in the publications about the East that appeared with ever greater frequency after 1650. These texts were always tailored to suit the demands of a Western readership and so continued to feed its collective imagination, but they rarely included illustrations. In 1655, for example, Father Alverez Semedo published four prints in the English edition of his *History of that Great Renowned Monarchy of China,* but they were only two maps and two portraits.

The Dutch, ever alert to opportunities for commercial gain, set out to increase the available store of such prints. Jan Nieuhoff, who visited the Manchu emperor in 1655, became a dominant influence on chinoiserie for more than a century by publishing an account of his Chinese voyage illustrated with more than a hundred prints, *An Embassy from the East India Company to the Grand Tatar Cham, Emperor of China.* The first edition of 1665 was in Flemish, but it was quickly translated into French and English, and in all three languages it enjoyed considerable success through the eighteenth and even into the nineteenth century. This volume

pages 241, 264, 266, 274, 282, 286, 292, 302

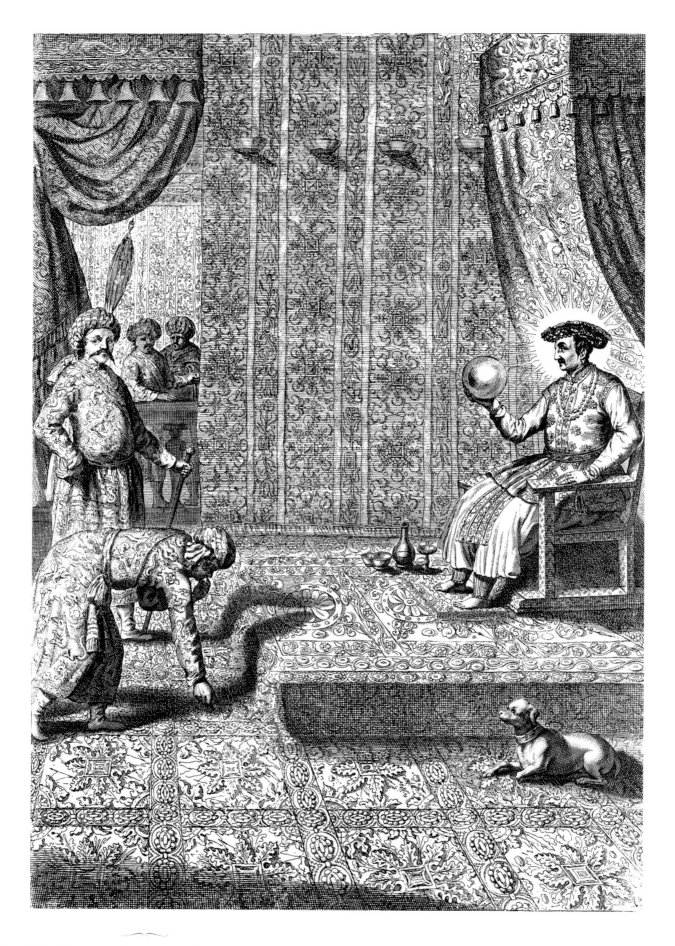

The Great Mogul, print, Athanasius Kircher (1601–1680), from *China Monumentis qua Sacris qua Profanis . . . illustrata* (The sacred and secular monuments of China . . . illustrated), Amsterdam, 1667.

Basel, university library

La Fontaine reports that barely a year after the publication of Father Kircher's book, which included illustrations of Asian rulers in sumptuously decorated interiors, Louis XIV, inspired by these images, had the walls of his private apartments at Versailles lined with fabric imported from China.

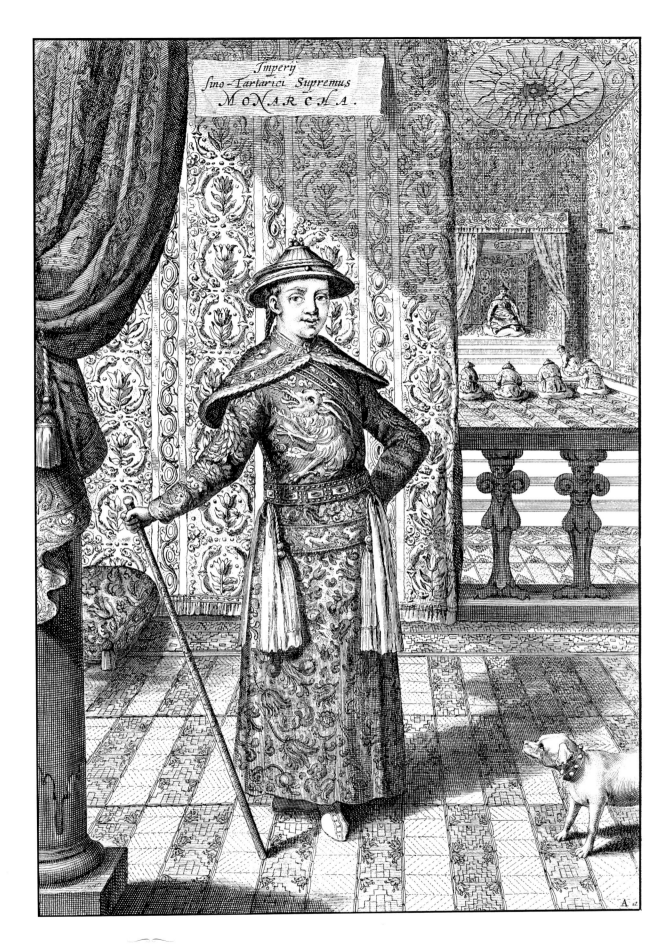

Chinese-Tatar Emperor, print, Athanasius Kircher, from *China Monumentis qua Sacris qua Profanis . . . illustrata* (The sacred and secular monuments of China . . . illustrated), Amsterdam, 1667.

Basel, university library

The flooding of the French market with Eastern fabrics—embossed, brocaded, painted, and printed—represented a serious threat to the weavers in Tours, Paris, and Lyons, who countered by producing fabrics featuring Eastern designs.

made it possible for architects to study—in prints that made them seem larger than they were—such wonders as the celebrated Nanjing pagoda, the imperial palace in Beijing, and the artificial rocks erected in Shanghai by Yu Yuan in 1559. It influenced many a reader, some of them famous—such as architect Johann Bernhard Fischer von Erlach (1656–1723), who in his *Entwurf einer historischen Architektur* (Outline for historic architecture) of 1721, published copies of several of Nieuhoff's plates that made these monuments seem even larger. Henceforth, architects of all nationalities turned to Nieuhoff's images when they were asked to design Chinese pavilions for princely gardens, from the Porcelain Trianon at Versailles to the Royal Pavilion at Brighton. The *Atlas Japannensis* and *Atlas Chinensis,* compiled by Arnoldus Montanus in 1670 and 1671, also proved influential with artists of all kinds, for the two volumes intrigued them with a hundred prints inspired more by imagination than accuracy and suffused with an irresistible Eastern exoticism.

pages 268–69

pages 266, 302

pages 266, 272, 286

After becoming interested in Egypt and attempting to decipher its hieroglyphs, Athanasius Kircher (1601–1680), an erudite German Jesuit, turned his attention to the monuments of China. His researches culminated in the publication of his *China Monumentis qua Sacra qua Profanis . . .* illustrated in 1667, also more a work of the imagination than of scholarship; doubtless this helped secure its success. Another Jesuit, Louis-Daniel Le Comte, one of a group of French priests who set sail from Brest in 1685 with ambassadors from Siam and French envoys headed for the Far East, returned in 1698 to publish *Nouveaux Mémoires sur l'Etat présent de la Chine* (New memoirs on the present state of China). This text was condemned in no uncertain terms by Jacques-Bénigne Bossuet, the powerful bishop of Meaux from 1681 until his death in 1704, but this did not prevent its meeting with such success that an English edition appeared three years afterward. Unlike his predecessors, Le Comte was extremely critical of Chinese architecture. He judged its ornament to be irregular and unworthy of imitation, a view that encouraged the free manipulation of "Eastern" motifs characteristic of chinoiserie. As already noted, concern for archeological accuracy in these matters developed only in the second half of the eighteenth century.

pages 234, 235

page 252

The Jesuits, caught between the conflicting demands of their policy of accommodation to local customs, which they had developed with great subtlety in the field, and Rome's intransigence, were exiled first to Canton (Guangzhou), then to Macao, by successive edicts in 1724 and 1734 proscribing Christianity in the Chinese empire. However, two Jesuits, Giuseppe Castiglione (1688–1766) and Jean-Denis Attiret (1702–1768), and Father Ignaz Sichelbart (1708–1780)—through their accomplishments as painters and architects—gained access to the Qing court under the successive reigns of Kangxi (1662–1722), Yangzheng (1723–1735), and Qianlong (1736–1796). From this period, the *Description géographique, historique, chronologique, politique et physique de l'empire de la Chine et de la Tartarie chinoise* (Geographical, historical, chronological, political, and physical description of the empire of China and of Chinese tatary; Paris and The Hague, 1735–36) by Father Jean-Baptiste Du Halde (1674–1743) was the last of the many publications by Jesuits to play an important role in the development of chinoiserie. Not all Jesuit accounts of their experiences were published. The case of Father Matteo Ripa,

page 254

who spent sixteen years at the Beijing court, is symptomatic. He was familiar with Chinese gardens and garden pavilions, and after his return to Europe after 1730 his accurate engravings influenced the evolution of the so-called "English" park.

Only a few wealthy rulers could boast of possessing real Chinese products. Although lacquers, porcelains, semiprecious stones, and all manner of cloth (with woven, embroidered, printed, or hand-painted decorations) were sold by the various India companies, the desire to create surroundings worthy of these collections led their owners to engage architects who could work in the chinoiserie mode, which was initially a courtly style. As already noted, only a handful of illustrated volumes about the Far East, which retained their status as standard references for decades, even centuries, were available to guide them. But inventive ornamentalists used these images as a springboard for the creation of additional chinoiserie models, and these were soon influencing a broad array of decorative arts productions.

The desire to imitate unfamiliar materials such as lacquer and porcelain lay at the root of the European chinoiserie phenomenon. The countries most active in this domain were those with limited access to genuine Far Eastern objects. Beginning in the mid-eighteenth century, the rising prices of genuine Chinese of even mediocre quality gave chinoiserie productions a competitive edge in the marketplace. Chinoiserie had the greatest impact in Italy, France, and Germany, followed somewhat later by England. It was their craftsmen who most assiduously developed the chinoiserie vocabulary, not those working in countries with long-standing Chinese commercial ties such as Portugal, Spain, or even Holland. The latter had less incentive to devise imitations, for the genuine article, while expensive, was readily available.

Textile Decoration

Given the realities of transport in this period, the first Western imports from the Far East were textiles, the least fragile products. Since antiquity, trade in silk—appreciated for its aesthetic qualities, its strength, and its softness—had dominated commerce between Europe and China. As early as the thirteenth century, Italian silk makers, aware of the success of Eastern silks and faced with the impossibility of satisfying the demand for them, began to use orientalizing designs in their own productions. These floral, geometric, and symbolic motifs picturing such woven or embroidered images as the sun, the moon, the stars, mountains, dragons, phoenixes, vases, and axes, were soon the admiration of the Western public.

For the Chinese, the ornamentation of woven fabrics was imbued with symbolic and possibly religious significance, whereas for the Europeans, its value was purely decorative. Technically, Italian production methods were unable to match the finesse and rich color schemes of Yuan silks. Toward the middle of the fourteenth century, the weavers of Lucca began to use free imitations of motifs devised by the Han dynasty several centuries earlier, combining them with Islamic and Italian decorative forms. After Lucca fell to the Florentines, its silk makers moved to Venice, which, as a center of international trade, could guarantee their continuing

success. Chinese influence was in momentary decline there, having been displaced by that of Persian, Turkish, and Near Eastern forms reflective of the city's long-standing commercial ties with the Middle East. Motifs derived from the flowers and fruit of the pomegranate as well as artichokes, fir cones, and palmettes were used in various combinations until the early seventeenth century. The taste for Far Eastern artifacts grew again when richly colored textiles began to be imported from India. Around 1630—probably in reaction against the growing classical tendency in architecture, sculpture, furniture, and the decorative arts generally—fabrics with fantastic and even exotic motifs became fashionable in Italy and France. Stylized India flowers, lotuses, chrysanthemums, and peonies familiar from Japanese lacquer and Chinese porcelain were taken up by textile designers in those two nations. These floral motifs soon attained widespread currency, and, despite the momentary eclipse of chinoiserie, they have remained popular until today.

Louis XIV and Colbert, having decided to break the Italian monopoly of luxury fabrics by dispensing royal commissions and state subsidies, found themselves obliged to protect domestic production by blocking imports from India and China—even though such actions undermined the recently established French East India Company, which had yet to establish strong trade ties with China. Cardinal Mazarin (1602–1661), who was himself a great collector of Eastern textiles, had sensed the danger such imports represented for French manufacturers as early as 1650. In 1683, de Louvois, then de facto first minister, imposed heavy tariffs on imported textiles for precisely this reason, but the measure was not entirely successful. France, then the wealthiest nation in Europe, had the most opulent court, and, with orientalism being all the rage at Versailles, its inhabitants remained deaf to the pleas of their own government. Manufacturers in Tours, Lyons, and Paris, concerned about competition from the East, decided to address the problem by producing fabrics with orientalizing designs. People of fashion insisted that there was no substitute for genuine imports, but in fact only a few of them could distin-

page 262 guish between Chinese originals and European interpretations. Manufacturers shamelessly misled their clientele as to the true origin of their fabrics—designated with a long list of exotic-sounding names intended to cloud the issue—such as *siamoises, chinés, bergames de la Chine,* and *pékins.* In an article entitled *"chiner"*—in *Dessinateur pour les fabriques d'étoffes d'or, d'argent et de soie* (Design handbook for makers of gold, silver, and silk fabrics), Paris, 1765—Joubert de l'Hiberderie wrote: "Such have been for several years these beautiful taffetas . . . that are worthy of comparison with Peking [silk] and appear to originate in the realm of China."

The many gifts presented to Louis XIV in 1684 and 1686 by the Siamese ambassadors helped to establish a taste for fabrics decorated with semi-abstract or geometric patterns, and with vaguely Japanese compositions—combinations of fantastic flowers and animals arranged in brightly colored, asymmetrical configurations, often woven into shot fabrics or materials incorporating gold and silver

pages 226, 259–61 thread. Such designs, which have been known as "bizarre silks" since being so designated by Ernst Scheyer in the early twentieth century, were used not only in Lyons, where silk producers catered to the prevailing tastes in Paris and Versailles, but also in Venice, which was still an active silk production center, though no

longer dominant in world trade. Manufacturers in Holland and London, new-comers to the field, did their best to imitate the fabrics produced in Venice and Lyons. "Bizarre" chinoiserie motifs enjoyed their greatest vogue between 1690 and 1725. Concurrently, "India flowers" inspired by lacquerwork panels from China and Japan also became a fashionable textile motif. The designs featuring these blossoms, in which they are juxtaposed with parasols, paper streamers, rocks, architectural elements, and Chinese grotesques engaged in absurd actions, were strongly influenced by the illustrations in the *Nieuwe geinnenteerde Sineesen* (New orientalizing motifs) by German ornamentalist Peter Schenk, which appeared in 1725, but work by Lyons native Jean Revel (1684–1751) and by Jean-Antoine Fraisse also influenced these compositions. The latter's *Livre des dessins chinois* (Book of Chinese designs, 1735) met with success on an international scale; and Revel developed a technique for weaving realistically shaded designs comparable to those admired in Chinese embroidery. In England, James Leman became the exclusive ornamentalist to the Spitalfield silk factories, which after 1685 benefited greatly from the presence of Protestant craftsmen fleeing religious persecution in France, and who gave its productions a markedly French inflection.

Despite the preeminence of textile production in the first half of the eighteenth century, the period's great ornamentalists had little impact on it. In fact, the evolution of fabric design has always been relatively independent of that of the other applied arts. Although silks painted with India flowers long remained fashionable in apparel and in the decoration of interiors, a trend toward floral motifs during the reign of Louis xv (r. 1715–74) led to the less frequent use of chinoiserie motifs in woven fabrics for interiors. A few damasks with large-scale motifs—clearly intended to adorn rooms—were based on designs in the *Quatrième Livre de formes rocailles et cartels* (Fourth book of rocaille forms and cartels) by François-Thomas Mondon, or on those in the *Nouveaux Cartouches chinois* (New Chinese cartouches) by Alexis Peyrotte, but these were exceptions.

Painted and printed fabrics were often used instead of woven ones. They *pages 258, 262–63* were less expensive, and the fact that their strongest markets were located in the provinces and abroad freed them from slavish adherence to changes in Parisian fashion. Whimsical orientalizing motifs survived in this production well after a taste for the "real" China had been stimulated by William Chambers, a development that brought the moment of chinoiserie to an end around 1760.

Imported in large quantities by the English beginning in the sixteenth century, chintz, or Indian printed calico, was so popular that in the mid-seventeenth century European designs were sent to India for printing. In France, where such fabrics were known as *indiennes,* their success was less impressive. A few were produced after designs by Jean Bérain, but only when a factory was established in Jouy-en-Josas by Christophe Philippe Oberkampf (1738–1815) in 1759 were they popular there, just when chinoiserie was about to go out of fashion. Prints by Jean-Baptiste Pillement (1728–1808) usually served as models for this production, but the anglomania then so pervasive in France led to the widespread use of ornamental designs published in *The New Book of Chinese Designs Calculated to Improve the Present Taste,* by Edward Edwards and Mathew Darly (London, 1754).

Chinese hand-painted papers were much sought after beginning in the sixteenth century. They were very expensive, however, and Europe undertook to imitate them, just as it had done with painted fabrics. England made them a specialty and long enjoyed a de facto monopoly, supplying Italy, France, and even America with large quantities of it throughout the eighteenth century. Fortunately, many examples of this production survive.

Architecture à la Chinoise

Surprisingly, chinoiserie is the only seventeenth-century ornamental type to appear first in architecture rather than in the decorative arts. The first sign of it can be found in the so-called Manueline style of architecture and decoration, named after King Manuel the Fortunate of Portugal (1495–1521). Characterized by extravagant contortions and idiosyncratic detailing, it might well be termed architectural chinoiserie, and in fact it drew inspiration from the Asiatic experience of the architects Diogo de Arruda, Mateus Fernandes, and Diogo Boytac, all of whom were admirers of Indian temples and Mogul buildings.

The Jesuit accounts of China, India, Indonesia, and Japan were full of admiring descriptions of temples and palaces. The book published by Juan Gonzales de Mendoza in 1585, along with the subsequent ones mentioned above, inspired architects to design strikingly exotic buildings that bore little resemblance to their supposed Eastern models.

Architectural chinoiserie was scarce until about 1665, a delay attributable to the paucity of published images of Eastern buildings. So the richly illustrated Dutch edition of Jan Nieuhoff's *Embassy from the East India Company* (1665) had a considerable impact. It is no accident that, in 1670, architect Louis Le Vau (1612–1670) oversaw construction of the famous Porcelain Trianon in the gardens of Versailles, which immediately became the prototype for other such structures. Its basic configuration was classical, but its decoration—both interior and exterior, but especially the blue-and-white faïence tiles covering it—was clearly inspired by the porcelain pagoda of Nanjing. The tiles, which resembled Portuguese *azujelos* but were made in Delft, Nevers, Rouen, and Lisieux, proved vulnerable to inclement weather, and as a consequence the building had to be dismantled in 1687. During its brief seventeen-year existence it was much admired; prints of it were circulated, and European rulers eager to emulate Louis XIV resolved to erect their own versions. The porcelain rooms and lacquer salons that proliferated in European palaces in the late seventeenth and eighteenth centuries were the result.

Maximilian II Emmanuel, elector of Bavaria, had developed a decided taste for all things French during his long exile at Saint-Cloud, and between 1716 and 1719 he erected the Pagodenburg in the garden at Nymphenburg, on the outskirts of Munich, after designs by Joseph Effner (1687–1745). Augustus the Strong (1670–1733), elector of Saxony and then king of Poland, who was renowned for his determined efforts to discover how to make porcelain in his Dresden laboratories, inaugurated a series of Chinese pavilions by building the Wasserpalais (Water

Performers, illustration from
Jan Nieuhoff, *An Embassy from the East
India Company to the Grand Tatar Cham,*
Emperor of China, Leiden, 1665.
Basel, university library

Painted wall panel,
Christophe Huet, c. 1749.
Paris, Hôtel de Rohan, 87 rue Vieille-du-Temple

Prince-cardinal Armand de Rohan, the second
member of a veritable episcopal dynasty in
Strasbourg, displayed his taste, wealth, and
position in important artistic enterprises, including
the complete redecoration of his Parisian resi-
dence between 1749 and 1752. Although the neo-
classical movement was gathering momentum at
precisely this moment, these interiors are among
the finest achievements catering to the taste for
chinoiseries. Architect and pedagogue Jacques-
François Blondel (1705–1774), a severe critic of his
period, wrote that the cardinal had had all the
rooms on the building's main floor "redecorated
with extraordinary magnificence . . . in the most
modern taste . . . with Chinese subjects, all painted
by Monsieur Huet, an artist extremely skillful
in this genre." Like François Boucher, Huet, who
first worked in the exotic mode at Chantilly in 1722
(see pages 209 and 281), remained faithful to it
throughout his career, occasionally assisted by
Dutour and Crépin. In his decorative treatments
for the Hôtel de Rohan, Huet combined several
orientalizing modes—*chinoiseries, turqueries,* and
singeries—inspired in part by prints after Watteau
as well as illustrations in the volumes by
Athanasius Kircher and Jan Nieuhoff *(see above).*
He framed these elegant scenes with painted
arabesques that echo similar configurations in
images by Gillot, Audran, and Watteau.

Palace) in Pillnitz, on the banks of the Elbe. It was soon followed by the Japanese palace erected in Dresden between 1723 and 1730 for the display of Meissen porcelain. For Stanislas Leszczynski, former king of Poland and then duke of Lorraine, Emmanuel Héré de Corny (1705–1763) built several exotic pavilions at

pages 272, 273

Lunéville and Commercy. One of these was copied by Johann Gottfried Büring in Potsdam for Frederick the Great's garden of Sans-Souci between 1754 and 1757.

page 274

Similar structures—alas, all destroyed—rose in Brühl, Bayreuth, Rheinsberg, Drottningholm, Stowe, Wotton, and Studley Royal, among other sites.

As previously noted, William Chambers's revolutionary *Designs of Chinese Buildings . . .* (1757) revived the vogue for fantastic chinoiserie constructions in the late eighteenth century, creating a new profusion of pseudo-Chinese kiosks, pagodas, and pavilions in English gardens.

Garden Design

Another set of misunderstandings arose due to enthusiastic but imprecise descriptions of gardens in China. Nieuhoff published a few images of these gardens, but a more complete picture was unavailable in the West until the detailed account by Jesuit missionary J.-D. Attiret, written in 1743, was published in France in 1749 and in England in 1752 (as *A Particular Account of the Emperor of China's Gardens Near*

page 266

Pekin). It contained admiring descriptions of palaces and gardens, featuring rock gardens and artificial valleys, canals, lakes, and islands, connected by bridges and winding paths, and furnished with pavilions, grottoes, and menageries, landscaped "so that those living in one may not overlook those in another." Many of these elements were imitated in Europe, but the rigor of the Chinese models, which were devised with careful attention to the unfolding of successive views, remained a closed book there. In the eighteenth century, Europeans remained largely oblivious of the philosophical traditions informing the Chinese garden tradition, focusing instead on its more picturesque qualities, notably its asymmetrical design formats and charming gazebos. They were intrigued, too, by the apparent formal similarities between Chinese and English gardens, which in fact owed more to chance than to any deep-seated affinity. However, beginning in the 1760s, even after architectural chinoiserie had become unfashionable, what we referred to as Anglo-Chinese gardens spread throughout Europe, in princely estates from Palermo to Stockholm and from Ireland to Russia.

Tapestry

All of these little palaces, pavilions, and gazebos required specially designed furniture and decor. The Porcelain Trianon, with its faïence tiles, was doubtless perfect for warm-weather diversions, but it was not a very useful model for luxurious late-seventeenth-century interiors intended for more than seasonal use. Tapestries provided a more appropriate and opulent solution in such instances. But they

were expensive and took a long time to produce, factors that militated against any tendency to surrender to passing fashion in their design. Nonetheless, "Chinese" designs, like classical, historical, mythological, and religious subject matter, were soon adopted by the prestigious tapestry factories. First the Gobelins, then Beauvais, Berlin, and Soho produced hangings with chinoiserie compositions based on cartoons commissioned from the genre's most accomplished practitioners.

Even Charles Le Brun, Louis XIV's powerful artistic major domo and the director of the Gobelins factory, was drawn to exotic themes and motifs, which he used in his wall paintings for the Ambassadors' Staircase in Versailles (destroyed) and in some tapestry designs. In 1687, he oversaw the production of a splendid set of tapestries collectively entitled *Les Indes* (India), presented as a gift to Louis XIV by the Prince of Orange at a moment when the fiscal viability of France's state-supported luxury artisanal production was in crisis.

The Gobelins operated exclusively for the Crown, but the Beauvais factory (established in 1664) catered to a private clientele able to afford its steep prices, and thus was somewhat more responsive to market pressures and the dictates of passing fashion. Its looms produced one of the most magnificent examples of chinoiserie: *The Story of the Emperor of China,* a set of ten tapestries inspired by illustrations *page 287* in Nieuhoff's *Embassy from the East India Company.* The compositions, which probably date from 1685–90, were woven after designs by several artists under the direction of Guy-Louis Vernansal (1648–1729), who had previously collaborated with Le Brun and Jean Bérain. The first two weavings of the set were purchased, respectively, by the duc de Maine and his half brother, the comte de Toulouse, two of Louis XIV's legitimated children. The grand dauphin also had a pronounced taste for Far Eastern objects, and this helped to legitimize a style that some contemporaries were inclined to regard as unsuitable for the residences of French princes. In any case, by 1732 the cartoons were so worn from repeated weaving that a committee deemed them useless. These ingenious, vividly detailed compositions exemplify a tempered exoticism based on Eastern motifs filtered through the Western sensibility of the Jesuit fathers and their illustrators. Some of the fathers are even represented personally in the tapestries. This is a fitting tribute to their crucial role in the genesis of chinoiserie, and there is reason to view these compositions as an homage to the Jesuit missionary presence in China.

The second set of "Chinese" tapestries made at the Beauvais factory, dating *pages 288–93* from 1742, was more than just a replacement for the first. Chinoiserie had evolved considerably, and this time the project was entrusted to an artist who, despite his youth, was already quite famous, but whose accommodating temperament and gift for decoration made him an ideal candidate for the job: François Boucher. A member of the Royal Academy since 1734 and named a professor at its school in 1737, he had been the recipient of important official commissions since 1735. In addition to his brilliant career as a painter, he was a prolific printmaker—whose endeavors in that medium proved immensely profitable, garnering him an international reputation in the domain of ornamental engravings. He was too young to have known Watteau personally, but he became the master's heir in the matter of chinoiserie. Between 1726 and 1735 he collaborated on a set of thirteen prints

after painted panels at the Château de la Muette. These *Diverses Figures chinoises et tartares peintes par Watteau* (Various Chinese and Tatar figures painted by Watteau)

page 282

were followed between 1738 and 1745 by a *Recueil de diverses figures chinoises du Cabinet de François Boucher* (Collection of various Chinese figures from the studio of François Boucher). He continued to produce images in this vein for the most famous print publishers of the period: Claude III Audran, Gabriel Huquier, Gilles Demarteau (1729–1776), and Jean-Michel Liotard (1702–1796).

Given the impossibility of engraving all of them himself, he farmed some of the work out to Jean-Joseph Balechou (1716–1764), Pierre-Alexandre Aveline (1702–1760), Philibert-Benoît La Rue (1718–1780), John Ingram (1721–1769), Jean-Pierre-Laurent Houël (1735–1813), Louis Jacob (b. 1696), and Jean-Baptiste Perronneau (1715–1783). Around 1742, the twelve prints that make up the *Scènes de la*

pages 275, 299, 306, 307, 316

vie chinoise (Scenes from Chinese life) were engraved by Gabriel Huquier's son Jacques-Gabriel (1730–1805) after drawings by Boucher, or after his ten marvelous oil sketches commissioned to serve as the basis for the new Beauvais tapestry set:

pages 288–93

The Audience with the Emperor of China, The Banquet of the Emperor, The Chinese Marriage, The Chinese Hunt, Chinese Fishing, The Chinese Garden, The Chinese Dance, The Chinese Fair, Curiosity, and *The Toilette.* These exquisite designs mark the apogee of the genre, but only six were actually woven. The enigmatic solemnity of the compositions in the first set was here abandoned in favor of a more frankly theatrical vision better suited to contemporary sensibilities, one characterized by gaiety, charm, and nonchalance. The set was quite successful; it was woven nine times (last in 1775), and the penultimate weaving, dating from 1759, was in fact presented by Louis XV to none other than Qianlong, the reigning emperor of China. Such a diplomatic gift might strike us today as risky, not to say culturally obtuse, but in fact the emperor was so delighted with the hangings that he ordered a special pavilion built to house them, and there they remained until the sack of the Summer Palace in Beijing in 1860.

In 1748, one critic of the Salon exhibition in the Louvre expressed the fear that the artist's apparent passion for the *goût chinois,* or things in the Chinese taste, would have a deleterious affect on his style. But the Beauvais tapestry set effectively ended Boucher's direct involvement with chinoiserie. The private Aubusson factory, which then made tapestries, offering them at prices well below those commanded by the Beauvais factory's offerings, marketed a few hangings based on designs influenced by Boucher's earlier prints in the genre.

In 1685, the revocation of the Edict of Nantes compelled Protestant artists and craftsmen to leave France. The great elector of Brandenburg, recognizing the extraordinary opportunity that this state of affairs presented, seized it by effectively making Berlin an outpost of the French decorative arts community. He sponsored the establishment of a tapestry factory there that produced imitations of French chinoiserie designs, some bordering on parody. Contemporaries, who often asso-

pages 209, 280, 281

ciated China with simian imagery, often decorated rooms with a mixture of monkey and Chinese motifs—which became a popular form of chinoiserie.

The flourishing tapestry factory in London's Soho district engaged Robert Robinson, who produced designs of great originality. Like the German porcelain

Saint-Cyr stitch embroidery (detail),
silk, France, c. 1720.

Private collection

Embroideries were often decorated with chinoiserie
motifs. Prints by the most accomplished artists were
too expensive for simple craftsmen and private indi-
viduals, so they turned to the models more readily
available in popular prints, such as those from the
Larmessin workshop. Such embroidery was produced
in large quantities for use on walls, in upholstery, and
in bedding, but only a few examples have survived.

painter Johann Gregor Hoeroldt (1696–1775), Soho opted for compositions featuring a series of small vignettes arrayed against a solid background. In fact, these London-made chinoiseries were directly inspired by Mogul miniatures imported from India: around 1700 Westerners did not distinguish the various Asian cultures from one another.

Embroidery

Since antiquity, a cheaper alternative to tapestry has been embroidery—hand-sewn needlework—serving as wall hangings, furniture coverings, bedding, table-cloths, *portières,* or screens. Its designs were often modeled after the same ornamental prints as those used by other decorative arts craftsmen—except makers of woven textiles, who had their own sources of inspiration. As these productions are fragile and were subjected to considerable wear and tear, very few have survived, but chinoiserie motifs often figured on them.

pages 245, 254

Furniture

Once the walls of pavilions and exotic salons were covered, matching furniture was needed. From the Middle Ages to the Renaissance, European furniture evolved at a very slow pace, in both its overall form and its decorative schemes. Often it was entirely covered with fabric, with the wood beneath invisible. But the introduction of exotic woods and other luxury materials suitable for use in marquetry and other forms of inlay utterly transformed furniture making. Henceforth, the evolution of Dutch, French, Italian, and English production took a revolutionary turn, shunning the purely utilitarian in favor of ostentatious display. From the end of the sixteenth century to the end of the nineteenth century, European craftsmen deviated more and more from long-hallowed prototypes, and chinoiserie became an all but inescapable factor in their designs. The word *ébéniste*—which emerged in this period as the principal French term for luxury furniture makers (as opposed to *menuisier,* which designated craftsmen who worked on unadorned furniture or provided *ébenistes* with their bare frames)—conveys something of the material specifics of this development, for it derives from *ébène* (ebony) and thus telegraphs the primary importance of inlay, precious materials from the Orient, and technical virtuosity in the evolving lexicon. In fact, in the sixteenth and early seventeenth centuries ebony was the material of choice for purchasers of luxury cabinets with carved decoration, first in the Netherlands and then in France and Italy.

A form of cabinetry that receives too little attention today is that of vehicles for transport, which were also sumptuously decorated. Coaches and sedan chairs were often lacquered, in part to waterproof them. In these instances, chinoiserie functioned as an exterior sign of wealth, taste, and social status.

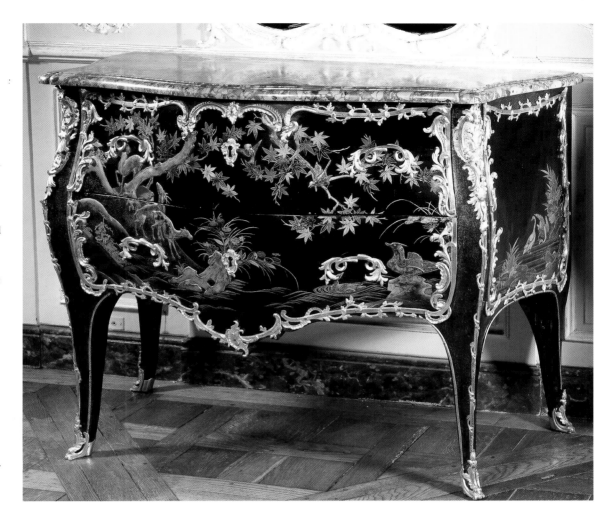

Commode,
Jacques Dubois,
Paris, c. 1745.

Paris, Musée Carnavalet

Dubois (1693–1763) made a specialty of furniture in the Chinese style. He frequently incorporated both genuine Eastern artifacts and Western imitations in his pieces, but the latter are sometimes of such high quality that it is difficult to tell them apart. In this commode, the black lacquer work is from a Parisian workshop. Suppression of the crossbar between the drawers allows the black lacquer design to be shown off to advantage. Curvilinear furniture frames proliferated during the Regency and under the reign of Louis xiv. They were inspired by Ming dynasty furniture (sixteenth-century), which sometimes featured sinuous legs.

The Vogue for Lacquer and its Derivatives

Lacquer, the brilliant and impermeable varnish made from the sap of the lac tree, known in the Far East for three thousand years, was the second Oriental lure to which the West succumbed. The combination of precious woods and lacquer, which beginning in the time of Cardinal Mazarin could be imitated almost perfectly in the West, gave much furniture an exotic aura akin to chinoiserie, even when more overt signs of its presence were absent. Oriental lacquer, invented in China but attaining its apogee in Japan beginning in the fifteenth century, was characterized by a brilliance similar to that of enamel, but it surpassed the latter in strength. Chinese lacquer shipped via India's Coromandel Coast, similar in certain technical respects to champlevé enamel, was especially favored by the French and English India companies in the late seventeenth and early eighteenth centuries. Unfortunately, Eastern suppliers responded to the growing Western demand by increasing production, and the result was a marked decline in quality.

Furniture was scarce in Chinese and Japanese interiors, which generally were organized by means of folding screens, usually consisting of twelve panels and often decorated with lacquer. These were much coveted by European merchants, who exported them in large quantities. Often they were broken up in the

West, their component panels being set into woodwork or cut down for incorporation into luxury furniture.

During the reign of Cosimo III de' Medici (r. 1670–1723), the Jesuit father Bommani succeeded in discovering some of the secrets of lacquer production. Between 1674 and 1688, John Stalker and George Parker of England published four revolutionary books on the subject, which, even though their actual readership was quite small, helped to popularize the techniques involved. In the wake of their influence, "Japan" became the principal English term for Western varnishes imitating lacquer, and "Japanning" a new vehicle for chinoiserie. Increasingly, English ladies of taste favored the making of Japanned objects over needlework.

Venice, which had fallen into decline as a result of the collapse of its commercial network, had not lost its flair in the realm of crafts, and its inhabitants made a specialty of *lacca contrafatta* or *lacca povera,* composed of small printed images that were cut up, colored, reassembled in tableaux, and then varnished. Produced in considerable quantities, frequently by amateurs, these lacquered compositions were often used to decorate furniture. In this form, chinoiserie penetrated the realm of the popular arts. The print dealers whose wares served as their basis profited from this vogue, too. Augsburg had long been the principal source of ornamental prints for the Italian market, but the emergence of this craft created a need for cheaper options. As a result, the Bassano-based publisher

page 282

Remondini began to specialize in plagiarizing ornamental sheets originally produced by others, and he soon acquired an international clientele.

Thanks to its commercial monopoly, Holland long remained the sole importer of Japanese lacquer. Nonetheless, beginning in the early sixteenth century it experimented with imitations, not without success, and several production centers emerged—notably at Spa in Belgium, which, in addition to being the most elegant European bathing resort of the eighteenth century, long remained the primary base of operations for the Dagly family, the first Japanning dynasty of international renown. However, Gérard Dagly (1657–1726) left the fold for Berlin in 1686. He became a favored craftsman at the court of Friedrich

page 303

Wilhelm, the "Great Elector" of Brandenburg, prefiguring the role of Johann Melchior Dinglinger (1664–1731) at the court of Augustus the Strong of Saxony. His brother Jacques (1655–1728) settled in Paris in 1713 and obtained a patent for a varnish factory there, making a specialty of chinoiserie and establishing ties with both the Audran studio, and hence with Watteau.

In England, the Puritan revolution spearheaded by Oliver Cromwell (from 1649 to 1660) and its aftermath temporarily impeded the development of Japanning techniques, but they soon established a foothold across the Atlantic. Thomas Johnson (born 1715, active until at least 1761) established a workshop in Boston, and other craftsmen there soon followed his lead: most of the Japanned furniture made in America in the first half of the eighteenth century was produced in that city.

Toward the middle of the eighteenth century the celebrated Martin broth-

pages 294, 298

ers, based in Paris, elevated Japanning techniques to an unprecedented level of perfection. Their royally sponsored factory for the manufacture of "Martin" var-

nish found one of its most enthusiastic clients in the dauphine, Marie-Josèphe de Saxe, whose taste had been formed at the Dresden court. The procedure of protecting marquetry inlay with varnish that also increased their brilliance became widespread in the eighteenth century. It was the perfect complement to Regency and Louis xv furniture, whose very forms were influenced by Chinese models: the curved legs so pervasive in these pieces derive from antique Ming furniture imported by the French East India company in the first years of the eighteenth century.

page 247

After having dominated the French decorative arts for half a century—along with the rocaille, with which it enjoyed a symbiotic relationship—chinoiserie entered a period of relative decline brought about by the advent of neoclassicism. In England, however, a variant of the chinoiserie/rocaille amalgam held its own against the rising neoclassical tide, thanks largely to furniture maker Thomas Chippendale (1718–1779), whose model-book *The Gentleman and Cabinet-Maker's Director* (1754) enjoyed an international success comparable to that of William Chambers's *Designs of Chinese Buildings* (1757). Under the leadership of these two form-givers, England set the rules for a new aesthetic dispensation.

page 299

page 300

The resulting English influence led to the establishment of a pan-European style of luxury furniture design. Abraham Roentgen (1711–1772) and his son David (1743–1807) were the most accomplished exponents of chinoiserie after 1750. Many refined designs in this mode accumulated in their Neuwied workshops, but those by Jean-Baptiste Pillement, Johann Esaias Nilson (1721–1788), and Januarius Zick (1730–1797), a German follower of François Boucher, most often figure in their pieces. Pillement, born in Lyons, had an unusually cosmopolitan career. He moved from France to Portugal, where the need to rebuild after the disastrous 1755 Lisbon earthquake had created many opportunities for him. Thereafter he spent longer periods in England and Poland but also worked in Piedmont, Milan, Rome, Venice, and Vienna. One of his prime vehicles was the single print marketed independently of an album, but he published many albums as well, notably *Oeuvres de fleurs, ornements, cartouches, figures et sujets chinoises* . . . (Chinese designs with flowers, ornaments, cartouches, figures, and subjects . . .), a collection of designs intended for use by craftsmen of all kinds, which appeared in Paris in 1776. Other collections produced by Pillement between 1750 and 1775 include *Cahier de cartels chinois* (Album of Chinese cartels), *Cahier d'oiseaux chinois* (Album of Chinese birds), *Petits Ornements chinois* (Small Chinese ornaments), *Suite de jeux chinois* (Suite of Chinese games), *Recueil des tentes chinoises* (Collection of Chinese tents), *Recueil des fontaines chinoises* (Collection of Chinese fountains), and finally *Cahier de balançoires chinoises* (Album of Chinese swings). Such a prodigious output reveals an ornamentalist of considerable invention, and his designs were gratefully appropriated by European artisans working in all media.

page 297

pages 265, 276, 277, 308, 313, 320

The Firing Arts: Faïence and Porcelain

Just as Eastern silks had spurred the fantasies of the Greco-Roman world, porcelain became something of an obsession among sixteenth- and seventeenth-century

European elites. The extreme fragility of these objects effectively precluded their importation prior to the establishment of maritime shipping routes. In the Middle Ages a few rare pieces miraculously reached Europe intact and were eagerly procured for princely collections and ecclesiastical treasuries, but no attempts were made to imitate them. After the various India companies were established, they made Eastern porcelain one of their principal objectives. The willingness of their agents to pay exorbitant prices for these prized productions inevitably led to a decline in quality, for their makers in China and Japan increasingly resorted to quasi-industrial methods to meet the considerable Western demand. But the intervention of Augustus the Strong, elector of Saxony and king of Poland, utterly transformed the market dynamics. He can justly be termed the godfather of European porcelain, for he was determined not only to break the secret of making the translucent white ceramic ware but to surpass Eastern porcelain in quality. His was not the first such attempt: similar experiments were made at the Medici workshops in Florence beginning in 1587, which resulted in nothing more than opaque pottery decorated with Chinese motifs. Faïence makers in Lisbon, Rouen, Nevers, Saint-Cloud, Sinceny, Strasbourg, Sceaux, Aprey, Marseilles, Delft, Hanau, Frankfurt, Berlin, Lodi, Bassano, Venice, Turin, and Milan also tried to develop the requisite techniques, but to no avail: conventional earthenware painted with rich chinoiserie decorations was the best they could do.

Beginning in 1650 the India companies asked porcelain producers in China and Japan to produce ceramics decorated with European designs, and they were happy to comply, for by then Eastern imports were competing with the chinoiserie produced by European pottery workshops. The latter continued their investigations into the manufacture of porcelain, notably in France, where in 1673 Louis Poterat (1641–1696) developed the soft-paste technique; and beginning in 1679 chemists working for the Saint-Cloud factory made real advances. Finally, in Meissen in 1710, Johann Friedrich Böttger and Count Ehrenfried de Tschirnhausen, spurred on by Augustus the Strong, outstripped their French competitors and definitively solved the riddle of hard-paste porcelain production.

Having succeeded in his cherished goal, this "most Oriental of Western monarchs," as Augustus was known, made the imitation of genuine Eastern porcelains and semiprecious stones pieces in the royal collection a priority. He was determined to keep "his" techniques a secret, but some members of the production team, indignant at being virtually imprisoned by the elector, managed to escape to Vienna, where in 1719 they collaborated in the establishment of a rival factory. However, Samuel Stölzel (d. 1737), the most technically informed of the renegade group, soon fell out with its director, Innocent-Claude du Paquier (d. 1751), and returned to the factory in Meissen where he was duly pardoned. He brought with him the young enamel painter Johann Gregor Hoeroldt, who was immediately placed in charge of the painting studios. The many responsibilities this entailed soon made it necessary for Hoeroldt to abandon miniature painting himself and turn his attention to providing designs for the craftsmen under his supervision. He obtained approval for the purchase of 147 French ornamental prints for this purpose, but he also proved to be an inventive designer of elegant

pages 319, 321

Porcelain plate, Vincennes, after a
design by François Boucher (*The Game
of Chinese Chess,* from a set of prints
engraved by Jean-Michel Liotard
[1702–1796]), 1740–45.
Paris, Musée des Arts Décoratifs

Porcelain group representing a Chinese
musician and servant, Meissen, c. 1748.
Paris, Musée des Arts Décoratifs

*G*roups such as this one—which was probably
modeled by Johann Friedrich Eberlein (1696–1749)
or Friedrich Elias Meyer (1724–1785)—were usually
conceived for table decorations like the one illus-
trated in Gilliers's *Cannaméliste françois* (1768). As
individual pieces they were delivered to dealers,
who provided them with gilt-bronze mounts.
Meissen craftsmen were adept at changing their
designs to suit varying needs—by replacing an
inkholder with a candleholder, for example. The
account books of Lazare Duvaux, a preeminent
eighteenth-century Parisian dealer specializing in
luxury objects of all kinds, indicate that in 1749 his
stock included a group similar to this one, inspired
by a print engraved by Boucher after Watteau.

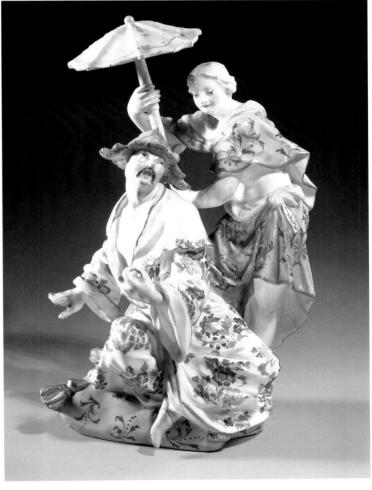

CAM-HY
*Empereur de la Chine
et de la Tartarie Orientale,
Agé de 41 an et peint a l'agé
de 32.*

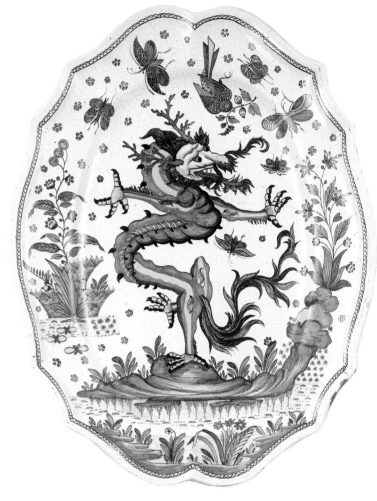

Frontispiece with portrait of
Emperor Cam-Hy (Kangxi), *Nouveaux
Mémoires sur l'Etat présent de la Chine*
(New memoirs on the present state of
China) by Father Louis-Daniel Le Comte
(Amsterdam, 1698).
Private collection

Plate decorated with dragon motif
("à la guivre"), faïence, Rouen, c. 1760.
Sèvres, Musée National de Céramique

Corbels supporting a balcony,
Paris, 1726–30.
Paris, 51 rue Saint-Louis-en-l'Isle

Dragons have been a constant in both Eastern
and Western imagery for millennia. Chinese ver-
sions were introduced into the West during the
Middle Ages on Far Eastern embroidery, and were
soon incorporated into decorative sculpture as
well as textile and ceramic designs, but Western
craftsmen remained oblivious of their symbolic
import. Interest in them was revived in the seven-
teenth and eighteenth centuries by illustrations in
the published accounts of Jesuit missionaries to
the East; the appearance of Le Comte's volume of
1698 sparked a particular resurgence.

chinoiserie compositions featuring India flowers and elegant, spidery figures, which were often executed under his guidance in vivid color schemes with gold and silver highlights. The drawings by him now in Leipzig, recently published by George Wilhelm Schulz, demonstrate his superb facility in this genre.

In 1726 this precursor of Pillement published a collection of ornamental prints intended for use only by factory craftsmen but pillaged by free-lance enamel painters called *Hausmaler* working with unadorned porcelain wares obtained from the factories. These same craftsmen also specialized in adding decoration to Asian porcelain. Of the many *Hausmaler* based in Dresden, Breslau, page 318 Vienna, Bayreuth, and especially Augsburg, the most famous were Bartholomaüs Seuter (1678–1754), Johann Aufenwerth (d. 1728), and Christian Friedrich Herold (1700–c. 1779). The latter was engaged by the Meissen factory in 1726, where he and Johann Ehrenfried Stadler (b. 1702) became its most accomplished chinoiserie ornamentalists. Under the direction of the ostentatious Count Heinrich Brühl from 1733 until his death in 1763, the factory favored designs in this vein, but by mid-century chinoiserie had become increasingly unfashionable. As a result, its practitioners were ousted and replaced by craftsmen versed in more current decorative idioms, and parallel changes were instituted more or less simultaneously in all the European pottery factories.

Inevitably, more rival factories were established after the initial information leak of 1719. Meissen managed to retain its preeminence in the realm of porcelain *pages 251, 311, 318,* production for at least another forty years, and even after 1760 it held its own *319, 321, 322–23* against the growing flood of wares made by dozens of factories, the most important of which were in Venice, Doccia, Vincennes-Sèvres, Capodimonte-Buen Retiro, Chelsea, Saint-Petersburg, Höchst, Nymphenburg, Fürstenberg, Berlin, Frankenthal, Ludwigsburg, Ansbach, Copenhagen, Zurich, and Fulda. In time these and other smaller factories presented imported Far Eastern porcelains with serious, eventually fatal competition.

Chinoiserie was initially nurtured as a courtly art, and it long retained its special ties to the social and financial elites of Europe. Gradually, however, it insinuated itself into cheaper, less prestigious decorative arts productions and even into popular crafts, where it had a surprisingly long life. Its success was not just a chance occurrence. Chinoiserie both fed upon and helped to shape Western fantasies about the East, but it also signaled a determination to reconsider the most prestigious of traditional Western ornamental vocabularies. The penchant for exoticism so pervasive in contemporary literature, theater, philosophical discourse, and theological debate was symptomatic of an increasing willingness to question indigenous traditions, and it gave seductive visual form to this emergent skepticism, which took root and flourished in the Enlightenment. Chinoiserie was to prove itself something of an ornamental chameleon. As we have seen, in the second half of the seventeenth century it figured largely as an adjunct to the arabesque or new grotesque, while in the eighteenth century it became an all-but-indispensable complement to the rocaille and even played a limited role in the heyday of the neoclassical style.

Gros point and petit point embroidery
intended for a bed hanging (detail),
silk and wool, France, c. 1740.
Riggisburg, Abegg Foundation

Mandarin in martial attire *(left)* and
Chinese lady *(right)*, illustrations
from Father Jean-Baptiste Du Halde,
*Description géographique, historique,
chronologique, politique et physique de
l'empire de la Chine et de la Tartarie chinoise*
(Geographical, historical, chronological,
political, and physical description of the
empire of China and of Chinese tatary),
Paris and The Hague, 1735–36.
Private collection

*I*llustrations in Du Halde's book provided
models for some of the figures in this embroidery
design, although they were not conceived for
such a purpose.

The Banquet of the Officers of the St. George Civic Guard Company, oil on canvas, Frans Hals, Haarlem, 1616.

Haarlem, Frans Halsmuseem

The production of damask tablecloths attained a high degree of perfection in early-seventeenth-century Flanders and the Netherlands. Their designs reflected contemporary political and religious concerns as well as changing tastes in ornamental motifs. The example in this painting by Hals is decorated with a Chinese scene featuring a man on a palanquin against a background of exotic trees and surrounded by India flower scrolls.

Silk damask hanging, Lyons, c. 1745.

Private collection

ℒyons silk makers used designs by both Parisian ornamentalists and in-house designers. The figures in this large-format pattern were based on several sets of chinoiserie prints by Gabriel Huquier after Boucher. His set of *Diverses Figures chinoises* (Various Chinese figures), dated between 1738 and 1745, is the source of the musicians perched on the framing rinceaux. Some of the other figures and clothing derive from another series entitled *Les Quatre Eléments* (The four elements), published by Huquier around 1740, after the *Livre de six feuilles représentant les cinq Sens par differents amusements chinois sur les dessins de François Boucher . . .* (Book of six sheets figuring the five senses as different Chinese amusements, after designs by François Boucher . . .). Boucher himself had been inspired by a cartouche illustrated in the volume by Martinus Martinius (1655), which reappeared in simplified form a few years later in a volume issued by Athanasius Kircher's publisher.

Hearing and *Taste,* prints by Gabriel Huquier from *Livre de cartouches inventés par François Boucher* (Book of cartouches invented by François Boucher).

Paris, Bibliothèque d'Art et d'Archéologie, Fondation Jacques Doucet

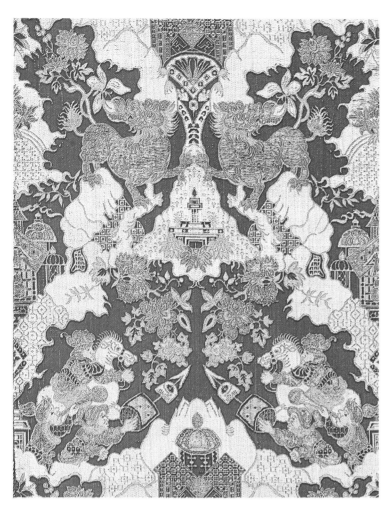

Damask, brocaded satin, France, 1707–10.

Riggisberg, Abegg Foundation

*W*arriors brandishing lances and blowing trumpets assault a snow-covered mountain defended by overscale, flower-eating lions. The figures, animals, and flowers all seem to have been inspired by lacquer panels from the Kangxi period (1662–1722).

Portrait of the Duchesse de Bourgogne, oil on canvas, Pierre Gobert (1662–1744), c. 1705.

Paris, Musée Carnavalet

*T*he Lyons silk factories modeled most of their patterns after designs by Parisian ornamentalists. Whatever failed to sell on the French market was made available to foreign customers. Around 1700 it became customary to revamp the fabric designs every year, the better to accommodate— and profit from—fluctuations in taste.

*T*he chinoiserie designs that they used in their productions combined motifs taken from Far Eastern lacquer and porcelain with details from the illustrations published in the Jesuit accounts of the East. Exoticizing forms even made their way onto church vestments.

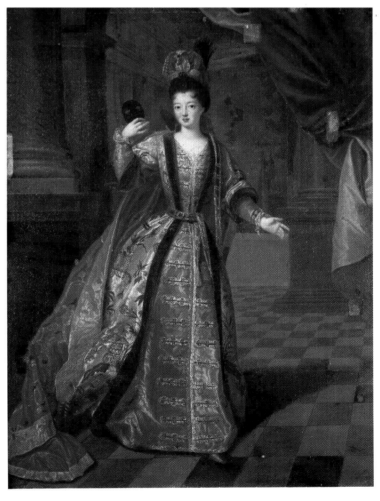

The Garter, oil on canvas, Jean-François de Troy (1679–1752), c. 1725–30.

New York, Metropolitan Museum of Art

This painting offers a tantalizing glimpse of a chinoiserie-inflected decor from early in the reign of Louis XV. Huge fortunes garnered by lucky investors prior to the collapse of John Law's banking and investment system (May 1720) encouraged lavish interior decoration schemes in subsequent years. Delicate wall and upholstery fabrics like those shown here, which feature *indienne* designs that are considerably less oppressive than the velvet brocade patterns traditionally favored, were especially fashionable in the 1720s. Both the manufacture and the import of such fabrics were repeatedly prohibited, a sure sign of their success.

Portrait of Elisabeth-Charlotte d'Orléans,
Duchesse de Lorraine, oil on canvas,
anonymous, c. 1698.

Versailles, Musée National du Château

The subject, daughter of Monsieur (Louis XIV's
brother) and the Princesse Palatine, was born in
1676; in 1698 she married the Duc de Lorraine,
and this portrait celebrates her new status. She is
pictured wearing a sumptuous dress made out of a
gold fabric, woven with India flowers inspired by
those on hand-painted Chinese silks and with
quasi-abstract *bizarre* motifs *(see pages 226 and 239)*
deriving from prints by Daniel Marot and
Jean-Antoine Fraisse.

FACING PAGE

Damask, brocaded Tours cloth,
Lyons, c. 1706–7.

Riggisberg, Abegg Foundation

The taste for richly brocaded fabrics characteristic of the Louis xv period could draw only limited inspiration from Chinese models, for these were usually painted or embroidered. As a result, orientalizing forms from a wide array of sources were combined into eccentric, quasi-abstract motifs to make what are now known as "bizarre silks" *(see also pages 226 and 239)*. Daniel Marot provided a few ornamental prints for textile designers working in this idiom, and other, less well-known ornamentalists did likewise.

ABOVE

Damask, brocaded satin,
Lyons, c. 1705.

Riggisberg, Abegg Foundation

Panel of painted silk, France or Canton, c. 1740 *(left)*.
Fabric, China or England, mid-eighteenth century *(right)*.
Private collection

Madame de Pompadour, oil on canvas,
François-Hubert Drouais (1727–1775), c. 1764.

London, National Gallery

*I*n this painting, the last large-scale portrait of the marquise (1721–1764),
Louis xv's official mistress, we see her amid the exotic appointments of her
private rooms, wearing a sumptuous silk dress painted with India flowers.
The material's origin is difficult to determine, for imitations of Eastern

painted fabrics produced in Europe in the mid-eighteenth century are all
but indistinguishable from their models. However, the pattern of the cloth
covering the sofa so precisely echoes that of the frame that it can only
have been produced in France. The bookcase on the right has a pronounced
Oriental inflection, and the crochet frame has a lacquered surface inspired by
Far Eastern artifacts. Even the undulating chair frame owes something to
Chinese models. Only the superbly detailed work table in the foreground,
designed to resemble an *athénienne* (antique brazier with a tripod base) reveals
the increasing prestige of ancient models in these years.

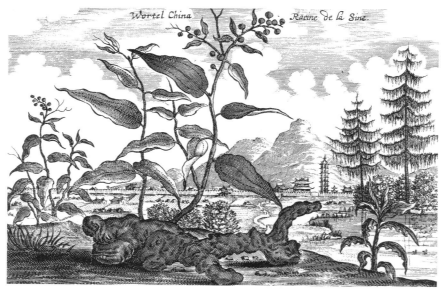

Wortel China Racine de la Sine.

Colored print, Gabriel Huquier, from
*Recueil des différentes espèces d'oiseaux, fleurs,
plantes et trophées de la Chine* (Collection
of different species of Chinese birds,
flowers, plants, and trophies), c. 1745.

*Paris, Bibliothèque d'Art et d'Archéologie,
Fondation Jacques Doucet*

Chinese Root, illustration from
Jan Nieuhoff, *An Embassy from the East
India Company to the Grand Tatar Cham,
Emperor of China*, Leiden, 1665.

Basel, university library

ABOVE LEFT

Print from
Cahier de cartouches chinois
(Album of Chinese cartouches),
Jean-Baptiste Pillement,
mid-eighteenth century.

*Paris, Bibliothèque d'Art et d'Archéologie,
Fondation Jacques Doucet*

ABOVE RIGHT

Colored print, Gabriel Huquier, from
*Recueil des différentes espèces d'oiseaux, fleurs,
plantes et trophées de la Chine* (Collection
of different species of Chinese birds,
flowers, plants, and trophies), c. 1745.

*Paris, Bibliothèque d'Art et d'Archéologie,
Fondation Jacques Doucet*

Fanciful compositions (such as these by Huquier
and Pillement) in which flowers and foliage inter-
mingle with ribbons, shells, and knotted roots are
rocaille variations on the botanical illustrations
in Nieuhoff's *Embassy*. They most often served
as the basis for woven fabric designs.

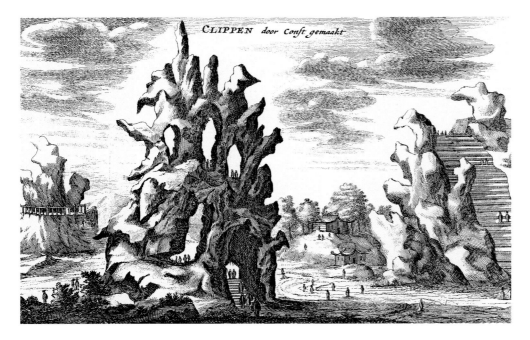

CLIPPEN *door Conft gemaakt*

Artificial rocks, illustration from
Jan Nieuhoff, *An Embassy from the East
India Company to the Grand Tatar Cham,
Emperor of China,* Leiden, 1665.
Basel, university library

Print from Johann Bernhard Fischer
von Erlach, *Entwurf einer historischen
Architektur* (Outline of a historic
architecture), book III, plate 15,
Vienna, 1721.
Basel, university library

One of a set of four chinoiserie images
set within interlace frames, print,
Elias Baeck, known as Heldenmuth
(1677–1747), Augsburg.
Private collection

*A*rtificial rocks are a pervasive chinoiserie motif.
They were introduced into the Western visual
lexicon by Nieuhoff's *Embassy*. Baeck used modi-
fied versions in ornamental prints intended
primarily for goldsmiths and porcelain painters,
but even so high-minded an architect as Fischer
von Erlach was responsive to their picturesque
qualities. The proliferation of images of such
rocks, which wildly exaggerated their size, gave
new impetus to the eighteenth-century taste for
artificial grottoes and for the bizarre rockwork
mounds supporting Chinese tableaux.

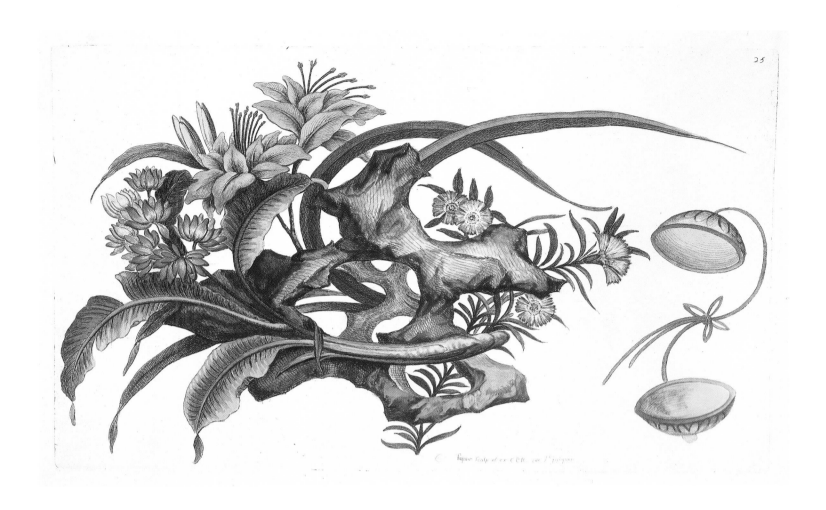

Colored print, Gabriel Huquier, from
Recueil des différentes espèces d'oiseaux, fleurs,
plantes et trophées de la Chine (Collection
of different species of Chinese birds,
flowers, plants, and trophies), c. 1745.

Paris, Bibliothèque d'Art et d'Archéologie,
Fondation Jacques Doucet

Snuff- or spice box, partially
nielloed gold, Vologda (Russia),
mid-eighteenth century.

Paris, Louvre

The gnarled, rootlike forms nielloed on this
gold box derive from compositions by Huquier
or Pillement. Both of these artists delighted
in woody roots resembling pierced rocks.
Interestingly, Parisian jewelers and goldsmiths
tended to avoid such forms.

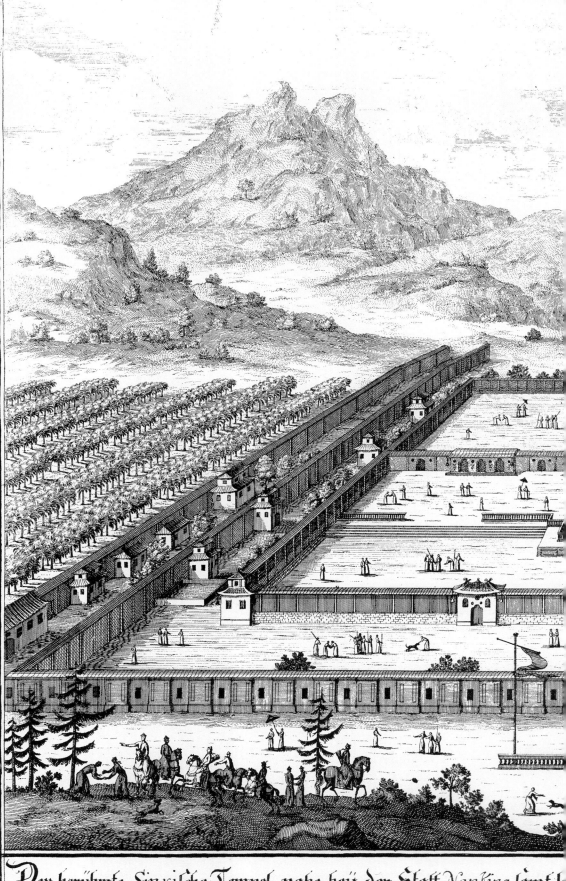

"The famous pagoda near Nankin, with its courts, mausoleums, paths, pools, and the magnificent nine-story porcelain tower," illustration from Johann Bernhard Fischer von Erlach, *Entwurf einer historischen Architektur* (Outline of a historic architecture), book III, plate 12, Vienna, 1721.

Basel, university library

The Western fascination with Chinese pagodas in general, and with the Nanjing pagoda in particular, found visual expression only with the publication of Nieuhoff's *Embassy* in 1665. The nine stories of the Nanjing pagoda, built during the reign of Yong-lo (r. 1403–24), were encased in porcelain tiles and adorned with large bells that tinkled in the wind. Nieuhoff's print and the accompanying caption secured its status as one of the wonders of the contemporary world. It spawned a host of Western imitations, from Le Vau's porcelain Trianon at Versailles (1670; destroyed 1687) to the pagoda-like pavilions that proliferated in eighteenth- and early-nineteenth-century gardens.

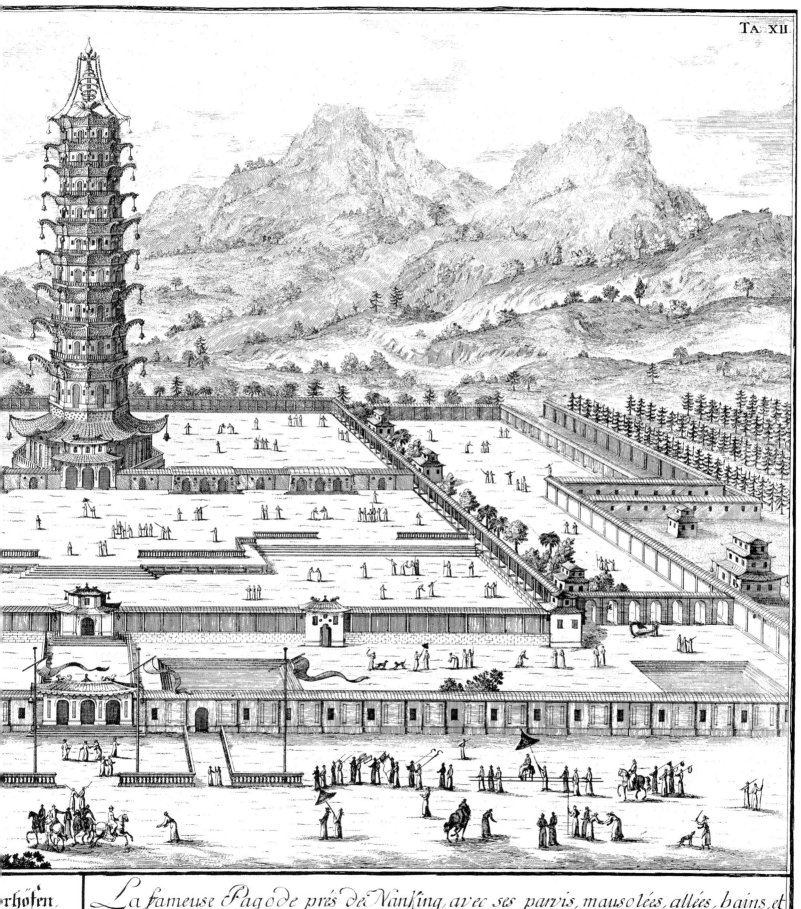

rhöfen,
ichen Por-
ßen Meilen.

La fameuse Pagode prés de Nanking, avec ses parvis, mausolées, allées, bains, et la magnifique Tour de Porcellaine á neuf étages. L'êtendüe de ses dependences a .12. lieues de circuit.

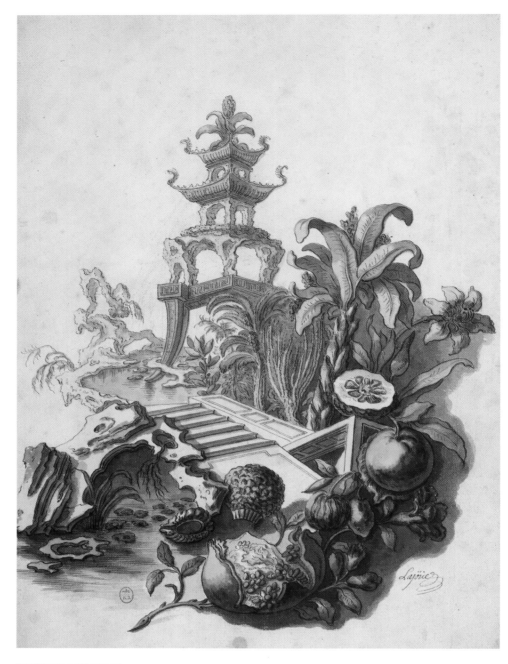

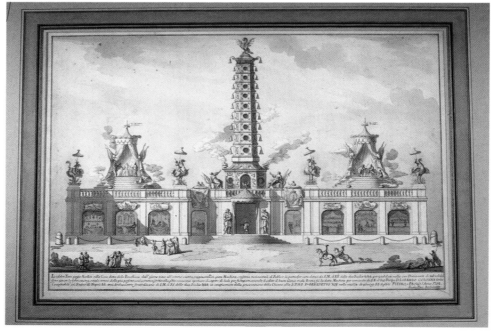

Silk design, pen, wash, and watercolor,
Jacques de Lajoüe (1686–1761), c. 1733–35.

Paris, Bibliothèque Nationale

ℒajoüe, a great master of the rocaille, was also drawn to chinoiserie, as can be seen in this design, which features an eccentric version of the Nanjing pagoda. He produced sixty-four such compositions, but we do not know if they were made for a specific artist, or if they were ever used by silk designers in Tours or Lyons.

Design for the Chinea, pen and wash, Paolo Posi (1708–1776), 1758.

Private collection

ℰphemeral pagoda structures also rose in Europe. Paolo Posi constructed one to mask the scaffolding used to set off a fireworks display during the annual Roman festival known as the Chinea, when the king of Naples presented tribute to the pope in the form of a white horse whose breed-name—Chinea—probably inspired the "Chinese" theme. This drawing by the architect was made as a preliminary to the print intended to commemo-rate this short-lived structure.

Pagoda at Chanteloup, Louis Denis Le Camus, 1775–78.

𝒯he Duc de Choiseul (1719–1785) was Louis xv's de facto prime minister from 1758 until his disgrace in 1770; thereafter he lived in diplomatic exile on his estate at Chanteloup, near Amboise, where he built this structure as an expression of gratitude to his many loyal friends. Le Camus's design, which features successive setbacks intended to allegorize Choiseul's fall from official favor, ingeniously combines neoclassical detailing with a Chinese building type.

Pagoda at Kew Gardens, William Chambers, 1762, London.

ℐn this structure, which was built for Augusta, dowager princess of Wales, Chambers adhered closely to Chinese models.

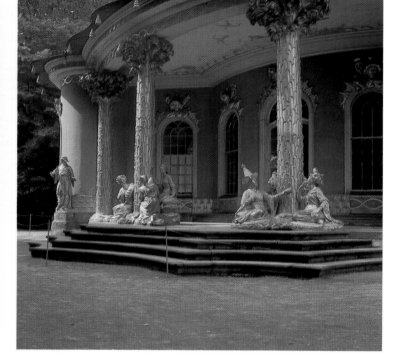

The tea-house in the garden of Sans-Souci,
Johann Gottfried Büring, 1754–57.

Potsdam

Stanislas Leszczynski, king of Poland and duke of Lorraine, was drawn to Far Eastern art. Having settled in Lorraine after being forced from the Polish throne, he set out to recreate in his Nancy, Lunéville, Commercy, and La Malgrange residences the luxurious orientalizing surroundings to which he had become accustomed. In 1746 his architect Emmanuel Héré de Corny had erected a pavilion at Commercy modeled after the small pagoda in Xinjiang. In 1747 Frederick II of Prussia resolved to have a similar structure in his gardens at Sans-Souci, and Büring was commissioned to build a "Chinese tea-house" there. Johann Melchior Kambly (1718–1783) and Matthias Müller (active 1745–74) added gilded Chinese figures grouped around gilded palm-tree columns; and for the roof, Benjamin Giese (1705–1755) sculpted a freely rotating seated figure with a parasol—also gilded—that functioned as a weathervane. The interior dome was painted with figures in the same style behind trompe-l'oeil banisters by Thomas Huber (1700–1779) after sketches by Blaise-Nicolas Le Sueur (1716–1783).

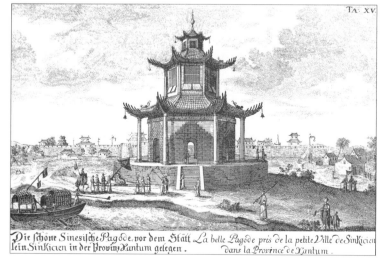

"The beautiful pagoda near the small town of Sinkian," from
Fischer von Erlach, *Entwurf einer historischen Architektur,* book III.

Basel, university library

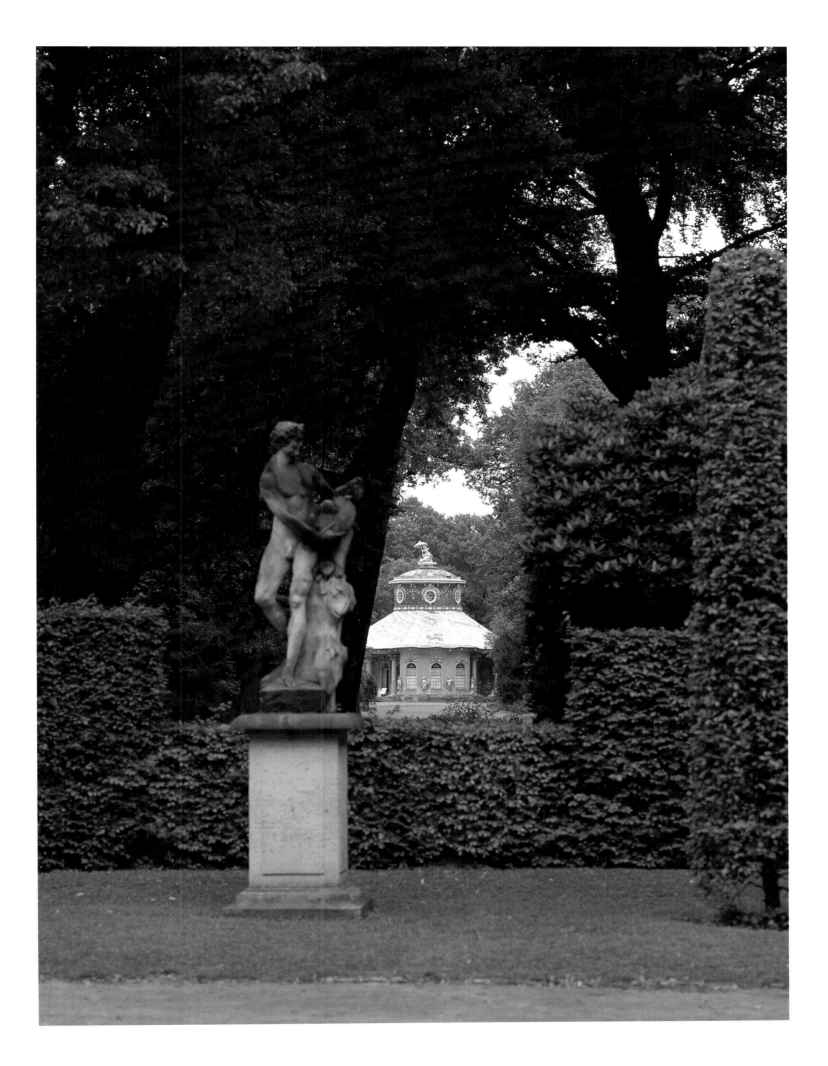

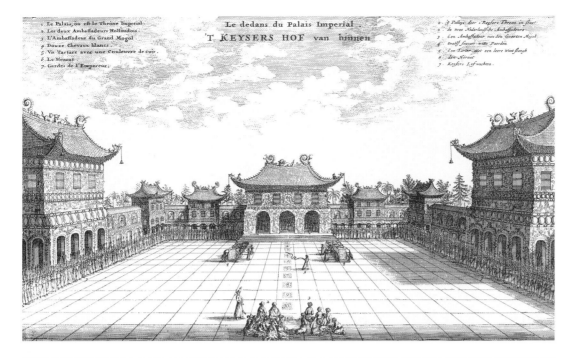

1. Le Palais, où est le Thrône Imperial.
2. Les deux Ambassadeurs Hollandois.
3. L'Ambassadeur du Grand Mogol.
4. Douze Chevaux blancs.
5. Un Tartare avec une Couleuvre de cuir.
6. Le Herant.
7. Gardes de l'Empereur.

Le dedans du Palais Imperial
'T KEYSERS HOF van binnen

1. 't Palleys, daer 't Keysers Throon in staet.
2. de twee Nederlandsche Ambassadeurs.
3. Een Ambassadeur van den Grooten Mogol.
4. twaelf specie-witte Paerden.
5. Een Tarter, met een leere Wint-slangh.
6. den Herout.
7. Keysers Lyfwachten.

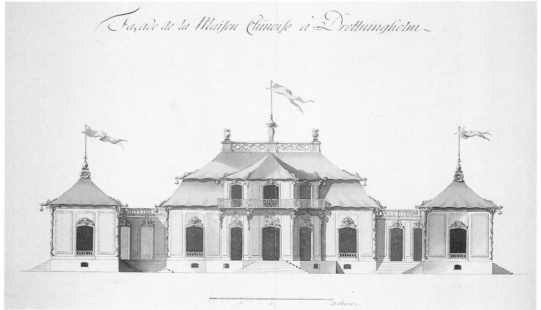

Façade de la Maison Chinoise à Drottningholm.

"Inside the complex of the Imperial Palace," illustration from Jan Nieuhoff, *An Embassy from the East India Company to the Grand Tatar Cham, Emperor of China,* Leiden, 1665.
Basel, university library

Elevation of the principal façade of the Chinese pavilion at Drottningholm, Carl Frederik Adelcrantz (architect), 1763.
Stockholm, Architekturmuséet

On the birthday of Queen Louisa Ulrica in 1753, King Adolphus Frederick of Sweden had a Chinese pavilion built for her in the park of their palace at Drottningholm. It was such a success that between 1763 and 1769 the original temporary structure was replaced by the one that still stands, and it is one of the best preserved examples of architectural chinoiserie. Behind its pink-and-gray façades topped by undulating copper roofs, animated with bell chimes and dragons, are varied interiors, all with Oriental decorative schemes. (In 1761, Gustave III, king of Sweden, son of Adolphus Frederick, had even considered enlarging the complex, but this project never came to fruition.) The interiors of the two salons on either side of the central building are the work of Johan Pasch, who decorated the paneling with motifs based on prints by Gabriel Huquier after François Boucher (*Scènes de la vie chinoise,* engraved around 1742, or *Figures chinoises,* published by Jean-Michel Liotard, the twin brother of well-known pastel painter Jean-Etienne Liotard [1702–1789]).

FACING PAGE (TOP)

Yellow salon and blue salon (details), Chinese pavilion at Drottningholm, c. 1763.
Drottningholm (Sweden)

FACING PAGE (BOTTOM)

Two prints from *Scènes de la vie chinoise* (Scenes from Chinese life), Gabriel Huquier after François Boucher, c. 1742.
Paris, Bibliothèque d'Art et d'Archéologie, Fondation Jacques Doucet

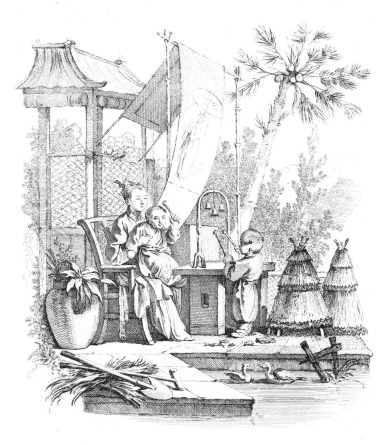

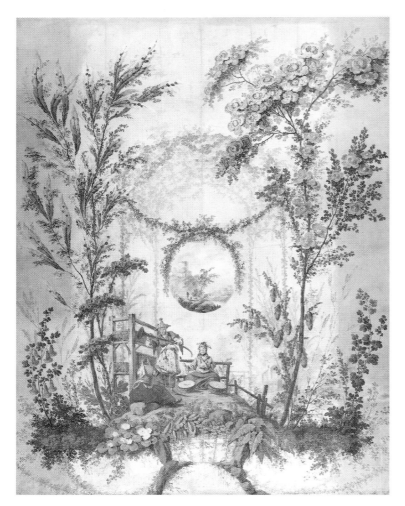

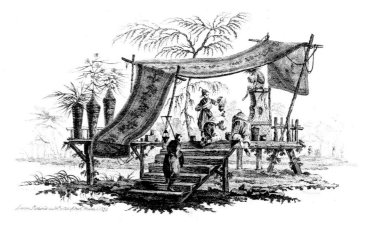

Decorative panel (one of four)
from the dining room of the
palace at Misnovrie, in Poland,
Jean-Baptiste Pillement, 1765–67.
*Paris, Musée Carnavalet, on loan to the
Musée du Petit Palais*

The decor commissioned by Stanislas Augustus
Poniatowski, king of Poland, for the residence of
his nephew Michel Krizeck, grand marshal of the
crown, is among the largest projects ever com-
pleted by Pillement. The artist began to execute
such decorative schemes prior to publishing his
several sets of print compositions in a similar vein.
He often indulged his fantasy to an excessive
degree, which put him a bit at odds with prevailing
French taste, but here he has kept it in check, with
delightful results: such open, airy effects are rare
in decorative painting of this kind.

Overdoor, after a design by
Jean-Baptiste Pillement, c. 1760.
Paris, Musée des Arts Décoratifs

Pillement's European travels did not slow his
print production, which was considerable and
resulted in images published in both Paris and
London. His distribution network was extremely
well organized, assuring the success of these
enterprises, and his compositions quickly found
their way into projects of all kinds; their blend of
clarity and fantasy made them useful to craftsmen
at all levels of technical sophistication.

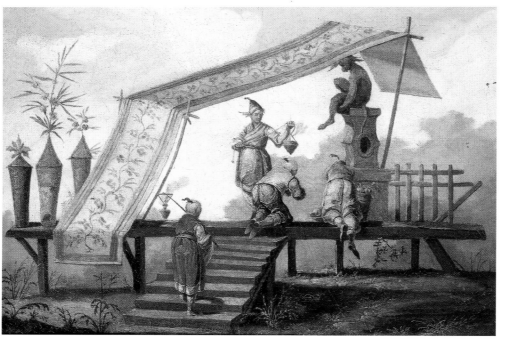

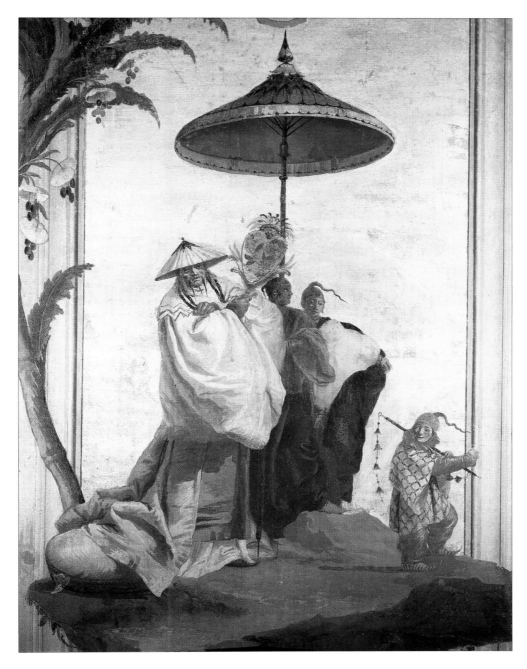

The Mandarin's Passage, fresco,
Giovanni Domenico Tiepolo (1727–1804), 1757.
Vicenza, guest house of the Palazzo Valmarana

Both Giovanni Battista Tiepolo (1696–1770) and his son Giovanni Domenico
(1727–1804) worked on the Palazzo Valmarana decorations, but the latter
frescoed the *foresteria* (guest house). This orientalizing vignette owes much
to compositions by Pillement, who had visited Venice: the floating rock
platforms, the large flowers, and even some of the figures (such as the child
on the right) were appropriated by Domenico from prints by Avril
after Pillement's designs.

Illustration from *Cahier de Fleurs singulières, inventées et
dessinées par J. Pillement* (Album of singular flowers, invented
and drawn by J. Pillement), engraved by Jean-Jacques
Avril the elder (1744–1831).
Paris, Bibliothèque d'Art et d'Archéologie, Fondation Jacques Doucet

Three details from a salon in the
Château de Champs painted by
Christophe Huet, 1747.

Château de Champs

In 1747, Huet, who specialized in painted schemes
of this type, was commissioned by the Duc de
La Vallière to decorate a salon and a bedroom
in the attractive Château de Champs, which had
been completed by Bullet de Chamblain in 1707
but had subsequently changed hands several
times. Madame de Pompadour purchased the
property in 1757. As in all the artist's decorative
schemes, both *singeries* and chinoiserie motifs are
featured. Boucher's influence is readily apparent
here, for the "Chinese" faces are nearly indistin-
guishable from Western ones, as in Boucher's
chinoiserie compositions.

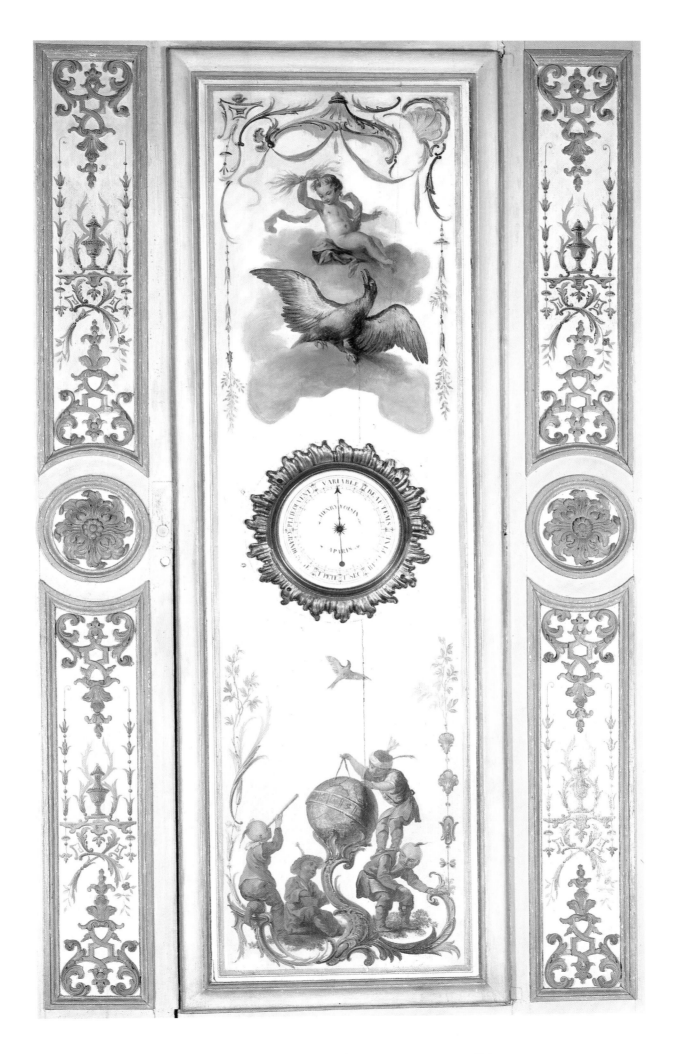

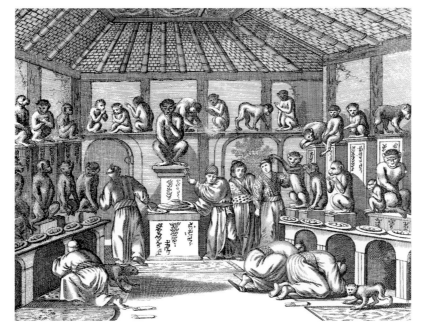

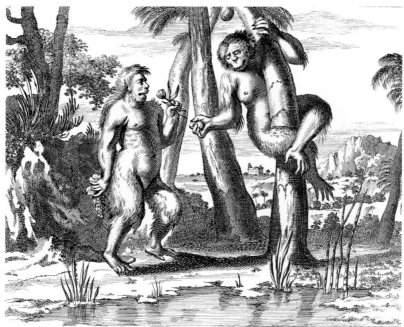

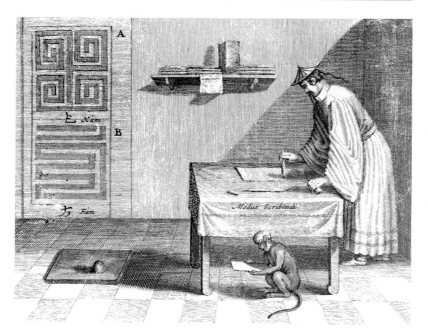

Offerings Made to Monkeys,
illustration from Arnoldus Montanus,
Gedenkwaerdige Gesantschappen,
Amsterdam, 1669.
Basel, university library

Monkeys, illustration from
Arnoldus Montanus, *Gedenkwaerdige
Gesantschappen,* Amsterdam, 1669.
Basel, university library

*Differences between Chinese Characters
and Egyptian Hieroglyphs,* illustration
from Athanasius Kircher, *China
monumentis . . . ,* Amsterdam, 1667.
Basel, university library

FACING PAGE

View and detail of the "Grande
Singerie" in the Château de Chantilly,
Christophe Huet, c. 1735.
Château de Chantilly

The decor of this room miraculously survived
extensive renovations undertaken at the château in
the 1790s; along with the "Petite Singerie" on the
floor below, it constitutes a characteristic example
of the pervasive association of monkey motifs and
chinoiserie in eighteenth-century Europe. Both
Jan Nieuhoff and Athanasius Kircher published
images showing monkeys being venerated by the
Chinese as divinities, and Europeans of that period
attributed similar high qualities to both. The
decorations at Chantilly were commissioned by
the Prince de Condé—a passionate admirer of
things Oriental, like his cousins the grand dauphin
and the Duc de Toulouse—to set off his porcelain
collection. The taste for chinoiserie became
something of a tradition at Chantilly: in 1782, a
marvelous Chinese tent was erected in its park
on the occasion of a visit of the future Paul I of
Russia, who was traveling in France "incognito"
as the "comte du Nord" (count of the north).

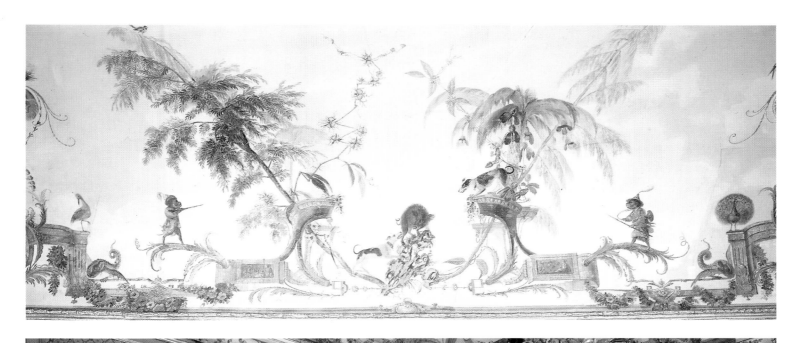

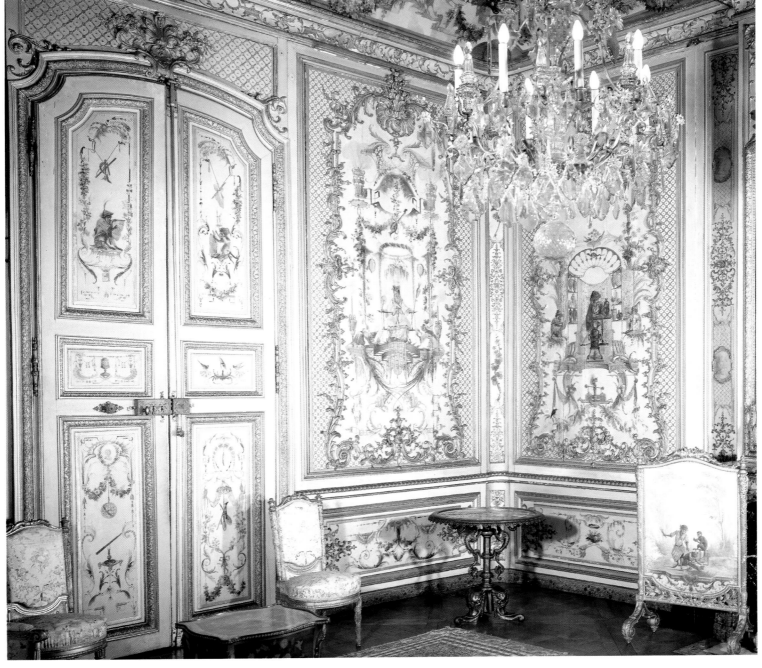

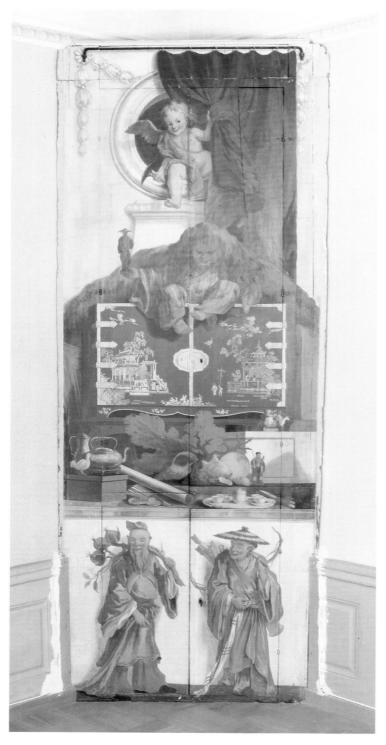

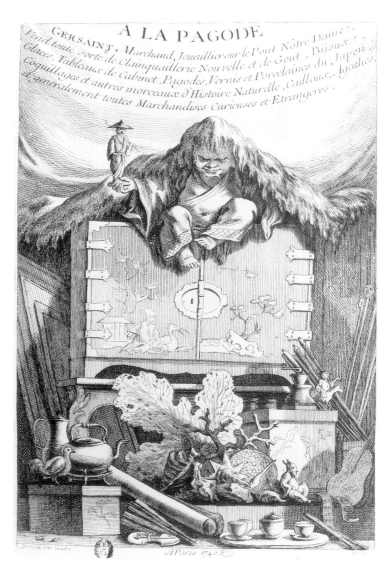

Current view of the corner closet in the salon at Åkerö,
Olof Fridsberg (1728–1795), after 1747.

Åkerö Manor (Sweden)

A la Pagode, print, François Boucher, Paris, 1740.

Paris, Bibliothèque Nationale

This print served as the trade card of Parisian dealer and merchant Gersaint
for his shop *A la Pagode* (At the pagoda). Sitting on top of a lacquer cabinet is a
grotesque Chinese man emerging from beneath a fringed drape; the latter is an
ingenious variation on a large hat in one of Nieuhoff's illustrations. (The same
figure makes a surreptitious appearance in one of Boucher's Beauvais tapestry
designs; *see page 292.*) The foreground is occupied by a tableau of curious objects
indicating the range of exotic artifacts available in Gersaint's shop.

Pomegranate Carrier, print by Remondini of Bassano.

Bassano del Grappa, Museo Civico

The publishing houses in Bassano made a specialty of images intended to be
cut out and used in making Italian *lacca contraffata* in the eighteenth century.

Chinese Soldier, print by Gabriel Huquier after François
Boucher, from *Recueil de diverses figures chinoises* (Collection
of various Chinese figures), between 1738 and 1745.

Paris, Louvre, Cabinet des Dessins

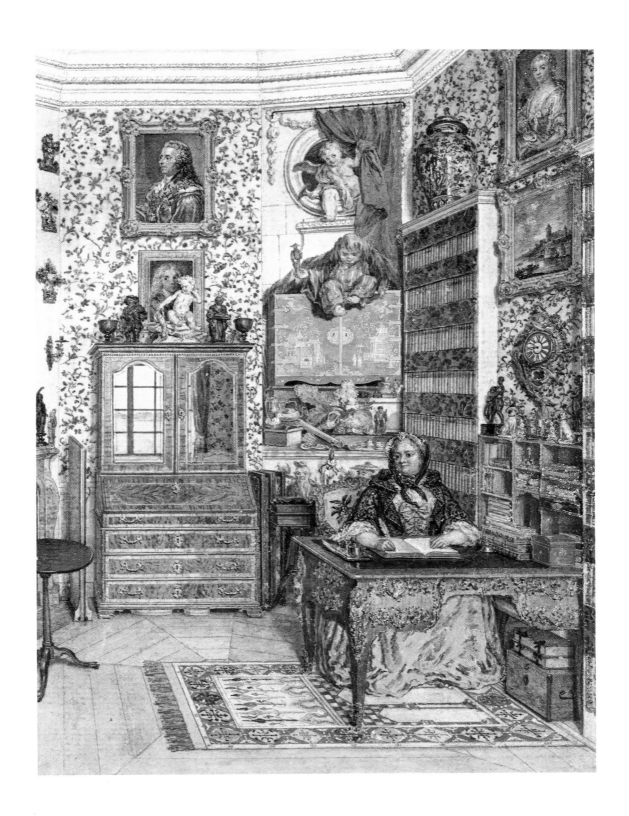

The salon of countess Ulla Tessin,
miniature, Olof Fridsberg.

Stockholm, Nationalmuseum

This tiny watercolor (16.6 × 12.3 cm) reproduces in minute detail a lavishly appointed mid-eighteenth-century interior at Åkerö Manor in Sweden. All that remains of it today are the trompe-l'oeil painted doors of the corner closet *(see facing page);* like the miniature, they are the work of Fridsberg, and they demonstrate how chinoiserie imagery was transmitted via prints. The central element of the closet decoration is a transcription of Boucher's trade card for Gersaint; below it are figures based on the other two prints on the opposite page. At the top is an accurate copy of an engraving after a painting by Charles Coypel (1694–1752), *Cupid as a Chimney Sweep.*

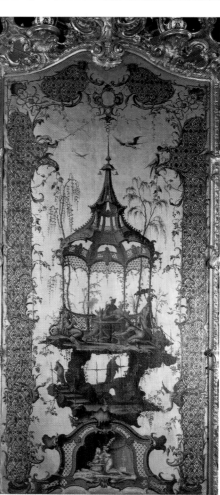

ABOVE AND FACING PAGE

Set of four panels (and details),
circle of Alexis Peyrotte,
France, c. 1725.

Private collection

The motifs painted in blue monochrome against a gold ground on these panels are all chinoiserie compositions, and they are all of exceptional quality. They were part of a decorative scheme for a salon in the residence of the Prince of Thurn and Taxis in Frankfurt, built to plans by Robert de Cotte (1656–1735), the various elements of which have since been moved. Clearly it was one of the great achievements of eighteenth-century decorative painting, but its attribution remains a matter of speculation. Any one of a number of Bérain's successors might have produced these refined compositions: Claude III Audran, J. A. Biarelle, Jacques de Meaux, or Jacques Vigoureux Duplessis; even Christophe Huet and Claude Gillot are possible candidates. Certain similarities with early eighteenth-century decorative paintings executed for the Royal Palace built by Nicodemus Tessin the elder in Stockholm suggest that their author might well have been Jacques de Meaux, whose oeuvre remains ill defined. They might also be from the hand of Alexis Peyrotte, who worked at the Château de Choisy about 1740 and produced ornamental prints that were much admired.

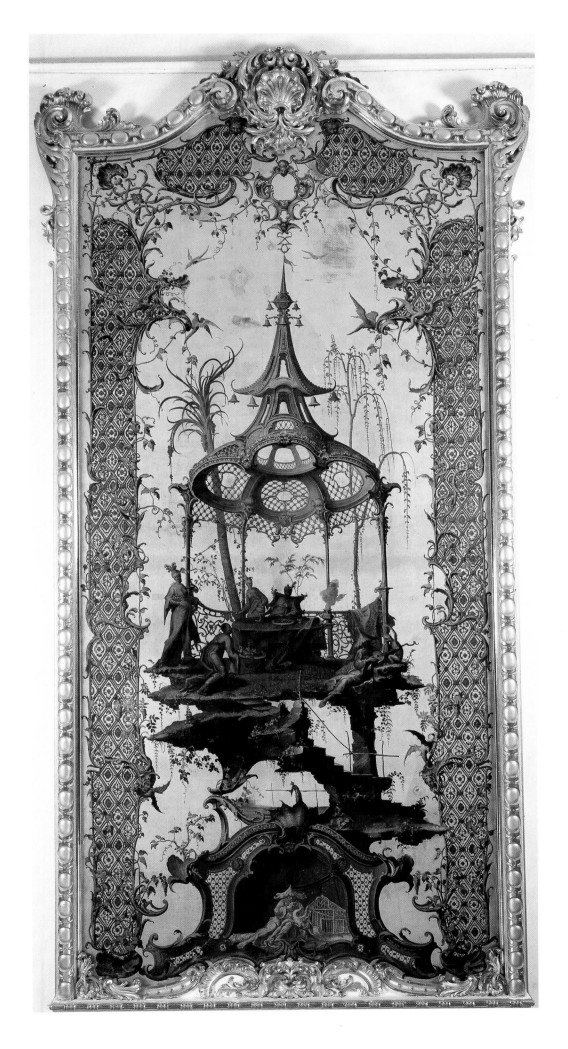

Prospect der KönigeResidence, Siam, nebst dem prächtigen Einzüge
der Französischen Gesandschafft, so Ao.1685. im Octobr. auf dem Fluß Menam mit 150.
Balons, oder Siamitischen Staats-Schiffen eingeholet worden.

Vüe de la Residence du Roi de Siam avec l'entrée magnifique
de l'Ambassadeur de France, la quelle se fit sur le Menam avec 150.Balons, où
navires d'etat à la Siamoise, l'an 1685. au mois d'Octobre.

*View of the Residence of the King of Siam with the Magnificent
Entry of the French Ambassador* (entire composition and detail),
illustration from Johann Bernhard Fischer von Erlach,
Entwurf einer historischen Architektur (Outline of a historic
architecture), Vienna, 1721.

Basel, university library

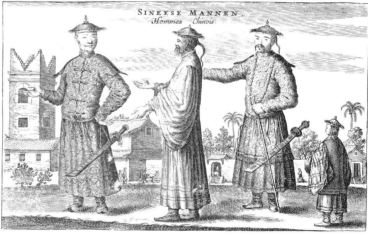

Chinese Men, illustration from Jan Nieuhoff,
*An Embassy from the East India Company to the Grand Tatar
Cham, Emperor of China,* Leiden, 1665.

Basel, university library

FACING PAGE

The Emperor Sailing, from the tapestry series
The Story of the Emperor of China, Beauvais factory, 1725–30.

Paris, Louvre

This tapestry series, first woven c. 1690–1705 after cartoons by Guy-Louis
Vernansal (1648–1729), Jean Baptiste Belin de Fontenay (1653–1715), and Dumons,
helped to stimulate the international vogue for French chinoiserie, and for
Beauvais factory productions in particular. Its designs are notable for combining
monumental figures with Bérain-like pavilions—such as the one here, which
serves as a spatially ambiguous framing element. Many details derive from
illustrations by Athanasius Kircher, Jan Nieuhoff, and Arnoldus Montanus.

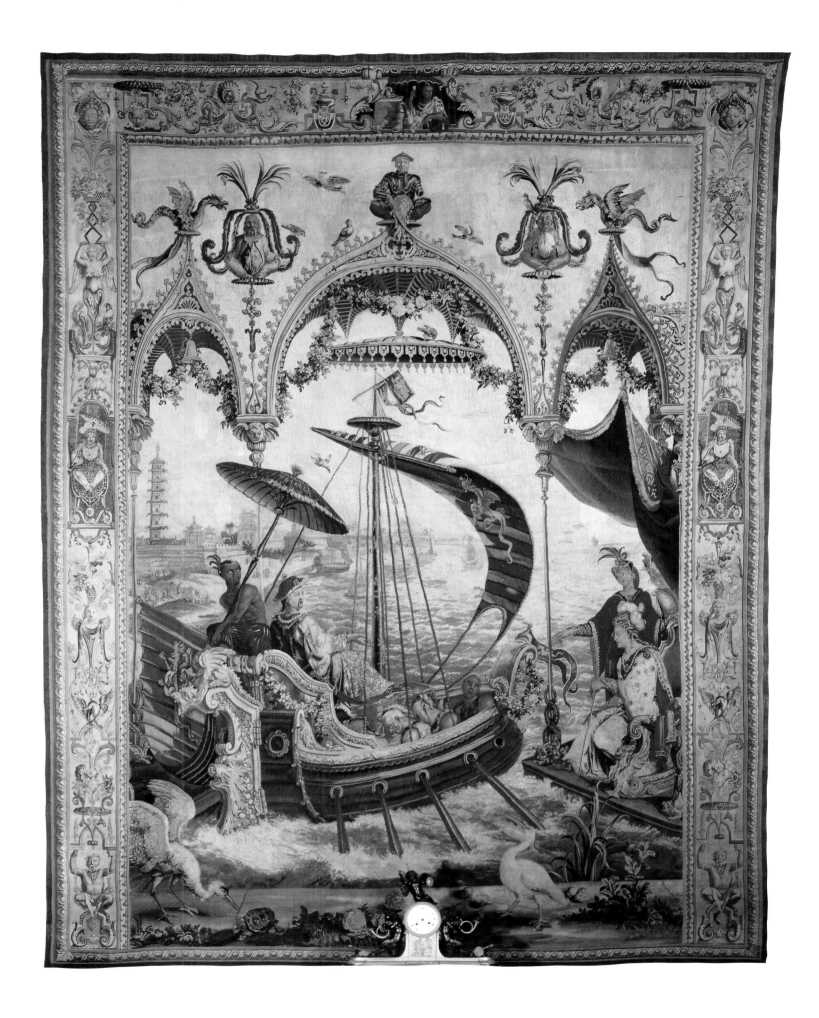

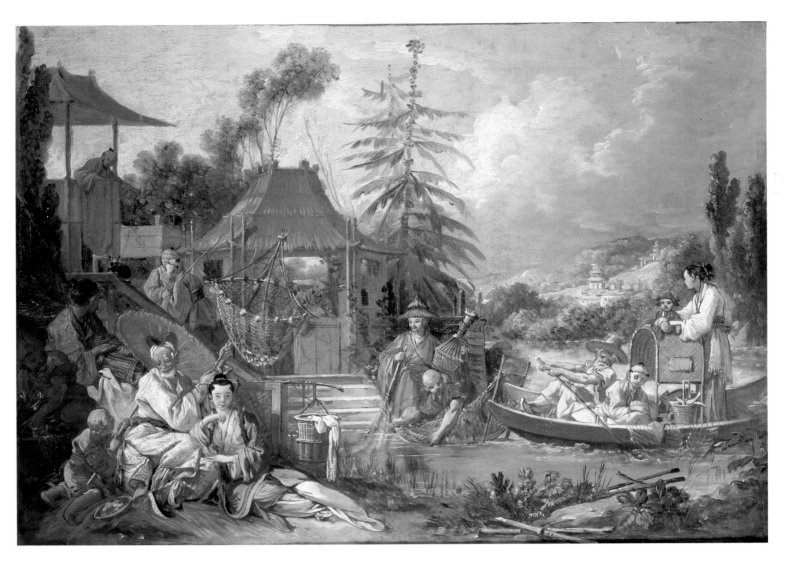

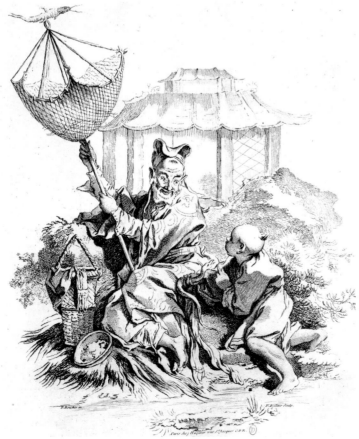

Chinese Fishing, sketch for a Beauvais tapestry cartoon,
oil on canvas, François Boucher, c. 1740.
Besançon, Musée des Beaux-Arts

Here, as in all his compositions for the Beauvais tapestry set, Boucher sets
the scene with considerable flair and attention to detail, giving this banal
Westernized subject a heightened theatricality.

Water, print by Pierre-Alexandre Aveline (1702–1760) from
Livre de cartouches inventés par François Boucher,
published by Gabriel Huquier, 1740.
Paris, Bibliothèque d'Art et d'Archéologie, Fondation Jacques Doucet

FACING PAGE

The Chinese Garden (detail), sketch for a Beauvais tapestry
cartoon, oil on canvas, François Boucher, c. 1740.
Besançon, Musée des Beaux-Arts

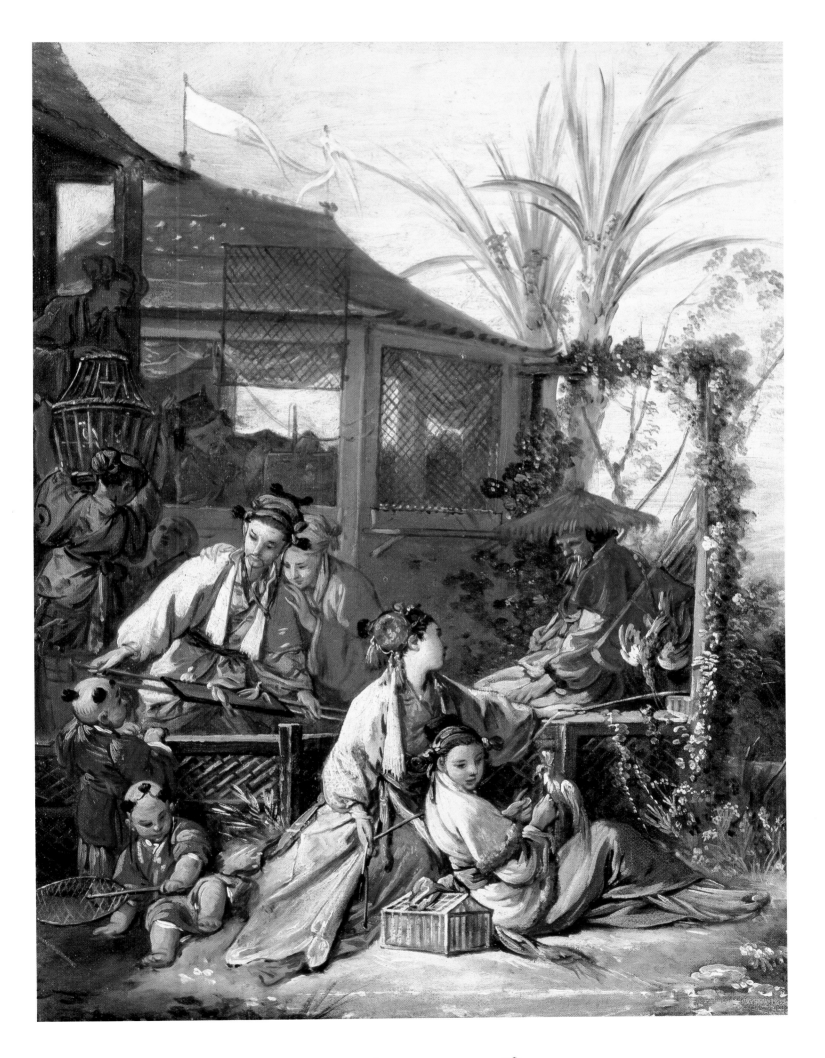

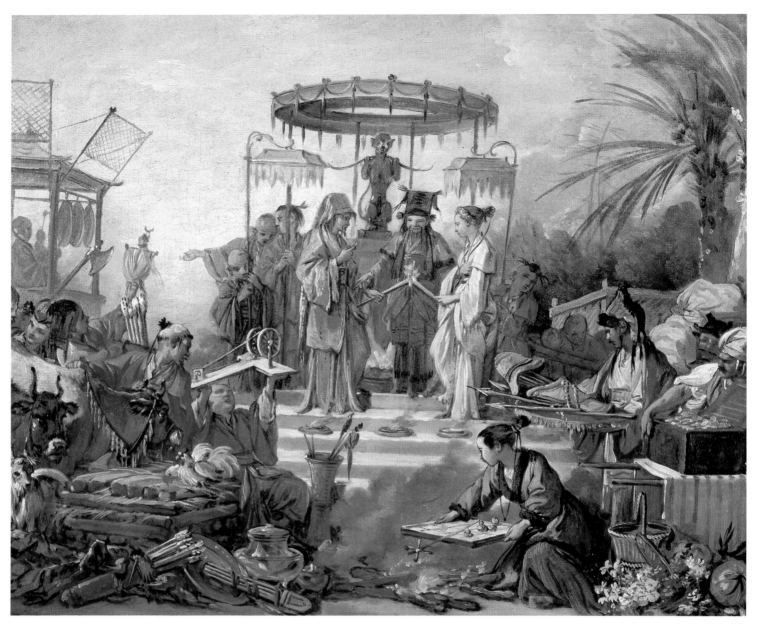

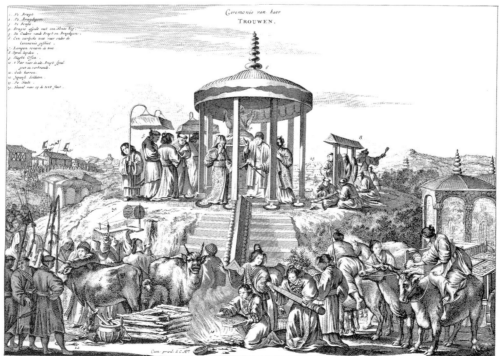

The Chinese Marriage, sketch for a
Beauvais tapestry cartoon, oil on canvas,
François Boucher, c. 1740.
Besançon, Musée des Beaux-Arts

Marriage Ceremony, illustration from
Arnoldus Montanus, *Gedenkwaerdige
Gesantschappen,* Amsterdam, 1669.
Basel, university library

Many details in the print remain obscure even
after reading the legend that Montanus has
keyed to fourteen elements of the composition.
Characteristically, Boucher gave free reign to
his imagination in interpreting them.

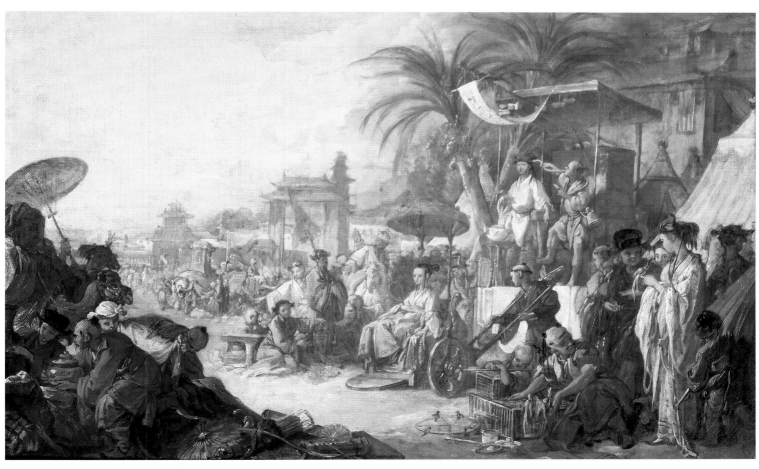

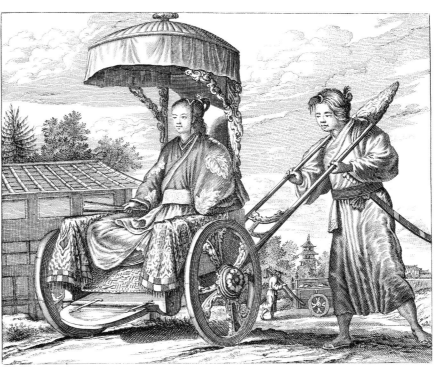

The Chinese Fair,
sketch for a Beauvais tapestry cartoon,
oil on canvas, François Boucher, c. 1740.
Besançon, Musée des Beaux-Arts

Chinese Lady in a Rickshaw,
illustration from Arnoldus Montanus,
Gedenkwaerdige Gesantschappen,
Amsterdam, 1669.
Basel, university library

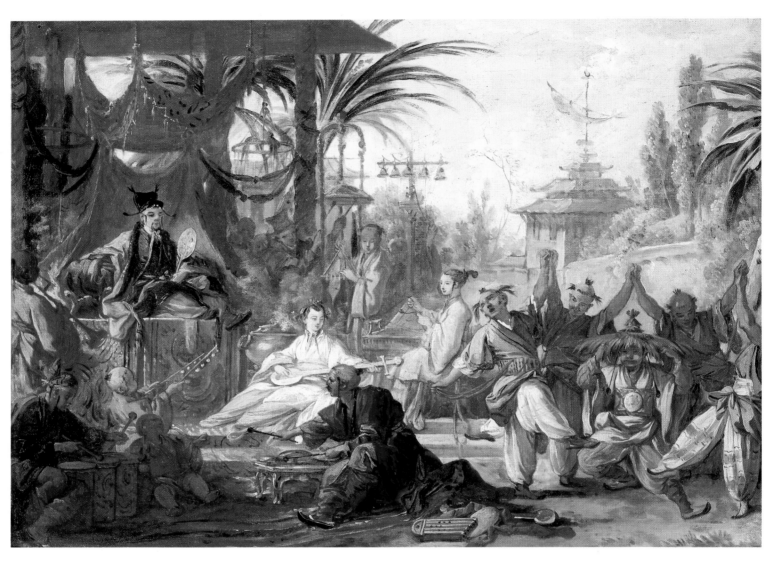

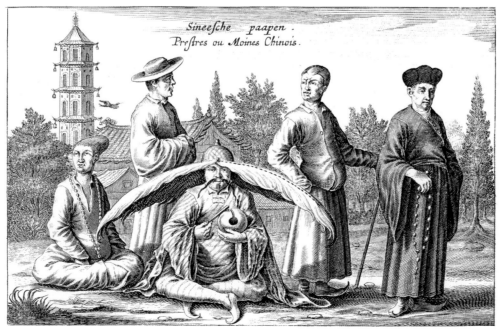

The Chinese Dance,
sketch for a Beauvais tapestry cartoon,
oil on canvas, François Boucher, c. 1740.
Besançon, Musée des Beaux-Arts

Chinese Priests or Monks, illustration from
Jan Nieuhoff, *An Embassy from the East
India Company to the Grand Tatar Cham,
Emperor of China,* Leiden, 1665.
Basel, university library

In this composition, Boucher ingeniously reinvents
Flemish genre paintings by David Teniers, Pieter
Brueghel, and Jacob Jordaens in the image
of chinoiserie.

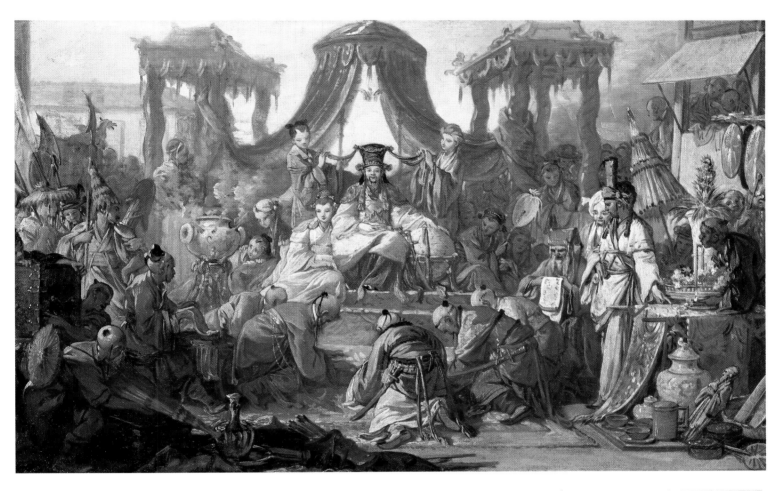

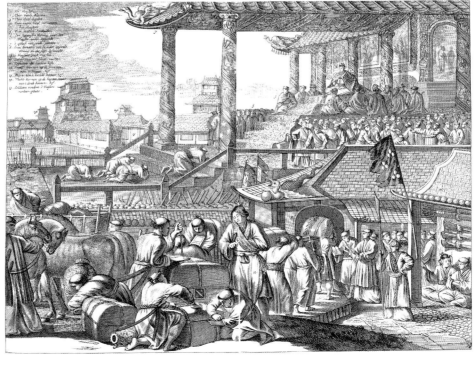

The Audience of the Emperor of China,
sketch for a Beauvais tapestry cartoon,
oil on canvas, François Boucher, c. 1740.
Besançon, Musée des Beaux-Arts

The Audience of the Emperor,
illustration from Arnoldus Montanus,
Gedenkwaerdige Gesantschappen,
Amsterdam, 1669.
Basel, university library

Audiences given by the king of France were
rare and always occasioned lavish spectacle,
making depictions of them popular. Here,
Boucher has translated this indigenous ritual
into "Chinese" terms.

Clock case with imitation black lacquer
painting (detail), France, c. 1720.

Paris, Musée Carnavalet

The high quality of the painting of the Chinese
musician on this Japanned clock case suggests that
it is the work of Jacques Vigoureux Duplessis
(d. 1730), a painter-decorator who worked at the
opera and collaborated with Jean Bérain. Hitherto
obscure, his artistic personality was brought
into clearer focus by Jérôme de la Gorce in his
recent monograph on Bérain (1986).

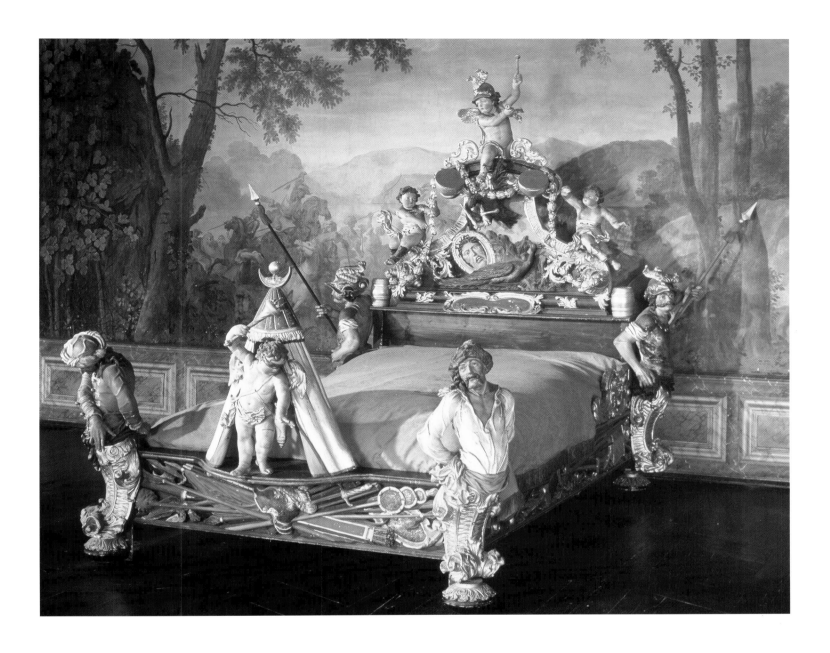

Bed in the Abbey of Saint Florian,
Leonard Sattler (sculptor) and
Matthias Müller (painter), 1711.

Abbey of Saint Florian (Austria)

*I*n the mid-eighteenth century, only a few erudite Westerners were capable of distinguishing between the various Asian traditions and cultures. Accordingly, in this period Turkish imagery—which held a certain fascination because of the proximity of the Ottoman Empire and its periodic European invasions—was often associated with chinoiserie. Compounding the confusion was the continuing impact of the allegories of the continents devised by Cesare Ripa at the end of the sixteenth century—in this case, his image of Asia as a beturbaned Turk. The Europeans nearly lost Vienna to the Turks in 1683, and the threat of an Ottoman invasion into central Europe remained very real until 1699. Nonetheless, the organizing principle behind this bed's elaborate iconographic program—most clearly expressed in the blindfolded cupid holding a burning torch and emerging from a tent topped by a Turkish crescent—would seem to be the impending triumph of the church militant over the Ottoman infidel.

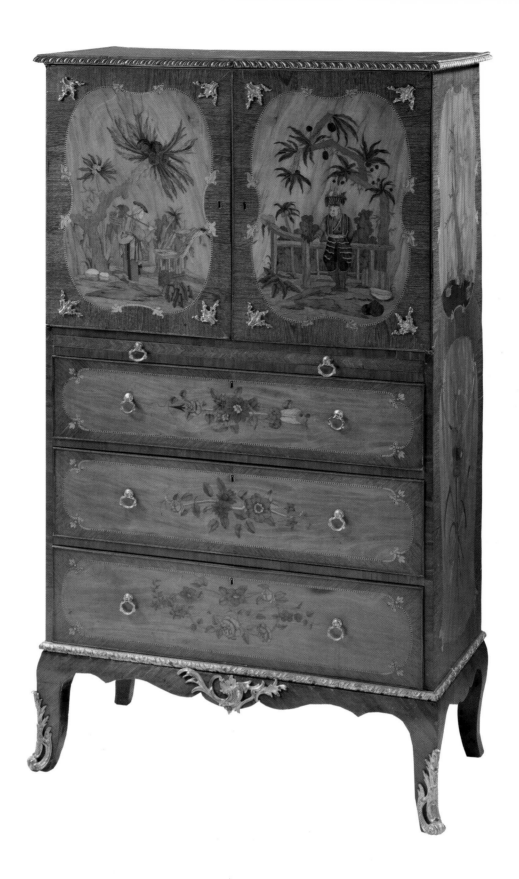

Commode and writing desk,
England, c. 1770.

New York, Metropolitan Museum of Art

The considerable renown of the Roentgen dynasty of German furniture makers led to the imitation of their work throughout Europe. A case in point is this surprising English piece with exquisite marquetry work. The vignettes derive from prints by the German artist Januarius Zick, whose compositions were in turn inspired by prints by Boucher and Pillement. The imagery of all three, however, were indebted to illustrations in the volume by Montanus (1669).

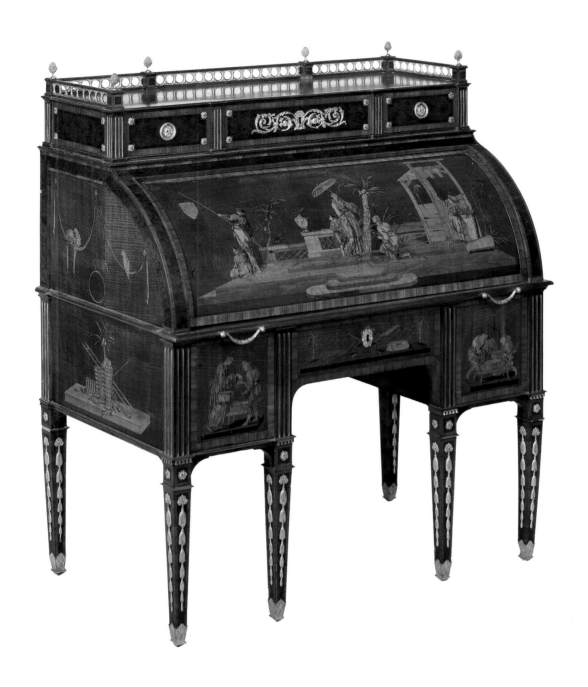

Roll-top Desk, David Roentgen,
Neuwied, c. 1775–80.

New York, Metropolitan Museum of Art

'Even at the height of neoclassicism, Roentgen
persisted in basing his compositions on prints by
Januarius Zick, who was an emulator of Boucher.
As the final quarter of the eighteenth century
dawned, France had largely abandoned chinoiserie,
but it remained popular with furniture makers
catering to the German, Scandinavian, English,
and Russian markets. Compositions very similar
to those on the desk shown here were often used
by Roentgen on other pieces, such as those now
in the ducal collections at Baden-Baden.

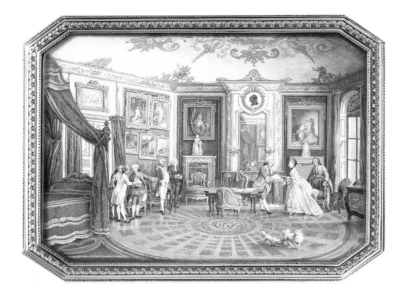

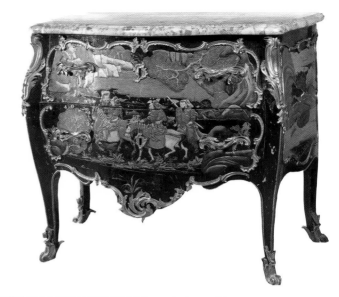

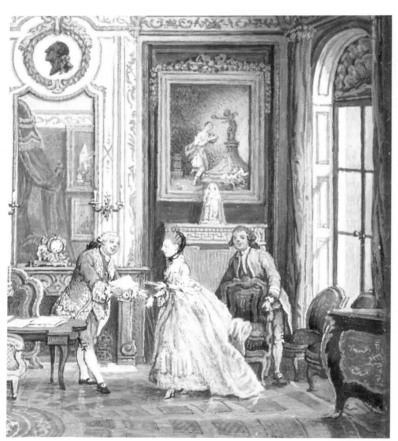

Study of the Duc de Choiseul (full view and detail), miniature, gouache on ivory, Louis-Nicolas van Blarenberghe, Paris, 1770.
Private collection

All French interiors of the first half of the eighteenth century reflect the pervasive taste for chinoiserie, and this room is a case in point. Undulating furniture legs were devised by French craftsmen in emulation of Chinese pieces from the late sixteenth century, and the use of brilliant varnishes was inspired by Oriental lacquer work. The commode shown on the right is of a type made fashionable by Jacques Dubois about 1737, one that combines Asian lacquer panels with European imitations. Opulent silk hangings, too, were associated with China since the publication of the portrait of the emperor in Athanasius Kircher's *China Monumentis . . .* in 1667 *(see page 235)*.

Commode incorporating lacquer panels.
Paris, Musée des Arts Décoratifs

French imitations of Far Eastern lacquer were so successful that they are difficult to distinguish from the real thing in eighteenth-century Parisian furniture. Today we appreciate these exercises on their own merits, but contemporary craftsmen often misled their clients as to the origin of such decorations, describing them as "Chinese work."

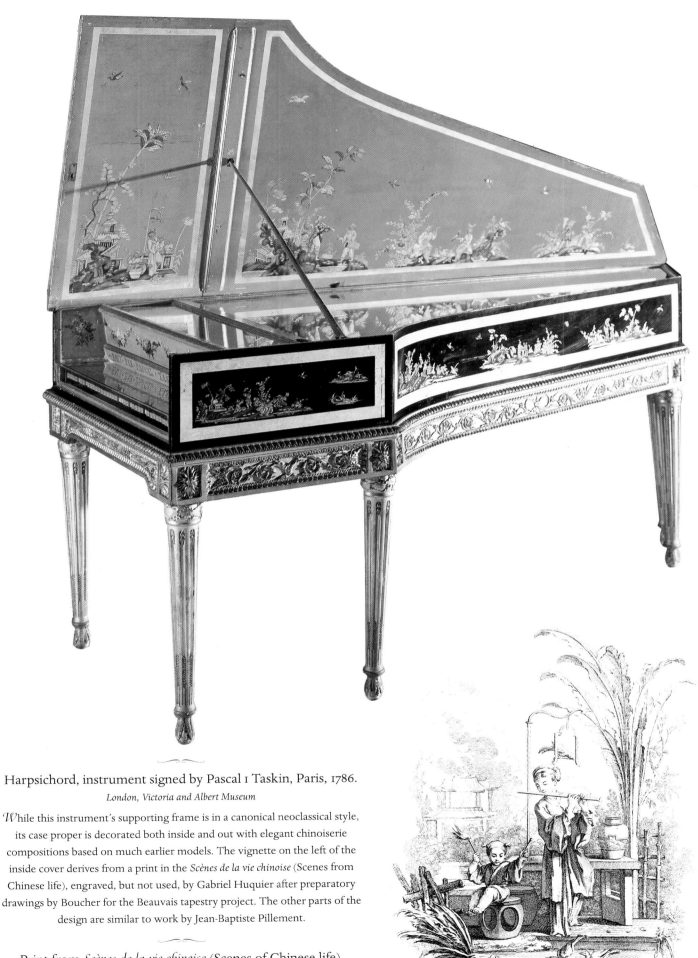

Harpsichord, instrument signed by Pascal 1 Taskin, Paris, 1786.

London, Victoria and Albert Museum

*W*hile this instrument's supporting frame is in a canonical neoclassical style, its case proper is decorated both inside and out with elegant chinoiserie compositions based on much earlier models. The vignette on the left of the inside cover derives from a print in the *Scènes de la vie chinoise* (Scenes from Chinese life), engraved, but not used, by Gabriel Huquier after preparatory drawings by Boucher for the Beauvais tapestry project. The other parts of the design are similar to work by Jean-Baptiste Pillement.

Print from *Scènes de la vie chinoise* (Scenes of Chinese life), by Gabriel Huquier after François Boucher, c. 1742.

Paris, Bibliothèque d'Art et d'Archéologie, Fondation Jacques Doucet

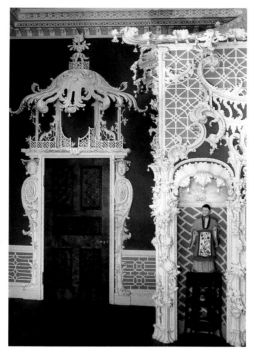

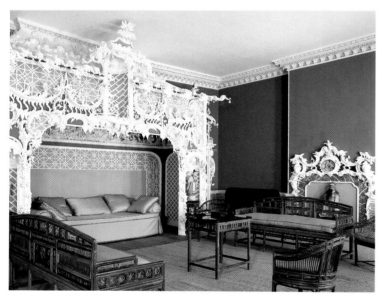

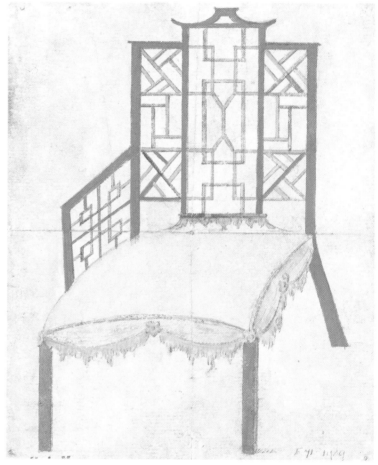

Design for a Chinese chair, drawing and watercolor,
William Linnell (d. 1763).

London, Victoria and Albert Museum

*M*any chairs of this type were created after the publication of Chambers's
book (1757), which made Chinese interiors newly fashionable in England. The
famous *Gentleman and Cabinet-Maker's Director* by Thomas Chippendale
(1718–1779) had preceded it by three years. Linnel's pieces in this vein resulted
from the happy marriage of a rococo furniture designer and Chambers's
erudition. Henceforth, chinoiserie would often cohabit with ethnographically
accurate forms in English productions, a tendency that was encouraged by the
newfound enthusiasm of both George III and his son, the prince of Wales, for
things Chinese. The combination of authentic latticework patterns with
polychromy and fanciful upholstery make the illustrated design altogether
representative of this moment in English furniture production.

Doorway *(above)* and alcove *(below)* in the
Chinese Bedroom in Claydon House, wood carvings
by Lightfoot, completed in 1769.

Claydon House (Buckinghamshire)

*E*ven after the publication of William Chambers's *Designs of Chinese Buildings*
(1757) had corrected many misconceptions about Chinese interiors and
furnishings, whimsical chinoiserie decorative designs like this one continued
to appear. Many details in Lightfoot's design—the work of a provincial
craftsman—derive from prints by Mondon, but the trellis pattern in the alcove
clearly indicates that he was familiar with Chambers's book.

Two panels from a folding screen,
anonymous, France, c. 1730–40.
Private collection

Oriental screens—usually Japanese—were
imported in large numbers by the various India
companies, for they were avidly sought after by
fashion-conscious Westerners. In Asia their pri-
mary purpose was to serve as space dividers, but in
Europe they were used to block drafts. The most
precious examples were lacquer, but most were
made of paper. European craftsmen imitated both
of these techniques, but they also used *cuir bouilli*
(softened and manipulated leather), which they
painted and gilded with motifs of birds and India
flowers. Even celebrated European artists pro-
duced these objects, which were popular in both
the seventeenth and the eighteenth centuries.

Design for a firescreen,
partly engraved and partly drawn,
with watercolor highlights,
Gabriel Huquier, Paris, c. 1730.
*Paris, Bibliothèque d'Art et d'Archéologie,
Fondation Jacques Doucet*

This combination of an early print impression
with a drawing (the mirror image on the left) was
probably a design for a firescreen; it could have
been woven, embroidered, or reproduced on paper
and then painted. The composition, with its
Chinese figures bowing down before a strange-
looking vegetal idol guarded by dragons, its
sinuous framing stalks culminating at the top in a
leafy bower supporting two long-eared rabbits, is
clearly the work of a gifted decorative artist,
perhaps François-Thomas Mondon.

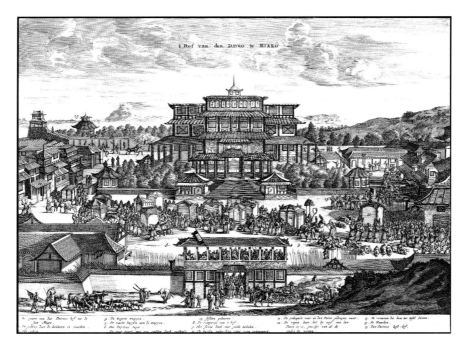

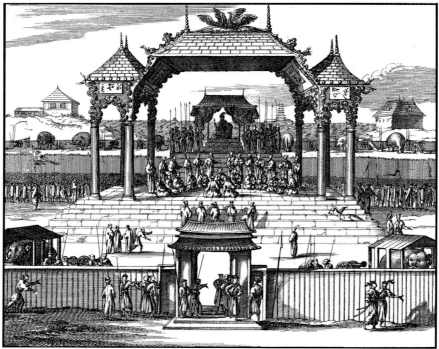

The Court of the Emperor,
illustration from Arnoldus Montanus,
Gedenkwaerdige Gesantschappen,
Amsterdam, 1669.
Basel, university library

The Audience with the Emperor of China,
illustration from Arnoldus Montanus,
Gedenkwaerdige Gesantschappen,
Amsterdam, 1669.
Basel, university library

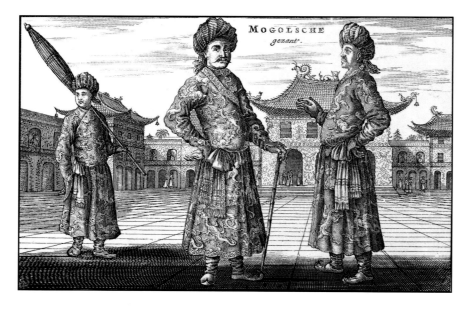

Mogul Ambassadors,
illustration from Jan Nieuhoff,
*An Embassy from the East India
Company to the Grand Tatar Cham,
Emperor of China,* Leiden, 1665.
Basel, university library

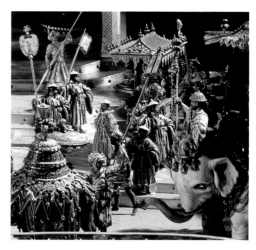

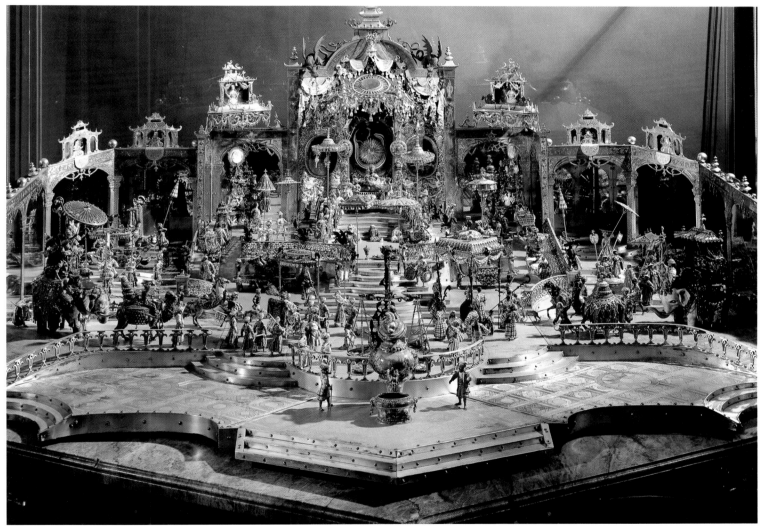

"Grand Mogul" centerpiece, enameled silver and gold, set with pearls and precious stones, Johann Melchior Dinglinger and collaborators, Dresden, 1701–8.

Dresden, Grünes Gewölbe

*A*ugustus the Strong (1670–1733), elector of Saxony and king of Poland, was fascinated by Asia and dazzled by the luxury of the court of the Grand Mogul Aurangzeb. He commissioned his favorite goldsmith to make a centerpiece depicting a ceremonial birthday gathering in which the court pays homage to their ruler. This lavish production, 142 cm wide, boasts 137 figurines in enameled gold set with some five thousand diamonds. It anticipates the centerpieces with porcelain figurines made some years later at the Meissen workshops for the same patron. Johann Melchior Dinglinger (1664–1731), who devised the composition, was clearly inspired by illustrations in the volume by Montanus. His brother Georg Friedrich and fourteen collaborators executed the piece, which inaugurated the magnificent exotic collections assembled by "the most Oriental of Western monarchs."

Binding, Jacques-Antoine Derôme
(1696–1760), Paris, 1740.

Paris, Musée du Petit Palais

There were severable remarkable makers of
luxury bindings in the eighteenth century. They
were partial to classical motifs and small stamping
irons, but even working within the established
traditions of mosaic binding they sometimes
produced designs of great originality, on occasion
tailoring them to the text.

Chinoiserie motifs introduced into the binder's
art by the celebrated Antoine-Michel Padeloup
(see right) were taken up by the equally famous
Derôme, who created this remarkable example
featuring flowers outlined in gold against a
rocaille ground.

Mosaic binding of an edition of works
by Horace, Antoine-Michel Padeloup
(1685–1758), Paris, after 1733.

Paris, Musée du Petit Palais

Although chinoiserie motifs rarely appear on
bindings, they were occasionally taken up by
workshops partial to classicizing designs. In this
example, Padeloup used a rather whimsical India
flower pattern in which blooms of different
kinds appear on the same stem. This design is
somewhat reminiscent of botanical illustrations
in the Nieuhoff volume (1665), but it also bor-
rows from compositions painted on imported
Eastern silks. Even now, the muted tones of this
binding—polychrome against a yellow ground—
have great appeal, but originally they were
much more vivid.

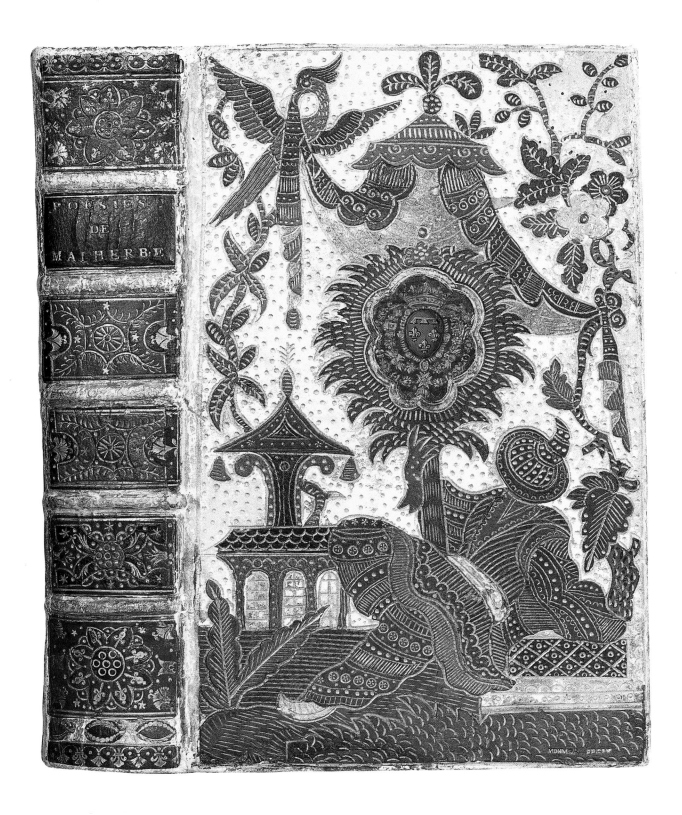

Binding of an edition of the collected
poetry of François de Malherbe
(1555–1628), Jean-Charles-Henri
Le Monnier (fl. 1757–72), 1757.
Versailles, city library
Chinoiserie motifs were more frequently
employed by binders working in England than by
those in France, where they were extremely rare.
This superb example, executed with small
stamping irons and featuring virtuosic mosaic

inlay work, pictures a Chinese figure reclining
beneath a stylized palm tree bearing the arms of
the Duc d'Orléans. A Bérain-like canopy, one of its
swags lifted by an airborne phoenix, hovers over
the scene. A Chinese pavilion and two sinuous
trees complete the exotic effect. One detects here
the influence of French chinoiserie prints: the
Figures chinoises, engraved by Boucher after
Watteau's designs for the Château de la Muette
and published by Jean de Julienne c. 1731.

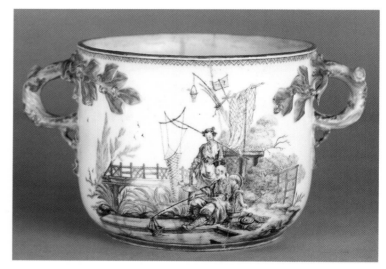

Overdoor, monochrome painting
after François Boucher, after 1743.
Paris, Musée des Arts Décoratifs

Fishing Scene, print from *Scènes de la vie chinoise* (Scenes from
Chinese life), by Gabriel Huquier after François Boucher, c. 1742.
Paris, Bibliothèque d'Art et d'Archéologie, Fondation Jacques Doucet

Few eighteenth-century artists mobilized as extensive an international
distribution network as did François Boucher. While enormously successful in
France between 1735 and 1750, after 1760 his work was in less demand there.
However, such was not the case in the rest of Europe, which continued to
favor his prints, until the end of the century—and even after, in the produc-
tions of less sophisticated craftsmen. Even so, Boucher abandoned the genre in
the second half of his career in response to the rise of neoclassicism.

Wine-glass rinser,
soft-paste porcelain, Vincennes, c. 1747–49.
Paris, Musée des Arts Décoratifs

Vessels of this type were placed on small tables between seats at lavish
banquets, as seen in a painting by Michel Barthélémy Ollivier (1712–1784)
representing a feast given by the Prince de Conti at the Temple in 1766
(Versailles, Musée National du Château). They enabled guests to rinse
their own wine glasses between courses, thereby limiting the need for
servants and so increasing the intimacy of the gathering.

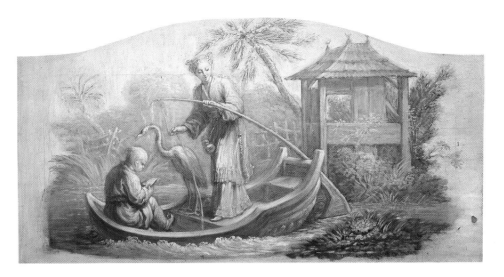

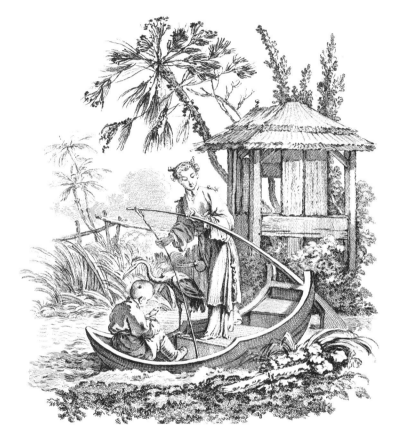

Overdoor, monochrome painting after François Boucher, after 1743.

Paris, Musée des Arts Décoratifs

The overdoors (above and facing page) and the other objects shown exemplify the enormous impact of Boucher's chinoiserie prints on artisans of all kinds. The overdoors reproduce compositions in the adjacent prints from *Scènes de la vie chinoise*. These images, engraved by Huquier after designs by Boucher for his Beauvais tapestry set that were never woven, influenced decorative arts productions throughout Europe. Peter Reinicke (1715–1768), who worked with Johann Joachim Kaendler (1706–1775) at Meissen from 1743 to 1768, used the composition shown above to decorate a porcelain group (Pauls Foundation, Basel).

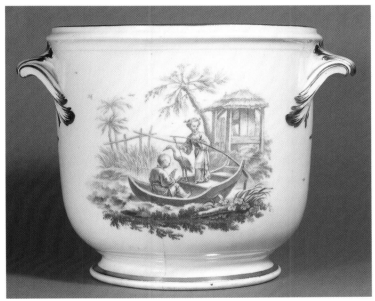

CENTER LEFT

Wine cooler, soft-paste porcelain, Vincennes, c. 1750.

Sèvres, Musée de la Céramique

CENTER RIGHT

Print from *Scènes de la vie chinoise* (Scenes from Chinese life), Gabriel Huquier after François Boucher, c. 1742.

Paris, Bibliothèque d'Art et d'Archéologie, Fondation Jacques Doucet

BOTTOM

Snuffbox, incised and enameled gold, Hubert Cheval, Paris, 1748–50.

London, Wallace Collection

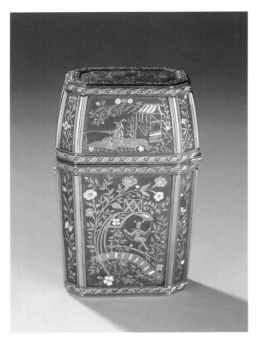

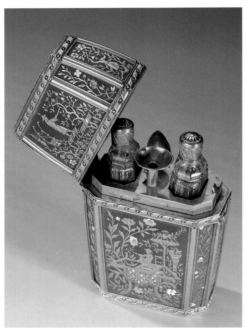

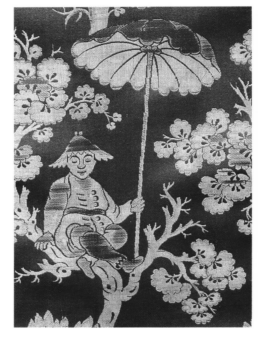

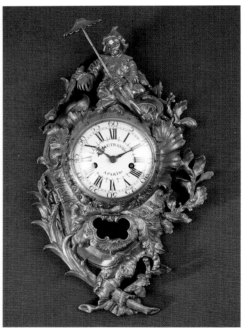

Nécessaire (two views), case made of eighteen red tortoiseshell plaques inlaid with gold and mother of pearl, 1762–63.

Paris, Louvre

Boxes of this type, intended to hold personal toiletries for travel, can be taken to exemplify the virtuosic craftsmanship and opulent materials lavished on relatively unimportant objects in this period. The chinoiserie motifs here are from the *Cahier de balançoires chinoises* (Album of Chinese swings) by Jean-Baptiste Pillement, and demonstrate the ingenuity with which goldsmiths adapted engraved models for use on objects of varying dimensions.

Print by Gabriel Huquier after Alexis Peyrotte, one of the seven images in *Nouveaux Cartouches chinois* (New Chinese cartouches), 1730–40.

Private collection

Silk fabric with chinoiserie pattern, Lyons damask, c. 1740–50.

Cologne, Museum für Angewandte Kunst

This *magot,* or *pagode,* sheltered by a large hat and seated beneath a parasol or treelike scroll forms, adheres to a prototype in wide circulation. This rocaille composition, from the set of prints by Alexis Peyrotte entitled *Nouveaux Cartouches*

chinois, is based on a print by Jan Nieuhoff *(see page 292).* Variations on it were used by European artisans working in many different media.

Cartel clock, gilt bronze, c. 1745.

Paris, Musée des Arts Décoratifs

Craftsmen in this period often produced matched ensembles for mantlepieces and fireplaces, known as *garnitures de cheminées.* In addition to fire dogs, these included candle sconces and cartel clocks intended to hang on the mirrored surface of an overmantel. Combinations of rocaille and chinoiserie forms were especially frequent in such clocks, for both vocabularies were ideal for free-floating openwork designs well suited to such objects.

Still Life, oil on canvas,
Jean-Etienne Liotard, 1781–83.

Malibu, J. Paul Getty Museum

*I*n both the seventeenth and the eighteenth
centuries, the high prices commanded by imports
from the East prompted the production of typical
European objects decorated with Oriental motifs,
and many were gullible enough to think they
were the real thing. This painting illustrates how
indigenous and imported objects were often mixed
together more or less indiscriminately: the tea
service appears to be Eastern, but the pressed-tin
tray, which is decorated with a design imitative
of Japanese lacquer, is European, and the silver
sugar tongs, with their openwork pattern
reminiscent of Chippendale latticework as well
as similar ornament illustrated in Chambers's
book, is typically English.

Enamel perfume bottle,
Berlin, c. 1710.

Paris, Musée des Arts Décoratifs

*B*efore the invention of Western porcelain, the
only material available to European craftsmen
wishing to imitate the brilliance and finesse of
Eastern porcelain was enamel paint. In the
seventeenth and eighteenth centuries, the most
celebrated German centers for such work were
Augsburg, Berlin, Nuremberg, Bayreuth, and
Dresden, where the *Hausmaler* produced the
first decorated porcelains outside the Meissen
factory. The central vignette on this example
derives from prints by Elias Baeck, who was
himself inspired by illustrations in Nieuhoff
and Montanus.

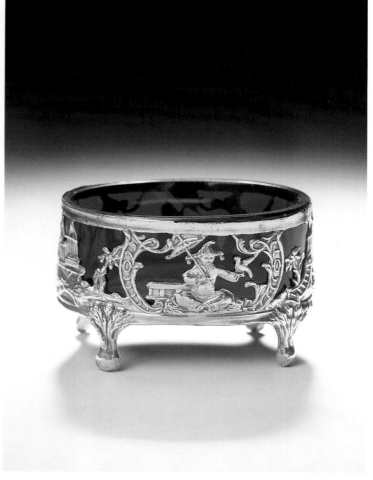

Tea box, gilt silver,
Paul de Lamerie (1688–1751), London, 1747.

London, Worshipful Company of Goldsmiths

*I*n this object, Chinese figures based on illustrations by Bernard Picard
(1673–1733) in *Cérémonies et Coutumes . . .* (Amsterdam, 1723–29) appear within
rocaille framing elements indebted to the auricular style, culminating in
Oriental mascarons and bats' wings. Such chinoiserie motifs are rare in the
work of Lamerie, a superb English goldsmith and silversmith of French
Huguenot extraction. Generally speaking, it was only in the second half of
the seventeenth century that metalworkers of French origin began to
deviate from classical models in favor of exotic motifs, which were especially
appreciated in England.

Small saltcellar,
Etienne Modenx (silversmith), Paris, 1777.

Paris, Musée des Arts Décoratifs

*G*iven the loss of so many French objects made of precious metal in the late
eighteenth century—which were often melted down—it is difficult to
determine whether chinoiserie motifs were indeed less common in this
production than in that of England, as the surviving corpus suggests. If so, the
small number of French chinoiserie objects in gold and silver might be
attributed to the fickle tastes of the French elite, which embraced and rejected
passing fashions with lightning speed. In any case, this saltcellar, made by
Modenx the year he became a member of the silversmith's guild, features the
canonical chinoiserie motif of a seated *magot* holding a parasol.

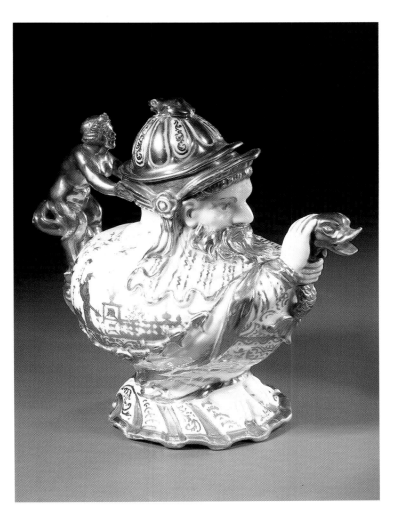

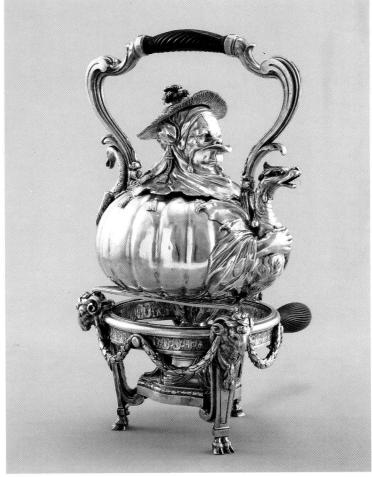

Teapot, Meissen porcelain,
Johann Friedrich Böttger (1682–1719), Meissen, 1719.

Paris, Musée des Arts Décoratifs

A 1667 print after Jacques Stella (1596–1657) featuring a grotesque vase served
as the basis for this design, which incorporates the head of a bearded, helmeted
old man gripping a dolphin that serves as the spout. Here an Oriental inflec-
tion is given typical sixteenth-century grotesque forms, one of which survives
intact in the gilded satyr serving as a handle. The chinoiserie vignettes on
Böttger's pot, which derive from prints by Elias Baeck published in Augsburg
by Jeremias Wolff the year the piece was made, were painted in the *Hausmaler*
workshop of the Seuter family, also in Augsburg.

Teapot with warming stand,
François-Thomas Germain (1726–1791), Paris, 1756–62.

Lisbon, Museu Nacional de Arte Antiga

This odd ensemble consists of a whimsical teapot incongruously mounted
on a warming stand of severe neoclassical design. Germain sold two of these
sets to King John v of Portugal when that monarch was enthusiastically
replacing silverware destroyed in the Lisbon earthquake of 1755. The design
was clearly inspired by the Meissen teapot illustrated at left, but it was
also influenced by Japanese Imari porcelain.

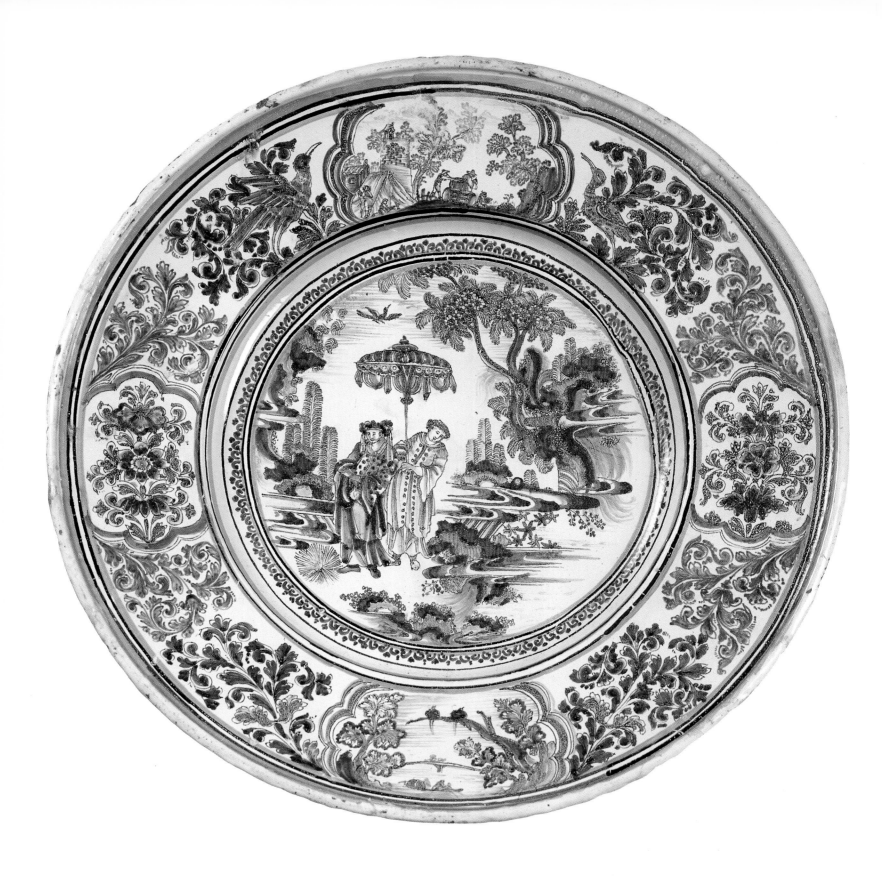

Platter with India flower border,
Nevers faïence, late seventeenth century.
Sèvres, Musée National de Céramique

*I*n the first half of the seventeenth century, pottery
makers wishing to use chinoiserie decoration had
very few models on which to draw, for publications
about China lacked illustrations until the appear-
ance of Nieuhoff's volume in 1665. Even after a
Western iconography began to develop, its
circulation was extremely limited, a situation that
changed only with the appearance of larger
printings in the eighteenth century. As a result,
chinoiserie motifs based on these early prints were
copied and recopied, rendering their forms
increasingly approximate, as here.

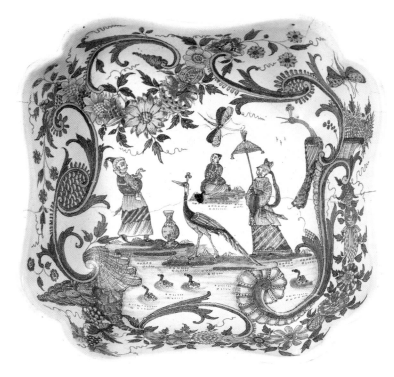

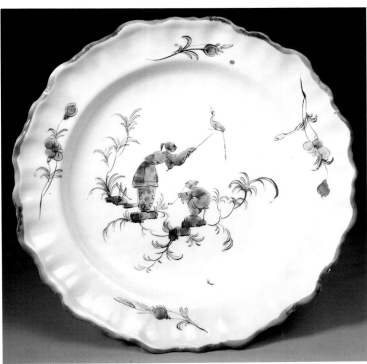

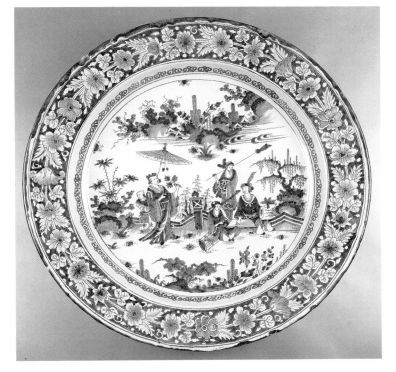

Vegetable bowl, Sinceny faïence, c. 1750.

Paris, Musée des Arts Décoratifs

The farther north one moves, the more French pottery becomes susceptible to the influence of Delft production, which began to feature chinoiserie designs in the early seventeenth century. The large quantities of Japanese porcelain imported by the Dutch East India Company were affordable only to an elite, but they stimulated a desire for cheaper objects with "Eastern" decorative schemes.

Plate, Moustiers faïence, c. 1770.

Paris, Musée des Arts Décoratifs

The monochrome design on this piece, featuring a Chinese woman holding a bird on a perch and thereby amusing a youngster smoking a pipe, paraphrases a composition by Jean-Baptiste Pillement. Here the painter has ingeniously placed the design on spare rocky outcroppings.

This brightly colored, Delft-inspired composition could not be more heterogeneous: within a frame consisting of floral sprays and exuberant vegetal C-scrolls, oversize insects are juxtaposed with diminutive Chinese figures, while ducks swim in a pond presided over by two majestic peacocks.

Plate with India flower border, Nevers faïence, c. 1760–70.

Paris, Musée des Arts Décoratifs

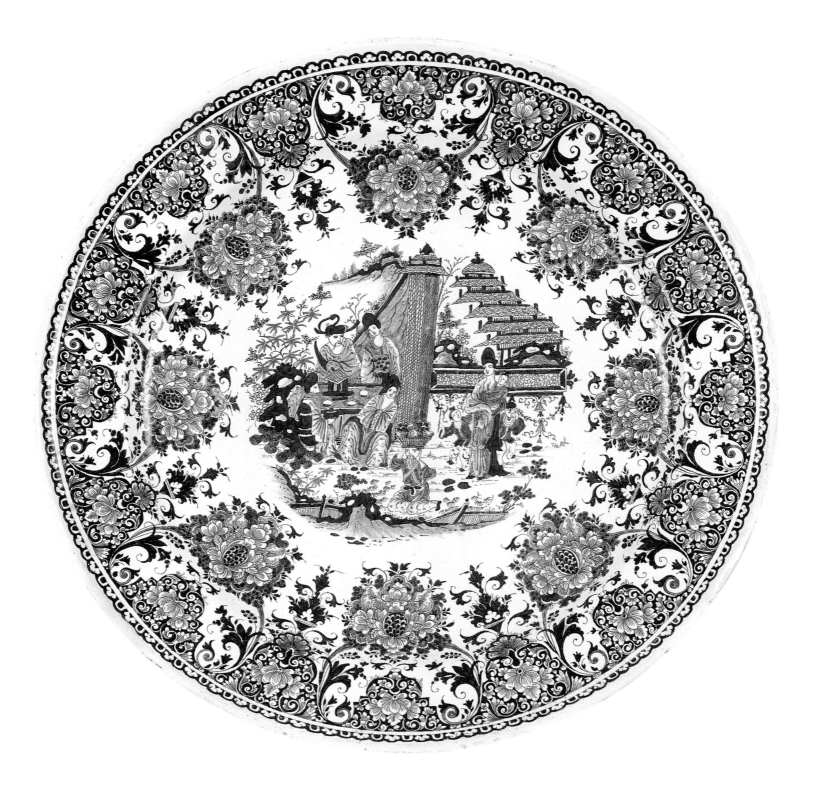

Plate, Rouen faïence, c. 1720.

Paris, Musée des Arts Décoratifs

At one point, the pottery workshops in Rouen deliberately set out to imitate Delft work in hopes of increasing their clientele. But later they used a broader range of models, occasionally basing their designs on German prints. In the second half of the seventeenth century Augsburg became a significant production center, and its importance increased in the eighteenth century, due in part to the activity of the Martin Engelbrecht workshop. The model for the central chinoiserie vignette on the illustrated plate is to be sought there, while the lacey foliate border design is altogether characteristic of Rouen production.

The cantilevered pagoda is a particularly amusing example of the measures that decorators were sometimes obliged to take in adapting rectangular compositions to circular fields.

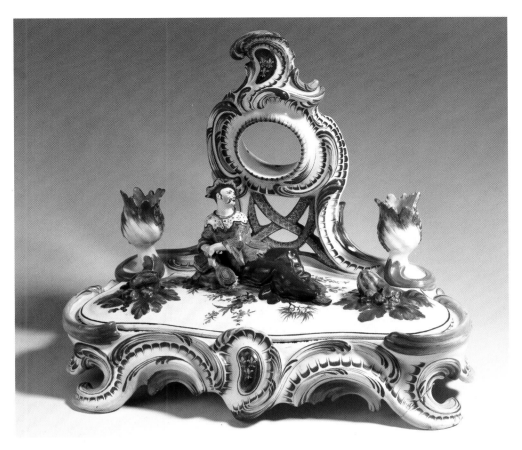

Print by François-Antoine Aveline after François-Thomas Mondon (1709–1755), from a set of seven images entitled *Quatrième Livre de formes rocailles* (Fourth book of rocaille forms), 1736.

Private collection

This image is from one of six sets of rocaille prints engraved after Mondon's designs by François-Antoine Aveline (1691–1742) and published in 1736. Here, Mondon has skillfully combined exuberant rocaille forms with Far Eastern birds and figures.

Tidy with clock mount, faïence, Paul-Louis Cyfflé (1724–1806), Lunéville, c. 1770.

Sèvres, Musée National de Céramique

This ravishing object was clearly influenced by the extravagant rocaille compositions of Mondon published in 1736, some of which combine undulant frames and cartouches with chinoiserie vignettes. Cyfflé's career as a ceramist began at the Nancy court of Stanislas Leszczynski, Duke of Lorraine, but after the latter's death in 1766 he settled in Lunéville, where he started his own factory.

The Chinese Conversation, print by François-Antoine Aveline after François-Thomas Mondon, from *Ornements chinois* (Chinese ornaments), 1736.

Private collection

The extreme eclecticism of this design—which combines agitated rocaille moldings with a dragon, a parasol, and Turkish figures—is typical of French decorative work from the 1730s and 1740s.

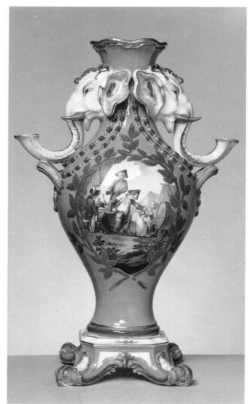

Colored print, Gabriel Huquier, from *Recueil des différentes espèces d'oiseaux, fleurs, plantes et trophées de la Chine* (Collection of different species of Chinese birds, flowers, plants, and trophies), c. 1745.

Paris, Musée des Arts Décoratifs

Porcelain figurine on an elaborate gilt bronze base with Vincennes porcelain flowers, Paris, c. 1745.

Paris, Musée des Arts Décoratifs

Parisian *marchands-merciers* undertook to please their wealthy, novelty-obsessed clientele by assembling luxury objects of little or no utilitarian value. Porcelain components were juxtaposed and given gilt-bronze mounts to make a single piece. The figurine of the Chinese child in this piece, made at the Meissen factory around 1745 by F. Elias Meyer, was originally intended for a tabletop centerpiece. It was modeled after a figure in the print at right.

Candelabrum vase with elephant heads, Sèvres porcelain, after a design by Hébert, c. 1760.

Waddesdon Manor (England)

This piece belongs to a set of vases probably acquired by Louis xv in 1760, and was duplicated several times at Sèvres between 1756 and 1766. The white elephant heads are reminiscent of an extravagant composition produced by Johann Joachim Kaendler at the Meissen factory around 1735, probably on commission for Count Heinrich Brühl (the factory's administrator, 1733–63), who also ordered the famous "Swan" service. The source for both productions is a Gabriel Huquier print featuring a Ming vase with a base composed of elephant heads *(above left)*.

Print from *Scènes de la vie chinoise* (Scenes from Chinese life), by Gabriel Huquier after François Boucher, 1742.

Paris, Bibliothèque d'Art et d'Archéologie, Fondation Jacques Doucet

Porcelain group representing the arts
paying homage to the emperor of China,
Johann Peter Melchior (1742–1825),
Höchst, before 1765.

New York, Metropolitan Museum of Art

Founded in 1746, the porcelain factory at Höchst
(near Frankfurt) found a ready market for its products
in France beginning in 1756, thanks to its affiliation
with the Parisian *marchand-mecier* Bazin. Its more clas-
sical designs had greater appeal there than the more
extravagant rocaille inventions typical of the Franken-
thal, Ludwigsburg, and Nymphenburg factories.
Melchior based his group on a Gabriel Huquier print
after Watteau entitled *The Chinese Emperor*.

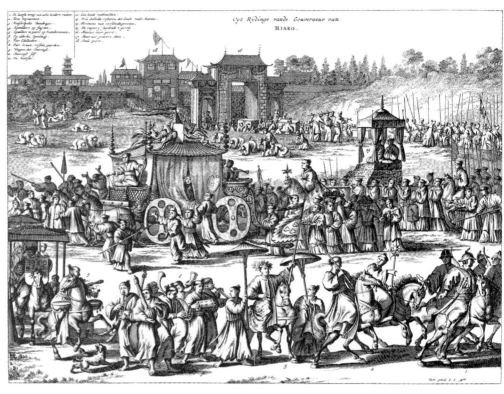

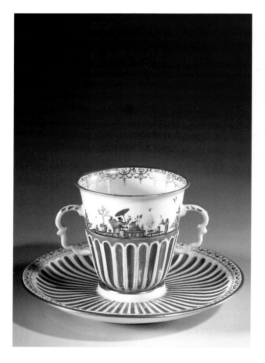

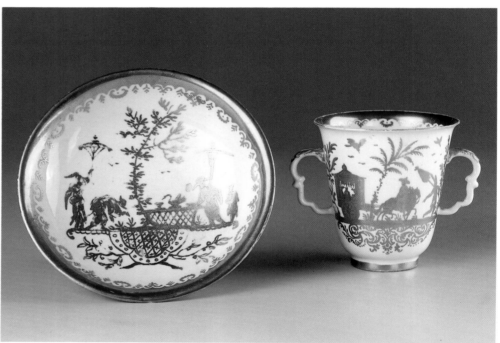

Trembleuse, Meissen porcelain, probably decorated in Augsburg, c. 1730.
Paris, Musée des Arts Décoratifs

This type of high cup with two handles, featuring a raised ring in the saucer to secure the cup, is known as a *trembleuse.* The example shown here is decorated with a vignette of a Chinese couple being served tea, reminiscent of the work of Johann Gregor Hoeroldt. Like in-house Meissen decorators, *Hausmaler* working in Augsburg continued to use Japanese motifs derived from illustrations in Arnoldus Montanus.

Outing of the Governor of Miako, illustration from Arnoldus Montanus, *Gedenkwaerdige Gesantschappen,* Amsterdam, 1669.
Basel, university library

Cup and saucer, Meissen porcelain, painted decoration executed in Augsburg, c. 1720.
Paris, Musée des Arts Décoratifs

The gold decoration here derives from prints engraved by the prolific, Augsburg-based Martin Engelbrecht, who opened his workshop in 1719 and soon made a specialty of adapting the latest French designs for the German market. This set might well be the work of Johann Khuen, who between 1714 and 1718 worked on the chinoiserie decoration of pavilions in the Nymphenburg Palace on the outskirts of Munich. Along with Elias Baeck, another famous ornamentalist of the period, the painter-decorators of Augsburg had access to numerous prototypes deriving from the work of Arnoldus Montanus (see page 266).

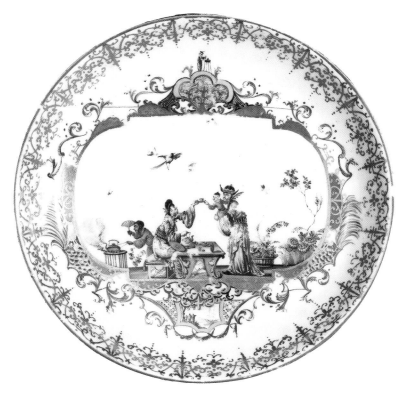

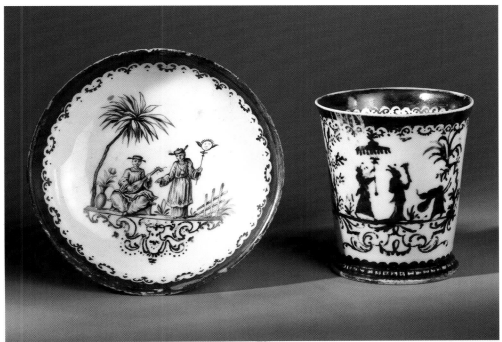

Saucer, Meissen porcelain,
decorated by Johann Gregor Hoeroldt, c. 1730.

Paris, Musée des Arts Décoratifs

Johann Gregor Hoeroldt—not to be confused with Christian Friedrich Herold (1700–c. 1779), who specialized in miniature landscape and chinoiserie painting between 1725 and 1740—solved problems in colored porcelain decoration that had troubled Böttger. Early in his career he painted richly hued and virtuosically executed chinoiserie designs, but soon abandoned miniature painting to become an ornamentalist, devising models to be executed by assistants. Designs by him survive in an album compiled by Georg Wilhelm Schulz and recently published in Leipzig, where they are now preserved. Like many others, he was influenced by Martin Engelbrecht's prints as well as by the illustrations in Arnoldus Montanus. The elegant vignette on this saucer of a family enjoying tea is characteristic of his chinoiserie compositions.

Tumbler and saucer *(below),* Meissen porcelain,
Johann Friedrich Böttger, decorated in Augsburg, c. 1718–19.

Paris, Musée des Arts Décoratifs

The technicians of the young porcelain factory had trouble developing methods for applying colored as well as gold and silver paints, so the most difficult projects were farmed out to Augsburg *Hausmaler.* Here, delicate silhouettes in partly burnished or polished silver are set within lacey arabesque border designs. The members of the Seuter family, who painted these pieces, often derived their designs from prints by Martin Engelbrecht. In 1717 he engraved a set of eighteen prints depicting Oriental costumes for Johann Andreas Pfeffel that could have been the source for these figures.

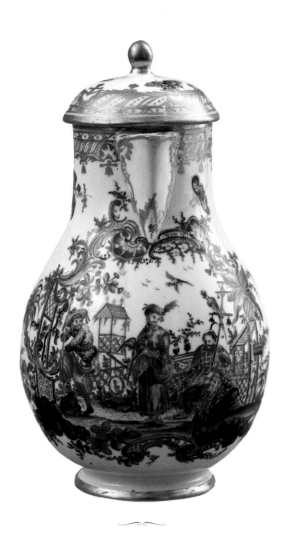

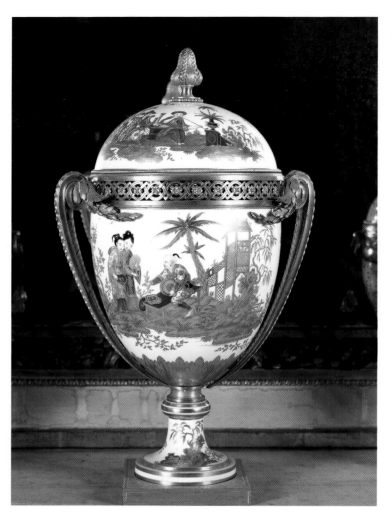

Coffeepot, Frankenthal porcelain, c. 1770–75.

Cologne, Museum für Angewandte Kunst

Following the lead established by Meissen under J. G. Hoeroldt's guidance, all the European pottery factories began to produce chinoiseries. The Frankenthal factory was established in 1755 by Paul-Antoine Hannong, who was forced to stop manufacturing porcelain at Strasbourg—which was then within French borders—after the Sèvres factory was awarded a monopoly over French porcelain-making in 1753. The Elector Palatine Karl Theodor acquired the operation in 1762 and brought it to its apogee between 1770 and 1775, when this coffeepot with decoration in the style of Jean-Baptiste Pillement was made.

Principal vase in a set of three, Sèvres porcelain, Louis-François Lecot, gilt bronze mount attributed to Jean-Claude Duplessis (d. 1774), 1776.

Versailles, Musée National du Château

This opulent vase in the form of an egg is decorated with Chinese motifs after Boucher (the lower composition is a paraphrase in reverse of the title page from *Suitte de Figures Chinois,* engraved by J. Houël after Boucher in 1745). After 1750, Boucher's chinoiserie designs were denigrated by French adepts of neoclassicism, but even in France they did not entirely disappear from view. In fact, this set of vases was acquired by Marie-Antoinette for her *grand cabinet intérieur* at Versailles and was subsequently placed in her rooms at the Château de Saint-Cloud.

Title page, *Suitte de Figures Chinois* (Suite of Chinese figures), print by J. Houël after François Boucher, c. 1745.

Paris, Bibliothèque Nationale

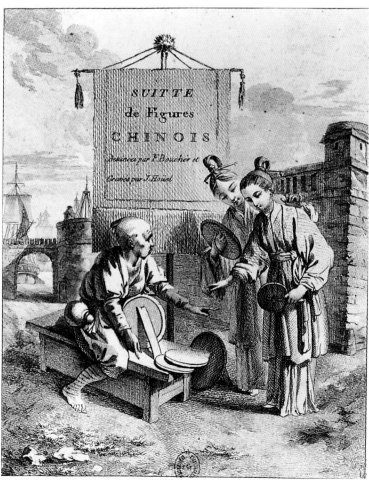

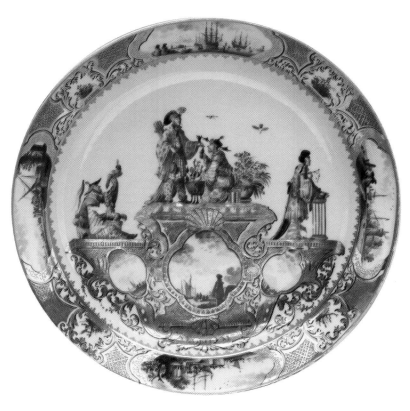

Plate, Meissen porcelain, decorated by
Johann Gregor Hoeroldt, c. 1730–35.

New York, Metropolitan Museum of Art

*I*n the first years after the Meissen factory was
established by Augustus the Strong in 1710, it
primarily produced wares decorated like those
from Japan in accordance with the king's wishes;
only subsequently did European decoration come
to the fore. It was in 1720 that Samuel Stölzel, who
had been trained in Saxony but had settled in
Vienna, returned to Augustus's service, bringing
with him Johann Gregor Hoeroldt, who developed
enamel-painting techniques of great brilliance and
reorganized the factory's painting workshops.
Named court painter in 1723 and "director of

painting and *arcaniste*" (keeper of the secrets of
porcelain-making) in 1731, he developed a special
style of chinoiserie decoration—humorous but
with refined, elongated figures—that earned
Meissen porcelain the esteem of all Europe
between 1725 and 1740. His work was influenced by
the prints of Martin Engelbrecht and by books
made available to him by Augustus, notably the
Arnoldus Montanus volume published in 1669.

Temple of a thousand idols, illustration
from Arnoldus Montanus, *Gedenkwaerdige
Gesantschappen*, Amsterdam, 1669.

Basel, university library

Snuffbox, Meissen porcelain, decorated
by Johann Gregor Hoeroldt, c. 1730.

Private collection

*A*ugustus the Strong's commitment to chinoiserie
is especially evident here: his court painter has
depicted two Chinese figures supporting his coat
of arms, in accordance with his instructions. Along
with two other figures on either side, they also
hold up the letters *FARP* (for *Fredericus Augustus
Rex Poloniae*), the monogram that appears on
pieces intended for royal use. Other chinoiseries of
Hoeroldt's invention accompany the cross of the
Polish Order of the White Eagle on the back of
this piece, and the inner surface of its lid bears
a miniature portrait of Augustus after a painting
by Georg Friedrich Dinglinger.

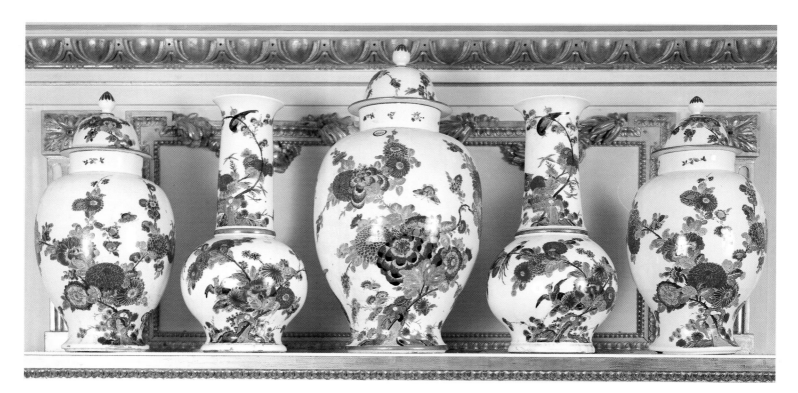

Colored prints by Gabriel Huquier,
from *Recueil des differentes especes d'oiseaux,
fleurs, plantes et trophées de la Chine*
(Collection of different species of
Chinese birds, flowers, plants,
and trophies), c. 1745.

*Paris, Bibliothèque d'Art et d'Archéologie,
Fondation Jacques Doucet*

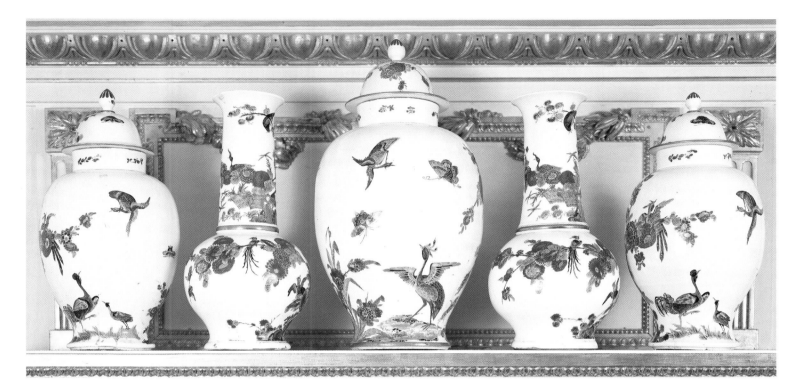

Set of five vases with
Japanese decoration (Kakiemon style),
Meissen porcelain, c. 1725–30.
Private collection

*I*nspired by the Kakiemon style of late-
seventeenth- and early-eighteenth-century
porcelain decoration (named after Sakaida
Kakiemon, credited with first enameling Japanese
porcelain about 1660 in Arita, Japan), Saxon
porcelain ensembles were soon in greater demand
among European collectors than those imported
from the East. This set bears the mark *AR* (for
Augustus Rex), which indicates that it was
intended for the collection of Augustus the
Strong, who assembled some twenty-five
thousand porcelain objects—both Eastern and
European—in his Japanese palace in Dresden.
One side of each piece is decorated with India
flowers and the other side with Oriental birds.
Gabriel Huquier, the great print entrepreneur,
responded to the vogue for porcelain decorations
of this type by publishing designs intended
to serve as models for them.

The Rocaille

—⚭—

As now used by cultural historians, the term *rocaille* is rife with ambiguity and equivocation. Some specialists in French eighteenth-century art employ the phrase *l'art rocaille* to designate the entire artistic production of the late Baroque era, but others are inclined to use it to describe not a reaction against the Baroque but rather a completely independent style. These divergent views result from misguided attempts to impose a rational schema on a period that was anything but rational, at least in its visual culture.

For present purposes, we should stress that what is in fact the name of a French ornamental style has become a moniker for the output of an entire period in the history of art. In this chapter, however, the focus will be on a part of that whole: not on "the art of the rocaille"—a phrase that, in French usage, encompasses arabesque compositions and exotic flights of fancy—but rather on rocaille and rococo ornament.

It is particularly difficult to come to terms with the decorative arts production of this period in general, and with the rocaille idiom in particular. Its practitioners favored anomalous forms and transformational processes leading to unexpected results. One of its most surprising features is that, although the style's component elements are generally natural in origin, the final results often border on total abstraction, thereby providing a signal demonstration of how imitation is not timeless and unchanging but is unavoidably colored by specific social context. If we are to understand this art, we must attend carefully to the context in which it was created.

—⚭—

The Definition of a Term: From Matter to Manner

Any attempt to find a definition of rocaille ornament in eighteenth-century lexicons or dictionaries will prove futile. In the 1771 edition of the Trévoux dictionary, *rocaille* is defined as "an assemblage of several kinds of shells and rough,

Plate 6 of *Wondertonel der Nature*, Levinus Vincent, print by Romeyn de Hooghe, Amsterdam, 1706.
New York, Metropolitan Museum of Art

As a great maritime and trading power, the Netherlands became fascinated at an early date with the creatures and contents of the sea, exotic animals, and the artifacts of alien cultures, examples of which found their way into natural-history collections, often kept in "curio cabinets." During the seventeenth and eighteenth centuries, the many scientific studies of the natural world written by scholars based in the region were disseminated throughout Europe by an extensive distribution network. Its painters introduced these objects into their still lifes; Rembrandt, for example, made a print of a shell that evidences his interest in such matters.

The print opposite reveals how these collections were organized. Drawer number 5 has been withdrawn and raised to the vertical, allowing us to view its contents: dozens of moths and butterflies arrayed in elaborate decorative patterns, outlined with smaller insects or tiny shells, a tableau emblematic of the close ties in the period between the scientific and the ornamental. Note also the large shells and coral on top of the cabinet; the shell at the left, a murex, was of particular fascination during this period.

unpolished stones that encrust certain rocks, which they are made to resemble. It is a rustic architectural composition imitating such natural rocks through the use of perforated stones, shells, and coral of many colors, as seen in grottoes and fountain basins." The terms here are vaguely mineralogical and invoke the garden, a major preoccupation of seventeenth- and eighteenth-century European culture, and specifically the rocaille garden and its association with shells. Artificial grottoes, then quite fashionable, were often decorated with shells and shellwork.

The Trévoux definition appears to encompass only the term's etymological origins and not the decorative vocabulary associated with it, suggesting that in the eighteenth century it was applied exclusively to grottoes and gardens. It is perhaps tempting to view this limited scope as reflective of the disapproval to which rocaille ornament had been subject since mid-century in France, above all in Paris, but in fact Jacques Lacombe's definition in his *Dictionnaire portatif des Beaux-Arts* (portable dictionary of the fine arts) of 1753 is almost identical.

In practice, contemporary observers of "bizarre" rocaille creations used various terms to designate the component elements, which, it must be admitted, do not readily lend themselves to conventional definition and description. Listen, for example, to Dufort de Cheverny, the introducer of ambassadors at the court of Louis xv. He belonged to a prosperous and enlightened court elite with sophisticated architectural tastes. Although not directly involved in artistic production, he traveled in the same circles as those who were, and doubtless he had acquired some expertise in these matters. At the moment of the French Revolution, he wrote about the beginning of Louis xv's reign with a reserve that would have not have come easily to most of his contemporaries: "The taste for true beauty had not been altogether lost in France, but fashions had changed: Boucher had introduced barefoot shepherdesses with hoop-skirts like those at the opera. All ornament was baroque, nothing was perpendicular, not even coats of arms, whether on tableware, seals, or coaches."

However, Charles de Brosses (1709–1777), another connoisseur, in his appealing *Lettres familières écrites d'Italie à quelques amis* (Intimate letters written from Italy to some friends), reports what inhabitants of that country were saying in 1739: "The Italians reproach us by saying that in France everything fashionable is in an outmoded Gothic style, that our mantelpieces, our gold boxes, our silver tableware are twisted and contorted as though we'd lost the knack of things round and square, that our ornament is the Baroque taken to its most extreme form."

In both of these passages the word *baroque*—deriving from *barocco,* a term used by jewelers to designate an irregular pearl—is used to describe something bizarre but above all irregular and picturesque, and the second of these writers even resorts to the term *Gothic,* which in this period carried purely negative connotations through its reference to the barbaric Goths. In December 1756, the Vincennes porcelain factory issued a new piece that it christened a *"gobelet*

baroc" (baroque goblet), a designation doubtless intended to underscore its irregular design.

Rocaille was also used in the bills and inventories of sculptors, silversmiths, bronze workers, and ornamental painters, who referred to *rocaillé* cartouches and cartels, overdoors with *rocaillé* frames, broken *rocaillé* ornament, architectural forms decorated "in the rocaille manner," etc., in one instance listing a "broken palmette in the center, accompanied by different pieces in rocaille."

When one compares such descriptions with actual artifacts, it becomes clear that they refer to objects with fluted, scalloped edges and openings that evoke not so much rocks as shells, especially nautilus shells.

In light of this information, we might reasonably ask whether it would be best to use *baroque* or *rocaille* when discussing such ornament. One answer to this query is provided by Charles Normand: in the Preface to his *Nouveau Recueil en divers genres d'ornements* (New collection of ornaments in various genres; Year VI/1803), he wrote of this "scraggy, incoherent genre that draftsmen have dubbed *rocaille* and *chicorée*," this last being the French term for the eccentrically shaped Chicoreus shell *(see below)*.

It would seem, then, that *rocaille* and *chicorée* were sometimes used to designate the same thing, though not by the same people. The former term was used by artisans, and sometimes by celebrated artists such as François Boucher, *pages 331, 332, 376, 407* who played an important but idiosyncratic role in its evolution. But those not directly involved in artistic production called these artifacts by other names: non-professional art lovers described them as "baroque," intellectuals as "Gothic," skeptics as "irregular," and outright opponents as "bizarre."

<center>~·~</center>

Rocaille Prints

The term *rocaille* does not often appear in the titles of print albums and collections. The great master of the style, Jacques de Lajoue (1686–1761), used it only once in an undated set of twenty-four prints published in two volumes under the title *Tableaux d'ornements et rocailles* (Tableaux of ornament and rocaille objects), *page 406* and his follower François-Thomas Mondon published at least five collections of seven prints each in about 1736, which he entitled *Livre de formes rocailles et cartels* or *Livre de formes ornées de rocaille* (Book of rocaille forms and cartels; Book of forms with rocaille decoration).

Rocaille is also the title of a print executed by Claude Duflos the younger *page 331* after a design by Boucher and published by Larmessin. It is one of a set of five vertical-format prints, the others of which are entitled *Hommage champêtre, Triomphe de Priape, Leda,* and *Triomphe de Pomone* (Rustic homage, Triumph of Priapus, Leda, Triumph of Pomona), the last of them engraved by Charles-Nicolas Cochin in February 1737. The design of *Rocaille* is unusually compelling, and it is the only one of the series from which the human figure is entirely absent. Its composition is dominated by the diagonal trunk of a palm tree

traversing much of the visual field, which seems to have been inspired by paintings of the flight into Egypt or by a similar palm tree next to the personification of the Nile in Gian Lorenzo Bernini's (1598–1680) Fountain of the Four Rivers (1648–51) in the Piazza Navona in Rome. But Boucher's image does not incorporate any of the craggy rocks so prominent in Bernini's great work, which would have been entirely appropriate in such a rocaille composition. Instead, Boucher gives us what is effectively a bouquet of shells—not a casual arrangement on a shore but an artistic tableau of eccentric and asymmetrical forms precariously arrayed against a pedestal: elegantly rendered conch and nautilus shells, corals, and porcelain objects that culminate in a superb sea-palm. The components are something of a hodge-podge and surround an enormous concave shell—anything but natural—whose lower portion merges with a pool of water from the cascading fountain above. The design might have been intended to evoke a rocaille grotto, but there's no saying for sure whether we are in a natural or an artificial realm, in one of reason or one of pure fancy, for the water below the giant shell is still rather than flowing. It is unmistakably a garden visible in the upper distance: we see trees, a large vase on a pedestal, and a balustrade, as well as the fountain set against a columned pavilion or retaining wall, the curving surface of which—rhyming with the curve of the palm tree—appears curiously unstable, as though it were liquefying and flowing into the sheets of water just below. Rarely have the two dimensions of a print captured such a variety of sculpted forms and vivid textures.

Though not, strictly speaking, ornamental, this print brings us to the very heart of the rocaille; it contains no cartouches or other paradigmatic rocaille forms, but the idiom's character is nonetheless strongly felt here. The whole is asymmetrical, fragmentary, and fantastic. Each component element is inspired by nature but deviates markedly from its model. It is a kind of visual caprice: there is no logical relation between the objects represented in the lower tableau and the garden composition above. The scales operative in the two parts are different (note how the shells seem vastly larger than the garden vase), and conventional compositional logic seems to have been abandoned. The depicted objects are themselves of irregular form, and the composition is dominated by diagonal configurations—not only those crossing the frontal plane, but another that appears to recede from the lower-left corner back toward the vase in the garden at the upper right, giving the illusion of depth.

So, despite the absence of explicit cartouches, scrolls, etc., this print is a representative production of the French rocaille in two crucial respects: chronologically, because it dates from about 1736, when the style was at its apogee; and semantically, because the objects depicted are consistent with the definition contained in Trévoux's dictionary.

page 331 Boucher also introduced rocaille ornament into *Leda*, another print in this series. Beneath a fountain consisting of a large shell (rising above the group of Leda and the swan) is another fountain closer in conception to what one might actually see in a garden, composed of a basin dominated by an elaborately

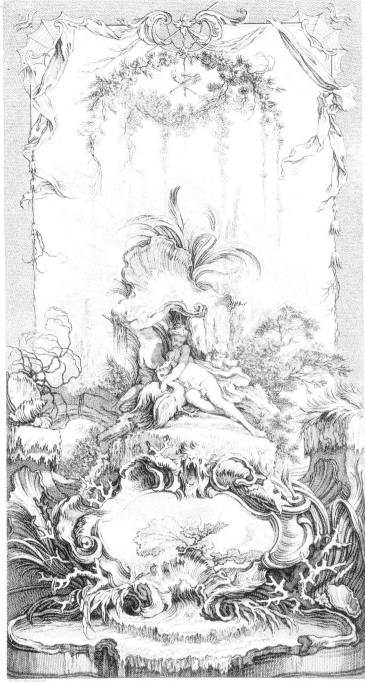

Leda, etching by Claude Duflos the younger
after François Boucher, c. 1736.

Paris, Louvre, Edmond de Rothschild Collection

Rocaille, etching by Claude Duflos the younger
after François Boucher, c. 1736.

Paris, Louvre, Edmond de Rothschild Collection

This etching, in which Boucher gave his imagination free reign, is one of the rare works to which the term *rocaille* was applied in the first half of the eighteenth century. It is a visual précis of the style's essential components: shell forms arranged in an extravagant tableau, elaborate fountain structures, sinuous outlines, strange creatures, and a general air of theatricalized exoticism. The slanted, wavy palm tree on the upper left was inspired by the one that rises above the personification of the Nile in Bernini's Fountain of the Four Rivers in Rome's Piazza Navona, a prestigious monument that was a constant point of reference for rocaille artists.

Leda, from the same set of prints as *Rocaille* (illustrated at left), could easily have the same title if not for its depiction of Leda and the swan. The story of Leda, who was impregnated by Jupiter in the form of this graceful bird, is a tale of transformation that also figures in the manner of presentation, for the composition takes the form of an arabesque vignette that has burst forward and overwhelmed its decorative frame. Something of the same effect is seen in *Rocaille*. In contrast to that image, however, which is composed essentially of "natural" forms, the lower part of this design features a large ornamental cartouche that gives a more schematic flavor to the same morphological vocabulary. Both prints, however, illustrate the close ties between rocaille ornament and the theme of water. The open-mouthed mascaron at the top of the cartouche, which derives from similar masks in mannerist grottoes by way of the auricular style, suggests the head of an otter, a river creature that also appears in *Rocaille*.

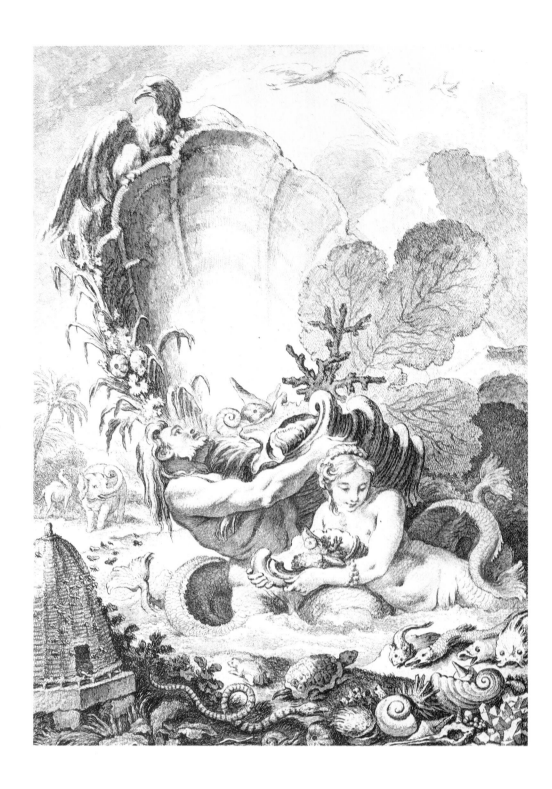

Frontispiece from Dezallier d'Argenville,
La Conchyliologie, print by Pierre-Quentin
Chedel after François Boucher, 1742.

Paris, Louvre, Edmond de Rothschild Collection

The passion for shell collecting took hold in France later than it did elsewhere in Europe. Around 1735, Parisian dealer Gersaint began to sell beautiful examples imported from Amsterdam, and in 1742 Dezallier d'Argenville published a manual designed to help amateurs identify and organize the species in their collections. Its frontispiece was designed by François Boucher, himself a collector of natural-history curios, including shells. The composition features a merman and mermaid, sea palms, large shells, coral, and a foreground array of crustaceans and other aquatic and amphibious creatures, with an eagle and other birds above, while the camel and elephant in the background attest to the exotic associations of such imagery. The beehive at left is meant to evoke Bernard Mandeville's *Fable of the Bees* (1714; French translation 1740), where it is argued that "private vices" (or luxury artifacts) make for "public benefits" (or a flourishing economy) through their subvention of a broad range of artisanal enterprises; thus its presence here underlines the connection between extravagant natural objects and virtuosic rocaille artifacts.

scrolled and contorted cartouche replete with gaping animal head. This is an unmistakably rocaille form.

<center>∼∂∽</center>

Shells

Any consideration of the rocaille must include shells—as seems only logical, given their role in rockwork and shellwork garden grottoes. But the shells prevalent in rocaille imagery are not the ones usually found in garden ornament.

The use of shells as ornament models paralleled the increasing vogue of natural-history collections and curio cabinets. In France, collections of this kind became more and more fashionable as the eighteenth century advanced, even displacing coin and medal collections in the hearts of the scholarly elite. They were not an altogether new phenomenon: many fine examples were assembled in the sixteenth and seventeenth centuries, especially in Germany and northern Europe. But these earlier collections had resulted from an interest that was primarily scientific, while in the eighteenth century shells became the object of a different, more frivolous kind of attention, almost a fad.

Gersaint, the famous dealer in luxury objects and *curiosités* for whom Watteau painted his celebrated sign in 1721, went so far as to announce publicly in 1734 that he would be making trips to Holland in the next two years to seek out choice shells for French collectors. In the catalogue of the 1736 sale in which he offered these objects to the public, he wrote: "The taste for shells which it seemed to me was taking hold in France . . . prompted me to return to Holland to make a choice selection of everything beautiful and rare of this kind that I could find there." The fact that Gersaint sold such objects strongly suggests that interest in them focused on their colors and decorative qualities. The composition of Boucher's print *Rocaille* is perfectly consistent with the language used by *page 331* Gersaint in his 1736 *Catalogue raisonné des coquilles, insectes, plantes rares et autres curiosités naturelles* (Catalogue raisonné of shells, insects, rare plants, and other natural curiosities), page 10: "Shells can be grouped together with agreeable results; looking at them can give architects as well as sculptors and even painters new ideas about form."

Shells had been favored for their decorative qualities since the seventeenth century, but artisans incorporating shell forms into their designs in this period chose the ones that had the most surprising and asymmetrical shapes and the roughest surfaces, rather than the perfectly regular scallop shell. Among this group was a relative of the conch and the whelk, called the murex, which had long been appreciated in Europe (not least as a source of purple dye); because of its large, irregular form, collectors gave it the colloquial name *rocher* (rock). The most beautiful of these were the *Chicoreus* and the *Murex ramosus,* two species found on the Lebanese coast and in the Gulf of Arabia; ornamentalists were attracted by their wavy, scroll-like, and sometimes spiny forms, which served as the basis for many a cartouche design. And it was the very irregularity of these shells, commonly called *chicorées* in French, that Cochin targeted in his

page 353
page 355
page 354

celebrated polemic imploring French silversmiths to abandon such forms—which he called *chicorées modernes*—and return to more normative standards of good taste (*Mercure de France,* December 1754), and that the marquis de Marigny, Louis xv's fine arts administrator (from 1751 to 1773), stipulated not be used in a frame for his portrait.

Natural-history collections also featured mineralogical examples, including irregular rocks and crystals that prompted reflection about picturesque natural forms. Their influence—also a factor in the Baroque era—is discernible in the table centerpiece made by Jacques Roëttiers (1707–1784) for the duc de Bourbon (1736), in the two holy-water stoups in the Parisian church of Saint-Sulpice (1745), and in the naturalistic rock forms incorporated into the façade of the Asamkirche in Munich (1733). Finally, minerals also had some influence on decorative arts designs. This is demonstrated by the title of the first illustrated manual intended for such collectors, by A.-J. Dezallier d'Argenville: *L'Histoire naturelle expliquée dans deux de ses parties principales, la lithologie et la conchyliologie* (Natural history explained in two of its principal parts, lithology and conchology, 1742). This work, financed by Parisian collectors themselves, was hugely successful, but in the two subsequent editions its two component parts were published separately. In 1760, the mineralogical part was published under the title *L'Histoire naturelle éclairée dans une de ses parties principales, l'oryctologie, qui traite des terres, des pierres, des métaux, des mineraux et autres fouilles* (Natural history clarified in one of its principal parts, oryctology, which deals with lands, stones, metals, minerals and other excavated things), but this volume proved less successful than the one on shells. Boucher, himself the owner of a natural-history collection, was commissioned to design the frontispiece for the latter work. It is worth noting that Dezallier d'Argenville also published a celebrated work on the theory and practice of gardening, underscoring the symbiotic relationship during this period between shell and garden imagery.

page 332

The argument of a direct correlation between the development of rocaille ornament and the craze for natural-history collections must be nuanced, however, for despite the fact that from the 1760s the prevalent ornamental vocabulary was distinctly neoclassical, the number of shell collectors steadily increased as the eighteenth century advanced. Very likely, the mutual interaction of the two phenomena was the function of a fleeting conjuncture whose dynamics were eventually transformed by the increasingly scientific character of the interest in shells, minerals, etc. In any case, their connection in the style's formative phase remains indisputable and is demonstrated by certain artifacts, such as porcelain objects shaped like shells with gilt-bronze rocaille fittings.

page 400

From the Sea

Rocaille ornament and decoration are inseparable from themes connected with water. Prints, objects, and paintings in this style consistently explore aquatic imagery: marine life, maritime allegories, fountains, and cascades all proliferate

in the print albums published in Paris, Augsburg, London, and Nuremberg, while contemporary painters delighted in glorifying Amphitrite, Poseidon, and Thetis, figures from Greek mythology whose habitat was the sea. Such themes had long been staples of European opera houses, which often staged elaborate tableaux featuring watery grottoes strewn with shells, or terrifying caverns decorated with rocks in angular, disturbing shapes.

In Paris, the rocaille found its earliest and most successful manifestations in residential interiors featuring marine imagery, as in the home of the grand *page 397* admiral of France, Louis-Alexandre, the comte de Toulouse (1678–1737). This is surprising, for the period in question was not notable for French maritime exploits and expeditions (which were more common, and more spectacular, in the second half of the century). Despite this, rocaille and rococo ornament was much more fully developed in France than in England—a nation deeply invested in its naval superiority—or the Netherlands. What's more, French artists of the period do not seem to have been particularly interested in the sea; Jean-Baptiste Oudry's trip to Dieppe to view its tidal pools is a rare exception. To be sure, French artists traveling to Italy sometimes made part of the voyage by ship (more often than not an extremely rough trip); but even central European artists making the same cultural pilgrimage, who crossed the Alps and took land routes the whole way, were partial to aquatic themes.

Most rocaille ornament prints were produced by craftsmen who had spent time abroad. These artists were often following in the footsteps of more powerful personalities such as Juste-Aurèle Meissonnier (1695–1750), Boucher, Thomas Germain (1673–1748), and Nicolas Pineau (1684–1754), all of whom traveled. More than the sea itself, the extravagant poetry of Rome's Baroque fountains and the more fantastic strain of European garden design, coupled with the pleasing irregularity of a wide range of natural objects, inspired these artists. The imagery of most rocaille prints is related to the same themes and traditions.

The Empire of the Rocaille

As we have seen, *rocaille* was used by contemporary craftsmen as an adjective, and in French it might be more accurate to speak of the *style rocaillé*. A text dating from 1751 and describing a silver centerpiece made by Claude II Ballin (1661–1754) for the Spanish marqués de La Ensenada describes it as representing a triumph of Neptune mounted on an "artistically *rocaillée* seashell." This centerpiece has since disappeared, but it must have been a virtual apotheosis of the rocaille idiom, for it apparently achieved the formidable feat of outdoing a shell, the natural inspiration for the style.

At the beginning of the eighteenth century, rocaille forms started to appear on a wide range of artifacts, beginning with fountains and garden pools, such as the Lago das Conchas (Pool of Shells) and the Nereid Fountain in the *page 337* gardens at Queluz, in Portugal (1715). They soon became standard decorative

motifs on articles associated with sociability and pleasure, notably tableware, buffet fountains, and decorative paintings. The sets of prints after designs by Lajoue entitled *Tableaux d'ornements et rocailles* (Tableaux of ornaments and rocaille objects), for example, which feature trellises, sumptuous silver vases, and fanciful moldings, were intended primarily for use in dining rooms.

page 406

Thus we should not be surprised to discover that the rocaille found its most striking expression in ornaments of the table, notably ceramics and porcelain (produced by the Hannong factory in Strasbourg, the Sceaux factory, the factory of the widow Perrin in Marseilles, and the Niderviller factory). The workshops in Meissen and Vincennes produced some of the most spectacular services. It is often noted that the Sèvres factory continued to turn out rocaille porcelain, tableware, and silverware until about 1770, by which time neoclassicism was at its height. In fact, the style proved more tenacious in some types of application than in others, and its evolution was linked in every case to specific media. During the Regency of Philippe d'Orléans (1715–23), rocaille forms were often used in ephemeral decorations and in silver, but only tentatively in interior decor. Around 1727–28 they became more pervasive in Parisian interiors, and *page 402* their triumph was assured by 1735, the year of Meissonnier's silver centerpiece design for the Duke of Kingston. The decade of the 1730s saw the widespread dissemination of the rocaille in the form of ornament prints by Mondon (1736), Boucher (1737), Huquier (1737), Chedel (1738), and Cuvilliés (1738). These designs were soon emulated throughout Europe, prompting the emergence of an international rococo style.

Rocaille ornament was also notably successful among silversmiths, who produced some of the most remarkable examples of the style. These included not only large, spectacular pieces such as wine coolers, terrines, and centerpieces but also smaller objects such as snuffboxes and watch cases. Designs incorporating shells and abstract swirls were common in every scale, the most *page 368* extravagant being those by Meissonnier, who started his career as a maker of clock cases. Indeed, it was the smaller, more portable artifacts that helped to spread the style throughout Europe.

Most of the ornamentalists responsible for the compositions in rocaille ornament prints, the principal mode in which the style was disseminated, were artisans accustomed to working in three dimensions: sculptors, silversmiths, casters, and chasers. Meissonnier, born in Turin, was a silversmith by training, though he later tried his hand at just about everything, including architecture and interior decoration. Nicolas Pineau was trained as an architect and sculptor but specialized in ornamental carving, notably of interior paneling. Pierre-Edme Babel (1720–1775) was a jeweler-silversmith before becoming a sculptor; François-Thomas Mondon was a jewelry sculptor and silver chaser; and Thomas Germain, while best known as a silversmith, also designed a church in Paris (St. Louis du Louvre, destroyed). The Slodtz brothers, while primarily sculptors, also provided designs for clocks, bronze fittings, furniture, and ephemeral decorations such as funeral catafalques. Jean-Claude Duplessis the elder (d. 1774) was a sculptor, silversmith, and caster; his son, a prolific designer of Sèvres porcelain,

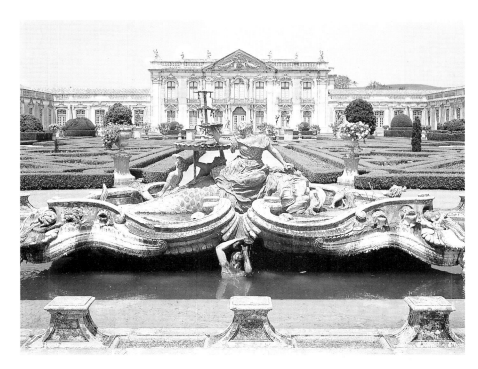

Nereid fountain,
Jean-Baptiste Robillon and
John Chere, 1788.

Queluz Manor (Portugal)

This imposing fountain features a figure of the
sea goddess Thetis atop a marine animal. Almost
as important as the statue itself is its immense
base, the protruding forms of which manage to
suggest both the waves of the sea and ships'
prows. The overall design makes it resemble a
giant silver centerpiece.

Alpheus Fountain, plate v from *Livre
des Fantaisies nouvelles* (Book of new
fantasies), Pierre-Quentin Chedel, 1738.

*Paris, Bibliothèque d'Art et d'Archéologie,
Fondation Jacques Doucet*

Chedel, who usually engraved compositions
by other artists, left a few images of his own
invention. This set of prints features anthropo-
morphic masks merging into shells in the Italian
mannerist tradition. He was the only artist in
eighteenth-century France to work in this vein,
which was very close to the rocaille. Here, the
juxtaposition of incongruous elements depicted
in slightly varying scales gives the whole a
fantastic character.

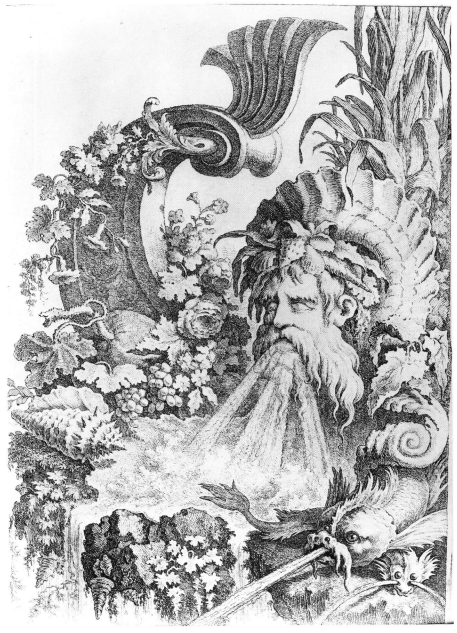

was also a caster, chaser, and gilder. And—to complete this list of rocaille artists with three-dimensional proclivities—Jacques Caffieri (1673–1755) was a sculptor, caster, and chaser. It is true that Lajoue and Boucher were painters, but both of them designed vases and mounts in addition to ornament models of various kinds. And Lajoue made a specialty of illusionistic depictions of gardens, terraces, stairways, and fountains in which his skill as an ornamentalist is indistinguishable from his gifts as a painter. We have already seen how much care was taken by Boucher in his *Rocaille* print with the expression of volume, in both its relief effects and its receding perspective.

Vases

The rocaille was better suited to some forms than to others, and one of its preferred formats was the vase. Here again, there were precedents. Sixteenth- and seventeenth-century craftsmen in Rome and northern Europe had produced vases of remarkable originality, but eighteenth-century artists gave the tradition a new rocaille inflection. Some of their designs are awkward, but there's no denying their striving for originality. It is not surprising that vases should have been favored by the period's more experimental artists; such objects were relatively compact, and their suitability for use in grottoes, gardens, tables, and interiors made them perfect vehicles for the style, which placed a high value on adaptability. A few artists set out to devise entirely new vase formats using the rocaille vocabulary, as in the illustrations published by the widow Aveline in *Nouveau Livre de formes d'ornements rocaille et vases inventés par Hubert* (New book of rocaille ornament and vases invented by Hubert). But the most common approach involved the application of rocaille mounts to conventional vase forms. Sometimes these encrustations all but devour the shape beneath them, as in the designs published by Pierre Germain in his *Elements d'orfèvrerie* (Elements of metalworking). Many of the more extravagant of these vase designs, the ones sometimes referred to by contemporaries as *estropiés* (distorted or mangled), were intended purely for painted panels, needlework, or tapestries. Such was the case, for instance, with those by Alexis Peyrotte.

The Universal Cartouche

Many of the rocaille ornament prints published in France the 1730s and 1740s, as well as those issued elsewhere in Europe, notably in Augsburg, featured scrolled and skewed cartouches in the form of fountains, trophies, and fantastic garden sculpture. François-Thomas Mondon, for instance, published sets of prints whose titles specify that they represent cartouches and cartels (a related form). In his third *Livre de cartouches* (Book of cartouches), Lajoue gave his versions elaborate settings similar to those in his paintings, and in two instances he even cast them as ship's sails, an utterly fantastic and illogical idea.

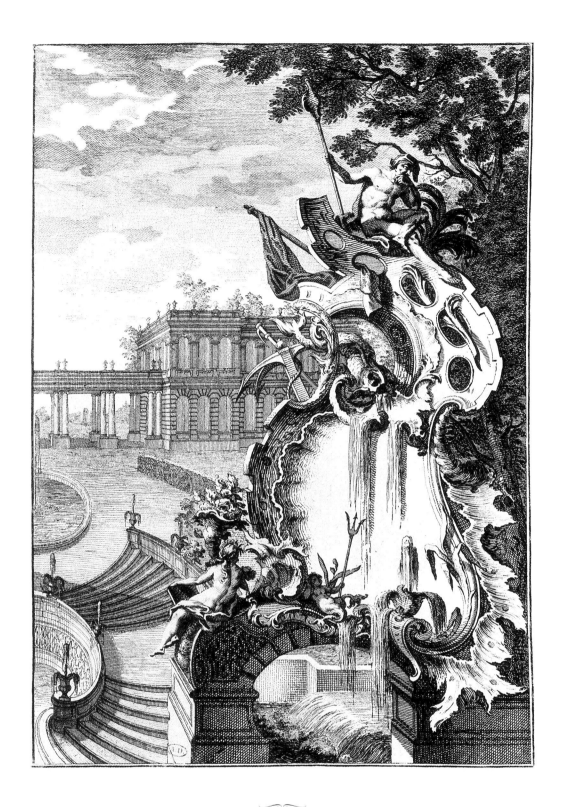

Plate from *Morceaux de caprice à
divers usages* (Caprice compositions for
various purposes), print, François
de Cuvilliés (1695–1768).

Each print in this set features a large rocaille
cartouche set off by architectural views. The
rocaille composition is situated in the foreground
and treated in high contrast, while the background
elements are treated in middle tones and so are
much less prominent. The eccentric shapes of
these configurations often suggest andirons.

Binding of a royal almanac,
Pierre Delorme, 1776.

Paris, Bibliothèque Nationale

Even bookbinding fell under the sway of the
rocaille, as can be seen in this lavish, brilliantly
hued example produced for the library of
Marie-Antoinette. Its cartouches, which bear
the queen's arms, are outlined by the curves
and countercurves that play a central role
in the rocaille vocabulary.

In some instances cartouches were set up on pedestals as though for veneration, while in others they were fully integrated into the design. Certainly they appeared in the most unexpected places and contexts during this period, becoming the principal vehicle by which the rocaille program of aesthetic transformation was implemented. Picture frames, overdoors, chair backs, porcelain trays, boxes, watch cases, keyholes, handles, and cane heads all assumed cartouche shapes, with their decoration concentrated on their sinuous edges. And cartouches played a prominent role not only in ornament prints but in printed images of other kinds, notably on maps and portraits, where they served as frames for legends. Some of the most striking designs in which they appear are the title pages of books, where they became quite popular, despite the compositional problems caused by their asymmetrical forms.

pages 365, 416

Interior decoration was another domain in which the cartouche flourished during this period. Carved paneling tends to be organized around empty central fields; this made them ideal for cartouche designs, which became popular in the decor of many interiors. Other objects, too, were turned into large cartouches, in many cases against expectation, including vases, ewers, and clock cases. Indeed, an entire class of objects came to be known as cartel clocks, after the cartouche-like form to which they conformed. Furniture-makers also contributed to this development, employing cartouches in every conceivable place, notably on mirror frames and console tables, which were sometimes designed such that their curving legs and aprons outlined giant cartouches. It might seem that commodes would not have been amenable to the form except as small keyhole fixtures, but the development of models without braces between the drawers changed this, making it possible to decorate their fronts with sinuous cartouches outlined in gilt-bronze fittings, marquetry inlay, or painted ornament. In some cases, the design was made more elaborate by nesting the cartouche profiles one within another; the most satisfying, fully resolved design solution entailed dividing their fronts into three cartouche outlines, with the central one predominant. The resulting emphasis on line and shape produces a typically rocaille effect, encouraging the viewer to take delight in the process of formal manipulation.

pages 383, 384

pages 379, 389, 429

pages 377, 378, 379, 388, 389

Other examples featuring cartouches in pure outline include the airy armatures of rocaille girandoles (elaborate wall sconces), and gilt-bronze pedestals for globes and armillary spheres. Piranesi even designed a large ceremonial gondola for a Venetian festival, with a canopy shaped like an enormous scrolled cartouche (drawing in the Pierpont Morgan Library, New York).

This impulse both to violate aesthetic decorum and to force nature's hand by applying ornament to every available surface is clearly rooted in anti-classical sentiment, in an animus against sanctioned rules and protocols. And one way of manifesting such antagonism was to stress edge and outline over content—quite literally—with the result that empty spaces surrounded by elaborate frames became something of a new aesthetic norm.

The shift of emphasis was apparent even in *meubles*—matched sets of bed drapes, window curtains, upholstery, and wall hangings that were changed with the season. Here, too, the traditional roles of center and periphery were

reversed: heavy borders began to take precedence over the patterns they framed, which became increasingly light and airy. Many drawings and ornament prints whose purpose at first glance seems mysterious were devised as models for fabric or large painted panels. It was a frequent practice to decorate alcoves with textile wall treatments in which panels covered with one fabric were "framed" by appliquéd borders of a more elaborate fabric.

page 390

The "cutout" effect this produced had its roots in contemporary social custom. Women of leisure were fond of cutting out the designs from specially devised ornament prints, which they then colored and applied to fans, folding screens, and decorative boxes. In some instances these models were even applied to wall paneling and painted by amateurs. In 1737, Gabriel Huquier, an important ornament print designer and entrepreneur between 1731 and 1761, announced the publication of twelve sheets designed to be *découpé* (cut out), in this way, and Alexis Peyrotte produced designs for prints in various formats which also seem to have been intended for this market. Both of these men were trained draftsmen. Peyrotte specialized in the design of furnishings for the court. He oversaw the production of painted panels as well as fabric designs and was doubtless responsible for some of the richly coordinated decorative schemes devised in this period—such as the blue-and-white bedroom of Madame de Mailly at Choisy— as well as for coaches and sedan chairs, which frequently incorporated *découpé* borders into their designs.

page 358

page 389

But the cartouche *par excellence* in the old regime was the heraldic coat-of-arms; its prevalence in old-regime culture made it a subliminal presence behind even abstract cartouche forms in this period. Forms of this kind, still bearing their arms, continued to appear on portals, façades, silver, bindings and bookplates, church pews, festival banners, coaches, and sedan chairs, to cite only a few of the most conspicuous examples. They were linked to the history of eminent noble families and thus to the extravagant displays of wealth which in this period were read as material signs of power and status. Their ubiquity goes a long way toward explaining the prevalence of the more stylized versions in ornament prints. More often than not, the designers of these fanciful printed cartouches obscured the form's connection to coats-of-arms by juxtaposing them with fantastic garden perspectives, or by transforming them into fountains, or by any number of self-conscious aesthetic maneuvers, none of which are really successful. In many cases, the figures and animals surrounding these "shields" derive from the putti and other creatures—panthers, lions, unicorns—often shown supporting them in more traditional heraldic tableaux.

pages 340, 364, 375, 420, 426

Despite their charged function as the indicators of social status, heraldic cartouches, too, were stretched and twisted into asymmetrical shapes. It is tempting to read this surprising submission of traditional forms to the dictates of fashion in a literal way—to surmise, for instance, that the heraldic cartouches with the most distorted, asymmetrical shapes bore the arms of newly ennobled families (*lettres de noblesse* were rather freely conferred in the eighteenth century—for a price). But caution is in order, for at the height of the rocaille, which is to say about 1736–40, even the arms of the French royal house

Titan Struck by Lightning, marble,
François Dumont, 1711–12.

Paris, Louvre

This work, the artist's reception piece for the
Royal Academy, demonstrates that even at this
early date young sculptors were interested in
mastering difficult poses and unbalanced
compositions. It cannot be classified as rocaille, but
it demonstrates a growing taste for asymmetry.
Instead of showing the Titan Urites at the moment
he is struck by the lightning bolt cast by Zeus,
Dumont depicts him seconds later, after he has
fallen to the ground. Prone figures in comparably
audacious poses were carved by several French
sculptors in the first half of the eighteenth century.

Doorway of the office of the linen merchants (detail), formerly on the rue Sainte-Opportune, Paris, 1716.

Paris, 22 rue Quincampoix

𝒩ote the still tentative asymmetries in the detailing of the cartouche.

Allegory of Vices Defeated by the Virtues of the Sovereign, corner of the ceiling of the Audience Room, François Chauveau (sculptor), 1694–99.

Stockholm, Royal Palace

𝒲hen decorating the ceiling in the king of Sweden's Audience Room, French sculptor François Chauveau looked to the mixture of painted and carved elements used by Charles Le Brun at Versailles, but diverged from his model in at least one important respect. Le Brun's compositional groups in this vein are more or less symmetrical, while here the dramatically unbalanced disposition of the sculpted figures is in marked contrast with the formal equilibrium of the cartouche-enclosed *quadri riportati* (illusionistic "paintings") behind them. It would not be long before such framing elements themselves would be treated asymmetrically.

were occasionally displayed within eccentric cartouches, as were those of the other ruling houses of Europe.

~⁌~

Asymmetry

The importance of asymmetry to the rocaille style in general, and to the cartouche vocabulary in particular, has prompted speculation about its origins. It is often suggested that it evolved from the practice of incorporating two alternative design treatments in the two halves of ornament prints. This hypothesis is seductive, but it should be borne in mind that the artisans for whom these images were made were fully conversant with this device and its purpose. It is also important to remember that asymmetry had become a strong component in the work of some French painters and sculptors as well as decorative artists by the final decades of Louis XIV's reign. In these instances, its roots are to be sought in the Baroque propensity for gestures implying movement and energy. The *Titan Struck by Lightning* carved by François Dumont is strongly asymmetrical, page 343 as is appropriate to the the subject matter. Likewise, some of the superb relief trophies executed for the chapel at Versailles in 1710—before the rocaille style per se had emerged—are asymmetrical, featuring shields hanging at oblique angles. Such small-scale imbalances were pervasive in the grotesque and arabesque traditions, from which these reliefs derive.

It is also worth invoking the arts of the jeweler, for these craftsmen often worked with irregular forms. In the Mannerist and Baroque periods they had become adept at devising settings for corals, shells, pearls, and other eccentrically shaped natural objects, a skill that was celebrated in the collection housed in the Grünes Gewölbe (green vault) of Augustus the Strong. Even the asymmetrical aspects of the rocaille had their precedents.

~⌒~

Rococo

By and large, rocaille decorative arts productions in France tended toward restraint, but the style exercised enormous influence outside French borders, inspiring what might be termed—to distinguish it from the French rocaille—the international rococo.

There were three principal elements in the spread of this influence: the work of foreign artists, such as the draftsman and designer Cuvilliés (1695–1768), who lived and worked for a time in Paris and then returned home or found employment elsewhere; the production of ornament prints; and the exportation of objects. The production of the prints has already been discussed in chapter 3. Their dissemination was rapid, and after first appearing in France they were often pirated by foreign publishers. The set published by Lajoue in 1734 was re-engraved and reissued in England three years later, and, similarly, the series of prints by Boucher that includes *Leda* first appeared in a French edition about page 331

Clock with Venus and Cupid,
studio of André-Charles Boulle,
before 1715.

London, Wallace Collection

Several such clocks survive; none are dated, but
the design must be earlier than 1715, for in that year
it is cited in a document.

Both figures have been shuttled to one side,
making this an early example of asymmetrical
design. The effect is heightened by the unstable
posture of Venus. The prominent conch shell is a
further indication of this piece's affinity with the
emerging rocaille vocabulary.

1736–37, followed by an English edition in 1738. French ornament prints reached Bavaria, Spain and Portugal quite soon after being issued, sometimes via diplomatic pouches. And the Swedes, who since the seventeenth century had made it a point of national honor to keep abreast of the latest developments in Parisian taste, organized what were to all intents and purposes aesthetic spy missions to the French capital.

Each country interpreted the style in accordance with its own traditions. England, for example, was not content merely to appropriate elements of French designs. It also maintained an artistic dialogue with Italy and so fell under the sway of artists such as Angelo Rossi and Gaetano Brunetti, whose ornamental vocabulary remained closer to the Baroque, and it proved more receptive to the designs of Meissonnier than to those of Pineau and Lajoue.

François de Cuvilliés, born in the province of Hainaut in the Spanish Netherlands (present-day Belgium), was destined to play an important role in the evolution of the German rococo. He was sent by his patron, the elector of Bavaria, to study with Germain Boffrand in Paris (1720–24). While there, he acquired a taste for work by French artists such as Pineau and Lajoue; after his return to Bavaria he was appointed court architect, and he used this post to further the development of a Bavarian variant of the rocaille. Prints were an ideal medium for the dissemination of his designs, which were often highly original, and he fully exploited it. He was the only artist from a German-speaking country whose prints were *pages 339, 367, 382* sold in Paris (they were available at Poilly's shop on the rue Saint-Jacques and were also distributed by architect Pierre Patte), but they were poorly received. Influential French architectural theorist Jacques François Blondel (1705–1774) lumped him together with Meissonnier, Lajoue, and Mondon, all of whose work he condemned. To some extent, this negative reception was influenced by the fact that Cuvilliés, the protégé of a German prince, was pushing a French idiom beyond the bounds of French aesthetic decorum. It is true that when he issued a series of prints entitled *Suite de cartouches réguliers* (Set of regular cartouches, 1738), their forms were in fact quite eccentric; and this series was soon followed by an album of "irregular" cartouches. French critics cast doubt on his inventive capacities, and some of his decorative schemes and caprices were indeed derivative. But the accusation cannot be sustained in connection with other of his published designs. His cartouche and panel compositions, whether regular or asymmetrical, are highly original, and his ceiling designs are even more so. Most notably, perhaps, they depart from the Gallic practice of relegating all ornament to border areas, instead covering each ceiling more densely and exuberantly than their French counterparts. Moreover, Cuvilliés accorded greater prominence to vegetal forms than did his French contemporaries. Foliage, tendrils, etc. figure in their work, of course, but they are far more prominent in designs by the likes of Franz Xaver Haberman (1721–1796), Jeremias Wachsmuth, and Eysler, as *page 364* well as in those devised by Rastrelli in Russia and by stuccadors such as Johann *page 371* Baptist Zimmermann. This vegetal emphasis in the non-French rococo results in more animated compositions and tends toward an intricacy that baffles retrospective attempts to envision them in the mind's eye.

Gradually, non-French artists transformed the delicate webs of the rocaille into the denser networks typical of the international rococo. Mention should be made, however, of an important exception to this rule: English rococo designs are often characterized by a remarkable lightness even when on a large *page 428* scale, as in the feathery mantelpiece designed by John Linnel (d. 1796). In contrast, the cartouches of non-French designers, especially those engraved in Augsburg and then executed in plaster, tend to be ample in form but rigid and extremely asymmetrical. Germanic cartouches are particularly heavy and bulbous. The armatures in designs by Nilson, Göz, Klauber, and Haberman, for example, seem to be made of a thick paste, an effect that differs markedly from that produced by the shellier material evoked in French compositions, and it is tempting to link this appearance of malleability to the auricular style. Unlike engraved German cartouches, French ones are conceived as borders or framing elements: as already noted, their centers are often empty or occupied by vignettes notably lacking in depth.

Rococo ornament prints—produced in large numbers in Augsburg and Nuremberg—varied enormously, but they had a deliberately multi-purpose character that paralleled French ornament-print production. Their forms could be adapted for use on a large scale or on smaller ones. A few were suitable only for specific uses—such as in the designs of pulpits, furniture, or candelabra— but most were conceived such that their applications were restricted only by the limits of an artisan's ingenuity. This protean quality was often reflected in the titles under which they were published, which often indicated their suitability for "various purposes." The radical adaptability of rococo and rocaille prints sets them apart from traditional ornament prints, which were devised with a few specific applications in mind. By simply looking at these designs, it is difficult to picture a specific cartouche on a snuffbox, a sinuous molding on a chair-back, an ovoid flourish at the end of a church pew, or a raffle leaf as part of a ceiling decor—in short, to imagine what practical applications these compositions might have. But if one is sufficiently conversant with the various modes of decorative arts production in the period, one can often make sense of such ambiguities.

Another important difference between the rocaille and the rococo concerns scale. Central European artists often used cartouches that are considerably larger than those usually encountered in France, where the rocaille was for the most part limited to relatively small objects. True, French designers of ornament prints frequently made their forms seem gigantic through the manipulation of perspective, notably by having them tower over nearby buildings or landscape *pages 359, 365, 372, 392, 410* vistas (Lajoue, Mondon, Babel), but French artisans and architects avoided such effects in their practice. Unlike their French counterparts, the forms in German ornament prints were made to seem immense as much through their own shapes and character as through juxtapositions of this kind, and the exaggeration of scale was meant to be carried out when the designs were executed. In *page 394* a published throne room design by Johann Michael Hoppenhaupt, shell-like

material envelops entire pilasters, which are juxtaposed with ornate cartouches almost as tall as a man; and similar gestures—quite distinct from the French tendency to keep such forms within bounds—are to be found in decors in the Stadtschloss and the Neues Palais in Potsdam and the Neues Schloss in Bayreuth. There are comparable designs in Portugal, where a mural of a scene framed by an enormous cartouche was painted on an array of *azulejos* (blue-and-white tiles). Cartouches that would have been used in Paris as a tax farmer's emblem or at most as the ornamental design on a piece of furniture, were blown up there to the scale of a wall in a garden or cloister and filled with full-dress compositions. *page 429*

page 152

The rococo remains closely linked to the idea of framing and bordering, though of a special kind—one that can accommodate thick moldings and eccentric angularity, and that has a more pronounced affinity for architectural articulations than does the rocaille. It is not surprising that this idiom developed in the countries of central Europe—so strongly influenced by the Italian Baroque, with its high premium on the play of solids and voids—as opposed to, say, Spain, whose indigenous baroque vocabulary was denser and more tightly packed. There's no denying that the international rococo introduced something new into the Western decorative arts, but it was not monolithic: it evolved in many different ways in dialogue with myriad local traditions.

Another important point should be made with regard to scale. The French rocaille was most typically associated with private residences: outside of Lorraine, there were no large-scale building projects in France during the Regency and the early years of Louis xv's reign. And in French churches, the style was most often used on furnishings rather than walls and entire decorative schemes, although there are a few exceptions, such as the abbey of Valloires. This reflects a contemporary French aversion to church decorations with domestic overtones, especially ones with overtones of salon culture. In central Europe, architects were engaged to design and build large princely houses as well as churches, convents, and abbeys, and even the houses they built often boasted lavish chapels or churches. In this region there was no cause for anxiety about matters pertaining to religious propriety, whereas France was wracked by religious controversy in the first half of the eighteenth century, and this made the French particularly sensitive to anything that might be seen as trivializing their faith.

In France, where the rocaille was largely a phenomenon of the domestic sphere, especially luxurious furnishings, it retained pronounced aristocratic associations. In contrast, the rococo variant developed stronger popular roots, as is evidenced by its remarkable proliferation in elaborately decorated churches from the Rhineland to St. Petersburg, a region in which its propensity for fantasy led to its adoption in countless representations of paradise. These differing social trajectories led to parallel differences in the speed with which the two areas responded to the advent of neoclassicism. In France the aesthetic about-face was largely engineered by an artistic and intellectual elite, and so was effected very quickly, roughly between 1755 and 1760. Areas where the rococo had been embraced *page 371*

by the populace proved more resistant to the new trend; in these regions the classical revival triumphed only later, in the 1780s.

Drawing was the mainspring of the rocaille. Like mannerism, with which it has much in common, the rocaille set out to explore the farthest reaches of taste. Precisely for this reason, its vitality was particularly dependent upon the extraordinary inventive skills of its practitioners. The style's most characteristic expressions were entirely a function of individual genius. It was inherently at odds with the notion of norms and protocols, so we should not be surprised to learn that as formula set in it became limp and lifeless, a development readily observable in the increasingly superficial elegance of its drawings.

This chapter began with a warning about the importance of social context and national tradition in understanding the stylistic currents I have been discussing, and it seems appropriate to close on a similar note. The rocaille, born within a circle of French artists and artisans, and regarded as a marginal phenomenon by most of their intellectual contemporaries, has never had strong popular roots in France, although today it is more enthusiastically embraced there by an intellectual elite. But the rococo that it inspired in other parts of Europe flourished as an important part of the intellectual life of those countries, and remained a tradition to be reckoned with.

Hermitage, Bayreuth,
Joseph Saint-Pierre and Carl Philipp
von Gontard, 1749–53.
Bayreuth, Neues Schloss

On the orders of Wilhelmina of Bayreuth (1731–1758), the sister of Frederick II of Prussia, the former menagerie of the palace there was transformed into an orangery, with delectable results. The walls of the pavilion dedicated to Apollo, protector of the arts, are encrusted with bits of rock crystal and blue, red, and yellow glass, giving them a fantastic quality, heightened further in their reflections in the adjacent pools. The design's affinity with rocaille grottoes is clear, although the "natural" decoration usually applied to grotto interiors has here been placed on the outside. In fact, a more telling parallel might be found in opera sets, which in this period often featured shimmering crystal palaces that were often meant to represent the abode of Apollo. References to such structures abound in the writings of Wilhelmina, who was an avid correspondent of Voltaire.

Print,

Johann Michael Hoppenhaupt, c. 1753.

Paris, Bibliothèque Nationale

Like Italian palazzi, large central-European resi-
dences often had *Gartensaalen* (showpiece garden
rooms) close to their entry vestibules.
Hoppenhaupt, a designer in the employ of Freder-
ick the Great of Prussia, envisioned this decor for a
room leading from a more conventional salon to
a garden grotto. The benches have craggy rocks
as bases and the mantelpiece is encrusted with
similar rock forms, but the inclusion of a clock
indicates that the design was intended for a palace
interior. The walls and benches also feature
stylized shell forms.

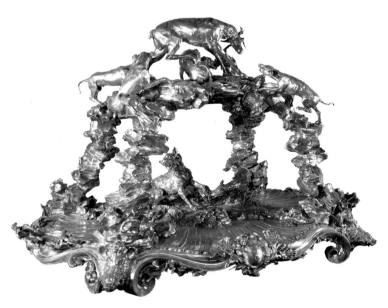

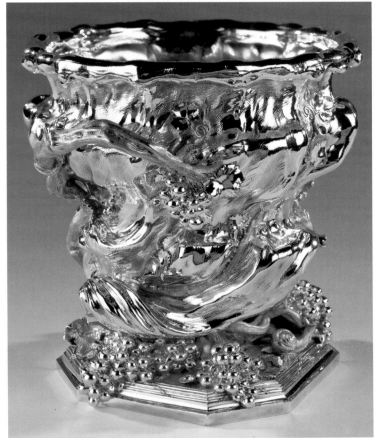

Centerpiece of the duc de Bourbon, silver,
Jacques Roëttiers (1707–1784), 1736.

Paris, Louvre

Silver centerpieces, which sometimes incorporated condiment dishes and
candle sockets, were the most spectacular feature of any lavish table setting.
This example by Roëttiers, which has eight candle sockets, was used by the
duc de Bourbon at the Hôtel Condé in Paris. Hunting themes were common
in such pieces, but here their treatment is anything but credible or logical:
below, a wolf is shown caught in a trap, while above, dogs attack a deer
eccentrically placed on top of an unlikely structure of intersecting rock arches.
The artificiality of the conception is countered, however, by the pronounced
realism with which the animals and objects—especially the craggy rocks—
are depicted. At the mid-point of one section of the base is a winged
cartouche bearing the arms of the Condé family.

Wine cooler (one of a pair), silver,
Thomas Germain (1673–1748), 1727–28.

Paris, Louvre

This piece offers a superb demonstration of virtuoso silversmith Thomas
Germain's mastery of a naturalistic rocaille idiom. The utilitarian form virtu-
ally disappears in a rocky, crustaceous mass strewn with bunches of grapes,
along whose base a snail slowly advances. The base itself, however, retains a
more conventional geometric form.

The two coolers now bear the arms of the duc d'Orléans (later King Louis-
Philippe). He obtained them after the death of the fabulously wealthy duc
de Penthièvre (1725–1793), whose silverware escaped being melted down for
coinage by the Revolutionary authorities. It is possible that these pieces
were commissioned by Penthièvre's father, the comte de Toulouse (one of
Louis xiv's illegitimate sons), who owned a collection of sumptuous
silverware and silver-gilt objects about which little is known.

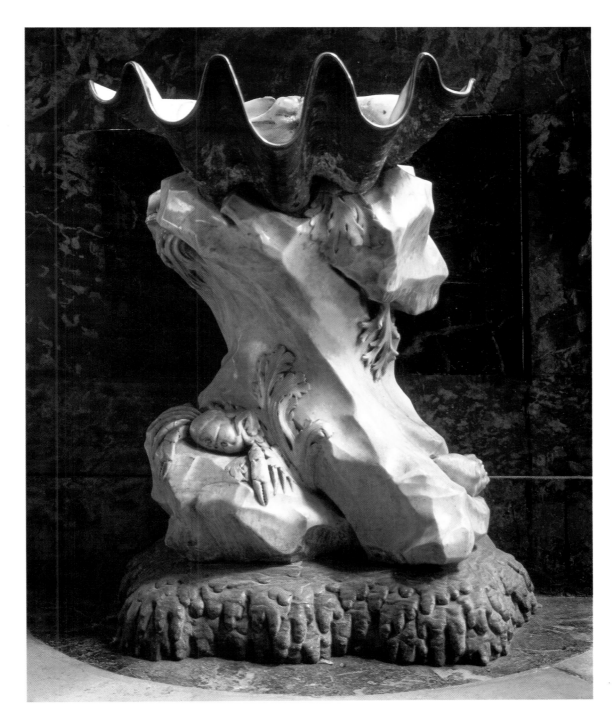

FACING PAGE

Façade of the church of Saint John Nepomuk (sometimes called the Asamkirche), Cosmas Damian Asam (painter, 1686–1739) and Ägid Quirin Asam (sculptor, 1692–1750), 1733.

Munich, church of Saint John Nepomuk

'This small church adjoins the residence of the brothers who designed it. The large "natural" rock forms on either side of its portal, of Roman Baroque pedigree, allude to Christ's punning remark to Saint Peter ("On this rock will I build my church") as well as to its titular saint, John Nepomuk, who was the protector of bridges and waterways. Nepomuk is depicted above the porch of the façade, poised to jump, a reference to his having been condemned to leap from the Saint Charles bridge in Prague for having refused to reveal the confession of the queen of Bohemia.

Holy-water stoup (one of a pair), Jean-Baptiste Pigalle (1714–1785), 1745.

Paris, church of Saint-Sulpice

'This object and its twin—composed of real shells set atop marble bases carved to look like naturalistic rock, animal, and plant forms—are paradigmatic examples of rocaille design.

In 1745, Louis XV gave the church of Saint-Sulpice a giant scallop shell that had previously been presented to Francis I by the Venetian Republic. Pigalle was asked to carve bases for the bivalve's two halves so that they might be used as stoups (holy-water basins). In an imaginative attempt at evoking the natural habitat of the shells, he transformed two blocks of white marble into asymmetrical pedestals reminiscent of the craggy rocks in Bernini's Fountain of the Four Rivers in Rome's Piazza Navona and set them on low platforms of gray marble carved to resemble receding water. Each marble crag is strewn with marine plant and animal life—on the one shown above, seaweed, a crab, a piece of coral, and a conch shell, and on the other, seaweed, another conch, a scallop shell, and a starfish. These works are emblematic of the enlightened Catholicism that was practiced at Saint-Sulpice, one that saw no inherent contradiction between contemporary scientific pursuits and the fundamental tenets of the Christian faith.

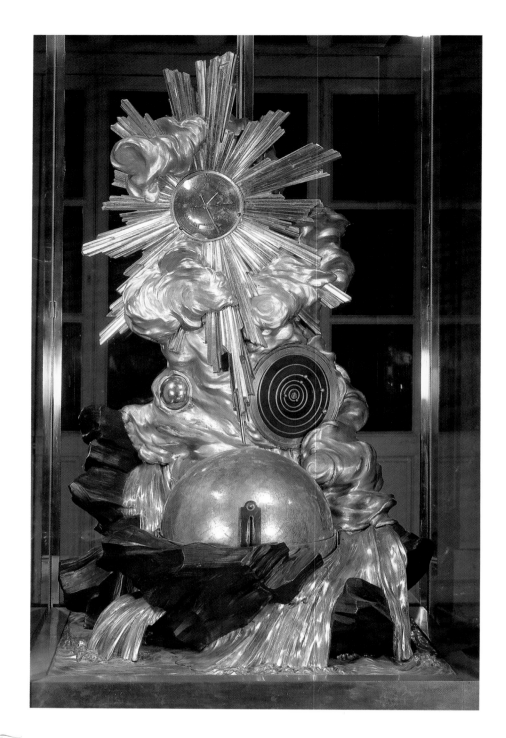

"Creation of the World" clock,
François-Thomas Germain (1726–1791),
1752–54.

This member of the Germain clan was somewhat
out of step with prevailing French tastes, for he was
partial to complex iconographic programs at a time
when more abstract ornamentation was the norm.
This clock was commissioned by Joseph-François
Dupleix, governor-general of the French India
Company, as a diplomatic gift for the king of Gol-
conda, in central India. But in 1754 Dupleix was
recalled to France, and he kept the clock. Germain's
remarkable composition, designed to house a
mechanism conceived by Passement and executed
by Roque, is a dazzling artifact with a distinct
rocaille flavor. The clock is set in an oblique, gilded

crystalline sunburst, emerging out of a swirling
mass of gold and silver "magma" that flows over a
"rock" of darkly patinated bronze; set in the silver
"magma" below the sunburst are a globe and a
model of the solar system. While working on this
commission, Germain was also executing a center-
piece for the king of Golconda with related imag-
ery, described as follows in the *Mercure de France:*
"As the artist was prohibited from using figures of
any kind, he chose to represent a rock from which
water pours at several points in great quantities;
from this rock there rises a pyramid crowned with
a vase decorated with branches arranged in gar-
lands." Human figures and animals were imper-
missible in these gifts for religious reasons, which
encouraged Germain to explore themes of nature
in the rocaille idiom in these two projects.

FACING PAGE

Stove, gilded cast-iron.
Vienna, Schönbrunn Palace

The painter Bergl decorated this room in the
Schönbrunn Palace as an immense landscape
panorama, an anticipation of the ones that would
proliferate in the nineteenth century. Ceramic or
cast-iron stoves (often used as heaters in central
European residences) were intrusive in elaborately
decorated rooms—as here, where no attempt at
integration is made. This piece takes the form of an
imposing gilded rock encrusted with plants and ani-
mals. Different tints of gold make the details of its
sur-face design more legible, and the contradictory
naturalistic/artificial effect is heightened by the use
of painted (but ungilded) stones at the base.

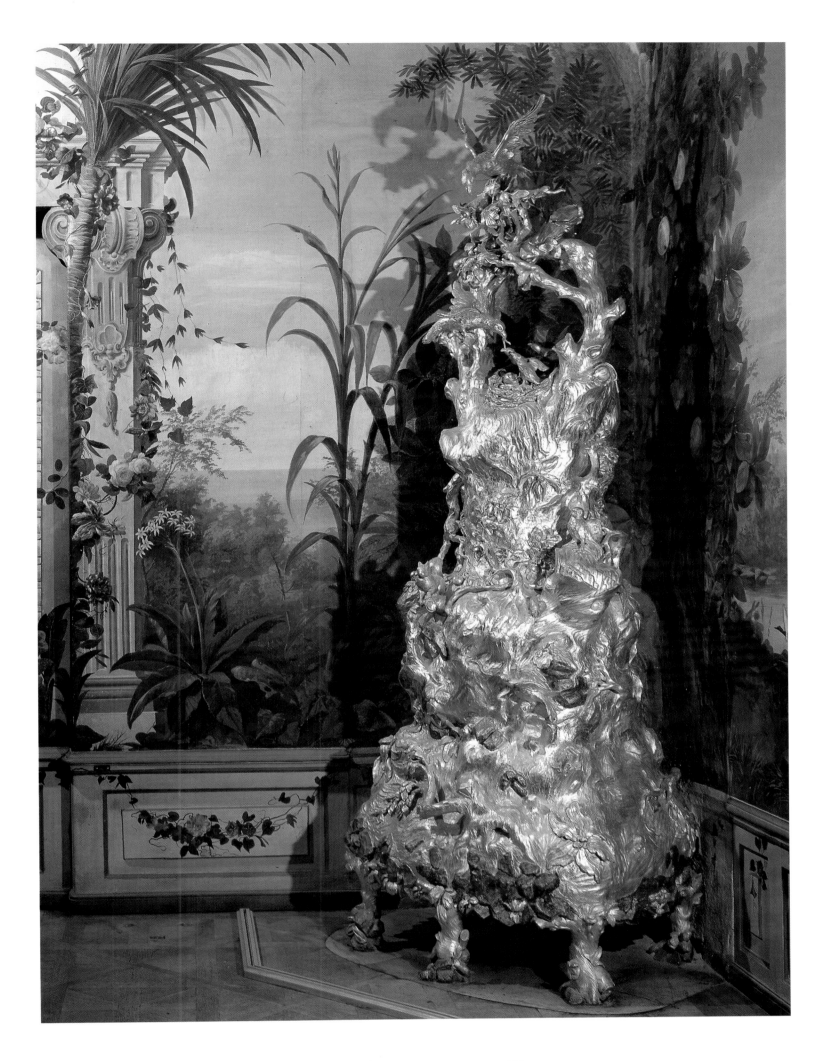

Nouveau livre propre à ceux qui veulent apprendre à dessiner l'Ornement et à différens Usages comme pour les feuilles de Paravent, Panneaux, etc. (New book for those who want to learn to design ornament of different kinds such as folding-screen compositions, panels, etc.), print, Gabriel Huquier, 1737.

Huquier, best known as a print publisher, got his start drawing and engraving his own designs. Simon Jarvis's suggestion that he is the author of the twelve plates in this series is probably correct. Their publication was announced in the *Mercure de France* in July 1737: "Monsieur Huquier, in consideration of ladies who like to cut out ornaments but are averse to unnecessarily complicated shapes, has had a skilled draftsman design twelve ornament sheets which he has engraved, and which when properly assembled form two different borders for folding-screen panels in admirable taste, these same sheets being useful in other ways as well, notably as models for learning to draw ornament." Clearly these prints were intended primarily for use by ladies of leisure.

When cut out and properly arrayed, they presented half of a border design that could be glued directly onto furniture, wall panels, etc. or redrawn; if desired, the other half of the composition could be obtained by the use of a mirror or counterproofs. Such compositions were devised for many uses in a broad range of contexts, not only as cutouts but as models for textiles, such as the hangings for the king's bedroom at Choisy. Chedel's *Fantaisies* of 1738, for example *(see page 337)*, were appropriate for various uses, including "textile designs" and *"découpures"* (cutouts), according to the published description. The adaptability of this kind of print gave it a value that sometimes caused problems; the Lyons publishers of such designs by Alexis Peyrotte took a Parisian colleague to task for having reproduced them without crediting him. Today, we can see that this adaptability arose from the polyvalent nature of the rocaille ornament print.

Hand-screen, colored print on cardboard, printed on both sides.

Print publishers found a ready market for hand-screen designs. These fashionable implements were used to protect one's face from the too-intense heat of a nearby fire, and by women in particular to keep its light from giving a reddish cast to their carefully made-up faces. These print compositions—which sometimes featured narrative or allegorical vignettes or evocations of recent political events—were often contained within eccentrically shaped cartouches; they could be colored either by the dealer or by the purchaser. Other fans of this type were painted entirely by hand, sometimes after printed compositions. This example is from a set of six whose compositions celebrate the birth of the dauphin on October 22, 1781.

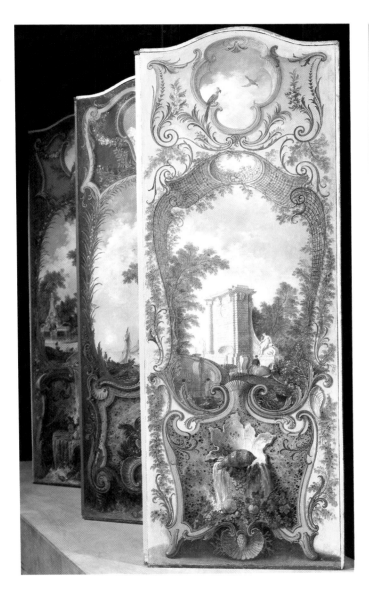
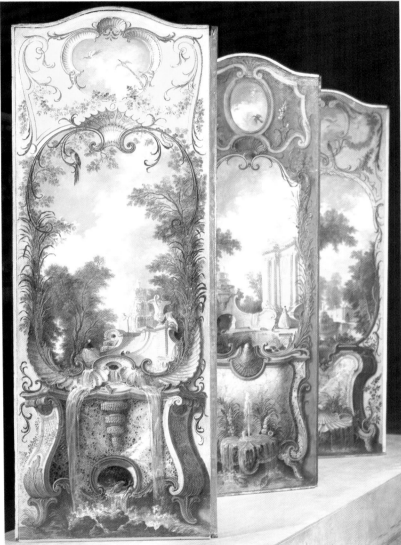

Folding screen, oil on paper applied to wood,
Jacques de Lajoue (1686–1761), c. 1735–40.

Paris, Musée du Petit Palais

The six compositions on this screen—which apparently belonged
to Huquier—are typical of the rocaille in general and of Lajoue's
style in particular, featuring low horizons, eccentric stairways,
extravagant fountains, illogical parapets, elaborate cartouches, and
showcased shells and corals . The combination of all these elements
and the use of *découpage* make this a stellar example of rocaille
design in two dimensions.

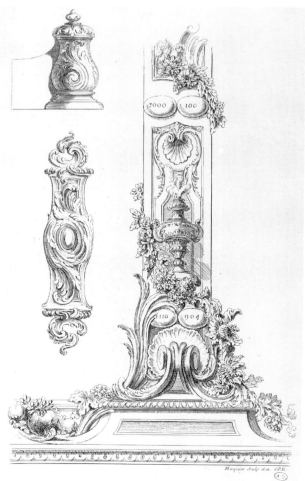

ABOVE AND RIGHT

Partie des ornées de la carte chronologique du roy faite en 1733 (Some of the ornament for a chronology made for the king in 1733), plates 35 and 36 from book VI of the works of Juste-Aurèle Meissonnier (1695–1750), prints by Huquier.

Paris, Bibliothèque des Arts Décoratifs

LEFT

Design for a pilaster, drawing attributed to Thomas Germain, 1730–33.

Paris, Bibliothèque Nationale

An annotation on this anonymous drawing of a pilaster specifies that it would have been 13 *pieds* (4.22 m) high, suggesting that it was intended for use in a wall treatment, perhaps to separate panels of wall fabric. Jean Coural and Chantal Gastinet-Coural have linked this sheet convincingly with the delivery in 1733 of eighteen pilasters after designs by Thomas Germain for use with a red brocade incorporating gold thread, commissioned from Lyons for the Salon of Mercury at Versailles. The executed pieces surely differed somewhat from this design. In any case, the cartouche at the bottom resembles similar forms used by Meissonnier in his contemporary designs for the king's historical chronologies.

Chronological chart of the history of the Old Testament,
gold paint and gouache on paper fixed to canvas, 1734.

Versailles, Bibliothèque Municipale

The work shown here is one of three chronologies listing the significant
dates of world history—recapitulating events from the Old Testament,
from the annals of Greek history, and from the birth of Christ to 1731—that
were commissioned for the young Louis XV; they were placed above the
bookshelves of the library in his private rooms at Versailles. This one bears the
somewhat ambiguous inscription "1734 scribebat et ornabat Pièche" (1734
written and decorated by Pièche). However, comparison with the two prints
from Meissonnier's collected works reproduced on the facing page reveals that
Pièche was basing his work—rather freely, it would seem—on designs by
Meissonnier created specifically for this project, even though the latter's name
appears nowhere on any of the three charts.

Plate 35 includes a series of aligned horizontal cartouches, while plate 36
depicts vertical-format cartouche compositions; without the caption,
it would be difficult to determine what their use might have been. In any
case, these designs by Meissonnier readily lend themselves to appropriation
for any number of purposes, as was customary for ornament prints in
general and rocaille prints in particular.

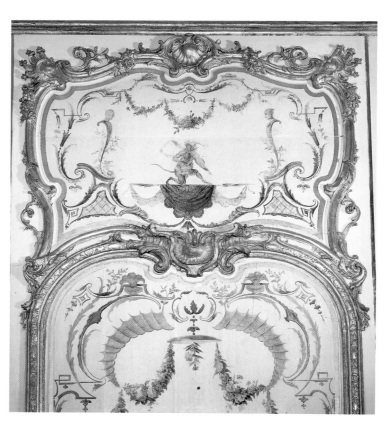

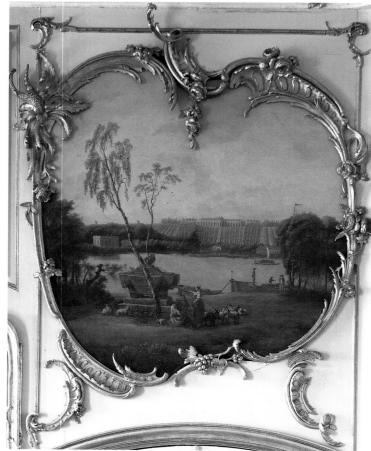

"Cabinet des singes" in the Hôtel de Rohan,
Christophe Huet, c. 1749.

Paris, Hôtel de Rohan (now Archives Nationales)

This celebrated room, executed for the Cardinal de Soubise, features
singerie arabesque compositions surrounded by sinuous gilded moldings,
punctuated with cartouches and decorative flourishes perfectly in
keeping with the painted designs. In fact, three important strains of the
European ornamental tradition are here made to harmonize perfectly:
arabesques, exoticism, and the rocaille. *(See also Huet's similar work
from 1735 for the Château de Chantilly, on page 281.)*

Overdoor in the music room at Sans-Souci, painting by
C.-S. Dubois, carved decoration by Johann Michael
Hoppenhaupt the elder (1685–1751), c. 1747.

Potsdam, Sans-Souci

Sans-Souci, built beginning in 1745 as a pleasure retreat for Frederick II of
Prussia, was designed by architect Georg Wenzeslaus von Knobelsdorff
(1699–1753). The king, a music lover, played the clavier and the transverse
flute, composed 121 flute sonatas, and was a generous patron of musicians,
including C.P.E. Bach and his father, Johann Sebastian. In the music
room at Sans-Souci (one of its most remarkable interiors; *see page 218*), all
the overdoors take the form of giant cartouches which, despite their
pronounced asymmetry, achieve a subtle equilibrium.

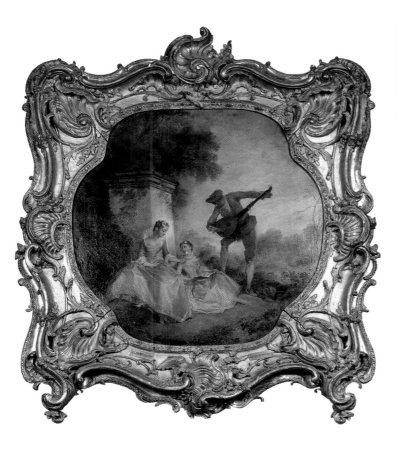

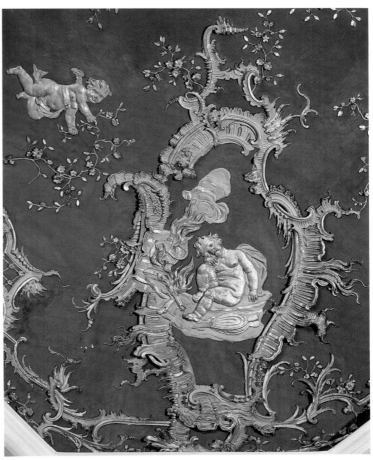

The Music Lesson,
oil on canvas, Nicolas Lancret (1690–1743), 1743.

Paris, Louvre

The shape of Lancret's canvas—designated in the eighteenth century as a *forme figurée,* a phrase indicating that it was neither rectangular nor oval— prompted the frame-maker to produce a real tour-de-force, a masterpiece of both joinery and sculpture in elaborate counterpoint to that shape. Skewed cartouches, shells, and sinuous curves press against its outer edges, compacting it with formal energy.

The asymmetrical cartouches are reminiscent of work by Nicolas Pineau, who may well have made it, but several contemporary Parisian sculptors worked in a style close to his, and no surviving documents provide guidance as to its authorship. Viewed as a whole, the frame is conceived as a single giant cartouche surrounding a painted scene, a conceit that was popular in the years 1740–45. Such productions prompted the abbé Le Blanc, a man of letters and an art critic, to condemn the modern taste for "bizarre" cartouche frames that cost more than the paintings within them.

Winter,
corner cartouche in the cornice of
the Festsaal in the Neues Schloss, c. 1754.

Bayreuth, Neues Schloss

The Festsaal was designed by architect Joseph Saint-Pierre and features sober wall treatments with wide white pilasters against a gray ground, but they rise to support an elaborate angled cornice of gilded stucco motifs against a blue ground by the stuccador Giovanni Battista Pedrozzi. The technique allows for filigree effects comparable to those in fine engravings. This corner composition is notable for its elegance, poise, invention, and transparency.

Ceiling design, print, Jeremias Wachsmuth.

Paris, Bibliothèque d'Art et d'Archéologie, Fondation Jacques Doucet

This plate, engraved in Augsburg, depicts two alternative ceiling treatments. Comparison with a ceiling by François de Cuvilliés (*see page 367*) reveals such differences as a notable lack of filigree here, the invasion of the central field by bulky cartouches treated as though they were sculpted metal, and a corresponding central rosette.

Cartouche, print, Franz Xaver Haberman (1721–1796).

Paris, Bibliothèque des Arts Décoratifs

Haberman was a prolific draftsman whose designs were published in Augsburg. This skewed cartouche composition would have been suitable for use as a noble coat-of-arms or as an abstract decorative pattern.

Cartouche bearing the arms of the prince-bishop of Würzburg, Antonio Bossi (stuccador), 1749–51.

Würzburg, Residenz

The door leading from the Kaisersaal (Hall of the Emperor) to its anteroom is surmounted by this immense heraldic cartouche, the scale of which reflects that of the room as a whole. All cartouches are descendants of such heraldic emblems of the nobility, but in the first half of the eighteenth century their characteristic forms were often twisted and contorted, resulting in the most paradigmatic expressions of the rocaille aesthetic, especially in some of the more unbridled treatments in contemporary ornament prints (*see print by Babel, facing page*).

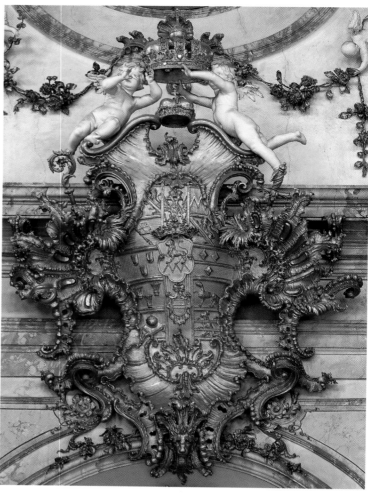

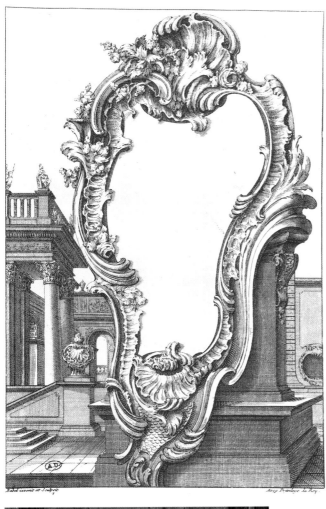

Cartouche pour être accompagné de supports et trophées (Cartouche to be accompanied by supports and trophies), print, Pierre-Edme Babel (1720–1775).

Paris, Bibliothèque des Arts Décoratifs

This extravagant cartouche is made to seem gigantic in juxtaposition with the architecture behind it. Such play with scale was pervasive in rocaille ornament prints.

Altar in the old chapel (detail), Lyons, 1751.

Lyons, church of Notre-Dame de Fourvière

The use of rocaille ornament in sacred contexts was relatively rare in France. As a rule, church authorities there regarded its playful formal vocabulary with suspicion, whereas in central Europe they embraced it. Most of the few documented French examples do not survive.

Among the ornaments in this Lyons chapel, attributed on shaky grounds to Ferdinand Delamonce (1678–1753), are two rocaille cartouches bearing religious emblems, the sinuous forms of which recall designs by Babel.

Paneling from the salon in the residence of the architect Michel Tannevot (detail), Nicolas Pineau (1684–1754), 1742.

Paris, private collection

Pineau trained first as an architect and then as a sculptor, and he soon began to specialize in interior paneling. After a stay in Russia (1716–26) during which he worked for Peter the Great, he returned to Paris, where he played an important role in the development of the later, more elaborate phase of the rocaille known as the *genre pittoresque*. A brilliant designer, he assembled a workshop of virtuoso craftsmen capable of realizing his most fantastic compositions. In addition to decorative paneling, he and his collaborators turned out precious objects, furniture, church stalls, etc. He eventually came under attack for the extravagance of his imagination, and it is true that, with Meissonnier, he stretched the idiom to its furthest limits. The decor executed by him for Tannevot, a friend, is typical of his interiors. It features dense knots of C-scrolls and cartouches judiciously spaced within an armature of more or less conventional panel formats.

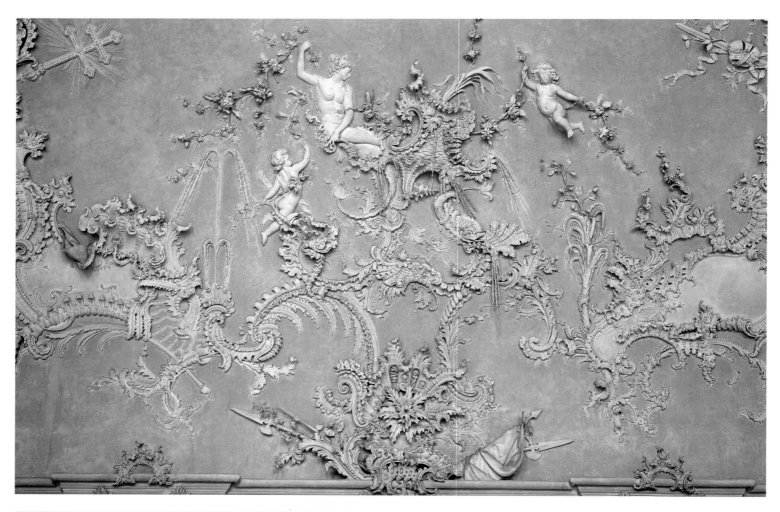

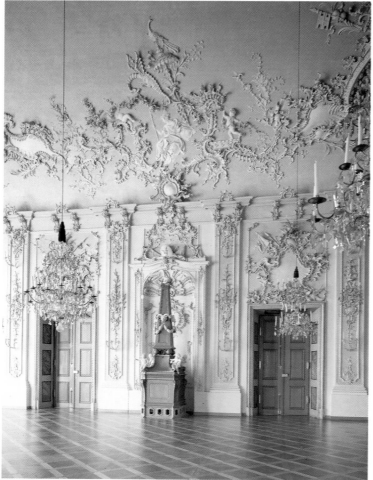

Weisser Saal (white room),
Antonio Bossi (stuccador), 1744–45.
Würzburg, Residenz

*W*hite stucco compositions against a pale gray ground create a sumptuous yet restrained effect in this salon, which served as the guardroom for the imperial apartment in the residence of the prince-bishop of Würzburg. The cartouches just above the doors are quite large, but they are dwarfed by those on the ornamented lower reaches of the enormous domed ceiling, featuring sinuous compositions of scrolls, cartouches, shell forms, foliage, etc. animated by putti, allegorical figures, dragons, and other fantastic creatures. Similar elements often figured in relatively discreet cornice friezes in this period, but here they have been cut from their moorings and given much more space, with entrancing results.

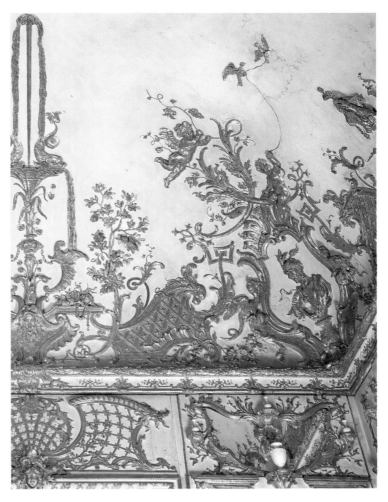

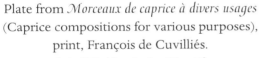

Plate from *Morceaux de caprice à divers usages*
(Caprice compositions for various purposes),
print, François de Cuvilliés.

Paris, Bibliothèque des Arts Décoratifs

Cuvilliés, like Meissonnier and especially Lajoue, tended to
favor architectural settings for his extravagant rocaille compo-
sitions, although in his designs the free-wheeling rocaille
motifs are pitted against a more sober architecture, in contrast
to the looser architectural fantasies of his two colleagues.

Cabinet des porcelaines, François de Cuvilliés,
Joachim Dietrich (wood sculptor), and Johann
Baptist Zimmermann (stuccador), 1730–33.

Munich, Residenz

Cuvilliés, who began his career as a court dwarf in Munich,
was trained in Paris under Jacques-François Blondel in the
early 1720s. His encounter with the emergent rocaille made a
lasting impression, as seen in his career in Bavaria, where he
became court architect to the Elector. He gave the French
style's ornamental vocabulary a new inflection, giving it a
more metallic feel without compromising its elegance, fili-
gree, or fantasy. The decor of this room was intended for the
display of the Elector's treasures (thus the depictions of a
scepter and metalwork in the cornice). The device of using
tiny gilded consoles to support porcelain objects is of French
inspiration, as is the scheme of gold relief designs against a
white ground, but Cuvilliés accords far more space to the
cornice ornament than was customary in France.

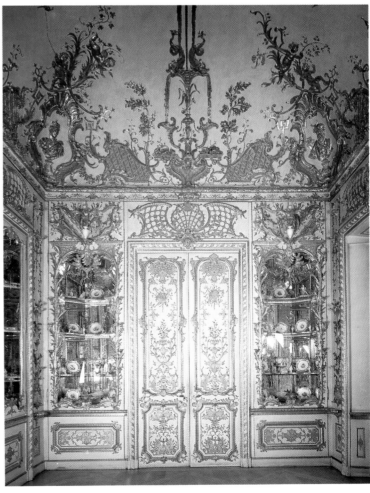

House in Dresden,
Johann Georg Schmid (architect), c. 1760.

Dresden, Moritzstrasse 6 (destroyed in 1945)

This simple residential façade, comparable to
many in eastern Europe in this period, is decorated
with relief compositions that wend their way
among its windows rather like temporary festival
decorations. The motifs resemble those on silver
boxes and in ornament prints. The rococo
aesthetic allowed for the application of a given
decorative form to almost any purpose, whereas
form and context tended to be more fully
integrated during the Baroque period.

Four box designs,
Juste-Aurèle Meissonnier.

Paris, Musée des Arts Décoratifs

These designs for silver or gold boxes reveal
Meissonnier's invention as a designer. Their shell-
inspired forms entice the eye but were also
conceived to be pleasing to the touch.

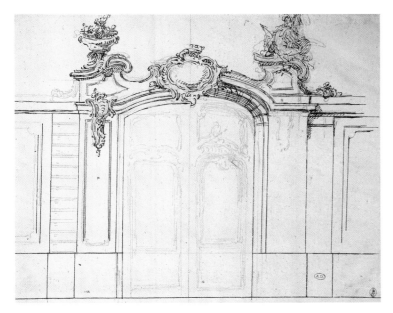

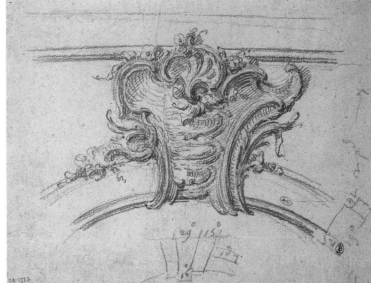

ABOVE

Design for a coach entrance, Nicolas Pineau.
Paris, Musée des Arts Décoratifs

TOP RIGHT

Design for a window *agrafe*, Nicolas Pineau.
Paris, Musée des Arts Décoratifs

*P*ineau's designs reveal a penchant for giving elements of the classical architectural vocabulary a rocaille inflection, as in the *agrafes* (bulging, asymmetrical forms sometimes used to decorate keystones), cartouches, elaborate vases, etc. in these two drawings.

CENTER RIGHT

Two carved window *agrafes*, 1739.
Paris, Hôtel Matignon, garden pavilion

*A*t the back of the grounds of the Hôtel de Matignon, the duc de Valentinois built, to designs by Contant d'Ivry, a small pavilion containing a complete set of residential rooms. The keystones of its arcade windows, traditionally carved with mascarons, were decorated with rocaille *agrafes*. These asymmetrical, flower-strewn arrays of sinuous C-scrolls and bulbous convexities suggest escutcheons transformed into marine creatures—or even a heraldic eagle with spread wings, as in the upper example shown here. Verbal description makes these elements sound cumbersome, but they strike the eye as light and fanciful.

BOTTOM RIGHT

Balcony of the house of architect Nicolas Simmonnet, c. 1740.
Paris, 27 rue Saint-André-des-Arts

*T*his second-story window facing the street is decorated with an elaborate balcony. Its delicate convex railing is supported not by a conventional schematic console but by a complex carved relief of enormous rocaille scroll-forms arrayed on either side of a central cartouche. The effect is that of a finely wrought piece of jewelry set into the otherwise staid façade. It also brings to mind the platforms lofted heavenward by clouds in countless Baroque paintings.

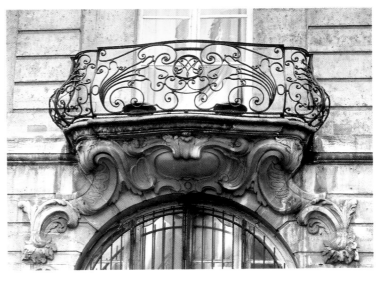

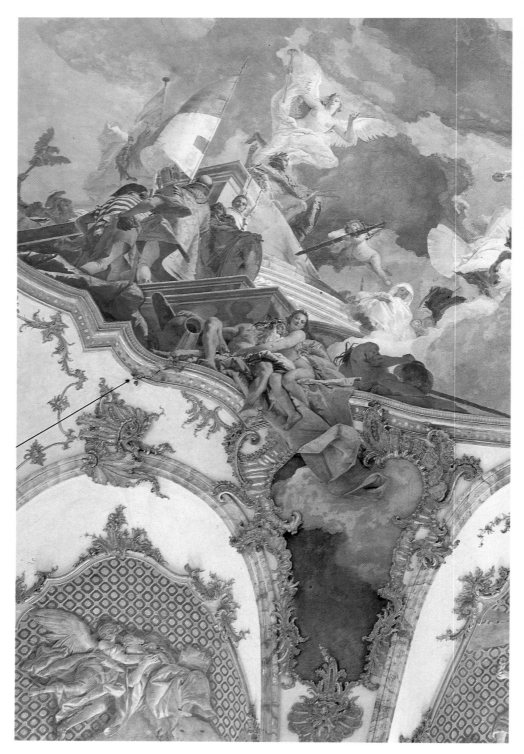

End of a church pew, c. 1750.
Wies, pilgrimage church

At Wies, extravagant rococo cartouches encrust even the ends of the pews.

FACING PAGE (TOP)

Ceiling of the nave
(detail, above the entrance to the choir),
Johann Baptist Zimmermann.
Wies, pilgrimage church

In southern Germany, which remained Catholic after the Reformation, the Rococo was embraced by the church fathers as a perfect means of evoking paradise, and, unlike in France, it was freely used there in sacred contexts of all sorts. The ceiling fresco in the Wieskirche is a vast illusionistic sky in which preparations are being made for the Last Judgment. Thus the detail of angels uncovering the throne of judgment, which is protected by a fanciful baldaquin similar to those depicted in rocaille and rococo ornament prints.

FACING PAGE (BOTTOM)

Inner vault of the choir, Domenikus Zimmermann and Johann Baptist Zimmermann, 1747–48.
Wies, pilgrimage church

The lavishly decorated choir of the Wieskirche shelters a statue of Christ, the miraculous image that prompted the church's construction. The inner vault above the columns is pierced with oculuses that take the form of empty cartouches with carbunclelike rococo ornament clinging to their edges. These openings allow more natural illumination to penetrate to the interior, thereby accentuating the warm glow created by the prevailing light palette used throughout *(see also page 431).*

Ceiling of the Kaisersaal (detail),
Johann Balthazar Neumann (architect),
Giambattista Tiepolo (painter), Antonio Bossi (stuccador), 1749–53.
Würzburg, Residenz

The Kaisersaal (Hall of the Emperor) in the center of the Würzburg Residenz is a room of vast dimensions intended to climax the sequence of spaces leading to it. Tiepolo was commissioned to decorate the ceiling with an apotheosis of Emperor Frederick Barbarossa, and he worked closely with Bossi, whose stuccowork is an integral part of the final design (some elements of which were already in place when Tiepolo arrived). The cartouches in the spandrels between the deeply recessed dormer windows are invaded by extensions from the ceiling fresco, a playfully illusionistic gesture typical of the decor as a whole.

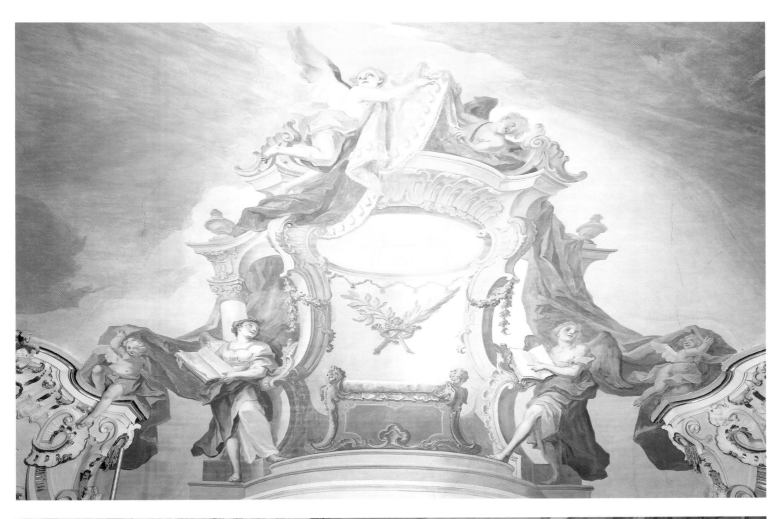

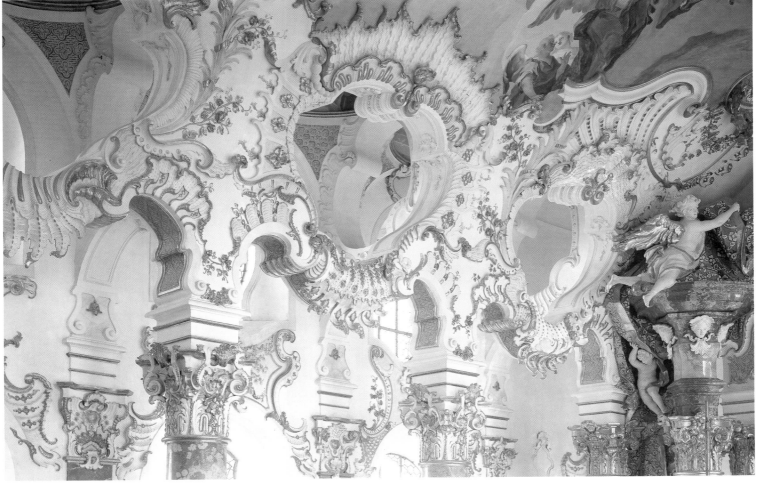

CARTOUCHES / THE ROCAILLE ～ 371

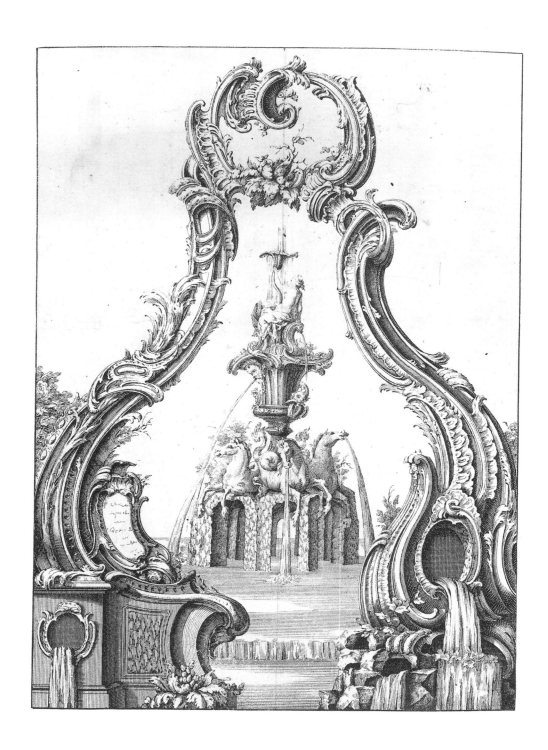

Print from *Différents Compartiments d'Ornements*
(Various ornamental enclosures), Pierre-Edme Babel.

Paris, Bibliothèque des Arts Décoratifs

*I*n this composition, a "rocaille ornamental enclosure" frames a
garden fountain, but the forms have been taken beyond the logical
and realizable into a world of pure decorative fantasy, as was often
the case in rocaille ornament prints. Such caprices could serve as
an inspiration to enterprising designers, to be sure, but they
were also meant to be sources of delight in their own right, and
not only for artisans.

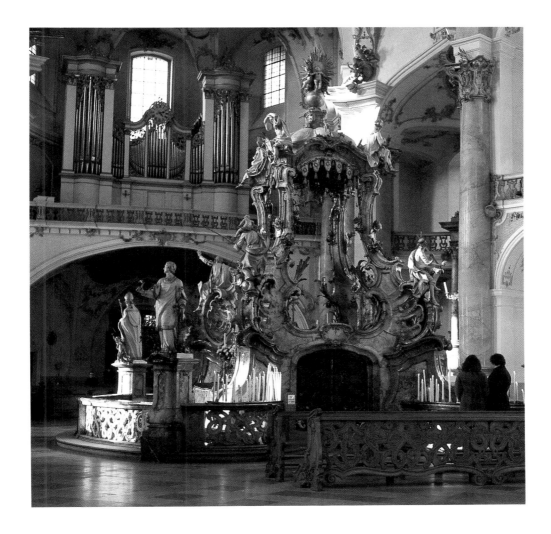

Altar of the Fourteen Intercessor Saints,
J. J. M. Kuechel (architect), Johann Michael Feichtmayr
and J. G. Übeelher (sculptors), 1764–72.

Church of the Vierzehnheiligen (near Langheim)

This oval altar, which commemorates the vision of Christ surrounded by
fourteen saints that appeared to a shepherd on this spot in 1445, was designed
to incorporate fourteen large figures. Its focal element is a baldaquin
supported by four enormous arches in the form of scrolled cartouches; their
shell-like scrolls provide perches for some of the saints' effigies. The altar is at
the center of the church's nave, which church architect Johann Balthazar
Neumann planned as a succession of three grand oval spaces—an
extraordinary example of the rococo preference for curvilinear forms.

Choir stalls, Basilica of Saint-Gall, Joseph
Anton Feichtmayr (1696–1770), c. 1760–65.
Saint-Gall (Switzerland), Stiftskirche

Five relief depictions of scenes from the life of
Saint Benedict enclosed within undulating rococo
cartouche frames are the dominant elements here,
but two- and three-dimensional cartouches have
been incorporated into this design at every oppor-
tunity, making this a textbook illustration of the
many ways in which the form could be manipu-
lated. Rarely has such intense formal energy
been compacted into so little space.

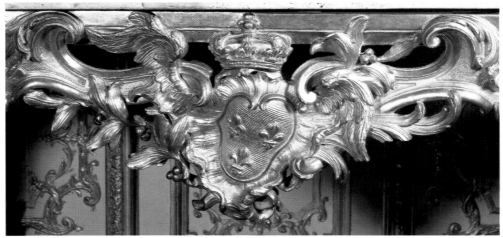

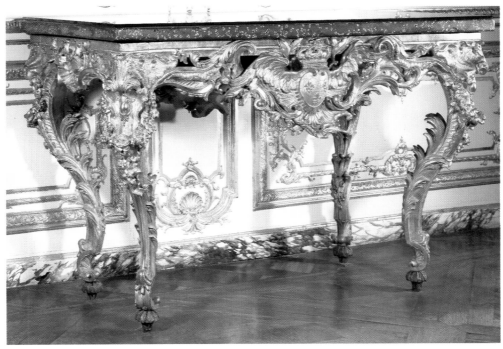

Table (detail), made for the *petits appartements* of Louis xv
at Versailles, François Roumier, 1737.

Versailles, Musée National du Château

Executed at about the same time as the medal cabinet by Antoine Gaudreaux
and the Slodtz brothers *(see page 378),* this remarkable bit of carving exemplifies
the confidence and freedom with which craftsmen working for the French
Crown in this period manipulated the traditional decorative vocabulary. It
must be said, however, that there are very few instances of skewed cartouches
such as this bearing the Bourbon arms.

Table, Slodtz brothers, 1739.

Versailles, Musée National du Château

Two years later, the Slodtz brothers delivered a table intended to serve as a
pendant to the one discussed above, and identical to it, save for one telling
detail: the winged cartouche bearing the Bourbon fleurs-de-lis was
returned to a stalwart upright position.

Cartouche, Gaetano Brunetti, 1731–36.

Paris, Bibliothèque des Arts Décoratifs

A painter of Lombard extraction, Brunetti settled in London, where he
worked, notably, for the Duke of Chandos. He had fully absorbed the Italian
tradition of illusionistic architectural painting. In 1731 and then in 1736 he
published furniture designs and ornament prints focusing on the illusionistic
treatment of openings, mantelpieces, and wall-to-ceiling transitions. They
represent a logical development of the Baroque, which delighted in such
theatrical play with formal elements.

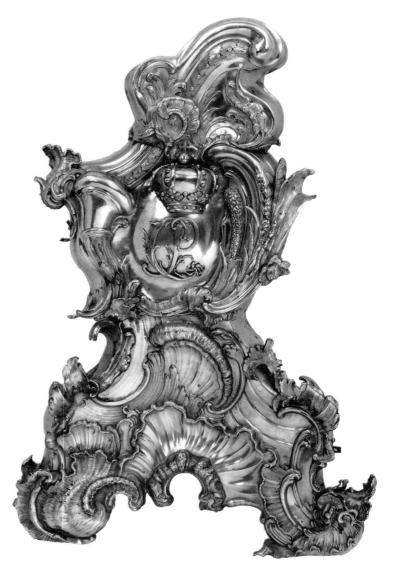

Plate 7, *Livre de vases* (Book of vases),
François Boucher, published by
Gabriel Huquier, 1734.

*Paris, Bibliothèque d'Art et d'Archéologie,
Fondation Jacques Doucet*

Vase designs were marked by considerable inven-
tion in this period. In his prints, Boucher decorated
them with figures, animals, putti, and nymphs.
Very few objects based on his designs have been
discovered, but he is known to have provided
models for sculptors of various kinds.

Muschelornament print, Johann Wolfgang
Baumgartner (1712–1761), Augsburg.

*Paris, Bibliothèque d'Art et d'Archéologie,
Fondation Jacques Doucet*

Baumgartner belonged to a distinguished family of
Augsburg engravers. On this sheet he proposed elab-
orate corner treatments for windows or frames—
dense concentrations of C-scrolls, foliate flourishes,
and shell forms added to otherwise spare moldings.
Muschelornament (from the German *Muschel,* which
means mussel or shell) was a rather crusty variant
of the rococo developed by eighteenth-century
engravers and silversmiths in Augsburg.

Andiron,
Philip-Jacob Drentwett, silver, 1747–49.

London, Victoria and Albert Museum

This large piece, made by a famous Augsburg
silversmith, differs markedly from contemporary
French andirons, which favor a rocaille idiom in
which serpentine lines are stressed. Here, the
dominant preoccupations are more tactile,
textural, and three-dimensional, making this a
paradigmatic example of *Muschelornament.*

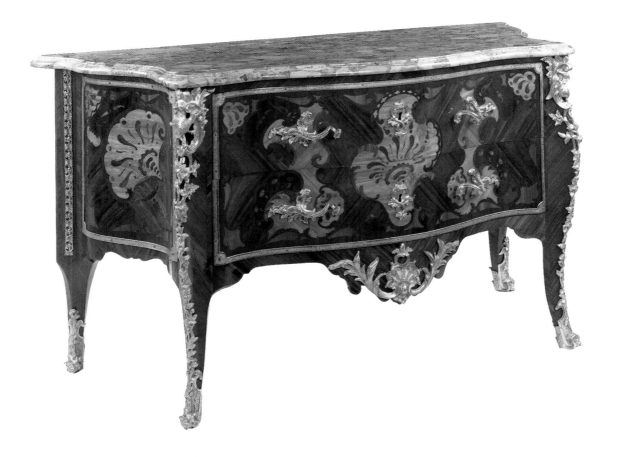

Commode (full view and detail),
stamped DF.

Malibu, J. Paul Getty Museum

The virtuoso marquetry work on this piece features
several "pierced," *agrafe*-like cartouches. Two gilt-
copper keyholes nestle within the central cartouche,
accentuating its eccentric profile, and the serpentine
gilt-copper handle fixtures seem like extensions of
the curving shapes of inlaid wood beneath them.

LEFT

Door of a bookcase (detail),
c. 1735–40, attributed to Bernard II van
Risenburgh (c. 1700–1765/7).

Malibu, J. Paul Getty Museum

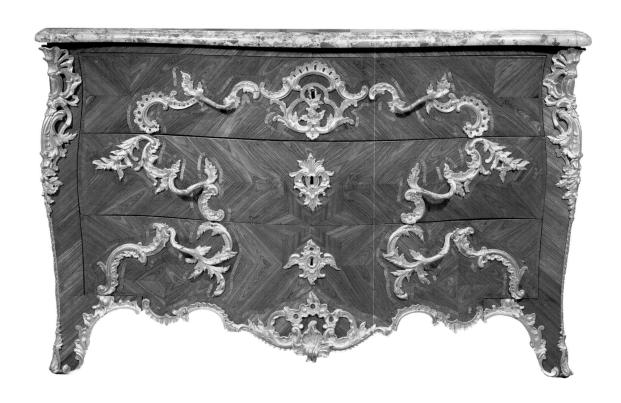

Commode for the bedroom of the dauphine,
Marie-Thérèse d'Espagne, in the Château de Fontainebleau,
Antoine Gaudreaux (c. 1680–1751), 1745.

Versailles, Musée National du Château

Cartouches sometimes appear in unexpected places during this period.
Commode fronts might seem less than ideally suited to them; even the
development of models *à la Régence* (without crossbars between the drawers)
did not entirely solve the problem. This piece, in which the sinuous outline
of a large, symmetrical cartouche wends its way across the entire front surface,
represents an ingenious design solution of great elegance and poise.

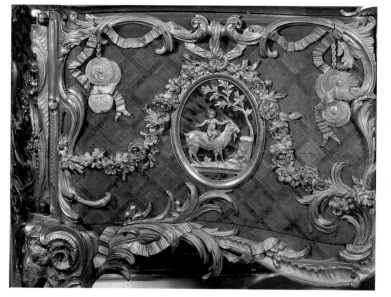

Medal cabinet from the king's office in the Château de Versailles
(detail), Antoine Gaudreaux and the Slodtz brothers, 1738.

Versailles, Musée National du Château

This opulent piece by Gaudreaux was intended to house a series of newly
struck medallions commemorating events in the reign of Louis XV. The rich
gilt-bronze fittings by the Slodtz brothers are characteristically rocaille in
their freedom and sinuosity.

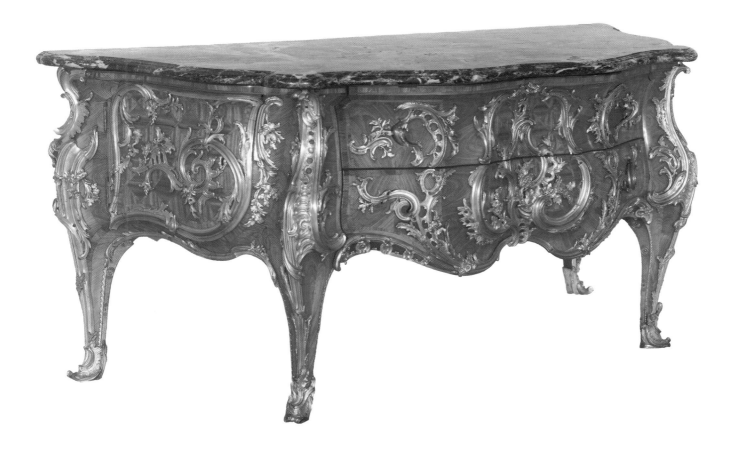

Commode, Antoine Gaudreaux and
Jacques Caffieri (1673–1755), 1738–39.

London, Wallace Collection

This important piece was made for Louis xv's
bedroom at Versailles on the occasion of its being
remodeled. The new paneling, carved by Jacques
Verberckt, was less audacious than the furniture,
on whose designs the Slodtz brothers collaborated
(and probably others as well). The play of convex
and concave surfaces is unusually rich. The absence
of a crossbar separating the two drawers prompted
Caffieri to produce unusually inventive gilt-bronze
fittings, which he arrayed across the front in nested
cartouche configurations which animate the sur-
faces without overloading them. The scroll motif
on the side panels was relatively new in 1738, but
it would become ubiquitous in rocaille designs in
the 1740s. The final result, far from being fussy,
has a deliciously light, insouciant quality.

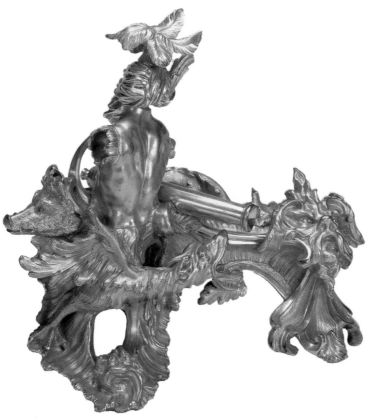

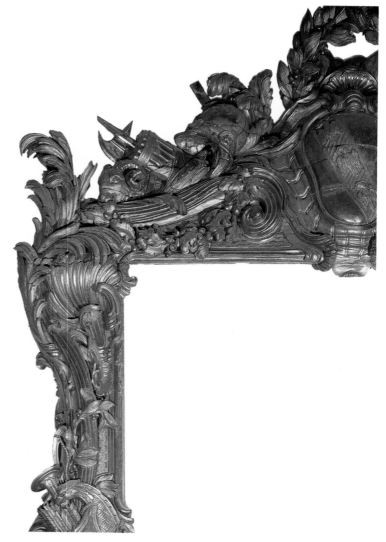

Leda (detail),
print by Claude Duflos the younger
after François Boucher.

Paris, Louvre, Edmond de Rothschild Collection

Andiron with military trophy, c. 1735.

Malibu, J. Paul Getty Museum

This andiron assembles a military trophy, a boar's head, a gaping dragon
head, and a mascaron on a shell-like rocaille armature. In its overall stylistic
approach and some of its details, it has much in common with Boucher's
Leda print (detail above; reproduced in full on page 331).

Frame with the arms of Lorraine (detail),
carved and gilded wood, c. 1730.

Paris, Musée des Arts Décoratifs

This frame bearing the arms of the House of Lorraine was clearly intended
to receive a portrait of someone in the family of Stanislas Leszczynski, who
was then the ruler of Lorraine and Louis xv's father-in-law. Royal portraits
were important symbols of authority during the period and were often placed
in elaborate frames. The undulating forms that envelop this corner of the
frame succeed in softening and blurring its harsh angle, a typically rocaille
notion; and the motifs—trophies, palm trees, shells, and curlicues—
are equally characteristic of the style.

Chandelier, gilt-bronze, c. 1750.

Paris, Bibliothèque Mazarine

\mathcal{M}adame de Pompadour ordered two gilt-bronze chandeliers for the former Hôtel d'Evreux (now the Elysée Palace): one for her bedroom and another for an adjacent room, one of which is shown here. Such pieces were rare in France. The pair, by an unknown bronze caster (perhaps Jacques Caffieri), skillfully elide the boundary between figurative and abstract forms. Within the curvaceous branches of each one are birds and music-making putti around a crenelated tower (the emblem of the marquise). The combination of extravagantly scrolled shapes of ambiguous character—neither fully vegetal nor purely ornamental—with freestanding figures is reminiscent of the similarly curious juxtapositions in many rocaille ornament prints.

Print from *Différents Compartiments d'Ornements*
(Various ornamental enclosures), Pierre-Edme Babel.

Paris, Bibliothèque des Arts Décoratifs

\mathcal{R}ocaille ornament prints such as this could be adapted for various purposes by a broad range of craftsmen. Comparison with the chandelier illustrated at right reveals how cartouche segments such as those pictured here could be appropriated by artisans. But there is reason to believe that such sheets were coveted by nonprofessional art lovers for the pleasure they provided in their own right.

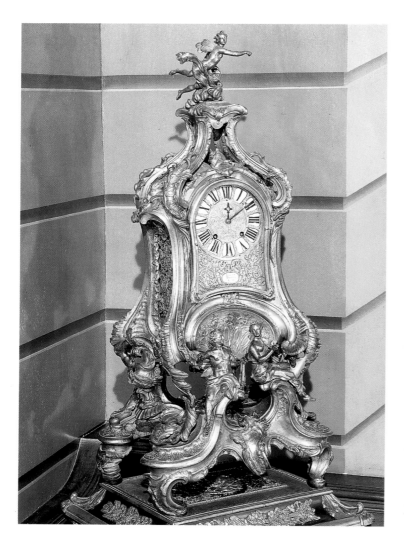

Clock,
Jacques Caffieri.

Boughton, The Duke of Buccleuch and Queensberry

In this clock case, which is one of several surviving examples, Caffieri demonstrates his exceptional powers of invention. Most notable, perhaps, is the way he managed to produce a satisfying whole from such disparate elements. The elaborate base features two figures in front of a concave oval and perched on the tips of an eccentrically shaped molding that bulges outward, as do portions of the case proper above. At the top, a winged putto appears to float on a platform supported by four sinuous S-scrolls, which echo the base's curved forms without imitating them, like interlocking cartouches.

Print from *Morceaux de caprice à divers usages*
(Caprice compositions for various purposes),
François de Cuvilliés.

Paris, Bibliothèque des Arts Décoratifs

The narrative vignette, which is in the best *fête galante* tradition, is set within a framing composition incorporating a large cartouche at the bottom— punctuated by an asymmetrical "gilled" *agrafe*—and, at the top, the face of the sun, which appears at a curious upturned angle, like one of the faces in the clock at right.

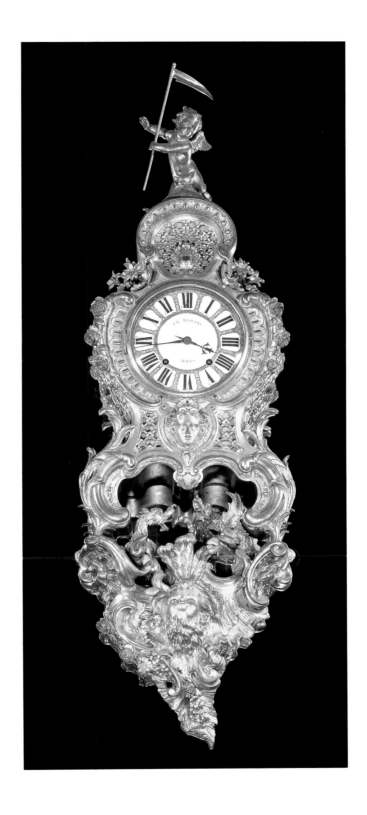

Cartel clock, gilt-bronze,
Charles Cressent (1685–1768) (sculptor and caster), 1745.
Versailles, Musée National du Château

A cartel clock of this design, supported by a console decorated with a
mask of Boreas, the west wind, was delivered in 1745 for the dauphine,
Marie-Antoinette, Louis XV's daughter-in-law; after becoming queen,
she had it moved into her bedroom at Versailles. Particularly ingenious
is the openwork transition from the clock proper to the cartel, which
gives this virtuoso piece a remarkable lightness. The intimation of
spatial complexity and movement around the upturned face of
Boreas is very much in the rocaille spirit.

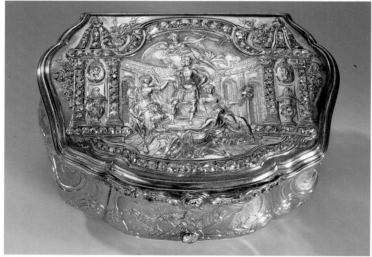

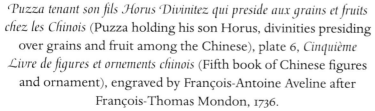

Puzza tenant son fils Horus Divinitez qui preside aux grains et fruits chez les Chinois (Puzza holding his son Horus, divinities presiding over grains and fruit among the Chinese), plate 6, *Cinquième Livre de figures et ornements chinois* (Fifth book of Chinese figures and ornament), engraved by François-Antoine Aveline after François-Thomas Mondon, 1736.

Paris, Bibliothèque des Arts Décoratifs

This print of 1736—in which partially aquatic figures emerge from the scrolled cartouches of a large rocaille structure that one might find on a gold or silver box—is typical of Mondon's work.

Tobacco box, François-Thomas Mondon and Thomas-Pierre Breton, c. 1740–42.

Paris, Louvre

It is sometimes said that rocaille artisans tended to work in several media, and Mondon was exemplary in this regard, for he was both a printmaker and a silversmith. This box, one of his few surviving pieces of metalwork, bears the repoussé image of a triumphant general in antique garb. Its ornamental designs are more restrained than those in his print work, which allowed his fantasy free reign.

Cartel clock, Jacques Caffieri.

New York, Metropolitan Museum of Art

Cartel clocks, in which the supporting console has been absorbed into a free-floating, cartouchelike whole, were hung on walls or in the center of mirrored surfaces. This model by Caffieri is notable for its asymmetry and its unbridled fantasy: a winged dog, a ram with a serpent's tail, and a female bust appear among naturalistic flowers and vegetation punctuated by S-curves and topped by a sunburst radiating from a volute. Compare this with the form on the illuminated page shown opposite.

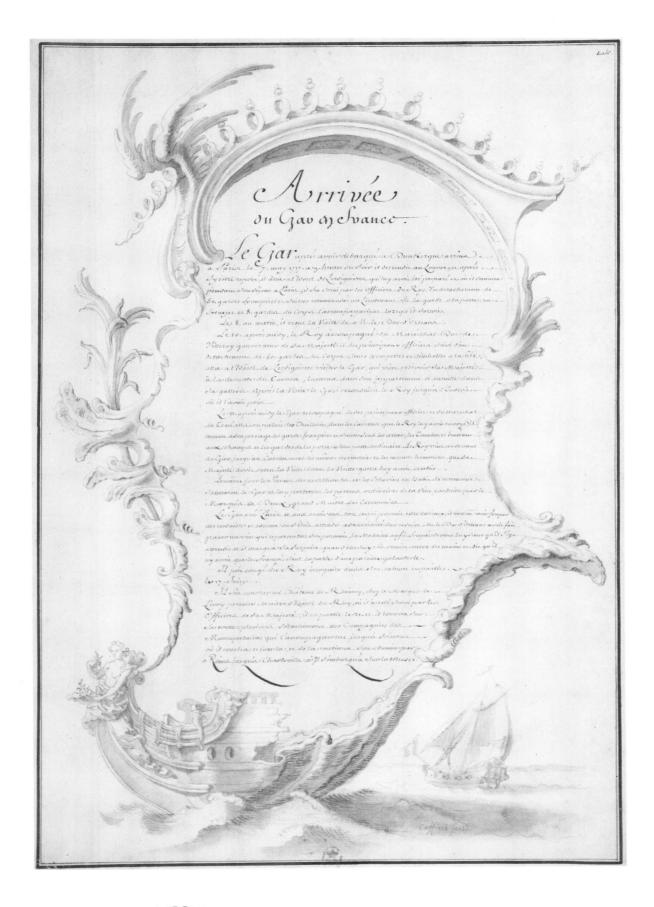

Title page of a manuscript recounting events at the French court, pen and wash, Jacques (?) Caffieri.

Paris, Bibliothèque Nationale

Among the collections of the Bibliothèque Nationale are a number of illuminated sheets with texts recounting events of the early reign of Louis xv, all of which are inscribed "Caffieri fecit" (made by Caffieri). The text of the example shown here concerns the 1717 visit to France of Peter the Great of Russia. The frame drawn around it, somewhat later in date (c. 1730–35), takes the form of a cartouche far more asymmetrical than would have been allowed in any artifact during the early part of the century, at least in France.

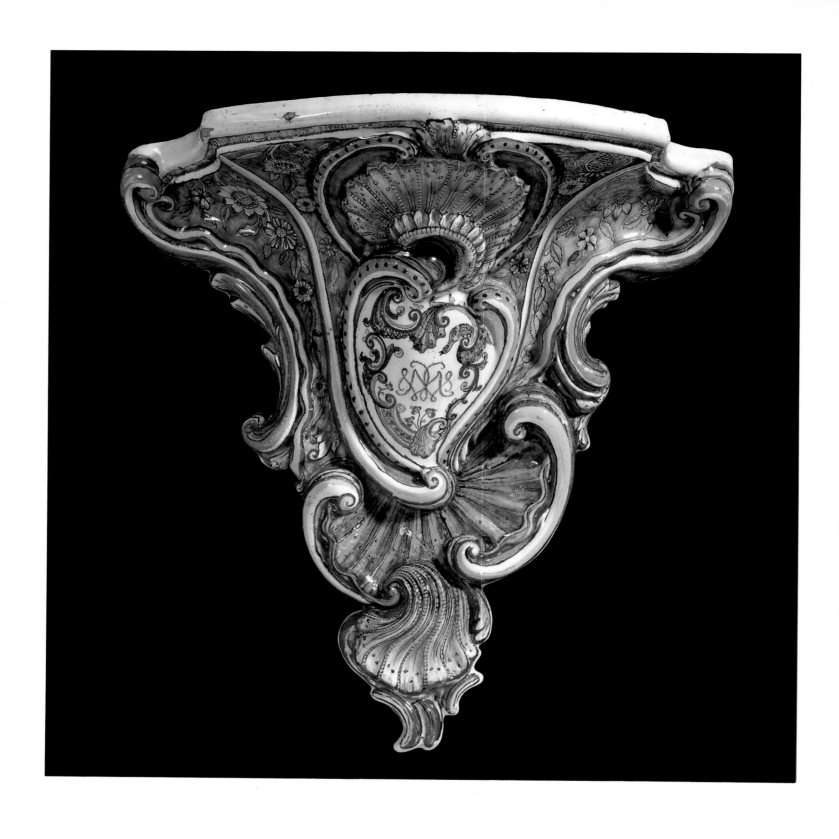

Wall console,
Rouen pottery, 1754.

Rouen, Musée de la Céramique

The formal agitation in the rocaille shapes
of this wall console is accentuated by its
vibrant color scheme.

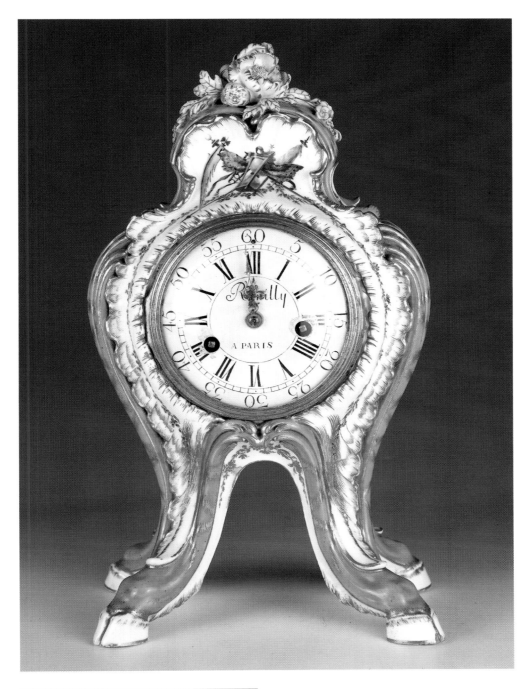

Clock, Sèvres porcelain case
(front and back views), movement by
Romilly, probably c. 1762.

Paris, Louvre

This clock case sits on four hoofed feet, which rise
to support the shell-like cartouches that frame its
face and back. It probably belonged to a *garniture de
cheminée* (a matched set of ornaments for a mantel)
that also included two pots-pourris with candle
sockets and and two more *à feuillages* ("decorated
with foliage") made for Madame de Pompadour
about 1762, after designs that may date as early as
1755. While the shell cartouches have more or less
naturalistic detailing, their general configuration is
pure invention on the designer's part. The back
features an openwork moresque panel.

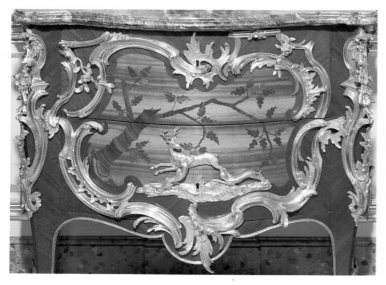

Commode,
Bernard van Risenburgh, c. 1750.

Malibu, J. Paul Getty Museum

This small commode, one of a pair, was part of a
set that also included four larger commodes and
some *encoignures* (corner pieces). It was made by
Parisian cabinet-maker Bernard van Risenburgh
(estampille BVRB) for the elector of Saxony, who
ordered the ensemble for Moritzburg Castle. This
explains the audacious character of the fittings,
which would have been too asymmetrical for a
Parisian client of that time. The front surface has
been conceived as a large cartouche, and the design
brings to mind the decoration on Vincennes porce-
lain flower containers and the interiors at Sans-
Souci. The set's larger commodes, now divided
between Dresden and Moritzburg, also feature
large front cartouches with hunting motifs.

Cubic flower container,
Vincennes porcelain, 1754.

Sèvres, Musée National de Céramique

The Vincennes factory was renowned for
its superb gold decoration, exemplified by the
delicate, unusually asymmetrical gold
cartouches in this piece.

Commode of Madame de Mailly, painted wood with silver-bronze fittings, Mathieu Criaerd, 1742.

Paris, Louvre

In 1743, Hébert, a Parisian dealer in objets d'art whose shop was on the rue Saint-Honoré, delivered this commode as well as two *encoignures* for the "blue room" of Madame de Mailly, Louis XV's current mistress, at Choisy. Blue-and-white rooms had enjoyed a certain vogue in the seventeenth century, and they returned to favor in the eighteenth, largely because of their suitability for the display of porcelain objects. In her bedroom, Madame de Mailly used a blue silk fabric she herself had woven, and had this commode, the cornice, the bed, the chairs, and the *encoignures* all painted in blue and white in emulation of Oriental porcelain. The front of the commode is decorated with sinuous silver-bronze fittings that trace the outlines of a cartouche nested within another cartouche. The painter—more likely Alexis Peyrotte than Christophe Huet—chose to broaden those outlines in blue as the framing elements for blue-and-white tableaus of plants, birds, and insects. The final effect brings to mind *découpures,* the decorative patterns on certain ornament prints intended to be cut out by amateurs and used on furniture, screens, etc.

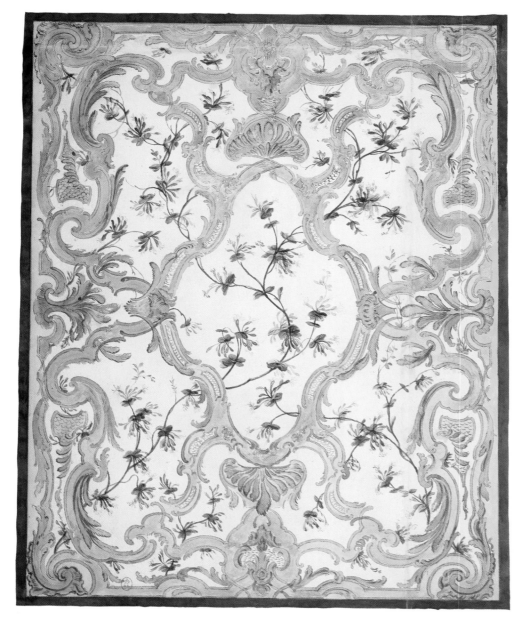

Design for an alcove hanging,
drawing and watercolor, 1743.

Paris, Bibliothèque Nationale

The configuration of this anonymous design
suggests that it was intended for weaving as an
alcove hanging, and it may have been meant for
Louis xv's bedroom at Choisy. The interiors there,
on which many artists collaborated (notably
Pierre-Alexis Peyrotte), were among the freest
and most inventive in any of the French royal
châteaux. The royal bedroom was decorated with
paneling carved by Jacques Verberckt, and its
summer *ameublement* (fabric furnishings) were in
white *gros de Tours* with a honeysuckle pattern,
similar to the floral print in the designs on this
page. *Ameublement* wall panels often had appliqué
borders made of a contrasting fabric, and the
rendering at left illustrates the delightful,
windowlike effect this produced. *(See page 421 for
another design intended for Choisy.)*

Design for wall fabric,
drawing and watercolor.

Paris, Bibliothèque Nationale

This anonymous sheet is from an album contain-
ing designs by Slodtz, Lajoue, and Mondon (and
a title page by Jean-Baptiste Chevillion) for the
Garde-Meuble de la Couronne, the agency respon-
sible for furnishing the royal households. Like the
sheet illustrated above, it probably illustrates a wall
panel treatment in two fabrics, and the honey-
suckle pattern suggests that it, too, may have been
intended for Louis xv's bedroom at Choisy. In this
instance, the framing elements are more assertive.
Another design in the same album uses a similar
vocabulary but in asymmetrical configurations.

FACING PAGE

Carpet from the factory of
Charles Vigne, wool and silk, c. 1765.

*Former residence of Emperor William III in exile,
Huis Doorn (Holland)*

This carpet, which features nine cartouche
armatures strewn with flowers, was probably
woven for the Neues Palais of Frederick II in
Potsdam. The effect is lighter than in comparable
Savonnerie designs: the shapes have been left
open in the tradition of Johann August Nahl and
Johann Christian Hoppenhaupt, and there is
ample space between them.

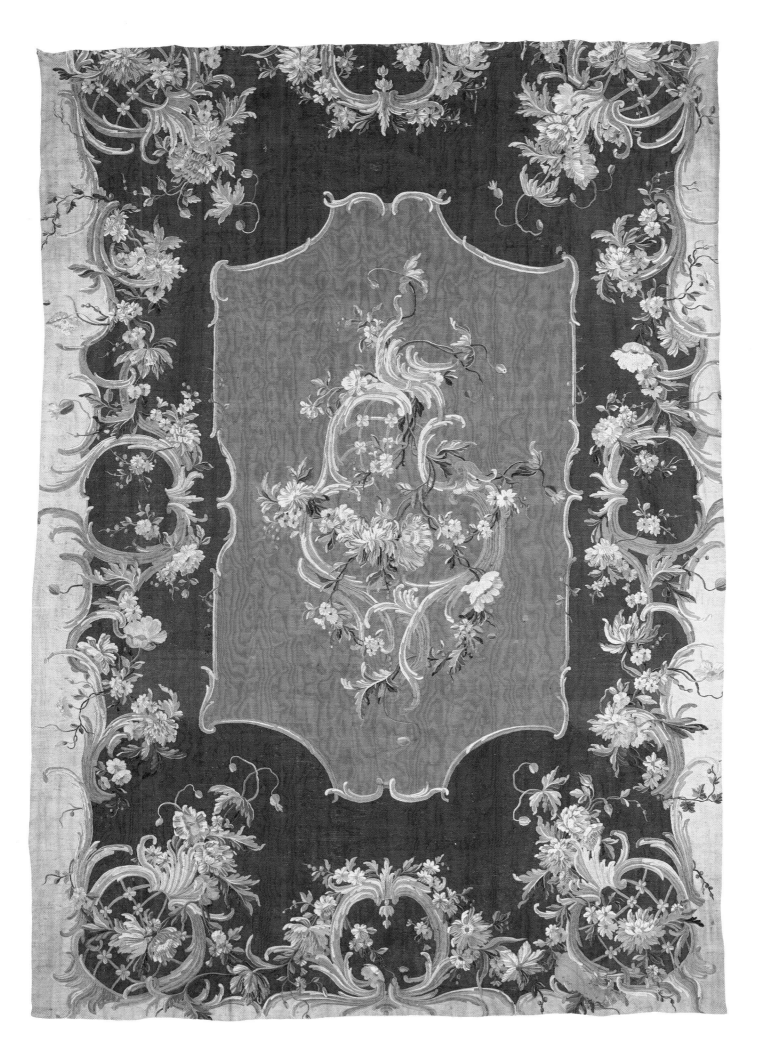

Print from *Livre de fontaines* (Book of
fountains), Pierre-Edme Babel.

Paris, Bibliothèque des Arts Décoratifs

Tapestry upholstery panel,
French (probably Beauvais),
wool and silk, c. 1735–50.

New York, Metropolitan Museum of Art

The nature of Babel's designs in this set of prints is
ambiguous. This image, which is typical of the
series, features a fantastic fountain-cartouche that
is difficult to envision as a built structure. Is it pure
fantasy with no application? In large part, but
surviving fragments of upholstery reveal that the

design was used by weavers, who devised their
own color scheme for it. The composition is
reversed, but, given the widespread use of mirrors
and counterproofs during this period, the precise
mechanism of transfer cannot be specified.

FACING PAGE

Tapestry executed at the Gobelins
(Neilson workshop) for Croome Court
(Worcestershire), 1764–71.

New York, Metropolitan Museum of Art

In the eighteenth century the Gobelins factory
received several tapestry commissions for English
country houses. The Croome Court designs now
in New York incorporate four oval medallions
containing allegories of the elements after Boucher
(not visible here), but the overall decorative scheme
was devised by Maurice Jacques (1712–1784), one of
the factory's designers. The architectural detailing
of the room itself—by architect Robert Adam, who
ordered the set—is neoclassical, but this did not
prevent Jacques from making the focal element of
his design an image of an immense blue vase on an
elaborate rocaille base that appears to be pressing
on a thick garland of leaves draped across the
mantelpiece beneath it. The set's border composi-
tions and the mantelpiece composition have much
in common with the French decorative vocabulary
of the 1740s. In this transitional decor, rocaille
extravagance and neoclassical restraint co-exist
in rare equilibrium.

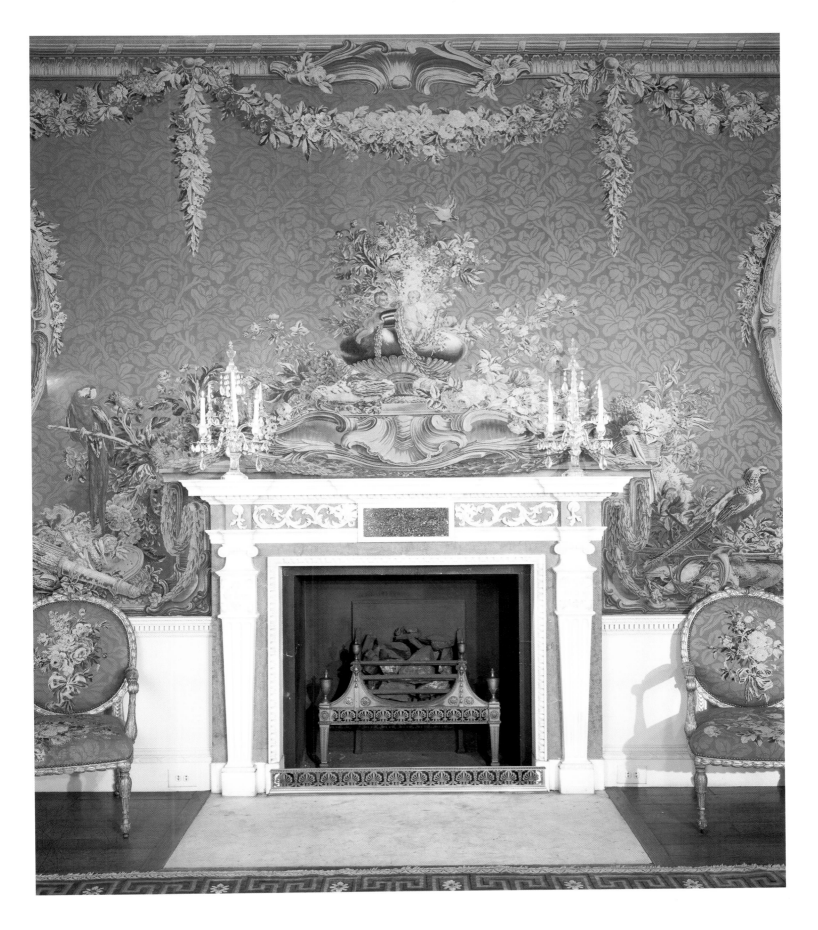

CARTOUCHES / THE ROCAILLE ~ 393

Design for a throne room, print,
Johann Michael Hoppenhaupt, c. 1753.

Paris, Bibliothèque Nationale

The large trophy-cartouches in this design are rather awkward, but their presence in a throne room decor underscores the form's roots in heraldry. Note the shell-like texture of the pilasters *(see also page 222)*.

Savonnerie carpet,
woven 1777–79 after a design of 1757.

Stockholm, Royal Palace

Famous engraver and book illustrator Hubert-François Gravelot was asked to design a carpet for the dauphine's bedroom at Versailles (first woven in 1757). In 1784, Louis XVI presented a later weaving of the same design to Gustavus III of Sweden. Gravelot was responsible for the central rosette and the cartouche configurations, while factory designers added the complementary garlands of flowers. The influence of the rocaille is discernible in small details, but the overall design, with its thick, classical moldings and clearly articulated compartments, harks back to seventeenth century models. The pink garlands and the white ground, however, are typical of the mid-eighteenth-century French sensibility.

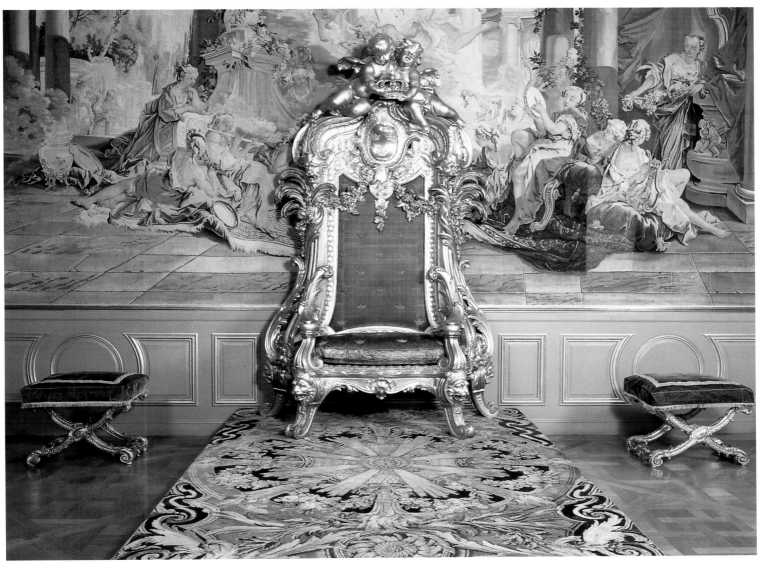

Throne for a royal reception room,
carved and gilded wood, 1751.

Stockholm, the Royal Collections

In 1751, architect John Rehn was commissioned to design a throne for the
coronation of Swedish kings. He chose as his model the throne designed
by the Slodtz brothers in 1743 for Louis xv and placed in the Salon of Apollo
at Versailles (now lost). As in the French prototype, vegetal forms derived
from the rocaille vocabulary are combined with more traditional lion heads
and volutes. The result is imposing indeed, but the form is not unlike
that of a large cartouche.

Print from *Diverses épitaphes à la moderne* (Diverse epitaphs
in the modern style), Jeremias Wachsmuth.

Paris, Bibliothèque des Arts Décoratifs

The title of the series clearly states that these designs were intended for use
in funerary or memorial plaques. The derivation of the cartouche from the
heraldic shield made it especially appropriate for this purpose, but the
illusionistic relief effect encourages the viewer to think in terms of more
plastic forms such as chairs, thrones, and confessionals. Ambiguity of this
kind is typical of both Augsburg rococo ornament prints and those
of French rocaille artists.

Cornice of the Queen's Bedroom
at Versailles (detail), François Boucher (painter) and
Jacques Verberckt (sculptor), 1735.
Versailles, Musée National du Château

Verberckt, of Brabant extraction, was senior decorative sculptor to Louis xv. He carved many panels with rocaille borders and flourishes for royal châteaux, but this one for the cornice of the queen's ceremonial bedroom at Versailles, which incorporates grisaille allegories by Boucher (here, *Charity*), is especially sumptuous. The framing cartouche is notable for its shell-like, ribbed surface treatment, described as *chicorée* in French.

Drawing of a shell, red chalk.
Paris, Fondation Custodia

This magnificent drawing of a murex shell was formerly attributed to Watteau. These mollusks—relatives of the whelk and the conch—proliferated off the Lebanese coast and in the Gulf of Arabia and were sought after as a source of purple dye. In seventeenth- and eighteenth-century France they were admired for their eccentric shapes, and their colloquial French name, *chicorée*, was used to designate the curved, sinuous forms—often ribbed—that proliferated in rocaille ornament.

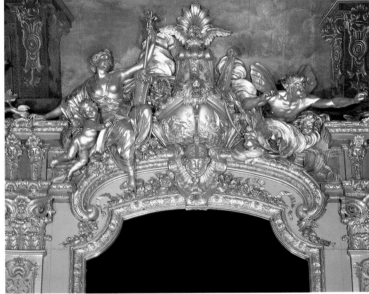

Galerie Dorée of the Hôtel de Toulouse
(two details and general view), Robert de Cotte (architect)
and François-Antoine Vassé (sculptor), 1714–18.

This gallery was originally conceived in the 1640s to display a set of history
paintings by Poussin, Guercino, Cortona, Reni, Maratta, and Turchi assembled
by Louis Phelypeaux de La Vrillière, many of which were specially commis-
sioned by him. It was remodeled in the early years of the Regency on the
orders of its new owner, the comte de Toulouse, one of Louis XIV's illegitimate
sons; the ceiling by François Perrier and the ten history paintings were
retained. Contemporaries described the new carvings by Vassé to be "sur-
prising," a strong word at the time. The medallion shown here *(above left),*
which is below the painting by Turchi, depicts the poet Arion saved by a
dolphin; note also the two lobsters nestling within the C-scroll above the
cartouche. Marine themes were also employed elsewhere in the hôtel,
notably in the silver service used by the count and then by his son, the duc de
Penthièvre, and in the group above the mantelpiece in this same room
(above right), an allegorical depiction of the triumph of the Marine. Its figures
are large in scale but have a delicacy more like the sculpture at Marly than
that at Versailles, making them perfectly at home in this ambitious foray
into large-scale interior decoration of a new kind.

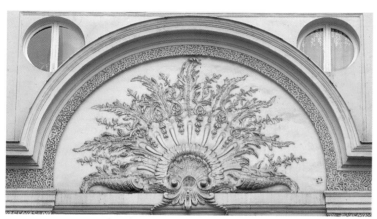

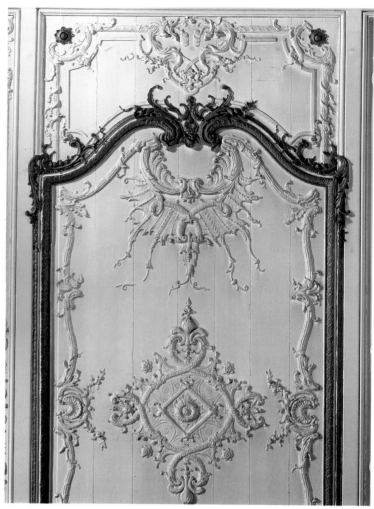

Entryway of the Hôtel Chartraire
de Montigny (detail), 1744.

Dijon, 41 rue Vannerie

Hôtel Guyot de Chenizot (detail),
Pierre de Vigny (architect), 1726–30.

Paris, 51 rue Saint-Louis-en-L'Ile

*I*t was customary for the entryways of important hôtels to be decorated with
the owner's arms or an allegory relative to his status. About 1730, however, the
vogue for rocaille forms became so pervasive that French architects began to
place purely decorative compositions in this position instead. The example
from Dijon shown above features a sinuous shell surrounded by a cornucopia,
bunches of wheat, grapes, and foliage. In the lunette panel below it, a
starburst effect is created by plant forms radiating outward from a central
shell; this unusual motif has more in common with designs by printmakers
from Augsburg than by those from Paris.

Carved wall panel from the bedroom of the duc de Bourbon
in the Hôtel du Grand Maître (detail), 1724.

Versailles, City Hall

*B*eginning in 1723, the duc de Bourbon, Grand Master of the King's Household,
was allotted a private house on the avenue leading to the Château de Versailles
for use in conjunction with his post. It was designed by the king's architect,
Robert de Cotte, and decorated with carved paneling and paintings by royal
artists more or less consistent with their work at the royal châteaux. The design
of this panel from the bedroom, however, is rather innovative. The outer
border and the central rosette are altogether conventional, but considerable
liberty was taken with the inner border, especially in the suspended element
above the rosette, an original amalgam of forms that resemble sea-palms
and squids without literally representing the shape of either one.

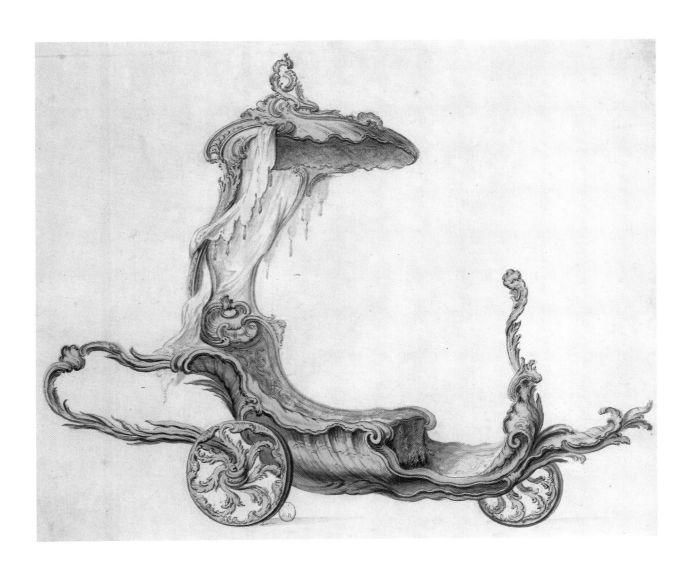

Chaise roulante (wheeled chair), drawing
and watercolor, Jean-Baptiste Chevillion.

Paris, Bibliothèque Nationale

This drawing, signed by Chevillion, represents
one of the wheeled chairs that were so popular
for garden promenades in this period. Several
surviving designs, notably by Hoppenhaupt, reveal
the great care lavished on them. In this little-
known example, Chevillion has turned the entire
vehicle into an undulating rocaille form, with a
result worthy of Thetis emerging from the middle
of a lavish garden fountain.

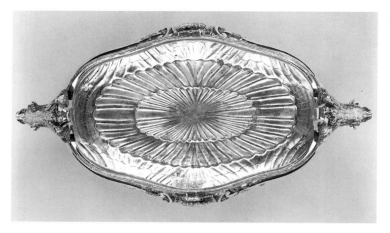

Wild-boar terrine (underside), silver,
Thomas Germain, 1726–28.

Malibu, J. Paul Getty Museum

Thomas Germain produced several silver terrines using this design. This one is dated 1726–28, but it was also signed by his son, François-Thomas Germain, in 1764, when it is believed to have arrived in Portugal. Especially remarkable is the care lavished on the underside; its carefully wrought surfaces would have caught the candlelight and reflected it onto the silver tray beneath. In this design, as often in rocaille artifacts, forms of natural derivation are given an abstract character.

BOTTOM LEFT

Plate from the *Schwanengeschirr* (Swan service), Meissen porcelain, 1735–38.

Sèvres, Musée National de Céramique

It is difficult for us today to imagine the rage for porcelain that swept Europe in the eighteenth century. Once the secret of making hard-paste porcelain had been broken in 1710, all the German principalities wanted their own factories, but Meissen long retained its dominance in the field. Beginning in 1735, sculptors Johann Joachim Kaendler and Johann Friedrich Eberlein devised models there for one of the most sumptuous services ever made: the so-called Swan service for the director of the Meissen factory, Count von Brühl. The set consisted of some 2,000 pieces, featuring tableaus of swans and other aquatic motifs, including nereids, tritons, dolphins, and shells, in delicate white bas-relief—an effect of such subtle and striking beauty that the set became widely admired throughout Europe.

TOP RIGHT

"Duplessis" sauceboat,
Sèvres porcelain, 1756.

Paris, Louvre

This piece was listed as a *saucière rocaille* (rocaille sauceboat) in an inventory of Sèvres models drawn up in the early nineteenth century. Its shell-inspired design has been credibly attributed to silversmith Jean-Claude Duplessis the elder. The restrained use of blue along the rim brings to mind the tinted edges of mollusk shells.

BOTTOM RIGHT

Potpourri vase,
porcelain and gilt-bronze, c. 1750.

Malibu, J. Paul Getty Museum

This potpourri vase is a composite object, consisting of a pale sea-green shell of Japanese porcelain from about 1700, decked out with French gilt-bronze fittings from about 1745–50. We know from surviving documents that similar objects were owned by Jean de Julienne and Madame de Pompadour.

"Fishtail" vase, Sèvres porcelain, 1765(?).

Paris, Louvre

Despite its late date, this design—probably
created for the duc de Praslin, Minister of the
Marine—retains a vestige of the rocaille
vocabulary in its fishtail handles. But the overall
conception is neoclassical, and the shells and coral
on its gold swag are naturalistic imitations of
their real models—and subsidiary in a way they
would not have been twenty years earlier.

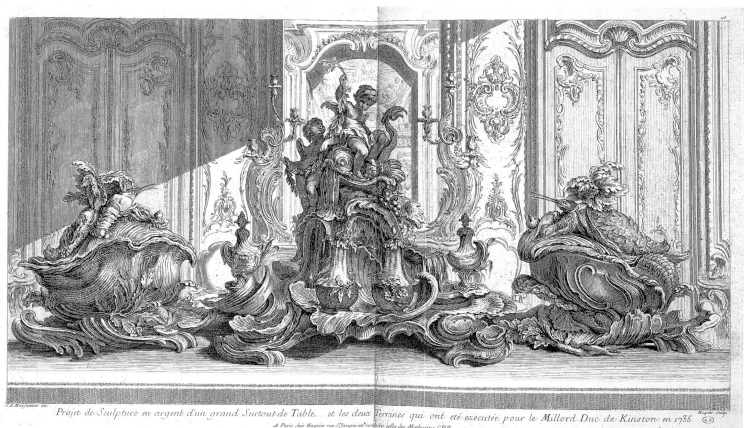

Projet de Sculpture en argent d'un grand Surtout de Table... et les deux Terrines qui ont été exécutée pour le Millord Duc de Kinston en 1735.
A Paris chés Huquier rue St Jacque au coin de celle des Mathurins CPR

Centerpiece and terrines for the Duke of Kingston, print, Gabriel Huquier after a design by Juste-Aurèle Meissonnier, 1735.

Paris, Bibliothèque des Arts Décoratifs

This print reproduces Meissonnier's design for a silver centerpiece with two terrines for the Duke of Kingston. Meissonnier was primarily a silversmith, but he also produced designs for buildings (notably an extravagant project for the façade of the church of Saint-Sulpice), interior decor, and ornament. His mastery of his craft, coupled with his penchant for virtuoso effects, enabled him to create spectacular designs at the very limits of the possible. The terrines pictured here were indeed executed, as noted by the caption, but apparently not by Meissonnier himself. In any case, Meissonnier's project is a veritable catalogue of rocaille effects, such as fluid shell and animal forms, asymmetrical cartouches, and inconsistent scale (the woodcock at right is as large as the putti in the center). One could even describe the terrines as bulbous, three-dimensional cartouches. Extravagant, illogical effects such as these, along with a consistent intention to blur the boundary between natural and artificial, prompted a backlash against the rocaille in midcentury.

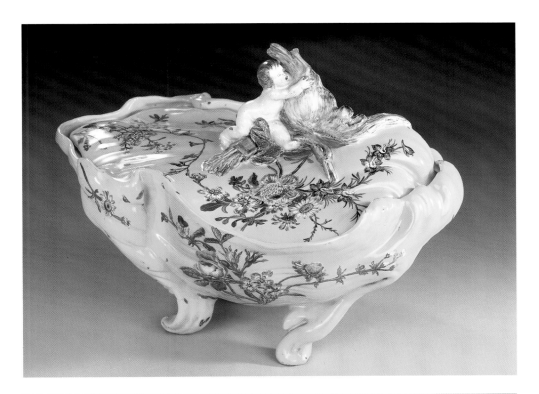

Terrine,
Marseilles faïence, c. 1760.

Paris, Louvre

The factory of the widow Perrin and other
Marseilles pottery factories used a yellow enamel
that gave many of their wares a special brilliance.
This piece exemplifies another Marseilles
characteristic as well: the latitude claimed by its
modelers. The form of this charming terrine was
inspired by shells, but its designer clearly felt no
qualms about paraphrasing his model.

Matching bowl and tray,
Chantilly porcelain (soft-paste),
mid-eighteenth century.

Sèvres, Musée National de Céramique

This soft-paste set—no hard-paste porcelain
was ever produced at Chantilly—is striking both
in its shapes and its vivid color scheme. Once
again, natural shell forms were the initial model
for the design, but the modeler has handled
them quite freely.

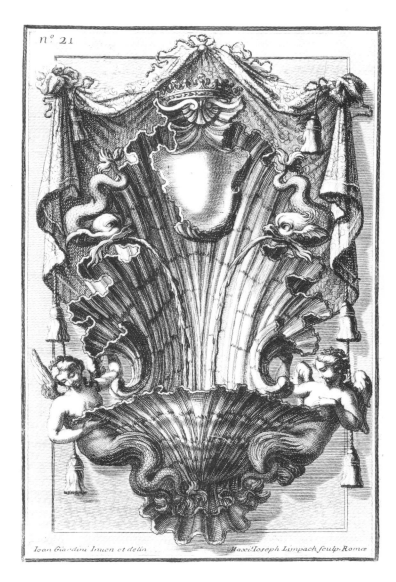

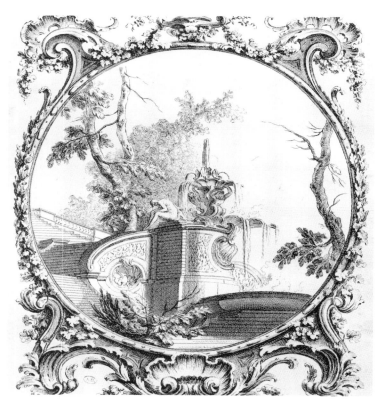

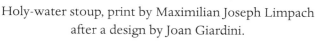

Holy-water stoup, print by Maximilian Joseph Limpach
after a design by Joan Giardini.

Paris, Bibliothèque des Arts Décoratifs

This stoup design by a Roman silversmith demonstrates how the rococo
vocabulary was inflected differently elsewhere in Europe, in ways consistent
with local tradition. Here, Roman Baroque precedent has been honored in the
prominent drapes, which establish a ritual context for the primary shell form,
while the dolphins and curious winged nereids are vestiges of the
Raphaelesque grotesque tradition.

Print from *Premier Livre de divers morceaux d'architecture,
paysage et perspective* (First book of diverse pieces of
architecture, landscape, and perspective), Gabriel Huquier,
after a design by Jacques de Lajoue.

Paris, Bibliothèque des Arts Décoratifs

An elaborate frame surrounds an architectural landscape designed around
two characteristic features of rocaille imagery: a fountain from which water
pours only to disappear, and a stairway leading nowhere. The figure of
the crouching nymph is ambiguous, again in a characteristically rocaille way.
Is she real, or is she a piece of garden sculpture? In any case, she sets the
melancholy tone of this odd composition.

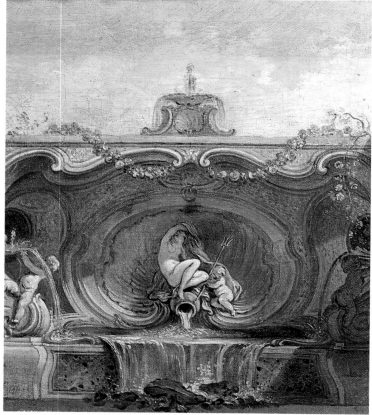

Fountain, oil on canvas, Jacques de Lajoue.

Paris, Musée des Arts Décoratifs

Unlike Boucher, who kept his activities as ornament designer and
painter distinct, Lajoue tended to combine them: skewed perspectives
and fantastic rocaille constructions appear both in his ornament
prints and in his canvases.

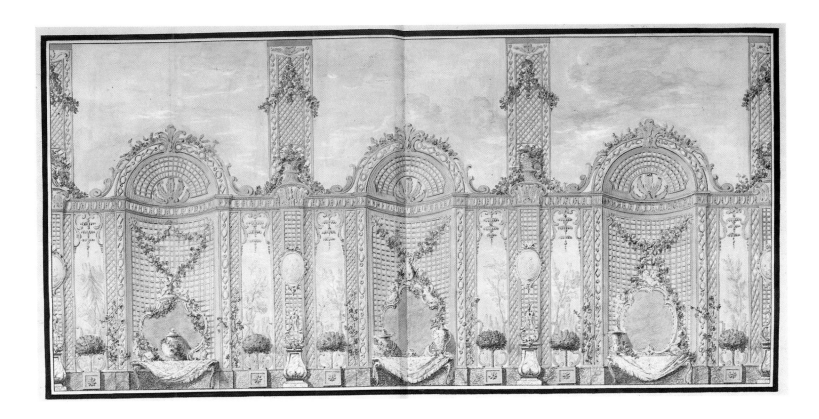

Design for decorations in the Orangery
at Versailles, drawing and watercolor,
Sébastien Antoine Slodtz and Paul
Ambroise Slodtz, 1751.

Paris, Archives Nationales

On December 19 and December 29, 1751, cele-
brations were organized in honor of the birth of
the duc de Bourgogne, and the Slodtz brothers
were commissioned to design the decorations for
the occasion. The structure built in the middle
of the Pool of the Swiss Guards for the fireworks
displays was neoclassical in inspiration, but the
decor for the interior of the Orangery featured
mirrors shaped like rocaille cartouches set
against elaborate trellises.

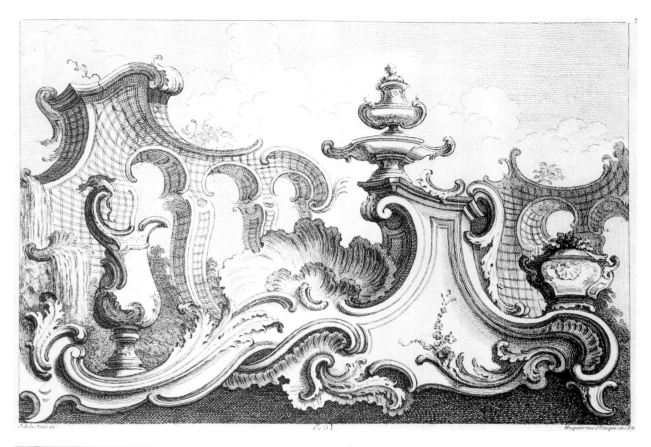

Print from *Tableaux d'ornements et rocailles*
(Tableaus of ornaments and rocaille
objects), Gabriel Huquier, after a design
by Jacques de Lajoue.

Paris, Bibliothèque des Arts Décoratifs

At first glance, this composition appears to be the
height of asymmetry, but in fact the foreground
and background ornaments are two different
designs, each of which, if extended by a mirror
reflection, would form a symmetrical design,
though in a rather extravagant rocaille idiom. The
presence of the vases serves as a reminder of the
close ties between metalwork and the rocaille, and
suggests that this composition might have been
intended for the decor of a dining room.

Brazier given to the Sultan's ambassador
by the king of France, copper vessel
and gilt-bronze support inset with
violet-wood, Jean-Claude Ciamberlano,
known as Jean-Claude Duplessis
the elder (d. 1774), 1742.

Istanbul, Topkapi Palace

Duplessis was a bronze-caster from Turin who
settled in Paris and became a protégé of the Prince
Carignan. In keeping with its status as a diplomatic
gift, this brazier is extremely virtuosic; its twisting
forms, which evoke swirling currents of water,
have an energy that brings to mind certain designs
by Meissonnier, who was also born in Turin.

Decorative painting (two details),
oil on canvas, François Boucher.

Paris, Musée Carnavalet

This set of decorative paintings was commissioned by engraver Gilles Demarteau (1729–1776) for the shop in his house on the Ile de la Cité in Paris, where it remained until his death. Most of the compositions consist of landscapes with animals over a lower level of trompe-l'oeil trellises, but the room's doors and narrow panels were painted with depictions of fountains incorporating putti. Despite the likelihood of a relatively late date for this decor (its precise date is unknown), Boucher used rocaille forms in the fountain groups, which play with the viewer's expectations. (Are the putti meant to represent real infants, as their almost tactile pudginess suggests, or stone sculptures, as is implied by their monochrome palette?)

During the reign of Louis xv, Demarteau's house and shop—on the rue de la Pelleterie, at the sign of the Bell—was frequented by French amateurs as well as foreign visitors. After 1756, Demarteau (who had previously been a silversmith) became one of Boucher's preferred engravers; his address appears on many prints of the artist's designs. Some of his most successful offerings were engravings done "in the manner of drawings," including one reproducing a fountain in this decor.

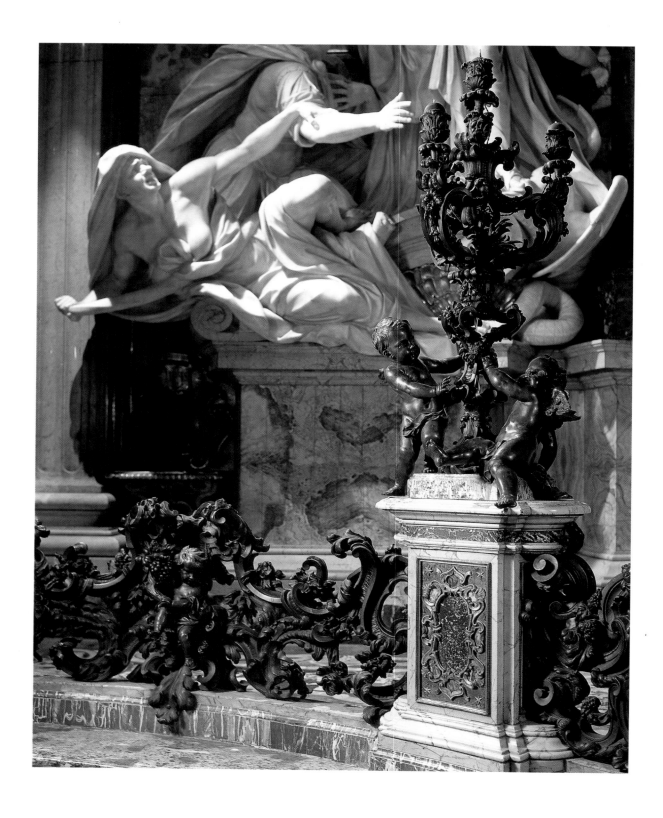

Communion rail,
chapel of San Ignazio, bronze, 1697.
Rome, Church of the Gesù

The completion of the Saint Ignazio altar—
to Andrea Pozzo's designs—in the Jesuit church
of the Gesù was eagerly anticipated in late
seventeenth-century Rome, for many of the city's
finest artists collaborated on this important project
in a new style. The eighteen-meter-long
communion rail received special attention. Its
design was unusual: the conventional balustrade
format was replaced by a swirling network of
openwork bronze curves linking eight marble
pedestals supporting bronze candelabra. Despite
the early date, its forms incorporate rococo and
rocaille elements. Throughout eighteenth-century
Italy, the most important manifestations of
the rococo style were chapel gates, communion
rails, and window frames.

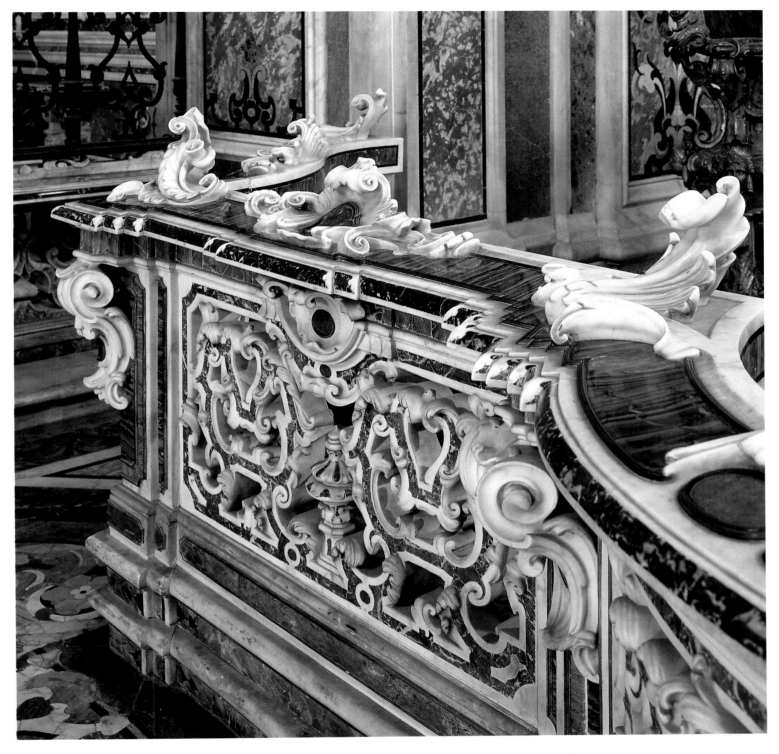

Communion rail, attributed to Giuseppe Sammartino, c. 1760.

Naples, Certosa di San Martino

The coiling marble carvings atop this balustrade, with their exaggerated shell-like scrolls, incorporate elements of the Baroque, rococo, and auricular vocabularies.

Title page, *Autre suitte de leçons d'ornemens dans le goût du Crayon* (Another set of ornament lessons in imitation of drawing), print, Girard, c. 1759.

Paris, Bibliothèque des Arts Décoratifs

Girard was a sculptor and teacher of ornamental design. Demarteau published a series of his prints in a technique he had perfected to produce images that would look like red charcoal drawings. Girard also produced designs specifically intended for furniture, but the rocaille compositions on these sheets have no apparent purpose. The soft, cartilaginous forms of this example bring to mind silver by François-Thomas Germain.

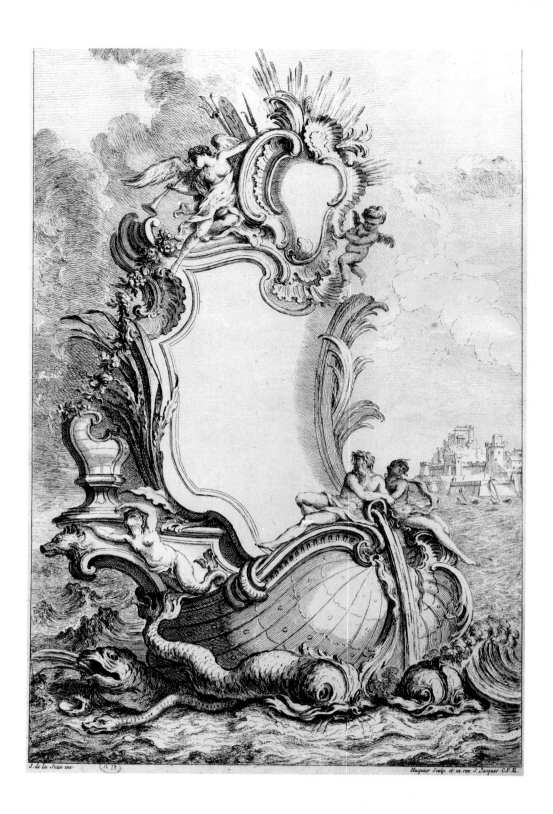

Rocaille ship, print from part 4 of *Livre d'architecture, paysage et
perspectives* (Book of architecture, landscape, and perspectives),
Gabriel Huquier, after a design by Jacques de Lajoue, c. 1740.

Paris, Bibliothèque des Arts Décoratifs

ℒajoue's inclusion of this composition, one of his most successful print
designs, in the *Livre d'architecture* suggests that he considered it to be a bit of
architecture in a marine setting. Its dominant element has very little to do
with the appearance of a real ship, however, for its "sail" is a large cartouche.
The form of the ship's hull repeatedly appears in rocaille artifacts of the
period, from silverware to pulpits.

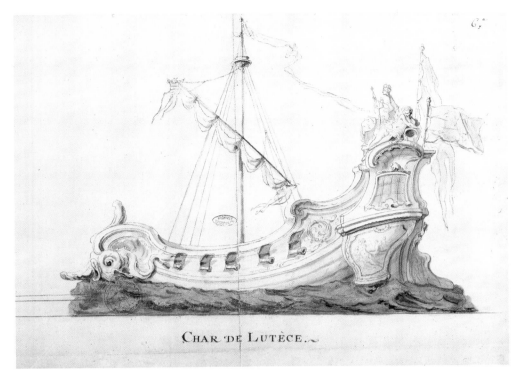

CHAR DE LUTÈCE.

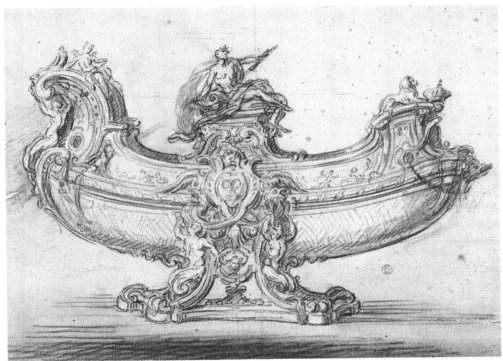

Char de Lutèce (Float of Lutèce),
drawing, wash, and watercolor, Dumesnil, 1747.

Paris, Archives Nationales

On the occasion of the second marriage of the dauphin, son of Louis XV,
the city of Paris organized a procession of allegorical floats. The one called
the *char de Lutèce* (after the ancient Roman name for Paris), as shown
here, bore the city's arms and was inspired by the city's emblem: the repre-
sentation of a ship in agitated water above the Latin motto *"fluctuat nec
mergitur"* (tossed by the waves but does not sink). Here, the vessel has been
recast in the rocaille vocabulary, which often found its most extravagant
expression in ephemeral decor.

Nef of Louis XV,
red charcoal, Paris, c. 1725.

Stockholm, Nationalmuseum

This nef was intended to hold the king's cutlery. Like the float pictured above,
it plays on the allegorical comparison of good government to skillful sailing.
Meissonnier included a print after a design by him for a royal nef in his
published *Oeuvres*, a project that would have been his province as *dessinateur du
cabinet et de la chambre du roi* (draftsman of the king's cabinet and bedroom),
but it is not clear that this drawing represents one of his designs for it.

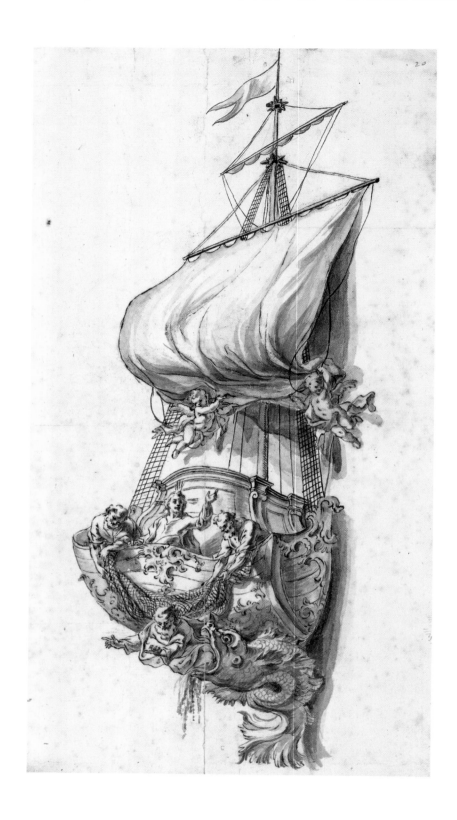

Pulpit, drawing and wash,
Franz Xaver Feichtmayr the younger.

Munich, Staatliche Graphische Sammlung

Baroque pulpits often feature elaborate iconographic schemes, especially those in
Austria and southern Germany. Their designs frequently allude to the wind of
Pentecost or employ aquatic imagery, which is ideal for visualizing the notion of the
word of God as a boundless source of nourishment and succor. In the seventeenth
century, schemes evoking Christ and the apostles as fishers of men became popular.
Some of them incorporate figures of Christ, while others are conceived such that the
preacher of the moment can stand in for him. When treated in a rococo style, as
here, the result is a curious amalgam of sacred and secular imagery.

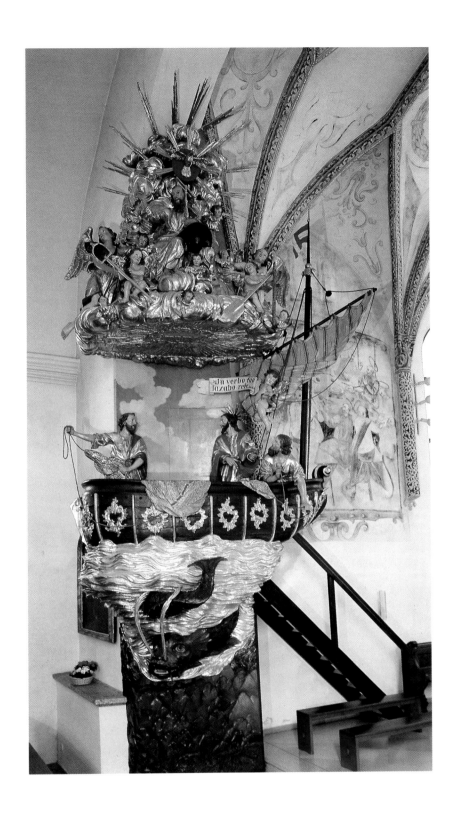

Pulpit, 1759.

Parish church, Fischlam (Austria)

This Austrian pulpit, another example that
uses the fishing simile, is less sophisticated
and more popular in conception. Provincial
work is dominated not so much by allegory
as by an awkward narrative realism, but
the result has irresistible charm.

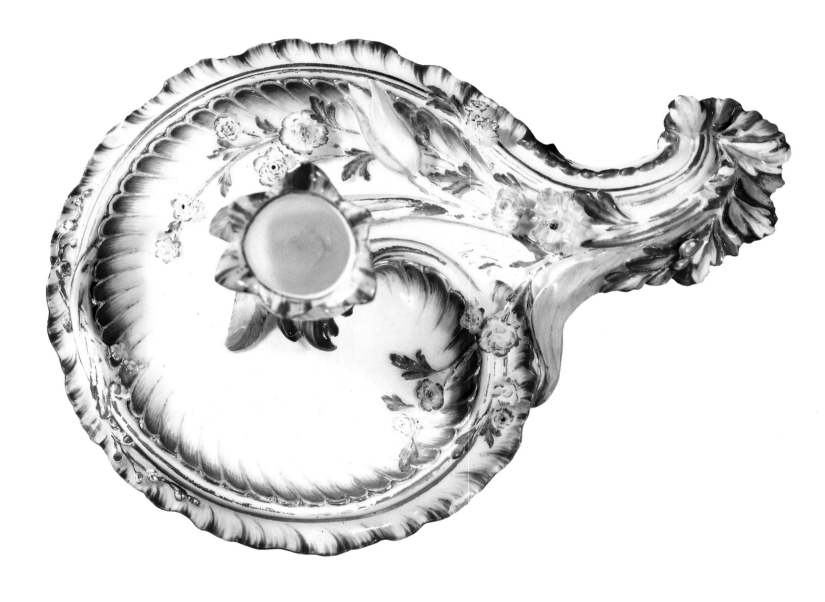

Candleholder,
Vincennes porcelain, 1753.

Sèvres, Musée National de Céramique

This piece is notable for its convenient, easy-to-hold shape and exquisite detailing. Red highlights are used to emphasize the scalloped inner edge as well as the irregular outer one. The base and candle socket flow together in a seamless swirl similar to those in contemporary ironwork and ornament prints, offering an object lesson in the adaptability of such decorative motifs to a wide range of purposes and contexts.

Ceiling of the Golden Gallery
in Charlottenburg Palace, 1742–44.

Berlin, Charlottenburg Palace

ᴰuring the 1740s, Frederick the Great of Prussia had his court architect,
Georg Wenzeslaus Knobelsdorff, add a new wing to Charlottenburg Palace.
Completed in 1746 after designs by Knobelsdorff and Swiss-born sculptor
Johann August Nahl, it included a gallery intended for the display of the king's
finest sculpture *(see also page 223)*. Its ceiling, which is decorated with
gossamer net motifs, rosettes, and rocaille swirls, is a Germanic variation
on decorative themes by Verberckt, Pineau, and Babel.

Ironwork in the Place Royale (detail), Jean Lamour, 1752–54.

Nancy, Place Stanislas

ᵀhe grills in this square in Nancy, dedicated by King Stanislas to Louis xv,
reveal Jean Lamour to have been one of France's finest ironworkers. They are
decorated throughout with gilded flourishes of swirls and foliage like the one
shown here. Such configurations had proliferated in ornament prints in the
1740s, notably those by Babel, whose work seems to have influenced Lamour.
He was an art lover and collector of natural-history curios; it seems likely
that he owned some of Babel's engravings.

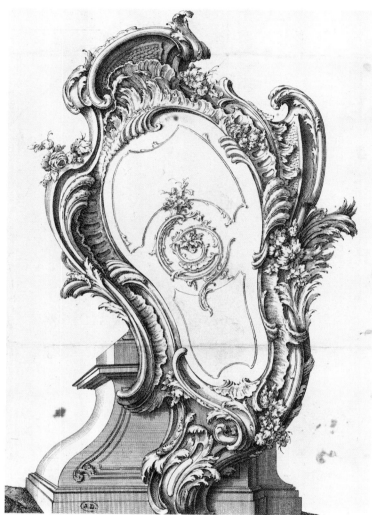

Andiron (overhead view), gilt-bronze,
François-Thomas Germain, 1757.

Paris, Louvre

This andiron (one of a pair) is notable for its large
scale (it is 16 cm high), its superb craftsmanship,
and the vigor of its design. It is composed of two
basic elements: a cassolette with an openwork
cover, and a scrolled rocaille molding that sweeps
outward in a commanding flourish from a rock
form beneath the cassolette's tripod base.

Cartouche, print, Pierre-Edme Babel.

Paris, Bibliothèque des Arts Décoratifs

In this composition, which Babel designed and
engraved himself, the center of the cartouche is
occupied by a spiral motif that appears frequently
in northern European decors and artifacts begin-
ning in the 1740s, in all media, such as wood, metal,
stucco, and porcelain.

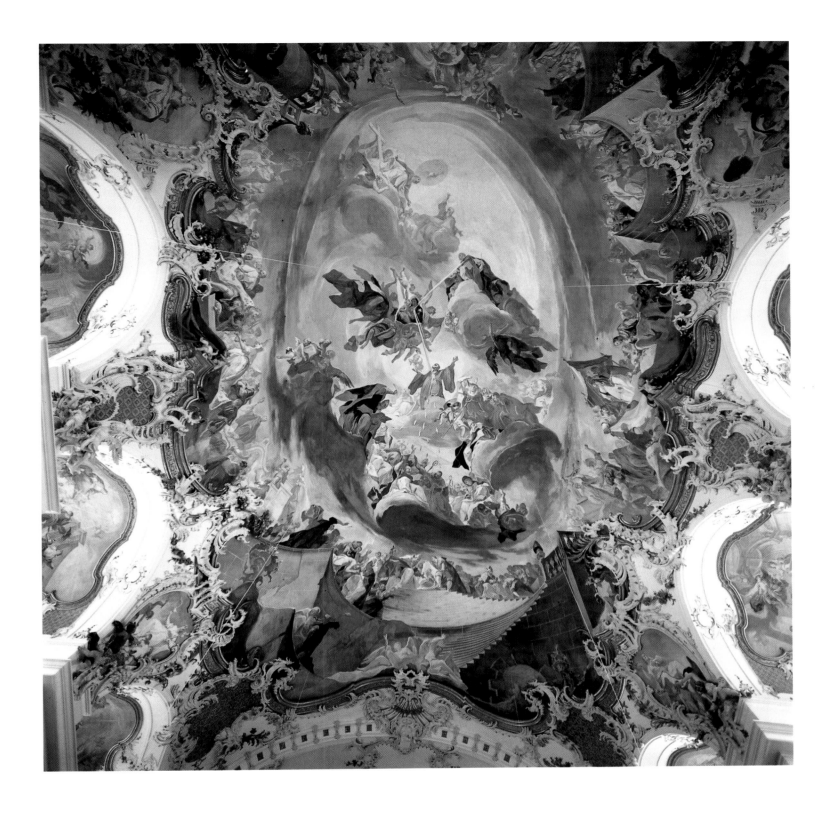

The Vision of Saint Benedict,
frescoed ceiling of the nave,
Benedictine Abbey Church at Zwiefalten,
Franz Joseph Spiegler, 1751.
Zwiefalten, Abbey Church

The vertiginous whirlwind pictured on the ceiling of the church at Zwiefalten makes a powerful impression when viewed from the floor below. Spiegler here combines the graduated golden tones characteristic of the Venetian school with perspective effects perfected by Andrea Pozzo in Rome (and readily accessible in an illustrated treatise by him) to create a disorienting vision that seems about to pull the viewer up and beyond the adjacent filigree stucco ornament. The composition's central feature is a great swirl, a form much favored by eighteenth-century European artists and craftsmen.

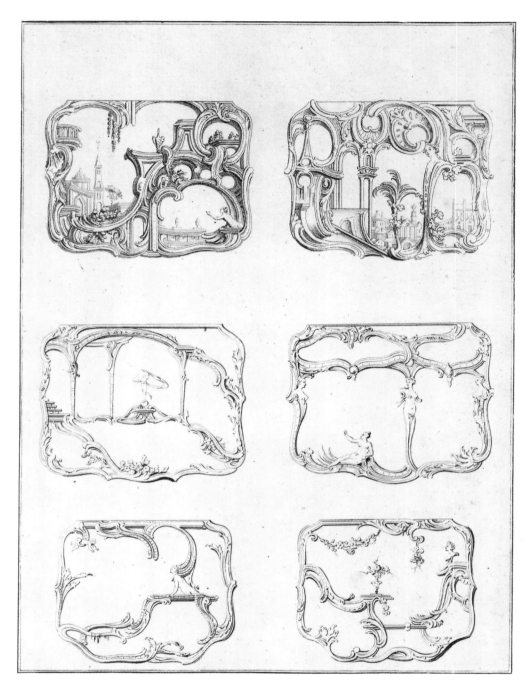

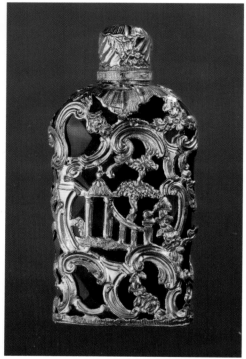

Glass bottle with gold *à cage* case, c. 1750–60.

Paris, Musée des Arts Décoratifs

Designs for snuffboxes, print by Jacob Bonneau (active 1741,
d. 1786) after William De la Cour (active 1740, d. 1767).

London, Victoria and Albert Museum

*A*n eminent English exponent of the rococo, De la Cour designed opera
sets and, about 1741–47, several sets of ornament prints. His idiosyncratic
style is visible in these designs for *à cage* (openwork) metal cases intended
to house snuffboxes in another precious material (*pietra dura*, rock crystal,
etc.). These whimsical compositions, which incorporate female nudes,
have a remarkable lightness and delicacy.

Glass bottle with gold *à cage* case.

Paris, Musée des Arts Décoratifs

*M*etalworkers were clever when it came to devising new outlets for their skill,
and the rococo, with its predilection for objects with metal mounts, presented
greater opportunities for them. Some craftsmen made bottles and vials
entirely of gold and silver, but English metalworkers, following De la Cour's
lead, made a specialty of *à cage* armatures for all sorts of containers. The
illustrated examples may be of French workmanship, for some of De la Cour's
ornament prints were published in France beginning in 1747.

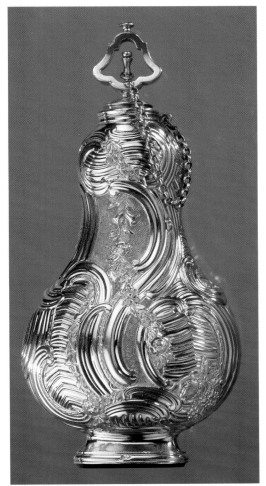

Design for a bottle (?), Juste-Aurèle Meissonnier.

New York, Metropolitan Museum of Art

This drawing, recently acquired by the Metropolitan Museum, has an ambiguity and adaptability typical of rocaille designs. The ribbed or gadrooned areas seem intended to catch the light. If one imagines the form executed on a small scale, the result is a gold or silver vial. If envisioned somewhat larger, it becomes a bronze cane head or coach finial. Alternatively, it could be incorporated into an andiron design like one by Jacques Caffieri featuring motifs that look like tongues of flame (examples in the Cleveland Museum and in the Wallace Collection, London).

Gold bottle.

Paris, Musée des Arts Décoratifs

Coach finial, gilt-bronze.

Normandy, Château d'Eu (near Le Tréport)

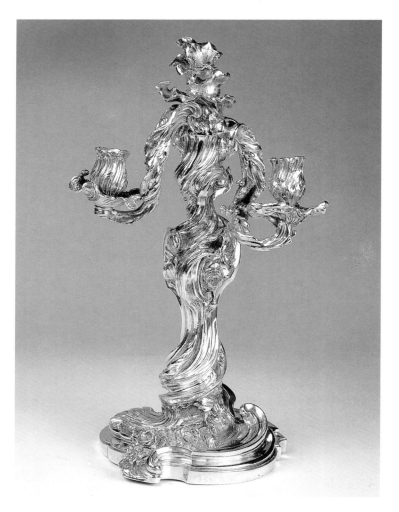

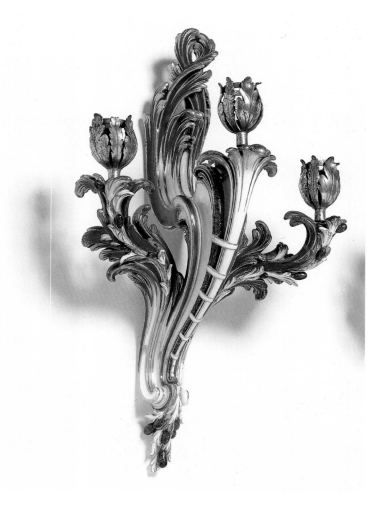

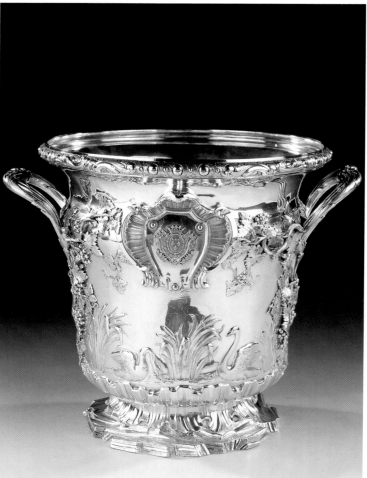

Candelabrum, silver, Claude Duvivier,
after a design by Juste-Aurèle Meissonnier, 1734–35.

Paris, Musée des Arts Décoratifs

Some of Meissonnier's more radical designs all but obliterate the characteristic
form of the object in question, as seen here. The candelabrum's base, stem,
arms, and sockets merge into a flowing mass of gnarls and swirls. A partial con-
cession to conventional form is the inclusion of a bulge to display a heraldic car-
touche bearing a coat-of-arms, which is as contorted as the rest of the piece.

Wall candelabrum, Sèvres porcelain,
Jean-Claude Duplessis the elder, c. 1760.

London, Victoria and Albert Museum

The Sèvres factory made only a few wall candelabra of this design. It is stamped
with the name of Duplessis, who provided the factory with several designs.
Madame de Pompadour owned several pairs, including one in the Hôtel d'Evreux,
her Parisian residence, and another in the Château de Menars. Few European
factories could have matched the virtuosity of these pieces. Vegetal forms pre-
dominate in the design, which should be considered in the context of a tradition
of metal or gilt-bronze wall sconces decorated with small enamel flowers.

Wine cooler from the Orléans-Penthièvre service,
silver, Edme-Pierre Balzac, 1759–60.

The main decorative motifs here are grapes, not surprisingly, and aquatic
scenes, presumably a reference to the duc de Penthièvre's status as a grand
admiral of France. Rocaille forms appear only in the *chicorée* cartouche
surrounding the royal coat-of-arms, the irregular rocklike base, and
some scroll-like flourishes on the lip.

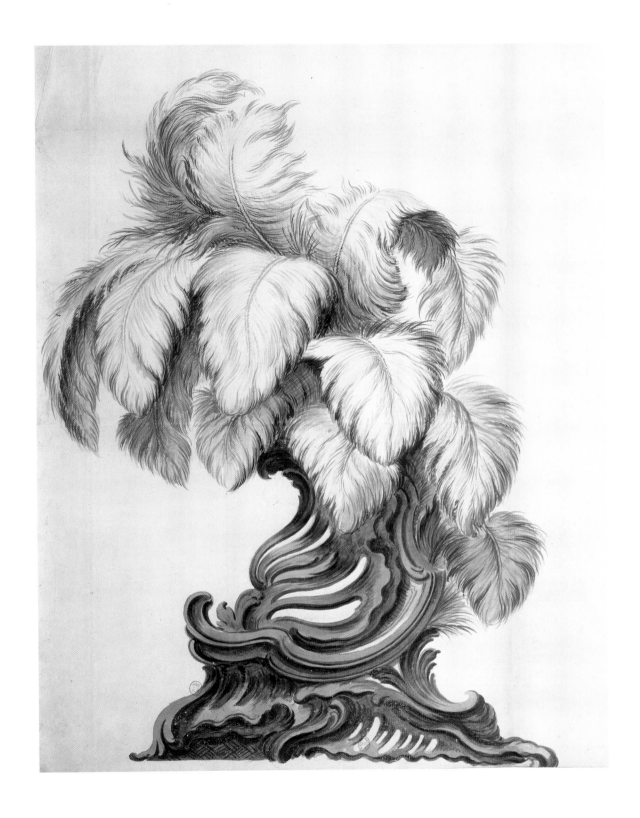

Design for a canopy-bed panache,
drawing and watercolor, 1743.

Paris, Bibliothèque Nationale

*B*ed canopies, like carriage tops, often featured
corner finials. They were made of various materials
and were frequently cast as spheres, obelisks, and
other basic forms—until the early eighteenth
century, that is, when more flamboyant shapes
began to appear. In this example, an openwork
rocaille base is topped by a spray of white feathers.
It is one of a series of designs commissioned for the
Château de Choisy; the use of emerald green
suggests it may have been intended for the
king's bed there *(see page 390)*.

Two prints from *Livre de vases* (Book of vases),
François Boucher, 1734.

Paris, Bibliothèque d'Art et d'Archéologie, Fondation Jacques Doucet

The print shown at the upper left, from a collection published by Huquier,
represents a vase on a pedestal in the niche of a grotto. All the vase's
component forms are natural, as in Chedel's ornamental caprices *(see page 337)*,
but here the final effect remains unforced, as opposed to the exaggerated
profusion typical of Chedel.

The print at the right, which is the final image in the collection of vase
designs, offers detailed views of the base, handle, and lid of a ewer plus
a small schematic rendering of its overall shape. The fluency of these
decorative elements is typical of Boucher's ornament designs.
(See illustration on facing page).

Chocolate-pot of Queen Marie Leszczynska, vermeil,
Henri-Nicolas Cousinet (active 1724–68), 1729.

Paris, Louvre

This pot belonged to a *nécessaire* set with matching rosewood case presented
to the queen after the birth of the dauphin in 1729. In acknowledgment of the
occasion, dolphins figure prominently in its design. However, the ornamental
profusion characteristic of rocaille ornament has been kept in check, with the
marine forms confined to just a few discrete areas.

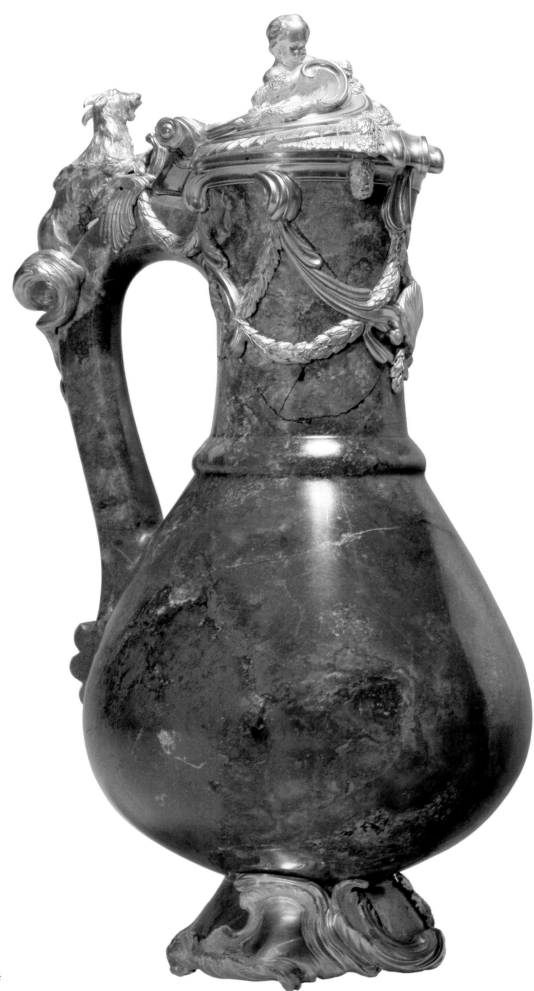

Ewer, jasper with gold mounts
(mounts: 1734–35).
Lisbon, Gulbenkian Foundation

This ancient jasper ewer has been given gold
mounts, a typical practice of the period.
Comparison with the print of a similar ewer
design *(facing page)* suggests that these
elements were designed by Boucher; we
cannot be absolutely sure, because the print
does not bear his name. But what is clear
from the photograph of the object—that the
designer added the mounts to a preexisting
ewer—explains why only the mounts were
depicted in the print. The complex cartouche
form of the base, the elaboration of the
handle, and the sensuous swirl of the lid make
these additions typical rocaille artifacts.

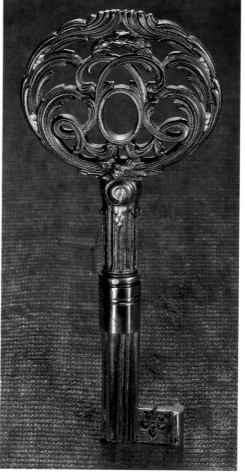

Models for an alphabet, print, Rouger.

Paris, Bibliothèque des Arts Décoratifs

Since the invention of the printing press, ornamentalists have devised decorative alphabets consistent with the taste of their day. Elaborate letter forms such as these were intended as models for decorative artists in creating monograms on a wide range of objects.

Key to the desk of Louis xv, gilt bronze, 1760–69.

Versailles, Musée National du Château

The famous rolltop desk made by Jean-François Oeben (c. 1721–1763) and Jean-Henri Riesener for the king's office at Versailles is both a mechanical wonder and a masterpiece of the cabinetmaker's art. A single turn of its key secured all of its locks. The key itself is decorated with the royal monogram of interlocking *L*'s, here enclosed within an oval and given an unusually sinuous character.

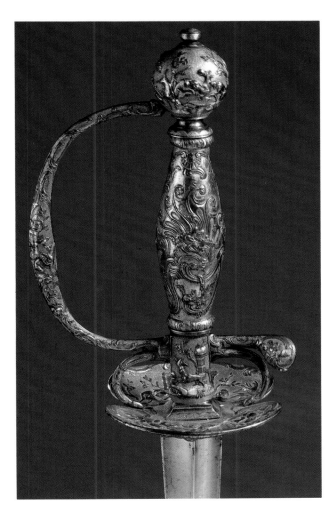

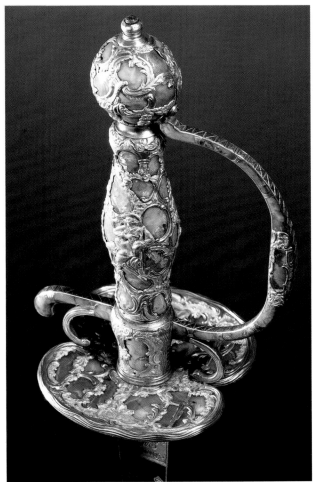

Sword handle, partially gilded silver,
eighteenth century.
Paris, Musée des Arts Décoratifs

Sword handle, *pietra dura* with *à cage*
gold case, mid-eighteenth century.
Paris, Louvre

The handles and hilts of ceremonial swords—
which were worn as important emblems of status
in this period—were a privileged site for the
display of decorative arts craftsmanship. In some
cases they were conceived as *à cage* armatures
encasing a semiprecious material, an approach
that gave free rein to the rocaille delight in spatial
ambiguity and eccentric forms.

Cane handle, silver gilt.
Paris, Musée des Arts Décoratifs

Even cane handles were given sensuous rocaille
forms during this period; indeed, the gentle
S-curve format used here seems made to order
for this purpose, and the richly worked surface
would have improved the user's grip.

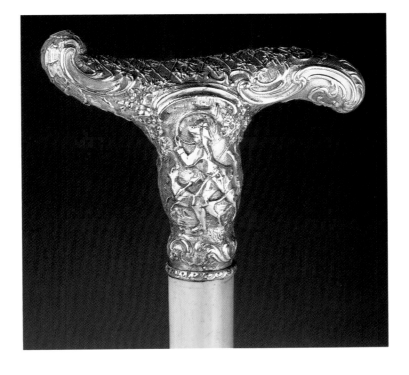

Two berlins (details).

*Vila Viçosa (Portugal), Museu Nacional des Coches,
on loan from the Bragance Foundation*

The two berlins (four-wheeled enclosed coaches) shown here were made for the Portuguese court, probably by French artisans. If so, they are among a handful of surviving examples made by Parisian craftsmen specializing in the production of these elaborate vehicles, and are all the more precious for retaining their painted panels. These are given considerable emphasis, more elaborate even than the sinuous forms of the enclosing frames, which in the upper example have been carved in an extravagant rocaille idiom. The central panel in both examples is dominated by an elaborate cartouche bearing the arms of the Portuguese royal house. In the lower example, this motif is surrounded by fountains, twisting stairways, swirls, and precarious pavilions adorned with floral swags, sustaining an illusion of spatial continuity "behind" the gilded moldings. A sense of spatial recession is also created through the judicious use of orange highlights in the foreground and dark shadows in the more distant layers of depth. The color schemes of both, which emphasize gold, red, and green, are not unlike those used in Gobelins tapestries, notably the *Loves of the Gods* series, and the resemblance may not be fortuitous: many varnished and painted panels for screens and coaches are known to have been produced at the Gobelins factory.

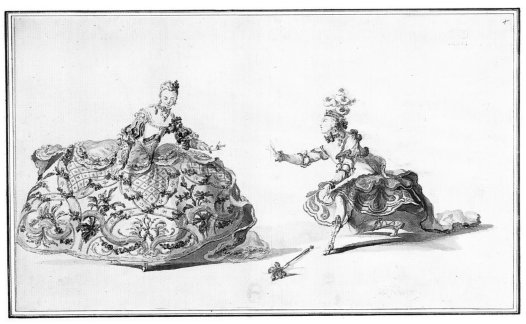

Scene from an opera,
drawing and watercolor,
Louis-René Boquet, c. 1757.

Boquet was a costume designer who worked for
the Menus Plaisirs beginning in 1764, occasionally
collaborating with Boucher and the Slodtz
brothers. Rocaille forms were especially favored
for festival decorations, and here we see how they
could be integrated into theatrical costume. These
figures bring to mind the accusation against
Boucher that he had populated his pictures with
shepherdesses in hoop skirts from the opera, a
criticism that implicitly targeted the entire rocaille.

In any case, the heightened illusionism and
artificiality of the style's vocabulary made it ideal
for theatrical presentations with a fantastic bent.

Tobacco grater, wood, c. 1735.
Paris, Musée des Arts Décoratifs

Even utilitarian objects were sumptuously
decorated in the eighteenth century. The central
element on the panel of this grater is a cascade
of musical instruments in the arabesque tradition,
but the lower end is carved with the form of a
shell and the top with a skewed cartouche.

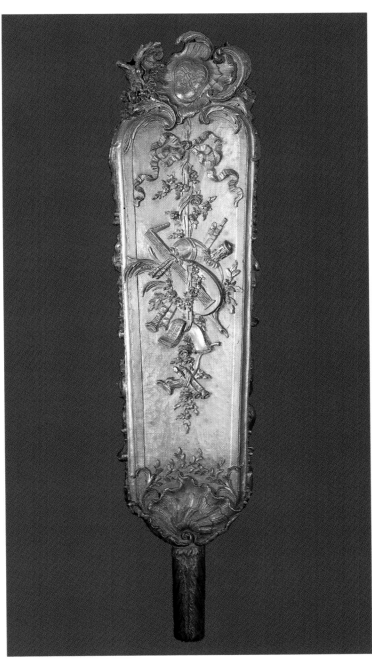

FACING PAGE

Design for a mantelpiece, ink and wash,
John Linnel (d. 1796), 1754.
Montreal, Canadian Center for Architecture

Linnel was among the most original of English
rococo designers. He was especially adept at
devising rococo decorative schemes that would
appeal to English taste. In this case he filled the
overmantel with a delicate network of simple
scrolled moldings and branches of foliage framing
a central Gothic pavilion. The innate affinity
between the rococo and Gothic styles, both of
which stress linear profusion, had yet to emerge in
France, but the suggestion of it in this mantelpiece
design parallels the early appearance of a Gothic
Revival movement in England. French critics
spoke admiringly of the technical achievements
embodied in the great Gothic cathedrals, but they
continued to use the term negatively in relation to
the decorative arts until the Revolution.

Kleine Palazzo, Gartensaal, Carl Philipp
von Gontard (architect), 1760–62.
Bayreuth, Neues Schloss

This small palace, built for the second wife of the
margrave of Bayreuth, was subsequently connected
to a wing of the Neues Schloss. This "garden
room" is a two-story space in the Italian style
meant to effect a transition between the garden and
the interior apartments. Each element of its decor
provides a pretext for ornate stucco work in the
mode favored by northern Italian stuccadors.

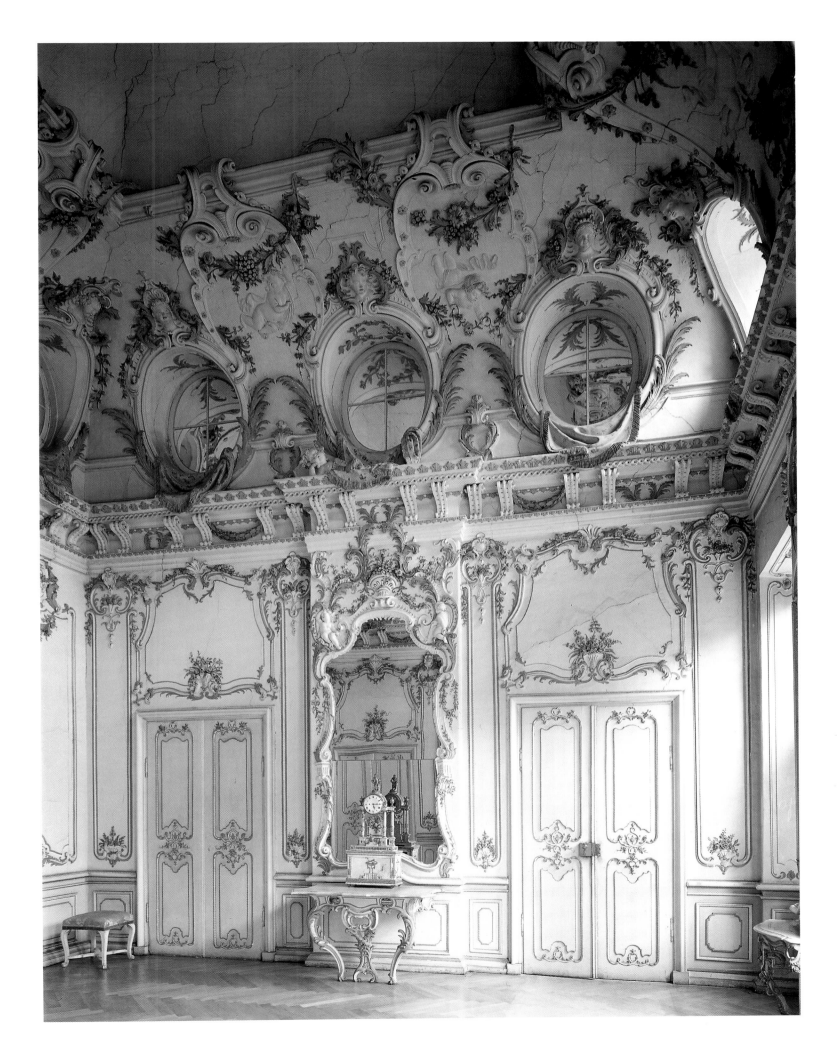

FACING PAGE

Lateral stall, Santa María de Victoria,
Bürgersaal, Michael Vogel and
Andreas Hofkofler, 1748.

Ingolstadt (Germany)

From 1732 to 1736, the Asam brothers oversaw the
decoration of this room in the Jesuit college in
Ingolstadt, an important Bavarian university town.
The upper part of this stall, which is fixed to one
of its side walls, is decorated with rococo swirls
and flourishes in gilt-bronze that are meant
to harmonize with the gilt-wood frame hanging
on the wall above it.

Pulpit, Domenikus Zimmermann and
Pontian Steinhauser, c. 1750.

Wies, pilgrimage church

The crowds of pilgrims visiting this church
listened to sermons delivered from this ornate
pulpit fixed to one of the white pillars of the
nave, one of the most dazzling of all rococo
productions. The design, which grows more and
more complex as the eye ascends, incorporates
many tiny cascades of water and is meant to
evoke the Pentecostal wind that descended
on the apostles, inspiring them to preach
the gospel *(see also pages 370–71)*.

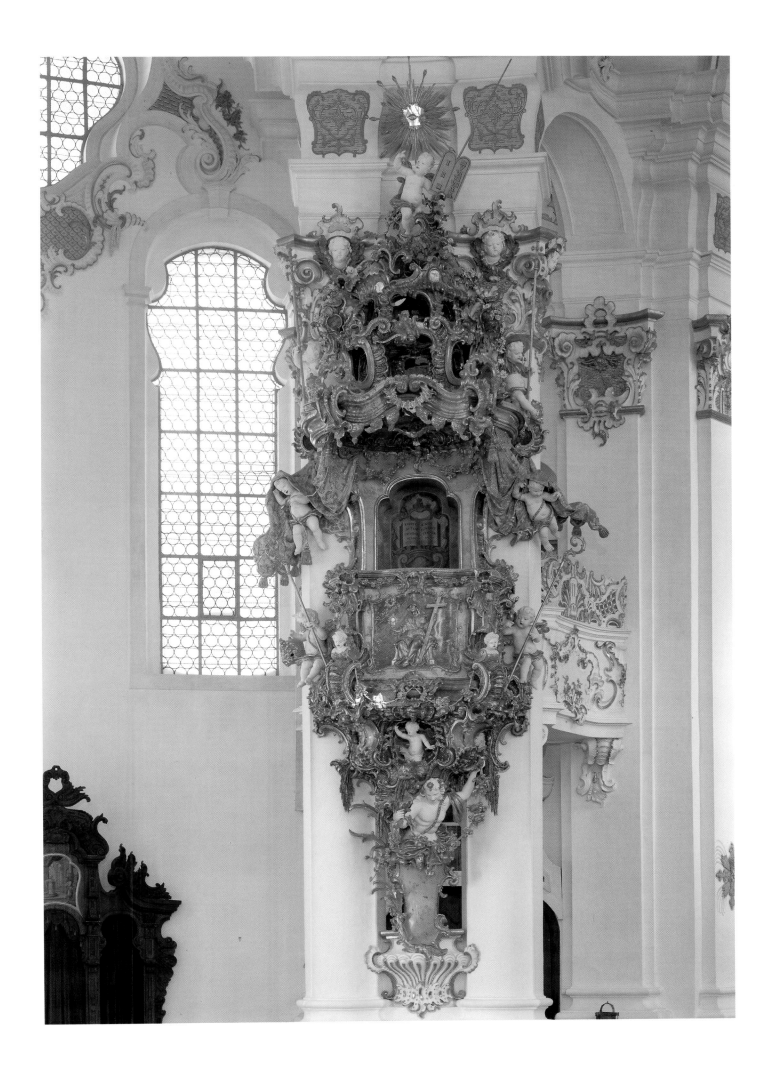

Appendixes

Architecture, Interior Decoration, and Furniture in Europe from 1630 to 1760

*T*he photographs on the following pages offer a representative sampling of architecture, interior decoration, and furniture in seven European countries or regions during the period of classicism and the Baroque: France, Italy, Great Britain, the Netherlands and Scandinavia, Spain and Portugal, the Germanic countries, and eastern Europe.

It seemed advisable, in addition to providing a history of ornament proper, to give some idea of the sequence of "styles"—that is, the changing or recurring characteristics (such as forms and materials) that define the aesthetic ensembles of these periods and geographic areas. The selection has been made with the intention of clarifying national traditions as well as the international currents to which indigenous productions contributed.

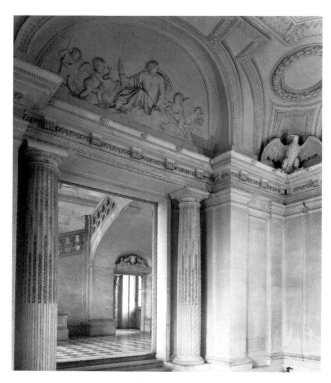

François Mansart, Château de Maisons, vestibule,
Maisons-Lafitte (on the outskirts of Paris), 1642–51.

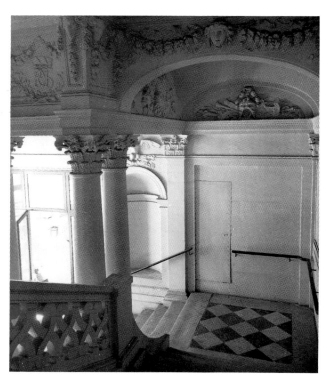

Antoine Le Pautre, Hôtel de Beauvais,
stairway, Paris, 1652–55.

François Mansart, Château de Balleroy,
garden façade, c. 1626.

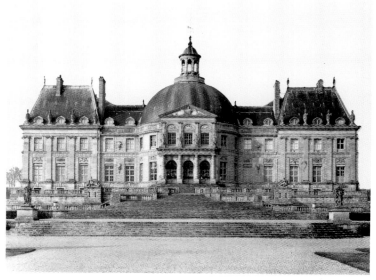

Louis Le Vau, Château de Vaux-le-Vicomte,
garden façade, 1656–61.

Louis Le Vau and Jules Hardouin-Mansart, Château de Versailles, central block and southern wing, garden façade, 1669–85.

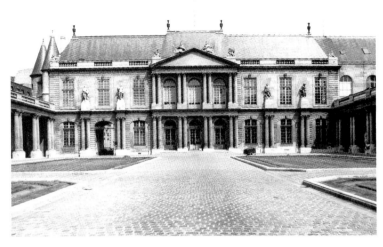

Pierre-Antoine Delamair, Hôtel de Soubise (now Archives Nationales), cour d'honneur, Paris, 1705–7.

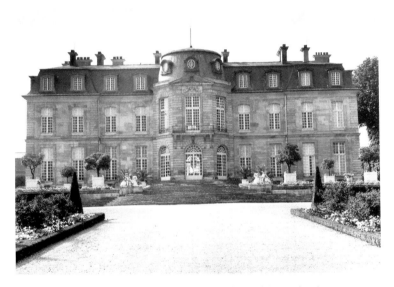

Pierre Bullet and Jean-Baptiste Chamblain, Château de Champs, garden façade, Champs-sur-Marne, c. 1701–7.

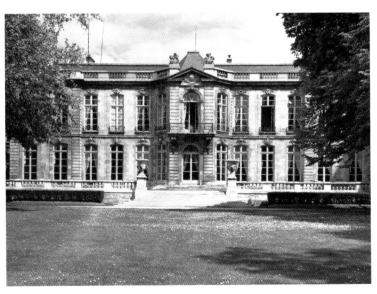

Pierre Courtonne, Hôtel de Matignon, garden façade, Paris, 1721.

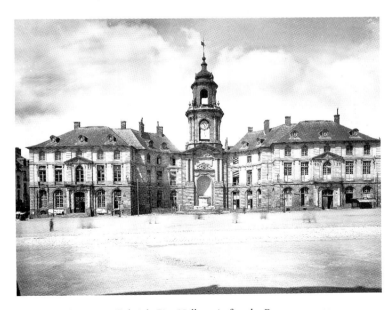

Jacques v Gabriel, City Hall, main façade, Rennes, c. 1730.

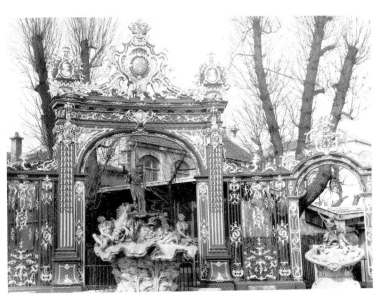

Emmanuel Héré and Jean Lamour, Place Stanislas, Neptune fountain, Nancy, 1752–55.

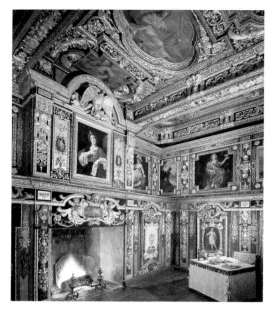

Anonymous, Château de Cormatin, study of
Marquis d'Huxelles, c. 1630.

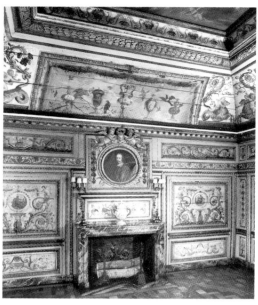

Anonymous, study from the Hôtel Colbert de
Villacerf, c. 1650, Paris, Musée Carnavalet.

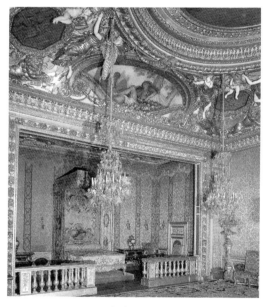

Louis Le Vau and Charles Le Brun, Château de
Vaux-le-Vicomte, king's bedroom, 1657–61.

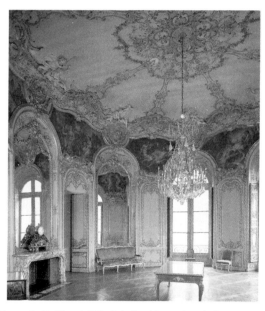

Germain Boffrand, Hôtel de Soubise, salon de la princesse
(with spandrel paintings by Charles Natoire), Paris, 1735–39.

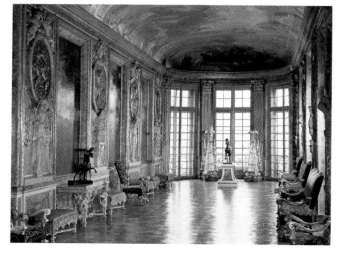

Louis Le Vau and Charles Le Brun, Hôtel Lambert,
Hercules Gallery, Paris, c. 1650–60.

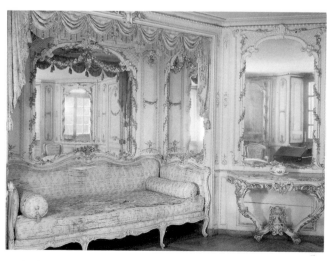

Charles-François Normand, Château de Millemont, boudoir,
mid-eighteenth century.

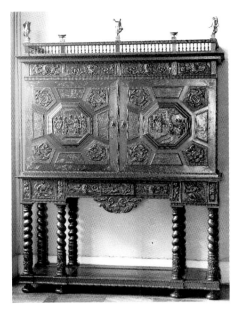

Anonymous, cabinet, ebony, France, second quarter of
the seventeenth century. Paris, Musée des Arts Décoratifs.

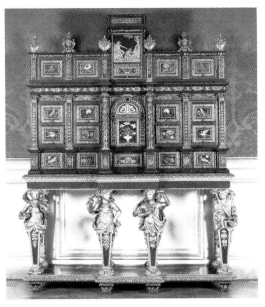

Gobelins factory, cabinet, ebony plaques, *pietra dura* marquetry,
gilded wood, c. 1680. Strasbourg, Musée des Arts Décoratifs.

Pierre Golle (?), cabinet, ebony, tortoiseshell, violetwood,
and rosewood marquetry set into an ivory ground, c. 1661–62.
London, Victoria and Albert Museum.

Anonymous, armchair, carved walnut, France,
c. 1650. Paris, Musée des Arts Decoratifs.

Anonymous, console, carved oak, France, c. 1700.
Paris, Musée des Arts Decoratifs.

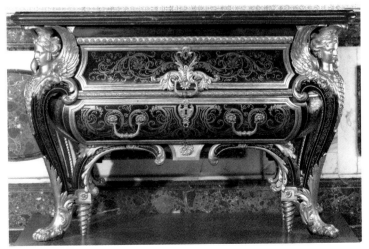

André-Charles Boulle, commode, ebony inset with copper and
brass against a tortoiseshell ground, gilt-bronze fittings, 1708–9.
Versailles, Musée National du Château.

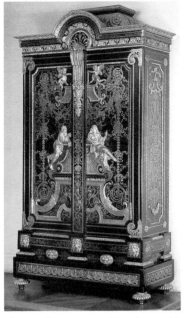

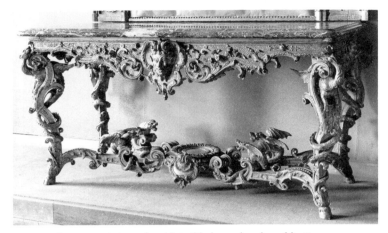

André-Charles Boulle, armoire, ebony inset with copper and brass against a tortoiseshell ground, gilt-bronze fittings, c. 1700–10. Paris, Louvre.

Anonymous, console table, gilded wood, red marble, France, first quarter of the eighteenth century. Paris, Musée des Arts Décoratifs.

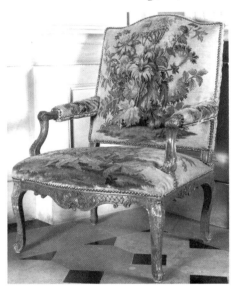

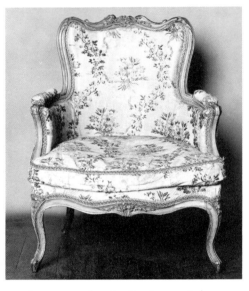

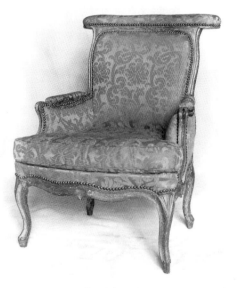

Anonymous, armchair (one of a pair), carved walnut, France, c. 1725–30. Paris, Musée des Arts Décoratifs.

Anonymous, bergère, Louis xv period. Paris, Musée des Arts Décoratifs.

Jean-Baptiste Tilliard, bergère voyeuse, carved beech, c. 1750. Paris, Musée des Arts Décoratifs.

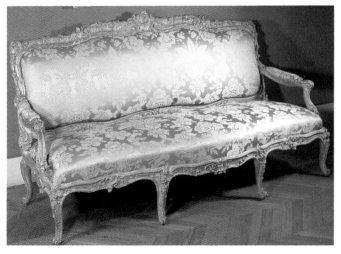

Nicolas Heurtaut (?), canapé, carved and gilded beech, c. 1753. Paris, Musée des Arts Décoratifs.

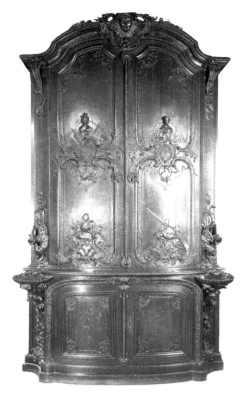

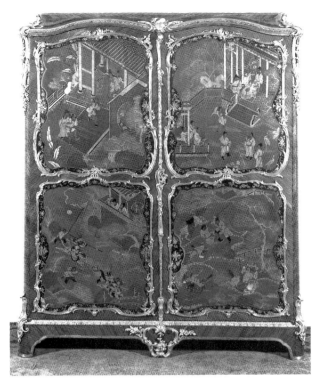

Anonymous, two-piece armoire, carved oak,
Aix-en-Provence (?), c. 1750. Paris,
Musée des Arts Décoratifs.

Bernard II van Risenburgh, armoire, rosewood, violetwood,
Chinese lacquer panels, gilt-bronze mounts, c. 1750–55.
Paris, Louvre.

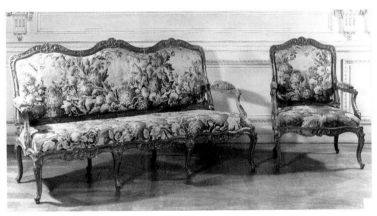

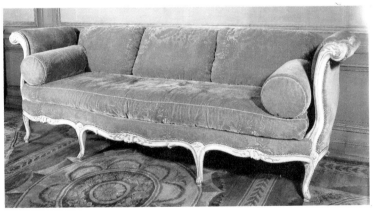

Pierre Gillier, canape and armchair, gilded wood, Aubusson tapestry
upholstery, c. 1750–55. Paris, Musée des Arts Décoratifs.

Jean Avisse, settee, painted wood, c. 1755. Paris, Musée Camondo.

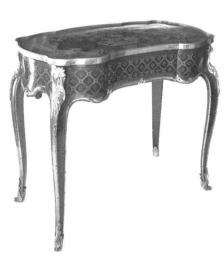

Jean-François Œben, writing table, wood
and stained ivory, 1755–60. Paris, Louvre.

Roger Vandercruse Delacroix,
cabaret table, c. 1760. Paris,
Musée Camondo.

Bernard II van Risenburgh and Simon Philippe Poirier, commode,
amboyna wood, Sèvres porcelain plaques, gilt-bronze mounts,
red and brown marble, c. 1760. Private collection.

Carlo Maderna and Gian Lorenzo Bernini, Palazzo Barberini,
Rome, 1628–33, central portion of main façade.

Gian Lorenzo Bernini, Palazzo Chigi-Odescalchi, main façade,
Rome. From 1664.

Baldassare Longhena, Palazzo Pesaro, Grand Canal façade,
Venice, 1679–1710.

Guarino Guarini, Palazzo Carignan, façade, Turin, 1680.

Filippo Juvarra, Villa Reale, main façade, Stupinigi, 1729.

Ferdinando Fuga, Palazzo della Consulta, main façade,
Rome, 1732–34.

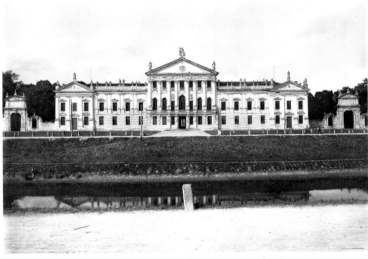

Francesco Maria Preti, Villa Pisani, main façade,
Stra, 1735–56.

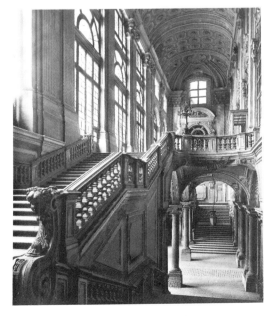

Filippo Juvarra, Palazzo Madama,
grand staircase, Turin, 1718.

Pietro da Cortona, ceiling of the grand salon,
Palazzo Barberini, Rome, 1633–39.

Pietro da Cortona, Jupiter Room in the Palatine Gallery,
detail of stucco decoration, Palazzo Pitti, Florence, 1643–45.

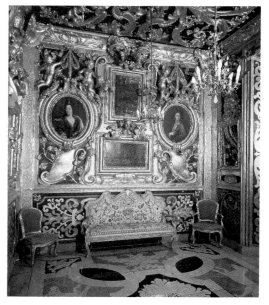

Anonymous, small salon, Rocca dei Meli-Lupi,
Soragna (Emilia-Romagna), c. 1690.

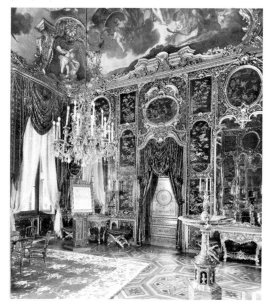

Filippo Juvarra, Chinese room,
Palazzo Reale, Turin, 1732–36.

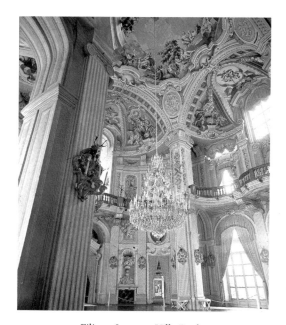

Filippo Juvarra, Villa Reale,
central grand salon, Stupinigi, 1729–31.

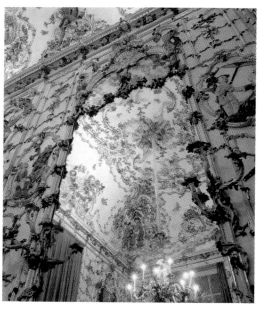

Giuseppe et Stefano Gricci, Porcelain room from the
Château de Portici, 1757–59. Naples, Musée National
de Capodimonte.

Anonymous, table, walnut, Piedmont, 1630. Turin, Museo Civico.

Daniel Seiter, console, carved and gilded wood, Piedmont, late seventeenth century. Turin, Palazzo Reale.

Leonardo van der Vinne, cabinet, ivory and wood inlay against an ebony ground, base of carved, painted, and gilded wood, 1667. Florence, Palazzo Pitti.

Giovanni Battista Foggini, cabinet, ivory inlay against an ebony ground, onyx columns, carved base, late seventeenth century. Florence, Palazzo Pitti.

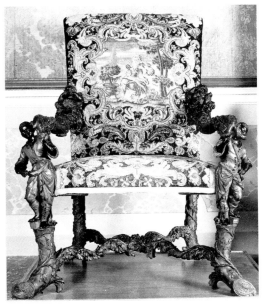

Andrea Brustolon, armchair, boxwood and ebony, c. 1684–96. Venice, Ca' Rezzonico.

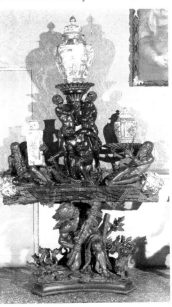

Andrea Brustolon, console table, boxwood and ebony, early eighteenth century. Venice, Ca' Rezzonico.

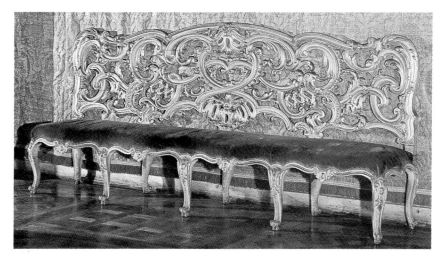

Anonymous, banquette, carved and gilded wood, Piedmont,
mid-eighteenth century. Turin, Palazzo Madama.

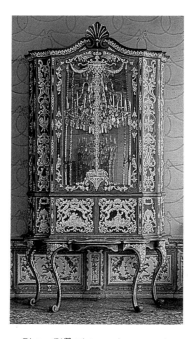

Pietro Piffetti, two-piece armoire,
ivory and wood marquetry inlay,
c. 1739. Stupinigi, Villa Reale.

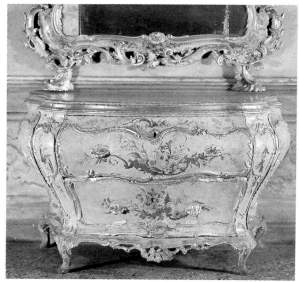

Anonymous, *bombé* commode, wood with painted
flowers against a yellow ground, Venice, c. 1750.

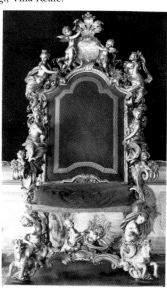

Antonio Corradini (?), ceremonial
chair, carved and gilded wood,
c. 1730. Venice, Ca' Rezzonico.

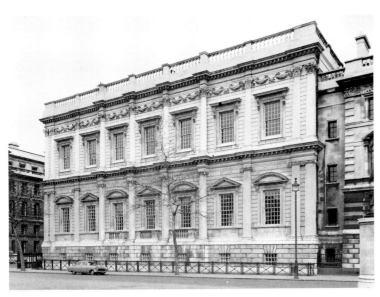

Inigo Jones, Whitehall, Banqueting Hall, façade, London, 1619–22.

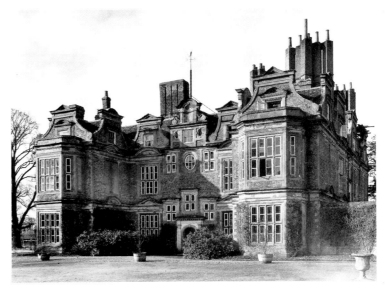

Anonymous, Swakeleys (Middlesex), main façade, 1629–38.

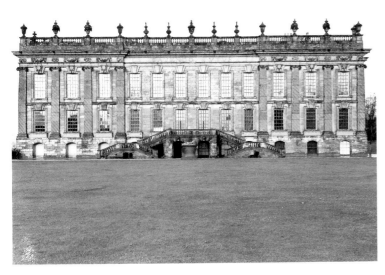

William Talman, Chatsworth, garden façade, 1687–96.

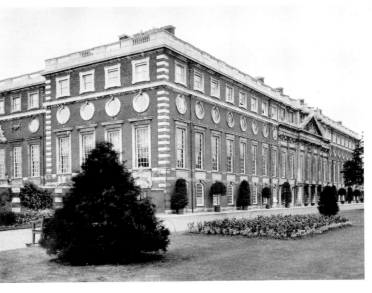

Christopher Wren, Hampton Court, east wing, 1689–1701.

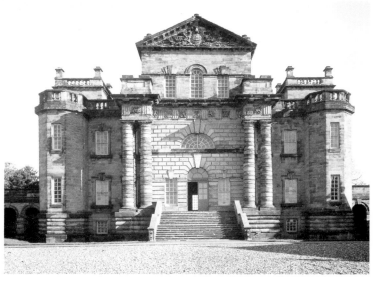

John Vanbrugh, Seaton Delaval Hall (Northumberland),
north façade, 1718–28.

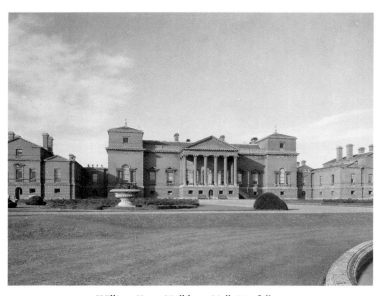

William Kent, Holkham Hall (Norfolk),
main façade, 1734–61.

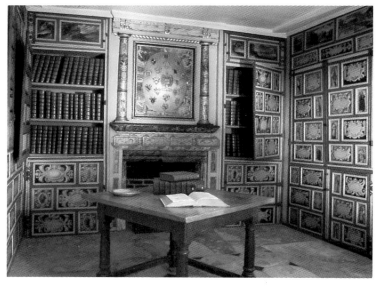

Anonymous, Langley Marsh (Buckinghamshire),
Kidderminster Library, c. 1625–31.

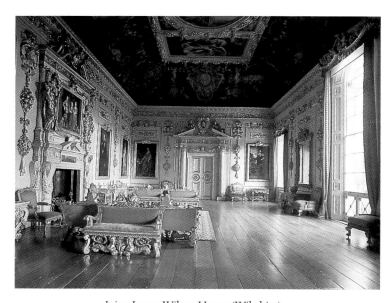

Inigo Jones, Wilton House (Wiltshire),
Double Cube Room, c. 1649.

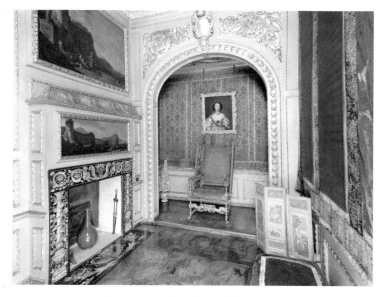

Anonymous, Ham House (Surrey),
Queen's Drawing Room, c. 1675–80.

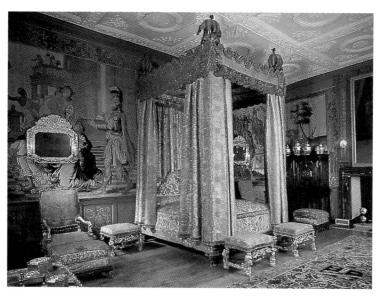

Anonymous, ceremonial bed of James I (?), King's Bedroom,
Knole, Sevenoaks (Kent), c. 1685.

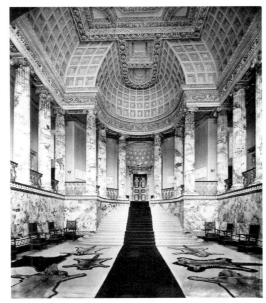

William Kent, Holkham Hall (Norfolk),
Marble Hall, 1734–61.

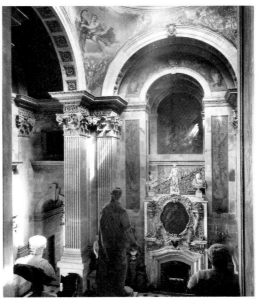

John Vanbrugh, Castle Howard (Yorkshire),
vestibule, 1699–1712.

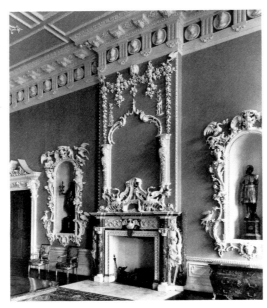

Claydon House (Buckinghamshire), grand north
salon, carved decoration by Luke Lightfoot, c. 1750.

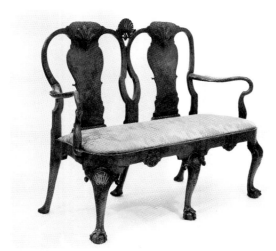

Anonymous, canapé for two, [?] walnut, England, c. 1725.
Toledo Museum of Art, Ohio (gift of Florence Scott Libbey).

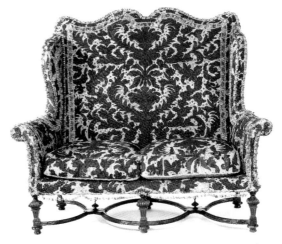

Anonymous, canapé for two (made for Count Conyngsby),
c. 1695. London, Victoria and Albert Museum.

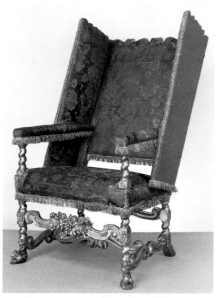

Anonymous, recliner, Ham House,
gilded wood, c. 1677–79. London,
Victoria and Albert Museum.

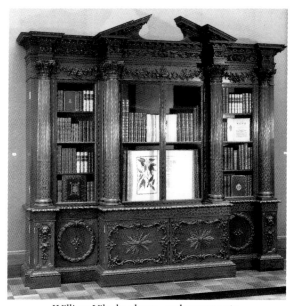

William Vile, bookcase, mahogany, 1762.
Buckingham Palace, Royal Collection.

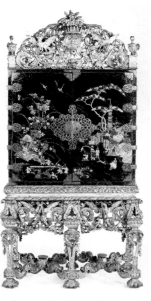

Anonymous, cabinet, Japanned panels, tortoiseshell, gilded wood,
England, late seventeenth century. London, Victoria and Albert Museum.

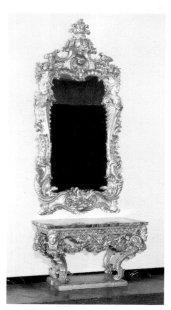

Matthias Lock, console table and mirror, carved and gilded wood,
c. 1745. London, Victoria and Albert Museum.

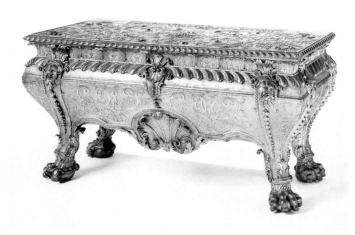

Anonymous, "Bateman Chest," gilded wood, c. 1720.
London, Victoria and Albert Museum.

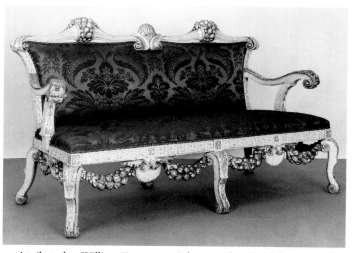

Attributed to William Kent, canapé, lacquered and gilded pinewood,
c. 1735. London, Victoria and Albert Museum.

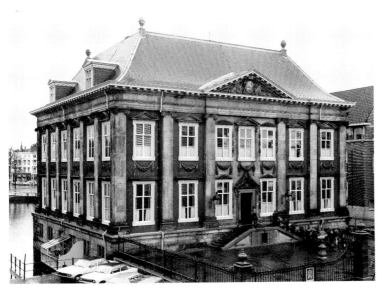

Jacob van Campen, Mauritshuis, The Hague, c. 1633.

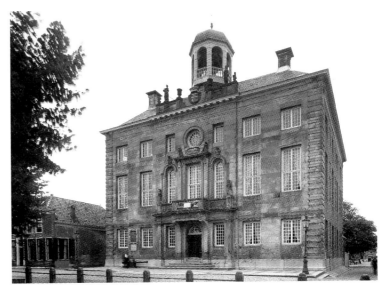

Steven Vennecool, City Hall, façade, Enkhuizen, 1686.

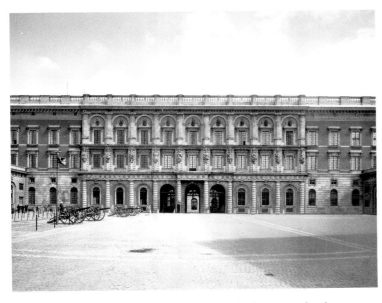

Nicodemus Tessin the younger, Royal Palace, main façade, Stockholm, after 1697.

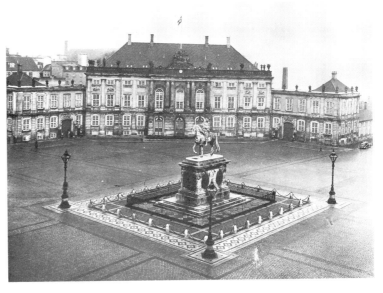

Nils Eigtved, Amalienborg Square, Copenhagen, from 1750.

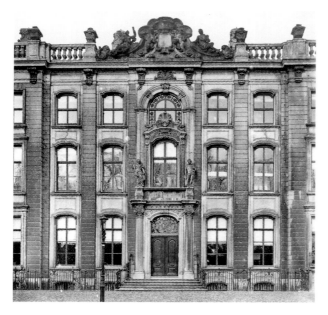

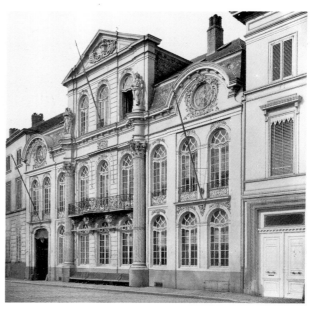

Daniel Marot, Hôtel Huguetan (now Royal Library),
main façade, The Hague, 1754.

Bernard de Wilde, Hôtel Falligan, main façade,
Ghent, 1755–63.

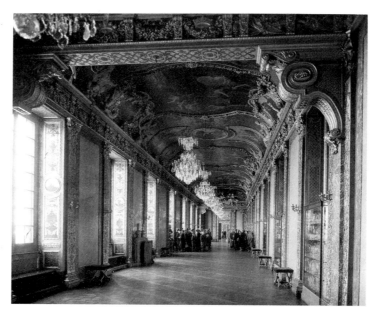

Nicodemus Tessin the younger, Grand Gallery (gallery of Charles XII),
Royal Palace, Stockholm, first quarter of the eighteenth century.

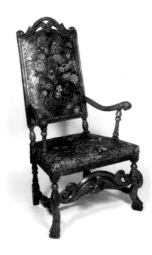

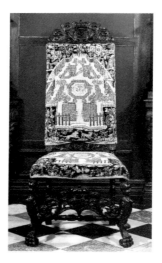

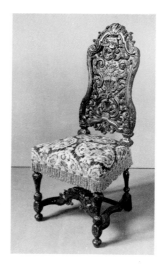

Anonymous, armchair in the English style,
oak, gilded leather upholstery, Norway,
c. 1700. Oslo, Kunstindustrimuseet.

Anonymous, chair, carved wood,
tapestry upholstery, early eighteenth century.
Copenhagen, Rosenborg Castle.

Anonymous, chair, carved
walnut, Netherlands, c. 1730.
Amsterdam, Rijksmuseum.

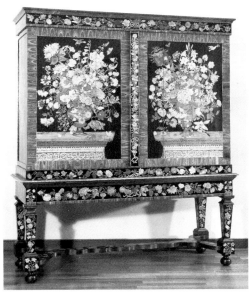

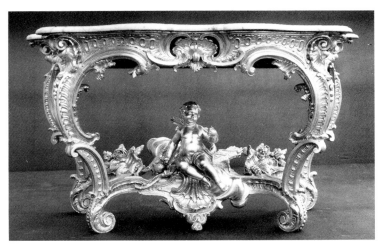

Jan van Mekeren, cabinet, marquetry in various
woods, c. 1690. Amsterdam, Rijksmuseum.

Carl Harlemann (after), console, carved and gilded wood, c. 1745.
Stockholm, Royal Palace.

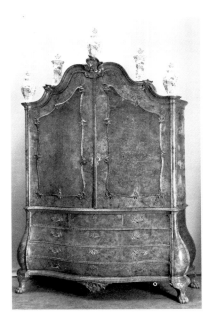

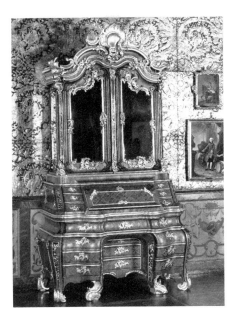

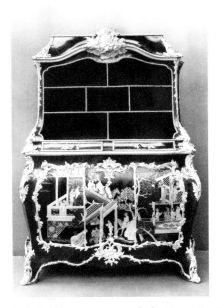

Anonymous, commode-cabinet surmounted
by porcelain vases, Holland, c. 1750–60.
Amsterdam, Rijksmuseum.

Christian-Friedrich Lehmann, desk-cabinet, bone and
ivory inlay against a metal ground, gilded wood with gilt-
bronze mounts, 1755. Copenhagen, Rosenborg Castle.

Nils Dahlin, secretaire made for Queen Lovisa
Ulrika of Sweden, oriental lacquer, gilt-bronze
mounts, 1771. Tullgarn, Royal Palace.

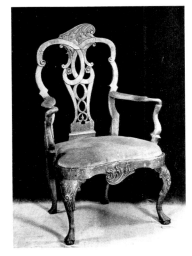

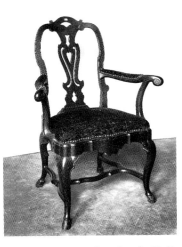

Anonymous, armchair with rocaille decoration,
carved walnut, Norway, c. 1770. Bergen,
University of Bergen, Historical Museum.

Anonymous, armchair, beech, Holland,
first half of the eighteenth century.
Amsterdam, Rijksmuseum.

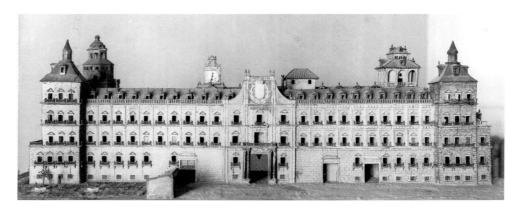

Juan Gómes de Mora, Alcazar, main façade, Madrid, 1608–30.
Scale model, Madrid, Municipal Museum.

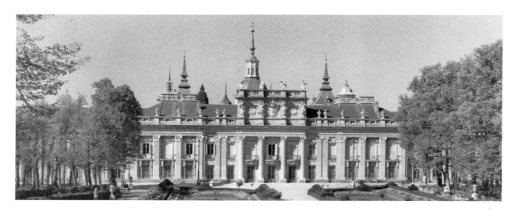

Teodoro Ardemans, La Granja, park façade, San Ildefonso, 1719–23.

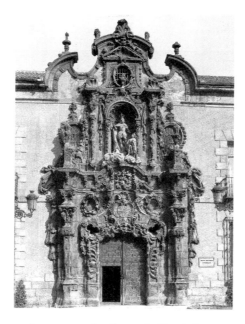

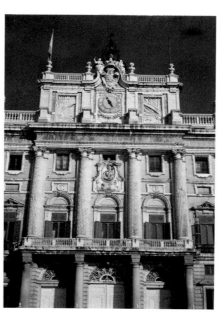

Anonymous, San Fernando Hospital
(now the Municipal Museum and Library),
monumental portal, Madrid, c. 1726.

Filippo Juvara and Giambittista Sacchetti,
Royal Palace, main façade, Madrid, 1734–64.

Alberto Churriguera and Andrés Garcia de Quiñones, Plaza Mayor, Salamanca, completed 1755.

Santiago Bonavia and Francisco Sabatini, Royal Palace, Aranjuez, west façade, 1752 and 1772–78.

University library, interior view, Coimbra (Portugal), 1716–28.

Royal Palace, Throne Room, Madrid. Ceiling frescoed by Giambattista Tiepolo, 1764.

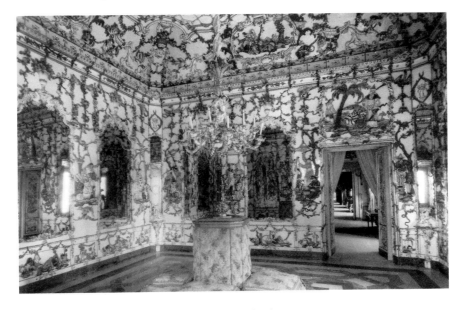

Giuseppe Gricci, porcelain room, Royal Palace, Aranjuez, c. 1750–60.

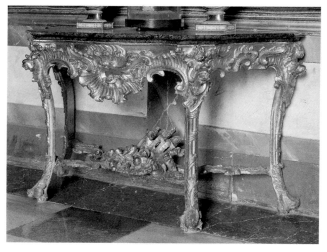

Anonymous, console table, carved and gilded wood, Spain, mid-seventeenth century. Monastery of San Lorenzo del Escorial.

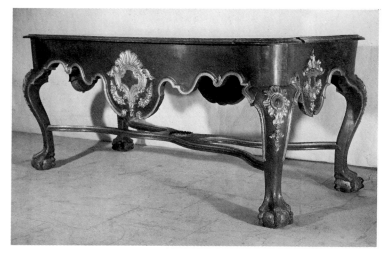

Anonymous, table, carved and gilded walnut, Portugal, mid-eighteenth century. Lisbon, Museu Nacional de Arte Antiga.

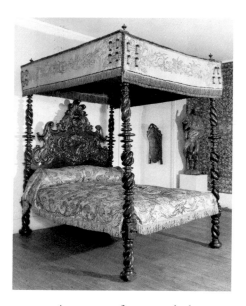

Anonymous, four-poster bed, carved wood, Spain, eighteenth century. Paris, Musée des Arts Décoratifs.

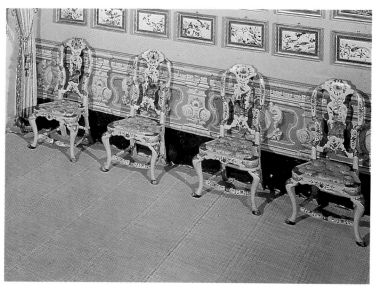

Anonymous, chairs, painted wood, naïve paraphrase of English Queen Anne style, Spain, eighteenth century. Royal Palace, Aranjuez.

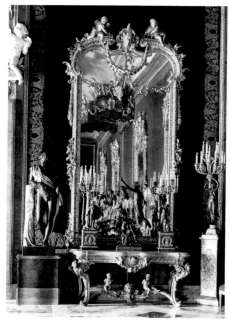

Attributed to Ventura Rodriguez, console table and mirror, carved and gilded wood, first half of the eighteenth century. Madrid, Royal Palace, Throne Room.

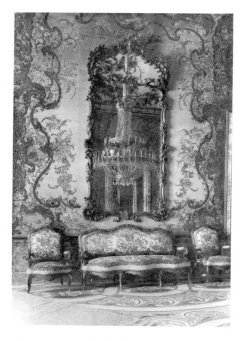

Matteo Gasparini, King's Dressing Room, known as the Gasparini Salon, Royal Palace, Madrid. Furniture made by Joseph Canops, tapestries woven by Luisa Bergoncini. 1760–65 and 1770–80.

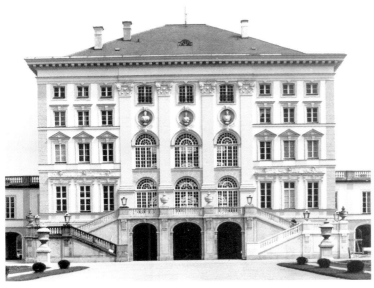

Agostino Barelli, Nymphenburg, central pavilion,
façade, from 1664.

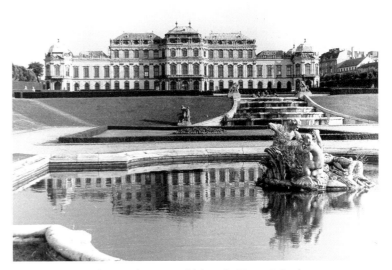

Johann Lukas von Hildebrandt, Upper Belvedere,
main façade, Vienna, 1721.

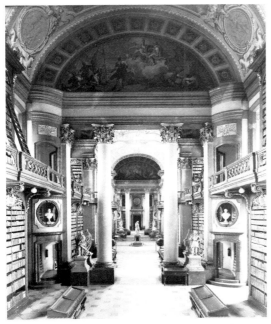

Johann Bernhard and Josef Emmanuel
Fischer von Erlach, Imperial Library,
interior view, Vienna, 1723–35.

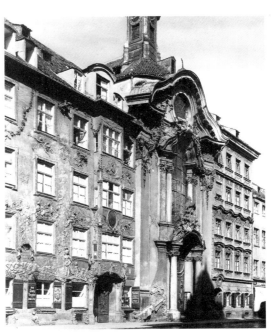

Egid Quirin Asam and Cosmas Damian Asam,
church of Saint John Nepomuk and Asam house,
façades, Munich, 1733–46.

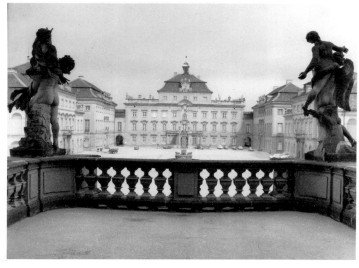

Philip Josef Jenish, Ludwigsburg, palace, interior court looking north,
old block, from 1704.

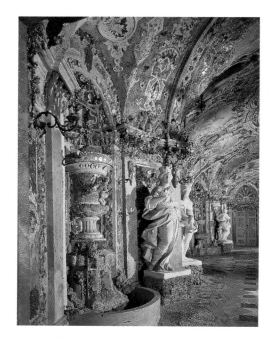

Georg Hennicke, Sala Terrena,
Schloss Weissenstein, Pommersfelden, 1722–23.

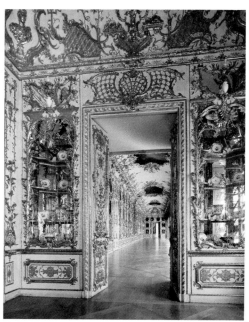

François de Cuvilliés, view of the ceremonial
apartments looking toward the Gallery of
Ancestors, Residenz, Munich, 1730–37.

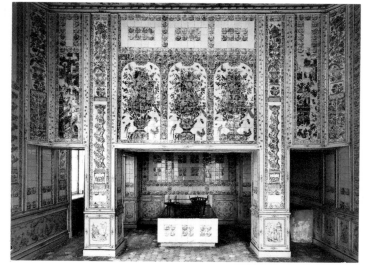

Kitchen, Amalienburg pavilion, decor of Delft
ceramic tiles, Nymphenburg, 1734–39.

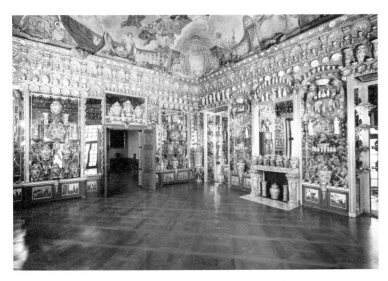

Eosander von Goethe (after a design by), Porcelain Salon,
Charlottenburg, 1710.

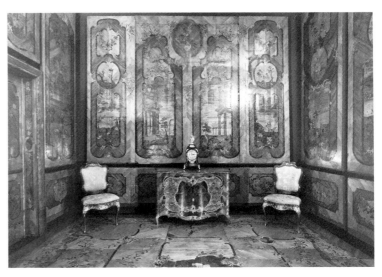

Johann Friedrich and Wilhelm Spindler, room with marquetry paneling
from the Schloss Fantasie in Donndorf (Bayreuth), mid-eighteenth century.
Munich, Bayerisches Nationalmuseum.

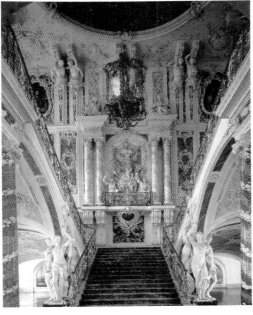

Johann Balthazar Neumann, Schloss Augusturburg,
grand staircase, Brühl, 1740.

Giuseppe Galli (known as Bibiena), Opera House
of the Margrave, Bayreuth, c. 1748.

Johann Balthazar Neumann, Kaisersaal, Residenz, Wurzburg, stuccowork and
sculpture by Bossi, frescoes by Giambattista Tiepolo, 1742–52.

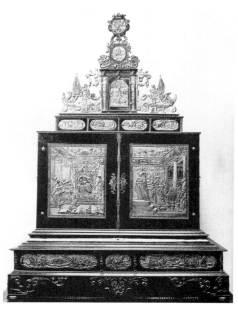

Anonymous, secrétaire, ebony and other rare woods, Eger, seventeenth century. Frankfurt, Museum für Kunsthandwerk.

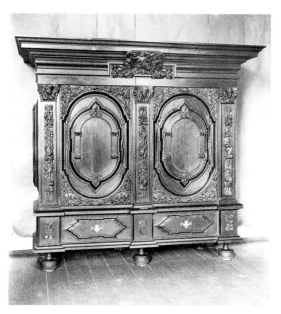

Anonymous, "Hamburger Schapp" armoire, walnut, Hamburg, 1682. Hamburg, Museum für Kunst und Gewerbe.

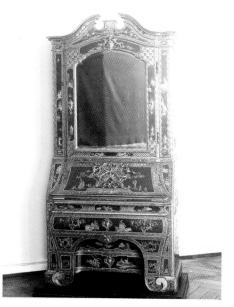

Martin Schnell, desk-commode, Japanned wood, gilt-bronze mounts, Dresden, c. 1740. Frankfurt, Museum für Kunsthandwerk.

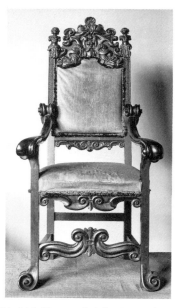

Friedrich Unteutsch (after?), armchair, carved wood, Ulm, c. 1650–60. Munich, Bayerisches Nationalmuseum.

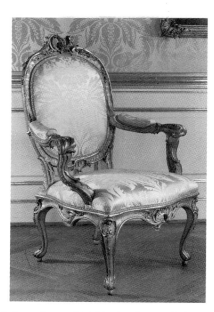

Johann August Nahl (style of), armchair, carved wood, 1740. Berlin, Charlottenburg Palace.

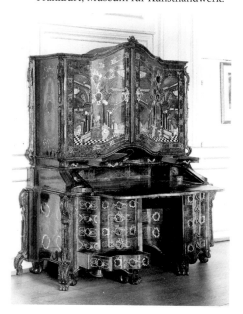

Johann Georg Nestfell, desk-cabinet, marquetry of various rare woods, c. 1750. Karlsruhe, Badisches Landesmuseum.

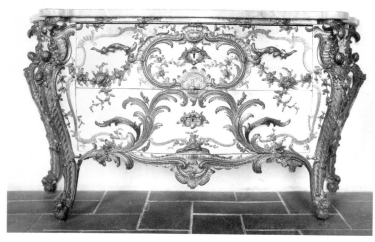

Johann Adam Pichler (after François de Cuvilliés), commode, carved, painted, and gilded wood, 1761. Munich, Residenzmuseum.

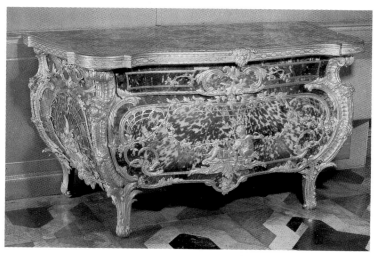

Johann Melchior Kambly, commode, tortoiseshell plaques, lapis-lazuli top, silver ornament, gilt-bronze mounts, c. 1769. Potsdam, Neues Palais.

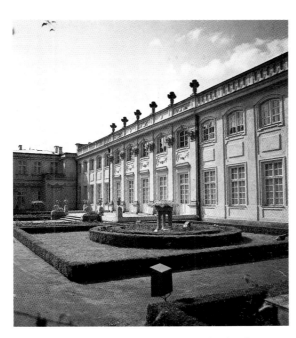

Agostino Locci, Wilanów Palace, garden façade,
Warsaw, 1677–96 (?).

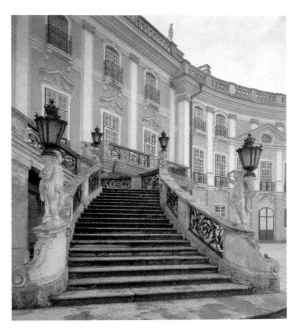

Esterhazy palace, stairway and façade,
Fertöd, Hungary, from 1763.

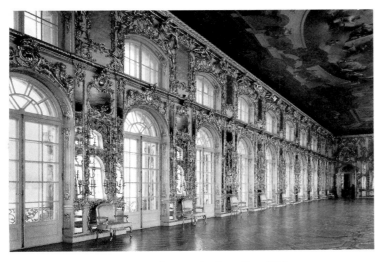

Francesco B. Rastrelli, Grand Palace, Grand Salon,
Tsarskoye Selo, 1752–56.

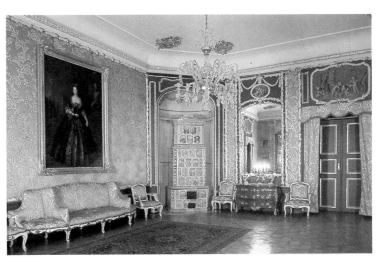

Salon Czewony (Red Salon), Nieborów Palace,
Poland, 1766–68.

Identification of Ornamental Motifs

The four objects, decors, etc., on this and the following pages have been selected for the variety of ornamental motifs used in their decoration. Artisans frequently combined newly fashionable forms with more traditional ones, such as those examined in volume 1 of *The History of Decorative Arts,* and such is the case in these designs. These succinct identifications are intended to help the reader determine the style, period, and provenance of any artifact with ornamental components.

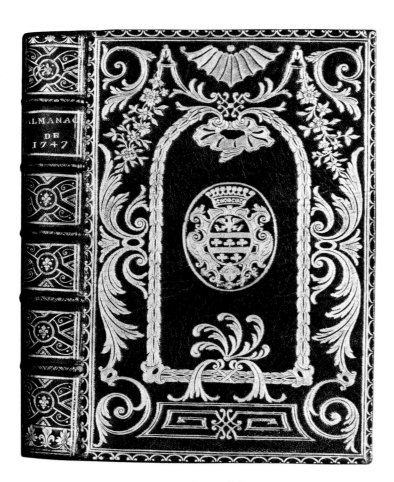

Binding, *Almanach de 1747.*
Paris, Musée des Arts Décoratifs

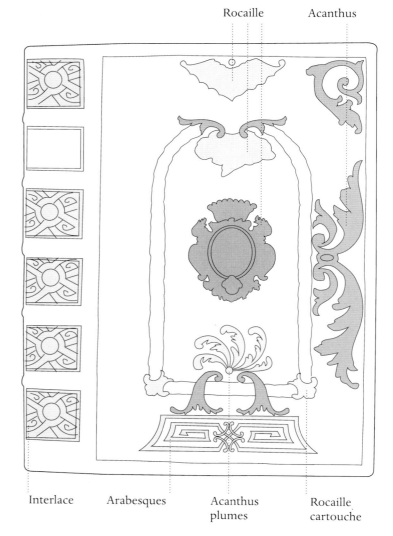

Rocaille Acanthus

Interlace Arabesques Acanthus plumes Rocaille cartouche

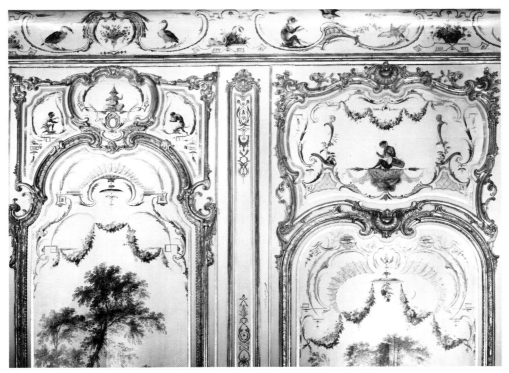

Painted wooden paneling (detail), Cabinet des Singes,
Hôtel de Rohan, Christophe Huet, c. 1749.

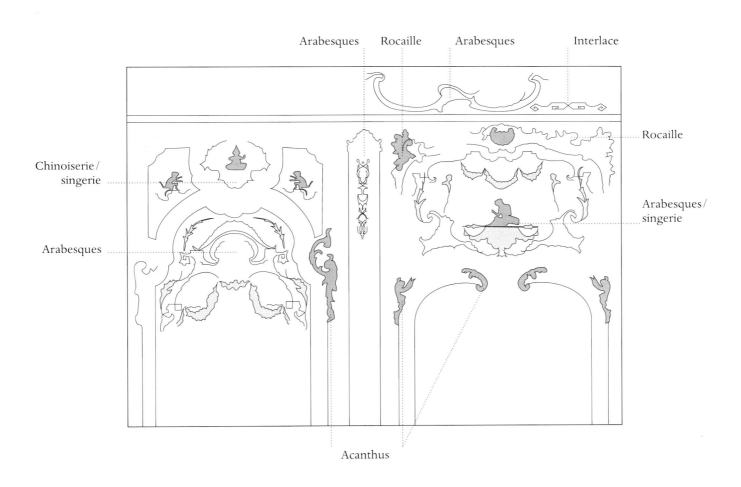

Arabesques Rocaille Arabesques Interlace

Rocaille

Chinoiserie/
singerie

Arabesques/
singerie

Arabesques

Acanthus

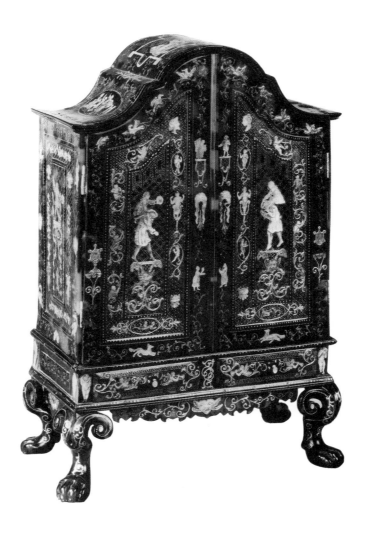

Miniature armoire for storing
jewelry, inlaid tortoiseshell,
Naples, first third of the
eighteenth century (?).
Paris, Louvre

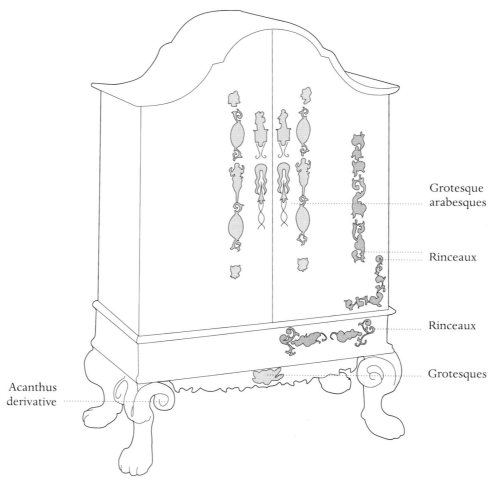

Grotesque
arabesques

Rinceaux

Rinceaux

Grotesques

Acanthus
derivative

Panel decor (detail), Salon of the Hôtel de la Chancellerie, Paris (now the Ministry of Justice), 1718.

Rinceaux

Chinoiserie

Arabesque

Acanthus

Acanthus

Arabesque

Acanthus

Glossary

A

abacus A flat slab between the capital of a column or pilaster and the architrave.

à cage *See* **openwork**.

acanthus Vegetal ornament used especially in Corinthian capitals. *See* chapter "Acanthus" in the present volume.

aedicule A small shrinelike structure consisting of two columns supporting an entablature and a pediment.

agrafe French term for a curved, convex relief ornament whose sinuous form is suggestive of shells, soft marine creatures, and cartouches. Often used as window keystones in the first half of the eighteenth century.

à la polonaise (**bed**) An elaborate fourposter bed, heavily draped and culminating in a peaked, tentlike element.

à la reine (**chair**) French term designating chairs without arms and with slightly inclined flat backs.

alcove Any recess to create a more intimate space, notably to contain the bed in a bedroom. It can be enclosed by a balustrade, curtains, or even doors.

amour *See* **putto**.

antependium Any work decorating the lower front surface of an altar. In the seventeenth and eighteenth centuries, antependia were usually made of fabric elaborated with embroidery or **passementerie**. Sometimes called an *altar frontal*.

appliqué Any fitting attached to an object for decorative purposes.

arabesque Intricate surface decoration based on scrolling and interlacing patterns of foliage, tendrils, etc.; usually without human figures, although these appear in early-eighteenth-century "new grotesques." *See* chapter "Arabesques, or New Grotesques" in the present volume.

arbalète (**en**) French term meaning "crossbow," often used to designate the convex profile of a certain kind of eighteenth-century French commode; also described by the French adjective *bombé*. *See* **serpentine front**.

arcaded decoration Arcadelike motifs sometimes used in furniture and decorative objects, notably chests.

arcanist Term used to designate craftsmen possessed of the technical secret (Latin, "arcanum")

of hard-paste porcelain production, which was closely guarded in the eighteenth century.

architrave The lowest part of an entablature, directly above the capitals of the supporting columns. *See* **entablature**.

archivolt (1) The continuous contour molding along the face of an arch. (2) The underside of an arch or portal.

armoire From the sixteenth century on, a cupboard consisting of one large or two smaller pieces and closed by doors. Sometimes monumental, with pilasters and other architectural elements.

arras In English, an archaic word for tapestry. It derives from the French tapestry factories in Arras, which from the mid-fourteenth century on was one of the principal European centers of tapestry manufacture.

astragal Molding separating the capital from the shaft of a column, or deployed along the length of an architrave or a door or window frame. Sometimes articulated in an alternating bead-and-reel motif.

Athénienne *See* **cassolette**.

Atlantes Sculptures of male figures, usually nude or scantily clad, supporting entablatures, balconies, or other decorative elements. The term derives from Atlas, the Titan condemned by Zeus to support the vault of heaven on his shoulders.

attribute A symbolic or decorative object conventionally associated with a given individual or activity.

auricular style A style characterized by a formal vocabulary that evokes the fluid morphology of the human ear. *See* chapter "The Auricular Style" in the present volume.

aventurine A kind of glass with gold specks in it (in fact, copper crystals). Aventurine tiles were used in Spain and Portugal to cover walls.

azulejo Ceramic tiles used in Spain and Portugal to cover walls. Of Arabic origin and most often blue-and-white, *azulejos* were sometimes used to create narrative compositions.

B

bahut French word for a wooden travel chest with a convex lid, often covered in studded leather and strengthened by iron braces.

baldaquin (or **baldacchino**) Canopy above a bed, throne, altar, catafalque, etc. *See* **dais**.

baluster Small pillar or post used in series to support a railing, thus forming a **balustrade**.

banquette French term used to designate a small bench without a back, usually upholstered.

baronne A French term used in the late eighteenth century to designate a comfortable armchair.

bas-relief Literally, "low relief"; sculpture that creates an effect of depth while actually using only shallow relief.

baton-rompu In French, used to describe any molding, frieze, or like element that is discontinuous or "broken" at regular intervals.

bergère French name for a low upholstered armchair with a wide seat, a high rounded back, and somewhat recessed arms designed to accommodate the wide dresses worn by society women in the late seventeenth and eighteenth centuries. This word—its literal meaning is "shepherdess"—is a playful extrapolation from the pastoral tradition, in which shepherds passed for ideal lovers. In French, the phrase *"l'heure du berger"* (literally, "the hour of the shepherd") is an idiomatic expression meaning a favorable moment for a lover to take action.

bezant A medieval Byzantine coin. By extension, an ornamental motif consisting of repeated roundels.

bibelot A small decorative object or curio, of either crude or luxury workmanship.

billet A Romanesque molding with adjacent bands of alternating projecting squares or rectangles and depressions of identical dimensions, staggered so as to create a checkerboard effect.

biscuit (1) Unglazed white porcelain with a texture similar to marble, often used for figurines and decorative groups beginning in the mid-eighteenth century. (2) By extension, any piece made of this material. *See* **porcelain**.

boiserie French word for wood paneling, often decorated with shallow relief carvings or paintings, notably arabesque or grotesque compositions.

bombé *See* **arbalète** and **serpentine front**.

bonheur-du-jour Eighteenth-century French term for a lady's writing desk consisting of a table with an organizer along its rear edge,

often with drawers or pigeon-holes. These pieces were extremely fashionable in France during the ancien régime's final decades.

boss, bossing (1) In architecture, a decorative knob or projection covering the intersection of ribs in a ceiling or vault; often carved. (2) By extension, any pattern of geometric relief on a piece of furniture or a decorative object, as in repeated diamond-point studding.

Boulle marquetry Brass and tortoiseshell marquetry; invented in tenth-century Italy but brought to its highest point of virtuosity in France by André-Charles Boulle (1642–1732), whose name has since been associated with it. Sheets of these two materials are glued together and then cut to delineate the armature of the design, after which other precious materials—rare woods, mother-of-pearl, horn, etc.—were added and the brass engraved, nielloed, etc. There are two basic varieties: "first-part" features a tortoiseshell ground inlaid with brass; "second-part" features a brass ground inlaid with tortoiseshell.

Bourdaloue French eighteenth-century term designating an oval urinal used mainly by ladies when traveling; sometimes carried in a muff. The name may be an allusion to the Jesuit preacher Louis Bourdaloue (1632–1704), whose sermons at Versailles were so popular that his congregations assembled several hours in advance.

brancard A stand used for the transport and display of large vessels. The most lavish examples were made of silver and used at Louis XIV's Versailles, but none of these survive.

bras d'applique or **bras de lumière** French names given to candle holders fixed to the wall. *Bras*, the French word for "arm," is used because originally the supports of such fixtures were shaped like human arms.

brazier A large flat pan or tray for holding burning charcoal, etc.

briqueté ground A decorative ground simulating brickwork; used notably in eighteenth-century Sèvres porcelain.

brocard French term for a silk fabric brocaded with patterns of flowers or figures in gold or silver thread.

brocatelle (1) A brocaded silk fabric, distinguished from **brocard** by the smaller scale of its decorative motifs and/or by the absence of gold and silver thread. (2) A particularly rich type of marble sometimes used for tabletops.

brûle-parfum A French term for **cassolette**, most often applied to depictions of containers from which smoke is escaping in decorative compositions.

bucranium or **bucrâne** An ox skull, often garlanded, widely used as a decorative motif in antiquity. It originally recalled animal sacrifices made to pagan deities.

buffet Large piece of furniture, usually in two tiers, used as a **sideboard**. Beginning in the seventeenth century, the term also designated a table or console lavishly decked out with silverware and food for a reception.

C

cabaret (1) A small tea or coffee service with matching tray, usually of porcelain. If there are two cups, called a *tête-a-tête;* if only one, a *solitaire.* (2) By extension, a small table with a porcelain top for serving beverages, etc.

cabinet (1) A small, intimate room. (2) A room containing a collection of some kind; by extension, the collection itself. (3) A piece of furniture, usually footed and sometimes fronted by doors, with many small drawers and compartments intended for the storage and display of precious objects. In the sixteenth and seventeenth centuries, when they were much in vogue, they were often made of precious woods and decorated with rare materials such as ivory and **pietra dura**.

cable molding Molding shaped like woven cord or rope, widely used in the medieval period. Sometimes called a *twisted fillet.*

cabochon A gem that has been cut into round or oval convex form and polished but not faceted; and, by extension, a similar shape applied to furniture molding, etc.

cabriole chair Chair with a padded back molded to accommodate the human form.

cabriole leg Curved outward at the knee and inward below; characteristic of Chippendale, French Regency, and Louis XV furniture.

cadenas French name for a small container made of gold or silver intended for the personal cutlery and seasonings of a nobleman or of the king and queen.

caduceus The attribute of Mercury; consists of a staff with two small wings emerging toward the top and encircled by two snakes.

calico A rather coarse cotton fabric often used for upholstery and bed linen in seventeenth- and eighteenth-century Europe. *See* **chintz.**

cameo A semiprecious stone (sardonyx, agate, amethyst, etc.) with two superimposed layers of different colors, the upper one carved in relief and the lower one functioning as a ground. The technique was widespread in the ancient world.

canapé French term covering the English appellations *settee* and *sofa,* but often used to des-

ignate examples in which the wooden frame is not entirely covered with upholstery.

candelabrum A standing candlestick with arms and nozzles for many candles.

canephorus A sculpted figure of a woman carrying a basket on her head; a motif of antique inspiration often used in both architecture and furniture. Compare with **Atlantes** and **caryatid.**

canopic vase An ancient Egyptian vessel with a cover shaped like a human head, intended to contain the viscera of embalmed bodies.

capital The head or culminating element of a column, pillar, or pilaster; often richly carved.

carpet Any thick textile intended to cover a portion of the floor. "Knotted carpets," which have been produced in central Asia for thousands of years, are made by knotting short lengths of yarn—usually silk or wool—to a fabric backing to produce a pile. "Tapestry," or "smooth-faced carpets," which began to be produced in post-Renaissance Europe, are woven in the same way as tapestries but with a thicker weft.

cartel A medallion-like form with a pointed bottom; most readily associated with eighteenth-century cartel clocks, but its affinity with eccentric shapes made it, along with escutcheons and **cartouches**, a focus of rocaille and rococo ornamentalists.

cartonnier French name for a piece of furniture, either independent or an accessory, fitted with compartments to hold papers. Sometimes called a *serre-papiers.*

cartoon A full-scale design for a mural painting or a tapestry. In the **low-warp** weaving process, tapestry cartoons must be executed in reverse.

cartouche An ornament resembling a sheet of paper or a piece of leather rolled and cut in various ways, and often intended to receive an inscription or armorial emblem. A favorite device of rocaille and rococo ornamentalists; for its earlier history, *see* chapter "Strapwork and Cartouches" in volume I, *The Renaissance and Mannerism in Europe.*

caryatid Female figure supporting a cornice, entablature, or capital. Compare with **Atlantes** and **canephorus.**

cassolette A small **brazier** in which aromatic pastilles can be burned or liquid perfumes evaporated; in the eighteenth century they were often mounted on tripods in an antique style and were sometimes called **Athéniennes.** *See* **brûle-parfum.**

chaise longue A long lounge chair, usually upholstered, intended to hold a single person in a semi-recumbent position. In eighteenth-century France, such pieces with rounded backs were called **duchesses**; if they terminated

in a curving element meant to protect the feet from drafts, they were called "duchesses en bateau" ("boatlike duchesses"), in acknowledgment of these prow-like shapes; if the extension took the form of a separable ottoman, the set was called a "duchesse brisée" ("broken duchess"). Since the nineteenth century, the phrase "chaise longue" has been used to designate any sofa with a chair-back at one end.

champlevé enamel A kind of enamel decoration in which the vitreous substance is poured into prepared grooves in a silver, bronze, or copper object and then polished down to the level of the surrounding metal. In French, sometimes called "en taille d'épargne."

chasuble A loose, sleeveless ecclesiastical vestment covering the torso, worn by a priest over the alb and stole when celebrating the Eucharist. In the Catholic church, its color—gold, white, black, silver, red, violet, or green—varies in accordance with the church calendar.

chenille (1) A cord with short threads set at right angles to it; used for needlework trimmings. (2) A term loosely applied to imitation velvet, beginning in the eighteenth century.

chiffonier or **chiffonnière** (1) In the eighteenth century, a small piece of furniture for the storage of fabric and articles of clothing; usually, but not necessarily, a low chest of drawers. (2) In nineteenth-century England, a small dining-room cupboard with a top forming a sideboard.

chimera A mythological composite animal with the head of a woman, the chest and legs of a lion, the body of a goat, the claws of an eagle, and a snakelike dragon's tail.

chinoiserie A mode of ornament in the post-Renaissance West based very loosely on forms in Far Eastern artifacts, freely adapted to suit Western taste. *See* chapter "Chinoiserie" in the present volume.

chintz A printed cotton fabric of Indian origin, usually glazed, sometimes given the generic term *calico;* very fashionable in England beginning in the eighteenth century, when imitations began to appear in large quantities.

cloisonné enamel A kind of enamel decoration in which the vitreous substance is poured into isolated metal compartments formed by metal bands on the surface; in the final result, the tops of these bands remain visible.

coffering Decoration of a ceiling or arch soffit consisting of sunken square or polygonal panels, often adorned with moldings, pateras, or paintings.

colossal order Columns or pilasters rising to a height of two or more floors of a building.

commode French name for a low chest of drawers, especially one of ornate design. They began to appear at the very end of the seventeenth century.

composite order A late Roman architectural order combining elements from the **Ionic order** and the **Corinthian order**.

confident or **canapé à confident** French term designating two different types of sofa: (1) with the ends curving forward so that two people sitting at the ends would be almost facing one another; (2) with small triangular seats beyond the arms at either end.

console (1) a carved ornamental bracket, often in the form of an S-scroll, more vertical in format than a **corbel**. (2) A table with two legs in the front, sometimes convergent, and none in the back, designed to be attached to or set against a wall, often beneath a mirror.

cope An ecclesiastical vestment worn over the shoulders. Semicircular, it is secured over the chest by a clasp. *See* **pluvial**.

coral Hard calceous substance, usually red, pink, or white, secreted by marine polyps; used in jewelry since antiquity, and prominent in rocaille ornamental compositions in the first half of the eighteenth century.

corbel A bracket projecting horizontally to support something above. Compare with **console**.

Corinthian order Architectural order of ancient Greek origin characterized by a capital with two rows of acanthus leaves from which volutes emerge, and by a richly decorated entablature.

cornucopia An ornamental motif consisting of a horn or pointed basket overflowing with fruit and flowers. Sometimes called a "horn of plenty."

cornice (1) The uppermost, projecting element of a classical entablature. (2) A similar horizontal molding at the top of any building or at the junction of a room's walls and ceiling. (3) By extension, a similar molded element on a decorative object, a piece of furniture, etc.

credence or **credenza** Archaic term for *sideboard*. Now used only to designate a small table or shelf near the altar intended to hold liturgical objects.

crosier A pastoral baton culminating in a volute, carried on ceremonial occasions by bishops, priests, and certain abbesses.

cul-de-lampe (1) A **corbel** or bracket used to support a lamp, a statue, a vault spring, etc. (2) An analogous two-dimensional ornamental form used by printers as a tailpiece.

cylinder desk A writing desk with a curved top that can be pushed back or pulled forward and locked; originated in the mid-eighteenth century. Sometimes called a *roll-top desk*.

cyma recta A molding with an S-like profile, concave above and convex below; sometimes called an "ogee molding."

cyma reversa A molding with an S-like profile, convex above and concave below; sometimes called a "reverse ogee molding."

D

dado (1) In classical architecture, the part of a pedestal between the base and the cornice; sometimes called a *die*. (2) In postmedieval architecture, the stone or wooden finishing of the lower part of an interior wall.

dagger A lancetlike shape used in moresques, usually with a pointed head and sometimes cusped within.

dais A raised platform for a throne, bed, etc.; often covered by a **baldaquin**.

damascening A technique for giving a watered surface pattern to steel blades, originally used by metalworkers in Damascus and elsewhere. The term now usually refers to a metalworking technique whereby gold, silver, steel, or copper filaments are beaten into prepared grooves in a metal ground to produce decorative patterns.

damask Textile made of silk or wool in which the decorative figures are brilliant on one side and mat on the other. By extension, the term is often used to designate any silk fabric with a rich raised pattern.

damasked Adjective used to describe any fabric with a damasklike appearance.

dart *See* **egg-and-dart**.

dentil A small square or rectangular block arranged in series beneath classical cornices, forming a pattern resembling a row of teeth; often encountered in the phrase "dentil molding."

device (1) In heraldry, a motto generally placed beneath an armorial shield. (2) By extension, an emblematic figure with an accompanying explanatory phrase.

diaper Originally, a textile whose weave outlines a repeated pattern of diamonds or lozenges; by extension, any such decorative pattern.

diamond pointing Surface treatment in which repeated rectangles rise to projecting, pyramidal points.

die *See* **dado**.

dinanderie Brassware—cooking utensils, candlesticks, platters, etc.—produced in and around Dinant, near Liège.

Doric order The oldest of the classical architectural orders, characterized by a column widening toward the base and either fluted (in Greek architecture) or smooth (in Roman architecture), with an unadorned **echinus** by way of

a **capital**, and an **entablature** with alternating **triglyphs** and **metopes**.

duchesse *See* **chaise longue**.

"a la duchesse" (**bed**) French term for an elaborate bed with a cantilevered canopy attached at the back to the wall or ceiling.

dumbwaiter A small stand, to facilitate self-service at the dining table, with several tiers of revolving circular trays.

E

ébéniste French term for a luxury cabinetmaker specializing in rich inlay or veneering (from the French word for ebony, which often figured in such pieces); as opposed to **menuisier**, a term designating the maker of the unadorned wooden furniture frames. This distinction was maintained in France during the century and a half preceding the Revolution, but it was not formally recognized in the guild statutes until 1745.

echinus A disk-shaped stone with a convex molding below the **abacus** of a Doric capital.

egg-and-dart A decorative motif often used in classical relief moldings, with alternating ovals and vertical arrowheads or darts.

enamel A vitreous substance, semitransparent or opaque, applied by fusion to various surfaces (metal, pottery, etc). *See* **champlevé enamel** and **cloisonné enamel**.

encoignure Triangular corner cupboard, sometimes left without a door to reveal the shelves within.

entablature The upper portion of a classical order, consisting of an **architrave**, a **frieze**, and a **cornice**.

escutcheon A shield intended to bear a coat of arms, an emblem, etc.

espagnolette A decorative motif popularized by Watteau and Audran, consisting of a female head, shown frontally or in profile, backed by a large, stiff collar of vaguely Spanish character.

estampille A maker's mark—name or initials—stamped on a piece of French furniture to guarantee its authenticity.

F

faïence French name for tin-glazed pottery.

fanfare binding A type of bookbinding used in France from the late sixteenth to the mid-seventeenth century, with rich decorative patterns of intertwining strapwork motifs.

fasces A bundle of rods with an axe in the center, its bladed end protruding at the top; an emblem of authority in ancient Rome.

festoon A suspended rope of flowers, fruit, and greenery tied together with ribbons. Generally somewhat thicker than **garlands** and used in single swags.

filigree Tracery ornament made from slender threads or tiny granules of precious metal, often in intertwining patterns.

fillet (1) A narrow, flat band, as for instance between two moldings. (2) A narrow horizontal strip separating the moldings in a cornice or base. (3) A tool used in bookbinding to impress straight lines on leather covers; by extension, the lines so produced. *See* **frieze** and **flat bandwork**.

firescreen A small screen on a stand intended to provide protection for those sitting near a fire; often decorated with tapestry, painting, etc.

flange A projecting rim, collar, or edge, especially in pottery and glassware.

flat bandwork A type of **interlace** in which the intertwining forms are flat and broad instead of narrow and cordlike.

floret A round decorative motif resembling a stylized flower, sometimes accompanied by greenery.

fluting Shallow, rounded, parallel grooves often deployed vertically on columns, pilasters, etc.

foil A lobe or leaf-shaped curve resulting from the cusping of a circle or an arch. A combination of three lobes is called a trefoil, of four lobes a quatrefoil, etc.

French order A variant of the **composite order**, devised in France in the late seventeenth century and featuring fleurs-de-lis, the emblem of the French royal house of Bourbon.

fret A geometric ornamental motif consisting of a continuous band of horizontal and vertical straight lines intersecting one another at right or oblique angles in repetitive configurations. *See* **Greek key**.

frieze (1) The part of an **entablature** between the **architrave** and the **cornice**. (2) An ornamental composition in the form of a continuous band.

G

gadrooning Series of repeated, adjacent convex moldings or concave channels used to form decorative bands, notably on silver. Compare **fluting**.

garland Decorative motif consisting of ropes of flowers, fruit, and greenery tied together by ribbons, often used in repeated swags. *See* **festoon**.

genre pittoresque French phrase used to designate the later, more extravagant phase of the rocaille (1730–50), most closely associated with Jacques de Lajoue, Juste-Aurèle Meissonnier, and Nicolas Pineau.

girandole In the seventeenth and eighteenth centuries, a term designating elaborate candelabra, especially wall sconces; from the Italian *girandola*, a whirling circle of fireworks. Now most often used to designate exaggeratedly asymmetrical rococo and rocaille examples.

glaze A vitreous coating applied to pottery to give it a polished surface and make it watertight.

grand goût French phrase—literally, "grand taste"—used in seventeenth- and eighteenth-century France to designate the classicizing artistic and artisanal production of the seventeenth century as well as the exalted, idealist aesthetic this was believed to exemplify; as opposed to "petit goût," a phrase often applied to all that was diminutive, pretty, "feminine," and complicit with the marketplace.

Greek key A kind of fret motif consisting of a running band with a single line repeatedly bending back on itself at right angles without crossing itself. Sometimes called a **meander**. Widely used in architectural ornament, furniture, and decorative objects.

griffin A mythological creature with the head and wings of an eagle, the body of a lion, the ears of a horse, and the tail of a fish. Often used in decorative compositions from the fifteenth century on.

grisaille Monochrome painting, usually executed in white and gray, creating the illusion of sculpted relief.

grotesque A playful variety of classically inspired decoration composed of small, loosely connected motifs and often featuring human figures, monkeys, and other fantastic creatures. *See* chapter "Arabesques" in the present volume.

guilloche A pattern of two intertwining curved bands forming a plait, used to decorate a molding or frieze.

guttae Small forms—sometimes blocklike, sometimes conical—placed in rows beneath the **triglyphs** in a classical **entablature** (plural of the Latin "gutta," meaning "drop").

H

hanap Drinking cup made of metal, often precious, mounted on a high foot and having a lid.

handle A projecting element, more or less richly decorated, in the form of a volute, cross, etc., that allows one to take hold of a vase, vessel, or utensil. They are sometimes shaped like human or animal figures.

haricot *See* **kidney table**.

heraldry The art or science of armorial bearings and coats of arms.

herm A three-quarter-length figure merging at the bottom into a pedestal; often used since

the Renaissance in architecture, furniture, and garden sculpture.

high-warp *See* **warp**.

horn Material from the horns and antlers of certain mammals—oxen, antelope, deer, etc.—frequently used in jewelry, furniture, and metalwork; often brightly stained.

humpen A cylindrical German drinking vessel or beer mug with a lid.

I

imperiale French name for an elaborate four-poster bed; by extension, the rosette or sunburst pattern frequently used on the underside of their canopies in the seventeenth and early eighteenth centuries.

intaglio Incised relief carving, as in stone, glass, or wood intended to impress wax seals.

intarsia An Italian form of inlaid wood paneling or **marquetry** used to decorate choir stalls, wall surfaces, boxes, etc., in which only woods of varying hues are used.

interlace Ornament consisting of intertwining cords or bands arranged in complex geometrical patterns. *See* chapter "Interlace" in volume 1, *The Renaissance and Mannerism in Europe*.

Ionic order Architectural order characterized by a capital whose **echinus**, decorated with egg forms, is flanked by two **volutes**.

ivory Strictly speaking, the bony substance from an elephant's tusk, but sometimes also the tusks of other animals. A precious material long favored as a medium for carving.

J

Japan or **Japanning** A name given to various Western varnishing techniques that imitate Oriental **lacquer**, but use a somewhat different basic component.

japonaiserie An exoticising Western style inspired by specifically Japanese forms; emerged much later than **chinoiserie**, in the nineteenth century.

jardinière A stand for flowerpots.

jasper An opaque variety of quartz with multicolored veining. Because of its highly decorative character, it was widely used in furniture and metalwork in the seventeenth century.

jet A type of lignite that is dark black; sometimes cut and polished for use in jewelry.

K

kidney table Table with a kidney-shaped top used as a writing- or dressing-table; first made during the reign of Louis XV and sometimes called a **haricot** (the French word for "bean").

L

laca contrafatta An imitation of Chinese lacquer invented in eighteenth-century Venice, in which relief decorations formed by cut-out printed figures are fixed to the surface and then varnished. The simplicity of this technique led to its widespread practice by amateurs.

lacquer A waterproof varnish of Asian invention whose basic ingredient was derived from the sap of the *Rhus vernificera* tree, indigenous to China but later introduced to Japan. The term is widely applied to Western imitations, but these are all made of different components and are more accurately termed **Japan** or **Japanning**.

lambrequin (1) In heraldry, a piece of material hanging from a helmet and draped on either side of an armorial shield. (2) An ornamental border decorated with fringe or tassel-like elements; used on furniture, in drapery, on ceramics, etc.

lamé A textile with a weft of metallic thread, usually gold or silver.

lampas A damasklike textile often used in eighteenth-century upholstery and usually featuring a relief pattern.

languet An ornamental motif consisting of repeated U- or tongue-shaped forms (from the French "langue," meaning "tongue").

lantern A small circular or polygonal turret with windows, usually crowning a dome.

laub und bändelwerk A German appellation (literally, "foliage and scrollwork") for a late Baroque framing motif consisting of stylized leaves and **strapwork**; often used in early eighteenth-century textiles, glassware, and ceramics.

laurel chain An ornamental motif of antique derivation consisting of a band of overlapping bay leaves.

listel *See* **fillet**.

low warp *See* **warp**.

luster A surface glaze with a metallic oxide base used on Islamic and Hispano-Moorish pottery as well as on certain types of *majolica;* its iridescent reflections range from pale yellow (with a silver-oxide base) to a rich red (with a copper-oxide base).

lyre A small, harplike instrument associated with Apollo and often used in decorative schemes.

M

magot French decorative-arts term that refers to monkeys (as in *singeries*), dwarves, and the curious-looking figures of Chinese men often found in **chinoiserie**.

majolica The Italian term for tin-glazed pottery, most accurately used only for productions made in that country. Majolica first appeared in fifteenth-century Tuscany and Romagna, and reached its peak in the following century with the richly decorated pottery fabricated in Gubbio, Castel Durante, Pesaro, etc. It was so named because it was introduced by craftsmen from the island of Majorca.

mantelpiece The frame surrounding a fireplace, generally made of masonry, and named after the mantel, the shelflike projection above its opening. The word generally designates the sculpted and painted ornament immediately surrounding the opening, although it sometimes encompasses an **overmantel** as well.

marbling Any of several techniques for creating an artificial veined effect resembling that of marble.

marli *Fillet* bordering the inside of a plate or dish.

marquetry A decorative veneer composed of precious woods and other rare materials (metal, mother-of-pearl, ivory, horn, tortoiseshell, etc.), most often associated with the rich ornamental inlay patterns on luxury furniture. *See* **Intarsia**.

marquise *See* **chaise longue**.

Martin varnish The finest type of European **Japanning**, named after the French family that developed and perfected it in the first half of the eighteenth century. Made from a cipolin base, it is extremely lustrous and fine-textured.

mascaron A fantastic head or mask used to decorate keystones, fountains, entablatures, etc.

matting In metalwork, the production of a dull mat surface achieved by hammering it with a matting-punch.

Mazarin desk Desk with two ranks of drawers beneath on either side. Pieces of this type first appeared in the mid-seventeenth century and are often decorated with rich marquetry inlay.

meander Any ornamental pattern of meandering or winding lines, or of rectilinear decorative lines that vaguely resemble a maze. *See* **Vitruvian scroll**, **Greek key**, and **fret**.

medallion Literally, a large medal; by extension, a circular or oval element in a decorative pattern or frame.

menuisier French term for a craftsman specializing in unadorned furniture frames. *See* **ébeniste**.

metope In a Doric **frieze**, the square space between two **triglyphs**.

meuble d'été or **d'hiver** French term (literally, "summer" and "winter furnishings") for a coordinated ensemble of bedding, curtain, wallpaper, etc.; these were changed on a seasonal basis in houses of the wealthy nobility.

modillion A small bracket or **console**, often

featuring **volutes**, placed in sequence beneath a **molding** or cornice.

molding A vertically or horizontally aligned ornamental strip of marble, plaster, wood, etc., recessed or projecting (or a combination of both), used in architecture, furniture, and precious objects. It can take any number of forms but is usually either unadorned or decorated with a repetitive pattern.

monstrance An elaborate piece of metalwork intended to display the consecrated host, either on the altar or in procession.

Moorish tracery *See* **moresque**.

moresque Ornament, of Middle Eastern derivation, consisting of intertwining frondlike tendrils with stylized "leaf" forms configured to create web patterns. *See* chapter "Moorish Tracery" in volume I, *The Renaissance and Mannerism in Europe*.

mortise and tenon joint A means of joining two pieces of wood, stone, or metal with interlocking rectangular cavities (mortises) and projections (tenons).

mosaic A decorative pattern made with multicolored tesserae (stone, glass, ceramics) held in place by cement or some other binder. Initially used only on floors, walls, and ceilings, but in the sixteenth century this technique began to be employed on furniture.

mother-of-pearl The iridescent white substance lining the shells of many mollusks, and often used as inlay in furniture and marquetry.

N

nailhead An ornamental motif consisting of a band of projecting pyramids. *See* **diamond pointing**.

nécessaire A portable case for private articles such as toiletries, sewing instruments, cutlery, etc. for use when traveling.

nef An elaborate piece of metalwork in the form of a ship, intended as decoration for the dining table.

niche A decorative recess in a wall, often intended to accommodate a bust or statue.

niello (1) A black enamel used as a filling for incised decoration on metalwork. It is composed of powdered silver, lead, copper, sulfur, and occasionally borax. (2) A small plaque decorated with niello work.

O

ogive arch A pointed arch, such as that characteristic of French Gothic architecture.

openwork Any form of ornament that is open like a grill, whether in architecture, furniture, woodwork, metalwork, etc.; in French, **à cage**.

order In classical architecture, a system of rules governing the use of pedestals, columns, and entablatures to assure stylistic unity. There are five principal orders: **Doric**, **Ionic**, **Corinthian**, **Tuscan**, and **Composite**.

ormolu Term applied to decorative objects in gilt-bronze, especially furniture mounts; most accurately reserved for those made in the eighteenth century with the mercury gilding process (which is lethal), as opposed to the much larger number of gilt-bronze objects dipped in acid and then lacquered.

overmantel The surface directly above a fireplace, whether on a projecting flue or flush with the wall. Generally, the term designates a decorative composition fixed to this surface, whether sculpted, painted, or both.

P

palmette An ornamental motif resembling a stylized palm-leaf or fanlike array of flowers.

panache French term for a cluster of feathers topping a helmet, canopy, etc.

panel stamp A metal stamp used to impress a single design on a bookbinding with a hand press, as opposed to repeatedly stamping a binding with smaller stamps or tooling the decorative pattern into the leather by hand.

papier mâché Material made from pulped paper, glue, chalk, and sometimes sand, or from sheets of paper glued together; produced in Europe since the second half of the seventeenth century. Used to make trays and other small objects, which were often **Japanned**.

parterre French term used to designate formal garden terraces planted in ornamental configurations resembling ribbon- or fretwork.

passementerie Lace or braid edging with a base of silk, cotton, wool, or metal thread and sometimes incorporating beads, pompoms, etc.; used since antiquity to decorate clothing, textiles, and furniture.

pâte de verre A glass paste made from colored glass that has been ground and then refired in a mold and made to resemble precious or semiprecious stones; used in a wide range of decorative objects.

patera A small circular ornament resembling a floret, often used in relief within ceiling coffers in classical architecture.

pedestal table A table with a single support.

pediment In classical architecture, the crowning element of a building façade or bay consisting of an oblong triangular form articulated by cornices composed of moldings that are identical to those of the **entablature** on which it rests. In subsequent usage, the upper edges of this gablelike shape sometimes outline a sin-

gle arc. Similar forms are often used on furniture and decorative objects.

pelta A small, light shield used by soldiers in the ancient world; sometimes employed as a decorative element from the sixteenth century on.

piano nobile The main floor in Italian palazzi, usually just above the ground floor.

pied-de-biche French phrase (literally, "doe foot") used to designate cabriole furniture legs terminating in cloven hoofs.

pietra dura Colored marble and semiprecious stones (agate, rock crystal, amethyst, lapis lazuli, chalcedony, onyx, etc.) used in sculpture, mosaics, jewelry, inlay for tabletops, etc. Though originating in ancient Rome, techniques for working with **pietra dura** were highly developed in Renaissance Italy.

pilaster A shallow pier or column, generally with a base and a capital, attached to a wall and projecting from it only slightly.

plinth (1) The projecting base of a column, pilaster, or statue. (2) The projecting base of a wall.

pluvial Liturgical vestment shaped like a large cape. *See* **cope**.

ponteuse A chair with a cushion or tablet on top of its back to facilitate leaning (this element is sometimes called a *voyeuse*); especially designed for the gambling table, and often equipped with a drawer for chips, etc.

porcelain A hard, translucent ceramic substance, most often white. There are two main types: hard-paste and soft-paste. The former, which is also known as true porcelain, was first developed in China about the seventh century A.D.; it was first produced in the West in 1709, at Meissen, whence (despite determined efforts to keep the process a secret) the technique spread throughout Europe. After the first firing, it may be decorated over with a glaze of enamel colors. If left unglazed it is called **biscuit** porcelain. Soft-paste porcelain is an alternative process developed before the West had unlocked the secret of hard-paste; it was first produced in late-sixteenth-century Florence and was made in quite a few European factories as late as the eighteenth century, but rarely thereafter. The production process entailed considerable losses in the kilns; as a result, relatively little survives, which has made it all the more appealing to collectors.

portière French term (from "porte," meaning "door") designating a vertical-format tapestry originally intended to be hung over a doorway to block drafts, but subsequently adopted for any tapestry with these proportions.

pot à feu A decorative motif consisting of a vase with a flame emerging from its mouth; inspired

by iron pots filled with fireworks formerly used in warfare to illuminate enemy camps.

potpourri A container with an openwork top designed to hold aromatic herbs and/or burning pastilles; often made of porcelain, and especially popular in the eighteenth century.

pouncing A technique for producing a mat, granular texture in metalwork, especially silver, by repeatedly hammering a pointed tool or pounce into the surface.

putto A mischievous nude infant, the image of which was frequently used in decoration from the Renaissance on; sometimes called an *amour*.

Q

quadratura Trompe-l'oeil perspectival depictions of architectural elements on walls and ceilings, often to create the illusion of additional interior space. Especially fashionable in Baroque Italy.

R

raffle leaf English term for a deeply serrated leaf used in ornament.

rafraichissoir French term for a wine-glass cooler or rinser, often placed between diners at eighteenth-century banquet tables to minimize the need for servants and so encourage frankness in conversation.

régulateur French name for a particularly accurate clock, usually in a vertical case and sometimes incorporating a barometer.

reliquary A container for holy relics; often made of precious materials and richly decorated, with an architectural or anthropomorphic design.

repoussé Relief work in metal produced by hammering its surface from beneath, with or without the aid of a mold. One of the oldest and most widely used of metalworking techniques.

retable A decorative ensemble placed above and behind an altar; sometimes used to designate a painted or sculpted altarpiece.

rinceau Ornament consisting of scrolled or rolling foliage, sometimes inhabited by human figures or fantastic animals. *See* chapter "Rinceaux" in volume I, *The Renaissance and Mannerism in Europe*.

rognon *See* **kidney table**.

römer A type of green-tinted wine glass produced in Germany since the late Middle Ages. It usually consists of a hemispherical vessel on a conical foot made of wound glass thread.

rosette A circular architectural ornament resembling a stylized rose or star. *See* **patera**.

rosewood A hard, purplish-red wood imported into Europe and North America from Brazil and Peru beginning in the mid-eighteenth century. Often used by furniture-makers in veneers and ornamental inlays.

running circles Ornamental motif consisting of aligned circles connected by tangents. *See* **running dog** and **Vitruvian scroll**.

running dog A classical ornamental motif consisting of repeated **volutes**. *See* **meander**, **running circles**, and **Vitruvian scroll**.

rustic order An architectural order whose columns and entablature feature rough or **vermiculated** surfaces.

rustication Masonry cut into massive blocks and often used to establish a contrast with more refined adjacent exterior wall treatments. There are several kinds of rustication, notably cyclopean (i.e., rough-hewn), **diamond-pointed**, and **vermiculated**.

S

sabot French term for a metal shoe, usually gilt bronze, enclosing the tip of the leg of a piece of furniture (literally, "clog").

satin A textile, usually made from silk, with a glossy surface.

scaling A pattern of overlapping circles reminiscent of fish scales.

schwarz ornament Black-ground interlace or bandwork designs popular in seventeenth-century Germany.

Schweifgroteske German word designating a particularly fantastic variety of **grotesque**.

scotia A concave molding, especially used to separate the two convex **torus** moldings on column bases.

scroll A decorative motif in the form of a spiral, as in an **Ionic** capital. *See* **volute**.

secrétaire French term for various kinds of writing desk in which papers could be locked away for safekeeping. They usually feature a flap that pivots down from the bottom of a "secretary-drawer" to provide a writing surface.

sedan chair A closed individual seat with handles designed to be lifted and carried by two footmen; often lavishly decorated.

semainier A case or organizer with seven compartments, one for each day of the week.

semis A kind of ornamental design that repeats a single symmetrical motif over a surface; frequently used to describe bookbindings with **diaper** patterns.

serpentine column A column whose shaft has been slightly coiled, creating an undulating effect.

serpentine front The undulating front surface of a piece of furniture, as in chests of drawers with bulging centers; the French adjective **bombé** describes such forms. *See* **arbalète (en)**.

serre-papiers *See* **cartonnier**.

serviteur muet *See* **dumbwaiter**.

settee A seat large enough for two persons with a back and arms; more formal than a **sofa** and more comfortable than a **settle**.

settle A bench with back and arms, usually without upholstery.

sideboard A piece of dining-room furniture for holding side dishes, plates, silverware etc., often having cupboards and drawers. *See* **buffet**.

sofa An informal, fully upholstered **settee** whose design invites lounging.

singeries Mode of ornament in which the main figures are monkeys, often depicted wearing clothing and "aping" the actions of human beings; prevalent in late seventeenth- and eighteenth-century French interior decoration and crafts production.

soffit The underside of any architectural element, such as a lintel, an arch, or a molding.

sphinx A fantastic animal derived from Egyptian mythology with the head of a man or woman and the body of a lion.

spindle-and-bead molding A molding with alternating round beads and oblong spindles.

stamped bindings Bookbindings decorated with patterns impressed into the leather by metal **panel stamps** or small blocks with a hand press. Used in the late Middle Ages and early Renaissance, this technique was much more efficient than the one previously employed, which involved stamping designs into the leather by hand.

steel An alloy of iron and carbon often used, in isolation or in combination with other metals, in applied-arts techniques such as damascening, marquetry, chasing, and engraving.

strapwork Ornament consisting of forms that resemble leather bands or straps, often with "curling" edges. *See* chapter "Strapwork and Cartouches" in volume I, *The Renaissance and Mannerism in Europe*.

stuccador A sculptor specializing in stuccowork.

stucco A fine plaster, especially one composed of gypsum and pulverized marble, used to cover walls, make moldings, etc. It can be made thick enough to be sculpted into relief and freestanding sculpture; such decoration is designated generically as "stuccowork."

stylobate The pedestal or substructure from which a colonnade rises.

surtout de table French name for a **table-center** or centerpiece.

T

table-center English term for an elaborate centerpiece of one or several components, and made of silver, ceramics, etc.

tabouret French term for a stool (from the French word for "small drum").

taffeta A generic term for various glossy silk fabrics, often patterned, used for hangings.

tapestry A generic term designating a thick textile into which a decorative pattern or composition has been woven by hand, intended to hang on the wall or over a piece of furniture. There are two techniques for weaving tapestries: high warp and low warp. *See* **warp**.

telamone A male figure emerging from a pedestal and supporting a cornice. Such figures are sometimes called **Atlantes**.

term A pedestal, tapering toward the base, from which a bust or half-length figure emerges.

thyrsus A staff decorated with vine or ivy leaves and topped by a pine cone; the attribute of Bacchus.

tin A metal characterized by a whiteness and luster that approach those of silver; it is highly malleable and ductile and is often alloyed with other metals.

tooling An incised or stamped pattern on a bookbinding. The phrase "blind tooling" is used to describe such designs when they have been left ungilded; when gilded, they are called "gold tooling."

tortoiseshell Precious material from the carapace of certain large tortoises; it was a crucial component of Boulle marquetry because of its translucency, richly mottled patterns of gold and reddish brown, pliability when heated, and surface capable of sustaining a high polish.

torus A convex molding of semicircular profile, as at the base of a column.

trellis An openwork screen, usually composed of thin wooden slats, of which garden arches and gazebos are often built; variations on such structures figure prominently in both garden design and ornamental compositions from the late seventeenth and the eighteenth centuries.

triglyph Blocks separating the **metopes** in a **Doric** frieze; each one has two vertical grooves in the center and half grooves at the edges, below which, underneath a molding, there are droplike **guttae**.

trophy Originally, a staff carried in procession and covered with the spoils of victory, or an analogous stationary monument. By extension, a decorative motif similarly composed of a set of allegorical objects or attributes, often those of the arts and sciences.

Tuscan order The simplest order of Roman architecture, distinguished from the **Doric** by an absence of decoration and by columns resting on high bases.

turquerie French term designating pseudo-Turkish ornament and iconography, which enjoyed a certain vogue in mid-eighteenth century France.

twisted fillet *See* **cable molding**.

U

urn A round, covered decorative vase inspired by the vessels the Romans used for the ashes of the dead.

V

verdure French term designating a tapestry with a vegetal or landscape composition, sometimes with animals.

velvet Textile made from silk or cotton that is smooth on one side and covered on the other with a thick pile. If the loops of this pile have been cut, it is called "cut velvet."

vermiculation The decoration of masonry blocks with irregular shallow channels resembling work tracks.

verre églomisé French term for glass decorated on the back by unfired painting or gilding, which is sometimes engraved with decorative compositions. The name derives from that of Jean-Baptiste Glomy (d. 1786), a Parisian framer who used the technique in his glass picture mounts.

Vitruvian scroll Decorative motif consisting of repeated volutes. *See* **meander** and **running dog**.

volute A decorative element in the form of a spiral scroll, especially that of a capital of the **Ionic order**.

voyeuse *See* **ponteuse**.

W

wardrobe A dressing room or other small space in which clothing is stored; by extension, a movable, closed cupboard in which garments are kept.

wings A motif often used in sculpted decoration since the Mannerist period; bat's wings and butterfly wings often figure in rocaille and rococo ornament.

warp In a woven fabric, the thick thread through which the thinner weft threads pass. In tapestry weaving, when the warp runs horizontally on the loom, the technique is called "high warp"; when it runs vertically, it is called "low warp." The latter technique is the easier and faster of the two, but the resulting image is of lower quality than in high-warp weaving, and it reproduces the tapestry **cartoon** in reverse.

Z

Zwischengold German word designating a technique for producing decorations on glass that are engraved and gilded, and then covered with another, protective layer of glass.

Biographical Notes

A

Asam, Ägid Quirin (1692–1750) German architect and decorator best known for his stucco decors (Munich, church of Saint John Nepomuk). Brother of architect and decorative painter **Cosmas Damian Asam** (1686–1739), with whom he collaborated.

Aubusson tapestries The workshops producing these tapestries, which were active beginning in the sixteenth century, were situated in individual homes. In the seventeenth century they depicted religious and mythological scenes and *verdures* (foliage or forest scenes). Most of the weavers were Huguenots, and they defected after the revocation of the Edict of Nantes in 1685, but a revival commenced in 1732.

Audran, Claude III (1658–1734) Born into a Lyons dynasty of painters and engravers, he worked for Louis XIV, notably at the Gobelins factory. Devised painted decors incorporating arabesques and *singeries* in the tradition of Jean Bérain.

Aufenwerth, Johannes (d. 1728) Augsburg-based porcelain painter. Decorated pieces for the Meissen factory as a *Hausmaler,* or independent painter working in an independent workshop.

Auvera, Johann Wolfgang von der (1708–1756) Sculptor and one of the finest practitioners of the German rococo; best known for the carved decor and furniture in the Spiegelkabinett (Room of Mirrors) in the Residenz in Würzburg, his native city.

Aveline family: Pierre-Alexandre Aveline (1702?–1760?) was an important engraver of compositions by Watteau, Boucher, Oudry, and Meissonnier. **François-Antoine Aveline** (1727–1780), his German cousin, engraved designs by Mondon and was the quintessential rocaille printmaker.

Avisse, Jean (1723–c. 1796) Parisian cabinetmaker who attained the guild status of master in 1745; worked for the court and for fashionable furniture dealers. His production marks the transition between Louis XV and Louis XVI.

B

Babel, Pierre-Edme (1700/11–1775) Parisian sculptor of decorative wood panels and engraver, active from at least 1736; also designed jewelry. Carved extensively for the crown from 1763 to his death in 1775. Issued fifteen suites of engraved ornament, the later ones showing a tendency toward elaborate, asymmetrical rocaille designs; executed many designs based on the work of such artists as Meissonnier and Boucher.

Ballin, Claude I (c. 1615–1678) Parisian silversmith who attained the guild status of master in 1637; executed the celebrated silver furniture and objects—tables, candelabra, orange crates, etc.—for Versailles that were melted down on Louis XIV's orders in 1689.

Barberini tapestry factory Established in Rome in 1627 by Cardinal Francesco Barberini, nephew of Pope Urban VIII, and active for about sixty years. Its most famous productions were sets of tapestries after designs by Pietro da Cortona, its artistic director.

Beauvais tapestry factory Founded by Colbert in 1664 with state subsidy but operated as a private enterprise. Its most celebrated tapestries were woven after designs by Jean Bérain, Jean-Baptiste Oudry, Jean-Baptiste Monnoyer, François Boucher, Charles-Joseph Natoire, Jean-Baptiste Deshays, and Jean-Baptiste Le Prince. In the nineteenth century it made a specialty of furniture covers. Merged with the Gobelins tapestry factory in 1945.

Bérain, Jean (1637–1711) Ornamentalist to Louis XIV: designer of opera sets, festival and funeral decorations, costumes, metalwork, interior decor, and Beauvais tapestry cartoons. He rejuvenated the grotesque tradition and effectively invented *singeries.*

Berlin tapestry factory Founded about 1690 by Huguenot refugees from Aubusson; specialized in imitations of Beauvais designs, and notable for producing the series *History of the Grand Elector* in 1693.

Berlin porcelain factories The first hard-paste factory was founded here in 1751, followed by another in 1763, which was nationalized by Frederick the Great. Influenced by the Meissen and Vincennes factories, they specialized in plates and figurines. Enjoyed a renaissance in the 1880s.

Biller family: Dynasty of Augsburg goldsmiths active in the seventeenth and eighteenth centuries. Its most notable figures included **Albrecht Biller** (1663–1720), who worked at the Dresden court, and **Johannes Biller** (1696–1745), royal goldsmith to the Prussian court.

Bohemian glasshouses Workshops active from the fifteenth century. Initially produced delicate glassware in the Venetian mode, then thick, brilliant ware imitating rock crystal and decorated with elaborate engraved patterns; the best of this work was made by independent craftsmen at the courts of the various German princes.

Bogaert, Thomas (1597–1652/3) Utrecht silversmith influenced by the auricular style of the Van Vianen family; he may have been trained by Adam van Vianen.

Bosse, Abraham (1602–1676) French engraver and draftsman, professor of perspective at the French Academy from its establishment in 1648 until 1665, when he was compelled to retire after a very public quarrel with Le Brun. He produced about 1,500 prints; most are allegorized depictions of daily life, but there are also a few ornamental sheets and Baroque mirror designs.

Bottengruber, Ignaz (active 1720–1736) Porcelain painter from Breslau who worked for the Meissen and Vienna factories as a *Hausmaler;* specialized in hunting and military scenes.

Böttger, Johann Friedrich (1682–1719) The inventor of European hard-paste porcelain and the first director of the Meissen factory from 1710.

Boulle, André-Charles (1642–1732) Celebrated furniture maker during the reign of Louis XIV. First worked for the Gobelins; named *ébéniste ordinaire du roi* in 1672. His name has become associated with the opulent style of brass-and-tortoiseshell marquetry that he perfected.

Bow porcelain factory Founded in 1744 in an eastern suburb of London. Known for its hybrid soft-paste production, using an American kaolin base, to make figurines, bowls (often chinoiserie), inkwells, mugs, etc. In 1748, Thomas Frye took out a patent for the production of bone china, a pure white porcelain made with bone ash.

Brandt, Reynier (1707–c. 1784) Dutch silversmith who worked in an Amsterdam variant of the rocaille style. He was prolific but did not produce table silver.

Bristol porcelain factories Between 1749 and 1752, a soft-paste porcelain made with Cornish soaprock was produced by Benjamin Lund in a factory in Lowdin's glasshouse: cream jugs, sauce boats, etc., often in chinoiserie designs. Hard-paste porcelain began to be produced there after 1770, in William Cookworthy's factory, notably tea-ware, vases, and figurines.

Bristol pottery A first tin-glazed earthenware factory with Italian craftsmen was in operation about 1650. In the mid-eighteenth century, blue wares with gold highlights and opaque cream-colored ware imitative of porcelain began to be produced there.

Brooks, John (c. 1710–c. 1756) Probable inventor of the transfer printing process for enamels and ceramics.

Brustolon, Andrea (1662–1732) Venetian sculptor, student of Filippo Parodi. Perhaps best known for a set of extravagant furniture carved for the Venier family and now in the Ca' Rezzonico in Venice: chairs with arms shaped like gnarled tree branches, tables supported by athletic African *atlantes,* and a vase-stand incorporating figures from classical mythology.

Brussels lace The city became a center for the production of both needlepoint and pillow lace in the early seventeenth century; the former is usually called *point de gaze* and is extremely delicate. Machine-made variants were first produced there in 1768.

Bruyn, Michiel de (1608–before 1670) Utrecht silversmith who settled in England in 1657; collaborated with Christiaen van Vianen beginning in 1661. Worked in the auricular and/or Baroque styles and made both secular and sacred pieces.

Bustelli, Franz Anton (1723–1763) One of the principal modelers at the Nymphenburg porcelain factory and perhaps the finest of all rococo modelers; known for mythological, Chinese, Turkish, and commedia dell'arte figures.

C

Caffiéri, Jacques (1673–1755) Born into an Italian family of sculptors and metal casters (his father Philippe Caffiéri was brought to France by Mazarin), he became one of the great virtuoso rocaille craftsmen, producing chandeliers, gilt-bronze mounts, clock cases, etc.

Capodimonte porcelain factory Founded in 1743 by Charles III, king of Naples. Produced delicate soft-paste porcelain, usually pure white and noted for its translucency. Many of its models were derived from Meissen production (plates, vases, figurines), but exuberant floral motifs characteristic of the Neapolitan tradition were also a specialty.

Chambers, William (1723–1796) Famous English architect and designer; studied with Jacques-François Blondel in Paris. His illustrated book *Designs of Chinese Buildings* (1757) was enormously influential, establishing a new standard of accuracy for the Western imitation of Chinese artifacts.

Channon, John (1711–c. 1783) English cabinetmaker; his pieces are inlaid with brass and feature lavish ormolu mounts.

Chantilly porcelain factory Established by Louis-Henri de Bourbon in about 1725 and operated by Siquaire Cirou until his death in 1751. Produced soft-paste porcelain—mainly plates and figurines—with so-called "Korean" polychrome motifs (dragons, partridges, processions, etc.), then with floral motifs imitative of designs from Meissen and Vincennes. Entered a period of decline after 1780.

Chelsea porcelain factory The first English porcelain factory, established in 1745. Soft-paste porcelain of great refinement and translucency: plates, saltcellars, tureens, and figurines. Reached its apogee in the 1750s. After 1758 a more opaque porcelain was preferred and the designs were inspired by French (Sèvres) as opposed to German (Meissen) models.

Chippendale, Thomas (1718–1779) The most famous English furniture-maker of the first half of the eighteenth century. His workshops produced rococo, chinoiserie, and neo-Gothic pieces, and he authored *The Gentleman and Cabinet-Maker's Director* (1754), the first comprehensive book of furniture designs, which was immensely influential.

Cousinet, Henri-Nicolas (active 1724–1768) Great Parisian silversmith who worked in the rocaille style; attained the guild status of master in 1724. Best-known for an elaborate silver-gilt *nécessaire* made for Queen Marie Leszczynska (1724–30, Louvre), whose components are decorated with flower, shell, and dolphin motifs.

Crespin, Paul (1694–1770) English silversmith of Huguenot origins. Author, with Nicolas Sprimont, of a large rocaille table service for Catherine the Great of Russia, most of which was later melted down.

Cressent, Charles (1685–1768) One of the great French furniture-makers of the eighteenth century. Worked in a sumptuous rocaille style and defied guild regulations to make his own bronze mounts, which are notable for their plastic force and formal invention. Best known for his clock-cases, commodes, and cartel clocks.

Cresson, Louis (1706–1761) The most famous member of a great dynasty of Parisian furniture-makers; attained the guild status of master in 1738 and was patronized by the crown.

Criaerd, Mathieu (1689–1776) Principal representative of line of Parisian cabinetmakers of Flemish extraction; attained the guild status of master in 1738. Produced furniture with floral and geometric marquetry, chinoiserie lacquer work, and rocaille mounts.

Cucci, Domenico Filippo (c. 1630–1705) Italian cabinetmaker and sculptor who settled in Paris about 1660; he worked for Louis XIV at the Gobelins factory until Le Brun's fall from favor in 1683, after which he took private clients. He produced sumptuous cabinets with opulent inlaid decoration; most of these have disappeared.

Cuvilliés, François de (1695–1768) Architect and decorator; born in Flanders, trained in Paris under J.-F. Blondel, and became court architect in Munich. One of the masters of the rococo (interiors in the Munich Residenz and the Amalienburg in the Nymphenburg park near the same city); published a series of engraved designs for ornament, woodwork, and furniture of remarkable lightness.

D

Dagly, Gerhard (active 1687–1714) Eminent Japanning craftsman who worked in Berlin for Frederick William, the Great Elector of Brandenburg, from 1696 to 1713.

Dahlin, Nils (d. 1787) Swedish furniture-maker; attained the guild status of master in Stockholm in 1761 and worked for the Swedish court. His early work is in a French rocaille style.

Dahlström, Carl Peter (1700–1794) Swedish cabinetmaker trained in Paris who worked for the Russian court.

Darly, Mathew (active 1741–1780) English draftsman and engraver who published chinoiserie designs that were instrumental in stimulating a taste for the style in England.

Decker, Paul (1677–1713) Architect and ornamentalist born in Nuremberg; some of his published designs for chinoiseries and grotesques were influenced by Jean Bérain.

Degoullons, Jules (c. 1671–1738) French sculptor, founding member of the *Société des sculpteurs ornemanistes;* his most notable work was done for the royal chapel at Versailles.

Delanois, Louis (1731–1792) Famous Parisian furniture-maker; attained the guild status of master in 1761. Most of his work is in the Louis XV style, but he also produced some chairs in the Louis XVI style for Madame du Barry's apartments at Versailles and Louveciennes.

Delft pottery Beginning in the mid-seventeenth century, this Dutch town was the most important center for the production of tin-glazed earthenware: vases, tulip-holders, tiles, table

services, etc. Famous for its blue-and-white color scheme, adopted after an initial polychrome period in which Italian majolica was the model, but such brilliant palettes were never entirely abandoned. Pottery produced elsewhere in Europe in a similar style is often called Delft, and in the eighteenth century the workshops actually situated in Delft faced stiff competition.

Dinglinger, Johann Melchior (1664–1731) Goldsmith to the court of Dresden who worked in the extravagant tradition of Cellini and Jamnitzer. Partial to exotic imagery and precious materials, he is perhaps best known for his elaborate tableaux of exquisitely wrought figurines. He was sometimes assisted by his brothers, Georg Friedrich and Georg Christoph.

Doccia porcelain factory Founded near Florence in 1737 in emulation of the Vienna factory. A grayish, slightly rough-textured hybrid hard-paste was used. Specialized in large figures inspired by antique sculpture.

Drentwett family: An important family of Augsburg silversmiths active in the seventeenth and eighteenth centuries whose collective production includes work in both the auricular and the rococo styles. **Abraham Drentwett** (c. 1647–1727) is known for engraved metalwork designs in an exuberantly Baroque idiom.

Dubois, Jacques (c. 1693–1763) Parisian cabinetmaker specializing in the rocaille style; attained the guild status of master in 1742. He sometimes worked after designs by Nicolas Pineau. Father of **René Dubois** (1737–1799), one of the creators of the Louis XVI style.

Duplessis, Jean-Claude (active before 1733–d. 1774) Also known as Jean-Claude Duplessis the elder. Goldsmith, ornamentalist, and metal-caster of Italian extraction (his original name was Ciamberlano), active first in Turin and then in Paris. Produced vase designs and rocaille porcelain mounts for the Sèvres factory, but he also worked independently, most notably as a maker of gilt-bronze furniture mounts.

E

Eberlein, Johann Friedrich (1696–1749) German sculptor who worked at the Dresden court, then in England and, from 1735 on, as a modeler at the Meissen porcelain factory, where he collaborated on the celebrated Swan Service (1737–41).

Egell, Paul (1691–1752) German rococo sculptor who worked at the Mannheim court beginning in 1721. Best known for his figural pieces, but he also produced carved furniture.

F

Feichtmayr, Johann Michael (1709/10–1772) German ornamentalist and stuccador who worked at the Ottobeuren Abbey. Brother of **Joseph Anton Feichtmayer** (1696–1770) also a stuccador.

Florentine mosaic The English name for "Comesso di Pietre Dure," decorative panels made from tesserae of *pietra dura,* first produced in a Medici workshop established in Florence in 1588. The technique was introduced into France under Louis XIV (Gobelins), and in the eighteenth century was taken up by craftsmen in Naples and Spain.

Foggini, Giovanni Battista (1652–1725) Florentine architect, sculptor, and draftsman who worked for the Medici beginning in 1687. Best known for his altar frontal designs (SS. Annunziata, Florence) and his ebony furniture encrusted with *pietre dure* and mother-of-pearl inlay (Palazzo Pitti, Florence).

Foliot, Nicolas Quinibert (1706-1776) Eminent member of an important dynasty of Parisian furniture-makers; attained the guild status of master in 1730. Played an important role in the development of the Louis XVI style chair and supplied much upholstered furniture for Versailles, Fontainebleau, and other important palaces and châteaux.

Frankfurt-am-Main pottery Founded in 1666. Its earliest production with brilliant blue or violet decoration was often mistaken for Delft pottery. Exotic floral motifs, chinoiseries, and biblical vignettes were specialties. Entered a period of decline in the eighteenth century.

Fulda pottery and porcelain factories The faïence factory was founded in 1741 and remained active until 1758, specializing in wares painted with enamel colors fired in *petit feu* (low-temperature or muffle) kilns. The porcelain factory was founded in 1764 and is best known for its delicate figurines.

Funk, Mathaus (1697–1783) One of the finest furniture-makers in eighteenth-century Switzerland; settled in Berne in 1706. His work was much influenced by Charles Cressent.

G

Gaudreaux, Antoine-Robert (c. 1682–1746) Parisian cabinetmaker; attained guild status of master in 1726. Best known for his sumptuous pieces for the crown, notably two made for Louis XV: a medal-cabinet (Bibliothèque Nationale, Paris) and a commode with extravagant gilt-bronze mounts by Caffiéri (Wallace Collection, London), both in collaboration with the Slodtz brothers.

Germain family: Dynasty of Parisian silver-smiths. **Thomas Germain** (1673–1748), probably the finest rocaille metalworker, was celebrated for his invention and virtuosity. He studied in Rome as a young man, where the Roman Baroque idiom made an indelible impression on him, and went on to work for the French court and other European courts, notably that of Portugal. **François-Thomas Germain** (1726–1791) took over his workshops after his death, but he declared bankruptcy in 1764 and never fully recovered financially.

Gibbons, Grinling (1648–1721) English Baroque sculptor of architectural decor best known for his ornamental woodcarving in a refined yet virtuosic naturalist style, most of which feature festoons of fruit, flowers, and foliage.

Gillot, Claude (1673–1722) French painter known for his tapestry cartoons and grotesque compositions in the tradition of Bérain; a teacher of Watteau.

Gobelins Tapestry factory that began to operate on the outskirts of Paris as early as 1607. In 1663, at Colbert's instigation, it was taken over by the Crown, redubbed the *manufacture royale des meubles de la Couronne,* and became a center for prestige artisanal production of all kinds, which it remained for several decades, turning out furniture, carpets, tapestries, metalwork, etc. After the early decades of the eighteenth century, when most of these craftsmen moved elsewhere, it remained the prime royal high-warp tapestry factory, and in fact the quality of its tapestry productions has never been surpassed. It was successively under the direction of Charles Le Brun, Pierre Mignard, Antoine Coypel, Jean-Baptiste Oudry (director beginning in 1733), etc. It enjoyed a revival after the Revolution, under Napoleon, and remains active to this day.

Golle, Pierre (active 1670–90) Dutch cabinetmaker brought to Paris by Mazarin; worked for Louis XIV at the Gobelins factory, specializing in sumptuous ebony and ivory pieces with rich floral marquetry inlay. A Protestant, he was forced to emigrate after the revocation of the Edict of Nantes in 1685.

Gricci, Giuseppe (1700–1770) One of the most inventive creators of models for Italian rococo porcelain; best known for his chinoiserie porcelain rooms in Capodimonte and Aranjuez.

Gumley, John (1691–1727) English furniture-maker who specialized in elaborately framed and engraved mirrors.

H

Habermann, Franz Xaver (1721–1796) German sculptor and ornamentalist. He produced

some 500 ornamental prints for furniture, silverware, ironwork, etc.; the earlier ones are in the rocaille style, but he later adopted a neoclassical idiom.

Halfpenny, William (d. 1755) English carpenter and architect who published popular books of chinoiserie and neo-Gothic architectural and furniture designs.

Hannong family: Strasbourg dynasty of faïence and porcelain factory owners and managers founded after 1709 by **Charles-François Hannong** (1669–1739). His son **Paul-Antoine** (1700–1760) devised new modes of decoration (India flowers), imported from Germany techniques for fixing painted decoration in low-temperature firing (*petit feu*) and for the production of hard-paste porcelain. Paul-Antoine's son **Joseph-Adam** introduced industrial production methods.

Harache, Pierre (d. 1700) One of the finest Huguenot refugee silversmiths working in London. Worked for King William III beginning in 1688. Partial to gadrooning, cut-card work, and figurative ornament.

Herold, Christian Friedrich (1700–c. 1779) One of the principal painters of the Meissen porcelain factory; specialized in chinoiserie motifs, landscapes, and harbor vignettes.

Heurtaut, Nicolas (1720–?) Parisian furniture-maker specializing in richly carved chairs; attained the guild status of master in 1755. Still active in 1771.

Höchst pottery and porcelain factory Founded near Mainz in 1746. Pottery characterized by bright enamel colors and original forms (pear-shaped vases, anthropomorphic platters, asymmetrical tureens, etc.). Porcelain production began in 1750 and pottery production ceased in 1758; rococo forms were favored, with figurines and table-ware predominating. The factory closed in 1796.

Hoppenhaupt family: Johann Michael Hoppenhaupt (1709–1769) designed furniture for the Prussian court and published designs for furniture and ornament in an exaggerated, impractical rococo idiom. His younger brother **Johann Christian** (1719–1786) was an ornamentalist specializing in interior decor. **Johann Michael Hoppenhaupt the elder** (1685–1751) is known for the music room at Sans-Souci, in Potsdam.

Huet, Christophe (d. 1759) French decorative painter best known for his *singeries* at the Château de Chantilly and his chinoiserie compositions at the Château des Champs. His engravings in these two idioms were widely imitated by marquetry artisans and porcelain painters.

Hund, Ferdinand (c. 1704–1758) German rococo furniture-maker and ornamentalist who worked with Balthasar Neumann on the south wing of the Residenz in Würzburg, for which he also produced much carved furniture.

Huquier, Gabriel (1695–1772) French engraver, ornamentalist, and print entrepreneur who worked from his own designs as well as after compositions by Watteau, Oppenord, and Meissonnier. An important figure in the diffusion of the rocaille style.

J

Jensen, Gerreit or Gerrit (active c. 1680–1715) Cabinetmaker active in London and presumably of Dutch or Flemish extraction who worked for the Crown after the 1688 Revolution. Partial to marquetry inlay and Japanning.

Johnson, Thomas (1714–c. 1778) English rococo furniture maker and designer who published designs for decorative furniture and ornament of French inspiration.

Joubert, François (active 1749–1793) Parisian silversmith; attained the guild status of master in 1749. Worked in the rocaille style, notably for Madame de Pompadour.

Joubert, Gilles (1689–1775) Parisian cabinet-maker employed by the Crown beginning in 1748; an accomplished craftsman who lacked originality. Much of his work was farmed out to other artisans.

Juvarra, Filippo (1678–1736) Architect born in Messina who studied with Carlo Fontana in Rome. Worked for the king of Piedmont in 1714, supervising the decoration and furnishing of the royal households there.

K

Kambly, Johann Melchior (1718–1783) German rococo furniture-maker and decorator. His furniture is notable for its elegance and its inventive gilt-bronze mounts. Worked for Frederick the Great in Potsdam and Berlin.

Kandler, Charles (active 1727–1775) English rococo silversmith influenced by French and German models.

Kaendler, Johann Joachim (1706–1775) Modeler for Meissen, renowned for innumerable statuettes representing the Chinese, the Turks, mythological figures, actors from the commedia dell'arte, etc. Co-designer of the Swan Service.

Kent, William (1685-1748) English architect of Palladian inspiration. Also an accomplished designer of interior decor and furniture more extravagant in style than his building designs, and an influential landscape gardener.

Kunckel, Johann F. (1630–1703) Chemist and glass technologist. In 1678 named director of the Potsdam factory, where he perfected a method for the production of fine crystal and a ruby glass suitable for use in glassware.

L

Lajoue, Jacques de (1686–1761) French painter and ornamentalist. Theater sets and imaginary gardens in the "genre pittoresque." With Meissonnier and Pineau, one of the great form-givers of the rocaille.

Lamerie, Paul de (1688–1751) Dutch Huguenot refugee silversmith who settled in England and worked for the Crown. His work evolved from the heavy "Huguenot" style fashionable early in the eighteenth century (featuring cut-card ornament, finely modeled cast-work, and much gadrooning) to a French-inflected rococo style.

Lamour, Jean (1698–1711) Metalworker from Lorraine. Under the direction of architect Emmanuel Héré, executed the monumental wrought-iron rocaille gates and railings in the Place Stanislas in Nancy.

Langley, Batty (1696–1751) English ornamentalist and interior designer, and author of numerous manuals for gilders, carpenters, gardeners, etc. with illustrated models; most of them are Palladian, but some are rococo and neo-Gothic.

La Salle, Philippe de (1723–1805) The most famous designer of eighteenth-century Lyons silks and velvets for furnishings. Favored large, naturalistic motifs incorporating birds, flowers, and swags executed in a lampas weave.

Latz, Jean-Pierre (c. 1691–1754) German cabinetmaker who settled in Paris and worked for Louis XV. Best known for his pendulum clock cases with rich gilt-bronze mounts.

Le Brun, Charles (1619–1690) French painter and designer; founding member of the French Royal Academy in 1648 and virtual artistic dictator under his patron Louis XIV. The "Louis XIV style" was largely his invention, promulgated in productions of the Gobelins factory and the royal sculpture workshops, which worked for decades to his designs. He was also largely responsible for the Italianate style of interior decoration still visible in the ceremonial rooms at Versailles.

Le Pautre, Jean (1618–1682) French engraver, maker of 2,200 prints (of which 1,125 are ornamental prints) after drawings by himself and others which were widely influential among decorative artists. His son **Pierre** (c. 1648–1716), a designer employed by the Crown, played an important role in the genesis of the rocaille style.

Lock, Matthias (c. 1710–1765) Author of ornament books and furniture designs that helped establish the rococo style in England. Probably worked with Thomas Chippendale.

Löwenfinck family: German porcelain painters. The most famous, **Adam Friedrich von Löwenfinck** (1714–1754), who specialized in floral motifs, worked at Meissen, Chantilly, Fulda, Höchst, and Strasbourg.

Lunéville pottery First factory established in 1731, and success rapidly ensued. Tableware similar to that produced in Strasbourg and Niderviller but of less refined workmanship. Large animals and figurines in *terre de pipe* (a soft white unglazed earthenware) after models by P.-L. Cyfflé. A branch operation was established in 1758 at Saint-Clément.

Lyons silk factories Flourished in the seventeenth century, notably under Louis XIV (flowered lampas, then velvet, damask, and brocatelle). Reached their peak in the eighteenth century, thanks to a happy collaboration between weavers and designers (Philippe de La Salle, Jean Revel).

M

Marot, Daniel (1663–1752) French engraver and designer; son of architect **Jean Marot** (1619–1679) and nephew of cabinetmaker **Pierre Golle** (active 1670–90). Worked primarily in Holland. Produced many model prints of furniture and interior ornament in the Louis XIV style.

Marseille potteries Flourished around 1675 thanks to **Joseph Clérissy,** whose Saint-Jean-du-Désert workshop produced blue-and-white pottery similar to that made by his brother **Pierre** in Moustiers. Around 1750 other workshops situated there (the **widow Perrin, Louis Leroy,** etc.) created brilliantly colored enameled pottery of unusual perfection.

Martin family French artisans, best known for their Japanning work and their invention of "Martin varnish."

Meissen porcelain factory Royal factory established in 1710 by Augustus the Strong, elector of Saxony. By 1720 **Böttger**'s discovery of the hard-paste technique brought its production to a peak, where it remained until the 1750s. Of its many products, perhaps the freestanding figures and groups, which owed their superb quality largely to modelers such as **Johann Joachim Kaendler** (1706–1775), should be singled out.

Meissonnier, Juste-Aurèle (1695–1750) French ornamentalist and silversmith. One of the form-givers of the later rocaille or "pitto-resque" style, which cultivated a bold asymmetry (*Livre d'ornements*, 1734). Named Bérain's successor in the post of "architecte-dessinateur de la Chambre et du Cabinet du Roi" in 1725. His work is now known almost exclusively through his prints and drawings, which are extravagantly inventive and (often) impractical, but he was immensely influential.

Mekeren, Jan van (c. 1690–c. 1735) Dutch furniture-maker specializing in cabinets decorated with floral marquetry compositions of great virtuosity.

Mennecy porcelain factory Established about 1735, near Paris; production probably ended about 1780. Very white soft-paste pieces of high quality. Forms inspired by silver.

Miseroni family Carvers and engravers of precious and semiprecious stones, of Milanese extraction. Worked for the Hapsburgs and the Medicis from the late sixteenth to the late seventeenth centuries.

Mondon, François-Thomas (1709–1755) French jewel cutter and designer of ornament prints in the manner of Lajoue. The word *rocaille* was first used in a collection of images in the title of his *Livre de forme Rocquaillé [sic] et cartel* (1736). He provided designs for nine such collections, some of which were fantastic, others of which had specific uses, notably for furniture decorations and frames; all of them were published by François-Antoine Aveline.

Moore, James (d. 1726) English furniture-maker who worked for the Crown beginning in 1715. Some of his pieces are after designs by William Kent.

Mortlake tapestry factory Established in 1619. Flemish weavers. Compositions inspired by Raphael and Mantegna, among others. Decline in the last quarter of the seventeenth century.

Moustiers potteries Center dominated by the **Clérissy** family, which beginning in 1675 produced beautiful faïence with blue decoration. Polychrome designs with high-temperature colors were introduced by **Joseph Olérys** in 1739.

N

Nahl, Johann August (1710–1785) German decorator and ornamentalist, one of the great figures of the German rococo. Worked for Frederick the Great in Berlin and Potsdam about 1745.

Naples *pietra dura* **factory** Established in 1737 by King Charles III. Florentine craftsmen. Tabletops in the style of the *pietra dura* factory in seventeenth-century Florence, and somewhat later use of petrified woods.

Nestfell, Johan Georg (1694–1762) German cabinetmaker born in Hesse. Sacred and secular pieces characterized by sumptuous Baroque marquetry in precious woods, ivory, horn, mother-of-pearl, and metal.

Nevers pottery Italianizing production beginning in the late sixteenth century (**Conrad brothers**). Commencing about 1630, narrative vignettes in white and yellow against a lapis lazuli or "Nevers blue" ground; then polychrome chinoiserie designs; finally, about 1670, decorative compositions against Persian blue ground. Decline by mid-eighteenth century.

Niderviller pottery and porcelain factory Founded in 1735, intensely active after 1748. Floral and figural decorative schemes against an ivory ground of Strasbourg origin. Terrines shaped like vegetables. Porcelain production began in 1762–63.

Nogaret, Pierre (1720–1771) The principal provincial French furniture-maker of the eighteenth century, active in Lyons. Carved rocaille chairs, often caned.

Nuremberg glass factories Numerous workshops beginning in the late fifteenth century. Production limited to light pieces in the Venetian mode. Nuremberg's finest painted and enameled glassware was produced in the seventeenth and eighteenth centuries.

Nymphenburg porcelain factory One of the finest in eighteenth-century Germany. Established in 1747. Ten years later it began to produce fine hard-paste porcelain. Rococo figurines, cane handles, and boxes with metal frames. Still in operation.

O

Oeben, Jean-François (c. 1721–1763) Celebrated Parisian cabinetmaker of German origin. Student of Charles-Joseph Boulle 1751–54. Began to work for the king in 1754; attained the guild status of master in 1761. Clients included Mme de Pompadour. Specialized in pieces with secret compartments (desk of Louis XV, Versailles).

Oppenord, Gilles-Marie (1672–1742) French ornamentalist who devised models for interior decor, paneling, silver, molding, mantelpieces, etc. Much favored by the Regent, whose official architect he became in 1715. Huquier published three sets of prints after designs by him after his death.

Oudenarde tapestry factories Active from the fifteenth century to shortly before the French Revolution. Apogee in the sixteenth and seventeenth centuries. Production of foliage and forest scenes, landscapes, and compositions inspired by Flemish painting.

Oudry, Jean-Baptiste (1686–1755) French animal painter. Executed cartoons for the Beauvais and Gobelins tapestry factories; appointed as designer at Beauvais in 1726, and co-director 1734–55.

P

Papillon, Jean (1661–1723) Parisian wallpapermaker. Raised the status of this material to such a degree that it began to appear in homes of the wealthy.

Paris tapestry factories Given new life by Henry IV. Flemish weavers. Three workshops active until the Fronde (1648–1752): Louvre, faubourg Saint-Antoine, and faubourg Saint-Marcel (compositions after Rubens and Simon Vouet).

Parodi, Filippo (1630–1702) Genoese Baroque sculptor known for his sumptuous carved furniture and decoration. Teacher of Andrea Brustolon.

Perrot, Bernard (d. 1709) French glass-maker of Italian extraction. Produced common "verre de fougère" as well as finer wares, such as crystal glass ("façon de Venise") and milky white glass resembling porcelain, used mostly for figurines. Inventor of a technique for casting glass in sheets that had immense impact on the production of mirrors.

Peyrotte, Pierre-Alexis (1699–1769) Parisian decorative painter and designer of fabrics and tapestries, known for his flower and chinoiserie designs. Specialized in decor and furnishings for the court, including decorative schemes at Versailles, Fontainebleau, and Choisy; issued fifteen suites of engraved ornament.

Pichler, Johann Adam (active 1709–1730) Tyrolian cabinetmaker trained in Paris during the Regency; worked in the rococo style for the Munich court.

Piffetti, Pietro (c. 1700–1777) Virtuoso Italian cabinetmaker who worked for the court in Turin. Influenced by Juvarra and by French rocaille models. Favored rich marquetry and gilt-bronze mounts of an overwrought, excessively showy character.

Pineau, Nicolas (1684–1754) Architect, decorator, and ornamentalist, one of the key figures of the later rocaille style known as the "genre pittoresque," characterized by an asymmetrical vocabulary he helped elaborate. Student of architects J.-H. Mansart and G. Boffrand. First worked in Russia for Peter the Great; on returning to Paris was much sought-after as a designer of furniture and decor.

Plitzner, Ferdinand (1678–1724) German cabinetmaker with a superb grasp of French Louis XIV furniture, notably that of Boulle.

Perhaps best known for his furniture in the mirror room at Pommersfelden.

R

Revel, Jean (1684–1751) One of the most famous Lyons silk designers. Largely responsible for popularizing naturalistic flower and fruit motifs, which remained fashionable in Europe until the late nineteenth century. He exploited a new technical development in weaving, *points rentrés* (interlocking areas of color blurring the division between adjacent colors), to achieve surprising relief effects.

Risenburgh, Bernard II van (c. 1700–1765/67) One of the great cabinetmakers of the Louis XV period; attained the guild status of master before 1730. Worked for Parisian dealers, through whom his pieces were channeled to prestigious clients at the French court and elsewhere. Sumptuous rocaille pieces—and occasionally more classicizing ones—with naturalistic floral marquetry, lacquer panels, and gilt-bronze mounts. He was the first to use Sèvres porcelain plaques on furniture. Estampille: B.V.R.B.

Roëttiers, Jacques (1707–1784) Silversmith of Walloon extraction who settled in Paris and entered the king's service as *orfèvre du roi* in 1737. Remarkable rocaille silver, then accomplished neoclassical pieces. Most of his large-scale work for the Crown was destroyed, but his lavish Orloff service for Catherine the Great—named after the Russian count to whom she gave it—survives, although it has been dispersed.

Roscher, George Michael (active about 1750) German ornamentalist who published inventive models for rocaille silver and furnishings (mirrors, chairs, inkwells, etc.).

Rouen potteries Flourished from the mid-sixteenth century; in the mid-seventeenth-century, factories established or directed by **Nicolas Poirel, Edmé Poterat,** and then son **Louis Poterat.** Initially, production with a marked Italian flavor; then, the Dutch-Chinese style associated with Delft and Nevers prevailed. The *style rayonnant* (a symmetrically radiating pattern) appeared at the end of the seventeenth century, sometimes *à lambrequins* (lacework or scrollwork patterns), followed between 1720 and 1750 by chinoiserie and rocaille designs.

Roumier, François (d. 1748) French sculptor. Worked for the Crown beginning in 1720. Gilded paneling and console tables in an ingenious rocaille idiom. Published models for furniture and ornament.

Roussel, Pierre (1723–1782) Parisian cabinetmaker; attained the guild status of master

in 1745. Geometric, floral, and landscape marquetry compositions, often of Far Eastern inspiration.

S

Saint-Cloud porcelain factory Established in 1677. Soft-paste work decorated with blue lambrequins in the Rouen style, then designs of Far Eastern derivation, in relief and either white or with polychrome color schemes. Closed in 1766.

Savonnerie carpet factory Founded in 1627 in Paris. Sumptuous *points noués* carpets, almost all of them reserved for the Crown. Reached its apogee under Louis XIV. Merged with the Gobelins in 1825.

Sceaux faïence factory Established in 1748. Soft-paste porcelain and faïence of high quality. Beginning in 1763, porcelain comparable to that from Mennecy, but with brighter colors and more naturalistic decorative schemes.

Schnell, Martin (active 1703–1740) German furniture and porcelain painter. Worked under Gerhard Dagley in Berlin and then at the Dresden court of Augustus the Strong, who named him his official lacquer-maker. Specialized in whimsical Japanned chinoiserie decoration, notably on trays but also on larger pieces of furniture.

Schübler, Johann Jakob (1689–1741) German Baroque furniture designer, architect, painter, sculptor, and mathematician. He claimed to have based his often scroll-encrusted forms on precise mathematical calculations. Also a deviser of mechanical contraptions: dumbwaiters, collapsible beds, ingeniously compartmentalized desks, etc. Published a collection of models for furniture and decoration (Augsburg, 1720) that was reissued twenty times.

Schumacher, Martin (1695–1781) One of the finest German cabinetmakers of the eighteenth century. Active in Ansbach. Elegant pieces with filigree marquetry in the manner of Boulle. Used mahogany, which was rare in this period.

Sèvres porcelain factory Royal factory started in Vincennes and transferred to Sèvres in 1756. First production was soft-paste, in the rocaille style: biscuit figurines after models by sculptors and polychrome pieces with sparkling gold designs against bright grounds of dark *gros blue*, sky blue, and lemon yellow. Still in operation.

Slodtz family: Parisian sculptors of Flemish origin, most famous for the work of three brothers, all sons of **Sébastien Slodtz** (1655–1726), who had studied with François Girardon. **Sébastien Antoine** (1695–1754), appointed "dessinateur de la Chambre du Roi" in 1750

(succeeding Meissonnier), was a designer of court festivities, theater sets, and furniture. **Paul Ambroise** (1702–1758) succeeded him in this post, and was succeeded in turn by **René Michel,** known as **Michel-Ange** (1705–1764), among the finest French sculptors of the century. Collectively, they are known for their sumptuous large-scale ceremonial forms (notably elaborate funeral catafalques and the four marble tombs by Michel-Ange) whose style is difficult to classify—especially after the return from Rome in 1746 of Michel-Ange, who injected a new grandeur into the family's work.

Spindler family German rococo cabinetmakers influenced by French models. Active in Donndorf, near Bayreuth (marquetry paneling in a room in Schloss Fantasie), in Potsdam (furniture for Frederick the Great), and in Berlin.

Sprimont, Nicolas (c. 1716–1771) Huguenot silversmith of Flemish extraction who worked in London. Worked with Paul Crespin; in 1742, admitted to the London Goldsmiths' Company. Favored a rococo style incorporating naturalistic forms: shells, crabs, dolphins, etc. Worked for the Chelsea porcelain factory beginning about 1745; proprietor 1756–69.

Strasbourg pottery and porcelain factories Pottery factory founded in 1720, directed by the **Hannong** family. Began to flourish about 1732. Decorative schemes featuring India flowers and chinoiseries, then "Strasbourg flowers"; figurines produced about midcentury. Porcelain was produced there between 1751 and 1755.

T

Tijou, Jean (active 1689–1712) Virtuoso French ironworker who settled in England. Worked notably at Hampton Court Palace and at Saint Paul's Cathedral (gates and balustrades). Published the first English book of metalwork designs (*A New Book of Drawings,* 1693).

Tilliard, Jean-Baptiste I (1685–1766) Leading Parisian chair-maker of the Louis xv period. Beginning about 1730, worked largely for the Crown. Sumptuous, amply proportioned pieces, often carved by Roumier and gilded by Bardou. Workshop taken over by his son **Jean-Baptiste** II after his death.

Toro, Bernard Turreau, known as (1672–1731) Sculptor and ornamentalist born in Toulon. Between 1716 and 1719, published in Paris sets of designs in a precocious rocaille idiom: furniture, trophies, cartouches, etc.

Tournai porcelain factory Founded in 1751. Began with Far Eastern designs; then forms inspired by silver as well as by Sèvres and Meissen porcelain.

V

Vandercruse Delacroix, Roger (1728–1799) Parisian cabinetmaker who attained the guild status of master in 1755. He specialized in small pieces of furniture in a transitional style using marquetry, Martin varnish, and placques of Sèvres porcelain. Estampille: R.V.L.C. or R. LACROIX.

Van Vianen family: Family of silversmiths originally based in Utrecht. **Paul** (c. 1570–1613), who worked at the royal courts in Munich and Prague, and his nephew **Christaen** (c. 1600–1667), silversmith to Charles I of England, are among the principal masters of the auricular style, which reached its apotheosis in a ewer made by **Adam** (c. 1565–1627) in 1614 as a memorial to his brother Paul.

Van der Vinne, Leonardo (active 1662–93) Dutch cabinetmaker active in Paris and Florence. He specialized in furniture, musical instruments, and firearms, and was known for his ivory and colored-wood marquetry and *pietre dure* inlay.

Vassé, François-Antoine (1681–1736) Ornamental sculptor who worked in the rocaille style. Active in Toulon, Paris, and Germany; specialized in gilt-bronze fittings, woodwork, and marble mantelpieces.

Venetian glasshouses Active as early as the tenth century. Workshops moved to Murano in the thirteenth century. Techniques of Eastern pedigree. Diverse production intended primarily for export: glass trinkets, enamels, glass- and crystalware (colored, filigree, engraved or enameled with vignettes, decorated with gold and pearls), mirrors, etc.

Verberckt, Jacques (1704–1771) Sculptor born in Antwerp and active in Paris. In 1730 began decorating interiors of French royal palaces. Created sumptuous panels in the rocaille style executed after designs by other artists, notably architect Jacques Gabriel.

Vienna porcelain factory Established in 1719 at the instigation of renegade artisans from Meissen. Sold to the Austrian state in 1744. Initial production similar to that of Meissen (chinoiseries, India flowers, etc.). A new high point was reached about 1750, especially in rococo tableware and figurines. Closed in 1864.

Vile, William (c. 1700–1767) Accomplished English cabinetmaker of the early George III period. Worked in a transitional idiom between the rococo and neoclassical styles. Associated with John Cobb 1750–65.

Vincennes porcelain factories Founded in 1738, made a royal factory in 1753, moved to Sèvres in 1756.

W

Watteau, Antoine (1684–1721) French painter, student of Claude Gillot and Claude Audran. Devised ornamental designs, arabesques, and grotesques in the rocaille style suitable for a variety of applications. His compositions and figures were adapted in porcelain, notably that produced in Meissen.

Wauters, Michel (d. 1679) Antwerp weaver who made important tapestries after cartoons by Giovanni Francesco Romanelli and Abraham van Diepenbeck.

Willaume, David (1658–1741) French Huguenot silversmith who sought refuge in London and worked for King George II. His work is characteristic of the so-called Huguenot style, which features richly gadrooned borders, cut-card ornament, and finely modeled cast-work.

Wood family: Dynasty of Staffordshire pottery makers active in the eighteenth and nineteenth centuries. Its founding figure was **Ralph** I **Wood** (1715–1772), who produced figurative and picturesque pieces in delicate colors.

Z

Zeckel, Johann (active 1660–1728) One of the finest Augsburg silversmiths specializing in Baroque religious articles such as reliquaries and statues.

Zerbst pottery German factory established in 1720, active until 1861. In the eighteenth century, production dominated by blue-and-white wares in the Delft style.

Zimmermann, Johann Baptist (1680–1758) German stuccador. Made the rococo ceilings in the Residenz in Munich and in the Amalienburg pavilion in Nymphenburg. Worked with his brother, architect **Dominikus Zimmermann.**

Bibliography

GENERAL

Andresen, A. *Der Deutsche Peintre-Graveur oder di deutschen Maler als Kupferstecher.* . . . 5 vols. Leipzig, 1872–78.

Bacou, R. *Le Cabinet d'un grand amateur, P. J. Mariette, 1694–1774: dessins du XVᵉ au XVIIIᵉ,* exhibition catalogue. Louvre, Paris, 1967.

Bartsch, A. *Le Peintre-graveur.* 21 vols. Vienna, 1803–21.

Bauchal, C. *Nouveau dictionnaire biographique et critique des architectes français.* Paris, 1887.

Berckenhagen, E. *Die französischen Zeichnungen der Kunstbibliothek Berlin,* exhibition catalogue. Berlin, 1970.

Berliner, R. *Ornamentale Vorlageblätter des 15. bis 19. Jahrhunderts,* 3 vols. Leipzig, 1925–26.

Berliner, R., and G. Egger. *Ornamentale Vorlageblätter des 15. bis 19. Jahrhunderts,* 3 vols. Klinkhardt and Bierman, Munich, 1981.

Bernard, C. *Crosscurrents: French and Italian Neoclassical Drawings and Prints from the Cooper-Hewitt Museum, the Smithsonian Institution's National Museum of Design,* exhibition catalogue. Cooper-Hewitt Museum, New York, 1978.

Bertini, A. *I disegni italiani della Biblioteca Reale di Torino.* Rome, 1958.

Bitouze, C. "Le Commerce de l'estampe à Paris dans la première moitié du XVIIIᵉ siècle (1715–1750)." Thesis for the Ecole Nationale des Chartes. Paris, 1986.

Bjurström, P. *French Drawings in Swedish Public Collections, Sixteenth and Seventeenth Centuries.* Stockholm, 1976.

Blanc, Charles. "L'Union centrale des Beaux-Arts appliqués à l'industrie." *Gazette des Beaux-Arts,* 19 (1865), pp. 193–217.

Blunt, Anthony. *Art and Architecture in France, 1500–1700.* 2nd ed. London and New York, 1970.

———, editor. *Baroque and Rococo Architecture and Decoration.* London, 1978.

Boerner, C. G. *Ornamente aus vierhundert Jahren.* Dusseldorf, 1970.

Bottineau, Yves. *L'Art Baroque.* Paris, 1986.

Bourgoin, J. *Théorie de l'ornement.* Paris, 1883.

Brinckmann, A. E. *Esprit des nations: France–Italie–Allemagne.* Paris and Brussels, 1943.

Bruand, Y. "Un grand collectionneur, marchand et graveur du XVIIIᵉ siecle, Gabriel Huquier (1695–1772)." *Gazette des Beaux-Arts* 37 (1950), pp. 99–114.

Buchmann, M. *Ornament? ohne Ornament,* exhibition catalogue. Kunstgewerbemuseum, Zurich, 1965.

Butler, Ph. *Classicisme et Baroque dans l'oeuvre de Racine.* Paris, 1970.

Byrne, J. "Een zeldzaam ornamentboekje uit het atelier van Jacques Androuet Du Cerceau." *Bulletin van het Rijksmuseum* 25, no. 1 (1977), pp. 3–15.

Calcaterra, C. "Il problema del Barocco." In *Questioni e correnti di Storia letteraria,* edited by Arnoldo Momigliano. Milan, 1949.

Casselle, Pierre. "Le Commerce des estampes à Paris dans la seconde moitié XVIIIᵉ siècle." Thesis for the Ecole Nationale des Chartes, Paris, 1976.

Catalogue d'une très importante collection de Livres d'Architecture et de Recueils d'Ornements. . . . Paris, 1914.

Cattaui, G. "Baroque et rococo." *Critique,* no. 122 (July 1957).

Champeaux, A. de. *Histoire de la peinture décorative.* Paris, 1890.

Charpentrat, P. "Les Français devant le baroque." *Critique,* no. 175 (December 1961).

Coleridge, A. *Chippendale Furniture.* London, 1968.

Collin, I. *Katalog der Ornamentstichsammlung des Magnus Gabriel de La Gardie in der Königlichen Bibliothek zu Stockholm.* Stockholm, 1933.

Coomaraswamy, A. K. "Ornament." *Art Bulletin,* 21 (1939).

Croce, Benedetto. *Storia della Età barocca in Italia.* 2nd ed. Bari, 1946.

Dacier, E., and A. Vuaflart. *Jean de Julienne et les graveurs de Watteau au XVIIIᵉ siècle,* 4 vols. Paris, 1927–32.

Debes. *Das Ornament: Wesen und Geschichte.* Leipzig, 1956.

Del Borgo, G., and G. Neerman. *Disegni antichi architettura, scenografia, ornamenti,* exhibition catalogue. Milan, 1978.

Destailleur, H. *Recueil d'estampes relatives à l'ornementation des appartements aux XVIᵉ, XVIIᵉ, and XVIIIᵉ siècles.* 2 vols. Paris, 1863–71.

———. *Catalogue de dessins originaux reunis en recueils, oeuvres importantes des Saint-Aubin composant la collection de M. Hippolyte Destailleur, architecte du gouvernement.* Paris, 1893.

Destailleur, R. *Documents de decoration au XVIIIᵉ*

siècle: Peinture et sculpture decoratives, tapisseries. Paris, 1906.

Dolmetsch, N. *The Historic Styles of Ornament.* Batsford, 1898.

Dory, B. L. *Katalog der Ornamentstichsammlung,* exhibition catalogue. Museum für Kunst und Gewerbe, Hamburg, 1960.

Dresser, C. *Principles of Decorative Design.* 1873.

Duclaux, L. *Inventaire générale des dessins du musée du Louvre, école française,* vol. 12. Paris, 1975.

Dufournet, P. "La collection de dessins de l'Académie d'Architecture." *Les Cahiers de l'Académie d'Architecture* 1 (1981), pp. 3–22.

Duville, D. *La Science ornementale.* Paris, 1936.

Egger, G. *Das Bild der Antike in Literatur und Druckgraphik der Renaissance und des Barocks,* exhibition catalogue. Österreichisches Museum für Angewandte Kunst, Vienna, 1976.

Elliot, S. *An Exhibition of Ornamental Drawings 1550–1900,* exhibition catalogue. New York, 1987.

Evans, Joan. *Pattern: A Study of Ornament in Western Europe from 1180 to 1900.* 2 vols. Oxford, 1931; 2nd ed. New York, 1975.

———. *Style in Ornament.* Oxford, 1950.

Faucher-Magnan, A. *Les petites cours d'Allemagne au XVIIIᵉ siècle.* Paris, 1947.

Fenaille, M. *État général des tapisseries de la manufacture des Gobelins depuis son origine jusqu'à nos jours.* 5 vols. Paris, 1904–07.

Ferri, N. *Catalogo delle Stampe esposte al pubblico nella R. Galleria degli Uffizi con l'indice alfabetico degli'incisori.* Florence, 1881.

Fischer, C. *Les Costumes de l'Opéra du XVIIᵉ au XIXᵉ siècle.* Paris, 1931.

Fleming, John, and Hugh Honour. *The Penguin Dictionary of the Decorative Arts.* London, 1977; rev. ed., 1989.

Francastel, P. *L'Histoire de l'art, instrument de la propagande germanique.* Paris, 1945.

———. "La Contre-Réforme et les arts en Italie à la fin du XVIᵉ siècle." In *A travers l'art Italien,* by several authors. Paris, 1949.

———. "Baroque et classique, une civilisation." *Annales. Economies. Sociétés. Civilisations* 12, no. 2 (1957).

———. "Baroque et classicisme, histoire ou typologie des civilisations?" *Annales. Economies. Sociétés. Civilisations* 14, no. 1 (1959).

French Architectural and Ornamental Drawings from the Eighteenth and Early Nineteenth Centuries, exhibition catalogue. Hermitage, Saint Petersburg, 1971.

Führing, P. "The Print Privilege in Eighteenth-Century France—I," *Print Quarterly* 2, no. 3 (1985), pp. 174–93.

———. "The Print Privilege in Eighteenth-Century France—II," *Print Quarterly* 3, no. 1 (1986), pp. 19–33.

———. *Design into Art: Drawings for Architecture and Ornament.* The Lodewijk Houthakker Collection, London, 1989.

Gardin, J.-C. *Code pour l'analyse des ornements.* Paris, 1978.

Getto, G. "La polemica sul Barocco." In *Litteratura e Critica nel Tempo.* Milan, 1954.

Gombrich, E. H. "The Priority of Pattern." *The Listener*, March 1, 1979.

———. *The Sense of Order: A Study in the Psychology of Decorative Art.* Oxford, 1979.

Gruber, A. *L'Argenterie de maison du XVIe au XIXe siècle.* Fribourg, 1982.

Guilmard, D. *Les maîtres ornemanistes.* 2 vols. Paris, 1880–82; new ed., Amsterdam, 1968.

Gurlitt, C. *Das Barock- und Rococo-Ornament Deutschlands.* Berlin, 1885–89.

Hall, J. *Dictionary of Subjects and Symbols in Art.* London, 1974.

Hamlin, A. D. F. *A History of Ornament Renaissance and Modern.* London, 1974.

Hanebutt-Benz, E. M. *Ornament und Entwurf: Ornamentstische und Vorzeichnungen für das Kunsthandwerk vom 16. bis zum 19. Jahrhundert aus der Linel Sammlung für Buch und Schriftkunst*, exhibition catalogue. Museum für Kunsthandwerk, Frankfurt, 1983.

Harris, J. *Architectural Drawings in the Collection of the Cooper-Hewitt Museum*, exhibition catalogue. Cooper-Hewitt Museum, New York, 1982.

Haskell, Francis. *Patrons and Painters: A Study in the Relations between Italian Art and Society in the Age of the Baroque.* New Haven and London, 1963; rev. ed., 1980.

Haskell, Francis, and Nicolas Penny. *Taste and the Antique: the Lure of Classical Sculpture 1500–1900.* New Haven and London, 1981.

Hautecoeur, L. *L'Art baroque.* Paris, 1954.

———. *Histoire de l'architecture classique en France.* 9 vols. 2nd ed. Paris, 1967.

Havard, H. *L'Art à travers les moeurs.* Paris, 1882.

———. *Dictionnaire de l'ameublement et de la décoration depuis le XIIIe siècle jusqu'à nos jours.* 4 vols. Paris, 1887.

Heaton, J. A. *Furniture and Decoration in England during the Eighteenth Century.* 1892.

Hollstein, F. W. H. *Dutch and Flemish Etchings, Engravings and Woodcuts ca. 1450–1700.* Amsterdam, 1949.

Holzhausen, W. "Die Entwicklung des deutschen ornamentstichs im Zeitalter des Barocks." In *Die graphischen Künste.* Vienna, 1922.

Hymans, H. *Catalogue des estampes d'ornement faisant partie des collections de la Bibliothèque Royale de Belgique . . .* Brussels, 1907.

Illustrierter Katalog der Ornamentstichsammlung des K.K. Osterreichisches Museum für Kunst und Industrie. Vienna, 1871.

Illustrierter Katalog der Ornamentstichsammlung des K.K. Osterreichisches Museum für Kunst und Industrie. Erwerbungen seit dem Jahre 1871. Vienna, 1889.

Illustrierter Katalog der Ornamentstichsammlung des K.K. Osterreichisches Museum für Kunst und Industrie. Erwerbungen seit 1889. Vienna, 1919.

Irmscher, G. "Das Schweifwerk: Untersuchungen zu einem Ornamenttypus der Zeit um 1600 im Bereich ornamentaler Vorgeblätter." Thesis. Cologne, 1978.

———. *Kleine Kunstgeschichte des europäischen Ornaments seit der frühen Neuzeit (1400–1900).* Darmstadt, 1984.

Jean-Richard, P. *L'oeuvre gravé de François Boucher dans la collection Edmond de Rothschild au musée du Louvre.* Paris, 1978.

———. *Ornemanistes du XVe au XVIIe*, exhibition catalogue. Louvre, Paris, 1987.

Jervis, S. *The Penguin Dictionary of Design and Designers.* London, 1984.

Jessen, P. *Das Ornamentwerk des Daniel Marot.* Berlin, 1892.

———. *Katalog der Ornamentstichsammlung des Kunstgewerbemuseums zu Berlin.* Berlin, 1894.

———. "Das Deutsche Kunstgewerbe und der Zeichenunterricht." *Zeitschrift für gewerblichen Unterricht* (Leipzig), 1896.

———. "Die Ornamentische als Vorlagen für den Goldschmied." In *Kunstgewerbeblatt für das Gold-Silber- und Feinmetall-Gewerbe.* Leipzig, 1898.

———. "Die Arbeiten der Silberschmiede im Ornamentstich." In *Kunstgewerbeblatt für das Gold-Silber- und Feinmetall-Gewerbe.* Leipzig, 1898.

———. *Der Ornamentstich: Geschichte der Vorlagen des Kunsthandwerks seit dem Mittelalter.* Berlin, 1920.

———. *Mesiter des Ornamentstich: Gotik und Renaissance, Das Barock, Das Rokoko, Der Klassizismus.* 4 vols. Berlin, 1923–24.

———. *Katalog der Ornamentstichsammlung der Staatlichen Kunstbibliothek Berlin.* Berlin and Leipzig, 1936–39.

Josephson, R., and P. Francastel. "Nicodème Tessin le Jeune, relation de sa visite à Marly, Versailles, Clagny, Rueil et Saint-Cloud en 1687." *Revue de l'Histoire de Versailles et de Seine-et-Oise* (1926), pp. 149–67.

Kroll, R., and R. Timm. *Zauber des ornaments: Ausstellungs- und Bestandskatalog des Kupferstichkabinetts der Staatlichen Museen zu Berlin.* Berlin, 1969.

Laing, A. "French Ornamental Engravings and the Diffusion of the Rococo." In *Le Stampe e la diffusione delle immagini e degli stili, Atti del XXIVe Congresso internazionale di storia dell'arte (Bologna, 1979)*, vol. 8, pp. 109–27, Bologna, 1983.

Lambert, S. *Pattern and Design: Designs for the Decorative Arts 1480–1980*, exhibition catalogue. Victoria and Albert Museum, London, 1983.

Lehner, E. *Alphabets and Ornaments.* Cleveland and New York, 1952.

Lewis, P., and G. Darley. *Dictionary of Ornament.* 1990.

Mabille, G. *Orfèvrerie française des XVIe, XVIIe et XVIIIe siècles*, catalogue of the collections of the Musée des Arts Décoratifs and of the Musée Nissim de Camondo. Paris, 1984.

Magni, G. *Il barocco a Roma nell-architettura e nella scultura decorativa.* 3 vols. Turin, 1911–13 (plates).

Mark, J. "The Uses of the Term 'Baroque.'" *Modern Language Review* 33 (1938).

Meyer, P. *Das Ornament in der Kunstgeschichte.* Zurich, 1944.

Mostra del barocco piemontese, catalogue of an exhibition held at the Palazzo Madama and the Palazzo Reale-Palazzini di Stupinigi. 3 vols. Turin, 1963.

Mostra di disegni d'arte decorativa, catalogue of an exhibition of prints and drawings in the Uffizi. Florence, 1951.

Myers, Mary L. *Architectural and Ornament Drawings: Juvarra, Vanvitelli, the Bibiena Family and Other Italian Draughtsmen*, exhibition catalogue. Metropolitan Museum of Art, New York, 1975.

———. *French Architectural and Ornament Drawings of the Eighteenth Century*, exhibition catalogue. Metropolitan Museum of Art, New York, 1991.

Oman, C. *English Engraved Silver 1150–1900.* London, 1978.

Pevsner, Nikolaus. *Pioneers of Modern Design.* London, 1960.

Préclin, E., and V.-L. Tapié. *Le XVIIe siècle.* Paris, 1949.

———. *Le XVIIIe siècle*, part 2: "Les forces internationales." Paris, 1952.

Présentation de dessins d'ornement du XVIIe au XXe siècle, exhibition catalogue. Musée des Arts Décoratifs, Paris, 1978.

Racinet, A. C. *L'Ornement polychrome.* Paris, 1873–76; new ed., published in English as *Handbook of Ornaments in Color.* 4 vols. New York, 1978.

Réau, L. *L'Europe française au siècle des lumières.* Paris, 1951.

Reynard, O. *Ornements des anciens maîtres des XVe, XVIe, XVIIe et XVIIIe siècles.* 2 vols. Paris, 1845.

————. *Catalogue d'ornments dessinés et gravés par les maîtres des XVe, XVIe, XVIIe et XVIIIe siècles.* Paris, 1846.

Riegl, A. *Problems of Style: Foundations for a History of Ornament.* Trans. Evelyn Kain. Princeton, 1992 (original German edition: *Stilfragen,* Berlin, 1893).

Robaut, A. "Alexis Peyrotte un peintre oublié: Alexis Peyrotte peintre du roi (1699–1769)." *L'Amateur d'estampes,* January 1930, pp. 200–204.

Rocheblave, S. *L'Art et le goût en France de 1600 à 1900.* Paris, 1923.

Samoyault, J.-P. *André-Charles Boulle et sa famille.* Geneva, 1979.

Schmitz, H. *Katalog der Ornamentstichsammlung der Staatlichen Kunstbibliothek Berlin.* Berlin, 1939; new 2-vol. ed. New York, c. 1960.

Schneider, E. *Paul Decker der Ältere: Beiträge zu seinem Werk.* Frankfurt, 1937.

Schoenberger, A., and H. Soener. *L'Europe du XVIIIe siècle: L'art et la culture.* Paris, 1960 (translated from the German).

Seelig, L. "Studien zu Martin van den Bogaert genannt Desjardins (1637–1694)." Ph.D. thesis, Munich, 1980.

Sedlmayr, H. *Johann Bernhard Fischer von Erlach.* Vienna and Munich, 1956.

Souchal, François, *Les Slodtz, sculpteurs et decorateurs du roi (1685–1764).* Paris, 1967.

Sternberg, S. H. *Five Hundred Years of Printing.* London, 1955.

Tapié, V.-L. *Baroque et classicisme.* Paris, 1957; new ed., Paris, 1986.

————. *Le Baroque.* Paris, 1988 (6th ed.).

Thornton, Peter. *Authentic Decor: The Domestic Interior 1620–1920 . . .* London and New York, 1984.

Ubisch, E. von *Katalog der Ornamentstichsammlung des Kunstgewerbe-Museums zu Leipzig.* Leipzig, 1889.

Van Marle, R. *Iconographie de l'art profane au Moyen Age et à la Renaissance et la décoration des demeures.* 1931.

Vanuxem, J. "Notes sur les contrefaçons de gravures et ornments français au XVIIIe siècle à Augsbourg et sur leur influence en Souabe." *Bulletin de la Société de l'histoire de l'art français,* 1953.

————. "L'art baroque." In *Histoire de l'art* ("Encyclopédie de la Pléiade"), vol. 3. Paris, 1965.

Verlet, Pierre. *The Savonnerie: Its History. The Waddesdon Collection,* vol. x of *The James A. de Rothschild collection at Waddesdon Manor.* London and Fribourg, 1982.

————. *Le Château de Versailles.* Paris, 1961; 2nd ed., 1985.

————. *Les Bronze dorés français du XVIIIe siècle.* Paris, 1987.

————. *Le Mobilier royal français.* 3 vols. Paris, 1990.

————. *French Furniture of the Eighteenth Century,* trans. Penelope Hunter-Stiebel. Charlottesville, 1991 (original French ed., 1958; 2nd French ed., 1982).

Ward, J. *Historic Ornament.* 1897.

Ward-Jackson, P. "Some Main Streams and Tributaries in European Ornament from 1500 to 1750." *Victoria and Albert Museum Bulletin,* 3, nos. 2–4 (1967), pp. 58–71, 90–103, 121–34.

Weigert, R.-A. "Les décorations de Jean Bérain à l'hôtel de Mailly-Nesles." *Bulletin de la Société de l'histoire de l'art français* (1931), pp. 167–74.

Weigert, R.-A., and M. Préaud. *Inventaire du fonds français, XVIIe siècle,* vol. 7 of the catalogue of the print collection in the Cabinet des Estampes of the Bibliothèque Nationale. Paris, 1976.

Weinhardt, C. J. "Ornament Prints and Drawings of the Eighteenth Century." *Bulletin of the Metropolitan Museum of Art* 18 (1959–60), pp. 145ff.

Weisbach, W. *Der Barock als Kunst der Gegenreformation.* Berlin, 1921.

Wessely, J. E. *Das Ornament und die Kunstindustrie in ihrer geschlichtlichen Entwicklung auf dem Gebiete des Kunstdruckes.* 3 vols. Berlin, 1877.

Winner, M. *Zeichner sehen die Antike: Europäische Handzeichnungen 1450–1800,* exhibition catalogue. Kupferstichkabinett, Berlin, 1967.

Wölfflin, H. *Principles of Art History: The Problem of the Development of Style in Later Art.* Trans. M. D. Hottinger. New York, 1932. (Original German ed., 1915.)

Wornum, R. *Analysis of Ornament.* London, 1879.

Wunder, R. P. *Architectural and Ornament Drawings of the Sixteenth to the Early Nineteenth Centuries in the Collection of the University of Michigan Museum of Art.* Ann Arbor, 1965.

THE AURICULAR STYLE

Gravenitz, A. M. von. "Das niederländische Ohrmuschelornament: Phänomen und Entwicklung, dargestellt an den Werken und Entwürfen der Goldschmiedefamilien van Vianen und Lutma." Ph.D. thesis, Munich, 1973.

Hayward, J. F. *Virtuoso Goldsmiths and the Triumph of Mannerism 1540–1620.* London, 1976.

Molen, J. R. ter. "Van Vianen: een Utrechtse familie van zilversmeden met een internationale faam." Ph.D. thesis, 2 vols. Leiden, 1984.

Pechstein, K. *Wenzel Jamnitzer und die Nürnberger Goldschmiedekunst 1500–1700,* exhibition catalogue. Germanisches Nationalmuseum, Nuremberg, 1985.

Ternois, D. *L'Art de Jacques Callot.* Paris, 1962.

Wurzbach, A. von. *Niederländisches Künstler-Lexikon,* vols. 1–3. Vienna and Leipzig, 1906–11.

Zöllner, R. "Deutsche Säulen-, Zieraten- und Schildbücher 1610 bis 1680: Ein Beitrag zur Entwicklungsgeschichte des Knorpelwerkstils." Ph.D. thesis, Kiel, 1959.

Zulch, W. K. *Entstehung des Ohrmuschelstiles.* Heidelberg, 1932.

ACANTHUS

Beard, Stuck G. *Die Entwicklung plastischer Dekoration.* Hersching, 1983.

Blunt, Anthony. *The Drawings of G. B. Castiglione and Stefano della Bella in the Collection of Her Majesty the Queen at Windsor Castle.* London, 1954.

Hammerle, A. "Die Kupferstecher Nikolaus Drusse und Andreas Gentzsch in Augsburg." In *Das Schwabisches Museum.* 1925.

————. "Daniel Mignot." In *Das Schwabisches Museum.* 1930.

Hauglid, R. *Akanthus: Fra Hellas till Gudbrandsdal.* 3 vols. Oslo, 1950.

————. "Feuilles d'acanthe: Deux sculpteurs royaux." In *Opuscula in honorem C. Hernmark.* Stockholm, 1966.

Jänecke, W. *Über die Entwicklung der Akanthusranke im französischen Rokoko (1650–1750).* Hannover, 1902.

Nordenfalk, C. "Bemerkungen zur Entstehung des Akanthusornaments." *Acta Archeologica* 5 (1934).

Rothe, F. *Das deutsche Akanthusornament des 17. Jahrhunderts, zur Frage seiner Selbständigkeit.* Berlin, 1938.

Scherer, M. *The Acanthus Motive in Decoration,* exhibition catalogue. Metropolitan Museum of Art, New York, 1934.

Strauss, E. "Akanthus." In *Reallexikon zur deutschen Kunstgeschichte,* vol. 1. Stuttgart, 1937.

Vesme-Massar, A. de. *Stefano della Bella: Catalogue Raisonné.* Introduction and commentary by P. Dearborn-Massar. 2 vols. New York, n.d.

ARABESQUES, OR NEW GROTESQUES

Bauer, M. "Christoph Weigel (1654–1725), Kupferstechner und Kunsthändler in Augsburg and Nürnberg." In *Archiv fur Geschichte des deutschen Buchandels.* Frankfurt, 1983.

Bénard, M. *Cabinet de M. Paignon Dijonval.* Paris, 1810.

Bérain (1640–1711): ornemaniste et dessinateur des Menus-Plaisirs de Louis XIV, exhibition catalogue. Musée des Beaux-Arts, Nancy, 1961.

Bérard, A. Catalogue de toutes les estampes qui forment l'oeuvre de Daniel Marot, architecte et graveur français. Brussels, 1865.

Berckenhagen, E. "Zeichnungen von Christophe Huet im Kestner-Museum zu Hannover." Niederdeutsche Beiträge zur Kunstgeschichte, 1972.

Clouzot, H. Pierre Ranson, peintre de fleurs et d'arabesques. Paris, c. 1918.

Dacos, N. La découverte de la Domus Aurea et la formation des grotesques à la Renaissance. London and Leiden, 1969.

Deshairs, L. Les arabesques de Watteau: Panneaux décoratifs, écrans et trophées, gravés par Boucher, Crepy, Huquier, etc. Paris, 1911.

Dimier, L. "Quelques notes nouvelles sur Christophe Huet et les nouveaux dessins au musée de Valenciennes." Chronique des Arts et de la Curiosité, May 25, 1901, pp. 164–165.

Eidelberg, M. "Gabriel Huquier, Friend or Foe of Watteau?" The Print Collector's Newsletter 15, no. 5 (1984), pp. 157–64.

Gruber, A. Grotesques: un style ornemental dans les arts textiles du XVIe au XIXe siècle. Riggisberg, 1985.

Jessen, P. Das Ornamentwerk des Daniel Marot. Berlin, 1892.

Kimball, F. "Sources and Evolution of the Arabesque of Bérain." Art Bulletin 23 (1941).

La Gorce, J. de. "Le Merveilleux, ou les puissances surnaturelles (1671–1715)." Ph.D. thesis. Sorbonne, 1978.

———. Bérain, dessinateur du roi. Paris, 1986.

Lefort des Ylouses, R. "Des dessins de Bérain à la bibliothèque et au musée des Arts décoratifs." Bulletin de la Société de l'histoire de l'art français, 1954, pp. 39–46.

Le décor Bérain, exhibition catalogue. Musée des Tapisseries, Aix-en-Provence, 1954.

Louis XIV, faste et décors, exhibition catalogue. Musée des Arts Décoratifs, Paris, 1960.

Ozinga, M. D. Daniel Marot, de schepper van den hollandschen Lodewijk XIV stijl. Amsterdam, 1938.

Pulvermacher, L. "Arabeske." In Reallexikon für deutsche Kunstgeschichte, vol. 1. Stuttgart, 1937.

Rosenmayr, H. "Die Grotesken des Jonas Drentwett im Belvedere." In Prinz Eugen und sein Belvedere. Vienna, 1963.

Rupp, C. F. "Das Dekor des Bandlwerkstils und des frühen Rokokos in Franken." Ph.D. thesis. Erlangen, 1934.

Weigert, R.-A. "La Tenture des Triomphes marins d'après Jean I Bérain." Gazette des Beaux-Arts, 1937, pp. 330–34.

———. Jean I Bérain, dessinateur de la chambre et du cabinet du roi (1640–1711). 2 vols. Paris, 1937.

———. "Un artiste français en Hollande: Daniel Marot." Bulletin de la Société de l'histoire de l'art français, 1939, pp. 42–55.

———. "Les Grotesques de Beauvais." Hyphé, March–April 1946, pp. 66–78.

———. "Deux compositions gravés d'après Jean I Bérain et leurs transcriptions textiles." Gazette des Beaux-Arts, 1948, pp. 153–72.

———. Dessins du Nationalmuseum de Stockholm. Collections Tessin et Cronstedt. Claude III Audran (1658–1734), dessins d'architecture et d'ornements, exhibition catalogue. Bibliothèque Nationale, Paris, 1950.

———. "Un collaborateur ignoré de Claude III Audran: Les Débuts de Christophe Huet décorateur (1700–1759)." Etudes d'Art 7 (1952), pp. 61–78.

———. "La Tenture des Grands Dieux d'après Jean I Bérain." In Mélanges en l'honneur du professeur M. D. Ozinga, Opus Musivum, 1964, pp. 271–84.

———. "L'oeuvre gravé de Bérain." Nouvelles de l'estampe, no. 9 (1969), pp. 412–16.

———. "Jean I Bérain, décorateur des vaisseaux du roi." L'art et la mer, no. 2 (August 15, 1974), pp. 17–27.

Weigert, R.-A., and M. Préaud. Paris. Bibliothèque nationale. Cabinet des estampes. Inventaire du fonds français XVIIe siècle. Paris, 1976.

CHINOISERIE

Arts and the East India Trade, exhibition catalogue. Victoria and Albert Museum, London, 1970.

Appleton, W. Cycle of Cathay: The Chinese Vogue in England During the Seventeenth and Eighteenth Centuries. New York, 1951.

Bauer, H. Fernöstlicher Glanz: Pagoden in Nymphenburg, Pillnitz und Sanssouci. Munich, 1991.

Belevitch-Stankevitch, H. Le goût chinois en France au temps de Louis XIV. Paris, 1910.

Börsch-Supan, E. "Chinoise Innenräume des späten 18. Jahrhunderts," exhibition catalogue. Berlin, n.d.

Chambers, W. Designs of Chinese Buildings, Furniture, Dresses, Machines and Utensils . . . London, 1757.

Chinamode, exhibition catalogue. Riegersburg, 1979.

China und Europa, exhibition catalogue. Berlin, 1973.

Conner, P. Oriental Architecture in the West. London, 1979.

Cordier, H. La Chine en France au XVIIIe siècle. Paris, 1910.

Danis, R. La Première Maison royale du Trianon. Paris, c. 1926.

Dapper, O. Gedenkweerdig Bedryf der Nederlandsch-Oost-indische Maetschappye . . . in het Kazerrijke van Taising of Sina. Amsterdam, 1670.

Dimier, L. "Christophe Huet, peintre de chinoiserie et d'animaux." Gazette des Beaux-Arts, 37, no. 13 (1895), pp. 353–66, and 37, no. 14, pp. 487–96.

Drège, J.-P. La Route de la Soie: paysages et légendes. Paris, 1986.

———. Marco Polo et la Route de la Soie. Paris, 1989.

Le Goût chinois en Europe au XVIIIe siècle, exhibition catalogue. Musée des Arts Décoratifs, Paris, 1910.

Gruber, A. Chinoiserie: L'influence de la Chine sur les arts en Europe, exhibition catalogue. Riggisberg, 1984.

Gruber, A., and D. Keller. "Chinoiserie-China als Utopie." DU, April 1975.

Guérin, J. La Chinoiserie en Europe au XVIIIe siècle. Paris, 1911.

Hakluyt, R. The Principal Navigations, Voyages and Discoveries of the English Nation, Made by Sea or Over Land. 1598.

Halde, J.-B. Description . . . de la Chine et de la Tartare chinoise. Paris, 1735.

Haug, H. "L'Influence de la Chine sur la céramique européenne du XVIe au XVIIIe siècle." Cahiers de Bordeaux, 1960–61.

Honour, H. Chinoiserie: The Vision of Cathay. London, 1961.

Impey, O. The Impact of Oriental Styles on Western Art and Decoration. London and Melbourne, 1977.

Jarry, M. "L'exoticism dans l'art décoratif français au temps de Louis XIV." Bulletin de la Société d'étude du XVIIe siècle, July–October 1957.

———. Chinoiserie: Le rayonnement du goût chinois sur les arts décoratifs des XVIIe et XVIIIe siècles. Fribourg, 1981.

Jean-Richard, P. L'oeuvre gravé de François Boucher, catalogue of works in the Edmond de Rothschild Collection of the Cabinet des Dessins of the Louvre. Paris, 1978.

Kircher, A. China monumentis qua Sacris qua Profanis . . . illustrata. Amsterdam, 1667.

Kollmann, E. "Chinoiserie." In Reallexikon für deutschen Kunstgeschichte, p. 446ff. Stuttgart, 1954.

La Gorce, J. de. "Un peintre du XVIIIe au service de l'Opéra de Paris: Jacques Vigoureux Duplessis." Bulletin de la Société de l'histoire de l'art français, 1983, pp. 71–80.

Lecomte, L. Un jesuite à Pekin: nouveaux mémoires sur l'état présent de la Chine 1687–1692.

Edited by Frédérique Touboul-Bouyeure. Paris, 1990.

Lecomte, N. "L'exotisme dans le ballet: les chinoiseries au XVIIIᵉ siècle." *La recherche en danse*, no. 3 (1984), pp. 29–41.

Mandeville, Sir John. *The Travels of Sir John Mandeville: The Version of the Cathay Manuscript in Modern Spelling.* Edited by A. W. Pollard. 1964.

Martinius, Martinus. *De bello Tartarico Historia.* Antwerp, 1654.

Mendoza, J. G. de. *Histoire du Grand Royaume de la Chine.* Paris, 1589.

Montanus, A. *Atlas Japannensis.* Translated by J. Ogilby. 1670.

Nieuhoff, J. *L'Ambassade de la Compagnie orientale des Provinces-Unies vers l'Empereur de la Chine ou Grand Cam de Tartarie.* Translated by Jean Le Carpentier. Leiden, 1665.

Picard, R., J.-P. Kernis, and Y. Bruneau. *Les Compagnies des Indes: Route de la porcelaine.* Paris, 1966.

Pillement, G. *Jean Pillement.* Paris, 1945.

Rawson, J. *Chinese Ornament: The Lotus and the Dragon.* British Museum, London, 1983.

Roland Michel, M. "Représentations de l'exotisme dans la peinture en France dans la première moitié du XVIIIᵉ siècle." In *Studies on Voltaire and the Eighteenth Century.* Oxford, 1976.

Semedo, A. *Relatione della Grande Monarchia della Cina . . .* Rome, 1643.

Stalker, John, and George Parker. *A Treatise on Japanning and Varnishing.* London, 1688; reprinted, London, 1960.

Standen, E. "The Story of the Emperor of China: A Beauvais Tapestry Scene." *The Metropolitan Museum Journal* 2, 1976.

Thornton, P. *Baroque and Rococo Silks.* London, 1965.

Trigault, N. *Regni chinensis descriptio ex variis auctoribus.* Lyons, 1632.

Verlet, P. "Le commerce des objets d'art et les marchands-merciers à Paris au XVIIIᵉ siècle." *Annales. Economies. Sociétés. Civilisations,* January–March 1958, pp. 10–29.

Wagner, J. C. *Das mächtige Kayser-Reich Sina und die Asiatische Tartary vor Augen gestellt.* Augsburg, 1688.

Wappenschmidt, F. *Chinesische Tapeten für Europa.* Berlin, 1989.

Yamanda, C. *Die Chinamode des Spätbarocks.* Berlin, 1935.

ROCAILLE

Baudouin, F. "Rococoproblem." In *Miscellanea Historica in honorem Alberti de Meyer.* Brussels and Louvain, 1945.

Bauer, H. *Rocaille: Zur Herkunft und zum Wesen eines Ornament-Motivs.* Berlin, 1962.

Boyer, J. "Une famille de sculpteurs bourguignons établis en Provence au XVIIᵉ siècle, les Turreaux (ou Toro)." *Gazette des Beaux-Arts,* 1967, pp. 201–24.

Brandis, I. "Die Genesis des süddeutschen Muschelwerks: Ein Beitrag zur deutschen Ornamentgeschichte des 17. und 18 Jahrhunderts. Ph.D. thesis, Frankfurt, 1943.

Caillet, R. *Alexis Peyrotte, peintre et dessinateur du roi pour les meubles de la couronne (1699–1769).* Vaison, 1928.

Charpentrat, P. "Remarques sur la structure de l'espace baroque." *Nouvelle revue française,* August 1961.

Cournault, C. *Jean Lamour, serrurier du roi Stanislas à Nancy.* Paris, 1886.

Donnell, E. "Juste-Aurèle Meissonnier and the Rococo Style." *Bulletin of the Metropolitan Museum of Art* 36 (1941).

Du Colombier, P. *L'architecture française en Allemagne au XVIIIᵉ siècle.* 2 vols. Paris, n.d.
———. *L'Art allemand.* Paris, 1946.

Ducret, S. *Keramik und Graphik des 18. Jahrhunderts. Vorlagen für Maler und Modelleure.* Braunschweig, 1973.

Eggeling, T. *Studien zum Friderizianischen Rokoko: Georg Wenceslaus von Knobelsdorff als Entwurfer von Innendekorationen.* Berlin, 1980.

Fitz-Gerald, D. *Just-Aurèle Meissonnier and Others,* exhibition catalogue. Seiferheld Gallery, New York, 1963.

Freeden, M. H. von. *Balthasar Neumann: Leben und Werk.* Berlin, 1953.

Gallet, M. *Paris Domestic Architecture of the Eighteenth Century.* London, 1972.

Hegeman, H. W. *Deutsches Rokoko.* Königstein in Taunus, 1958.

Jessen, P. *Das Ornament des Rokoko und seine Vorstufen.* Leipzig, 1894.

Kimball, R. *The Creation of the Rococo.* Philadelphia, 1943; new ed., New York, 1980.

Krull, E. *Franz Xaver Habermann (1721–1796), ein augsburger Ornamentist des Rokoko.* Augsburg, 1977.

Lagrange, L. "Toro." *Gazette des Beaux-Arts* 25 (1868), pp. 345–52, 477–508.
———. "Catalogue de l'oeuvre sculpté, peint, dessiné et gravé de Bernard Toro." *Gazette des Beaux-Arts* 26 (1869), pp. 289–96.

Laran, J. *Cuvilliés, dessinateur et architecte.* Paris, 1932.

Laufer, R. *Style Rococo, style des "Lumières."* Paris, 1963.

Minguet, P. *Esthétique du Rococo.* Paris, 1979.
———. *France baroque.* Paris, 1988.

Nyberg, D. *Oeuvre de Juste-Aurèle Meissonnier.* New York, 1969.

Pons, B. *De Paris à Versailles: 1699–1736.* Strasbourg, 1986.

Powell, N. *From Baroque to Rococo: An Introduction to Austrian and German Architecture from 1580 to 1790.* London, 1959.

Reuther, H. *Die Kirchenbauten Balthasar Neumanns.* Berlin, 1960.

Roland Michel, Marianne. *Lajoue et l'art rocaille.* Paris, 1984.

Rupprecht, B. *Die Bayerische Rokoko-Kirche.* Kallmünz, 1959.

Schlagberger-Simon, A. *Süddeutsche Entwurfszeichnungen zur Dekorationskunst in Residenzen und Kirchen des 18. Jahrhunderts,* exhibition catalogue. Kunstbibliothek, Berlin, 1976.

Schreyer, A. *Die Möbelentwürfe Johann Michael Hoppenhaupt des Älteren und ihre Beziehung zu den Rokokomöbeln Friedrich des Grossen.* Strasbourg, 1932.

Schuster, M. *Ein Kupferstecher des süddeutschen Rokoko 1721–1788.* Munich, 1936.

Sedlmaier, R. *Grundlagen der Rokoko-Ornamentik in Frankreich.* Strasbourg, 1917.

Snodin, M. *Rococo Art and Design in Hogarth's England,* exhibition catalogue. Victoria and Albert Museum, London, 1984.

Teufel, R. *Vierzehnheiligen.* 2nd ed. Lichtenfels, 1957.

Vanuxem, J. Articles on the abbeys of Swabia, *Congrès archéologique de France,* 105th session, 1947.

Volle, N. "Toro: dessins d'ornement." *Etudes du Louvre* 1 (1980): "La Donation Suzanne et Henri Baderou au musée de Rouen," pp. 58–61.

Index

Photography Credits

The photographs in this volume were taken specially for it by Hubert Josse, with the exception of those listed and credited below.
The letters after the page numbers indicate the placement of the photographs reading from left to right and top to bottom.

Abegg-Stiftung, Riggisberg: 254 a; 257 a; 260; 261
A. C. L. Brussels: 452 b
Alinari: 442 b; 443 c; 444 a, c; 445 a, f
Alinari / Giraudon: 442 d
Alinari / Viollet: 442 a
Jörg P. Anders, Berlin: 223; 391; 415 a; 459 a; 460 e
Anderson / Giraudon: 443 b
Archives Fabbri: 446 a, b, c; 456 a, b
Artothek, Munich: 77 a
Ashmolean Museum, Oxford: 85 b
Badisches Landesmuseum Karlsruhe Bildarchiv: 460 f
Bayerisches Nationalmuseum, Munich: 131 c; 221 a; 459 b; 460 d
Bayerische Verwaltung der Staatlichen Schlösser, Gärten und Seen, Munich: 86 b
Bibliothèque d'Art et d'Archéologie, Fondation Jacques Doucet, Paris: 125 a, b; 138 b; 145 a; 163 c; 175 b, c; 183 a; 186 a, b; 188 b; 190 b; 225; 256 b, c; 264 a; 265 b, c; 267 a; 275 c, d; 276; 277 b; 288 b; 299 b; 301 b; 303 b; 306 b; 307 c; 316 a, d; 322 b; 323 b; 337 b; 364 a; 376 a, c; 422 a, b
Bibliothèque Nationale, Paris: 19; 21; 111; 134 c; 171 b; 186 c; 194 b; 200 a; 212 a; 213; 220; 222 b; 270 a; 276 a; 282 b; 320 c; 340; 352; 360 a; 385; 390 a, b; 394 a; 399; 421; 427 a
Bildarchiv Foto Marburg: 451 b, c; 457 b, d; 458 a
Bildarchiv Preussischer Kulturbesitz, Kunstgewerbemuseum, Berlin: 129 c; 132 a; 155
Osvaldo Böhm: 445 e; 446 d
Osvaldo Böhm: Museo Correr, Venice: 130 a
British Library, London: 66 b
British Museum, London: 56 a
Brumaire / Artephot: 271
Bulloz: 440 d
Achim Bunz: 370 b; 371 a, b; 431
Patrick Cadet © CNMHS / SPADEM: 437 c
Canadian Centre for Architecture, Montreal: 205 b; 428
Centraal Museum, Utrecht: 76 a; 80 b
Charlottenburg, Berlin: 129 a
Charles Choffet, Musée des Beaux-Arts et d'Archéologie, Besançon: 288 a; 289; 290 a; 291 a; 292 a; 293 a
Christie's, London: 321 c
Ciné Photo Provence, Aix-en-Provence: 194 a
Conway Librarian, Courtauld Institute of Art, London: 447 c
A. C. Cooper, Ltd.: 450 b

Alexis Daflos, The Royal Collections, Stockholm: 344 b
Dagli Orti: 139 a; 408; 455 c
De Danske Kongers Kronologiske Samling på Rosenborg: 452 e
Araldo De Luca, Rome: 215
Documents Mercier-Ythier: 201 a, b
Ecole Nationale Supérieure des Beaux-Arts, Paris: 163 b
Andreas von Einsiedel / National Trust Photographic Library: 448 f
Ellebé, Rouen: 386
FA-Viollet: 457 c
J. Feuillie © CNMHS / SPADEM: 438 b
The Fine Arts Museums of San Francisco: 200 b
Fondation Custodia (F. Lugt Collection), Institut Néerlandis, Paris: 55 b; 396 b
Foto Dikken & Hulsinga / Popken, Leeuwarden: 65 c
Foto Popken, Leeuwarden: 91 b
Frans Halsmuseum, Haarlem: 76 b; 255 a, b
Gaeta & Gaeta, Laura Valentini, Naples: 145 c; 409 a
Giacomo Gallarate, Oleggio: 135 a; 445 b
Gemeente Archief, Rotterdam: 47 b
Dominique Genet: 436 d; 437 b, f; 438 c, d
Germanisches Nationalmuseum, Nuremberg: 87 d
Giovetti, Mantua: 104 d
Giraudon: 436 b; 437 d; 438 e
Roger Guillemot / Edimedia: 438 a
Jacqueline Guillot / Connaissance des Arts, Edimedia: 436 c
Reha Günay: 406 b
Haags Gemeentemuseum, The Hague: 74 c
Tom Haarsten: 29 a; 39 a; 41; 46 a, b; 47 a; 56 b; 61 b; 63 a, b; 66 a; 67; 68 a, b; 69 a, b, c, d; 72 a, b; 75 a; 78 a, b, d; 79 a, b; 82 a, b, c; 83 a, b; 84 a; 86 a; 136 b, c
Ham House, Victoria & Albert Museum Picture Library: 78 c; 116 a, b; 185 b
P. Hinous / Connaissance des Arts Edimedia: 438 f
Historisk Museum Universitetet I, Bergen: 453 f
Institut für Denkmalpflege, Dresden: 368 a
Inventaire Général des Monuments et des Richesses Artistiques de la France, Centre de Documentation du Patrimoine © SPADEM 1992: 398 a; 415 b
The J. Paul Getty Museum, Malibu: 183 b, c, d; 309 a; 377 a, b, c; 380 b; 388 a; 400 a, d

Krzysztof Jablonski: 461 d
A. F. Kersting: 459 c
Koninklijk Penningkabinet (royal medal cabinet), Leiden: 62 a, b
Kulturhistorisches Museum, Magdeburg: 87 a, b
Kunstindustrimuseet, Oslo: 452 d
Kunstverlag Hofstetter, Ried im Innkreis: 413
Lucinda Lambton / Arcaid: 448
Lucinda Lambton / National Trust Photographic Library: 300 a
Landesmuseum Joanneum, Graz: 131 a
Lauros-Giraudon: 436 a; 437 a
Erich Lessing: 16; 126; 127 a; 357; 459 d; 461 b
Erich Lessing / Magnus: 295; 303
E. Liljeroth, The Royal Collections, Stockholm: 275 a
Håkan Lind, The Royal Collections, Stockholm: 395 a
Livrustkammen Skoklosters Slott, Hallwylska Museet, Stockholm: 86 a
The Living Landscape Trust: 184 b; 382 a
C.-G. Magnusson, Riksarkivet, Stockholm: 174 b
Paolo Marton, Magnus Edizioni: 121
Mas, Barcelona: 205 c; 454 a, c, d; 455 b; 456 a, d
MAS Patrimonio Nacional, Madrid: 454 b; 455 d, e; 456 e, f
Mauritshuis, The Hague: 451 a
Arnold Meine Jansen, Baarn: 185 c
The Metropolitan Museum of Art, New York: 71 a; 136 a; 167 a; 181 b; 258 a, b; 296; 297; 317; 321 a; 326; 384 b; 392 b; 393; 418 a; 419 a
Alain Moatti: 322 a; 323 a
Mobilier National, Paris: 94; 191 a; 198; 214 a, b
Musée des Arts Décoratifs, Paris: 439 a, d, e; 440 b, e; 441 a; 456 c, e, f;
Musée Camondo, Paris: 440 c; 441 c, d, f
Musée National Suisse, Zurich: 138 c; 140 b; 146 a; 191 a; 226
Musées de la Ville de Strasbourg: 204 c; 439 b
Museo Biblioteca e Archivio. Bassano del Grappa: 282 c
Museum für Angewandte Kunst, Cologne: 127 b; 148 a; 153 a; 154 a, b; 192 b; 308 d; 320 a
Museum für Kunsthandwerk, Frankfurt: 460 a, c
Museum für Kunst und Gewerbe, Hamburg: 460 b
Museum of Fine Arts, Boston: 63 c; 91 c; 189 a
National Gallery, London: 263
National Gallery of Art, Washington: 210
The National Portrait Gallery, London: 91 a

495

National Trust Photographic Library: 316 b; 449 c

Werner Neumeister: 117 a, b, c; 118 a, b; 119 a, b;
120 a, b; 202 b; 208; 212 b; 272 a, b, c; 273;
284 a, b, c, d, e, f; 285; 351; 354; 363 b; 364 c;
366 a, b; 367 b, c; 370 a; 373; 374; 417; 429;
430; 457 a; 458 c, d

Sven Nilsson, The Royal Collections,
Stockholm: 52

AB Nyköpings Bildjarst, Nyköping: 282 a

Paulmann-Jungblut, Staatliche Museen
Preussischer Kulterbesitz, Kunstbibliothek,
Berlin: 205 a; 217 a

Luis Pavao, Arquivo Nacional de Fotografia
Instituto Portugues de Museus, Lisbon:
311 b

Clay Perry / Arcaid: 448 d

Yves Petit, library, Besançon: 227

Phedon Salou / Artephot: 337 a

Private collections: 10; 57; 70 b; 144 a, b; 149;
150 b; 207 a, b; 245; 252; 254 b, c; 256 a;
262 a, b; 270 b; 298 a, c

RCHM (England), National Monuments
Record: 447 a, b, d; 448 a, b; 449 a, b

RMN, Paris: 439 f; 441 b, e

Rijksbureau voor Kunsthistorische
Documentatie, The Hague: 29 b

Rijksdienst voor de Monumentenzorg: 452 a

Rijksmuseum, Amsterdam: 25; 26; 33 b; 39 b;
55 a, c; 58 a, b, c, d; 59 a, b, c; 60 a, b;
61 a, c; 64 a, b; 65 a, b; 70 a; 71 b; 73 b;
74 a, b; 75 b, c; 76 c; 77 b; 80 a; 84 b, c; 90 b;
452 f; 453 a, c, g

Rijksmuseum Twente, Enschede: 75 d

Roger-Viollet: 437 e; 443 d; 451 d; 461 a

Royal Botanical Gardens, Kew: 271 b

The Royal Collections, Stockholm: 113 a; 275 b;
394 b; 452 c; 453 b, e

The Royal Danish Collection, Rosenborg
Palace: 453 d

Santos d'Almeida: 152 a

Scala: 97 a; 104 a, b, c; 105; 277 a; 443 e; 444 b, d;
445 c, d; 458 b; 459 e

H. P. Schreiber, Cologne: 211; 219 a; 222 a

Service de Restauration des Musées de France:
419 c

Pedro Soares: 426 a, b

V. Solomatine: 461

Spanish Tourism Office: 455 a

Staatliche Graphische Sammlung, Munich: 412

Staatliche Museen Preussischer Kulturbesitz,
Kunstbibliothek, Berlin: 163 a, b; 204 a, b;
209 a; 218 c; 358 a (montage of seven prints)

Staatliche Schlösser und Gärten, Potsdam,
Sans-Souci: 218 a; 362 b; 460 h

Staatliches Museum, Schwerin: 64 c

Staats- und Stadtbibliothek, Augsburg: 221 b

Städtisches Museum, Flensburg: 200 c

Statenskonstmuseer, Stockholm: 60 c; 113 b;
158; 171 a; 182 b; 191 b; 192 a; 196; 197; 199 b;
202 a; 203 a; 206; 283; 411 b

John Stoel, Groningen: 81

Vladimir Terebenine: 88 b

Dr. Eva Toepfer, Königstein im Taunus: 147 a

The Toledo Museum of Art: 449 d

Denis Toulet, Musée des Beaux-Arts et de la
Dentelle, Calais: 142 b

University Library, Basel: 54 a; 234; 235; 241;
264 b; 266 a, b; 267 a; 268-69; 272 d; 274 a;
280 a, b, c; 286 a, b, c; 290 b; 291 b; 292 b;
293 b; 302 a, b, c; 318 a; 321 b

Victoria & Albert Museum Picture Library,
London: 33 a; 54 b; 90 a; 150 c; 184 a ; 185 b;
218 b; 299 a; 300 c; 376 b; 418 a; 420 b; 439 c;
448 e; 449 e; 450 a, c, d, e, f

Reinaldo Viegas, Calouste Gulbenkian
Foundation, Lisbon: 423

Wallace Collection, London: 139 b; 193 c; 307 d;
346; 379

Kit Weiss, Rosenborg Castle: 62 c; 88 a; 89

Jeremy Whitaker, National Trust Photographic
Library: 300 b

Cuchi White: 443 a; 444 e

O. Woldbye, Copenhagen: 73 a

Worshipful Company of Goldsmiths, London:
310 a

We would like to offer special thanks to the
Visual Arts Library, London, for its
assistance.